Moving Rooms

A
CATALOGUE

OF ALL THE

Materials of the Dwelling-House,
Out-Houses, &c.

OF HIS GRACE

James Duke of *Chandos,*

Deceas'd,

At his late Seat call'd CANNONS,

near *Edgware* in *Middlesex* :

Divided into such easy Sortments, or Lots, *as to make it agreeable to the Publick.*

Which will be sold by AUCTION,

By Mr. *COCK,*.

On *Tuesday*, the 16th. of *June* 1747, and the Eleven following Days (at CANNONS aforesaid.)

The said HOUSE, &c. *may be view'd every Day* (Sunday *excepted*) *to the Hour of* SALE, *which will begin each Day at Half an Hour after Eleven precisely, by all Persons who shall produce a Catalogue of these Materials, which may be had at One Shilling each.*

CATALOGUES may be had at *Grigsby's* Coffee-House behind the *Royal Exchange* ; at Mr. COCK's, in the *Great Piazza, Covent-Garden* ; at the *White Hart*, in *Watford* ; the *Three Pigeons*, in *Brentford* ; and at either of the Lodges leading up to *Cannons*, from *Stanmore*, or *Edgware*.

N. B. *In the first Day's Sale will be sold, the* Gardens *and* Pasture-Land, *round the said House, being* FREEHOLD, *in four Lots, containing* 415 *Acres, agreeable to the Plan which may be seen at the said House,* or at Mr. COCK's, *with the Conditions of Sale.*

The CONDITIONS of SALE.

Imprimis, THAT each Lot is to be put up as *per* CATALOGUE to the highest Bidder, who shall be deem'd the Buyer ; *unless any other Person as a Bidder immediately claims it,* then it's to be put up again.

Secondly, the Buyer is to give in his Name and Place of Abode, and make a Deposite in Part of Payment for every Lot he shall buy,

of

Moving Rooms

JOHN HARRIS

PUBLISHED FOR THE PAUL MELLON CENTRE FOR STUDIES IN BRITISH ART

BY YALE UNIVERSITY PRESS NEW HAVEN AND LONDON

FOR ABIGAIL

Copyright © 2007 Yale University

Typeset in Sabon by SNP Best-set Typesetter Ltd., Hong Kong
Designed by Sally Salvesen
Printed in China through World Print

Library of Congress Cataloging-in-Publication Data

Harris, John, 1931–
Moving rooms : the trade in architectural salvages / John Harris.
 p. cm.
Includes bibliographical references and index.
ISBN-10 0-300-12420-1 (alk. paper)
ISBN-13 978-0-300-12420-0
1. Interior decoration. 2. Period rooms--Conservation and restoration.
3. Decorative arts--Collectors and collecting. 4. Moving of
buildings, bridges, etc. 5. Salvage (Waste, etc.) I. Title.
NK1860.H37 2007
745.028'8--DC22
 2006029075

FRONTISPIECE: Mr Cock's Canons, Edgware, demolition catalogue, 16–27 June 1747.
Yale Center for British Art, New Haven

CONTENTS

10 APRIL 1912, A TITANIC LOSS

WRITING OF WRECKS REMINDS ME of the ill-fated *Titanic*. I had sold some thirty tons of old oak beams, doors, etc., to an American, and I shipped them on the *Titanic*. The day the vessel sailed a friend of mine, who knew that I had shipped this valuable old oak on the vessel, said to me, 'You nearly lost all your oak this afternoon; there was a great displacement of water in the docks as *Titanic* was going out, and she broke away from her tugs, and the Dock authorities thought she would smash into the pier.' Coming events sometimes cast their shadows before them with a vengeance; in this instance, it was not many days after that that I heard of the dreadful disaster. My poor little cargo of oak was of little consequence in comparison with the dreadful loss of life. I can still visualize the ancient oak I had so lovingly handled lying fathoms deep in the ocean, a loss to humanity.

Thomas Rohan, *Confessions of a Dealer*
London, 1924

ACKNOWLEDGEMENTS

The journey to these acknowledgements has been long and protracted, for I was delving into museum accession files in the USA in 1962, following which there occurred a long hiatus. With the exception of one female Decorative Arts Curator, now retired, who sifted the files before showing them to me, I have met with courtesy and kindness wherever I enquired. First and foremost I must acknowledge a Leverhulme Foundation grant of £12,000 for travelling expenses. Alas for my pocket, that cost exceeded the grant by £15,000. I have received a grant towards photography from Christopher Gibbs on behalf of the Getty Trust; a generous grant from Drue Heinz; and another from the J.M. Kaplan Fund. My warm thanks go to the Paul Mellon Centre for Studies in British Art in London, and especially to Brian Allen and Frank Salmon there, who agreed to co-publish my book with Yale University Press. The Getty Center for the Humanities in Los Angeles enabled me to spend two periods studying the archives of Carlhian et Cie, relevant not immediately to this book, but for their role as the most important transhipper of *boiseries* to the Americas. At the Getty I must thank Wim de Wit and his one-time periodic colleague, Teresa Morales, the efficient cataloguer of the Carlhian archive, who has been a trusted researcher on my behalf.

It is necessary to single out certain museums where I have worked for lengthy periods or received co-operation and patient answers to my many enquiries. I recollect with fondness: at the Museum of Fine Arts, Boston, Malcolm Rogers, Tracey Albainy, Julia McCarthy and, late of the museum, Curt di Camillo; and also in Boston Richard Nylander at Historic New England (still familiarly known by me as the Society for the Preservation of New England Antiquities); at the Art Institute of Chicago, Ghenete Zelleke; at the Cincinnati Museum of Art, Carola Bell, and late of the museum, John H. Wilson; at the Detroit Institute of Arts, Alan Darr and Brian Gallagher; at the Nelson Atkins Museum, Kansas City, Catherine Futter, Elizabeth Walker and, late of the museum, Michael Churchman; at Long Island University, C.W. Post Campus, Dr Donald Ungarelli and Donna Marciano; at the Minneapolis Institute of Arts, Christopher Monkhouse, Jennifer Komar Olivarez and Jennifer Carlquist; at the Nassau Museum of Art, Jean Henning; at the Metropolitan Museum of Art, New York, late of the museum my old friend Bill Rieder, and Danielle Kishik-Grossheide, Jeff Munger, Morrison Heckscher, Tim Husband and Christina Alphonso; at the Frick Collection, Colin Bailey and Mary Lydecker; at Avery Library of Columbia University, Gerald Beasley; at the Philadelphia Museum of Art, Kathryn B. Heisinger and her charming staff includ-

Acknowledgements

ing Donna Corbin and Diane Minnite, as well as the museum's archivist Susan K. Anderson and her assistant Louise Rossmassier, and in Rights & Reproductions Holly Frisbee; at the North Carolina Museum of Art, Raleigh, Michael Klauke and Neil Fulghum; at the Art Museum of St Louis, David Conradsen; at the Legion of Honor Museum, San Francisco, and late of the museum, Lee Hunt Miller; at Wake Forest University Library, Josh Berkov; at the Zanesville Art Center, Debbie Lowe. In Canada, at the Royal Ontario Museum, Toronto, Peter Kaellgren and Bob Little, and also Bob's wife Myra. In the Netherlands I owe much to my friend Rainier Baarsen and his colleague Dirk Jan Biemond, for their explanation of Dutch period rooms.

In England, at the Bowes Museum, Claire Jones; at the Bristol Museums and Art Gallery, Sheena Stoddard and Julia Carver; at the Victoria and Albert Museum my undying thanks go to Christopher Wilk and his staff, including Sarah Medlam, James Yorke and Frances Collard, and to Elaine Morris in Images and Reproductions. A special thank-you goes to Barbara Shapiro Comte for facilitating research in Paris; to Jennifer Park at Columbia University who has ably enquired after houses in the USA furnished by Charles Roberson; to Catherine Wright for her extensive research into the documentation of Wroxton, Highcliffe Castle and Rothamsted Park; to Marcus Koehler in Berlin for providing me with much information on period rooms in German museums; to my friend Peter Lang in New York for his enthusiasm for delving into dealers' catalogues and enriching my check-list, and to Christopher Jussel in that city for his knowledge of his family firm, Arthur S. Vernay; to Georgina Gough for her knowledge of the Anglo-American firm of Stair and Andrew; to James Miller for sharing his research on the restoration of Berkeley Castle; to Ian Gow for answering my endless enquiries about period rooms; to Desmond Fitz Gerald, Knight of Glin, always willing to participate in debate; to Ian Leith and Alyson Rogers, always helpful at English Heritage, Swindon; to my old mentor, my constant correspondent, Sir Howard Colvin, the recipient of all sorts of enquiries; to William Howard Adams for conversationally giving me so many ideas; to Brian Mitchell, the grandson of Francis Lenygon, for being so free with his trove of information on the firm of Lenygon & Morant; to William Palin at Sir John Soane's Museum, for being my aimable computer doctor, so patient with my constant cries for lap-top help; to Tim Knox for the first reading of my text, one that I am sure he could have written better, and to Maurice Howard for the second reading, both offering valued and rigorous criticisms. As a special acknowledgement, I pay tribute to the local history librarians in our towns and cities and to the archivists in our County Record Offices. Without them where would we be?

No doubt I have missed out many, but I hope I have included them in the following general list: James A. Abbott, David Adshead, Rebecca Aken, Chris Alexander, John Allan, Dr Astrid Arnold, Amy Babinec, Ingolf Bauer, Rainer Baum, Sir Geoffrey de Bellaigue, Marianne Berchtold, Barry Bergdoll, Roger Berkowitz, Amy Berman, Michael Bevington, E. Charles Beyer, Marcus Binney, Claude Blair, John Lord Booth II, Paul Bradley, Tammy Braithwaite, Steven Brindle, Ronald

Brister, Mosette Broderick, Haydon Burns, Donald Cameron, Lindsey Campbell, Karen Cardinal, Mrs Muriel Carrick, Julia Carver, Lord Cavendish of Furness, Martin Chapman, Angelica Condrau, Marguerite Coppens, Carolynn Cotton, Mrs Cummins, Anna Eavis, Nancy Edwards, Scott Erbes, David Esterley, Hoyt Fields, Hazel Forsyth, Jo Friedman, Holly Frisbee, R. Neil Fulghum, Claire Gapper, Carole Garrard, Nicole Garnier, Richard Garnier, Christopher Gibbs, Mark Girouard, Dr Wolfgang Gluber, Andor Gomme, Alvar Gonzales Palacios, Todd Longstaff Gowan, G. Ulrich Grossman, Francoise Hack, Katie Haigh, Michael Hall, John Hardy, Bernard Heitmann, Richard Hewlings, Sally Hinkle, M. J. Hinman, Wilhelm Hornbostel, Margaret Iacono, Anne van Ingen, Sylvia Inwood, Simon Jervis, William R. Johnston, Clair Jones, D. Rainer Kahsnitz, Frank Matthias Kammel, Victoria Kastner, Gerhard Kaufman, Robin Kern, Anthony Kersting, Katy Kline, Gordon Kingsley, Wolfgang Koeppe, Alistair Laing, Roberta Laynor, Mary Levkoff, Tom Lloyd, Todd Longstaffe Gowan, Carl Lounsbury, Julie A. Ludwig, Mary Lydecker, Robert B. Mackay, Richard Marchant, Michele D. Marincola, Aimee Marshall, Etienne Martin, S. J. Mason, Malcolm McKie, Andrew Mealey, Arline Meyer, Craig Miller, Donald Miller, James Miller, Paul Miller, Denise Milliner, Diane Minnite, J.J. Minton, Tom Mitchie, Lee Mooney, Rebecca More, Roger O. Moss, Susan Munt, John Murdoch, Bill Murray, Jeremy Musson, David Neave, Charles Noble, Magnus Olausson, Noel Osborne, Konrad Ottenheym, Hans Ottomeyer, Richard Pare, Liana Paredes, James Peill, Elizabeth Pergam, Anne L. Poulet, Genevieve Preston, Uwe Quilitzsch, Nancy Richards, Timothy A. Riggs, Jane, Lady Roberts and Sir Hugh Roberts, John Martin Robinson, Mrs Frances Roden, Bertrand Rondot, Treve Rosoman, Frank Salmon, Peter Sandbeck, Harold Winthrop Sands, Robert Scaler, Mrs Raquel Saye, Jonathan Scott, Mathias Senn, Josephine Shay, Josephine Shea, Kate Silverman, Robert M. Skaler, Dr Anna Zofia Skarzyniska, Bianca Slowik, David Steel, Sheena Stoddard, Bob Strong, Lanto Synge, Roxamme Tanemori, Christopher Terry, Hildegard Vogeler, Marc Wanamaker, William Wanamaker, Giles Waterfield, Peter Welford, Andrew Wells, Gloria William, Ute Winkelmann.

Finally, two heartfelt acknowledgements: to my wife who has been a long-suffering observer and bystander during the long gestation of this book, and last but by no means least, to Sally Salvesen, for no author could have had a better, more co-operative, and sensitive editor; to the fine copy-editor, Beth Humphries who has so improved my text; and to Catherine Bowe. I salute all three.

PROLOGUE: A BOOK IS BORN

I HAVE REFERRED IN TWO earlier autobiographical writings to the excavation of the memory.[1] In those books I had forgotten about an incident in Uxbridge that had involved both Uncle Sid and a young John Harris. In the very July of 1945 when I left Greenway Elementary School, aged nearly fourteen, a US Army B25 crashed into the 78th floor of the Empire State Building in New York. As a consequence of this, Armand Hammer bought the ruined 78th floor to house his United Distillers of America. His refurbishment included the installation of a room from the Medici Palace of San Donato near Florence to serve for the Tasting Room, and two Elizabethan rooms, the larger the so called Treaty Room (see Fig. 104) and a smaller adjacent one, called the Presence Chamber, both from the Treaty House at Uxbridge, in which the Royalist and Parliamentarian commissioners attempted a treaty in January 1645 to end the Civil War.[2] Sid had known the rooms well, for he regularly fished in the adjacent River Frays, as indeed did I, and took refreshment in the inn. He had joined a local protest group in August 1929 against the sale of the rooms to the USA, but in 1953 he announced with some excitement that Armand Hammer had presented the rooms to the Queen as a celebration of her Coronation. Upon advice from the Victoria and Albert Museum they were re-installed in the Treaty House in 1958.[3] I recollect that not only did we go to see the rooms, but we also fished.

There have been several other personal events on my route to this book. In the early 1960s I bought Le Pautre's engravings of the Château de Richelieu, and in 1968 had been intrigued to read that when Jacques Lemercier began to build Cardinal Richelieu's new chateau late in 1631, the Gothic chapel and a *salon* from the old family castle were to be incorporated, 'a sentimental act which betrayed the Cardinal's self-consciousness of his own restricted and rather humble childhood'.[4] Clearly this was an act of family piety. I had also visited the eighteenth-century Gothic House at Schloss Worlitz, then in East Germany, and noticed the sixteenth-century Renaissance portrait room that Prince Franz of Anhalt-Dessau had saved[5] from his town palace in Dessau when it was under reconstruction by G.W. von Knobelsdorf in 1750 (Fig. 1).[6] It was first put into storage until incorporated into his Gothic house in the 1780s. It too was obviously venerated for its family associations. In 1970 I had admired with Alvar Gonzales Palacios the exquisite 'Gabinetto della Libreria' (Fig. 2) in the Palazzo Quirinale in Rome. Made for the royal Villa della Regina near Turin in 1733 by Pietro Piffetti for Carlo Emanuele II of Savoy, it was moved to the Castello di Moncalieri nearby, and moved again in 1880 with the royal family to the Quirinale Palace.[7]

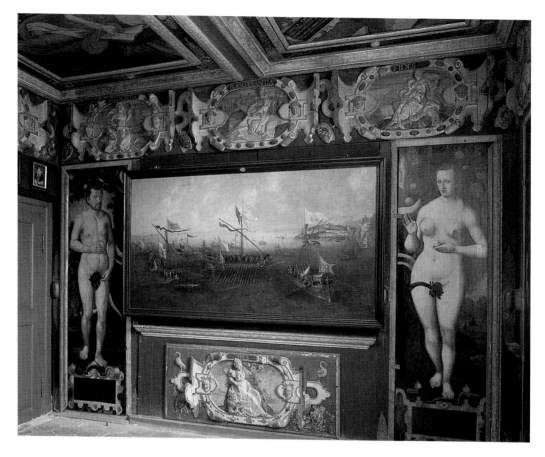

1. Schloss Worlitz, Germany. The sixteenth-century renaissance portrait room removed from Schloss Dessau, now in the Gothic House, Schloss Worlitz

Also in Rome marbles had been collected for a room described as the 'Gabinetto' or 'Petit cabinet', which was shipped to England in 1728 for the 3rd Duke of Beaufort at Badminton House, Gloucestershire, to house his celebrated cabinet.[8] I associated this type of Roman export with the Chapel of John V of Portugal in the church of San Roque, Lisbon, a wondrous marble and ormolu confection ordered specifically from Rome in 1748.[9] In Rome too, in the Palazzo Braschi, I had noted an Etruscan-style grotesque décor of 1837, saved from the Palazzo Torlonia when it was demolished in 1902. It had been sold to the Neapolitan antiquary Francesco Tancredi in 1903 and eventually was bought for the Museo de Roma in 1952. Of course, from more modern times, I had also read of the most famous, or rather infamous, travelling room, the Amber Room,[10] a treasure cabinet of carved and polished amber made by Gottfried Wolfram for King Frederick I of Prussia in 1701 and presented by Frederick Wilhelm I as a diplomatic gift to Peter the Great in St Petersburg in 1716. It remained in store until the Empress Elizabeth came to the throne in 1743. It then started on its travels, first to her Winter Palace on the

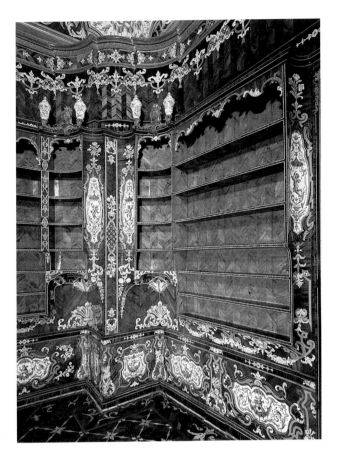

2. Detail of the Biblioteca dell'Piffetti, Quirinale
Palace, Rome

Neva,[11] where by the end of 1745 it had moved from room to room no less than
five times, until it ended up in the Catherine Palace at Tsarksoye Selo, where under
Catherine II it was expensively reconstructed with the addition of French mirrors
and Florentine *pietra dura* pictures. Like the Biblioteca del Piffetti it was composed
of demountable sections, as a wooden panelled interior might be, and in 1941 the
German army packed it into twenty-eight crates and moved it to the castle of
Königsberg in East Prussia, a repository for works of art stolen by the Nazis. There
it remained until early 1945, when it disappeared on further mysterious travels and
was probably destroyed.

I had also read[12] about the travels of the Spiegelkabinett[13] now in the Munich
Residenz, which originated in the suite of Karoline, Countess Palatine in the Hôtel
des Deux-Ponts, in Strasbourg, was richly furnished between 1780 and 1785, by
King Max Joseph of Bavaria on the occasion of his marriage, and moved to Munich
in 1799 after the French revolution. I had visited Franz II of Austria's hunting lodge
of Laxenburg near Vienna, where on an island in the English park he had built the

3. Court Room of the Foundling Hospital, London, rococo interior of late 1740s

astonishing Franzenburg between 1798 and 1801 in the form of a medieval castle, almost entirely made up of architectural salvages. In the later 1960s I visited the Thomas Coram Foundation in 40 Brunswick Square to enquire about architectural designs of the Foundling Hospital, demolished in 1926. There I admired the re-installation in this neo-Georgian building in 1937 of the hospital's celebrated Court Room (Fig. 3).[14]

In 1959–60 I began the long odyssey that led to this book. When I was married in New York in 1960 I began to make notes on the English rooms we saw in American museums. I wanted to enquire as to their origins.[15] Already I had explored the ruins of Piercefield Park, Monmouthshire, so in 1960 I examined its chimneypiece by Joseph Bonomi in the Philadelphia Museum of Art;[16] or in 1959 I had examined the architectural drawings owned by Mrs Budgett of Kirtlington Park, Oxfordshire, and eventually I related them to the Kirtlington Saloon (see Fig. 155) in the Metropolitan Museum of Art. These preliminary enquiries came to fruition in 1974 when I was the co-organizer with Marcus Binney of 'The Destruction of the Country House' exhibition hosted by Roy Strong at the Victoria and Albert Museum. What I had observed of empty and derelict country houses in the 1950s, as related in my *No Voice from the Hall*, now had a more poignant and

4. The Long Gallery at Ashley Park, Surrey, 1720s, prior to demolition *c.* 1925

telling significance. Here on view were all the demolished houses from which complete rooms, staircases, or built-in furniture, had been extracted for sale, burnt on lawns, broken up, or transhipped across the Atlantic. From *c.* 1920 to *c.* 1960 this resulted in one of the largest movements of architectural and decorative salvages in history. One example was the splendid and noble Long Gallery (Fig. 4) from Ashley Park, Surrey, a house demolished *c.* 1920. This was the masterpiece of Sir Edward Lovett Pearce. Through an unknown English dealer Ashley's rooms were dispersed and the Long Gallery was seen by me in 1962 in the warehouse of French & Co. in New York. Since then it has disappeared, no doubt broken up into many portions. All these individual examples persuaded me to enquire further into the circumstances of moving rooms, to investigate the movement of architectural salvages throughout the ages, and to scrutinize how these rooms became period rooms in European and American museums.

5. Kilnwick Hall, Yorkshire, the Justice Room. Sixteenth-century panelling from Leconfield Castle, Yorkshire, before removal to Burton Agnes Hall, Yorkshire

INTRODUCTION

THE SUBJECT OF THIS BOOK has been the moving and transformation of architectural salvages, and by salvages is meant not only interior elements or fitments, but also complete rooms. The transformation from one place to another, often as an association of like elements, was described by Bruno Pons as metamorphosis. *The Moving of Rooms* was an obvious title, for as far as the transatlantic trade was concerned rooms were a principal and expensive item of export. A companion in my odyssey from the late 1970s was the work of Clive Wainwright, whose parallel study of antiquarianism in architecture, décor and the arts culminated in 1989 in *The Romantic Interior: The British Collector at Home 1750–1850*.[1] He recognized that many interiors were created from architectural and ornamental salvages displaced from somewhere else. His tale was essentially of the late eighteenth and early nineteenth centuries–Walpole of Strawberry Hill, Scott of Abbotsford, Beckford of Fonthill, Meyrick of Goodrich, Scarisbrick of Scarisbrick–and he was among the first to discuss the roles of the auction house, dealer and broker in marketing these salvages.[2]

Wainwright did not consider the use and importation of ecclesiastical woodwork, the subject of Charles Tracy's *Continental Church Furniture in England: A Traffic in Piety* in c. 2001. Tracy's catalogue is a demonstration of the huge movement of carved woodwork, mainly from the Netherlands and the Low Countries, most of it due to French revolutionary depredations, to the London auction houses. So common was this trade with dealers around Oxford Street and in Soho, that it was described as the 'Wardour Street Trade'. Individual articles on country houses have dealt with the use and dissemination of salvages : Mark Girouard on Scarisbrick Hall, Lancashire,[3] Tim Knox on Harlaxton Manor, Lincolnshire,[4] Christopher Hussey on Highcliffe Castle, Dorset,[5] Howard Colvin on Eythrope House, Buckinghamshire,[6] or Shena Stoddard on Brislington House, Bristol.[7] But one of the most compelling documents for the re-use of materials in the first half of the eighteenth century is the unique annotated copy (Fig. 10 and frontispiece) of *A Catalogue of All The Materials of the Dwelling-House, Out-Houses, &c, Of His Grace James Duke of Chandos Deceas'd at his late Seat Call'd Cannons*,[8] a revelation of how a great mansion was lotted up and totally dismembered between 16 and

27 June, 1747, encouraging a rush by architects, masons and sculptors to buy its parts. Nevertheless, all this only adds up to a piecemeal assessment, and the phenomenon of salvage and re-use has never been broadly examined, whether in England or anywhere else.[9]

In England what needs to be emphasized is the huge scale of demolition, and consequent re-use of materials. Although there are no collected statistics on re-use previous to 1900, the replacement or rebuilding of any house, or indeed of any building, resulted in salvage of some sort. Giles Worsley's statistics in *England's Lost Houses: from the Archives of Country Life*,[10] are an admission that such houses are hard to accumulate or quantify. For example, he notes that of 267 notable Early Tudor houses, more than half had gone.[11] His gazetteer of lost houses since *c.* 1885 now lists more than 1200, and it is not far-fetched to reckon that the total loss in this span of nearly 120 years may well exceed 1,500.[12] In such a period there was nothing like this destruction on the continent, even in wartime. It is mind-boggling to think that at least 4,000 chimneypieces have gone travelling due to the vigorous post-1900 trade in such interior elements.

The phenomenon of travelling salvages is not confined to recent times. Great landowners who possessed several castles or houses might demolish one that had become redundant and move useful materials to another seat, while unfashionable medieval or Tudor panelling might be used to line the walls of the attics of new or rebuilt houses. In Yorkshire, when Leconfield Castle was reduced in 1608, salvages were removed to Wressle Castle, and subsequently from there to Kilnwick Hall (Fig. 5), and then on to Burton Agnes. There was always the question of thrift, and some owners were reluctant to lose great chimneypieces adorned with family heraldry. Hence when Canonbury House, Islington, became redundant, chimneypieces were moved by the Earls of Northampton to Compton Wynyates, Warwickshire and Castle Ashby, Northamptonshire. Movement might also be caused by the demolition of a house and the dispersal of its salvageable parts to houses in the locality. When Nonsuch Palace was demolished in 1682 much material was used at nearby The Durdans; the loss of Eythrope House, Buckinghamshire led to a scattering of bits and pieces throughout the Vale of Aylesbury[13] and further afield (Fig. 12).

By 1700 there is growing evidence of a specialized use of salvages occasioned by the increased appreciation by families of the antiquity of their house and the wish to provide an appropriate antiquarian ambience. In particular the embellishment of Great Halls became a fashion. Burton Agnes in Yorkshire (Fig. 20) and Cowdray Park, Sussex (Fig. 24), are examples of this in the early eighteenth century. By 1820 in the age of Wainwright's *Romantic Interior*, the making of complete antiquarian rooms out of salvages was becoming commonplace.

Unless a room was demountable, such as Robert Adam's Glass Drawing Room in Northumberland House, or the Biblioteca Piffetti in Turin, both of which were assembled in parts, it would have been difficult to remove a room in its entirety, and enormously costly to remove plaster ceilings and wall decoration. An original ceiling is one of the most noticeable omissions in period rooms in museums. Hence nearly all transatlantic exported rooms were of the wood-panelled sort, whether of

Tudor wainscot or Williamite bolection framed panels. There is far more documentation about the movement of rooms in France than in England,[14] for the average French room of the ages of the 'Three Louis's' was one composed of wood and gilded *boiseries* that were easier to move. The first *boiseries* to be imported into England were for the Elizabeth Saloon at Belvoir Castle, Rutland, in 1824 (Fig. 53), but these did not comprise a complete room. Amplification by a process of mix and match was necessary. The problem of moving and installing a room was comparable to finding a picture to fit a frame, so whatever their nationality, rooms usually required manipulation to fit the site.

There was another consideration related to the making of period rooms. Rooms in a new-built house are programmed for use and function, and every room answers via its windows to the external architecture. There are internal connections throughout the plan. Extract those rooms and much is lost: the iconographic meaning associated by ornament with a dining-room chimneypiece ornamented with bunches of grapes, for example, would become redundant. Hence the sequence of three rooms from Sutton Scarsdale in the Philadelphia Museum of Art may be fitting for the display of paintings, and may represent a continuum of stylistic décor, but they have lost their intrinsic meaning, and are no more than an appropriate background for display. Many lose much else, for even if there are only minor manipulations as regards size and plan, entrance walls or window walls must often be exchanged to accord with museum planning, and if rooms are to be entered, as they should properly be, there must be an entry and an exit. Nowadays fire regulations prohibit single entry and exits. It is becoming more and more evident that the need for manipulation has been a constant and necessary agreement made between the dealer and the museum director. In Philadelphia again, the New Place, Upminster room and two of the Sutton Scarsdale rooms have giant orders on high pedestals flanking the chimneypiece. Not a coincidence, but a means by which the dealer Charles Roberson was able to give his order that extra height to serve the museum's needs. We may regard this with some alarm, but it was a necessity. This raises the whole issue of fakery and forgery which has bedevilled considerations of rooms in museums over the past fifty years.[15]

In the USA directors or curators of almost every museum of any size presenting the decorative and applied arts have vied to possess one or more period rooms in a chronological development. The Art Museum of St Louis, emulating Philadelphia, installed a Jacobean room from Prinknash, Gloucestershire, a baroque one from Wingerworth Hall, Derbyshire, a Palladian one from Charlton House, Kent, and a neo-classical one from Kempshott Park, Hampshire, all supplied, as at Philadelphia, by Charles Roberson in the later 1920s. As in many museums, all have been dismantled and de-accessioned.[16]

Before the 1950s the period room in American museums was rarely examined as to authenticity, as a painting or sculpture might be. For rooms, directors or curators were entirely at the mercy of dealers in New York, London or Paris (whether Duveen or French & Co. in New York, Charles Roberson or Gill & Reigate in London, or Carlhian et Cie in Paris).[17] Hence, 'The Dealer Ruled',[18] and many

museums received what today we would recognize as swans that turned out to be geese, and in some cases completely invented composites.[19] Whereas from the late nineteenth century there were experts such as a Bode or a Berenson to authenticate painting or sculpture, if a room from a long since demolished English country house required authentication, an American curator would have found this almost impossible to achieve. English furniture might have been authenticated by a Percy Macquoid or a Margaret Jourdain, who were in any case deeply involved with the trade, but rooms fell into the category of architectural history. In Britain between the First and Second World Wars country house muniment rooms were inaccessible, regional archive offices were not seriously in business until after 1945, and architectural history was not yet a profession. It would have been impossible to authenticate the history of an offered room. Even an intelligent museum director such as the distinguished architect–historian Fiske Kimball in Philadelphia was at a loss how to confront this problem. Of course, the problem grew slowly and insidiously. Whereas even as early as 1928 the furnishings of the Woodcote Park Room in the Boston Fine Arts Museum were under serious scrutiny, the room was not, and it was only in the late 1950s that the composition of the room was seen to differ from what was first taken out of the house. In that gap of thirty years architectural history had come of age. Only recently have eleven variant hands been identified in the so-called 'Louis XIII Gold Room' (Fig. 185) in the Nelson Atkins Museum, Kansas City, and this is due to curatorial expertise and modern techniques of paint analysis.

In the history of the emergence of the period room, the year 1876 appears to be a useful marker. In the USA the Philadelphia Centennial Exhibition of 1876 showed composed ambiences displaying furniture and objects, some rather like antique shop displays. This exhibition, known as the Centennial, had already underlined the need to study and reassess native American and Colonial cultures. In 1876 too, at the Historiche Tentoonstelling van Amsterdam, the architect Pierre Cuypers installed a number of seventeenth-century period rooms partly using old panelling and chimneypieces. In the same year in Boston, there occurred two, perhaps linked, events, the acquisition of the iconic Lawrence Room for the Boston Athenaeum, and an exhibition of three simple rooms or alcoves made up by Benjamin Perley Poore from wooden salvages from his house at Indian Hill.[20] A year later, in 1877, the artist J.E. van Heemskerck van Beest sold to the Nederlandsch Museum (the precursor of the Decorative Arts Department of the Rijksmuseum) two panelled rooms from Dordrecht which had been installed in his own house in 1869. These were the first rooms acquired by a Dutch museum, and such early initiatives were probably far more important than the emphasis usually placed upon tableau of the Madam Tussauds's sort exhibited by Artur Hazelius in 1878 at the Paris World's Fair at the Trocadéro Palace.[21]

Museum displays were to be affected by a burgeoning of interest in Europe after the 1860s in the collecting and display of the furniture, sculpture, ceramics and other manifestations of the decorative arts. The standard museum display based upon private galleries with framed paintings and perhaps a collection of antique and

modern sculpture was not enough. There was now a need for a more contextual dis-
play, and there can be little doubt that museum directors and curators absorbed
what they saw or knew of the private interiors of rich collectors such as the
European Rothschilds. The idea was that such assemblages, then becoming com-
mon to the private salon, could be transferred to the public gallery: this happened
first in the Netherlands, Switzerland and Germany, when a chronological proces-
sion of period rooms was seen as the ideal means of presenting the arts and fur-
nishings of the interior. Nationalism was a growing incentive, particularly in
Zurich, Nuremberg, Munich, Berlin and Stockholm,[22] where curators sought to
identify and display what they regarded as characteristic of their national styles.
There was the related phenomenon in Europe of creating rooms in open air and folk
museums, especially in northern Germany and the Scandinavian countries, in
response to the growing sense of nationalism and a concern for a fast-disappearing
culture. The aim was to enquire into ethnic origins and exhibit the life of the bour-
geois and farming classes. Not surprisingly, this was also a time when Europe's great
medieval and Renaissance castles were being restored as national icons. At
Gripsholm in Sweden some of the prevailing 'Gustavian' neo-classic eighteenth-cen-
tury interiors that had usurped the original Renaissance ones were replaced by oth-
ers considered to be in a more appropriate Swedish Renaissance style.[23] All over
Europe there was a growing concern for the preservation of endangered architecture
and interiors at a time when urban development was destroying so much.

Despite the Philadelphia Centennial, the USA was slow to respond to these
European initiatives. The Lawrence Room, iconic as the first imported European
room into the USA, was not moved from the Boston Athenaeum into the new
museum on Huntington Avenue until 1909. This was also the year of the opening of
the Hudson Fulton Exhibition at the Metropolitan Museum of Art, whose aim was
both to encourage the initiation of period room displays and to boost studies of
American Colonial architecture, furniture and the decorative arts. This much-
applauded-exhibition led to a programme of period room acquisition beginning
with the Hewlett House panelling in 1910, the first in a sequence that resulted in the
opening of the new American Wing in 1924.[24] Not until 1918–19 did the
Minneapolis Institute of Arts buy its Hingham Manor, Suffolk Room, and in 1922
Philadelphia acquired its Tower Hill Room. But certainly between these two dates
museum directors were discussing the acquisition of period rooms, as they might
say, 'in the manner of the German Museums'.

It seems extraordinary that there has been no all-embracing study of the
American period room. Naturally, there are many in-house studies of individual
rooms by museum curators[25] using material lying in the rich accession files[26] of
each museum. It is surprising that a study of these files has never been made, since
they document the changes in taste in the life of the object. There is now easy access
to these files, whereas fifty years ago departmental curators were loath to make
them available. At that time, all was not well with perceptions of these rooms. By
creating these rooms, curators were not just slavishly following a European fashion,
for the rooms responded to different needs. In the vast land mass of North America,

although internal tourism had been encouraged by the creation of National Parks, such as Yosemite in 1864, and the establishment of the National Park Services in 1903, European travel was still élitist, and restricted to the upper classes. This is borne out by a statement by that much-travelled sculptor and salvage scavenger George Grey Barnard. At the celebrated opening of his Barnard Cloisters (Figs 161–62) on Washington Avenue, New York, on 14 December 1914, he explained that he intended them 'for Americans who never can, or will see Europe'.[27] This was ironic in view of the fact that within three years thousands of American soldiers would see French cathedrals and die on the killing fields of the Western Front. Nevertheless, Barnard was implying that the answer was to import European architecture and art. Barnard's Cloisters were acquired for the Metropolitan Museum of Art in 1925, but not until 1938 would they open in Fort Tryon Park as the famous Cloisters, one of the world's largest and most distinguished gathering of salvages.

By 1925 the Metropolitan was well into its programme of installing European period rooms, although it would not be until 1932 that they acquired English rooms. What differentiates sequences of period rooms in the USA from those in Europe is that the major European museums, such as the Musée Carnavalet or Musée des Arts Décoratifs in Paris, generally confined themselves to the presentation of décor originating in their own country. The principal exception in Europe was the Victoria and Albert Museum. The urge and educational necessity to represent world art in the USA led to the presentation of a confection of rooms, cloisters, doorways, alcoves, ceilings, and all sorts of architectural and interior salvages, from France, England, Germany, Italy, the Netherlands and Spain, and of course from the Near and Far East. To our travel-weary eyes and educated minds in the third millennium, a Renaissance chimneypiece from Bristol (see Fig. 186), now in the Cincinnati Museum of Art, may seem an anomaly.

Most period rooms, especially in the USA, are installed without their original ceilings and with only three walls. As the visitor can rarely pass through them, they are picture boxes, typified at the highest artistic level by the post-Second World War Wrightsman Rooms in the Metropolitan Museum of Art presented by the French decorator Henri Samuel for Mrs Jayne Wrightsman. Even in these the *boiseries* have had to be cleverly adapted to the offered space, and are subservient to the great paintings and decorative and applied arts that they contain. The rooms are no less than glorious treasure caskets, vitrines of a very special sort.[28] If the museum was able to invite the eighteenth-century inhabitants back to their rooms, they would hardly recognize them, and were it possible to furnish in the style of the period, visitors would feel cheated by what they saw, for the arrangements would be quite different to what they might imagine them to have been. The problem that has recently beset curators is a concern not only about the authenticity of the provenance of the room itself and the composition of the décor, but also about the authenticity of its furnishings. This is particularly so with sixteenth- and seventeenth-century furniture. When the Victoria and Albert Museum wished to re-present its Elizabethan Bromley-by-Bow Room (Fig. 130), only one piece of appropriate and authentic furniture could be found in the entire museum! It is now accepted that many examples

of Renaissance furniture in public and private collections are either composite or fake.[29] Numerous museums have dismantled their rooms, preferring fluidity of display. When a period room is dismantled much woodwork is discovered to be either 'modern' or composed of differing and unrelated woods, as when the Charlton House room was dismantled at the Art Museum of St Louis.[30] It is not quite like the variety of woods to be found in the hundreds of fragments of the True Cross, but nearly so. Before coming to the Cincinnati Museum of Art, the Henry IV Cabinet had a combination of old and modern pastiche paintings, and most of the framing elements were modern. In the same museum, the Louis XV Huet Painted Room comprised the work of three hands, two of them modern. The large Louis XVI Anson Room with five 'lives' had been expanded to three times its original size since 1913, when it was described as a Petit Cabinet. What is not appreciated is just how many 'lives' these rooms can have. It could be said that the majority of rooms in American museums have had at least one other life, if not more. The Anson Room, bought by Carlhian in Paris in 1913, had been extracted from a nineteenth-century Parisian mansion, sold to the Ansons for New York, removed after the First World War to their apartment in Paris, returned to their new house on Fifth Avenue, New York, then bequeathed to the Metropolitan Museum of Art, who passed it on to Cincinnati. The travels of the so-called 'Louis XIII Gold Room' (in fact Louis XIV) in the Nelson Atkins Museum, Kansas City, are even more astonishing. It may have had nine or more lives.[31] Even at the venerated Musée des Arts Décoratifs, where it might be expected that authenticity would have been respected, when Bruno Pons examined the history of successive room installations and re-installations he found evidence of the constant mixing and matching of fragments of *boiseries* irrespective of provenance.[32] The wooden elements were arranged almost aesthetically. Not surprisingly he describes this process as a 'metamorphosis' of salvages.

If we consider the average museum visitor, their vision of historic accommodation is a populist one, not necessarily discriminating. They must have enjoyed the lost sequence of furnished rooms once in the Art Museum of St Louis, or in the Legion of Honor Museum, San Francisco, or rooms that can still be seen in their original installation, secure in their success, in Minneapolis or Philadelphia. In general these visitors do not question authenticity of room or furnishings. Yet even in the most carefully researched and presented sequence of rooms such as the American examples in the Brooklyn Museum of Art[33] or the American Wing at the Metropolitan Museum of Art, furnishings are in general hypothetical selections.[34] If the question was put, 'Why are American rooms not subject to the same stringent examinations as to authenticity as are works of art?', the answer would be that they are, but more are swans and fewer are geese, because in contrast to European rooms there is neither necessarily a dealer, nor the Atlantic, between room and the museum. Many of the Brooklyn rooms were carefully extracted from existing houses, arousing much venomous criticism because they were not all salvages from a doomed house. This is an acute reminder that consideration of the American period room cannot be dissociated from experiences of the creation and furnishing of rooms in Colonial houses. The same criteria apply.

Those great museums that have resolutely retained their sequences of European period rooms, notably the Metropolitan Museum of Art, the Philadelphia Museum of Art and the Minneapolis Institute of Arts, recognize that if the public were asked what aspect of museums they liked best of all, the populist reply would be the period rooms. Whenever a room is de-accessioned or sold off by a museum there is an outcry in the press. There can be little doubt that old-fashioned ambiences still hold visitors spellbound. The making of these rooms in the 1920s and 1930s cannot be detached from the invented rooms at Colonial Williamsburg, where the task was to decorate and furnish newly created rooms as they might have been under a succession of governors. The problem at Colonial Williamsburg, as indeed anywhere else, is that each successive restoration is reflective of its time. Henry Francis du Pont's creation of his house/museum at Winterthur sits right in the centre of all this. He may have started out with the idea of creating a logical sequence of furnished domestic interiors, but so omnivorous was Du Pont in his collecting, making, and furnishing of rooms that he ended up with an indigestible assemblage. In more recent years there have been many revisions, but the house is still redolent of Du Pont's taste, and only rarely does the authentic taste of the eighteenth or nineteenth century come through. It is exactly the same with the Thorne Miniature Rooms in the Chicago Art Institute. From the 1920s Mrs James Ward Thorne made sixty-eight rooms in styles ranging from 1600 to 1940, and imagined that she was creating accurate ambiences, whereas with our more educated, and perhaps tired eyes, we see the rooms as perfect examples of Revival styles (Fig. 180). Similarly at a much later date with the reconstruction of Tryon Palace, North Carolina, burnt down in the later eighteenth century and rebuilt from 1950. In order to convey authenticity the interiors incorporated identified salvages from London dealers, principally Crowthers of Syon Lodge, Isleworth. However, the accepted view of Tryon Palace is that the interiors still look of their time, the 1950s, and may they long remain so.

In this third millennium we can stand back and reassess the period room, so essential to a study of salvages. It is obvious that the role of American museums has been to educate, and the furnished period room was one way of presenting not only its own history, but that of world civilization. After the Second World War with the astonishing rise of country house tourism and with television programmes on upstairs and downstairs life in the English country house, sequences of English rooms in American museums were seen as irrelevant. This became even more true from the 1960s, when American tourism in Europe became populist. Tourists could now see the convincing real thing in ways that would be impossible in the USA.[35] Another criticism of the period room in the USA is that although it may demonstrate the stylistic progress of interior décor and furnishings, it is often presented without any history of provenance and use. What cannot be conveyed by a museum display is how the room was used within its house, and obviously the lifestyle of the occupants of that house. Herein lies the great divide between the period room in a museum and the reality of visiting a functioning country house, whether it be National Trust, English Heritage or a private house open to the public. Today it is

possible to identify interactions and cross-fertilization between the American presentation of their Colonial and greater country houses and country house presentations in Britain. It is probable that American Colonial house curators were in on the act of upstairs/downstairs well before England. All are now accepting the need for what at one time were regarded as fringe attractions: functioning kitchens offering period food and beverages, life in the attics and nurseries, flower displays, guides in period costumes, and the revival of old walled kitchen gardens, or indeed of stables. All this Colonial Williamsburg does to perfection.[36] This renaissance has gone hand in hand with the parallel worldwide phenomenon of open air and folk museums, where many exhibits are salvaged buildings from elsewhere, but that is an international salvage tale that must be told elsewhere.

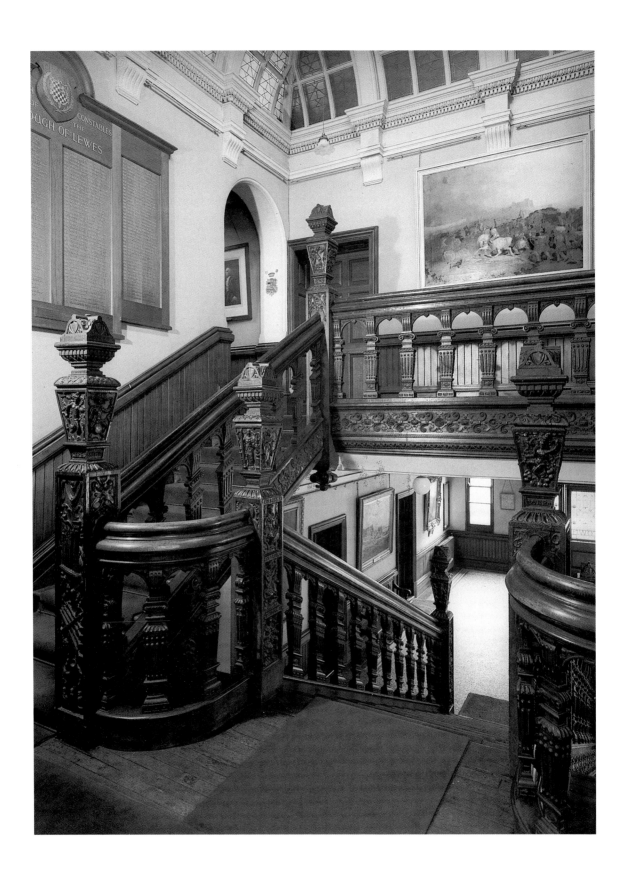

1

SALVAGING THE INTERIOR:
1500–1820

A SIMPLE PERAMBULATION OF A great Elizabethan and Jacobean house such as Knole in Kent, with eyes trained on the panelling, or wainscot as it is familiarly called, not on the glorious furniture or paintings, will demonstrate the extent to which wooden elements have been moved or rejigged over the centuries. Unhappy conjunctions of mouldings or string courses are tell-tale evidence of movement, as in Lady Betty Germaine's Dressing Room, or indeed in the Brown Gallery, which may well be an early eighteenth-century antiquarian compilation, made up in veneration of an earlier period, or where the retention of a pilastered order was for sheer economic necessity, re-used to save money. In many cases such movement was simply good housekeeping: it must have occurred in every great medieval or Tudor–Jacobean mansion before the renovations of the eighteenth and nineteenth centuries. Alas, these renovations destroyed much precious internal evidence, so much so that controversy arises over the dating of many installations that incorporate salvages.

Basically, panelling was a wall covering intended to minimize the chill from medieval stone walls. It served as an alternative to the more expensive tapestry. The earliest form of panelling in England was vertical boards.[1] By the 1520s these tall narrow panels became progressively square, and in the fourteenth century developed into what was known as 'wainscoting'. The plain fields would later be elaborated by carved linenfold – panelling resembling folded linen – covering the lower parts of a wall, often as a base to an encircling frieze of ornamental or heraldic panels, as can be seen (Fig. 84) in the Ellenhall, Staffordshire, wainscot.[2] It might simply cover entire walls from floor to ceiling. Wooden elements were not confined to walls: they would join and interact with door frames, or would be attached to and include chimney surrounds and overmantels, or tie in with wooden-beamed ceilings. The whole might be typified by the Abbot's Parlour with its internal porch at Thame Park, Oxfordshire, c. 1530.

6. Slaugham Place, Sussex, Elizabethan stair installed in the Star Inn, Lewes, Sussex, rearranged when the inn was adapted to Lewes Town Hall

The potential for moving carved wooden elements is borne out by legal documents drawn up to prevent removal at the termination of a lease,[3] or by evidence in *The Wainscot Book* kept by the Dean and Chapter of Winchester Cathedral as a record of all panelling in the house of the Close.[4] The value placed upon panelling, and on *seeling*,[5] has been dealt with by Maurice Howard in his study of inventories.[6] Sir Cotton Gargrave's goods at Nostell Priory in Yorkshire in 1588 included *'The seelinge In the newe great chamber'*, which must imply a wooden panelled and carved ceiling, and in *'the little newe chamber nere to the great chamber'*. The entry, 'i *framed* table ii furmes [sic] and ii other formes joyned to the seelinge', must describe a conjoined wooden wall to ceiling element, and 'the seelinge in the gallery not praysed (priced)' implies a potentially movable wooden element, not a decorative plastered ceiling.[7] In other words, carved wooden panelling, doors and chimneypieces were in certain circumstances regarded as movables, valued as a chair, cupboard or tapestry might be.

What is movable can obviously be moved! Old-fashioned linenfold panelling might be replaced or updated by Renaissance panelling, as in the Long Gallery at Haddon Hall, Derbyshire, first installed by Sir George Vernon *c.* 1550 with perhaps a form of linenfold, as can be seen in the present Parlour,[8] then dismantled *c.* 1603 when Sir John Manners installed a richer ornamental system.[9] Whether due to redecoration or rebuilding, or because it increasingly became unfashionable after 1700 (as did tapestry-hung or mural-painted rooms), panelling became obsolete, however it was not necessarily destroyed. In a Great House it might be used to seal in attic or servants' rooms or it might be put into storage. At Croome Court, Worcestershire some of the minor attic rooms are dressed in seventeenth-century panelling, left over from the 1630s courtier-style house. Although undocumented, there must have been many instances when woodwork was later brought out of storage and given a new lease of life in an antiquarian situation. This may have been so with redundant chimneypieces and overmantels, but if emblazoned with arms, they might be kept for family piety. Even in the greater manor houses it must also have been a matter of thrift, for it was much cheaper to buy magnificent chimneypieces second-hand than to have them made.

All sorts of wooden and stone carved elements became peripatetic. Sir John Fastolfe bought Blickling Hall, Norfolk in 1432. He died at Caistor Castle in 1459. From here two beautiful Late Gothic spandrels from a carved window embrasure found their way to that deeply Catholic Oxnead Hall, Norfolk; and at the demolition of that ancient house in 1732, Norfolk piety was uppermost in the mind of the antiquarian-minded Earl of Buckinghamshire, who brought them to Blickling, to be incorporated into a fireplace in the Brown Drawing Room.[10] Leconfield Castle,[11] near Beverley, Yorkshire, the great fortress of Henry, 'the Magnificent', fifth Earl of Northumberland, in the early sixteenth century, had already decayed by the 1570s. Redundant in 1608–9, its timber, glass and carved images were removed first to Wressle Castle near Howden, Yorkshire, another of Henry's old fortresses, then to Kilnwick Percy Hall (Fig. 5),[12] and finally to Burton Agnes. In the case of Wressle the imagery of Leconsfield may have been retained for its 'curious antiquity'.[13]

Despite the reduction of Leconfield by the Cromwellians in 1650 to all but a south range, and its subsequent use as a farmhouse, an evocative description of what survived in 1790 records that, 'The ceilings still appear richly carved and the sides of the rooms are ornamented with a great profusion of ancient sculpture, finely executed in wood, exhibiting the ancient bearings, crests, badges and devices of the Percy family, in a great variety of forms, set off with all the advantages of painting, gilding and imagery'.[14] This passage of salvages from one place to another must have been far more common than existing documents indicate. It is worth remembering that medieval timber work was nearly always carved and prepared near to where the timber was felled. Henry VIII's new chapel ceiling at Hampton Court was prefabricated in 1535 in the forests at the manor of Sonning in Berkshire by a team of carvers, and would have been transported by barge to Hampton Court.[15] It was exactly the same in France.[16] Panelling ordered from the sculptor Liottier in Paris was carved in the workshops, then carried by river to the Château de Scey-sur-Saône in the Franche-Comté. Had the Hampton Court ceiling really been made for Cardinal Wolsey as legend would have it,[17] it might have been regarded as salvage. One salvage in 1537 – of 20 windows from the cloister and 20 from the clerestory of Rewley Abbey, then on the edge of Oxford – was ordered by Henry VIII after the Dissolution to be brought to Hampton Court for the new Bowling Alley.[18] Unfortunately, there has been no study of the movement of salvages from the dissolved religious houses to the great courtier houses. The panelling in the hall at Dorney Court, Buckinghamshire,[19] is supposed to have been brought from Faversham Abbey, and if Faversham was the provenance, there may well have been a few stops on the way, for the introduction could be a twentieth-century one, as for the screens passage in the house. There is no documented evidence for the moving of a complete panelled room before *c.* 1650, although there are ample references to this movement of panelling, such as at Chatsworth when the 4th Earl of Devonshire was remodelling the Elizabethan house. It was thought appropriate to consign old-fashioned fittings to Hardwick Hall. 'Wainscot' was sent in 1690, the Apollo chimneypiece in 1691, and a coat of arms of Mary, Queen of Scots, for her supposed bedchamber at Hardwick. The present panelling in the dining parlour at The Vyne, Hampshire, is a case for speculation.[20] Lord Sandys's linenfold from 'My Lady's Closet next the chapell' is in the 1541 inventory. The campaign that changed that room and staircase space into a single room took place in the 1650s, but complications at The Vyne suggest that the linenfold may have been put up by either Anthony Chute who died in 1754, John Chute who died in 1776, or even by Wiggett Chute in the nineteenth century.[21] In all these cases it could be regarded as an antiquarian initiative. This uncertainty only underlines the complexities of moving panelling in the greater houses.

A celebrated example wrapt in the legend of the dispersal of salvages is Nonsuch Palace, Surrey. In the 1680s the Tudor palace belonged to the Duchess of Cleveland, and the Keeper of Nonsuch was George, Lord Berkeley. Although the duchess ordered the demolition of the palace in 1682, setting off a train of salvages to probable and improbable destinations, Lord Berkeley had been expropriating useful items

7. Stowe, Cornwall. An Adams Acton photograph of a late seventeenth-century room once at Cross, Little Torrington, Devon, now in an unidentified location in USA

for his new house at The Durdans in Surrey,[22] and in Jacob Scmits's painted view of the garden front in 1689 can be seen a set of Tudor carved and painted heraldic beasts guarding an entrance front. What is undocumented Nonsuch legend is the great Tudor Renaissance chimneypiece at Reigate Priory, now believed to have come from Catherine Parr's palace at nearby Bletchingley. Similarly, the provenance of the panelling at Loseley House, Surrey remains unsubstantiated.[23] When John Leland visited Lord Northampton's Fulbroke Castle in Warwickshire in the 1530s,[24] it was ruined and was a quarry for salvages. At an uncertain date a later lord removed the hall roof to Compton Wynyates in Warwickshire. When the first Duke of Beaufort pulled Worcester House down off the Strand, London, in 1681/82, the 'wainscot' was carefully removed,[25] obviously for its value and re-use. There were adaptive uses too in churches, as at Little Gidding, Huntingdonshire, where the rebuilding in 1714 must surely have incorporated the Jacobean nave stalls from the old church, an act of devotion and piety on the part of this religious community.

Naturally, for every building demolished there must be some economic advantage from the disposal of its salvages. Paper evidence for such demolitions is exceedingly rare. As there are no auction catalogues or contracts for demolition before 1700, it is still not clear how the break-up of a fabric was advertised, if at all. On a great estate there might be a careful dismantling by the estate carpenter or surveyor, or an abandoned house might simply have its chimneys toppled by ropes.[26] Probably the commonest form of demolition was by contract between a landowner and a local builder.

In 1735 the ancient Tudor mansion of Slaugham Place in Sussex was sold only for the land, partial demolition following. Obviously it attracted local buyers, and the carved Elizabethan stair was incorporated into the Star Inn in Lewes, Sussex, (Fig. 6) in what has been Lewes Town Hall since 1893.[27] The year 1739 saw the demolition of Lord Bath's great Carolean mansion of Stowe in Cornwall, but its break-up can only be reconstructed through hearsay and legend.[28] At Prideaux Place,

8, 9. Stowe House, Buckinghamshire. Late seventeenth-century salvages from the chapel of Stowe, Cornwall. Views to the altar and the gallery as fitted out by William Kent in the 1730s

Cornwall, the reading room was entirely fitted up with doors and overdoors and paintings from Stowe,[29] and a baroque mirror frame and console table there may also have been part of Stowe's 'Grand Alcove', attributed by Daniel Defoe to the carver Michael Chuke.[30] More carved panelling can be identified in the courtroom of the Town Hall or Guildhall at South Molton, Devon, designed by Mr Culler the builder, and paid for in the year of Stowe's demolition.[31] In the same town the dining room in Molford House, South Street, is an entire Stowe room with carved chimneypiece and overmantel picture with a Diana the Huntress painting by Van Diest; and in the same county, at Cross near Torrington, a richly carved seventeenth-century staircase was installed by the Stephens family, as well as at least two finely panelled rooms, the existing one the Morning Room, with Grinling Gibbons's carving clearly in Michael Chuke's style. The other (Fig. 7) is now in an unidentified location in the USA.[32] In 1746–47 the chapel at the other Stowe, in Buckinghamshire, was fitted out with a ceiling by William Kent and 2,500 square feet of cedar wainscoting featuring swags and pilasters (Figs 8, 9), appropriately taken from the Cornish Stowe's chapel.

Proof of the extreme rarity of demolition auction catalogues is the singularity of three surviving ones, for Canons, Middlesex in 1747, Fonthill House (Fonthill

A

CATALOGUE

OF ALL THE

Materials of the Dwelling-Houfe,

Out-Houfes, &c.

Of His G R A C E

James Duke of *Chandos,*

Deceas'd,

At his late Seat call'd CANNONS,

near *Edgware* in *Middlesex* :

Divided into fuch eafy Sortments, or Lots, *as to make it agreeable to the Publick.*

Which will be fold by AUCTION,

By Mr. C O C K,.

On *Tuefday,* the 16th, of *June* 1747, .and the Eleven following Days (at CANNONS aforefaid.)

The faid HOUSE, &c. *may be view'd every Day (Sunday excepted) to the Hour of* SALE, *which will begin each Day at Half an Hour after Eleven precifely, by all Perfons who fhall produce a Catalogue of thefe Materials, which may be had at One Shilling each.*

CATALOGUES *may be had at* Grigfby's *Coffee-Houfe behind the Royal Exchange;* at Mr. COCK's, *in the Great Piazza, Covent-Garden;* at the *White Hart, in Watford;* the *Three Pigeons,* in *Brentford;* and at either of the Lodges leading up to *Cannons,* from *Stanmore,* or *Edgware.*

N. B. *In the firft Day's Sale will be fold, the Gardens and Pafture-Land, round the faid Houfe, being* FREEHOLD, *in four Lots, containing* 415 *Acres, agreeable to the Plan which may be feen at the faid Houfe, or at Mr.* COCK's, *with the Conditions of Sale.*

The CONDITIONS of SALE.

Imprimis, THAT each Lot is to be put up as *per* CATALOGUE to the higheft Bidder, who fhall be deem'd the Buyer; *unlefs any other Perfon as a Bidder immediately claims it, then it's to be put up again.*

10. Frontispiece of Mr Cock's Canons, Edgware, demolition catalogue, 16–27 June 1747

Splendens), Wiltshire in 1807, and Eythrope House, Buckinghamshire in 1810. There was financial advantage to be gained by carefully lotting up the fabric of these houses. Because Canons was barely forty years old when demolished, its fabric was sought after by masons for current use, whereas the salvages from Eythrope, although also of current use, were sought after for a quite different reason: its ancient woodwork attracted antiquarian buyers. These three demolitions stand astride half a century or more of the re-use of salvages.

The manner by which Canons,[33] almost certainly Fonthill House,[34] Eythrope,[35] and probably Wanstead House, Essex in 1824, were lotted up for their materials may not be exceptional. The method can be read from a mere sampling of Mr Cock's Canons catalogue 16 June 1747 and 'Eleven following Days', of more than a thousand lots (frontispiece, Fig. 10). From the Marble Parlour, 'Crofts' bought 650 feet of black and white marble paving, and 'Kemp' 138 yards of deal wainscoting including doors, and from the parlour next to the billiard room, Kemp also bought 'A fine black and gold Italian marble chimney piece'. 'Woodroffe' bought the stable cupola with its 'turret clock compleat', and 'Wilkinson' bought an almost complete carved room from the Great Dining Parlour, including

About 180 yards of deal wainscoting, large ovalo and rais'd pannels, two circular niches, with architrave, impost and fluted pilasters, 9 ft 6 high, a screen next the sideboard, with an eliptic arch twelve ft wide, 13 ft 6 high, with base impost architrave, keystone and spandrells inrich'd with two composite pillasters, and sliding doors behind ditto 2 right wainscot, eight pannel doors, with brass hinges, locks and pediments, with trophies finely carv'd over ditto, right wainscot window seats, backs, elbows and soffets.

The two chimneypieces from this room were bought respectively by 'Dennis' and 'Allen'. 'Devall' bought the 'Colonade of 4 portland stone Doric columns' 'going into the Chapel' from the courtyard. In the chapel itself, 'Captn Lovell' bought most of the interior: the fittings of the gallery, an iron balustrade, folding doors, flooring, and the 'grand Portland stone Venetian opening to the Organ loft, with four Ionick

columns'. But there were other salvage seekers, including 'Shakespear' for wall wainscoting under the gallery and in pews and benches against the wall, and for the front of the altar piece as well as the pulpit. Stovell bought 'About 42 yards of right wainscot, round the walls of the gallery'.[36] Between them 'Banks', 'Devall' and 'Bird' more or less scooped up the Marble Hall, and 'Devall', with help from 'Kemp', 'Cock' and 'Lovell', accounted for the Marble Staircase.

Most of the lots of Canons salvages found a new lease of life in a different context. John Devall the mason was obviously buying for Isaac Ware, who through Devall acquired the marble facings from the Marble Staircase for his staircase at Chesterfield House, London, where the Corinthian columns can also be identified as 'A pair of white and vein'd Corinthian columns fluted, with base and capitals', bought by Devall.[37] George Shakespear was buying for the amateur architect John Freeman of Fawley, in Buckinghamshire, where in the church he incorporated the chapel fittings.[38] The eight stained glass windows in the Canons chapel attributed in the catalogue to Sebastiano Ricci, but in fact by Francesco Sleter and manufactured by Joshua Price in 1719, were apparently purchased together with ceiling paintings by Antonio Bellucci, by Lord Foley,[39] who instructed James Gibbs to incorporate them into his chapel at Great Witley.[40] The most considerable single removal from Canons may have been stonework and salvages built in the park by the cabinet maker William Hallett and incorporated in his villa.[41]

Writing in 1807 William Beckford, the 'Caliph of Fonthill', excused his filial impiety in demolishing his father's great Palladian Fonthill House:[42] 'you will forget the old palace of tertian fevers with all its false Greek and false Egyptian, its small doors and mean casements, its dauberie a la Casali, its ridiculous chimney pieces, its wooden chalk-coloured columns without grace, nobility or harmony . . . I cannot honestly regret this mass of very ordinary taste'. The first proper fabric and fittings sale is recorded in H. Phillips's *A Catalogue . . . of Fonthill Mansion*, Monday 17 August, 1807 and the six following days,[43] when the Duke of Somerset bought thirteen pairs of mahogany doors, almost certainly for Bulstrode Park, Buckinghamshire, the Prince Regent bought the great organ, 'an instrument of extraordinary dimensions, built by a German by the name of Crang'[44] (in fact by John Crang c. 1760–65), and a Mr Cox bought five ceiling paintings by Andrea Casali,[45] possibly for P. C. Methuen of Corsham Court, Wiltshire. The latter were later given to the Theatre Royal, Bath by Sir Paul Methuen, and in 1845 'blackened by smoke', were bought by Colonel Blathwayte for the hall at Dyrham Park, where they remain. This was also the sale of the seventeen splendid chimneypieces by Bacon, Flaxman, Banks and Moore. The vicissitudes of just one (Fig. 11) of these chimneypieces, that from the Great Dining Room by John Francis Moore, with 'two PASTORAL FIGURES of *exquisite sculpture*, and *tablet* of DIANA and APOLLO',[46] are typical of the travels of notable chimneypieces. It was bought by the Duke of Newcastle for Clumber Park, Nottinghamshire, sold in the 1937 Clumber sale[47] prior to the demolition of this great house, and then bought by Olaf Hambro for Linton Park, Kent; it was then bought by Stanley H. Pratt Ltd in 1961, installed in a London flat, and sold by Christie's in 1989. At Fonthill the demolition

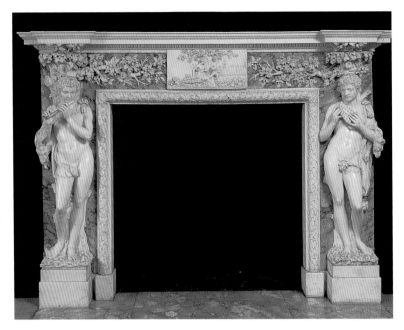

11. Fonthill House, Wiltshire. Chimney-piece by John Francis Moore, 1760s, bought from Clumber Park, Nottingham-shire, Christie's 19 October 1937, lot 289. Installed in a London house; sold again

sale, also held by Phillips, was hurriedly advanced to 16 September 1807: 'the whole of the massive and valuable materials of that noble and modern stone mansion' comprised 'an immense quantity of hewn stonework in ashlering, cornices, cills, porticoes, columns, pilasters and frontispieces, three handsome geometrical stone staircases, with ornamental and other railings, black and gold and veined marble and other paving . . . eleven water closets, with mahogany fittings and apparatus, panelled doors with gilt metal fastenings . . . 130 mahogany and other sash frames . . . a large quantity of seasoned wainscoting, chimney pieces, the bells and pulls'. Lotting up followed the general system of Canons, in general moving from attics down to the basement, then dealing with the stonework of the four fronts. The unusual scenario with Canons and Fonthill involved their demolition less than forty years after completion. These were unwanted Georgian 'prodigy houses', dismembered by contractors. No doubt the same treatment was meted out to the vast Palladian mansion of Wricklemarsh, Blackheath, in 1787. The demolition of George IV's Carlton House, Pall Mall, in 1827–28, released choice fittings and salvages for the royal apartments at Windsor Castle, but the rest of the fabric must have been disposed of, either commercially or through the Office of Works.

The demolition of Eythrope House, Buckinghamshire, in 1810[48] was occasioned by the death of Sir William Stanhope in 1772, when this great ancient Elizabethan house passed to Philip Stanhope, fifth Earl of Chesterfield, who allowed it to fall into disuse and ruin. In 1797 it was described as 'uninhabited and barely kept'.[49] In consequence Lord Chesterfield instructed Mr Hermon of Conduit Street, Hanover Square, London to auction 'The Valuable Building Materials of Eythrope Mansion – House', from 15–17 August 1810, comprising all the internal fitments.[50]

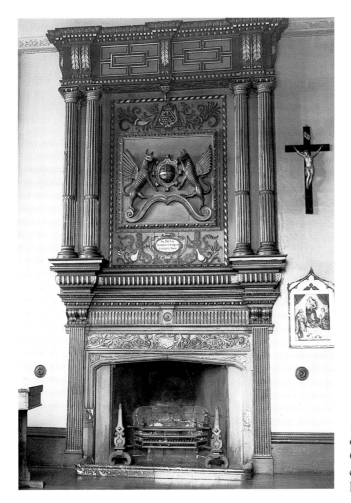

12. Grove Park, Hampton-on-the-Hill, Warwickshire. One of three Jacobean chimneypieces from Eythrope House, Buckinghamshire

According to an inscription on the title page of the sole surviving catalogue,[51] 'The whole of the valuable Materials of the Carcase Timber roof & walls of the Mansion will be sold in Lots early in February next 1811'. Alas, no printed record of this sale survives. The lotting up in 1810, a total of 451 lots, followed a standard procedure for each room: first, floorboards and skirting, then the battening, canvas and cornice, then the window elements, then the doors, and finally the chimneypiece. This last was usually the most expensive item, as in lot 6, in the South West Room: 'A veined marble chimney, consisting of slab, mantle and jams, Ogee moulding,[52] and moulded slips and plinth 10.10'. The chapel was divided up into 20 lots, the Long Gallery into six, for example lot

49: One half only of the deal floor boards; 50: The remaining half of the deal floor boards; 51: The window side and farthest end of the wainscoting with entablature, pilasters, and window linings; 52: The chimney side and nearest end of ditto, with doors, locks and hinges; 53: The wood pedestals, and plaster busts

and 2 medallions over the chimney; 54: a veined marble chimney of jams, mantle, slips, slabs and black border, stone covings and hearth.

No doubt every country house demolition sale was a much talked of event in its county. In the valley below Eythrope stood Nether Winchendon, where Scrope Bernard (afterwards Sir Scrope Bernard Morland) was a neighbouring landowner, but also an amateur architect thirsting to take advantage of the sale, to buy salvages not only for his house at Nether Winchendon, but also for the new Gothic house he planned to build at Little Kimble, where he had bought the manors of Little Kimble in 1792 and Great Kimble in 1803. There in Little Kimble Rectory he planned his new house to supplant that at Nether Winchendon, which his wife disliked for its low situation. Scrope Bernard had been embellishing Nether Winchendon inside and out with salvages since 1790, with Thomas Harris of Aylesbury as architect. In Nether Winchendon today, itself the remains of a medieval and Tudor house,[53] it is difficult to determine what may have been imported from Eythrope in 1810, for Scrope Bernard was looking around to ransack other houses in the county doomed for demolition. These included the Duke of Portland's Bulstrode Park, the late Edmund Burke's Butler's Court near Beaconsfield, and from Mrs Seare's Tring Grove came a 'fine marble chimney piece at a bargain price'.[54] Salvaged panelling and bits and pieces can be identified at Nether Winchendon, but it is difficult to know if the linenfold panelling in the drawing room with an eighteenth-century chimneypiece was in fact salvaged from Eythrope.

Long before the Eythrope sale Scrope Bernard had been looking enviously at the empty mansion. On 26 June 1800 he wrote to Lord Chesterfield about 'several Articles' that had not been removed 'and which are useless there, & subject to decay',[55] including 'the old Armour in the Entrance Hall'[56]and a 'large Stove in the Gallery'. Not surprisingly he was unsuccessful in his presumptuous bid, but Chesterfield's brother, Lord Stanhope Dormer, replied on 24 August 1810, referring to his own removal of three Jacobean chimneypieces, one from the 'State bed room' to his house at Grove Park, Hampton-on-the-Hill, Warwickshire, where it remains today (Fig. 12).[57] No doubt Eythrope was scattered far and wide, but alas although he salvaged Eythrope's Gothic roof from the Great Hall 'to be erected nearly in the same state, & to form part of my new Mansion there, which is planned in a suitable stile of Architecture',[58] what Scrope Bernard built before his death in 1830 is unknown, as no view of it has ever come to light.

2

SALVAGE AND A MORE AMATEUR ANTIQUARIANISM

ONE OF THE GREATEST ACTS of destruction by demolition was due to the dissolution of the monasteries between 1536 and 1540, by a tyrannical Henry VIII and effected by his minister Thomas Cromwell. There is no evidence that these destroyers felt any sentiment towards the hundreds of ecclesiastical monuments that were being demolished or vandalized. Buildings were seen as quarries for building materials. As Howard Colvin aptly wrote,[1] it was 'already too late that men began to appreciate the work of previous generations, and it needed the shock of the "bare ruin'd choirs" to arouse in antiquaries such as Dugdale, Dodsworth, Erdeswicke and Aubrey that sense of the past that has been with us ever since'. Since the Elizabethan age in fact, for Queen Elizabeth issued a proclamation in 1560 against 'defacers of monuments in churches', and in 1562 a committee of her courtiers concluded that many of the greater castles, such as 'old and statly' Tutbury, were to be deemed 'ancient monuments'. Already there was an awareness of the magic of ancient houses and castles. In the same spirit, Lady Anne Clifford, Countess of Pembroke, restored her northern castles.

Supportive of this attitude was the revival of interest in old documents, chivalry, genealogy and heraldry, and topographical enquiry. Castle-style houses such as Bolsover, Derbyshire, Lulworth in Dorset and Ruperra in Glamorgan are symptomatic of this.[2] These stand at the beginnings of antiquarianism and an enthusiasm for archaeology, and in the following century enthusiasts such as Sir William Dugdale or John Aubrey laid the foundations for a study of the past and the genealogy and topography of family possession, eventually leading to the founding of the Society of Antiquaries in 1717. Something salvaged from a building need no longer be destroyed, but might be valued as a family antique, commemorative of longevity of possession.

When many houses were being modernized, reduced, or demolished for a new replacement, family piety meant that there was a reluctance to lose rooms with heraldic displays commemorative of family possession. Owners might look upon great Elizabethan chimneypieces or panelling emblazoned with family or royal arms

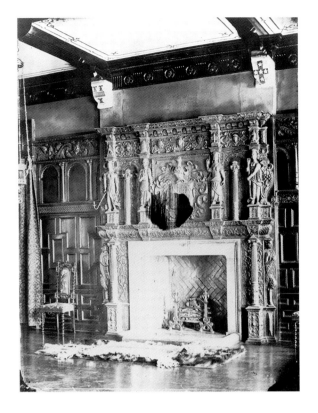

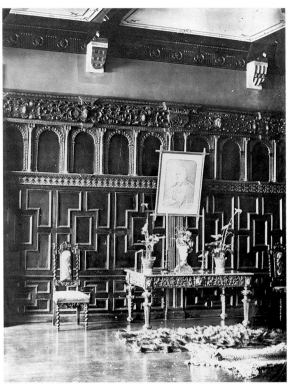

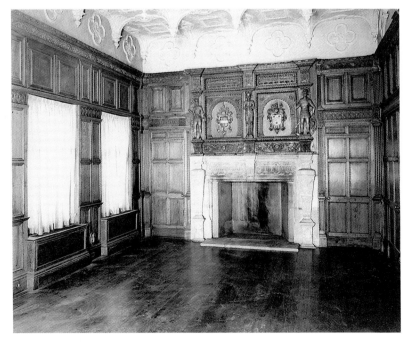

Rotherwas, Herefordshire

13. Elizabethan chimneypiece in post-1731 installation

14. Detail of wall adjacent to chimneypiece in post-1731 installation

15. The 'Julius Caesar' Room, panelling bought by Hearst, photographed *in situ* with eighteenth-century fan-vaulted ceiling attributed to T. F. Pritchard, 1750s

with veneration, as did Charles Bodenham in 1731 when James Gibbs was building a great new house for him at Rotherwas in Herefordshire. In the old house was a celebrated chimney piece (Figs 13–14) long regarded as a family heirloom.[3] No description of the interior of Gibbs's new house has come down to us before its demolition in 1913. At first the room's incorporation into the modern mansion was not accompanied by a ceiling in an associational Jacobean style, as it might have been later in the century. We know from photographic evidence[4] that an adjacent panelled room (Fig. 15) was given a Georgian fan-vaulted ceiling probably by Thomas Farnolls Pritchard in the 1760s,[5] for a later generation of Bodenhams, which can only have been provided for associational and antiquarian reasons. As one correspondent in the *Hereford Times* surprisingly reports,[6]

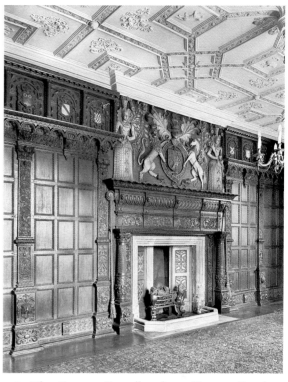

16. The Grange, Broadhembury, Devon. South chimney side of the Jacobean Great Drawing Room in 1921

> When, in 1731, all the panelling was removed from the old house, and set up in the new mansion, there was not a room large enough to contain the panelling of the 'fair parlour', and it was consequently distributed over four apartments. Demonstrating the piecemeal way in which the salvages were distributed, is the surprising fact that one half of the parlour chimney piece was in one room while the other half was discovered in the cupboard of what is now the bathroom. The remainder of the parlour panelling adorned an ante room, while the coats of arms were placed on the beams of a fourth room'.[7]

This is not entirely correct, for surviving photographs in Hereford City Library show the 'fair parlour' with an eighteenth-century frieze to a beamed ceiling, the beams resting upon consoles.[8] This may be Pritchard's doing too. Had James Gibbs in 1732 provided an associational ceiling to this famous chimneypiece, it would have been recognized as a remarkably early example of antiquarianism.

The Rotherwas room can be compared to the Oak Drawing Room (Figs 16–17) at The Grange in Devon, now at the Speed Art Museum, Louisville, Kentucky.[9] Even in 1829 it was commended for its Ovidian iconography and rich heraldry, although the writer was significantly cautions, 'much of the carving was probably collected from more ancient buildings to ornament this room'.[10] There is a distinct possibility that when the Tudor and Jacobean Grange, built from the 1590s by Edward Drewe (1542–98) and completed by his son Thomas,[11] was reduced in the

later eighteenth century, maybe in the 1770s, a substantial part of the room was retained for its antiquarian and heraldic interest, cobbled together and reconstructed within the Georgian rebuilding. As a physical examination will disclose, not only is the central part of the entrance wall composed of Flemish carved wood salvages, but the end wall and the wall facing the chimneypiece may well be due to the inventive skill[12] of Charles of London, whose brochure published in 1927, describes the room as 'One of the few remaining Carved Stuart Masterpieces Magnificent, Authentic, Historical . . . To be seen at Charles of London Two West 56th Street, New York'.[13] Hearst snapped it up almost immediately, and like so many other purchases the room lingered in his warehouse until bought in 1944 by Dr Preston Pope Satterwhite, a Louisvillian, for the Speed Art Museum.[14] In the case of both Rotherwas and the Grange, whereas panelling and wooden wall elements were easy to move, ceilings posed problems, hence both ceilings in their new situation are inventions, and the ribbed one in the Grange today seems to be eighteenth-century Jacobethan.

Historians are discovering that many houses were built or altered in the second half of the seventeenth century with a conscious concern for associational reasons, often due to the owner's antiquarian interests and veneration for family. Giles Worsley has demonstrated that in the 1660s George Vernon put arched Jacobean-style voussoired door surrounds into the Great Hall at Sudbury Hall, Derbyshire, as an antiquarian compilation.[15] The exteriors were treated in a similar associational manner, in the style of a previous generation, and Sudbury is related to the refashioning of the entrance front of Crewe Hall, Cheshire. In 1657 when Wencelaus Hollar viewed Crewe, the extraordinary bulgy-bayed upper windows, looking very precarious, were still in position, but they had gone by the early eighteenth century, so both Crewe and Sudbury may have been refashioned more or less simultaneously in an associational style.[16]

A very similar alteration occurred at another Jacobean house, Aston Hall near Birmingham, built by Sir Thomas Holte in 1618. There was a re-ordering of the entrance front (perhaps for Sir Charles Holte, who died in 1722), remarkably sensitive to the existing Jacobean fabric.[17] The exterior bay with its asymmetrical entry into a screens passage was replaced by a central entry leading directly into the Great Hall, giving a view through a new door in the Great Hall's west wall and straight through the house to the garden. The present wall arrangements in the Great Hall (Fig. 18) must surely be related to these new works. As Fairclough rightly observes, the chimneypiece was moved from the west wall to the north wall where the old screens passage had been. However, the fine traditional chimneypieces and overmantels in the rest of the house belie his suggestion that the present chimneypiece with its bizarre strapwork overmantel could have anything to do with its Jacobean predecessor. The strapwork elements here and elsewhere in the Great Hall must surely have been terminations to the old screens. The present arrangement of the west wall comprises an invented composition using two old Corinthian doorways and one of two arched doors, of which the other is now the north door from this Great Hall to the Oak Hall and staircase. The Corinthian arches frame perspective

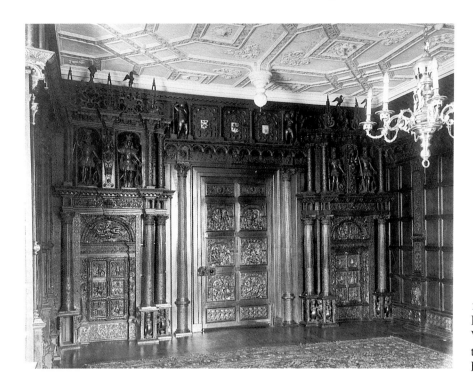

17. The Grange, Broadhembury, Devon. West entrance side of the Jacobean Great Drawing Room in 1921

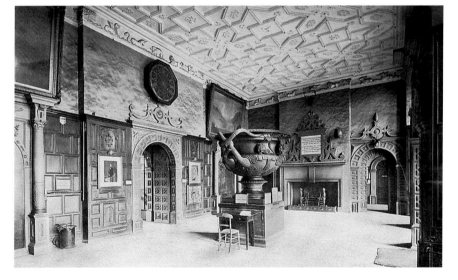

18. Aston Hall, Warwickshire. The Jacobean Great Hall, *c.* 1880

views convincingly attributed to Jacques Rousseau, who was in England from 1685 until his death in 1694, and of the same date are the two grisaille warriors set in panelling at the west ends of the north and south walls. The whole composition is made up of reworked salvage, and the panelled bays next the central door do not look Jacobean. Indeed the profiles of their mouldings seem analogous to the panelling in the old dining room, refitted as a chapel. If the perspective pieces painted by Jacques Rousseau are in their original positions, they must have been painted

19. Burton Agnes, Yorkshire. The antiquarian staircase

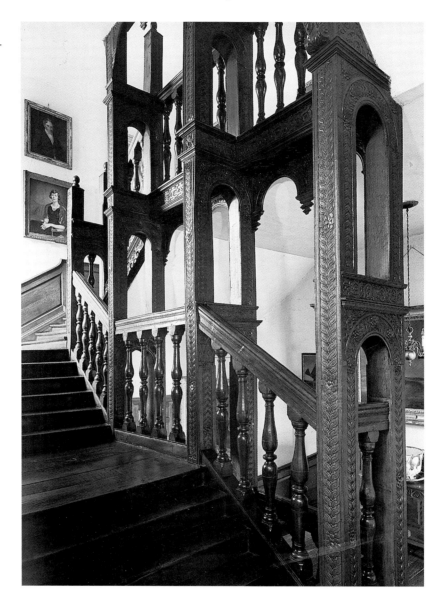

and fixed there by 1694. A clue to this remaking of the hall may lie in the full-length portrait of Sir Thomas Holte,[18] which by tradition has always hung in the hall. Fairclough suggests that it is a copy of the original and may have been painted *c.* 1710–30.[19] But surely this is a purely antiquarian image. Had it been a copy, it ought to show the entrance front before remodelling, according to Fairclough's suggested reconstruction based upon John Thorpe's plan. Sir Charles Holte, who succeeded in 1679 and died in 1722, is known to have converted the Great Dining Room into a chapel, 'between 1679 and 1722'.[20] Was he not then the antiquarian who commissioned the Holte portrait, and sympathetically rearranged the Great Hall in the late seventeenth century?

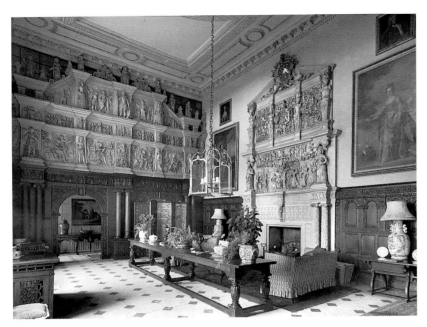

20. Burton Agnes, Yorkshire. The Great Hall with chimneypiece capped by an addition brought from Barmston Hall, Yorkshire, in the 1760s

With Sir Charles Holte's refashioning of his old Great Hall, Aston may represent a new attitude to Great Halls in 'Mansions of ye olden tyme'. There was now no need for a Great Hall as a place of public congregation and assembly upon entry, with screens and raised dais as in medieval and Tudor halls. Later owners of such houses saw the old Great Hall not only architecturally as the most important space in the house, but also as the one room in the house that spoke for the antiquity and longevity of the family. The Great Hall needed dressing up. Its large wall areas offered hanging space for portraits and sporting pictures, and those owners with an antiquarian bent saw such halls as a theatre for the display of carved wood salvages, symbolizing an 'olden tyme' décor of banners, armour and stags' antlers. The seventeenth-century Great Hall at Badminton might be seen as an extension of all this, redecorated in the 1740s and used to display John Wootton's great landscapes celebratory of the family's hunting achievements. More can be learned from Burton Agnes in Yorkshire, another early example of antiquarianism affecting Great Halls, where Sir Griffith Boynton, third baronet, who had married in 1712, embarked upon internal improvements that incorporated salvages from the dismantled old Great Chamber, including panelling arranged in the King's state bedroom and a surprising Jacobethan insertion of arched doorways to the east end of the hall incorporating more salvaged woodwork from the Great Chamber. The most astonishing incorporation at this time is surely the celebrated stair, long regarded as a Jacobean version of that at Audley End (Fig. 19). It is not authentic at all, but an antiquarian compilation arranged around the balusters of the late seventeenth-century stair.[21] In the next generation, maybe between 1762 and 1767, the original Jacobean chimneypiece in the Great Hall (Fig. 20) was elaborated and heightened with an Elizabethan sculptured overmantel brought from Barmston near Bridlington,

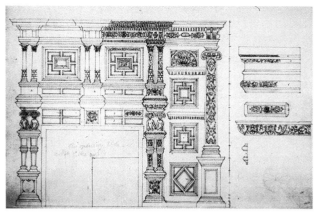

21. Belhus, Essex. View from front entrance door to hall chimneypiece

22, 23. Ditton Park, Buckinghamshire. Eighteenth-century Jacobethan designs for arranging old woodwork

Yorkshire. There are also later incorporations in the Justice Room, where the pan-elling is enjoying its third incarnation: after starting in Leconfield Castle, Yorkshire, around 1608 it was removed to Kilnwick Hall, Driffield, Yorkshire (see Fig. 5), and finally, following the demolition of Kilnwick in 1952,[22] it moved on to Burton Agnes.

The problem of identifying the early re-use of salvages in the great and ancient mansions of England is complicated, not least when those salvages were re-used again or incremented in the nineteenth and early twentieth centuries. Wroxton Abbey in Oxfordshire and Belhus Hall in Essex both feature in any account of the Gothic Revival, and in particular the work of that Georgian amateur Gothicist Sanderson Miller. At Wroxton,[23] Miller is known to have remodelled the window of the chapel for the third Lord Guildford in 1747.[24] The ceiling of the chapel's chancel is also convincingly Miller's, as must be the Gothick frieze beneath the gallery and the ceiling frieze above it. But what can one deduce of the gallery itself with its front made up of carved wood panels that appear to be Flemish or French

salvages, as are the chancel rails, once French stair rails?[25] These salvages are unlikely to have been Miller's, and must belong to the extraordinary importations into Wroxton of 'Wardour Street' continental woodwork by Colonel John and Lady North in the 1850s.[26] The distinction between eighteenth-century Gothick and nineteenth-century work is made more difficult by juxtapositions. The Gold Room, for instance, was panelled in Jacobethan style in the nineteenth century by Sidney Smirke, yet has an existing ceiling that appears to be Elizabethan Revival, maybe of Miller's intervention, like the ceilings in the old dining room and above Roger North's late seventeenth-century Great Stair. Miller's several marble chimneypieces in the house are taken from models in the pattern book of Batty Langley.[27]

A similar conflation of associational salvages can be seen in Belhus Hall, Essex,[28] where Sanderson Miller is documented as the architectural adviser of Thomas Barrett-Lennerd, afterwards seventeenth Lord Dacre, for alterations to the interior of his ancient Tudor house, certainly from 1752 to 1757 but also possibly earlier between 1745 and 1749 when the south and west fronts were rebuilt in Tudor Gothic style.[29] The sparse photographic evidence of this magical house prior to its tragic demolition in 1957[30] suggests that a truly 'Jacobethan' style of woodwork was being invented and compiled during this lord's tenure. The main stair could be mistaken for a Jacobean one, as might the chimneypiece and overmantel in the upper drawing room. Yet they appear on close inspection of photographs to be Georgian inventions. The hall was ornamented with arms and armour: helmets, breastplates, pikes, guns, and boots,[31] and the dating of this is uncertain. The extraordinary entrance door (Fig. 21)[32] to this baronial ambience is made up of early Renaissance Flemish carving not unlike Colonel North's entrance door to the hall at Wroxton. Both smack a little of the sort of late eighteenth-century and early nineteenth-century antiquarian compilations to be found (Fig. 30) in the house of the Ladies of Llangollen at Plas Newydd.[33] It may well be that Miller did not incorporate salvages in his interiors, but preferred to invent appropriate antiquarian features.

If Sanderson Miller was at Belhus, he was also at Eythrope House, Buckinghamshire,[34] the seat of his friend Sir William Stanhope, at whose death in 1772 Eythrope reverted to his nephew, the fifth Earl of Chesterfield, who ordered its demolition. Whether Miller and Stanhope were responsible for the astonishing antiquarian display of armour in the Tudor Great Hall is undocumented, but it must have been formed as a display before 1772. According to the 1810 sale catalogue,[35] in 'The Large Hall or Armoury' were displayed more than 500 pieces of arms and armour, a collection that may have been an ancient one originating with the Dormer family during the Civil War. Such a collection must have produced an impressive effect, and it is not possible to recollect another Great Hall with armour so densely displayed.[36] It was antiquarian theatrics at its best. Wroxton, Belhus and Eythrope all had these antiquarian great halls.

If ever there was a father of this reverence for Great Halls, it would be John, second Duke of Montagu, who by 1715 at his Palace House, Beaulieu had formed out of the old vaulted gatehouse a Great Hall with a wall covering of simple square-

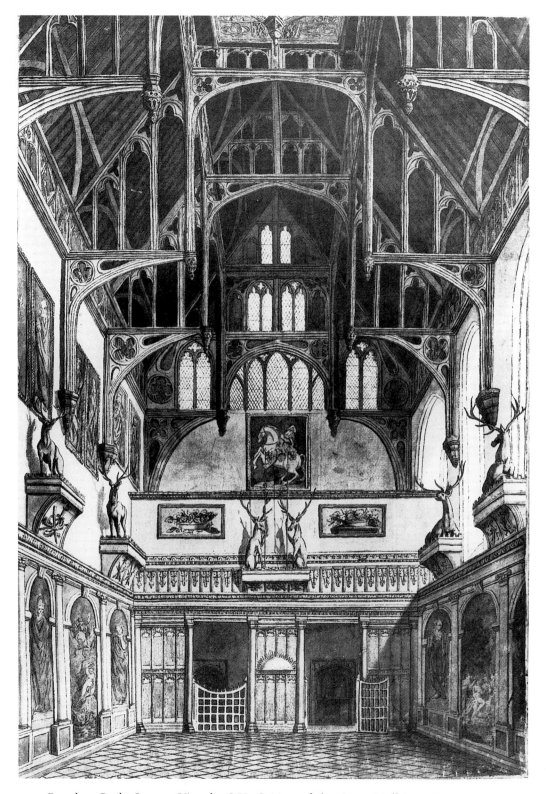

24. Cowdray Park, Sussex. View by S.H. Grimm of the Great Hall in 1782

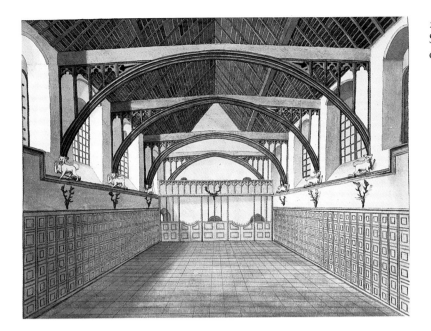

25. Herstmonceux Castle, Sussex. View by S.H. Grimm of the Great Hall in 1780s

panelled wainscot, which he furnished by the 1730s with a set of the earliest Gothic Revival chairs; and had mock-fortified Ditton Park, Buckinghamshire before 1732. Ditton may have been the subject of the eighteenth-century 'Jacobethan' drawings (Figs 22–23).[37] These comprise designs for Jacobethan ceilings and two for a chimneypiece and associated wall panelling, surely the earliest designs for composing a Jacobean chimneypiece and overmantel out of salvaged parts. Montague's father, the second Duke, at Boughton, Northamptonshire, was also sensitively arranging things in an antiquarian way, but it was his son who formed the Audit Gallery there with faux Elizabethan panelling, many family coats of arms and devices, and one of two Elizabethan chimneypieces salvaged from a family house in 1729.[38]

These revered Great Halls at Aston Hall, Burton Agnes, Eythrope, Belhus, Wroxton and Palace House, and probably Ditton, evoke longevity and legitimacy of family possession.[39] This was summed up by the anonymous writer of an essay in 1739 in the *Gentleman's Magazine* entitled 'Common Sense': 'There was something respectable in those old hospitable Gothic halls hung round with helmets, breast-plates, and swords of our ancestors: I entered them with constitutional sort of reverence . . . and when I see them thrown by to make way for some tawdry gilding and carving, I can't help considering such alterations as ominous even to our constitution'.[40]

The Great Halls of Cowdray and Easebourne Priory or Herstmonceux Castle, both in Sussex, are also romantic evocations of the view of the contributor to the *Gentleman's Magazine*, both creations in an antiquarian mode. Hieronymous Grimm's watercolour of the Great Hall at Cowdray in 1782 (Fig. 24)[41] shows the hall re-formed probably in the 1720s by the sixth Viscount Montague with Ionic arches containing perspective paintings, an invented Jacobethan-style screens passage, and wooden bucks (the crest of the family) set high on brackets, all evocative

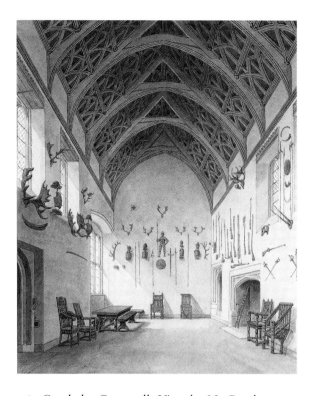

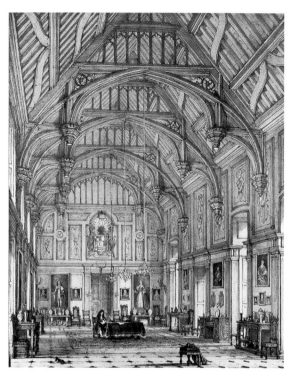

26. Cotehele, Cornwall. View by N. Condy, *c.* 1840 of the Great Hall. City of Plymouth Museum and Art Gallery

27. Beddington Park, Surrey. The Great Hall, lithograph for Joseph Nash's *Mansions of England in the Olden Time*, 1838

of ancient lineage,[42] as indeed was the hall at Herstmonceux, also as drawn by Grimm (Fig. 25).[43] As the century progressed the Great Hall became a sort of theatre for this reverence for ancient lineage and seats.

The Great Hall (Fig. 26) at Cotehele House in Cornwall has been regarded as iconic as one of the few eighteenth-century antiquarian Great Halls to have survived, albeit in restituted form.[44] In descent from Cowdray or Herstmonceux, the antiquarianizing of Cothele's hall and the tapestry hanging of the rooms, together with the provision of at least one antiquarian ceiling, are commonly said to have been achieved by Richard Edgcumbe, who became the first Lord Edgcumbe in 1742. No document supports such an early date,[45] and it is far more likely that the antiquarian restoration of this decayed house was achieved by George Edgcumbe, who succeeded as third Baron in 1761. He was not only an enthusiastic Fellow of the Society of Antiquaries, but an antiquary in the mould of Horace Walpole. The effect in Cothele's hall is gained not with salvaged carvings, but through the display and presentation of arms and armour, antlers, chairs and tables, curiosities and, of course, tapestries.[46] Strawberry Hill contained no salvages, although in the chapel were two wings from an altarpiece, reputedly from Bury St Edmunds Abbey. Nevertheless, Walpole sawed them up to make four pictures. Surprisingly, he never

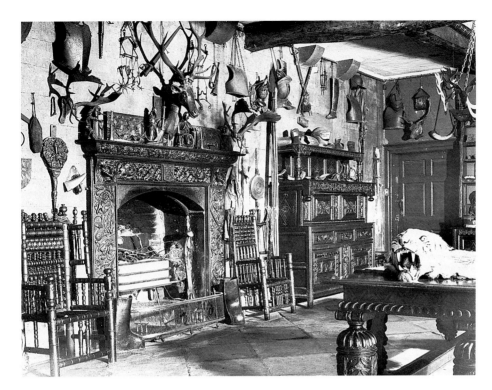

28. Browsholme Hall, Yorks. The Great Hall as antiquarianized in the early nineteenth century, photographed in 1960

collected a Gothic tapestry, and even his stained glass was mostly Renaissance in date. Strawberry was a modern Gothick house with modern Gothick interiors based upon models selected from English and European provenances. The same could be said of Miller's work at Wroxton and Eythrope.

J.N. Brewer's description of Chavenage House, Gloucestershire is equally evocative, even if it is turn of the century in date: 'As usual, in mansions, which . . . are frequently called *Elizabethan*, the chief attention . . . was bestowed on the hall . . . In the large windows is much stained glass . . . The walls are covered with objects of considerable interest. Among these are several suits of armour, and antient offensive arms, of various ages'.[47] By 1825 Henry Willis Stephens's Chavenage could boast of three antiquarian tapestry rooms, much reworked panelling, at least one antiquarian chimneypiece, together with an astonishing variety of antiquarian furniture, although the 'two very antient and magnificent bedsteads' have gone.[48] A perfect lithographed example of this reverence is the Great Hall in Beddington Park, Surrey, romanticized as befits Joseph Nash's 1838 view extolling the antiquity of this ancient seat of the Carews.[49] The Great Hall is shown (Fig. 27) dolled up in the earlier eighteenth century with Anglo-French plaster *boiserie* decorations.[50]

Another antiquarian Great Hall at this time, but of a different character, was Speke Hall, Lancashire, improved by Richard Watt after his purchase in 1795. This sixteenth-century timber-framed house, romanticized in Joseph Nash's coloured lithographs in 1849, was given the antiquarian treatment, first perhaps by Richard Watt II (died 1803), then by Richard Watt III (died 1855). Much is still perplexing,

Plas Newydd, Denbighshire

29. The porch of the Ladies of Llangollen

30. The Alcove Seat of the Ladies of
Llangollen

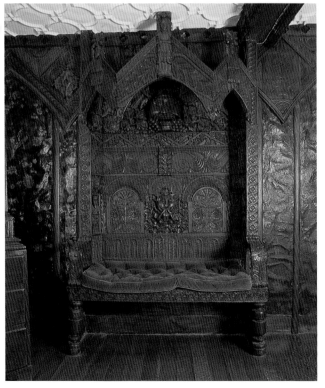

not least what was achieved by George Bullock's antiquarian restoration of the hall in 1808.[51]

By this time the focus of antiquarian attention on Great Halls was becoming commonplace, and this was the age too of the importation of Anglo-Franco-Flemish wood salvages. A singular description in 1821 of Mr Cawthorne's house in Lancashire, as 'a neat building in the Gothic style which he has called Wyresdale Tower . . . the whole interior strongly reminds one of Di Vernon in *Rob Roy*. The oak parlour . . . is fitted out in the style of Henry eight's time. The dark oak panels have a somber appearance',[52] typifies what must have been an interior full of old oak carvings. Alas, Wyresdale was demolished in 1868 and no other description of it survives. It would be intriguing if Wyresdale Tower was as evocative as Browsholme Hall in Yorkshire, a house and collection iconic of the particular brand of amateur antiquarianism that preceded the beginnings of the import of continental salvages. Browsholme was inherited in 1797 by Thomas Lister Parker, a pioneer of the Elizabethan revival and the dedicatee of Henry Shaw's *Specimens of Ancient Furniture*, 1836. It was Parker who commemorated the completion of his new antiquarian arrangements by commissioning J.C. Buckler to write a *Description of Browsholme Hall*, in 1815. Although his library received oak diagonal panelling from Parkhead near Whalley, a few miles from Browsholme, the house is not an obvious repository for salvages. A watercolour of the hall about the time of Parker's inheritance, shows evidence of much simpler decoration and fitting-out. The hall (Fig. 28) may now be the epitome of an antiquarian Great Hall, but the interiors are antiquarian by virtue of their movables.

Browsholme was no match for the 'salvage mania' of Plas Newydd,[53] first rented in 1780 by Lady Eleanor Butler (who died in 1829) and Miss Sarah Ponsonby (who died in 1831), a pair of lesbians familiarly known as the Ladies of Llangollen. Between 1798 and 1814 they embarked upon an astonishing salvage Gothicization of both the inside and the outside of their relatively small house, but mostly externally, with canopied windows and a porch made up from carved-wood Elizabethan and Jacobean salvages (Figs 29–30). The influence of the Ladies in this matter of salvages cannot be overestimated, for they were a tourist attraction as much as Walpole and Strawberry Hill: 'All statesmen and nobles paid tribute and homage at Plas Newydd, and none ventured a second visit without bringing a contribution of carved oak, which was a passport.'[54] Today it is difficult to differentiate between what the Ladies did and the continuation of their salvage mania by General John Yorke, who bought Plas Newydd in 1876. General Yorke had the same passion for salvage as did Colonel John North at Wroxton, both later customers of dealers importing continental salvages. The beginning of this continental importation marks a new phase in the story of antiquarian salvages.

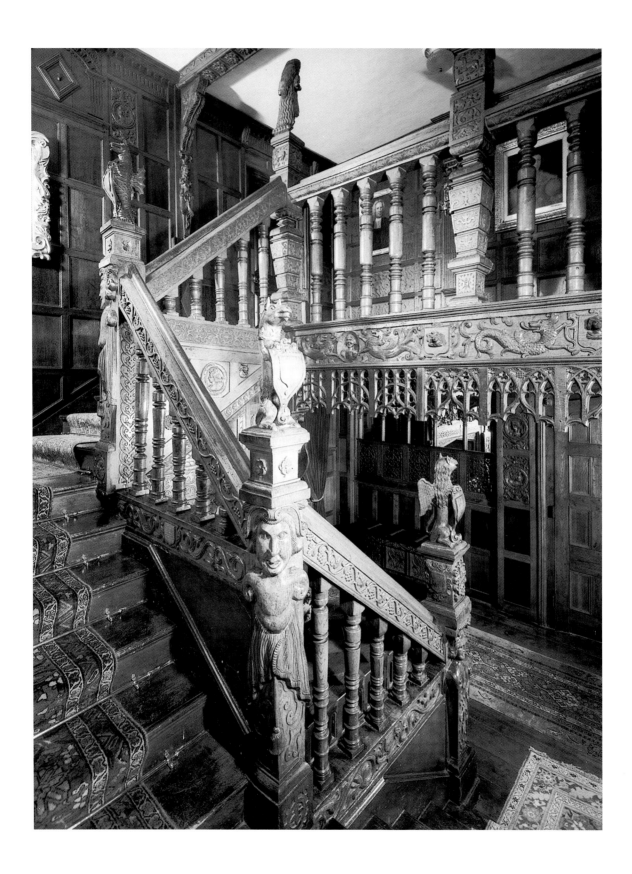

3

CONTINENTAL IMPORTS AND THE WARDOUR STREET TRADE

CHARLES TRACY IN HIS CONTINENTAL *Church Furniture in England. A Traffic in Piety* observes how rare the importation of church furniture and wooden salvages was before the French revolution.[1] He refers to the disputatious Flemish pulpit in the chapel of Capesthorne Hall, Cheshire. The question is whether it was acquired around 1722 or whether it belongs to the early nineteenth-century Wardour Street trade. He underlines the exception of Charles Towneley's acquisition of a Bruges altarpiece for the chapel in Towneley Hall, Lancashire, possibly even earlier than 1772. As recusants the Towneleys had kept up their connections with Catholic Belgium and France and Charles Towneley had studied at Douai.[2] The effect of the Revolution, particularly upon north-east France and the Belgian provinces, is well summed up in an unusual preamble to a sale catalogue as early as 1791: *Catalogue of the Pictures, Drawings, Painted Glass etc., etc., . . . sold by private contract at the European Museum, King Street, St James's Square*, quoted by Tracy.[3] 'Wars and Commotions are seldom favourable to the fine Arts, the late Revolutions in France and Flanders have deprived these countries of many inestimable Productions which otherwise, could never have been removed . . . The Demolition of the Convents and Religious Houses has also contributed to this Collection.' It would seem that 'Convents and Religious Houses' provided the majority of imported salvages, not secular buildings such as châteaux or *hôtels*. Out of thousands of examples of desecration at Senlis Cathedral, 'In 1793 the portals were mutilated, the pavement taken up, the choir screens taken away, the stalls and organ screen taken down and the pulpitum of 1532 destroyed',[4] while at Saint-Etienne, Dijon, the famous choir stalls set up in 1537 were taken out by the Jacobins and sold at auction.[5] The ransacking of churches and monasteries is well established, but there is far less evidence of how private secular accommodation was treated. It is surely significant that the majority of imported salvages were ecclesiastical, via brokers and auction houses in

31. Godington Park, Kent. The Stair with antiquarian embellishments

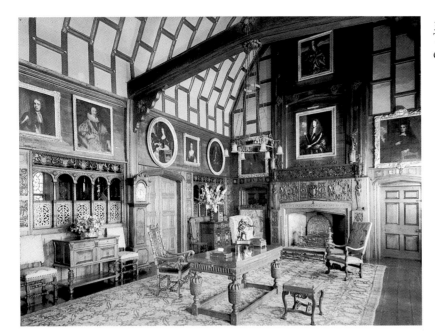

32. Godington Park, Kent. The Hall with antiquarian embellishments

London, bought for use in secular as well as ecclesiastical English contexts. In some cases a parcel of salvages might be divided up and distributed to several houses.

Most of the brokers were located off Oxford Street, where the 'Wardour Street Trade' had become synonymous with dealers in wood salvages, who served clients infected with the oak carving mania. Among the brokers were John Swaby at 109 Wardour Street from 1822 to 1834, John Webb at 8 Old Bond Street from 1822 until 1834 specializing in antique furniture and wood salvages, Edward Baldock in Rathbone Place, and Horatio Rodd in Great Newport Street, both north of Oxford Street. Edward Hull was further away in Curzon Street.

In the matter of using continental salvages, the Ladies of Llangollen belonged to the amateur tradition in the making of décors (see figs 20–30). Theirs was an unsophisticated taste, quite different to the hall and staircase (Figs 31–32) at Godington Park, Kent,[6] an Elizabethan and Jacobean brick house occupied from 1817 by Nicholas Roundell Toke, who died in 1837. It is likely that he paid attention to the house earlier rather than later. He would have recognized the distinction of the surviving Elizabethan gallery with its grand carved chimneypiece and array of Flemish-style reliefs, and may have wished to match these by embellishing the existing hall and staircase with imported salvages. What he achieved was a most sophisticated synthesis, the hall a peculiar composite of ornamental woodwork. The two screened recesses came from a batch of French balustered triple arcades, and a third group was used upstairs to make a chapel closet in the Priest's Room. The existing Bethersden chimneypiece and wall is enriched with ornamental carving and an overmantel formed around two magnificent Flemish oak panels, one dated 1574. French Renaissance panels form the reveals of windows, in which stained glass of *c.* 1500 was reputedly brought from Olanteigh, also in Kent. The staircase from the work of

33, 34. Broomwell House, Bristol. Drawings by W.H. Bartlett of the Library, *c.* 1825

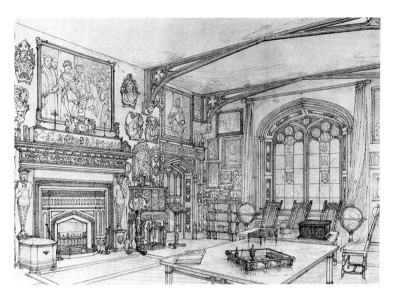

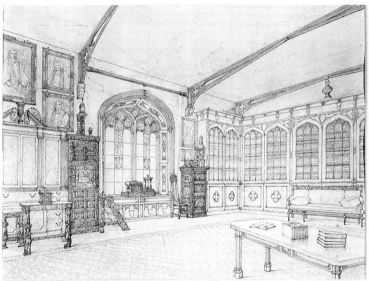

1628 is likewise embellished, to such an extent that it is difficult to make out what is mix and what is match or imported. Not surprisingly the stained glass in the windows is by the antiquarian-inclined designer Thomas Willement.

The probability that Godington received its antiquarian embellishment as early as *c.* 1820 makes for an interesting comparison with a quite different salvage mania, by George Weare Braikenridge, who became the darling of the Wardour Street brokers, especially Horatio Rodd, when he purchased Broomwell House, at Brislington on the edge of Bristol, in 1823.[7] On 30 July 1830 the Reverend Joseph Hunter could exclaim with astonishment that on The Lodge, the St Martin and Beggar outbuilding, and the Emblems of Passion doorway entirely made up from fragments of continental church furniture, was a

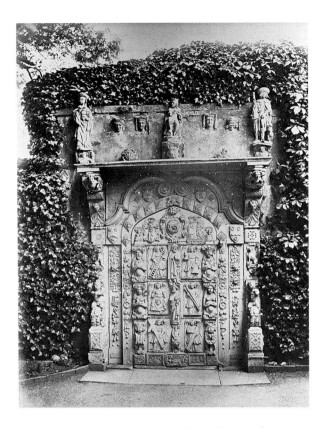

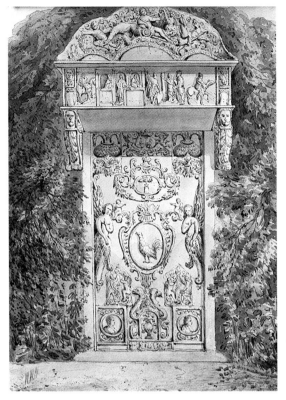

35. Broomwell House, Bristol. Emblems of the Passion Doorway in the garden

36. Broomwell House, Bristol. Watercolour by W.W. Wheatley of a composite doorway in the garden, *c.* 1830

profusion of woodcarvings of the 15th, 16th and 17th centuries. This is the great peculiarity of him and his Collection, but it is nothing compared with that we find in his house. The Hall, the breakfast room, and the Library are perfectly covered with it and some of it is perfectly exquisite in execution and the other pieces remarkable for the curiosity of the design. Such an assemblage was never before made. The Library (Figs 33–34) is the most extraordinary room.[8] Saving that there are books and pictures, the interior gives one the idea of a broker's shop, so crowded is it with what may be called salvage or hybrid furniture. Not a chair or a table but is thus elaborately carved.[9]

The chimneypiece with its caryatids, in style belonging to the Longleat Renaissance, is a rare salvage that came from a house in Small Street, Bristol,[10] but it may have originated from elsewhere. In the gardens, the lodge, cottages, and a row of so-called 'composite' doorways (Figs. 35, 36) in the shrubbery were ornamented with wood carvings: 'saints stood on the tops of walls, corbels peered out through the ivy and there was even a dovecot constructed in the same style'. After Braikenridge's death in 1856, his son the Reverend G.W. Braikenridge moved the library fittings to

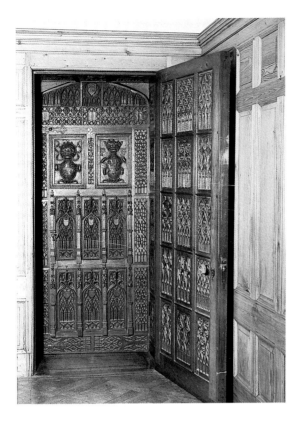

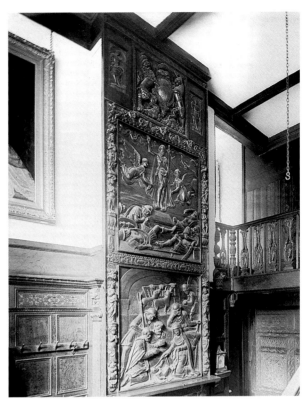

37. Claremont Lodge, Weston-Super-Mare, Somerset. The double door removed from Broomwell House, Bristol

38. Weare Giffard, Devon. The Staircase showing Flemish reliefs and the stair balustrade made up from French eighteenth-century newels

Claremont Villa, now in Highdale Road, Clevedon, Somerset, a house that George Weare had begun to build from one of a pair of small villas in 1839. This was externally rebuilt in Victorian Gothic by the Reverend in 1866–67, shortly before the sale of Broomwell House in 1868.[11] The Broomwell library was transferred intact, including the double door (Fig. 37) made up from a variety of panels and composed very much in the manner of the garden doorways.[12]

Braikenridge's choir stalls, incorporated into the library,[13] are recorded in a watercolour by W.W. Wheatley inscribed 'Broomwell House 1829' and appear to be from the same choir (perhaps with added carved elements)[14] as those installed in the Great Hall at Weare Giffard in Devon in 1832 (Fig. 39), and the stalls in the Music Gallery at Snelston Hall, Derbyshire, where L.N. Cottingham was the architect for John Harrison in 1828. All could well have come from a single shipment of Flemish salvages into the Wardour Street trade to furnish Snelston, Brougham Hall and St Wilfrid's Chapel, Brougham, Cumbria (Fig. 43). Cottingham,[15] of the Museum of Medieval Art at 43 Waterloo Bridge Road from 1828,[16] stands astride all this and was doubtless a supplier to the trade. He was collecting models and casts as early as

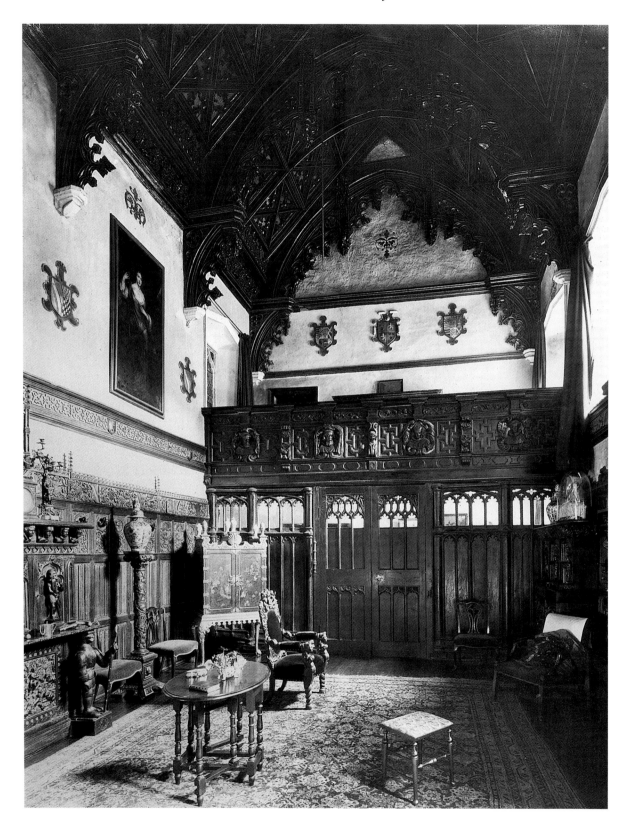

1822, and must have been warehousing much of his collection before he moved it into his house/museum.[17]

A mass of Wardour Street trade salvages went into George Matthew Fortescue's restoration in 1832 of Weare Gifford, his medieval manor house in Devon. His stalls are identical to those at St Mary's College, New Oscott, Warwickshire, put in place shortly before 1837. The hall staircase (Fig. 38) has Jacobean bedpost newels. The Great Hall (Fig. 39) was lavishly embellished, the screen a composite. Over the chimneypiece in the hall is a sixteenth-century Flemish relief of the Nativity and Resurrection, and elsewhere a mass of salvaged carved woodwork, Elizabethan panelling, sixteenth-century busts of bishops, and Flemish misericords, all providing convincing evidence of baronial pretensions.[18] The uncertainty of dating these imported salvages is underlined by the fact that at Weare Giffard there had already been an incorporation of salvages in 1812, described as 'a tantalizing jumble of woodwork in the C19 porch'.[19] This jumble is supposed to consist of salvages from North Aller Manor and the Sham Castle at Castle Hill, other Fortescue seats. Much later, Jacobean chimneypieces are also known to have been introduced in 1858.

In browsing through the four volumes of John Bernard Burke's *A Visitation of The Seats and Arms of the Noblemen and Gentlemen of Great Britain and Ireland*[20] for antiquarian descriptions, I found his account of Whitmore Park, Warwickshire, just a bare two miles from the centre of Coventry, a singular entry in the whole of the series.[21] Burke writes that the seat of Edward Phillips, FSA, 'a neat structure in the Elizabethan style, was erected mainly of stone by the present possessor: it contains an abundance of oak carvings of that period, and the staircase and dining room walls are hung with arras tapestry', the subject Achilles and Agamemnon. Burke refers to the 'antique relics of the interior' in keeping with the ivy-covered exterior. Phillips apparently bought the estate on 1 November 1841,[22] and his must surely have been an antiquarian house. Although a Katherine Hannah Phillips died as recently as 1901 and the house was not demolished until the 1920s, surprisingly no photographs appear to have survived of either exterior or interior.[23] Like Braikenridge of Broomwell, no doubt Phillips of Whitmore bought his carvings from the Wardour Street trade.

This trade in salvages had increased mightily by late eighteenth and early to mid nineteenth-century urban developments, not least the successive rebuilding and alteration within the parameters of the Palace of Westminster, which must have disgorged masses of early wooden salvages. Then, as later in the 1920s and 1930s, dealers rejoiced in inventing royal provenances: the 'Queen Elizabeth slept here' syndrome. A chimneypiece in Leasowe Castle, Wallasey, Cheshire, at first a hunting lodge or stand built for the Earls of Derby around 1593, is a case in point. The castle was enlarged in the castellated style for Mrs Boode, and from 1834 for her son-in-law, Colonel the hon. Sir Edward Cust, later Comptroller of the Household to Queen Victoria, who installed what became the notorious 'Star Chamber Room', or

39. Weare Giffard, Devon. The Great Hall, view towards the screen

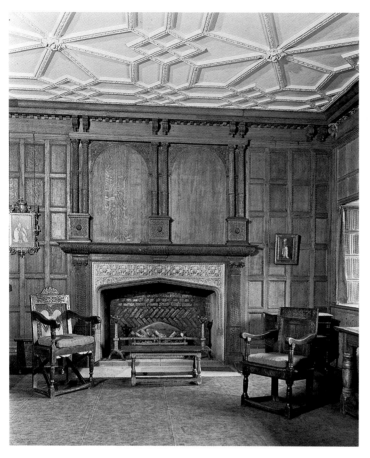

40. Windsor Castle, Berkshire. The Star Chamber Room as installed after 1913

perhaps just the chimneypiece, rescued in 1836 when 'the Chamber itself was dismantled'. Today (Fig. 40) this is room no. 280 in Windsor Castle, formerly called The Equerries' Writing Room. Leasowe Castle had been inherited in 1878 by Cust's grandson, Commander Sir Charles Leopold Cust, Bart, who eventually removed the room and presented it to HM King George in 1913.[24] Of course, in retrospect, the Star Chamber must have had many manifestations, but it was surely originally a large meeting chamber, not this single room of moderate size. A comparison can be made with the celebrated room in the Treaty House, Uxbridge,[25] which could never have seated the Royalist and Parliamentary commissioners. It is not certain where the Star Chamber fiction begins, but in W.W. Mortimer's *History of the Hundred of Wirral* of 1847 the chimneypiece is lithographed by C. Hutchins and titled 'Chimney Piece From The Ancient STAR CHAMBER Removed From The Palace Of Westminster to Leasowe Castle'. Mortimer or Hutchins would have found their information in Brayley and Britton's *Ancient Palace of Westminster* (1836) or J.T. Smith's *Antiquities of Westminster* (1837), both authorities firm in the belief that this chimneypiece, then in the Tally Office of the Exchequer, had been in the Star Chamber until its abolition in 1641. In fact, to keep up the pretence the overmantel was embellished with two heraldic cartouches with the royal arms.[26] The Star Chamber in Windsor Castle it remains!

On 15 June 1836 there was a typical importation sale of Flemish and Netherlandish carvings, held at Deacon's Rooms at 2 Berners Street, London: the 'Sale of Gothic and other oak carvings just landed comprising fine specimens of the XV and XVI centuries about 10,000 pieces. The whole well worthy the attention of the nobility, Gentry, Architects and collectors . . . by Mr C. Deacon at his spacious rooms'. It has been suggested that this was where the sixth Duke of Devonshire purchased his German Oak Room at Chatsworth (Fig. 41).[27] In his reminiscences the duke charmingly describes the circumstances of this purchase:

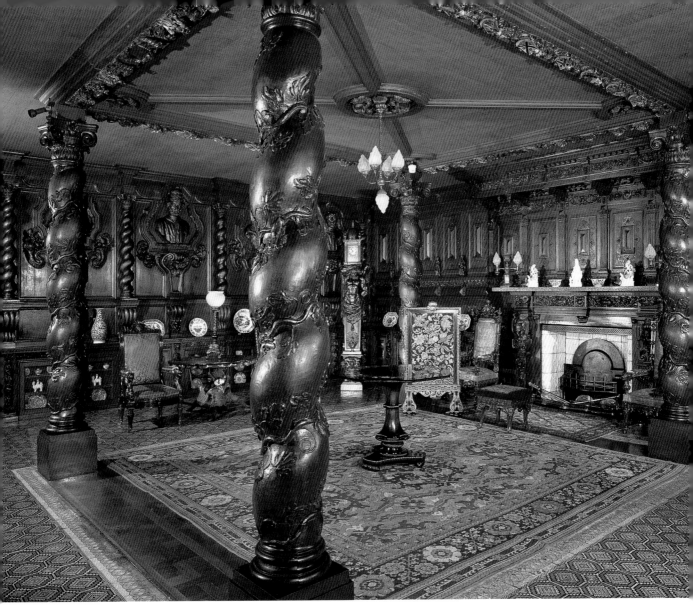

41. Chatsworth, Derbyshire. The German Room, installed 1840–46

One day, walking with a friend in Berners Street, we were tempted into the auction room, and found carved oak being knocked down. I bought to the right and left, and became possessed of almost all that you see here, the fittings of some German monastery, and the woodwork of an old fashioned pew. So inconsiderate a purchase was never made – however, look at the result. Is it not charming? What discussions might be raised upon it hereafter! – what names given to the busts unknown to the buyer as they were to the seller![28]

In fact what the duke bought was a load of miscellaneous carved woodwork. The room was clearly a composite, probably assembled by Sir Jeffry Wyatville from perhaps half a dozen sources, its range of barley sugar colonnettes looking suspiciously like those reputedly from Breschia, installed much later by the antiquary Vincent J.

42. Cockayne Hatley, Bedfordshire. Three bays of the choir stalls

Robinson after he purchased Parnham House, Beaminster, Dorset in 1896.[29] The
Duke of Devonshire was not in London on the day of the Deacon sale,[30] and
according to his building accounts the carvings must have been bought before 26
January 1839, when preliminary installation work is first mentioned.[31] This con-
tinued through 1840 and 1841, with framing and fitting still in progress in 1846
('cutting away moldings [*sic*] in Oak Room'). This extended time may imply that
the duke did buy a huge collection of salvaged carvings that demanded sorting out
into a cohesive design for the room. Indeed he sent parcels of this carving over to
Holker Hall, Lancashire, the seat of a cadet branch of the family, to ornament the
private wing.[32]

 The variety of assemblage, 'bought to the right and left' by the duke for secular
use, can be compared to an importation of salvages at Cockayne Hatley church in
Bedfordshire by the Reverend Henry Cockayne Cust. Although it is ecclesiastical,
Cockayne Hatley might usefully be compared with what Braikenridge achieved at
Broomwell.[33] The Hon. Henry Cockayne Cust was the second son of Lord
Brownlow at Belton. He settled at Cockayne Hatley in 1806 as rector and squire, a

'squarson'.[34] Cust described the church in 1806 as in a 'most lamentable state of neglect', and it was not fully restored until 1830. Fortunately Cust's journals reconstruct his furnishing campaign.[35] His friend, mentor and agent, Colonel Robert Rushbrooke of Rushbrooke Hall, Suffolk, was himself an amateur gentleman architect who guided Cust into the ways of London salvage dealers.[36] But what stands out as exceptional is that Cust and Rushbrooke also bought directly from dealers in Belgium. The baroque monastic choir stalls (Fig. 42) from the Augustinian Priory of Oignies in Belgium, and the Mannerist pulpit from St Andrew, Antwerp, were shipped and installed at Hatley in 1826. In addition there were three sets of altar rails and a pair of folding doors that may have been associated with a Rhine excursion in April 1827. In 1828 Cust was buying miscellaneous woodwork from John Swaby in Wardour Street, but not a great deal.

Broomwell, Weare Giffard, Cockayne Hatley, Chavenage – all were constructed by amateur owners. As far as we know, professional architects were not involved or, if they were, they acted closely with the owner. There is no evidence that later eighteenth-century architects such as James Stuart, Robert Adam, James Wyatt, Sir William Chambers or George Dance the younger incorporated salvages in their décors, although Soane did so in the special archaeological context of his house/museum in Lincoln's Inn Fields. In 1828 the two events that would change this were the opening by L.N. Cottingham of his Museum of Medieval Art at 43 Waterloo Bridge Road and the laying of the foundation stone of Goodrich Court, Herefordshire, by Sir Samuel Rush Meyrick and his architect Edward Blore. In both cases two professional architects were making rooms in various styles, Cottingham composing, presenting and weaving thousands of medieval and Elizabethan salvages in his display rooms and Meyrick inventing rooms in a sequence of styles, many intended for the display of his collection of armour, although in his case the rooms were modern inventions with the exception of the late seventeenth-century ceiling from the Palace of Breda and folding doors from Louvain. When we review the use of salvages in the preceding half-century, we find that none have the integrity or homogeneity of an original late Gothic interior or a Flemish baroque one. Maybe Horace Walpole in his making Strawberry Hill recognized the impossibility of this.[37] Had it been fifty years later he might well have incorporated salvages, as did A.W. N. Pugin at Scarisbrick.

Pugin, a contemporary of Cottingham, had admired Cottingham's Magdalen College Chapel begun in 1829 as an archaeologically correct Gothic Revival interior, and he must surely have visited Cottingham's museum.[38] After all, Cottingham was presenting exemplars and setting standards for Gothic design that no one else was at the time. In the 1830s he designed and built two modern Gothic houses, the fourteenth-century style Snelston Hall, Derbyshire, for John Harrison, and the medieval castle style Brougham Hall, Westmorland, for William, Lord Brougham. The music room or gallery at Snelston received a row of seventeenth-century Flemish stalls, perhaps from Cottingham's collections,[39] and from the same source may have come the astonishing collection of continental woodwork crammed into St Wilfrid's Chapel, Brougham (Fig. 43), the most notable of which was its Flemish

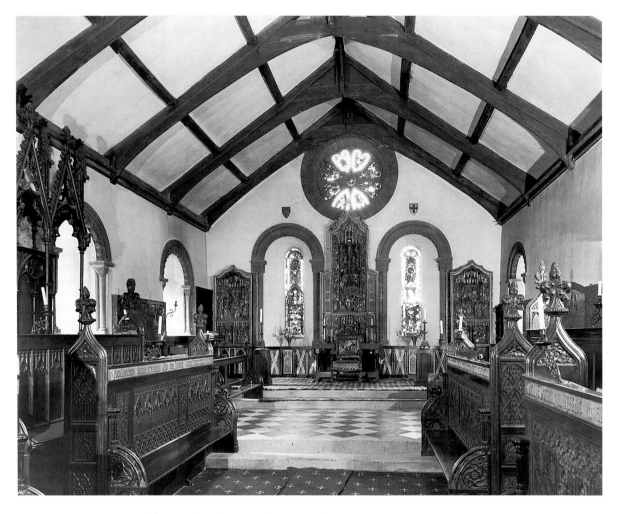

43. St Wilfrid's Chapel, Brougham, Cumbria. View to east

altarpiece now removed for safety to Carlisle Cathedral.[40] Even today, long after Brougham Hall's demolition in 1935, what survives of the curtain walls is extraordinarily convincing. Lord Brougham demanded 'true antiquarian feeling' for his Armour Hall in a baronial mansion intended to echo 'the true medievalism of nearby Naworth' Castle.[41] As may be seen in old photographs and postcards (Figs 44–45), Brougham's was the perfect example of a romantic antiquarian Great Hall,[42] more convincing than Cotehele, despite the scurrilous review in the *Gentleman's Magazine* by 'Old Subscribers' in June 1848,[43] claiming, almost certainly correctly, that 'all the suits of armour and accoutrements were in reality bought from various curiosity shops in Wardour Street'.[44] The linenfold panelling in the dining room and surrounding the hall and screens there are clearly Cottingham salvages.[45] George Shaw comments that 'much old oak was brought from Scailes Hall [Cumberland][46] for the recent repairs to this staircase'. There was

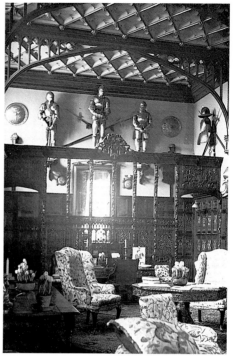

Brougham Castle, Cumbria, the Armour Hall

44. View to the chimneypiece *c.* 1900

45. View to the screen *c.* 1900

a contents sale on 21 June 1932, by Garland Smith & Co., Mount Street, London, and a fixtures and fittings sale on 18 July 1934, by Messrs Perry & Phillips Ltd., of Bridgnorth, when the reconstructed Scailes staircase, sold for £32, was torn out prior to the demolition of Brougham.

The influence of Cottingham upon the young Pugin can hardly be exaggerated, and one channel of influence must surely be Cottingham's museum. It would be intriguing to know who at Scarisbrick Hall in Lancashire[47] – Charles Scarisbrick or Pugin – determined to spend more than an astonishing £5,500, a huge sum, on Gothic wooden salvages from Edward Hull in Wardour Street between December 1836 and March 1846.[48] The bills are annotated by Scarisbrick himself, and it is almost certain that he was acting as a creative amateur, but he required Pugin to translate the salvages first on to paper as designs and then into the intended location. The Scarisbrick papers contain the richest evidence we have of trade in medieval salvages at this time. An intriguing entry of 21 May 1841, is 'Paneling from Strawberry Hill and Commission' for £105 1 sh., obviously referring to the Strawberry Hill sale.[49] Identified entries in the accounts include, for the 'Library' in February 1838, 'The very Fine Gothic chimney piece £300' and for the 'Middle Library' 'The large oak Doorway including the new carvings on top of frieze £94.10'. In June 1839 'Gothic Pillars for the [centre of] Large Doors library' cost £4. 10sh.' In August 1840 for the 'Ante Room to Libraries', 'Canopies bought at sale' cost £100, and the 'Two double doors carved on both sides making out of my old materials' cost £165, £94.10 and £259.10. In the 'South Library' a 'Chimney piece made out of my own carving' cost £30. In December 1840 there is another bill

46. Scarisbrick
Hall, Lanca-
shire. The Oak
Room, carved
woodwork
assembled by
A.W.N. Pugin

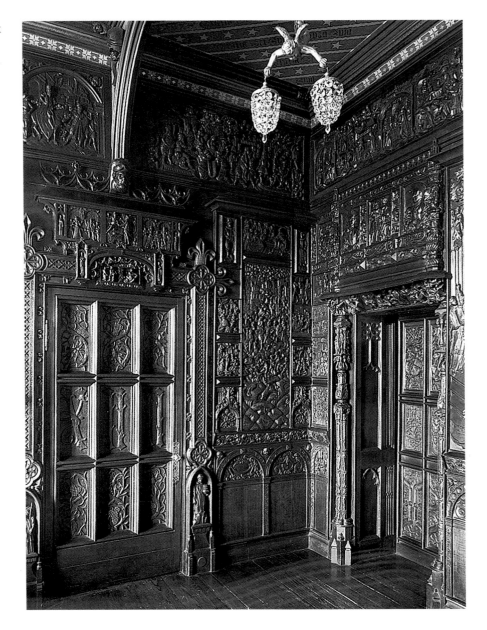

for £94. 10 sh. for 'Making pair of large Gothic doors for Library', and a puzzling
repeat of this in October 1841. A costly entry in December 1840 was for 'The very
fine Screen and Panelling Doors etc – for end of the Hall', £1,000, and this is also
repeated in October 1841.[50] In October 1844, the 'Lot of very fine Gothic Work to
be used for the Lanthorn over Staircase & window frame' cost £150. Dominating
the Great Hall is a carved relief of Christ Crowned with Thorns, reputedly from
Antwerp Cathedral, but making an 'Unnatural union'[51] with Salomonic, or barley-
sugar, columns topped with Gothic tabernacle work. Indeed, again *pace* Knox, 'The
chimneypiece in the Oak Room is a copulation between some medieval choir stalls

Wroxton Abbey, Oxfordshire

47. Panel of Colonel North's imported woodwork

48. Passage screen combining Colonel North's imported woodwork and rococo fret panels from an eighteenth-century garden pavilion, maybe the India House

and a Rococo cresting, the throne in the Great Hall a most convincing and ingenious composite,'[52] the chimneypiece in the Red Room a mongrel Gothic affair with finial urns of Renaissance design, and the extraordinary Oak Room (Fig. 46) a composite of carved wood salvages layered like wallpaper – all this, to quote Girouard, 'fantastical confections, quite un-Puginian in their lack of scholarship and playfulness', a suggestion that highlights the amateur intervention of Charles Scarisbrick himself.[53]

'Lack of scholarship' or 'playfulness' might be applied to a salvager even more enthusiastic than Scarisbrick under the tutelage of Pugin: Colonel the Rt. Hon. John Sidney Doyle, who married Susan, Baroness North of Wroxton, Oxfordshire in 1835 and assumed the name of North in 1838. Documents relating to his astonishing importations of salvages into Wroxton Abbey, Oxfordshire, are frustratingly elusive. A date of 1858 is a likely commencement, when John Gibson built the two bays to the right of the entrance front. Sir William Pope's house was incomplete in 1631, and the character of the interior by 1835 was a mishmash comprising Sanderson Miller's ogee – Gothick windows and ceilings and Batty Langley chimneypieces, with a dose of Sidney Smirke's Elizabethan Revival. Colonel North must have suffered from a *horror vacui* for he emptied the Wardour Street shops into Wroxton. In almost every room are Flemish, Italian and French wood carvings of the very highest quality (Fig. 47), to the extent that it is sometimes difficult to disentangle Wardour salvages from real Jacobean work. The entrance door would look convincing in a Portuguese Manueline interior, in the Great Hall a variety of woodwork makes up the chimneypiece, and the screens passage is part Jacobean, part

North salvage. A telephone kiosk is composed from an Italian Renaissance door, in several rooms Miller's Batty Langley chimney mantels are enclosed in baffling composite surrounds, and on the first floor a gallery passage is screened by Georgian fretwork panels (Fig. 48) that may once have belonged to a chinoiserie garden kiosk, perhaps the 'India House'. In Miller's Chapel the galleries are fronted with Flemish panels and the altar rails are made up from a French early eighteenth-century stair balustrade, as is the balustrade to the pulpit in the nearby parish church. It is an excess of salvage piled upon excess. Colonel North must have been the delight of the Wardour Street traders, shopping 'to right and left', as was the Duke of Devonshire at Chatsworth at the time of his short-lived interest in continental woodwork.

The architect who must have supervised Devonshire's installation of the German Room in the late 1830s was Sir Jeffry Wyatville. He served this sixth Duke of Devonshire, better known as the 'Bachelor Duke', as Sir Charles Barry served William Bankes at Kingston Lacy, Dorset.[54] The two were patrons born within four years of each other and both were bachelors of a tasteful sort, although Bankes, as an expatriate homosexual, would be forced to patronize his architect from a distance in Venice. They possessed similar passions for collecting and moving salvages. The duke commemorated his own achievements in his delightful *Handbook to Chatsworth and Hardwick*, privately printed in 1845.[55] Bankes was less fortunate in his memorials, but from lonely exile he sent back a stream of letters and memoranda, which are preserved in the archives.[56]

The sensitivity of Duke William to the beauty and romance of Hardwick can hardly be exaggerated. In his Chatsworth *Handbook* he recollected that much of his childhood had been spent there, and he later confessed that in the 'delusions of my youth . . . I lived in a house furnished and arranged just as Mary left it'. Mary, Queen of Scots, was imprisoned in the Elizabethan Chatsworth, not at Hardwick. Later, after the duke's inheritance in 1811, when he stayed at Hardwick to escape the noise and inconvenience of the great additions being made by Wyatville to Chatsworth from 1820, he occupied what had been known as 'Bess's Drawing Room and Bedroom'. He made capital out of the romantic connections between Hardwick and the Rose of Scotland, and when he introduced a statue of Mary, Queen of Scots by Sir Richard Westmacott, he wrote that it 'represents popular belief and tradition in defiance of the dates and facts'. The duke revered Hardwick. He delighted in its fragile and beautiful ambience, which he felt needed to be amplified by appropriate furnishings. So out of the duke's 'mine', his 'lumber room over the stables' at Chatsworth, came beds, stools, tapestries, mirrors, and much of 'that treasury of mouldings' that had survived from his own remodelling of Chatsworth when he swept away what remained of Mary's apartments. A continuous procession of wagons trundled along the lanes to Hardwick, and in one wagon was the most precious salvage of all, a relief of Apollo and the Muses with the arms of Queen Elizabeth, now known to have originated in the Great High Chamber of the Elizabethan Chatsworth, whence it was removed to a steward's room during William Talman's late seventeenth-century remodelling.

Chatsworth itself was not exempt from the duke's attentions. Over and above the splendour of the Williamite baroque interiors, the duke wanted a more exotic and richer environment, and so vases and statues came from the celebrated auction sale in 1823 of Wanstead House, in Essex; yellow marble columns from Carthage were purchased; and eight more columns of 'surpassing beauty' came from Richmond House, Whitehall. Many picture frames were composed from the so-called Grinling Gibbons carvings brought out of store, or from what had been displaced from Mary's apartments by Sir Jeffry Wyatville. The duke reminiscenced, 'when Lord and Lady Dumfermline[57] established themselves at Stubbing Court and repaired it, I sent a whole cartload of Gibbons's carving, that was lying unemployed in the lumber room, to decorate their drawing room, little foreseeing that I should become so eager a collector of carved wood afterwards. When they went to live in Scotland, I thought of getting it back, on finding that it was highly valued and going to be removed with care, I became consoled and satisfied. Some of the festoons had the initials of the first Duke at their base'.[58]

William Bankes had an advantage over Duke William. In not being heir to a dukedom he was able to travel freely across Europe and the Middle East between 1812 and 1820. He had inherited Soughton in Flintshire in 1815, but not Kingston Hall (later Kingston Lacy) in Dorset until his father died in 1834. Long before this though William was dreaming of 'Castles in Spain'. Initially he would have to be content with Soughton, where he was making a distinguished collection of old master paintings as well as Egyptian antiquities. In 1820 the young Charles Barry was commissioned to alter Soughton to resemble 'some of the old villas in the north of Italy' with 'towers and much ornamented stonework,'[59] and it was here that Bankes installed his first salvages, of which there are survivals in the entrance hall. John Bischoff's letter in 1826 from Rouen, obviously referred to Soughton: 'The person who showed me a small circular room with a curiously carved and gilded ceiling said that the . . . owner would be glad (tho' a rich man) to sell the bas reliefs you wish for & a clever Frenchman might manage the business.' Bischoff also tempted Bankes with 'stained glass in the Church of St Patrice and St Godard', in Rouen. Far more intriguing was a letter from a James Frampton[60] advising Bankes that knowing he 'had been buying some old carved oak for Wimborne Minster'

Sir Arthur Brooke de Capel Brooke had bought the whole oak fitting up of the library of some convent in Flanders most beautifully carved with some figures as large as life & very richly worked made for a room eighty feet long which was too long for his own room & it was now in a stable in Northamptonshire & is to be sold if taken all together – but not in parts'. According to Tim Knox; 'the De Capel Brooks were seated at Great Oakley Hall near Kettering, Northamptonshire, which is a very tricky house and the convent library was undoubtedly intended for the hall there.[61]

In 1837 Bankes bought '11 pieces of carving' from H. Nurse, Dealer in Antique Furniture in Cavendish Street'.[62]

What Bankes determined, and Charles Barry carried out, was the restoration of Kingston Lacy as it is better known, to what was believed to have been its 'Jonesian'[63] form. But an impediment arose when in September 1841, after an indiscreet encounter with a guardsman in Green Park, Bankes skipped bail and went into exile. So began his expatriate life: he sent back shiploads of works of art and salvages of all sorts, for which voluminous memoranda survive in the family archives, now deposited with the Dorset Record Office. Most are letters to his clerk of works, but also to his sister Lady Falmouth, who was charged with superintending the work because his brother Henry, the manager of his affairs, was 'but a poor judge in art and has but an indifferent eye'.

The Spanish Room, or Spanish Golden Room as he called it (Fig. 49), serves as a role model in England for the integration of disparate salvages into a perfect whole. The great gilded Venetian ceiling with inset paintings attributed to Veronese, bought from Town and Emmanuel of 103 New Bond Street for £100 in 1839, came from Vincenzo Scamozzi's Palazzo Contarini degli Scrigni, 'in the fitting [of which] some modifications were made to make the dimensions conform'. The oval cartouches or 'labels' in the frieze are also Venetian, but from another source. This was but a few years after Disraeli wrote of Venice, 'Palaces are now daily broken-up like old ships and their colossal spoils consigned to Hanway Yard and Bond Street whence, reburnished and vamped up, their Titanic proportions in time figure in the boudoirs of Mayfair and St James's'.[64] The Spanish Picture Room became a totality only after Bankes searched for gilded leathers. Town and Emmanuel offered some from the Palazzo Manin, but instead he preferred the 'cuojo indorato della Casa Barbarigo' – bought in June 1850 from Pietro Foco, another Venetian dealer. In other rooms salvages found their place: the dining room with 'Bavarian' carvings, and a ceiling by Guido Reni bought in 1840 from the Palazzo Zani in Bologna; or in the Saloon a buffet of crouching atlantes supporting a huge scallop flanked by dolphins with trumpeting tritons and a pair of candelabra – all these probably Genoese woodwork. There is a fine letter to Seymour, his later clerk of works, revealing the complexity of installation ordered from abroad: 'Having got the Tortoises to those Italian Candelabras gilded we have commenced the céntral group in the Saloon & have made good the piece of Rock that was missing at the foot of the statue – I sent to London for some patterns of gold one of which we are now about to employ for the Shell Dolphins and other Figures below (which is to remain dark) I find is a very dark Bronze colour'. It is wondrous to realize that all this was organized from his rented apartment in a Venetian *palazzo*, where he died on 15 April 1855.[65]

Although it could be said that Bankes was acting as an amateur, Barry must constantly have intervened between Bankes and his clerk of works. Bankes was exceptional because he was manic in what he was determined to achieve at his beloved family seat from his continental isolation.

A quite different creation was to be found at Methley Hall in Yorkshire, where in the early 1830s, during his general renovation of the sixteenth-century house, Anthony Salvin created for Sir George Savile a bedroom with four-poster bed, 'Jacobethan' chimneypiece, and tapestries obviously hanging from a Georgian cor-

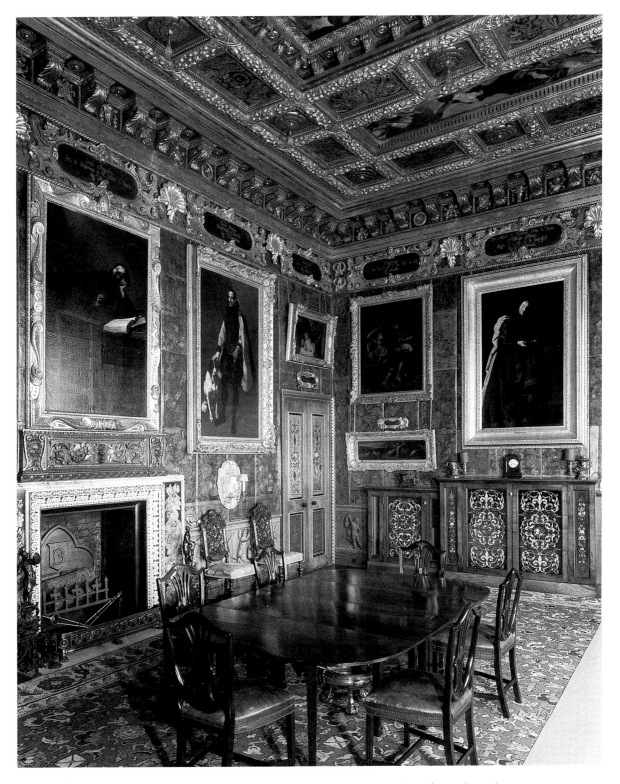

49. Kingston Lacey, Dorset. The Spanish Picture Room with the ceiling from the Palazzo Contarini, Venice

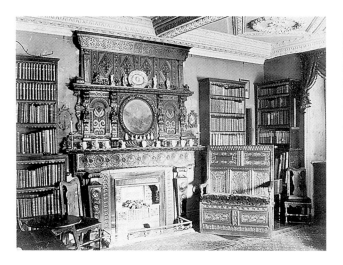

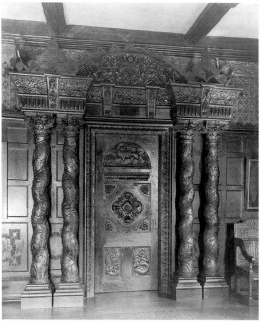

50. Derwydd, Carmarthenshire, the Library *c.* 1900

51. Gwydir Castle, Carnarvonshire. The Sitting Room doorcase

nice,[66] the ambience convincingly evoking the ancient Elizabethan Methley. The Jacobean screen in the hall also looks reconstructed by Salvin; this may have occurred when stair access was provided to one side of it. The incorporations of salvages are not immediately obvious in this house, which possesses scanty visual interior documentation. Clearly the motivation was antiquarian, as it was at Campden House, Kensington, bought by William Frederick Woolley in 1854.[67] According to *Chambers's Journal* Woolley found this great Elizabethan house

> in a very dilapidated state. With the exception of one room, the dining room, there were merely the bare walls . . . I fitted it up in the style of the original age of the house . . . I was always purchasing things, such as panels, and had them put together. I purchased them in all places, at home and abroad. I recollect purchasing a place in Essex called Fearing [*sic*]. It was an old house, and there were very remarkable carvings in it . . . which were of the time of Henry VII, remarkable indeed, there are casts of them in the Kensington Museum . . . They were removed to Campden House, and one room – the breakfast room – was entirely fitted up with them, and furnished in keeping with the carvings.[68]

It is not amiss to compare the professionally conducted antiquarian taste at Methley with the rustic library furnished in the 1870s or 1880s by Alan Stepney Gulston, whose romantic befuddled view of 'Old Derwydd', Carmarthenshire, saw the yard in front of the house as King John's jousting court (Fig. 50).[69] The house was full of the 'Jaco-bogus', all arranged below early eighteenth-century ceilings. The same might be said of another rustic seat, Gwydir Castle, Llanrwst, Gwynedd. Before its dismantlement and sale in 1921 the interior décor (Fig. 51) appeared as a

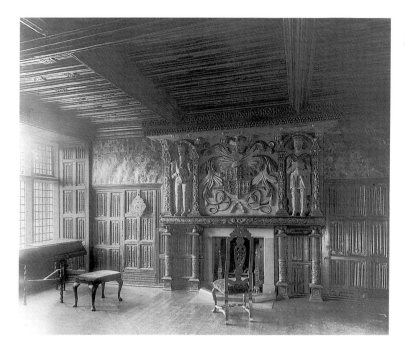

52. Gwyddir Castle, Carnarvon-
shire. The Breakfast Parlour

mixture of the real and the make-believe, not least the amazing 'Jacobogus' table, or the drawing room given the character of a Great Hall. At the sale the dining room was sold to French & Co., who sold it on to Hearst. The oak parlour (Fig. 52) appears to have gone to the USA, but has never been located.[70] At Boxwell Court, Gloucestershire (a gentry house of great antiquity), a mid-nineteenth-century Huntley squire tried to erase the Georgian modernizations of 1796 by replacing a more ancient and rural style with 'Jacobogus' furnishings, knowing that Charles II slept here on his flight from the Battle of Worcester in September 1651. A late example of this amateurism in the 1890s and the turning years of the millennium could have been observed at The Hendre near Monmouth, the seat of the Rolls, Barons Llangattock. In this vast rambling, mostly Victorian house a great number of Elizabethan and Jacobean salvages from derelict Welsh mansions were incorporated to serve as a background to 'Jacobogus' furniture of every sort, all seemingly bought and arranged by Lady Llangattock.[71] The link back through the past century to the Ladies of Llangollen is obvious. Even today, to walk from these somewhat incoherent rooms to the Cedar Library in the wing added in 1896 by Sir Aston Webb is to sense the change from an owner's enthusiastic amateurism to the sophistication of a leading metropolitan architect uninterested in the recent antiquarian taste of his patrons.

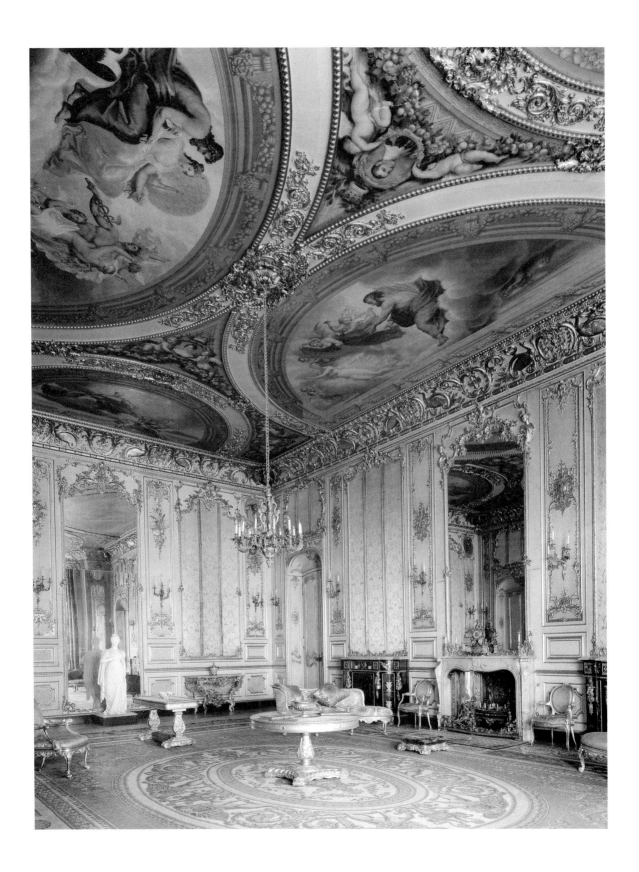

4

ENGLAND AND THE FRENCH CONNECTION

IN LEWIS NOCKELLS COTTINGHAM'S MEDIEVAL museum all sorts of continental décors and salvages could have been found, but not French *boiseries*. As far as is known they do not feature in the Wardour Street trade. *Boiseries* referred to another quite distinct type of continental salvage imported into England in the nineteenth century, initially as an isolated phenomenon of the late 1820s and early 1830s. In July 1824 Elizabeth, Duchess of Rutland's purchase in Paris of the 'Maintenon' *boiseries* to form her Elizabeth Saloon at Belvoir Castle (Fig. 53) was prophetic of a flood of such imports.[1] This salvage is the first documented French *boiserie* import into England, unless Charles Stuart, Lord de Rothesay, had bought *boiseries* during his first embassy in Paris from 1815 to 1824,[2] which is possible but unproven. The Belvoir acquisition would become a role model in the history of French *boiserie* installation *outré mer* in both England and the USA. The *boiseries* were believed to have come from the apartments of Madame de Maintenon in the Grand Trianon at Versailles. This most desirable association would prove untenable to Bruno Pons,[3] although James Yorke makes a very plausible suggestion that the *boiseries* came from the hôtel De Noailles in the rue St-Honoré, as this was the hôtel of Madame de Maintenon's niece who married into the De Noailles family.[4] In any case dealers were always keen to attach or invent a royal association. In fact, the saloon as created by Matthew Wyatt was composed of a set of high quality Louis XV rococo *boiseries* of *c.* 1735 from an unidentified Paris *hôtel*. Even if they and the associated mirrors had to be amplified and woven in with plaster additions by a Mr Alcock (who was 'really a very clever and accurate man'[5] and had to create a new dado for a room whose height and proportions were not French), the Elizabeth Saloon would be the first representative of the much later French imported décors, many for the Rothschild family after 1850. Similar weaving occurred at Windsor Castle in the Grand Reception Room, exposed during the restoration after the 1992 fire, when it

53. Belvoir Castle, Rutland, The Elizabeth Saloon

was possible to distinguish between carved *boiseries* and the plaster mix and match. These *boiseries* came from a shipment bought in Paris by George IV's cabinet-maker Nicolas Morel, who had been sent there by the furnishing committee of George IV and Sir Jeffry Wyatville, 'for the purposing of procuring Patterns and drawings of an appropriate description to be used in the designs for furnishing Windsor Castle'. As a consequence, on 31 October 1826 there arrived thirteen cases of carved wood. Bought for £500 from the Paris dealer S. Delahante, these were described as 'sundry large carved panels of rooms', and doors, to be 'advantageously used as patterns from which composition ornaments might be made.'[6] Progressively at Windsor some of the new state and private rooms became a receptacle for salvages, not least from the demolition of Carlton House that began in 1827 when such movable ornamental effects as gilt wood door trophies were transferred to the new Crimson Drawing Room.[7] Vulliamy chimneypieces were also moved, such as the example in the White Drawing Room, which came from the basement dining room in Carlton House. This was commonplace, for throughout the history of royal building projects there was a constant re-use of salvages. However, at this time the Duke and Duchess of Rutland, George IV,[8] and Lord Stuart de Rothesay, were exceptional in using French salvages.

Charles Stuart, Lord Stuart de Rothesay, our philandering ambassador in Paris,[9] was a highly cultured connoisseur well known to the Duchess of Rutland from her forays to Paris. Indeed, it is very likely that she stayed at the Embassy in the hôtel de Charost. His two embassies were from 1815 to 1824 and from 1828 to 1831. During the former he was buying much Empire furniture and actively scavenging for Gothic salvages. The old Bute house at Highcliffe, Dorset was ruinous and had been demolished in 1798. Lord Stuart's ideas for a new house at Highcliffe had been slowly maturing since 1807–8 when he began to repurchase land.[10] As early as 1820 one French commentator observed that 'the English carried away for cash the sculptured remains of Jumieges',[11] reporting that the cloister 'was thought to have departed . . . with the family of the ambassador'. In 1828 J.S. Cotman wrote to Lord Stuart apropos the Grande Maison at Les Andelys in Normandy: 'I have no scale or measurement of any kind belonging to the House of Andelys.'[12] By 1830 Stuart had commissioned his architect William John Donthorne for an extension to his small house then called Penleaze. What evolved would be a shock for his mother, who thought he was adding no more than a 'few rooms', and whose first intimation of what her son was about was 'the spectacle of the Manoir des Andelys littering the cliff-top at Highcliffe when next she went there.'[13] However keen Stuart was on plundering and ransacking French buildings, taking advantage of the depredations of the Revolution, he was not alone. In fact the Abbey of Jumièges had been bought by a M. le Fort expressly to make money by selling the stonework. Nevertheless, Baron Taylor was scathing: 'Nous n'exprimerions pas de regrets aussi amers si toutes des productions des arts avaient été transportées en Angleterre',[14] and Victor Hugo certainly included Stuart in his criticisms of English aristocratic collectors exporting works of art across the Channel, when he launched a tirade in 1825 in his article 'Guerre aux demolisseurs', accusing them of Elginism.[15] In 1885 Abbot

54. Highcliffe Castle, Dorset. Château des Andelys bay window over entrance and three windows on the rear south elevation

Julien Loth noted that the cloister of Jumièges, the Benedictine Abbey of St Peter, and 'other beautiful sculptures . . . were bought by an Englishman, and reconstructed in an English park.'[16] Nevertheless, whoever was doing the plundering, there was an established and ready market in London.

On 7 January 1830 Donthorne provided a detailed statement on the treatment of the Great Hall,[17] and by 1834 Highcliffe was more or less finished, although interior work, notably for mosaic pavements, continued until the later 1830s. When Pugin, full of curiosity, visited the castle and was refused access, he huffed and puffed that 'the architect Mr Donthorne could not have had the slightest idea of Gothic architecture as he has turned Norman capitals upside down to serve for bases to the latest style of Louis XII and Francis I and made a sad havoc of everything.[18] It would seem that Highcliffe was the first house in England to incorporate large imported architectural salvages, and in this Stuart anticipated the scavenging of Stanford White and Grey Barnard half a century later, or that of the 1920s, when Keebles were scouring Parisian dealers for medieval elements for Berkeley Castle (Figs 78–81).

The odd mixture of Flamboyant and Perpendicular Gothic mixed with Elizabethan suggests the influence of Stuart intervening as an amateur obsessed with the French *style Troubadour* of his embassy years. The great window in the eastern tower, the Flamboyant doorway under the porch (Fig. 54), and the many and various external decorative or ornamental sculptured elements, came from 'La Grande

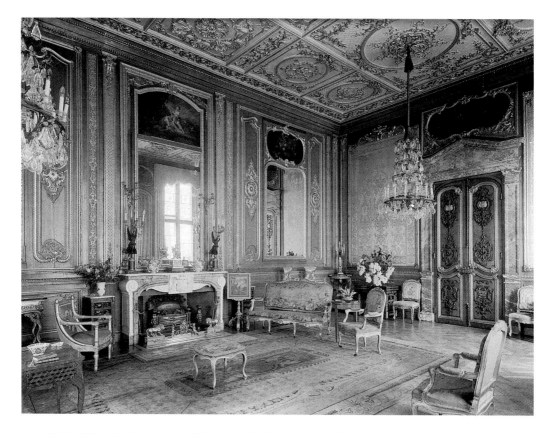

55. Highcliffe Castle, Dorset. Pineau style *boiseries* in the Drawing Room

Maison des Andelys',[19] and no doubt from many other sources.[20] Stuart imported several complete panelled rooms,[21] but there is no photographic evidence to prove this. There were certainly Louis XV doors,[22] overdoor paintings, chimneypieces,[23] and some rooms were composites of mix and match with Pineau-style *boiseries*, as in the dining room (Fig. 55)[24] the Octagon,[25] and the drawing room. They formed backgrounds to Stuart's collection of French furniture, including pieces from Marshal Ney's sale of furniture that belonged to the Empress Josephine at Malmaison, a bed with hangings reputedly worked by Marie Antoinette, and Gobelin tapestries said to have been looted by Napoleon from the Knights of St John at Valletta. The choir stalls of Jumièges provided the remarkable set of carved wood panels of the Life of Christ commissioned in 1501. These were set into wainscot to decorate the lower walls of the Great Hall (Fig. 56), and most appropriately have ended up in The Cloisters, New York. Also imported was much fifteenth- and sixteenth-century stained glass from the church of St Vigor in the rue des Bons Enfants, Rouen, to fill the great window in the Great Hall.

It may not be a coincidence that Les Andelys and Jumièges are on the Seine, enabling barges to carry materials directly to Highcliffe, where they landed at

Steamer Point. The handful of surviving letters published by Sarah Medlam[26] disclose that Lord Stuart's agent was George Gunn, an Englishman who had settled in Paris at 64 rue Amelot, and his London agent may have been James Nixon, cabinet-maker and upholsterer, described in an 1835 directory as 'importer of marbles and ancient furniture'. By 1830 or 1831 thirty-one cases had been shipped, including the 'whole of the marble at Labiois' – a marble merchant at 12 rue Amelot, Paris. Nixon had already supplied marble chimneypieces for Stuart's house at Carlton House Terrace, and it is almost certain that Nixon was responsible for many of the fixtures and fittings at Highcliffe. Gunn deserves further study as a supplier 'pour l'Angleterre, anciennes meubres principalement, cheminées et statues du siècle de Louis XIV, Objets d'art, curiosité, bronze, pendules, boiseries sculptées, meubles de marqueterie.'[27] The scale of Gunn's exports is measured by references in 1832 to case numbers up to 534.

Harlaxton Manor in Lincolnshire is the one other house that needs close scrutiny as a vehicle for the importation of *boiseries* at an early pre-Rothschild date. This gloriously eclectic house was the invention of Gregory Gregory, who had inherited the estates of Harlaxton and Hungerton Hall in 1822.[28] When interviewing Gregory in 1840, J.C. Loudon could comment that 'Mr Gregory possesses an ample stock of vases, statues and other sculptural ornaments, and of rich gates and other iron work, collected by him in all parts of the continent after the peace of 1815.[29] In 1853 James C. Burke recorded that 'during the last thirty five years, Mr Gregory has been unwearied in collecting the most beautiful and rare objects in virtu and taste in France and Italy, and, about twenty three years ago he commenced the palace of Harlaxton, as a fitting receptacle for his varied acquisitions'.[30] Inside this extraordinary house it is difficult to disentangle what is imported and re-used salvage and what is an invented style, whether Louis XIV, Jacobean or Dietterlin Mannerist. Anthony Salvin was first consulted in 1831, but by 1838 only the shell was finished and Salvin was dismissed. The task of completing the interiors under Gregory's interfer-

56. Highcliffe Castle, Dorset. Life of Christ panels from Abbey of Jumièges, France, in the Great Hall

57. Harlaxton Manor, Lincs. Panel of Pineau-style gilded carvings removed from a enframement

ing and dominating supervision fell to William Burn, who had used salvages at two other Lincolnshire houses, Stoke Rochford and Revesby Abbey,[31] the former containing a huge Flemish–Rubens style chimneypiece, the latter German baroque panelling. However, nothing that Burn ever did was as theatrical as Harlaxton's cedar staircase, and as David Durant has discovered, and Tim Knox interpreted, the J.G. Graef who received a large payment of £2,744' is almost conclusively the decorator John Gregory Crace, related to the Gregory family.

The dining room chimneypiece incorporates twelve colonnettes of black Dinant marble, known to have come from the Mannerist Jubé (rood screen) at the church of Sainte-Waudru at Mons in Belgium.[32] Marble doorcases in the conservatory appear to have begun life as Flemish altarpieces, and the pavement of the staircase is made of up of 'French *pietra dura*'. In the Gold Drawing Room and the Anti-Room doors appear to incorporate panels of delicate Pineau-style Louis XV carvings (Fig. 57), not complete *boiseries* in their enframement, but perhaps belonging to a set that had been broken-up.[33] Therefore it is probable that Harlaxton does belong to this pre-Rothschild *boiserie* phase, although it is more likely to have been installed in the 1840s.

The importation of these French *boiseries* and salvages marks a watershed in this tale of the importation of French salvages into Britain. This importation was guaranteed by virtue of the active trade in salvages established in France. As Bruno Pons has demonstrated,[34] there is unique documentation for this trade in the public notices in the *Petites Affiches* and the *Journal de Paris*, and a contrasting lack of such public notices in England. What stands out in France is veneration for décors, not only of the highest quality, but also those with royal associations. A typical *sauvage* occurred in 1817 when P. F. L. Fontaine dismantled the old state bedchambers of Henry II and Louis XIV in the Louvre, décors regarded as enormously important, not only because Henry II's bedchamber had been designed by Pierre Lescot and carved by Scibecq de Carpi, but because it was the very room in which Henri IV died. Louis XIV's bedchamber was designed by Louis le Vau in 1654 and carved by Louis Barrois and Gilles Guérin. Both décors were carefully put into store, and brought out by Fontaine in 1829 when Henry II's bedchamber, and the alcove and ceiling of Louis XIV's, were installed adjacent to each other in what are now known as the Colonnade Galleries of the Louvre.[35] We can observe mix and match in the rehabilitation of this woodwork, especially on the doors. However, in this period there was still no populist fashion for collecting old décors, even in France in 1846, when Honoré de Balzac with his passion for carved wood salvages bought his chartreuse (monastery) on the rue Fortunée

in Paris, and created a *salon* with a mélange of *boiseries* and salvages all with exalted and fictitious provenances.[36] In 1848 the export from France, by E.P. Deacon of Boston, of the eight panels (Fig. 136) of *boiseries* carved by Joseph Metivier for Ledoux's hôtel de Montmorency is unique, anticipating what would become a flood in the next century. Installed the following year, they made up his 'Montmorenci Room' in the Deacon House, Boston.[37] The situation had changed when Adèle, widow of Baron Salomon de Rothschild, demolished Balzac's house after Madame de Balzac's death in 1882.[38] There was now

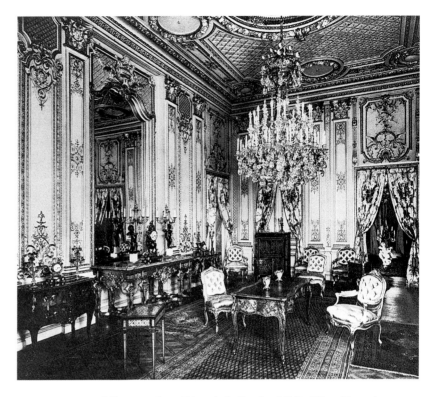

58. 148 Piccadilly, London. Lionel de Rothschild's West Drawing Room as in Sotheby sale catalogue, 14–17 April 1937

an international market for sets of *boiseries* to make up a French room, and Anglo-French tastes in England would feature prominently in this.

French rooms were on the move to England. By 1850 at the latest, we know that important *boiseries* from the hôtel de Villars on the rue de Grenelle, Paris, were on the market, for the dealer Mr Roe in London purchased some, perhaps as early as the mid-1850s, for the dining room at Waddesdon Manor.[39] Dealer Alexander Barker sold *boiseries* and a chimneypiece from the De Villars gallery to Baron Meyer Amschel de Rothschild for his dining room at Mentmore Towers in Bedfordshire;[40] and Mr Pratt of New Bond Street brought over *boiseries* from the hôtel de Noailles-Mouchy in the rue de l'Université.[41] The English Rothschilds would now join their continental relations in their enthusiasm for French décor. In 1860–68 a Louis XV room (Fig. 58)[42] was installed for Lionel de Rothschild at 148 Piccadilly, and due to destructions during the War of 1870 and the Commune, Rothschild incorporations were on the increase. In Paris, 1860 was a watershed, marked by the scandalous ransacking and demolition of the celebrated château de Monsieur de Bercy,[43] the last surviving fully furnished château in the environs of Paris. As *L'Illustration* commented when announcing the sale, 'tous les vrais amateurs de cette belle époque de l'art français saisiront l'occasion, unique, peut être, d'introduire dans leurs demeures une ornementation authentique incontestable.'[44]

59. Camden Place, Chislehurst, Kent. Château de Bercy panelling installed in what became Napoleon III's Cabinet

It was then that Lord Hertford bought the first floor *salon de compagnie*, first storing it, then passing it on to William Strode for Camden Place, Chislehurst, Kent, where it later served for Napoleon III's *cabinet*, and where it remains today (Fig. 59). The Rothschild name was now synonymous with the acquisition of French salvages, and François-Hippolyte Destailleur was the chosen architect when Baron Ferdinand de Rothschild bought the estate that would from 1874 see the construction of Waddesdon Manor in Buckinghamshire. Here were the most exceptional incorporations of any great house in Europe. Pons's magisterial catalogue, *The James A. De Rothschild Bequest at Waddesdon Manor: Architecture and Panelling*, 1996, enumerates 385 entries of *boiseries* and wooden elements with at least a

dozen Parisian provenances.[45] A typical entry is his account of Waddesdon's West Gallery with its composite incorporations: the oak half-columns matching similar elements in the Musée des Arts Décoratifs, from the *salon* of the duchesse d'Orléans in the Palais Royale; *boiserie* panels from the hôtel de Humières, 88 rue de Lille; various panels from the hôtel Le Bas de Montargis in the place Vendôme, and other elements from elsewhere. Not only *boiseries* but of course chimneypieces, many of which were frequently not at one with the surrounding *boiserie*. Alas, it was commonplace for chimneypieces to be sold without provenance, and this applies to nearly all chimneypieces of whatever country of origin exported *outré mer*. Waddesdon is a veritable Musée des Arts Décoratifs for the eighteenth century now that that once-celebrated Paris museum has disgracefully dismantled its wonderful and evocative sequences of period rooms (Fig. 127). What matters is that by 1900 the Rothschild mansions were admired models for that generation of American collectors and patrons who flocked to Paris, Vienna, Venice and Rome from the 1880s. Travelling Beaux-Arts architects were also involved, and so was an emerging new breed of decorators such as Jules Allard and Lucien Alavoine, both Paris–New York based. With the installation in 1893 by Allard of the first floor Parisian *salon* of Madame Megret de Serilly in Cornelius Vanderbilt II's The Breakers at Newport, Rhode Island, the stage was set for a transatlantic export trade from France of rooms and salvages, in which the Paris firm of Carlhian–Beaumetz, later Carlhian et Cie, would play a major role.[46] The incorporation of *boiseries* and salvages by the Rothschilds into the interiors of their European châteaux and town houses serves well to encapsulate the growing fashion for installing old *boiseries* in 'modern' houses, often mixing and matching with copywork. Both Pons[47] and Prevost-Marcilhacy[48] document these Rothschild incorporations, and Pons rightly observes that this is one step towards the concept of the American period room.

There was a most astonishing reversal of the passage of imported rooms in 1874, the year that Destailleur commenced building Waddesdon and Honoré Daumet was building the great house/museum at Chantilly for Henri d'Orléans, duc d'Aumale. In exile in England, Queen Marie-Caroline de Bourbon-Siciles had given Orleans House, Twickenham, to her son the duke, exiled from 1848 to 1871. It was a house already venerated by exiled French royalty, having served as the residence of Louis-Philippe, duc d'Orléans during his exile from 1815 to 1817. Both dukes were accommodated in a baroque house of 1710 designed by John James for the Hon. James Johnston. If the staircase painted by Sir James Thornhill is used as a measure, the rooms were a mixture of English panelled and plastered baroque, but with much wooden carved rococo decoration designed by John Linnell for Admiral Sir George Pococke, who had bought the house in 1763, ironically, in view of its later French connection, with his prize money from the capture of Havana from the French.

It could hardly be believed that when Daumet referred on 28 June 1877 to the fitting of 'boiseries du salon de Mme Clinchamp' at Chantilly, and to the problems of restricted access through a narrow corridor from the *salon de musique* in the Jean Bullant Renaissance pavilion, he was installing Linnell's English rococo bed alcove and its adjacent dressing room (Fig. 60) removed at the duc d'Aumale's behest from

60. Orleans House, Twickenham, Middlesex. eighteenth-century rococo woodwork by John Linnell, now installed in the Jean Bullant apartments at the Musée Condé, Chantilly, France

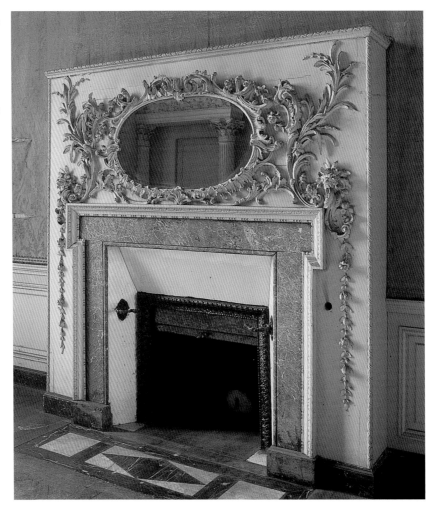

Orleans House.[49] The duke's wife, Marie Emilie de Bourbon-Sicile, princesse de Salerne, had died in 1869, and Madame Berthé, comtesse de Clinchamp, long since the duc d'Aumale's mistress, dutifully followed him to Chantilly. Possibly these rooms had been hers, and were to be hers again when she happily reigned at Chantilly as the duke's companion. For years the rooms survived in desuetude, hidden away in a cul-de-sac, windows cobwebbed, long an enigma in this very French ensemble, until their Englishness attracted Olivier Meslay, a scholar of the duke's English collections. French rooms came to England, English rooms travelled to the USA, but maybe the Chantilly rooms are the only English rooms to have been imported into France.

5

INTERIORS AND A NEW
PROFESSIONALISM: 1850–1950

DURING THE SECOND HALF OF the nineteenth century the use of salvages in interior decoration was on the increase. A fraternity of antique dealers were growing rich from European salvages. Just as Lord Stuart de Rothesay had led the way in the 1820s and 1830s in despoiling historic buildings in France, so twenty or thirty years later hundreds of religious buildings were in even greater decay than when first abandoned and left empty at the time of the Revolution. Rural buildings whose ownership had been secularized were now the prey of travelling scavengers keen to buy a cloister here or the panelling from a choir or sacristy there. When we read of the medieval French sculpture that George Grey Barnard bought for his Barnard Cloisters,[1] opened in 1914 and later to be transformed into the Metropolitan Museum of Art's Cloisters in New York, we wonder at the easy availability of salvages often bought from farmers on whose land the buildings stood. Barnard is said to have made his greatest finds while 'poking around in old farmyards'.[2] Many architects took advantage of this glut of architectural elements, panelling or chimneypieces, but other people were involved too, for the mid-nineteenth century saw the emergence of the decorator as a professional, with a profession. It was often cheaper to buy ready-made than to design and have made new.

Two Welsh houses, Clyne Castle near Swansea and Dyffryn (or Duffryn) House near Barry, both in Glamorgan, can be used to represent this later Victorian incorporation of salvages into country houses in the century after 1850. Neither can be confused with Georgian amateurism in arranging salvages. William Graham Vivian (1827–1912), who belonged to the prominent family of Swansea-based industrialists specializing in the processing of copper, purchased Clyne in 1859–60. The house had been built in 1791 and extended in a simple castellated style in several phases from 1800, the main south block remodelled in Gothic style by William Jernegan. Here William Graham led the life of an 'independent gentleman'.[3] It has been suggested[4] that Vivian may have employed Matthew Digby Wyatt, who lived at Cowbridge in the Vale of Glamorgan, for the Tudor-style Great Hall and north wing, with rooms ceiled after models at Knole and Holland House, although the

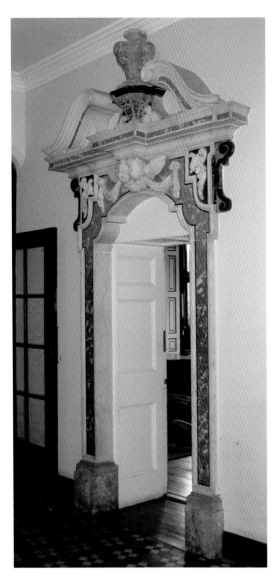

61. Clyne Castle, Swansea, Glamorgan. One of a pair of eighteenth-century baroque Sicilian doorways in staircase hall

manner of the incorporation of salvages may suggest that he acted as an amateur architect.[5] At the foot of the stairs (Fig. 61) are two glorious polychrome marble *settecento* doorcases in pink, white and yellow, maybe Neapolitan. They open to the Great Hall, which is dominated by its pink Rosso di Verona marble hooded and consoled Italian late sixteenth-century chimneypiece with rare Sevillian tiles. Around the upper parts of the hall Vivian installed an early seventeenth-century painted frieze four feet deep of boys and leopards, said to have come from a Venetian *palazzo*.[6] The supporting wooden frieze below it came from Ferrara. Alas, the 'fine painted glass' by 'Bernard Palissy' in the skylight is no longer there. The hallway to the Great Hall was inlaid with mosaic pavement from Carthage. The dining room, demolished in 1955, had a late baroque Florentine painting from a Medici palace fitted into the ceiling. Other notable salvages in the present dining room include a carved wood French rococo door and doorcase and two niches with musical trophies, said to have come from the *hôtel* of the Archbishop of Paris on the Isle Saint-Louis, the panelling inaccurately described in 1919 by Lord Duveen as 'Portions of a fine Louis XIV boiserie, very finely carved'.[7] According to a *South Wales Daily News* article, the niches at the western end of this room contained busts on marble columns from the 'Roman Villas at Cuma',[8] and a 'marble mantelpiece . . . from an old Chateau in Holland, whence it was brought by Mr Ferdinand de Rothschild, who found it did not suit the height of his room, with the result that Mr Vivian bought it'. Fine Adamesque doorcases elsewhere in the house may be by 'Wyatt',[9] in the curved double drawing room with a pair of splendid Louis XV marble chimneypieces (Fig. 62). These had been flanked on the wall by four 'pieces of old Italian carving' bought by Vivian in Naples. Vivian's fascination with continental embellishment is even better displayed in his nearby Clyne Chapel built as late as 1907. Perhaps more than any other church in Britain, this contains an unusual import and fusion of continental salvages and works of art, comprising a Neapolitan or Sicilian early eighteenth-century altar front of polychrome marble scrollwork, Italian marble altar rails (Fig. 63), an eighteenth-century

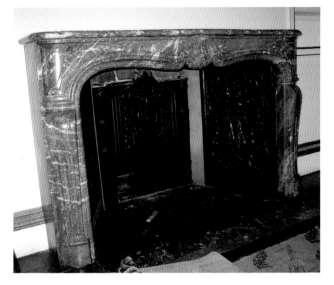

62. Clyne Castle, Swansea, Glamorgan. One of a pair of French eighteenth-century chimneypieces in the Red Room

63. The Clyne chapel. Neapolitan altar rail

north Italian marble relief of the Transfiguration, a thirteenth-century Opus Alexandrinum mosaic panel from St Bartolommeo, Rome, a rare twelfth-century Italian font, a pair of eighteenth-century chimney terms of angels, a composite English late seventeenth-century pulpit, and a tripartite Gothic screen that may once have been an organ case. Outside the chapel the balustrade to the crypt is made up of two sections of eighteenth-century French stair ironwork. Here, as in the castle, Vivian does not appear to have employed a professional architect. In the absence of documents, the dating of his incorporations in the castle is unknown, and may well be later than the 1860s, especially in view of the salvages in the 1907 chapel. This might be relevant when considering its links to Dyffryn House.

It is impossible to believe that Vivian was not familiar with the vastly wealthy Cardiff shipowner, John Cory, who bought Dyffryn House in 1891. In 1893 Cory's architect for his huge 'vaguely French Second Empire' house[10] was the conventional E. A. Lansdowne, who could hardly have been expected to have had access to, or indeed have sympathized with, the astonishing 'fireplace' salvages that came Cory's way, notably in the hall and Oak Room that incorporated German or Netherlandish early seventeenth-century Mannerist ecclesiastical carving of stunning quality, including two cherubim from a confessional. In the Red Drawing Room and the adjacent Blue Drawing Room are two magnificent and related Jacobean alabaster and coloured marble chimneypieces with overmantels (Figs 64–65) that must once have ornamented a long gallery. The inscriptions on them for Curzon and Zouche might suggest they came from the Long Gallery at Parham in Sussex, a house where Robert Curzon, fifteenth Lord Zouche, made extensive

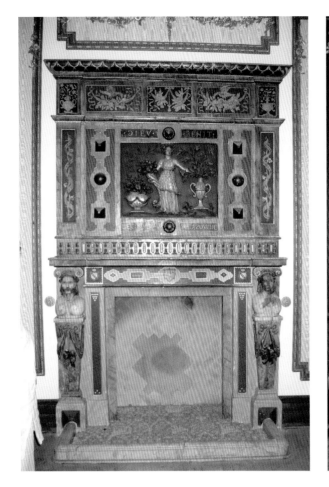
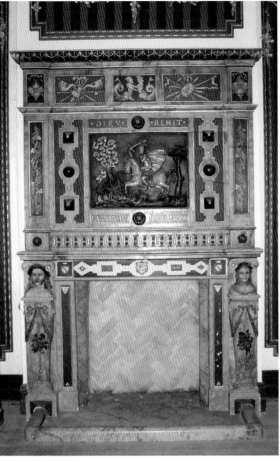

64. Dyffryn House, Glamorgan. The
Zouche–Curzon Elizabethan chimney and
overmantel

65. The pair to the Zouche–Curzon Elizabethan
chimney and overmantel

alterations from the 1570s.[11] What strikes one in both Clyne and Dyffryn is the
use of salvages as an amateur intervention of a decidedly Victorian sort, an inap-
propriateness in the construct of the ensemble caused by the variety of salvages
imported into the rooms, whether French, Flemish, German or Italian. There must
surely be some connection between Vivian of Clyne and Cory of Dyffryn in their
penchant for continental decorations.

It was not a case of moving family salvages from one seat to another, as occurred
in 1856 when Robert John Smith, second Baron Carrington, a noted eccentric, took
a twenty-one-year lease on the Elizabethan Gayhurst House, Buckinghamshire. By
1860 he had called in William Burges and became that architect's first major patron;
Burges's decorations required the removal of Elizabethan décors in the Abbess's
Room. According to a note appended to a measured drawing (Fig. 66) of the pan-
elling in a volume of Burges's Gayhurst designs: 'This room was taken down by

Wycombe Abbey School, High Wycombe, Buckinghamshire

66. Measured drawing by William Burges of a detail of the Jacobean panelling removed from the Long Gallery at Gayhurst House, Buckinghamshire

67. Chimneypiece by Sir William Chambers removed from Gower House, Whitehall, London, 1886

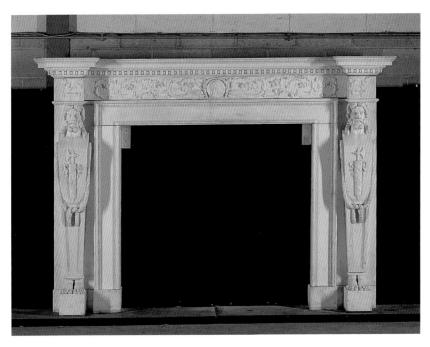

Lord Carrington in 1860 & the panelling was replaced by painted panels representing English Flowers – under the superintendence of Mr Burgess the architect – The panelling was subsequently put up in Wycombe Abbey in 1880 & then transferred to Daws Hill in 1896 – the arms are those of Lord Keeper Wright'.[12] The second Baron had died in 1868 and his successor the third Baron had country estates at

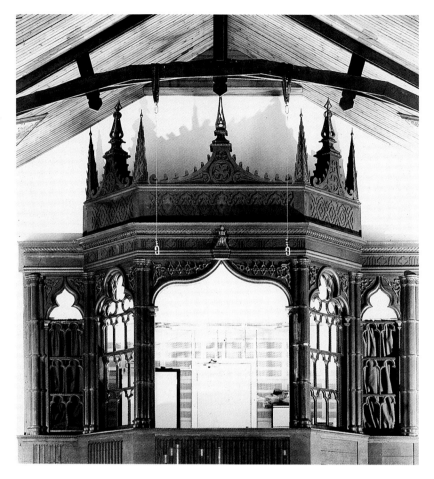

68. Wycombe Abbey School, High Wycombe, Buckinghamshire. The Shelburne Pew designed 1754 by Henry Keene for High Wycombe parish church, now in the Assembly Hall

Gayhurst, High Wycombe, Gwydir Castle in North Wales, and Gower House in Whitehall. At this time of the Agricultural Depression the message was retrenchment, so in 1886 Sir William Chambers's splendid Gower House was demolished, a demolition as disgraceful as that of the Château de Bercy in the environs of Paris. From Gower House came many salvages, first to store, then to Loakes Hill, a Palladian house built in *c.* 1725 by Giacomo Leoni for the first Earl of Shelburne. It was renamed Wycombe Abbey to reflect James Wyatt's abbatial Gothic house built from 1803. Finally in 1886 the Gower House salvages went to the Arts and Crafts Daws Hill in the park, to which in 1899 Lord Carrington retreated when he sold the abbey to the present school. Gower House doors, Chambers's great neo-classic chimneypiece (Fig. 67),[13] the Gayhurst panelling, painted ceilings, ironwork and chimneypieces can all be identified at Daws Hill. Remaining in the abbey in the school's assembly hall added in 1891 is the spectacular eighteenth-century Gothic Revival Shelburne Family Pew (Fig. 68), designed *c.* 1754 by Henry Keene for High Wycombe parish church, and removed at J. Oldrid Scott's restoration in 1887. It is now almost a room within a room.[14]

As the nineteenth century progressed salvage antiquarianism became more self-conscious, due in great part to the growing use of the professional interior decorator or an architect with a flair for arranging interior décor, often working in close liaison with the client. The later Victorian and early Edwardian ages did not produce the somewhat naïve and unaffected amateur intervention as might have been found even so late at The Rolls. The newer style was more urbane, as can be seen at Beaudesert, Staffordshire, following a disastrous fire in 1909 that severely damaged the interiors. Ten years later in 1919, as shown in *Country Life*,[15] it had arisen anew like a phoenix, at phenomenal expense. Between 1911 and 1914 the sixth Marquess of Anglesey regenerated it with the advice of a gentleman architect, Captain (later Colonel) Harry Lindsey, uncle of the Marquess of Granby (the future ninth Duke of Rutland), completely redecorated the interior of this great Elizabethan house. He replaced what might have survived of the predominantly neo-Gothic decoration of James Wyatt and Joseph Potter with a most convincing sequence of panelled interiors intelligently and sensitively modelled after those that might have been in the house during the tenures of the medieval Bishops of Coventry and Lichfield, and the Elizabethan, Thomas, Lord Paget. The interiors were provided by Gill & Reigate[16] and their cost alone was an astonishing £16,608, 8s 2d. The new work was a mix–match with what had been found in the Long Gallery after the fire, but also involved the restitution of the original Tudor oak roof of the Great Hall that Wyatt had hidden behind his classical ceiling when remodelling the Great Hall. The extent to which Gill & Reigate supplied woodwork is unclear and undocumented, except for an early sixteenth-century ceiling taken from a timber-framed house in East Anglia[17] and an early eighteenth-century back stair with balusters. There feature two inexplicable curiosities. Firstly the Waterloo Stair, said to be based upon that at Theobalds Palace, which, if correct, must surely have been the one put into Herstmonceux Castle, Sussex (Fig. 74), after 1911. Secondly a reproduction of a mid seventeenth-century 'Artisan Mannerist', 'Thorpe Hall', Cambridgeshire, room (Fig. 69),[18] surely connected to the genuine Thorpe Hall Room taken out of that house and installed by Arthur Wilson Filmer and his wife Lady Baillie, Lord Anglesey's niece, during their restoration of Leeds Castle, Kent, between 1927 and 1930 (Fig. 70).[19] As a connoisseur and collector Filmer was well known to the trade. As with Beaudesert, this castle restoration is urbane and suave. Lady Baillie first employed the French designer Armand Albert Rateau, who installed the Thorpe Room supplied by White Allom, created the Banqueting Room with its imported French early Renaissance chimneypiece,[20] installed the three heavy pedimented doorcases in the Yellow Drawing Room, and, perhaps later, added an Elizabethan chimneypiece with a mongrel overmantel in the library, where the contractors were Keeble & Son, still heavily preoccupied with their restorations at Berkeley Castle. It need not be stressed that following the end of the First World War the market in salvages from demolished mansions was at a peak.

Not surprisingly, when in 1920 Lord Granby decided to restore the decaying Haddon Hall, Derbyshire,[21] he turned to Captain Lindsey. Due in great part to Lindsey's unaffected and sensitive professionalism, Beaudesert and Haddon stand

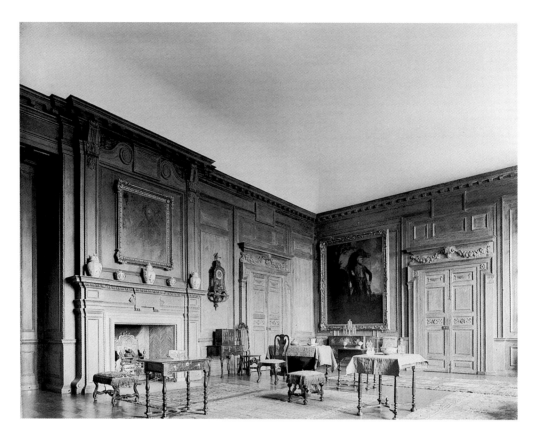

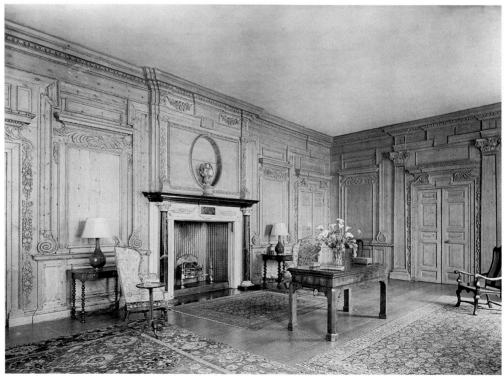

71. Montacute House, Somerset. The west front removed from Clifton Maybank, Dorset

together, although whereas Beaudesert was in part a receptacle for salvages, Haddon was a delicate overall restoration of a Great House in need of sympathetic attention. What was desired at this time was authenticity and comfort, but not at the expense of aesthetic restoration. Lindsey, with his wife Nora, would accomplish one of the most perfect of these restorations at his own Sutton Courtenay, Oxfordshire, in 1931.[22]

If Beaudesert and Haddon are grouped as great house or castle restorations, so are Montacute House and Barrington Court, both in Somerset, both owned by the National Trust, and both receptacles for salvages. Long before Lord Curzon's tenure of Montacute in 1915, the house had already undergone internal vicissitudes during periods of Phelips's family succession,[23] the Great Chamber having degenerated into a store for 'Lumber Goods' by 1728. The renovations that Edward Phelips V (1725–97) made soon after his mother died in 1750 are unrecorded. It is only in 1785 that he embarked upon the unexpected decision to form a new west front (Fig. 71) by removing from Sir John Horsey's mid-sixteenth-century Elizabethan Renaissance house at Clifton Maybank, 'The Porch, Arms, Pillars and all the

69. Beaudesert, Staffordshire. The 'Thorpe Hall' room

70. Leeds Castle, Kent. The Thorpe Hall, Cambridgeshire, room

Ornamental Stone of the Front to be Transferred to the Intended West Front of Montacute': all were bought at the demolition sale on 2 May 1786. Pevsner describes this 'as a sign of the doting medievalism or Gothicism of the late C18',[24] but it is nothing of the sort. The west front's unadorned façade had previously faced an empty courtyard, overlooking a footway to Clare Mill. It was Phelips's intention to make clearances and a new approach, so he needed an ornamental front, and the Horsey front was the perfect solution, appropriate because the Horsey and Phelips families were related. Phelips V had inherited a house that had been stripped during the Civil War and the family had been on the poverty line. A large inheritance in 1772 changed all this.[25] However, even in 1848 S.C. Hall in his *Baronial Halls* described Montacute as 'stripped in great degree of its internal decorations'.[26] In 1852 William Phelips, who died in 1889, imported the panelling in the ground floor parlour from the Wardour Street trade. What matters later is the general 'comforting' ambience of Montacute as Curzon left it, identifiably twentieth-century, not only in panelled wall surfaces, but in the very arrangement and choice of furniture and furnishings.

Many of the introductions at Montacute are imports made by Lord Curzon after 1915 using Thornton Smith as architect. Throughout the house evidence can be found of his insertions and modifications, as we might expect of a client who wanted modern comfort and was very decided in his tastes. According to Curzon's own inventory,[27] in 1918 he added panelling in the West Entrance Hall similar to that on the east wall of the corridor, and he panelled up a small drawing room off the screens passage with salvages from Clifton Maybank that he must have found in store, and – to genealogically confuse matters – he added Phelips's arms. In particular the Oak Parlour in the south wing is witness to Curzon's most extensive makeover. His wife commissioned Thornton Smith to put up a ceiling copied from the notorious Globe Room in the Reindeer Inn at Banbury.[28] In his notes, and no doubt also in communications with his wife, Curzon fulminated at the cost.

> When Lady Curzon began her conversion of this room into a gorgeous boudoir of a part Jacobean, part Italian style . . . she was remorselessly swindled by Thornton Smiths [*sic*] (Soho Square) who charged her the most iniquitous prices . . . The plain ceiling was replaced by a plaster ceiling, a direct reproduction of the famous ceiling from the Reindeer Inn, Banbury. This was the ceiling about which I had a controversy some years ago in the Times with Lenygon, who had ravished the room and ceiling from Banbury, gave a solemn promise to restore them, broke his word and was exposed by me in the press'.[29]

Elsewhere the Crimson Bedroom and the library are two typical Curzon makeovers, and in the library he reinstated the internal porch.

Barrington was restored by J.E. Forbes from 1920 for Colonel A.A. Lyle.[30] Its interior was entirely amplified with salvages and a certain amount of mix and match. What Lyle found there is uncertain, but little rather than more. He brought in much linenfold panelling and Italian wooden salvages to the Great Hall; and the whole east wall of the Small Dining Room (Fig. 72) was originally an outside wall

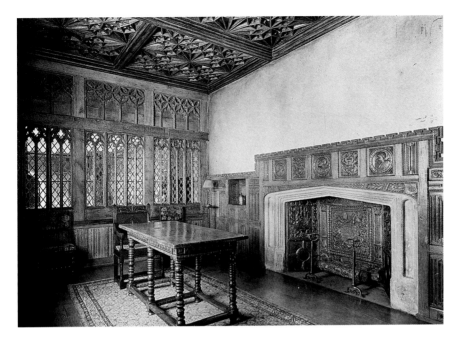

Barrington Park, Somerset

72. East wall of the Small Dining Room made from King's Lynn salvages

73. The Strode Quadrangle Morning Room, or 'Christopher Wren' room

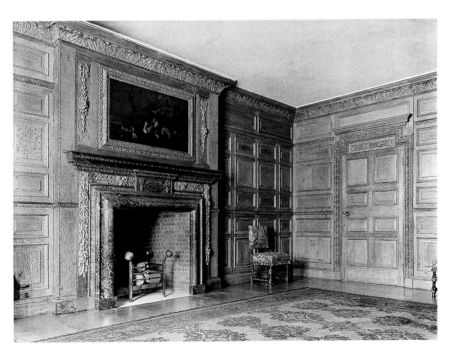

of a house in Kings Lynn,[31] from which town also came the wooden star-patterned ceiling. Elsewhere the remarkable wooden ceiling of the stair hall came from Hereford, but other provenances are unknown, such as those of the fine Jacobean wainscot in the buttery and an intriguing French Renaissance chimneypiece with console jambs on lion's feet in a bedroom. A more modern touch in two rooms (Fig. 73) in the Strode quadrangle is the exceptional late seventeenth-century wainscot

74. Herstmonceux
Castle, Sussex. The
Elizabethan Stair
reputedly from
Theobalds Palace,
Hertfordshire

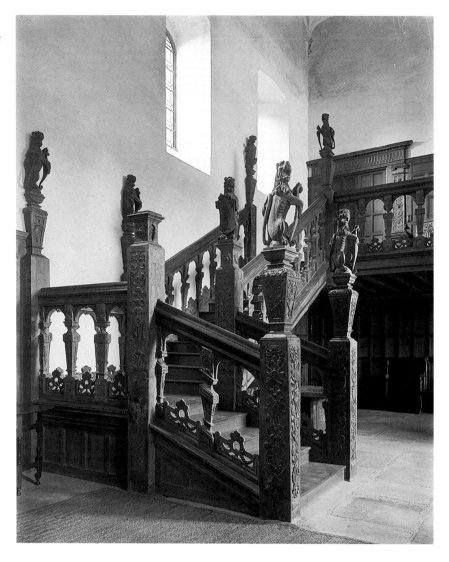

bearing the exalted and disputable dealer's provenance of Sir Christopher Wren's
house in the City of London.[32]

In this era of castle restorations, Herstmonceux, Berkeley and St Donat's stand
out as recipients of dealer salvages. Herstmonceux Castle would have been well
known to Captain Lindsey. This great Sussex fortress had been gutted and unroofed
in 1777, remaining entirely dilapidated and covered in ivy until Colonel Claude
Lowther began his restoration in 1911.[33] He or his architect created an effect more
with furnishings than by the use of salvages, although there are some notable ones.
The placement and choice of furnishings in the Ladies' Bower and the State
Bedroom are unconvincing, and look entirely twentieth-century, as are the medieval
arrangements. The salvage that stands out is the Elizabethan south-east stair (Fig.
74) said to have come from Theobalds Palace, an undocumented provenance that

smacks of dealer's imagination, although a building of that name survived until 1970 on the site of the Tudor palace. The north-west stair came from Wheatley Hall, Yorkshire, a house finally demolished in 1934. The gallery chimneypiece was removed from Madingly Hall, Cambridgeshire,[34] when J.A. Gotch rebuilt its north-east wing, a sixteenth-century fireplace is said to have come from an unlocated château near Rouen reputed to have been owned by Colonel Lowther,[35] and in the Drummers' Hall Jacobean oak panelling and a chimneypiece with an overmantel are said to have come from 'another house' of Col. Lowther's, probably Scaleby Castle, Cumberland. In fact Herstmonceux was not fully restored until after it was bought in 1933 by Sir Paul Lathom.

Geoffrey Houghton Brown, who knew Lindsey well, described Beaudesert as 'comfort taste',[36] referring to the desire in the first half of the twentieth century for modern conveniences and comfort in an antique setting. This is particularly the case at Berkeley Castle, Gloucestershire from 1919 and St Donat's Castle, Glamorganshire from 1925. Randal Berkeley, who became the eighth and last Earl of Berkeley as early as 1888, was most unusual and talented. In his house on Boars Hill, Oxford, extended by Sir Ernest George by 1904,[37] he had his chemical laboratory, and it was for his distinguished experiments in chemistry that he became a Fellow of the Royal Society in 1908. When he finally inherited Berkeley Castle in 1916 from a kinsman, Lord Fitzhardinge, he found himself the possessor not only of most of Berkeley Square in London, but also of a famous castle that had been partly reduced and ruined following the Parliamentary siege of 1645. Previously the family had lived at The Durdans near Epsom, Surrey, then at Cranford House, Middlesex. For the next century or more their castle was patched up in the 1750s and early nineteenth century,[38] used only for transient occupation and hunting with the famous Berkeley Hunt. It was quite another matter when Randal Berkeley became, in James Miller's words,[39] 'his own architect, surveyor, archaeologist, and even builder'. In his forceful determination to restore to the medieval castle what he regarded as the true spirit of its age, he eliminated most of the eighteenth-century and earlier nineteenth-century work. He was aided in this by the sale in 1918 of the Berkeley estates round Berkeley Square, in retrospect a grotesque error of judgement. In 1942 Sir Harold Hartley, his obituarist in the *Proceedings* of the Royal Society, which was existent by virtue of Randal's fame as a scientist, wrote,

> For a time, the inside of the castle was in chaos and access to some of the rooms was only by high ladders, which Berkeley would shin up as quickly as anyone. He was intent on discovering every bit of old carved masonry and woodwork and he used to carry a small hand-pick to test any plaster he found. Wherever it was hollow, down it came, revealing perhaps an entry to a passage, a garderobe, or a store cupboard . . . Every detail of work had to be approved by him as his own architect. Berkeley Castle stands as a memorial to his taste, his sense of perfection and that capacity for taking pains that is akin to genius, if it is not genius itself.

The transformation that began in 1920 and finished about 1932 was from the first managed by Herbert Keeble of Keeble Ltd of Carlisle House, Soho Square, who

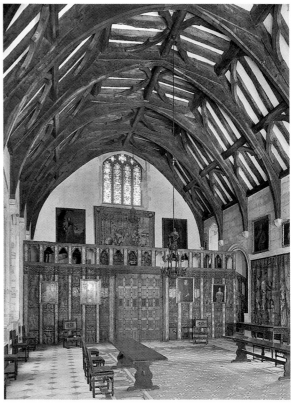

Berkeley Castle, Gloucestershire

75. The making of the Entrance Tower with its French pinnacled doorway in the inner bailey

76. The Great Hall with the hall screen from Cefn Mabli, Glamorgan

was Berkeley's executive agent as well as his executant in architecture and interior decoration. The task was given a boost and change of direction in 1924 when Randal married the vivacious and rich Molly Lowell of Boston. The 'comfort style' was now to the fore, but it had to be married to Randal's passionate antiquarianism. With the discovery of the pink folders of the Keeble papers in the Estate Office, the history of the fabric of Berkeley Castle must be written anew, for the folders[40] contain all the evidence for the astonishing incorporation of both English and French salvages (Figs 78–81). Demotte in Paris was supplying ornamental stonework costing £3,774 17sh. 5d. in 1919–20,[41] when there was a continuous offer and supply of medieval salvages. Notably, this was for the windows in the outer wall of the Great Hall in 1922–24: '16 or 18 windows [from the Château de Charentonnay] for which I want francs 10,000 . . . and a stone doorway for francs 125,000'. In 1923, from Bacri Frères, also in Paris, came the French Late Gothic entrance (Fig. 75), built by Anne de Bretagne in 1493 from the Château de Chenaze, and two doorways, costing £368 7sh. 5d. A Francis Horner writing to Lord Berkeley from the Carlton Hotel, Paris on 20 June 1923, says that 'The Gothic

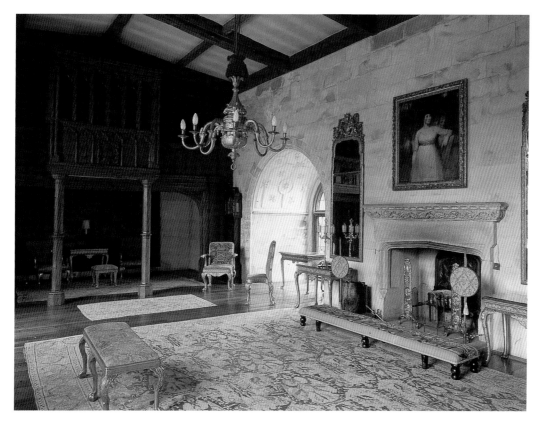

77. Berkeley Castle, Gloucestershire. The Long Drawing Room with the screen removed from the Chapel but originally in Longridge Priory, Gloucestershire, and an imported French chimneypiece

stone work I wired about is in a garden at Fontainebleau (Fig. 81) – it has just been bought by a decorator from Sens I think'. On 1 June 1922 Keeble had estimated that the 'New building in keep' would cost £7,640, the 'New entrance tower', £380, the 'Norman Chapel', £1,380, and the 'Great Hall', £3,080.[42] Local houses in Berkeley ownership were raided for enticing lootings. The Great Hall fireplace came from Wanswell Court north of the castle, the new screen at the lower end of the hall (Fig. 76) from Cefn Mably in Glamorganshire. The screen (Fig. 77) in the Long Drawing Room came from the chapel, and before that from Longridge Priory, Gloucestershire. Yate Court in the south of the county, a Berkeley family ruin,[43] was plundered for doors, arches, buttresses, and the fourteenth-century gatehouse. This last was the subject of a letter on 9 February 1929, from Herbert Keeble, obviously in reply to Randal: 'The Gatehouse certainly calls for a Portcullis, and I shall be pleased to go into this matter and make suggestions after I have got the building drawn out'.[44] But always the initiative is Randal's, as Keeble implies on 24 August 1929 when referring to the 'window from Yate Court adapted as you suggested, for the Mid Drawing Room'.[45] Within a few years from 1920 the confraternity of deal-

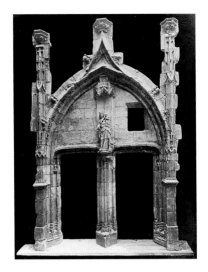
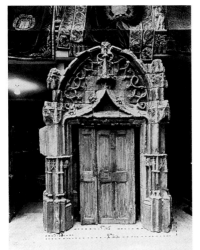

Berkeley Castle, Gloucestershire

Figs 78–81. Four Gothic salvages offered by the Paris trade to Lord Berkeley, including medieval items in a garden at Fontainebleau

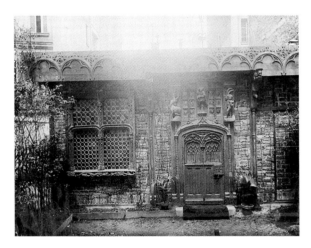

ers were well aware of Randal's voracious appetite for salvages (Figs. 78–81). Horner, writing from Chelsea, offered a 'Gothic fireplace' (from a house in Windsor) for £400 and another via Keeble for £250. This world of scavenging European salvages was no different to that of Stanford White and Grey Barnard twenty years earlier, or indeed that of William Randolph Hearst, who was as voracious for salvages as was Randal Berkeley. To perambulate the rooms at Berkeley and St Donat's is to appreciate the making of an Anglo-American 'comfort' style.

Sir Charles Allom, of the international decorating firm White Allom, was one of Duveen's favourite decorators, and the favourite of Anglo-American clients in the USA wanting the English interior style. So when William Randolph Hearst succeeded in buying a British castle, he decided to employ the efficient Allom. Upon reading in *Country Life* in 1925 that St Donat's Castle, Glamorganshire, was up for sale, he immediately cabled his agent in England, Miss Alice Head, with an order to buy the castle. St Donat's[46] is not a San Simeon, and possesses not one iota of San Simeon's continental eclecticism in the composing of eclectic salvages. But in many

St Donat's Castle, Glamorgan

82. The Banqueting Hall with the French sixteenth-century chimneypiece and windows from Bradenstoke Priory, Wiltshire

83. The passageway to Hearst's Banqueting Hall: fifteenth-century screen from a house in Bridgwater and Flemish sixteenth-century vaulted roof, from St Botolph's church, Boston, Lincolnshire

ways it is a more telling and cohesive example of salvage incorporation. Of course, San Simeon was a new house, whereas the Stradling family's St Donat's was a major late medieval castle principally of the fourteenth and fifteenth centuries. Hearst's imports are a product of his 'fall guy' mania for buying anything and everything offered by the antiques trade. His attention to detail is proved by the twenty-five-page letter he wrote giving elaborate instructions as to what needed to be done,[47] detailing many of the salvage incorporations to be executed by Sir Charles Allom and his team. Yet Allom's was a most skilful amalgamation. The Banqueting Hall (Figs. 82–83) combines a late medieval Valois fireplace from Beauvais with a Late Gothic screen from a house in Bridgwater, Somerset. In the dining room is the early sixteenth-century nave ceiling carved by Flemish craftsmen, disgracefully removed at a restoration in 1931 from St Botolph's church, Boston. Adjacent in Hearst's breakfast room is more of the Boston ceiling and a splendid fireplace of *c.* 1514 from Bradenstoke Priory, Wiltshire, the dismantling of which by Hearst became a *cause célèbre* in the annals of the Society for the Protection of Ancient Buildings.

84. The Ellenhall panelling before purchase by Hearst

Bradenstoke's great early fourteenth-century roof was used to form the Bradenstoke Hall, as were three contemporary windows, and two mighty French sixteenth-century chimneypieces. In the College Library the linenfold panelling came from Ellenhall in Staffordshire (Fig. 84), and the fireplace was an import, as was the wooden gallery and a remarkable door surround of Boston-style Flemish work.

The Ellenhall panelling, venerated for its antiquity, is a tale in itself. Indeed, the veneration was appropriately commemorated by the anonymous author of *The Ellenhall Wainscot*, an attractively illuminated booklet printed on Whatman 1885 paper,[48] quoting from an 'account written in May 1716'. When medieval Ellenhall, Staffordshire was demolished in 1686, the wainscot was removed to a manor house on the Shugborough estate. When it became a farmhouse, some time in the 1870s or early 1880s the wainscot was again travelling,[49] this time to Lord Lichfield's Shugborough House, where it is assumed to have been put into store. The compiler concludes, 'Still we have learned enough to understand that these carvings are worthy of careful preservation – not only as genuine monuments of Elizabethan art, but as interesting relics of a Family[50] once intimately connected with Ellenhall.' A later Lord Lichfield sold the wainscot at Christie's on 7 May, 1918 (lot 147) for 500 guineas to the antique dealer Peter Turpin, who no doubt sold it on to Hearst. Tracking Hearst salvages in the castle is like train spotting, for medieval and Tudor wooden elements are to be found everywhere, especially in bedrooms,[51] even as radiator screens. All these will only be fully elucidated if ever the Hearst Corporation allows access to their files, which they persistently refuse. Although the salvages Hearst and Allom introduced are old, so immaculate and precisely adapted are the incorporations that St Donat's lacks an ambience of medieval authenticity. However, Hearst's make-over provides a cosy comfortable interior typical of the richer landed classes of the earlier twentieth century.

Four further contrasting interior transformations using salvages at roughly the same time are Rothamsted Manor, Hertfordshire, Hursley Park, Hampshire, Fairlawn, Kent, and Polesden Lacey, Surrey, the three last named for satellite luminary cronies of Edward VII. In contrast to their courtly lifestyles, Sir Charles Bennett Lawes-Wittewronge of Rothamsted[52] was someone different, an agricultural experimentalist and eminence behind the founding of the Rothamsted

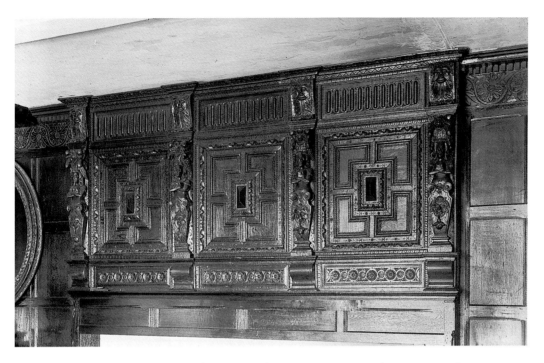

85. Rothampstead Manor, Hertfordshire. The Morning Room chimneypiece from
Rawden House, Herts

Experimental Station. The house, built by Sir John Lawes Wittewronge, is some-
what old-fashioned in style for the middle years of the seventeenth century. Having
been extended for another Sir John Lawes Wittewronge in 1863, after his death in
1900 it was extensively remodelled by Sir Thomas G. Jackson for his son Sir
Charles Bennett Lawes, using many salvages. Whether the initiative was that of Sir
Thomas or Sir Charles is uncertain, but one source for the salvages can be found in
the *Connoiseur* for January 1903,[53] where Gill & Reigate advertise panelled rooms
from Rawdon House, Hoddesdon, Hertfordshire. This is the source for the big
caryatid chimneypiece (Fig. 85) in the morning room commemorating a Rawdon
marriage in 1611, possibly for the strapwork chimney in the Oak Room, and cer-
tainly for that in the Pink Room. But the Rawdon *pièce de résistance* is the elabo-
rate Jacobean chimneypiece in the library added in 1910. Gill & Reigate obviously
gutted Rawdon, and there are probably many more unidentifiable Rawdon salvages
in the house. The linenfold panelling of *c.* 1550 in the hall came from Clare in
Suffolk and contributed to an amplification of Sir John Wittewronge's interiors,
which seem to have been plain and uncomplicated. No doubt they were amplified
with these earlier décors in the mistaken belief that the house belonged to the ear-
lier Jacobean decades of the century rather than to the later.

In 1901 the *nouveau riche* Sir George Cooper leased 26 Grosvenor Square,[54] em-
ploying Howard & Sons for decoration. Under Duveen's recommendation Anatole
Beaumetz put in eighteenth-century French *boiseries* for tapestries. Then in 1905

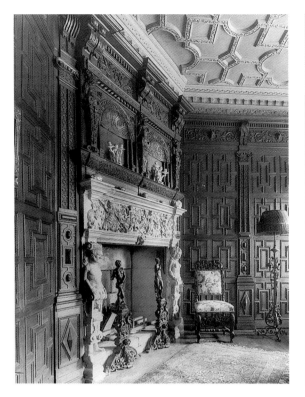

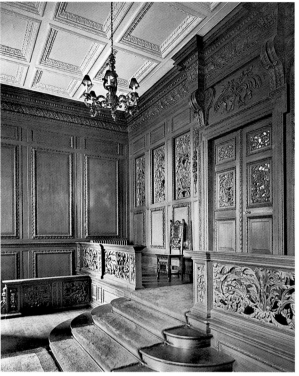

Hursley Park, Hampshire

86. The Boudoir, with a French Renaissance chimney mantel married to an English overmantel

87. The Outer Entrance Hall from the Chapel of Winchester College, carved by Edward Pierce, 1680, as in 1905 when installed and amplified by H.H. Martyn & Co.

Cooper bought Hursley Park, Hampshire,[55] a brick hunting lodge built by Sir William Heathcote in 1721, probably to the designs of Sir Thomas Hewitt. This time his chosen architect was A. Marshall Mackenzie & Son who had designed the Waldorf Hotel, London. They enlarged Hursley sympathetically in the same unaffected brick style. Nothing would have contrasted more with the décors of the new crafted interiors and their thoroughly Anglo-American ambience. The now familiar duo, Sir Charles Allom and Sir Joseph Duveen, imposed a variety of interior styles, many in the English Palladian style that Allom would use in 1916 at the vast anglophile Whitemarsh Hall, built by Horace Trumbauer outside Philadelphia. So clever was Allom in inventing convincing English Palladian interiors that it is sometimes unclear to what extent he incorporated Palladian salvages into his English designs, particularly with chimneypieces. This is the case at Hursley, for a chimneypiece there is identical to one installed by Allom in the 1920s in the Childs Frick house at the Clayton Estate, Long Island, and to another in the Royal Ontario Museum, Toronto, and to an original once in 15 Hanover Square, London, removed in 1904.[56] In the Boudoir (a panelled room of Elizabethan vintage) a stone chimney mantel with caryatid figures could be imported French Renaissance mar-

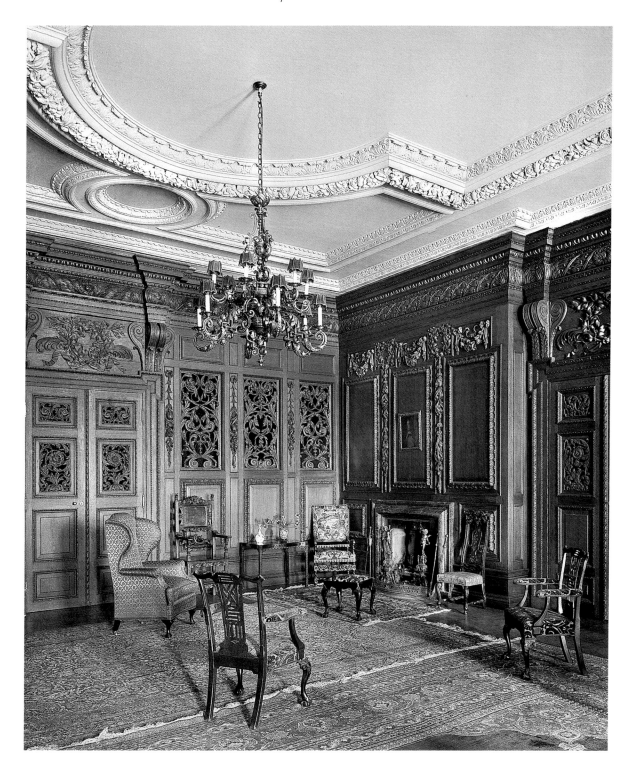

88. Hursley Park, Hampshire. The Inner Hall from Winchester College Chapel, as in 1905.
Amplifications by H.H. Martyn & Co. All now repatriated to the Winchester College New
Hall

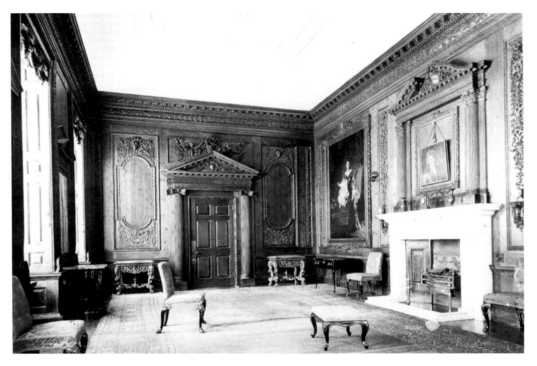

89. Fairlawn, Kent. James Gibbs's Great Room embellished with French eighteenth-century *boiseries*

ried to a carved wood English overmantel (Fig. 86). The most spectacular salvage intervention was in the foyer and entrance hall, enriched with the 1680s 'Wren', or rather Edward Pierce, Winchester College woodwork (Figs 87–88), which had been thrown out by William Butterfield from the college chapel restoration.[57] The opulent Louis XV style ballroom, perhaps one of the grandest French *dix-huitième* rooms created in Britain, was more match than mix, Carlhian – Beaumetz[58] offering the match. At Grosvenor Square in 1909 it was Allom who added a dining room in an English Palladian style, again using Mackenzie as architect. It is interesting to compare the interior fitting-out of Hursley with Fairlawn in the later 1890s by Trollopes, and Polesden Lacey after 1906 by White Allom, for an appreciation of their different effects.

Fairlawn near Sevenoaks, Kent, was celebrated before and after the First World War for the Cazalet house parties, high on the social register. When W.M. Cazalet succeeded to Fairlawn in 1883, the seventeenth- and early eighteenth-century house had been substantially enlarged and improved by his father Peter Cazalet following purchase of the estate in 1872. In 1885 W.M. Cazalet married Maud Maxwell, a society hostess requiring a grand entertaining room. James Gibbs's 'Great Room' decorated in *c.* 1722 was there for that purpose, but not before Maud had it smartened up (Fig. 89) by Trollopes. What they achieved is a perfect case study of the attitude of Late Victorian decorators to the English baroque status quo. Gibbs's rich plastered and painted coved ceiling was swept away and his painted panelling

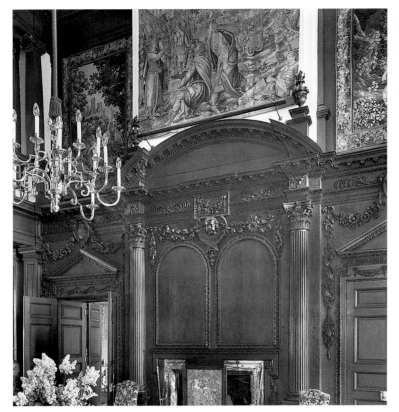

90. Polesden Lacey, Surrey. Hall with the reredos by Edward Pierce 1680s, from St Matthew, Friday Street, City of London

popped into the acid bath, as fashion then dictated. Trollopes's early eighteenth-century French rococo *boiseries* are obviously high-quality French salvages, as must be much of the applied ornamental carved woodwork. The result is a chic and sophisticated synthesis more common to the style of later Mewès and Davis, creators of the London and Paris Ritz style.[59] Indeed, one wonders if the Great Room caught the eye of the Hon. Ronald and Mrs Greville, who attended the Cazalets' house parties.

In 1906, when Captain and Mrs Greville bought Polesden Lacey near Dorking in Surrey[60] – an attractive porticoed Regency villa designed by Thomas Cubitt in 1821 and enlarged by Sir Ambrose Poynter for Sir Clinton Dawkins between 1896 and 1905 – it could not be expected that two such prominent members of the racy Marlborough House set would have been content to treat their new house modestly. Yet what surprises at Polesden Lacey is the exquisite but luxurious understated taste displayed by Mrs Greville, intent to display her furniture, paintings and works of art as a background to dazzling social entertainment, in contrast to the *nouveau riche* vulgarity at Hursley. It was, as Osbert Sitwell observed at first hand,[61] a kind of 'unobstrusive [sic] luxury of life and background'. Captain Greville's unexpected death in 1908 may have persuaded his widow to call in Charles Mewès and Arthur Davis as architects, with White Allom as decorators for a series of rooms in differing styles, perhaps bearing in mind the recommendations in 1909 of H.P. Shapland in his popular *Style Schemes in Antique Furnishings*. The effect of entering Poynter's

91. Lenygon & Morant's photograph of a door and a bay of panelling of the Burlington Hotel Deal Room from 29 Old Burlington Street, later installed in the hall at Godmersham Park, Kent

92. Lenygon & Morant's photograph of the upper part of the overmantel of the Burlington Hotel Deal Room, later installed in the hall at Godmersham

entrance hall is the confrontational visual wallop of the north wall, taken up by Edward Pierce's splendid 1680s reredos (Fig. 90) from Wren's church of St Matthew, Friday Street, in the City of London, demolished in 1883. This is comparable to the Hursley experience of finding Pierce's Winchester carvings in the new hall there. St Matthew's must have been a White Allom salvage, and so must the carved and gilt panelling of the red and gold drawing room taken from an unidentified north Italian palace of *c.* 1700, or the Georgian trim and chimneypiece of the dining room. On the other hand the French *boiserie* style of the tea room is like a bedroom in Claridges designed by the Parisian Sergent – Carlhian partnership that fits in better with the Ritz fashion.

Just as Clive Aslet applied Shapland's style schemes to Mrs Greville's rooms, it could be observed that the theories in Shapland's book were anticipated by the restorations and furnished schemes achieved by Frank Green following his purchase of the Treasurer's House at York in 1897. Over the years Green created a series of furnished rooms, each of whose styles reflected the various building periods of the house. Green, and not his architect Temple Moore, was the motivating force for a house in which imported salvages were not many, but were carefully selected, as were Green's furnishings, to ensure the accuracy of the required stylistic ambience. Right up to the 1920s Green was making alterations and constantly refining what had appeared in *Country Life* in 1906,[62] and later in 1922.[63] His was a period room display, with a Restoration Room, a Tudor Drawing Room, a Queen Anne Drawing Room, a Georgian Bedroom, a Chippendale Bedroom, and Sheraton

Room. But he laid down the criteria right from the beginning that his house was to be a 'house not a museum'. In fact, it was a living museum, created when the making of period rooms was at the height of popularity, and it does resemble much that was done in the USA. When appropriate, salvages were introduced, such as the chimneypiece in Princess Victoria's Room from the York town house of the Bouchiers of Beningborough, or the Queen's Room with a doorcase of the 1730s, or the drawing room made up from elements once in the old dining room and library.

It is not too fanciful to imagine a social link between Polesden Lacey in Surrey and Buxted Park in East Sussex or even a call upon old Mrs Margaret Greville by Nellie Ionides when she and her husband Basil bought Buxted in 1930,[64] thus saving it from being included among the near 700 country houses demolished between the wars. In contrast to Mrs Greville, who relied upon professional advisers, Basil and Nellie Ionides were connoisseur collectors of a particular sort. Since about 1922 Nellie, an enthusiastic 'antiquer', had been advised by *Country Life*'s consultant on the decorative arts, Margaret Jourdain, so she was in the thick of dealer activity. As a professional architect and licentiate member of the Royal Institute of British Architects, Basil knew the antiques trade well. The house they bought was a Palladian pile of some distinction, boasting a two-storey hall of Jonesian and Kentian aspiration. This they first treated conservatively, filling it with recently acquired fine furniture and objects. But the fire that gutted the house on the night of 2–3 February 1940,[65] led to one of the most unusual country house restorations in the history of the use of salvages.[66]

Their decision to rehabilitate entirely using salvages may have been spurred on by what their friends Mr and Mrs Robert Tritton had achieved from 1935 in refashioning Godmersham Park in Kent with Walter Sarel as their architect.[67] Their saloon was panelled from 30 Old Burlington Street (Figs 91–92), designed by Lord Burlington but with interiors by Roger Morris in 1725. Lenygon & Morant had their showrooms at no. 31 in the street, and not surprisingly they took out the interiors from no. 30 when it was demolished in 1935. Another link with Buxted was the incorporation there of the staircase from no. 30, surely acquired from Lenygon & Morant. The trade rallied to their need, even in a time of war, which was extraordinary as the Battle of Britain was being fought in the skies overhead. They reduced the original north front of three storeys and a basement to one of two storeys; the entrance hall was thus reduced in height and turned into a garden hall, with above it the China Room. In this new garden hall the chimneypiece came from the second Queensbury House, Richmond, another casualty of the thirties; doors from Kingston House, Knightsbridge, demolished in 1937; the skirting and dado from Norfolk House, St James's Square, demolished in 1938; the great urns by Albert Xavery of Antwerp came originally from the Wanstead House, Essex sale of 1823. The pedimented door from West Harling Hall in Norfolk, demolished 1931, leading into the new entrance hall, may have been designed by Sir Andrew Fountaine and Roger Morris. In the new hall were Robert Adam's doors from 23 and 25 Portland Place; a chimneypiece of *c.* 1740 from 19 Arlington Street, demolished 1936; the skirting and dado from Norfolk House, and the long glazed display cab-

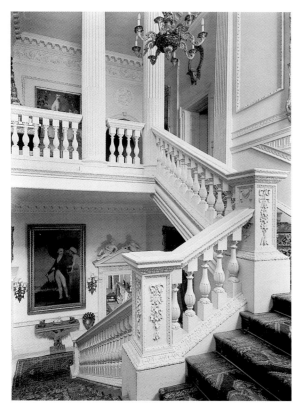

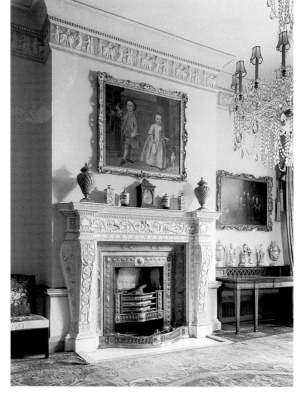

Buxted Park, Sussex

93. Stair re-adapted from 30 Old Burlington Street, London, designed by Roger Morris in 1729

94. Chimneypiece by Stephen Wright, from Clumber House, Nottinghamshire, removed at demolition in 1938 by Bert Crowther

inet from John Carr's Basildon Park, Berkshire. A passage from here led to the stair-case (Fig. 93) taken in 1935 from 30 Old Burlington Street, obviously from Lenygon & Morant. In the Yellow Drawing Room a chimney overmantel was from Hamilton Palace, demolished 1920. In the Boudoir the chimneypiece was another salvage from 30 Old Burlington Street, and the damask hangings came from a contents sale at Belhus, Essex, long before its demolition in 1956. The dining room chimneypiece (Fig. 94) designed by Stephen Wright was from Clumber House, Nottinghamshire, demolished 1938, as was the chimneypiece in the Chinese Room, but with an overmantel taken from the State Dressing Room at Stowe, Buckinghamshire. Also in the China Room the fretwork niches came from the Gothic House, Richmond, Surrey, demolished in the late 1930s and the oval reliefs from Adam's Adelphi. In the saloon the doors came from 38 Berkeley Square designed by Robert Adam for Robert Child in 1769 and demolished in 1939; the oval plaques as overdoors came from Adam's Adelphi Terrace, demolished 1936; the two chimneypieces were from the Kingston House demolition in 1937, and the window architraves from Chesterfield House, Mayfair, demolished in that year too.

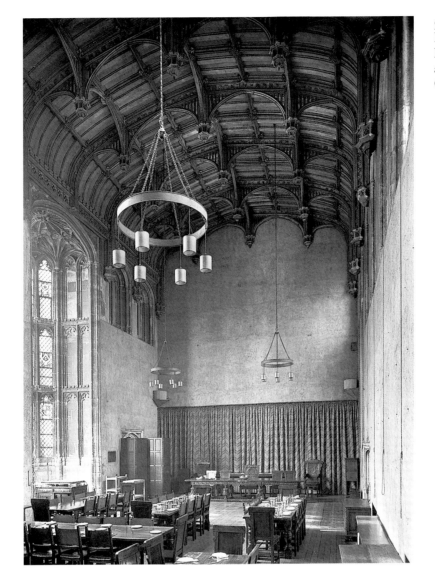

95. Crosby Place, London. The Great Hall as reinstated and restored in Chelsea

The chimneypieces in the drawing room and the library were from Felix Hall, Essex, probably from the wings demolished *c.* 1939. Mrs Ionides's bedroom chimneypiece came from Chipstead Place, Kent, demolished 1931. In comparison with all other houses incorporating salvages at any time previously, Buxted was exceptional, with many of the incorporated salvages remaining today.

The demolition in 1886 of Gower House, Whitehall, passed with hardly a murmur of protest, so out of fashion was Georgian architecture, but in contrast, in 1909 when a bank bought for demolition what remained of Crosby Place, one of the most important medieval palaces in the City of London, there was a howl of protest, led by the Society for the Protection of Ancient Buildings. Yet neither the London County Council nor the supine Ministry of Works lifted a finger to find a solution,

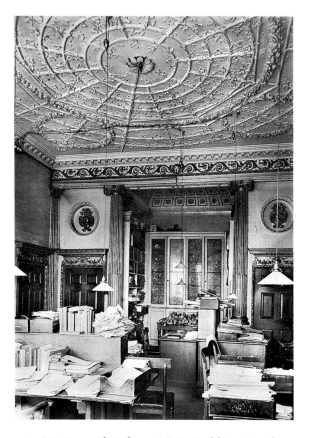

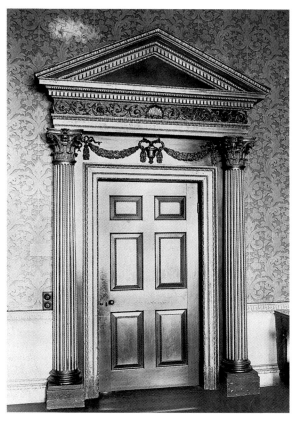

96. Ministry of Defence Main Building, London. Room 24 from Pembroke House, Whitehall Gardens, comprising Roger Morris's Bed Alcove with ceiling by Sir William Chambers

97. Ministry of Defence Room 26. The doorway by Sir William Chambers from the Saloon, Pembroke House, Whitehall Gardens

and it was left to the Earl of Sandwich and Professor Patrick Geddes to conspire to move Crosby Place's Great Hall (Fig. 95) to the University of London's new college at Cheyne Walk, Chelsea, an appropriate location because part of the site had been owned by Sir Thomas More, who had owned, but never lived in, Crosby Place in its heyday. So in 1910 the Great Hall was moved. What matters today is its successful incorporation into Christopher Moran's 'Tudor house for the twenty-first century',[68] an evocation of a Tudor mansion of the earlier sixteenth century.

The loss of Gower House, Whitehall, a masterpiece of Sir William Chambers, was recollected twenty-five years later when the adjacent old Privy Garden, or rather as it was then called, Whitehall Gardens, was identified in 1911 as the site for the Ministry of Defence's new Government Offices, so threatening Montagu House and Pembroke House, the latter a distinguished Palladian Thames-side villa. In retrospect it can now be assessed as a complex Georgian Thames-side villa of the utmost importance. Its eventual demolition in 1938, a monstrous act of vandalism, was a prolonged saga. The hero of the tale was H. Llewellyn Smith, an unsung but enlightened civil servant in the Office of Works.[69] Llewellyn made the surprising

98. Ministry of Defence Room 25. Detail of Sir William Chambers's ceiling from the Dining Room in Pembroke House, Whitehall Gardens

comment on 21 January 1914 that there was a need to preserve 'several beautiful and valuable ceilings, mantels and pieces of iron-work' from Pembroke House, a rare sentiment in an age of spoliation. He chose four of the State Rooms. That his will prevailed is demonstrated by the second stage brief for the competition for the new building, requiring the competitors to 'preserve' (three) rooms as *in situ*, but it was not yet to be, for the death of Pembroke House was to be long and drawn-out. Vincent Harris, having won the competition in 1915 when serving with the Artists' Rifles on the Western Front, would have to wait until 1934 and a new brief even to commence basic work. In 1938 Pembroke House came tumbling down, resulting in two auction sales of salvages. 61 lots on 2 May made a pathetic £248 8*s.* and 555 lots on 12–13 September just £150. The four chosen rooms were crated up and languished in a Ministry of Works store throughout the Second World War, and even then they were not taken out of store until 1951.[70] These comprised rooms 13 and 24, two Palladian bed alcoves by Roger Morris from the 1740s, one with a ceiling by Sir William Chambers 'of fantastic elaboration and beauty'[71] executed by the unsung William Perritt (Fig. 96); room 25 (Fig. 98), the old dining room, also by

99. The Heinz Gallery, London, as installed in 21 Portman Square, 1972, removed to the Irish Architectural Archive, Merrion Square, Dublin

Chambers; and Room 27, the saloon, again Chambers, and boasting a rich pedimented doorcase (Fig. 97). Because of their situation in what is known as the Ministry of Defence Main Building, this extraordinary and felicitous ensemble is one of London's best kept secrets. The installation more or less coincided with the emptying prior to demolition in 1957 of Bowood House, Wiltshire, from which Robert Adam's Great Drawing Room was extracted to serve as the Lloyd's board room in their Lime Street extension opened in 1957. It is rumoured that a representative was sent along to buy brocade from the walls, and instead bought the whole room! However, there may well have been a Lloyd's connection with the Marquess of Lansdowne. The room moved from there in 1963 to the top of Richard Rogers's new Lloyd's, where not only does it appear as an anachronism, but gossip has it that a well-known paint consultant was overruled by the Chairman's wife who had her own ideas as to Adam's colouring, commenting, 'Mr Adams always painted in pink and duck green'.

Perhaps the last moving of a room in modern times was that of the celebrated

Heinz Gallery, of the Drawings Collection of the Royal Institute of British Architects in 21 Portman Square, London. Designed by Alan Irvine in 1970, it was a model of his veneration of the interior décor of Carlo Scarpa (Fig. 98). Thirty years on and the gallery was doomed to be dumped,[72] a consequence of the impending move of the Drawings Collection to the Victoria and Albert Museum. Unwanted, it would become a moving room, until enthusiastically claimed by the Irish Architectural Archive and installed in their building in Merrion Square, Dublin, in January 2005, where it can be described as a phoenix arisen from a skip.[73]

THE WOODCOTE PARK COLLECTION

WOODCOTE PARK, SURREY, has had a chequered history. The present house stands on the site of a monastery, of which some traces survive in the basement of the house. It was with Richard Evelyn, however, the brother of the famous diarist, that the architectural history of the present building began about 1650. Tradition has associated the name of Inigo Jones with the original design, but it must have been carried out by one of his successors, and the hand of the disciples of Wren may be distinguished in some of the internal work. It is unlikely, therefore, that much of the Woodcote

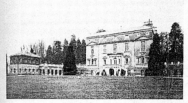

WOODCOTE PARK

DRAWING ROOM DOORS AND PANELLING

which John Evelyn saw at his brother's wedding has survived, but the chief decorations are of a no less distinguished period in the history of English architecture. The estate passed from the Evelyns to an Irish Peer, Lord Baltimore, and remained in his possession until 1768. During this time the house was redecorated within by Thomas Chippendale, and the accompanying illustrations show what dignity and charm this great artist brought to the work.

The drawing room in particular is a very notable example of what Chippendale called the "French Taste." So faithfully does it represent the spirit of the style of Louis XV. that it is only from slight indications that it is possible to distinguish it from the contemporary work of France. The carving has a crispness and a vitality altogether admirable, and shows the masterly way in which Chippendale had assimilated the essence of French work.

The Library is no less notable.

THE LIBRARY CEILING

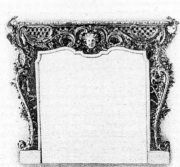

Not only are the folding doors beautiful examples of the period, but the chimneypiece of wood, richly carved and gilt applied on a background of green marble, with statuary marble edging, is a perfect example of its kind. The central feature of the Library ceiling is an exceedingly fine painting of a child borne by an eagle, attributed to Rubens. It has an admirable setting of a reeded floreated wreath framed in rays softly modelled in the plaster.

But there is earlier work, part surviving from the pre-Chippendale decorations and part which must have adorned the house which Richard Evelyn's building displaced. The dining room door frame is as dignified a piece of Palladian work as one may meet.

The decorations of Woodcote Park are in effect a symposium of the decorative manners of two great centuries and when, after various changes of ownership, the house became a golf club, the best of the interior decorations had to be removed.

CHIPPENDALE FIREPLACE

In normal times no doubt there would have been a movement to acquire them for one of the National Collections, and, failing its success, there would have followed an outcry against its removal to America. But times have changed, and with them our outlook on most things.

It will give general satisfaction to know that the collection has been acquired by Mr. C. J. Charles, of Brook Street and New York, and that it will soon be on exhibition at his Galleries in Fifth Avenue. England will regret its loss, but some American connoisseur will be the gainer, and the collection will be helping to restore that parity of exchange which nothing but the export of precious things can establish at this time of crisis.

6

THE GROWTH OF A
TRANSATLANTIC TRADE IN ROOMS
AND SALVAGES

IN 1876 A PURCHASE IN London prefigured the transatlantic trade in salvages and rooms between Britain and the USA, namely the acquisition by Mrs Timothy Lawrence of a 'Jacobethan', more likely 'Jacobogus', room that ended up in the new Boston Museum of Fine Arts that opened in July 1876. She may have bought it from the broker W. Thrale Wright of 144 Wardour Street. The Lawrence Room was iconic in the history of the period room in American museums, for the first recorded installation of an English room in a North American museum did not occur until 1910 when the Royal Ontario Museum in Toronto bought a crude bourgeois room reputedly from Norwich; and in the USA not until 1918–19 when the Minneapolis Society of Arts[1] bought a Jacobean room from the dealer Arthur S. Vernay of New York.

In 1896 it was reported that following the demolition of Sir Stephen Fox's grand Chiswick Manor House built in 1691, Sir Joseph Joel Duveen (1843–1909) bought the 'fine carvings and panelling of the interior'.[2] This purchase may possibly relate to references in the Duveen sales/stock entries referring to Mrs William C. Whitney.[3] The first in November 1897 refers to a 'large Louis 14 Style Brown & Gold Room' costing $10,000, 'delivered free New York',[4] and more relevantly in May 1898, for the same client, 'Charges for Carriage of 25 Cases Containing Oak Room' to Paris.[5] However, in April 1898 Duveen had recorded '1 Carved Oak Room Consisting of 1 Mantel Piece 20 Panels 1 Double Door', sold to Wm Young of 6 Lancaster Place, Strand for £280.[6] Young may have been a dealer. Whether this was the same salvage as the '31 Panels, Chimney Piece, & double door' costing £208 17sh. 10d.,[7] is uncertain, but possible. In July 1900[8] there is a reference to the

100. The Woodcote Park Collection, a trade article by C.J. Charles of Brook Street, illustrated in *Country Life*, 4 March 1916

101. Late eighteenth-century chimneypiece from Tunbridge Wells, Kent, from Lichfield & Co., *Old English Panelled Rooms, Mantelpieces . . . of the 17th & 18th Centuries*

102. Lichfield & Co.'s advertisement in the *Connoisseur* for an early to mid-eighteenth-century chimneypiece as in their showrooms

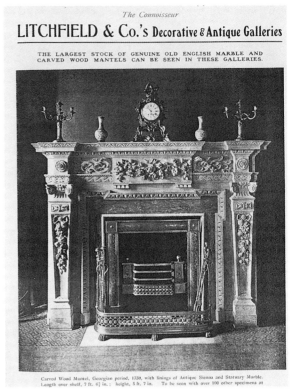

The Connoisseur

LITCHFIELD & Co.'s Decorative & Antique Galleries

THE LARGEST STOCK OF GENUINE OLD ENGLISH MARBLE AND CARVED WOOD MANTELS CAN BE SEEN IN THESE GALLERIES.

Carved Wood Mantel, Georgian period, 1730, with linings of Antique Sienna and Statuary Marble.
Length over shelf, 7 ft. 6½ in.; height, 5 ft. 7 in. To be seen with over 100 other specimens at

packing of '8 Carved wood panels' for the banker William Solomon, at 1020 Fifth Avenue, New York.[9] These references are indecisive, but they indicate the first stirrings of a transatlantic trade, preceding the benchmark of 1903 when Sir Charles Allom, of White Allom & Co., decorators, at 15 George Street, Hanover Square, established a trade partnership with Duveen, whose Gallery of Fine Art was established on Oxford Street from 1879, with a branch house in New York from 1877. Encouraged by Duveen, in 1905 Allom also opened a New York office.[10] Joseph Joel's son Joseph Duveen, later Lord Duveen (1870–1939), the principal behind the firm Duveen Bros from 1907, cemented that relationship, and Duveen's brother Charles Joel established himself[11] dealing as Charles of London from 27 & 29 Brook Street, with 'old Georgian Mantelpieces' and 'old Marble' in his first advertisements in the *Connoisseur*.[12] Charles may have bought the three fine chimneypieces in the Frick Collection, including one probably from 15 Hanover Square,[13] a house demolished in 1904.

These *Connoisseur* advertisements are a measure of the growing trade in salvages. In January 1903 Gill & Reigate at 77–85 Oxford Street and 6–7 Dean Street, founded in 1899, were offering a Jacobean panelled room, one of nine they took out of Rawdon House, Hoddesdon, Hertfordshire;[14] Geo. Trollope & Sons of West Halkin Street, London, had a set of high quality French Régence *boiseries*;[15] Warings Antique Galleries at 76–80 Oxford Street offered a Jacobean chimneypiece

with arms of the Collingwood family found in an inn in Newcastle upon Tyne; and the first advertisements appeared of Thomas G. Litchfield at 3 Bruton Street, offering 'Genuine Antique Panelling Fine Stock of Antique Carved and Inlaid Marble Chimney pieces . . . Most of these Chimney Pieces have been purchased on the demolition of Mansions'. These (see Figs 101–2) would be their speciality for some years to come. The year 1903 was also when Charles Roberson started trading as Robersons at 83 Knightsbridge. Much later (1920) he would handle trade of the celebrated Knightsbridge Halls, although at this early date the firm dealt in conventional antique furniture, as in fact did most other dealers who later specialised in rooms and salvages. In September 1904 Mellier's Galleries in Margaret Street advertised a seventeenth-century screen from the church of San Luca, Cremona, which they had exhibited in 1904 in the British Pavilion at the Louisiana Purchase Exhibition in St Louis, Missouri. In May 1905[16] Litchfield's offered a chimneypiece by 'Robert Adam'[17] from Sheen House, Richmond, and in October 1905[18] a superb set of Louis XV *boiseries* taken out of Newtonbarry House, Co. Wexford, the house having been built in the 1860s for the Hall-Dare family.[19] Advertisements in the *Connoisseur* continue through 1905 and 1906, with Roberson offering in January 1906,[20] 'Old Oak Rooms etc' and in May having '100 Old Marble Mantelpieces in Stock'; Druce & Co. had 5,000 feet of old panelling. In 1906 too Litchfields' were offering Jacobean panelling from Leighs, Essex, while in October 1907 Hampton & Son offered more than 1,000 square feet of Tudor oak panelling from the 'Ipswich home of Duke of Brandon and Suffolk'.[21] In 1906 the English expatriate dealer Arthur S. Vernay opened an antique shop at 45th Street, just off Fifth Avenue, New York, and would specialize in the installation of period rooms, many imported from England; in 1919 he was to sell to the Minneapolis Institute of Arts the Jacobean room from Higham, Suffolk. Oak rooms would continue to obsess dealers, and especially transatlantic buyers. In January 1910 Litchfield's had on offer a Jacobean room from 'an old house in Derbyshire', and in the same *Connoisseur* Gill & Reigate were still offering their Rawdon House rooms to illustrate an exhibition of 'The Charm of Old Oak'.

Dealers' growing obsession after 1900 with Elizabethan and Jacobean panelling was encouraged by the three lavishly illustrated folio volumes of Charles Lathom's *In English Homes*,[22] particularly the first volume in 1904 and the second in 1907. Indeed, the 1904 volume could almost be regarded as a picture book of antiquarian interiors, or those early interiors altered and extended after 1850. Here is Agecroft, Lancashire, in 1926 to be transported to Richmond, Virginia; Bradfield, Devon, Burton Agnes, Yorkshire, Godington and Groombridge, Kent, Wroxton, Oxfordshire, Castle Ashby, Northamptonshire, Speke Hall and Smithills Hall, Lancashire, Bramhall, Cheshire and Ockwells Manor, Berkshire. Lathom did as much as any to create the fashion, and the dealers followed. It is obvious that dealers scoured magazines, notably *Country Life*, or books featuring country houses. Fletcher Moss's nine volumes of *Pilgrimages to Old Homes* appeared between 1901 and 1920.[23] A run of *Country Life* was in Duveen's London office, as were sets of the *Connoisseur*. A fascinating by-product of all this

103. Two details of chimneypieces from 15 Hanover Square, London, demolished 1904. Thomas Carter sculptor, Charles Cameron architect, for Jervoise Clark, 1770–74. Illustrated in Guy Cadogan Rothery, *English Chimney Pieces*, 1927

interest was Leonard Willoughby's article 'Some Famous English Halls' in the *Connoisseur* of December 1910,[24] which illustrated twenty-eight halls in great houses using *Country Life* photographs. The connections with *Country Life* magazine are crucial, since Lathom's co-author for *In English Homes* volumes 2 and 3 was H. Avray Tipping, who would become the magazine's principal architectural writer before Christopher Hussey.

With the arrival of Margaret Jourdain as the first decorative arts contributor, an unsatisfactorily close relationship developed between writers and dealers.

Even as early as 1910 Herbert Cescinsky warned that 'A considerable amount of mischief has been caused by the publication, during the last twenty years of certain books on the subject of furniture, in which statements have been made with seeming authority, but utterly without foundation of any kind or even any research as to their accuracy.'[25] In the 1920s dealers of the Roberson sort rarely did their homework. Frequently, illustrations in books are, or had been, trade objects. An example, if somewhat later, is Guy Cadogan Rothery's *English Chimney Pieces*, published by John Tiranti in 1927. A whole host of dealers are acknowledged: Mr Pratt, Messrs Keeble, Sir Charles Allom, Gill & Reigate, Howard & Sons, Walter L. Brothers, and Mr Roberson. Turning the pages we find many relocated chimneypieces: plate 7, a Tudor Renaissance one from Piercefield Park, Monmouth (Fig. 222), this bought by Hearst; plate 20, a Jacobean one from Lyme Regis, Dorset;[26] and plates 121–22, the Charles Cameron ones (Fig. 103) of the 1770s, taken out of 15 Hanover Square, London, a model copied and marketed by Sir Charles Allom.

In 1904 Francis H. Lenygon had founded Lenygon & Co., and Charles of London opened an office in New York at 251 Fifth Avenue. Here he would soon establish himself as the leading importer of English 'olde worlde'[27] rooms in which 'The presence of antiquity dwells in the house'.[28] In 1926 he became the founder of the Art and Antique Dealers League of America. In 1909 Lenygon in collaboration with Colonel H. H. Mulliner took a lease on 31 Old Burlington Street.[29] There they merged with the upholstery firm of Morant & Co. and traded as Lenygon & Morant. The year 1909 saw the publication of *The Decoration and Furniture of English Mansions during the Seventeenth and Eighteenth Centuries*, by Margaret Jourdain ghosting under the pen name of Lenygon, as well as books on furniture

and interior decoration, many published by *Country Life*. In the 1909 book, illustrations show the Campbellian Palladian rooms of 31 Old Burlington Street fitted up as showrooms with some of their trade rooms installed, including a composite unidentified 'Early English Renaissance Room' with a magnificent chimneypiece and overmantel, a Cedar Room,[30] and the Dutch Painted Room from Groningen, Holland.[31] Jourdain's book is evidence that Lenygon was acquiring rooms for export as early as 1909, probably even by 1908, in particular two Dutch rooms, one described as 'the most interesting and important complete room – both historically and artistically – which has ever been exhibited', in the firm's *Description of the Painted Room in the Collection of Messrs Lenygon & Co. Ltd*, 1910.[32] This was a late Dutch baroque room with a fully painted ceiling, walls and overdoors by Hermanus Collenius, of Amsterdam and Groningen, the large canvases occupying the walls down to a dado, the subjects the lives of 'Collenius, Masinissa and Cloelia', the carved woodwork in the Williamite, Dutch Hampton Court style, the chimneypiece overmantel with a picture of Europa and the Bull by Peter van Ruyven, signed and dated 1712. Lenygon writes that the room was 'purchased by the present owners out of the house', and Brian Mitchell has identified it as a house that stood on the eastern side of the Oude Boteringestraat in Groningen. One overdoor painting shows the centre of a Netherlandish late medieval and Renaissance town house flanked by gabled wings, before rebuilding, whilst the other shows the centre section rebuilt in a characteristic late seventeenth-century redbrick Dutch style. According to the editors of *Thieme Becker*, compiled before 1912,[33] this room was sold to the USA for '22,000 Gulden'. It may not be a coincidence that 1912 was the year Lenygon opened a New York office: it should be added that in preparation for extended business, in 1911 the company built over the garden of 31 Old Burlington Street, creating a showroom, work rooms and frontage on 21 Cork Street, a back-to-back development.[34] An appendix to the 1910 *Description* is a stock list recording seventeen rooms on their inventory. The import of a second Dutch room is imprecisely documented.[35] It is described as the 'Andriesson Room' on a Lenygon photograph, 'One of the painted canvas panels in the drawing room of Mrs George Keppel's house. These old paintings were taken from a house in Tiel, Holland. Painted by [Jurriaan] Andriesson 1777'. Mrs Keppel was Alice Frederica Keppel; married to Colonel George Keppel, she was the mistress of Edward VII. She acquired a lease of 16 Grosvenor Street in 1909, and her alterations included the installation of a 'Dutch room', 'for which she paid £5,000'.[36] Such a sum then must imply a set of canvases, not just one. Apparently the room was also exhibited at 31 Old Burlington Street.[37]

In 1907 the firm of French & Co. had been founded by Mitchell Samuels in New York, and they specialized in French rooms, establishing trade relations with Carlhian-Beaumetz in Paris; later they would broaden their interests to take advantage of the English export trade. In 1908 White Allom organized the display of five furnished period rooms, 'with panelled interiors from old houses', exhibited in the Palace of Decorative Art at the Franco-British Exhibition in Paris.[38] This comprised a William and Mary room, a Queen Anne room, an Early Georgian room (in fact

the Hatton Garden room acquired by the Victoria and Albert Museum in 1912), a Chippendale room and a second Queen Anne room lent by Sir Edmund Davis, probably intended to be installed in his house at 13 Lansdowne Road, Holland Park. However, the most astonishing exhibit must have been the complete L-shaped half-timbered house with a date of 1563, removed from Ipswich by Gill & Reigate (who had their workshops in the town), which was immediately exported to the USA,[39] qualifying as the first English house to be exported across the Atlantic.

The desirability of an American base was demonstrated by Litchfields when they opened an office at 200 Fifth Avenue, New York, and in May 1910 advertised their new office in the *Connoisseur*, claiming 'The Largest Stock of Genuine old English Marble and [more than 100] carved wood Mantels'. They offered a variety of handsome chimneypieces (Fig. 102) including two from the Earl of Bristol's 'Old Park, Enfield',[40] a 'Splendid' 'Queen Anne' carved room 'from an old mansion in Essex',[41] Jacobean panelling from an 'old Dower House Parlour in Hertfordshire',[42] and Louis XVI *boiseries* from the hôtel Martagnac, 52 rue de Grenelle, Paris.[43] At around this time[44] they also issued a catalogue entitled *Old English Panelled Rooms, Mantelpieces, Firegrates, Mirrors, Chandeliers, Wall Brackets, Etc. of the 17th & 18th Centuries*,[45] as Litchfield & Co., Ltd., directors Walter H. Brothers and Sydney W. Brothers, at 35 Bruton Street, London. This featured a Jacobean room from the west of England, 80 feet of linenfold panelling made in 1815 for the first Earl Howe's chapel,[46] a 1730s room from 'an old North London mansion', a pair of 'Pergolesi' chimneypieces from the Isle of Wight, another from Old Park, Enfield, a group of chimneypieces and 'Adam' door architraves from 18 Stratford Place, London, a 'Pergolesi' chimneypiece[47] from St James's Square, and several from Tunbridge Wells, including a remarkable neo-classic example (Fig. 101). This undated catalogue seems to have been followed by *The Collection of Antique Furniture, Works of Art, Oak & Pine Panelled Rooms, Mantelpieces, etc*,[48] which includes a William and Mary room from Langley House, Hippesholme, Halifax, a Queen Anne mantel from the Bull Inn, Guildhall, London, a mantel with pewter enrichments from Chesham House, Buckinghamshire, and a stunning 'Queen Anne' room with 'Gibbons' style carvings from 'an old mansion in Essex'.

During the half-dozen pre-First World War years Gill & Reigate of the Soho galleries, and now also in New York, were prominent in trade advertisements. In June 1909 they offered through the *Connoisseur* nine late seventeenth-century rooms removed from a house in Uttoxeter, exhibiting three of them[49] at the Fine Art Palace at White City, London. They also sold[50] a Jacobean panelled room to William Randolph Hearst in August 1912.[51] In 1911 Druce's of Baker Street advertised a grand Wren period carved room 'from a North Country Mansion'.[52] In 1911 too Arthur Stair and Valentine Andrew founded Stair & Andrew at 25 Soho Square, and a year later Valentine would open offices in New York at Fifth Avenue and 38th Street to head one of the most successful firms of Anglo-American antique dealers, boasting Frick, Morgan, Vanderbilt, Whitney, Rockefeller and Duveen as clients. After the First World War they moved to a complete house at 59 East 57th Street, jostling with Mrs Cornelius Vanderbilt. In 1913 the firm had two rooms from Great

104. The Reindeer Inn, Banbury, Oxfordshire. The Globe Room in 1910

Yarmouth, the Fenner House Room and the Star Room. The latter (Fig. 160) had a chequered career, having first been installed for Commodore Morton F. Plant at 1051 Fifth Avenue; then passing into the stock of the anglophile Arthur S. Vernay by 1927 before being sold to Mrs John E. Rovensky; it was then sold at her sales to Hearst, later acquired by Mrs A. Hamilton Rice and given to the Metropolitan Museum of Art in 1965.[53]

Dealers, and indeed brewers, saw inns as potential sources of conquest for exportable rooms. The complicated saga of two rooms from inns, the Treaty House, Uxbridge, and the Reindeer Inn, Banbury, are related case studies of attempts to export panelled rooms in 1912 that neatly encapsulate the machinations of the transatlantic trade at this time. Lenygon was involved in Banbury, and would certainly have been interested in Uxbridge, had he not been publicly crucified by Lord Curzon over the purchase of Banbury's Globe Room (Fig. 104). According to Banbury historian William Potts, proposals to move the Globe Room had first been made in 1909 and 1910.[54] The architect and architectural historian J. A. Gotch had examined the room when he and members of the Architectural Association had visited Banbury in 1885, and he published the room and chimneypiece in his *Early*

Renaissance Architecture in England, 1901.[55] It was also included by L. A. Shuffrey in *The English Fireplace* in 1912,[56] so it had received ample publicity. Lenygon was well aware of the importance of this room installed in a wing of the inn dated 1637, especially as the chimneypiece was reputed to be a 'work of [the] famous carver Inigo Jones',[57] although Gotch himself as a future biographer of Jones would surely have been sceptical. In the *Banbury Guardian* there was a flurry of concern and protest:[58] 'It is with regret that we have to announce that the Hook Norton Brewery Company have accepted [an] offer for the purchase of the ceiling, panelling, windows and fireplace of the historic Globe Room . . . We understand the gentleman purchasing represents a London and American firm' – the 'gentleman' of course being Francis Lenygon.

The intensity of opposition to the export of the room was such that it attracted the attention of Lord Curzon, who had recently been fulminating at the proposed export of four Tudor chimneypieces from Tattershall Castle, Lincolnshire, and even the proposed export of the castle itself, to an 'American syndicate'. This was a potential transatlantic tragedy, for having been sold in 1910 by the Hon. Hugh Fortescue to a speculator, mortgaged to a bank, sold on to other speculators, bought by an American syndicate who planned to remove the castle brick by brick to the USA, it was saved by Curzon after the National Trust had discussed the problem between 18 April 1910 and 18 December 1911.[59] In triumph Curzon found the fifteenth-century chimneypieces in packing cases in Tilbury Docks. They were bought back in 1912 at the cost of £5,155, and returned in a procession of wagons decorated with the Union Jack. After this, it is not surprising that apropos the Globe Room, on 1 August 1912 Curzon laid into Lenygon in *The Times*. On the following day Lenygon vigorously replied,[60] observing that in 1909 he had approached the Victoria and Albert Museum, who had declined purchase of the room because they already had the Sizergh Castle room and were looking for an Elizabethan linenfold room. In a further letter of 6 August, Lenygon castigates Curzon for his 'offensive expressions' and 'abuse', and explains that responsibility for the removal of the room rested entirely with the brewers; for two years the room was 'publicly on sale', and he says that 'various museums, local bodies and influential people were approached by myself and others to buy it'. There can be little doubt that had Curzon not intervened, the room would have been exported. Lenygon had won the *Times* contest, but at a cost. The Globe Room never did get exported, and at war's intervention it was put into store. Significantly it was White Allom who advertised it in the *Connoisseur* in 1929 and 1930 following that firm's exhibit at the Daily Telegraph Exhibition of Antiques and Works of Art at Olympia in July 1928, when they also exhibited rooms from Combe Abbey, Warwickshire, the Chantry House, Newark, Nottinghamshire, and an old house in Worcester. The Globe Room survived the London blitz, because it had been stored outside central London, but its ceiling did not. The panelling was eventually returned to Banbury, where it was first installed in the Library and Museum in Marlborough Road, opened on 12 May 1966, and then was happily returned to the Old Reindeer Inn and opened there on 17 February 1984.

105. The Treaty House, Uxbridge, Middlesex. The Treaty Room before removal and sale

The connection between the Uxbridge Treaty Room and Lenygon is admittedly tentative. In November 1912 a correspondent in the *Sphere*[61] published an article about panelled rooms, focusing on a visit to the Lenygon galleries at 31 Old Burlington Street[62] where the Globe Room was on view, as was an 'Oak Room'.[63] The article illustrates the Globe Room, the Haynes Grange Room (sold by Hindley & Wilkinson to Sir Edmund Davis for his house at 13 Lansdowne Road, Holland Park[64]) and what is referred to as the 'Presence Chamber' in the Treaty House (Fig. 105). It cannot be a coincidence that the room was included in this article centred on Lenygon. The room was even more notorious for what it was not, for it is highly unlikely that these were the rooms[65] in which, between 30 January and 22 February 1645, the sixteen commissioners appointed by Charles I and Oliver Cromwell met to negotiate an ending to the Civil War.[66] At that time the present Treaty House was but a small part of the much larger Place House, belonging to Sir John Bennett. The *Middlesex and Buckinghamshire Advertiser* complained on 10 August 1912, 'surely something should be done to keep this fine old panelling in the town'. The comment that the room was 'now the property of H. Burgess of Hounslow'[67] has caused historians to date its removal to 1912. This is not so. The *Advertiser and Gazette* of 30 August 1929, under 'Loss to Uxbridge', reveals that in 1912 Burgess had taken an

option on the panelling, had never completed on it, and that only at his death many years later did it become available on the market.[68] The dealer was now Charles Roberson, who unsuccessfully offered the room to the Philadelphia Museum of Art. On 9 July 1929 he wrote to Fiske Kimball, 'I have personally known of this room for many years, and have always wished to acquire it.'[69] On the 15th, in a further letter to Kimball, Roberson wrote that the room would cost £11,250 plus cost of packing and shipping, and demanded 'instructions immediately', 'as I have this room under offer in several directions, and it may be sold at any moment',[70] as indeed it was: at an uncertain date to Louis H. Allen of 521 Madison Avenue, New York, whose undated brochure *The Short History of the 'Treaty Room'* must have been compiled by Roberson, quoting the *London Daily Chronicle*,

> Now, having been sold to an American, Mr Louis L. Allen, it has been dismantled. Soon after its arrival in America it will be re-erected in his galleries on Madison Avenue, New York. We can afford to lose pictures such as 'Pinkie' and the 'Blue Boy', for we have even finer Lawrences and Gainsboroughs, but nothing can replace a room of such historic and unique interest as that now lost to us forever.

It is wrongly assumed that Allen sold the room to Armand Hammer, who either put it into store or installed it somewhere else. All that can be read from Hammer's unreliable comments[71] is that when an American B25 crashed into the Empire State Building on 28 July 1945, the destroyed floor was acquired by Hammer for his United Distillers of America Inc.; the opening party was held in June 1946. Hammer claims that 'Victor', his aide, received a message from an 'English antiques and art dealer', that the Treaty Room was available, implying that the room was somewhere else in the USA.[72] It was installed as his personal office, and the Distiller's Tasting Room was the Council Chamber from a Medici Palace in San Donato in Collina, near Florence. In 1953 Hammer gave the Treaty rooms to Queen Elizabeth as a Coronation gift, and on the advice of the Victoria and Albert Museum they were passed to Uxbridge and reinstated in the Treaty House in 1958. Banbury, Uxbridge and Tattershall Castle all serve as early ill omens for the export of rooms and salvages from England to the USA.

The bevy of London dealers grew in the half a dozen pre-First World War years. Among these dealers, all establishing offices or contacts in the USA, can be singled out Herbert Gould Lucas, 'Architectural Experts', of Conduit Street; Fryer of 6 Henrietta Street; and Harold D. Lancaster at 55 Conduit Street. In 1913 there was a reversal of the fashion and export of English rooms, when St Mary's, the English church in Rotterdam, consecrated in 1708, was demolished. This was scathingly reported in the *Architectural Review*.[73] Due to the vigilance of A.C. Benson, the organ case went to Eton College Memorial Hall; St Giles church, Cambridge, was given altar rails and other salvages; and the altarpiece and panelling was set up at the west end of the Hall of Selwyn College, Cambridge. 1913 also saw another act of vandalism, when the Royal Automobile Club instructed Lancaster to extract panelled rooms from their newly acquired Woodcote Park, Surrey, a house redolent of

French rococo taste and the lords Baltimore. These rooms and salvages (Figs 147–51) would eventually travel far and wide through many dealers, who included Charles of London (see Fig. 100). He bought Gibbs's noble and soon to be demolished Rotherwas Park, Herefordshire, in order to take out 13 rooms,[74] including the fabled Jacobean Rotherwas Room, now at Amherst College, Massachusetts (figs 13–14). In the *Connoisseur* for January 1913 Daniell of 42–46 Wigmore Street advertised an exceptionally fine Elizabethan room from the 'Manor House, Oulton, Suffolk'. The *Connoisseur* (May and June 1914) exposes a typical clean-up in Evesham, in Worcestershire, when Fryer could offer a Tudor chimneypiece that had originally been removed from the Town Hall in 1830, oak panelling from a summerhouse in the garden of Dresden House, and also an oak screen dated 1514 that had been taken from Evesham Abbey in 1729.[75]

The year 1919 marked the end of the First World War, the consequences of which led to the hotting up of a transatlantic trade in rooms and salvages due to the postwar crisis in unwanted country houses. This crisis gave rise to an expansion of the antiques trade in Britain and to one of the biggest movements of salvages in European history. The country house crisis had been signalled by the Great Agricultural Depression,[76] reckoned to have become manifest from 1873. Ironically, one factor was the importation of cheap American wheat. It meant a severe reduction in rental income from the management of land so crucial to pay for the indebtedness and maintenance of country houses. As a consequence the byword among the landed classes was 'retrenchment', meaning the disposal of secondary houses, the sale of 'outlying portions of the estate', and of works of art and books. When John Bateman published his encyclopaedic *The Acre-ocracy of England. A List of All Owners of Three Thousand Acres and Upwards . . . The Modern Doomsday Book* in 1878, the Depression was already looming. The Settled Land Act was introduced as a lifeline in 1883 to enable the sale of inalienable works of art, or heirlooms, leading to those many and celebrated auction sales in the 1880s (Hamilton Palace, 1882; Narford, 1884) that would eventually enrich those American collectors, especially after the US government lifted its import tax on works of art in 1909.[77] Just as the Depression rendered many houses redundant, the First World War was the last straw that broke the back of the landed classes. The Great War struck at the very heart of morale. In 1914 the officer class *was* the landed class, and even if that class were younger sons in a family maintaining a great house and estate, the death of several hundred thousand officers dealt the country estate a mortal blow. Not only were there multiple death duties to pay, but the war left hundreds of houses in the care of an older generation who lacked the vision to adapt. It would recur again with a vengeance in 1945.

There were other sources of this transatlantic trade, not least urban demolitions in central London. Although country house demolitions were essentially a post-First World War crisis, the demolition of a house as a provider of trade salvages not only followed the loss of a redundant one, but also happened when a house was rebuilt or replaced by a modern one. Using this as a measure, more than fifty fairly large houses enriched the demolition contractors between 1875 and 1910.

The Connoisseur
HAMILTON PALACE
The Complete Collection of Seventeenth-century Oak-panelled Rooms, etc.,
PURCHASED BY **ROBERSONS** *of Knightsbridge*

THE CHARLES II. OAK BALUSTRADE
to the staircase leading to the old portion of the Palace, carved with Amorial, and including monogram, unicorns, and a coronet among profuse acanthus foliage, consisting of seven sloping flights, each about 8 ft. long, two straight lengths of balustrade, and a plain panelled dado.
Late Seventeenth Century.

ROBERSONS, 83 & 85 Knightsbridge, S.W.1

The Connoisseur
HAMILTON PALACE
The Complete Collection of Seventeenth-century Oak-panelled Rooms, etc.,
PURCHASED BY **ROBERSONS** *of Knightsbridge*

PANELLING OF THE OLD STATE DINING ROOM
with carved enrichments in the overdoor and chimney-piece panels, the latter surmounted by the Hamilton Arms, garlands of flowers, fruit and birds, with black marble fireplace opening and bevelled mirror. 15 feet 6 inches high, 22 feet square.
Late Seventeenth Century.

ROBERSONS, 83 & 85 Knightsbridge, S.W.1

106. Hamilton Palace, Lanarkshire. The late seventeenth-century Staircase. Charles Roberson's advertisement in the *Connoisseur*, January 1920

107. Hamilton Palace, Lanarkshire. The Old State Dining Room. Charles Roberson's advertisement in the *Connoisseur*, January 1920

For antique dealers and demolition contractors these provided an undreamt-of mountain of salvages. It has been said of the approximately 1,800 houses demolished in the century from 1875 that each has its own personal case history. It was not the eighth Earl of Essex's death from an accident in 1916 that led to the demolition of Cassiobury Park, Hertfordshire, for instance, but rather the strangulation of the estate by industrial Watford that led to its gutting in 1922 and eventual demolition in 1927, and so to the dispersal of the finest group of Grinling Gibbons's carvings from that house (Figs 157–58, 179) outside of Windsor Castle or Hampton Court.[78] These carvings were a magnet for dealers, and they all ended up in the USA, doled out by French & Co. who bought the majority. It was undermining for coal in Derbyshire that led to the gutting of Sutton Scarsdale in 1920, and the demolition of Wingerworth Hall in 1924, both prey to Charles Roberson, who tore out their carved panelled rooms (Figs 170–72, 215) and manipulated them to serve the requirements of many a museum director.

House loss after 1920 rose to an annual peak of about twenty in 1925 and twenty also in 1930, 1934 and 1935, and again in 1938, with a total loss of perhaps

500 houses before the onset of the Second World War. It is not surprising that during these two decades the antique shop in country towns and larger villages became ubiquitous. In 1918 the British Antique Dealers' Association was founded. As they would be for the next fifty years, shops overflowing with antiques were visited by a bevy of runners, who fed the metropolitan dealers in the transatlantic trade. A whole host of London dealers now advertise in magazines such as *Country Life*, the *Connoisseur* and *Architectural Review*. Not all the rooms or salvages offered were necessarily exported to the USA, but many were.

In the *Connoisseur* for 1920 Druce & Co. of Baker Street and King Street offered three oak panelled rooms from the 'north country', and also had a Tudor long gallery.[79] Robersons were now to the fore. In 1920 not only did they acquire the grand Knightsbridge Rooms (Fig. 224) for their showrooms, but they invested heavily, buying all the rooms from Hamilton Palace, and advertising this fact in the *Connoisseur* for January 1920 with illustrations (Figs 106–7) of the Old State Dining Room and the Charles II oak stair.[80] In October they offered[81] an Elizabethan chimneypiece from Sheldon Hall, Warwickshire,[82] and in March a fine French *Régence* room.[83] They advertised a room from Hatton Garden, London in the *Connoisseur* for May 1926, probably one of the several that had been taken out of no. 26 in that street when the house was pulled down in 1907. The grandeur of their Knightsbridge Halls is matched by the four handsome volumes entitled *Historical Rooms from the Manor Houses of England*, c. 1924–25.[84] A curious advertisement in the *Connoisseur* for December 1921 is that of Burt, Escaré & Dentelle of 195 Wardour Street, offering eight eighteenth-century English chimneypieces belonging to Valentine del Synore (dealer?) 'killed in rebuilding of premises in Regent Street'.[85] In 1922 Hindleys (once Hindley & Wilkinson) of 70–71 Welbeck Street offered a pair of doorways from the first Earl of Carnarvon's 'London house' in Hanover Square, and in November[86] the Bell Range & Foundry Co. of 16 Berners Street offered a neo-classical chimneypiece[87] from the State Drawing Room at Stowe House, Buckinghamshire.

The break-up of Stowe House in 1922 had been a magnet for dealers. Following the contents sale, for three days from 11 to 13 October, all the chimneypieces bar a few were dispersed (no fewer than fifteen).[88] In June 1923 Gill & Reigate, now busy at 18 East 57th Street, New York, could offer 'a dozen Oak Panelled Interiors'. In June 1924 W. Turner Lord of 20 Mount Street was selling a fine chimneypiece of c. 1740 from Sussex, and surprisingly, in the *Architectural Review* for March, C. Pratt & Sons in the Brompton Road could claim to possess 'twenty Early Georgian Panelled Rooms . . . secured from old houses in the City', illustrating one from the 'old Whitefriars Glass Works'. Also in 1924 the firm of Hotspur was founded, then at Streatham Lodge, Richmond, later at Hazlitt's House, 6 Frith Street, near Soho Square, and eventually as today at 14 Lowndes Street.[89] Their surviving albums of photographs appear to date from September 1925 and include numerous unidentified rooms, as well as a Gibbons overmantel enframement from Cassiobury.[90] In July 1925 when Moss Harris & Sons advertised an 'old William & Mary Room', shown at the Wembley 1924 British Empire Exhibition, Palace of Industry, they

claimed to stock 'over 100 rooms', a ludicrous exaggeration.[91] In this year a typical auction sale that attracted many dealers, including Hotspur, was the Sir George Donaldson Collection 'at his Private Museum' at 1 Grand Avenue, Hove, Sussex.[92] Lots 410–57 formed a huge collection of wood carvings, and lot 395 the fittings for a room comprising panelling 'chiefly from Rouen', a chimneypiece 'from the Old Duke's Head at Yarmouth', Norfolk, with a 'stone mantel from an old house in Barnet', Middlesex.

Characteristically, Margaret Jourdain is to the fore in illustrating dealers' wares in her books, such as *English Interiors in Smaller Houses* of 1923, with Roberson rooms from Wingerworth Hall,[93] the hall at Whitley Beaumont, Yorkshire,[94] the library from Standish Hall, Lancashire,[95] and a room from a house in Grosvenor Square.[96] In 1926 there commenced abortive negotiations between Charles of London[97] and New York and Robersons as to amalgamation of their businesses,[98] revealing Charles's profits at the end of July 1926 to be approximately £45,000, an astonishing figure. However, Charles had already sold a 'Charles of London Collection' at the American Art Galleries, on 15–20 November 1920, that included an Elizabethan carved and panelled oak room,[99] the William Kent Cruikshank Room,[100] a Queen Anne Room from Middlemore House, Grantham,[101] and the set of 'Regent d'Orleans' eight painted panels from Woodcote Park, Surrey. In 1928 Acton Surgey of 1 Amberley Road, Paddington and Crews Hill, Sussex,[102] as well as Paris, advertised the Haynes Grange Room,[103] now extracted from Sir Edmund Davis's house in Lansdowne Road, and offered to the Victoria and Albert Museum; this was a second offering, for the room had been rejected by them in 1908 when Hindley & Wilkinson sold it to Davis. In the late 1920s Keeble & Co.[104] were in Carlisle House, Soho Square, with an oak room from East Anglia, and from 1919 they would tranship a mass of salvages from France into Berkeley Castle, Gloucestershire,[105] a job that suddenly brought them to the fore of London dealers and decorators. The French salvage photographs in the archives of Berkeley Castle demonstrate well Anglo-French trade in salvages (Figs 78–81). An article in *Country Life*[106] in August 1926, 'Jacobean Woodwork', illustrates a room set up in Keeble's showroom, with a Jacobean chimneypiece from Albyns in Essex and wainscot from Mildmay House, Newington Green, both Mildmay properties. The chimneypiece was sold to French & Co.[107] In the same article Keebles were exhibiting a set of fourteen velvet and silk festooned pilasters and five demi-pilasters from Wrest Park, Bedfordshire, as reported by John Nichols in his *Progresses of Queen Elizabeth [1603]* as having been made for a visit to the house by Queen Anne of Denmark.[108] From September 1928 Arthur Edwards of Wigmore Street[109] became a familiar advertiser in the *Connoisseur*, offering in that month[110] a room dated 1699 from 'The Old Manor House at Little Hoole', Lancashire, and in August 1929 an Elizabethan oak panelled room.

A notable measure of trade activity in panelled rooms at a time when American museums were thirsting for English rooms is the exhibition catalogue of the London, Olympia Exhibition of Antiques and Works of Art in 1928. Maples advertised a Queen Anne panelled room;[111] Keeble a Withdrawing Room from Albyns, Essex,[112]

and a James I Room,[113] and the Wrest Park, pilasters.[114] Charles of London with Acton Surgey had a Henry VIII Linenfold Room[115] from a fifty-foot-long Tudor hall, whose panelling in the early nineteenth century had been divided up between Great Saling Manor and Great Saling Hall, both in Essex. Charles also exhibited a James I Oak Room;[116] Gill & Reigate had an Elizabethan room from a Tudor house in Ipswich[117] and a Jacobean room from the Chantry House, Newark, Nottinghamshire;[118] White Allom showed their fourteenth-century Gothic Room with a French mantelpiece,[119] their Eyrecourt Room,[120] and formed a display with various wood salvages, mostly Elizabethan. Waring & Gillow had a Jacobean room from Great Yarmouth,[121] and advertised a suite of five rooms including a Marlborough Hall.[122] Stair & Andrew offered a William and Mary Carved Pine Room,[123] the same as advertised in the *Connoisseur* in August 1931. Trollopes had a fifteenth-century Italian room and a French *Régence* room;[124] and T. Crowther & Son, of the North End Road, had a Georgian Room from Stanwick Park, Yorkshire,[125] which was surprising, considering that these Stanwick rooms were a Roberson speciality. Only later would Crowther take over much of the Roberson inventory when the firm

108. Portman Square, London. A room from one of three houses removed by C. Pratt & Sons. Advertisement in *Apollo*, September 1934

went bankrupt in the US stock market crash. A newcomer in advertising was G. Jetley at 52 South Audley Street, offering 'Fine Old Panelled Rooms and Chimney pieces'.

In 1930 Waring & Gillow presumptuously advertised 'a series of period rooms, which have no equal in Europe and America', including one from Toftwood Old Hall, Norfolk. But this was a time too for US stores to have period rooms on their inventories. For example, B. Altman & Co. offered an 'Original Pine Room Removed from Great George Street, Westminster', suitable for 'a present-day apartment or country home that is American in spirit'.[126] In 1931 Stair & Andrew had a 'pine room' of the 1740s, and in 1932 Edwards & Sons could offer 'This magnificent Grinling Gibbons Staircase (Fig. 158) from Cassiobury Park.[127] Stair & Andrew also offered a distinctive mannerist Jacobean room described as from an unidentified 'Old Hall in Lancashire', maybe Hale Hall.

A welcome newcomer, *Apollo* magazine, had now become an outlet for trade advertisers in competition with the *Connoisseur*. In September 1934 C. Pratt & Sons at 160–166 Brompton Road announced and illustrated (Fig. 108) the taking out of the interior decorations of three houses in Portman Square:

T. CROWTHER & SON

DEALERS IN ANTIQUES AND WORKS OF ART
OF EVERY DESCRIPTION

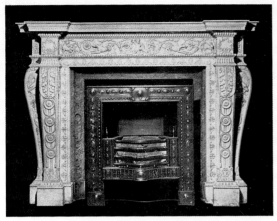

A Beautifully Carved Statuary Marble Mantelpiece with a finely engraved Register Grate.
Size : Length over Shelf 8 ft. 9 ins. Height 6 ft. 2 ins.

We specialise in mantelpieces and amongst our collection we have
them from the following Historic Mansions of England :—
Chesterfield House, Stowe House, Queensborough House,
Chipstead House, Litchfield House, Adelphi, Basildon Park,
Calcot Park, Ashley Park, Kyre Park, West Harling Hall,
Hals Place, Drakelow Hall, Berkeley Square and Norfolk House.

282, NORTH END ROAD, FULHAM, S.W.6

KYRE PARK, WORCESTERSHIRE
FOUR MILES FROM TENBURY WELLS AND SIX FROM BROMYARD
Part dating from Saxon times and rebuilt in 1588 and 1753

PERRY & PHILLIPS LTD.

have been favoured with instructions from the owner who intends to retain the original
part of the mansion intact and to SELL by AUCTION on the premises on
WEDNESDAY, FEBRUARY 25th, 1931
the remaining VALUABLE AND RARE INTERIOR

FIXTURES and FITTINGS

in and about the premises previous to the demolition of part of the Mansion that was added
in 1753, including :

4,000 sq. ft. OLD OAK FLOORING

2,700 sq. ft. Pine Flooring 57 Sash and Casement Windows
73 PANELLED OAK, MAHOGANY and PINE DOORS
12 Ionic Columns 14 Cupboard and Dresser Fitments
30 FINE CARVED WOOD AND STONE MANTELPIECES
Basket and Interior Grates Bookcase Fitments

2,280 sq. ft. RARE OLD OAK PANELLING

and Dado ; including :—A genuine Georgian Room complete.

ORIGINAL ELIZABETHAN OAK STAIRCASE

in four flights ; two other oak staircases ; 7 bathroom and lavatory fittings ; 937 sq. ft.
flag flooring, cooking ranges and store cupboards ; red quarry flooring

TWO PAIRS HANDSOME WROUGHT IRON GATES

with side wings and posts. UNIQUE OAK STABLE FITTINGS.
Old lead rainwater pipes ; a large galvanised roof Timber Shed ; quantity of galvanised
iron sheets ; and many other interesting fittings.
After the sale of the fixtures and fittings, part of

THE FABRIC OF THE MANSION

as clearly marked, will be sold for demolition. This includes the whole of the floor joists
and roof timbers ; LARGE QUANTITY OF LEAD on the roof, gutters and ridges ; about
15,000 SLATES AND TILES ; the whole of the excellent stone and brickwork, and many
other important lots.

SALE TO COMMENCE AT 11 O'CLOCK.
The Mansion may be viewed the week prior to the sale on production of Catalogue
(Price, 1/- each), obtainable from E. T. Langford, Esq., Land Agent, Arley, Bewdley ;
or the Auctioneers, 59, HIGH STREET, BRIDGNORTH.

Inserted in THE CONNOISSEUR, *February, 1931*

109. An 'Adam' chimneypiece (in fact by Stephen Wright, from Clumber) and list of houses advertised by T. Crowther & Son, *Apollo*, September 1934

110. Kyre Park, Worcestershire. Advertisement for the auction of the fixtures and fittings in the *Connoisseur*, 25 February 1931

111. Stourbridge, Worcestershire. Mid-eighteenth-century room in the New York showrooms of Arthur S. Vernay, 'Spring Exhibition Early English Furniture and Decorative Object', April 1935

one being the residence of the late Princess Royale, Duchess of Fife. These houses were built and designed by Robert Adam and the fitments include some of the finest marble Chimney pieces, wrought iron Staircases, mahogany Doors, Architraves and panelling, etc, all of Adam design.

In fact, this must refer to numbers 11–15 on the north side, built from 1773 for speculation by James Wyatt. Pratt continued to advertise, especially chimneypieces, one from Runcorn, Cheshire in November 1934. In July 1935 Moss Harris had a fine Robert Adam chimneypiece from Brasted Place, Kent. In October 1935 W.F. Greenwood & Sons at 24 Stonegate, York offered a 1720s room from Potternewton Hall, Yorkshire, while in November 1936[128] Charles Angell of Bath was obviously party to the salvage extractions from the important Elizabethan Siston Court, Gloucestershire with a very grand Renaissance chimneypiece,[129] a William and Mary panelled room and several other chimneypieces of the 'Tudor, Chippendale and Adam' periods. With Moss Harris's rococo chimneypiece from Aston Hall, Cheshire in August 1937,[130] the advertisements slowly dry up. From the mid-1930s Bert Crowther of Syon Lodge, Middlesex, and the related T. Crowther & Son of 282 North End Road, came to the fore. T. Crowther's advertisement (Fig. 109) in 1937 is telling as to the popularity of chimneypieces on dealers' inventories: 'We specialise in mantelpieces and amongst our collection we have them from the following Historical Mansions of England: Chesterfield House,[131] Stowe House,[132] Queensborough House,[133] Chipstead Place,[134] Litchfield House,[135] Adelphi,[136] Basildon Park,[137] Calcot Park,[138] Ashley Park,[139] Kyre Park,[140] (see Fig. 110) West Harling Hall,[141] Hals [?Hall] Place,[142] Drakelow Hall,[143] Berkeley Square[144] and Norfolk House.[145] Surprisingly the awful spate of post-Second World War demolitions in England did not result in the export of many complete rooms, despite the loss of at least 700 country houses, if not considerably more. The salvage furnishing[146] of Tryon Palace at New Bern, North Carolina, by Crowther of Syon Lodge in the 1950s was an exceptional transatlantic transaction. By 1950 museums in the USA were already assessing the authenticity of their holdings and were reluctant to acquire rooms, despite the fact that very many exceptional rooms could have been bought in the same discriminating way that the Metropolitan Museum of Art acquired their Kirtlington Park room in 1931.

The demand for period rooms and architectural salvages obviously came to a halt with the stock market crash, which affected both museums and private clients of the trade. It may not have been such a slowdown for antiques, and a dealer such as Arthur S. Vernay continued to offer enticing selections in his catalogues, although rooms such as the eighteenth-century one from Stourbridge, Worcestershire, could still find a buyer (Fig. 111). Hardly had the market begun to recover in the mid-1930s when transatlantic trade ceased entirely at the onset of the Second World War. For this reason the vast Hearst Corporation disposals in 1941 were an internal American trade matter only, and in retrospect could be seen as a disaster, leading to the later Hearst Corporation disposals in the 1950s, which initiated transatlantic restitutions such as the Gwydir Castle Room or the famous Great High Chamber from Gilling Castle, Yorkshire.

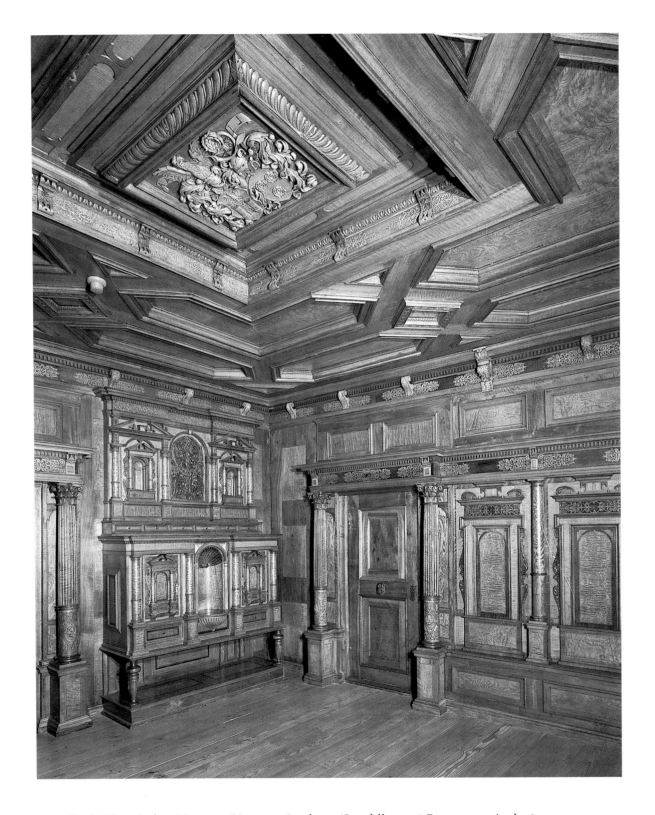

112. Basle Historisches Museum. Haus zur Isenburg (Stapfelberg 9) Room, acquired 1879

THE PERIOD ROOM IN
EUROPEAN MUSEUMS

THE MAKING AND INSTALLATION OF period rooms for public display and education in European museums is a phenomenon of the second half of the nineteenth century. In the long history of the re-use of salvages or the moving of rooms, the presentation by P.F. Fontaine in 1829 of the bedchambers of Henri II and Louis XIV in the public Colonnade rooms in the Louvre is an obvious precedent. These two rooms were so venerated that Fontaine must have seen them as something precious in the context of the new Musée du Louvre. After all, he had dismantled them in 1817 and carefully stored them until this time. It needs to be stressed that they were not furnished ensembles.[1] In Paris too the antiquary Alexander Lenoir had formed his Musée des Monuments Français in the secularized convent of the Petits Augustins, where from 1793 he displayed royal tombs and architectural salvages rescued from the revolutionary mob. Although Lenoir's Musée has been described as the first museum of medieval art, it did not display 'period rooms' as such. It was dismantled in 1815, by which time it had inspired Alex de Sommerard in the installation of his collections of medieval art in his hôtel de Cluny.[2] In the matter of what we recognize as period rooms in museums, two semi-private collections in England stand out as precedents. Significantly, not only did the creators of both know each other, but the making of the two collections was concurrent.

The antiquarian architect–enthusiast Lewis Nockells Cottingham (1787–1847)[3] was skilled in Gothic Architecture and upon friendly terms with many in antiquarian circles. The preface to his *Plans . . . etc. of King Henry VII's Chapel* (1822–29) at Westminster states that 'Mr Cottingham gives lessons on civil architecture for which purpose he has made an extensive collection of models and casts from the best remains of Grecian and Gothic buildings'. The connections between Cottingham and Sir John Soane at his Museum in Lincoln's Inn Fields were close and fruitful. Both their collections were used for purposes of instruction. In 1814 Cottingham had established his practice nearby at 66 Great Queen Street, so it must be assumed that he was collecting salvages and exemplars from at least *c.* 1820. In 1828 he moved his collections to premises at no. 43 Waterloo Bridge

Road on the corner of Boyce Street. Unlike Soane's purpose-built museum, Cottingham's elevations gave no hint of the Gothic Aladdin's cave inside, except for a side entrance made from a salvaged Norman dog-tooth ornament. Cottingham's vision was to promote an archaeologically correct Gothic Revival. The links with Soane's museum are close, for both are resources for private study, professional practice and public attraction. We must bemoan the loss of his exhibit in 1832 at the Royal Academy of Arts, 'Part of Mr Cottingham's studio of English Antiquities', for no views of his antiquarian interiors now survive.[4] We lack contemporary comment from visitors, because although his museum had been viewed by 'several noblemen and many distinguished literary characters as well as by numerous professional friends', it was not regularly opened to the public. The report published in the *Civil Engineer and Architect's Journal* is more explicit about what was on display:

> Mr Cottingham the architect invited a numerous party to a conversazione at his Museum of English Antiquities, in Waterloo Road, on Thursday the 25th ult. [June 1840] We, certainly, were never so much surprised on passing through the numerous rooms, to witness such an immense collection of specimens (about 31,000 we understand) of domestic and ecclesiastical architecture, painting, sculpture and furniture. Every architect, artist, and lover of antiquities should not fail visiting this Museum – next month we intend to give a description of it.[5]

At Cottingham's death in 1847 his family and circle launched a campaign to persuade the government or the trustees of the British Museum to purchase the collection *en bloc* for the nation. This was unsuccessful, but fortunately as part of the campaign the auctioneers Christie & Manson produced a *Descriptive Memoir of the Museum of Medieval Architecture and Sculpture by the late Lewis N. Cottingham, Esq. F.S.A. 43 Waterloo Bridge Road, Lambeth*, and when a break-up by sale was inevitable, the antiquary Henry Shaw produced for the auctioneers Messrs Foster & Son the *Catalogue of the Museum of Medieval Art Collected by the Late L.N. Cottingham*, in 1850.[6]

The *Descriptive Memoir* and the *Catalogue* enable us to reconstruct a tour of the museum. The *Memoir* explains:

> This fine and extensive collection of ARCHITECTURAL EXAMPLES was made by the late Mr Cottingham during a practice of upwards of thirty-five years, for the purpose of professional study, and comprises original specimens, Models, Casts, Furniture, and Decorations, from the most perfect remains of each epoch and style, arranged in apartments of appropriate character, thus forming a complete practical illustration to the study of English Architecture, Ecclesiastical and Domestic, from the period of the Norman Invasion to the close of the reign of Queen Elizabeth

It continues, 'The Range of Apartments in which these works are deposited consists of an Elizabethan Parlor and Ante Room, two Galleries connected by an intermediate room: a Chapel with a series of Vaulted Chambers: and two Apartments chiefly

devoted to monumental sculpture. In addition, to which, are a number of Rooms and Ateliers, entirely filled with choice Details of every description and style.' It is reasonably clear that Cottingham never installed a period room as a complete entity, but made up composites to look like furnished rooms. The visitor was greeted upon entrance by a 'Bust of Shakespeare from the Monument at Stratford on Avon', on a plinth.[7] The ante-room contained an Elizabethan Caen stone chimneypiece, 'with Fire-dogs, once the property of Sir Thomas More', mullioned windows with the initials of Queen Elizabeth and a plaster (cast?) ceiling, a 'small rare' portrait of Queen Elizabeth, and 'a cancelle of German stone ware, with its metal lid having embossed on its front a bust and shield, with the date 1604. It was found in Shakespeare's garden . . . in the year 1818.' This was followed by the Elizabethan Parlour with an original ceiling from the Palace of Bishop Bonner at Lambeth, demolished in April 1836,[8] a sixteenth-century carved door dated 1652, 'a unique ebony table from the Palace of Nonsuch', and over the chimneypiece 'some rare old Nuremberg Carvings'. In addition there were 15 other ornamental lots, and busts of Queen Elizabeth, Mary Queen of Scots, Sir Walter Raleigh, William Camden, and Cecil, Lord Burleigh.

Throughout the museum, provenance was stressed: tapestry from Hunsdon House, Hertfordshire, or a chandelier from the 'Palace at Heidelburg'; two carvings from the church of St Sebald at Nuremberg. In the first gallery the carved oak ceiling was from the council chamber of Crosby Hall, bought by Cottingham at the sale of Charles Yarnold's museum[9] in 1825. Also here were a Flemish altar screen of 1490 and an 'exceedingly elaborate chimney piece . . . in great part the original one from the Star Chamber in Westminster Abbey'. Here, and in two other rooms, were three lots comprising 95 linenfold panels from Layer Marney, Essex, a Henry VI ceiling, stall seats from the church of St Gereon at Cologne, eight carved panels from the cathedral at Rouen, the complete fittings of a staircase (maybe leading to the sequence of basement rooms), stone windows from the almshouses of Queen Catherine in the Tower, along with more than 175 other lots as well as 20 lots of metalwork. Then there was a closet with a 'beautiful pendant Ceiling, temp, Henry VII', opening by an archway to the North Gallery and North Gallery ante-room which contained 146 lots of Gothic salvages: misericords, shields, corbels, canopies. Here were further stairs 'with perforated balustrading [and]newels surmounted by lions holding shields &c' and with three lots of woodwork leading down to the labyrinthine basement, the 'first portion fitted up as a Chapel' with altar, altarpiece and thirteenth-century stall seats, beyond which could be found 213 lots that included metalwork and 26 lots of composition 'models'.

Off a corridor with sixty-seven lots were four numbered vaults containing 200 lots which included twenty-five wooden bosses from the ceiling of the cloisters in Westminster Abbey. In a communication passage were 189 lots of salvages, leading to the 'Brocas Room',[10] with an ante-room on the west side with ninety-five lots, and a West Room containing eighty-three lots, including sixty-two pieces of carving from the demolished Westley church, Suffolk, and a pair of angels from St Mary's church, Bury St Edmunds. Also in the basement, the *Memoir* notes

113. Goodrich Court, Hereford-shire. The Library with the Breda Palace ceiling and panelling incorporating old woodwork

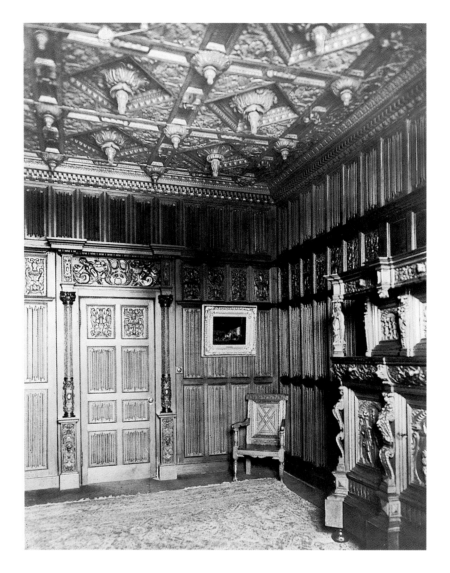

a beautiful open timber Roof of English oak, from an ancient Hall of temp. Edward III. This latter is in pieces, unframed, and as a genuine work, would admirably suit the requirements of any gentleman desirous of obtaining a Baronial Hall Roof for his Mansion: it is of moderate size and quite perfect, in a beautiful state of preservation; and having been taken down under the direction of Mr. N. J. Cottingham, he is enabled from sketches and admeasurements taken on the spot with exactness to restore the whole according to its original design.[11]

The impression of the museum is of a glorious *mélange* of salvages created for picturesque and antiquarian effect. Cottingham was the darling of the Wardour Street trade and of the auctioneers who were the scavengers of Britain and the rest of Europe. His house and museum was a depot for antiquarian salvage.[12] His interiors

were among the first, in Knox's words, to 'conjure up an entire historicist interior out of combined old and new work' right down to the 'ancient Elizabethan Fire Stove', the carpet 'planned to the two rooms' with matching hearthrug, and the 'rich ancient cut velvet hangings to the windows, with valence, tassels, &c complete'.[13] Even if Cottingham only installed composite rooms, he must be judged as one of the precursors of the public museum with period room décor.

By a serendipitous coincidence, 1828 was also the year Sir Samuel Rush Meyrick laid the foundation stone of Goodrich Court, Herefordshire, evoking a neo-medieval castle, built by Edward Blore between 1828 and 1831.[14] Barely half a mile away stood the great rose-red twelfth- and thirteenth-century castle that Meyrick dreamed of converting, but could not buy. From the first he saw his new castle as a public monument, as we can surmise from reading Charles Nash's *Goodrich Court Guide* of 1845. Although Meyrick imported no sets of panelling that might comprise a whole room, he presented a series of style rooms: a medieval entrance hall, the asiatic armoury, a sequence of rooms in the style of James I, Charles II and William III, and the breakfast room in a prescient Queen Anne Revival style with ceiling paintings imitating Verrio. Meyrick furnished these rooms accordingly, so the William III room contained a four-poster bed made up of Dutch seventeenth-century woodwork. Unlike Cottingham's museum, Goodrich was not principally a vehicle for salvages, and indeed the only significant salvages were 'folding doors from Louvain' and a ceiling (Fig. 113) from the state apartments at Breda, described as 'The oak ceiling . . . supposed to be the premier specimen of the kind in this country. It was removed here from the Breda Government House in Holland, and was by Italians expressly for the Spaniards at the time of Henry VIII'.[15] In fact, the ceiling would certainly have been of the period 1686–95, and by the sculptor Jan Claudius de Cock, and Meyrick must have bought it from the Wardour Street trade. There are further Breda salvages in Brooke Place, Chobham, Surrey.[16]

To what extent Meyrick's private house-museum of period ambiences was a known model for European museums is uncertain. As a celebrated international collector of arms and armour, Meyrick would have been a familiar figure in the circles of European collectors, and indeed he had been an adviser to Sir Walter Scott at Abbotsford. However, so rare is the *Goodrich Court Guide* that it can hardly be used as a measure of the castle's popularity, although both Goodrich castles must have been a magnet for those on the picturesque and popular Wye tour.[17] Nevertheless, what stands out is that in all essentials Meyrick at Goodrich created exactly what would characterize the 'style' rooms at the Bayerische Nationalmuseum in Munich, opened in 1867 and presented anew in 1902.

It is not easy to identify the specific influences on the growing fashion for period rooms in European museums. In the USA, perhaps too much emphasis has been placed on the innovations of Artur Hazelius in Sweden.[18] He had certainly exhibited ethnographical tableaux in Stockholm in 1873 and revised ones at the Paris World Exhibition of 1878. His Nordic Museum opened in 1888 and his open-air museum at Skansen – where traditional regional Swedish buildings were re-erected – was inaugurated in 1891. Skansen's achievement was to pioneer the world-wide

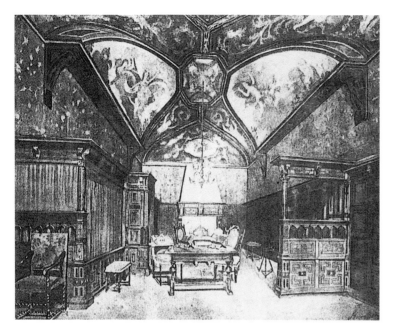

114. Rijksmuseum, Amsterdam. Room from Dordrecht installed by J.E. van Heemskerck van Beest in his house in 1869, and sold to Nederlandsch Museum (later Decorative Arts Department of the Rijksmuseum), 1877. Watercolour by J.A. van Staaten Jnr, 1894 (now missing from Utrecht's Archive)

phenomenon of regional folklore and folk art museums. It is more profitable to recognize that as early as 1876 the distinguished Dutch architect Pierre Cuypers, who would design the Rijksmuseum from 1877, installed a number of seventeenth-century period rooms combining old panelling and chimneypieces in the Historische Tentoonstelling van Amsterdam that included the presentation of a Renaissance *wunderkammer*.[19] In 1877 the painter J.E. van Heemskerck van Beest sold to the Nederlandsch Museum two panelled rooms[20] from Dordrecht that would later be installed in the new Rijksmuseum in 1885, one (Fig. 114) a *prinsenkamer*.[21] The year 1877 was also crucial because that summer in Leeuwarden the Frisian Historical Exhibition that opened in the Royal Palace included one of two Hindeloopen interiors.[22] This popular and much discussed exhibition was regarded as the first folkloric exhibition in the Netherlands, and this room and a second one were installed in Eysinga House, acquired in 1880.

Here in the Netherlands rather than in Hazelius's tableaux should be seen the initiation of the European, and later the American period room. The influence on the USA might be seen as crucial if more was known about an exhibition held in Boston in 1894 of Dutch painting and watercolours,[23] when apparently the painter J.A. van Straaten exhibited two watercolours of Dutch period rooms. In national museums, once the decorative and applied arts were seen as essential companions to galleries of painting and sculpture, the furnished period room, whether invented or imported, was one answer to the problem of display and presentation. All this was concurrent with the phenomenon of studies of ancient furniture. Viollet-le-duc's encyclopaedic *Dictionnaire du mobilier français*, began to appear in the 1850s; in the 1870s there was J. Hungerford Pollen's *Ancient and Modern Furniture and Woodwork*, and in 1892 Frederick Litchfield's *Illustrated History of Furniture*.[24]

Although both the Bayerisches Nationalmuseum and the Victoria and Albert Museum are regarded as early decorative and applied arts museums, neither was advanced in the presentation of sequences of period rooms. At South Kensington, after the museum's move from Marlborough House in 1857, period rooms were not

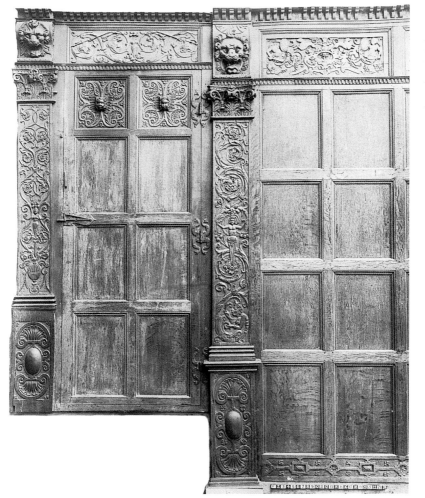

115. Panelling from an unidentified house near Exeter, Devon, acquired 1856. Victoria and Albert Museum

on the agenda, although individual salvages were being collected. It is tantalizing that there is no documentation to explain why in 1856 the museum purchased fifty-two feet of late Elizabethan ornamented and pilastered panelling from a house near Exeter (Fig. 115).[25] Although lacking a chimneypiece, it certainly could have served as a complete room or as a convincing backdrop for the display of furniture. As the move to South Kensington did not occur until the following year,[26] it was obviously intended for Marlborough House. It stands alone as an historical curiosity thirteen years before the museum acquired the celebrated *Boudoir* of Madame Mégret de Serilly (Fig. 116), removed from her *hôtel* in the Paris Marais by the dealer Récapé. Designed in 1778 by Rousseau de la Rottière, this exquisite masterpiece was acquired by the museum in 1869 for £2,100.[27] The claim that the Serilly *Boudoir* is the first 'period room' publicly and properly installed in any museum[28] must be disputed, even if the room came complete with chimneypiece, ceiling and floor. At first it was not displayed with an ensemble of furniture. Surely the definition of a 'period

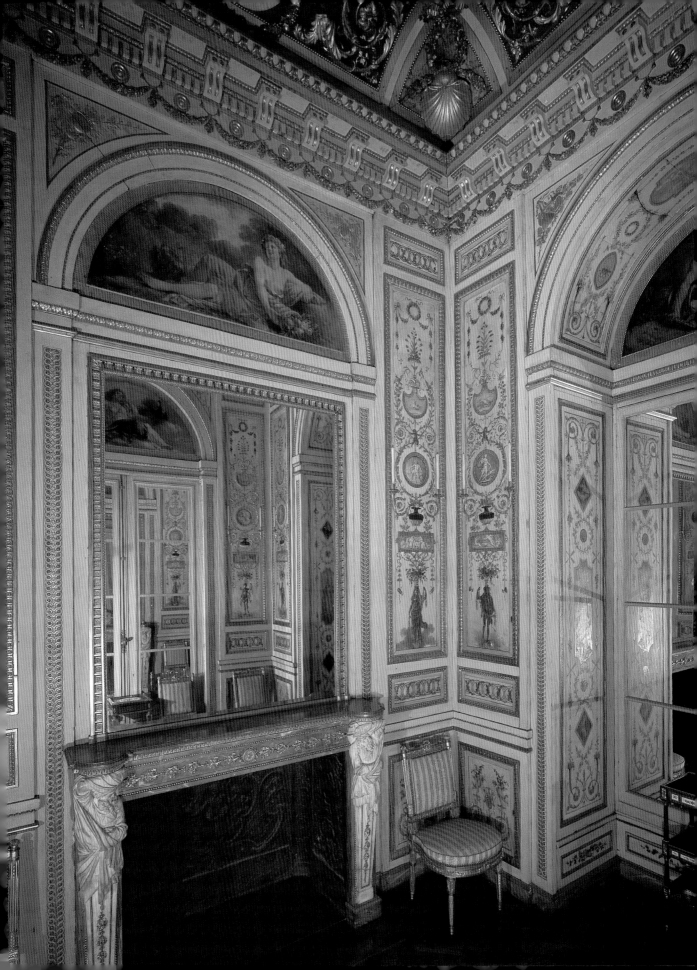

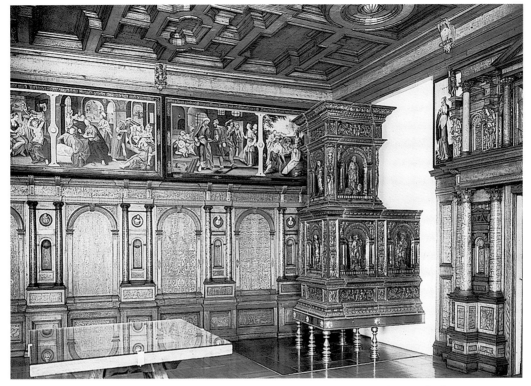

117. German National Museum, Nuremberg. The Bibra-Stube, Tyrol, installed 1887–88

room' must be that it is furnished. A sequence of unfurnished period rooms does not exist. Although the hôtel de Serilly had been internally stripped of its rooms, in 1894 the *Cabinet* was discovered hidden behind metal shelving, and in 1895 the Parisian decorator Jules Allard[29] installed it in The Breakers as the first complete French room to enter the USA, where it still exists. Of course, both *Boudoir* and *Cabinet* are small rooms, and therefore the ceilings were easily dismountable and transportable. Both are highly ornamented rooms, masterpieces of the craftsmen's skills, and the *Boudoir* was probably first intended to show 'beaux modèles d'un goût rigoureusement pur, indiquant à nos fabricants modernes quel idéal il fait atteindre à leur tour',[30] a comment later used to describe the policy of acquisition of salvages by the Musée des Arts Décoratifs. More to the point was the myth that the room was ordered by Marie Antoinette, and even painted by Natoire, thus giving it a desirable royal provenance. The *Boudoir* was not to form a sequence with other period rooms in the museum until after the acquisition of the Sizergh Castle Room in 1891,[31] that stands at the beginning of a programme of period room

116. The Mégret de Serilly Boudoir, acquired 1869, exhibited by 1874, Victoria and Albert Museum

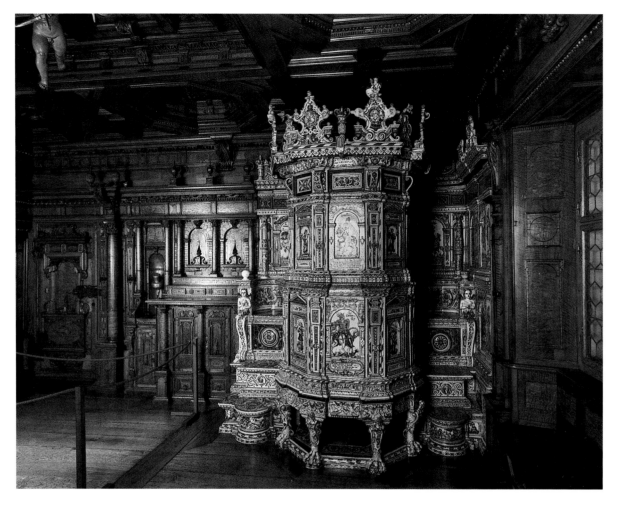

118. Swiss National Museum, Zurich. Room from the Alten Seidenhof, Zurich, 1602. Acquired by Zurich Kunstgewerbemuseum 1873, gifted to SNM 1896

acquisition. This demonstrates that the museum in South Kensington was not at first following the fashion for period rooms that was developing through the 1870s and 1880s in Switzerland, Germany and the Netherlands. For nearly twenty years the museum would be overshadowed in the presentation of period rooms by these continental museums.

Claims of primacy are fraught with problems, not least because many rooms were composites made up by the museums from miscellaneous salvages acquired at earlier dates. A typical example is an acquisition tag of 1862 in the Royal Museums for Art and History (Cinquantenaire Museum) in Brussels for their *Régence salon* from Liège. It could not have been offered whole in 1862, and is obviously a composite of later compilation.[32] In general the creation of sequences of period rooms in European museums was at first a Netherlandish, German and Swiss initiative, carried out with varying success. Founded in 1852, the German National Museum

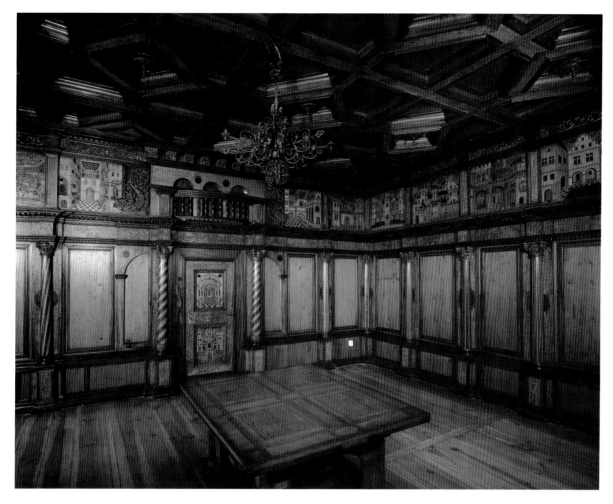

119. Schloss Kopenik, Berlin. *Prunkstube* from Schloss Hoellrich, inv. no. 1883.751

in Nuremberg might have acquired a period room even earlier than the V&A, for the intention was in the founder's mind that early, but difficulties in finding complete German Late Gothic or Early Renaissance rooms seemed insurmountable, and only in 1888 were two acquired from the Tyrol (Fig. 117). The intended programme was to show a series of complete authentic rooms with their furniture. However, 'authentic' could mean authenticity of style rather than authenticity of actual panelling and elements. Only later would Nuremberg show proper period rooms, when ten more from Germany, Austria and the Netherlands were added in time for the fiftieth anniversary of the museum in 1902.[33] More needs to be known about an unusually early acquisition in 1873 in Switzerland, when the Kunstgewerbemuseum in Zurich acquired the *Prunkzimmer* from the Alter Seidenhof in Zurich (see Fig. 118).[34] This saved a magnificent Swiss Renaissance interior, but was exceptional, and the museum did not acquire any further period rooms. It would later present

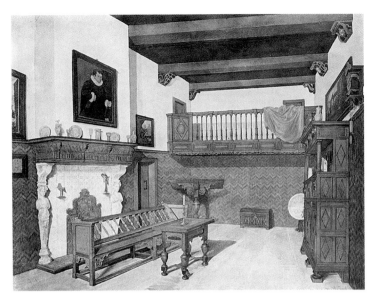

120. Centraal Museum, Utrecht. Renaissance room installed 1892. Watercolour by J.A. van Straaten Jnr, 1894

this room to the National Museum in Zurich. Switzerland was ahead in the installation of period rooms. In 1879 the Historical Museum in Basle acquired the panelling, ceiling and sideboard from the Haus zur Isenburg, Martingasse 18 (Fig. 112), a room of 1607, to which was added a door of 1593 from the Guildhall of the Building Trades Guild. However, this seems to have been an exception, for not until after 1891 were more rooms acquired,[35] such as the Grosser Spieshofzimmer, no doubt influenced by what was happening in Zurich at the Swiss National Museum. The next benchmark was in Berlin, when the Deutsche Kunstgewerbemuseum (in Schloss Köpenik, Berlin) founded in 1867 to display acquisitions from the Paris *exhibition universale*, discussed installing period rooms,[36] but it was not until 1883 that the museum acquired a *Prunkstube* (Fig. 119) of *c.* 1550 from Schloss Hoellrich near Gemünden, Lower Franconia, and in 1884 a *Prunkstube* of 1548 from Schloss Haldenstein.[37] In 1890 the director Julius Lessing installed with the advice of the Musée des Arts Décoratifs a French *Régence cabinet* of *c.* 1725 from the Hôtel Sillery, rue de Tournelles, Paris, which he furnished with contemporary French furniture.[38] Such a Parisian room was an exception in Germany, for in general the emphasis there was not on sophisticated interior architecture, but on farmers' and Burghers' rooms present to the everyday life of the working and farming classes that was in great danger of extinction.[39] The 'Heimatschutz-Bewegung' movement was discovering and recording the life of farmers.

Perhaps the most concentrated display in a German museum of such regional rooms was at the Altonaer Museum outside Hamburg, which had six farmer's rooms in 1901 and seventeen by 1914.[40] In contrast, the Museum für Kunst und Gewerbe in the city of Hamburg concentrated on acquiring more sophisticated rooms: in 1896 the early seventeenth-century Rendsburger Zimmer and in 1902 the Lüneburg Zimmer of *c.* 1575. Both compare unfavourably with the renaissance rooms in Zurich, and neither are properly furnished. In addition to a rococo hall from the Jenisch house of 1775, there followed a sequence of nineteenth-century rooms: the Nolting's house chamber of 1835–37; the Karl Sieveking country cabinet of 1830; a room painted by Ernst Speckter, 1834; the Martin Haller Mirror-Hall from the Budge Palais, 1909; and a Paris-Zimmer by Justus Brinckmann 1900,

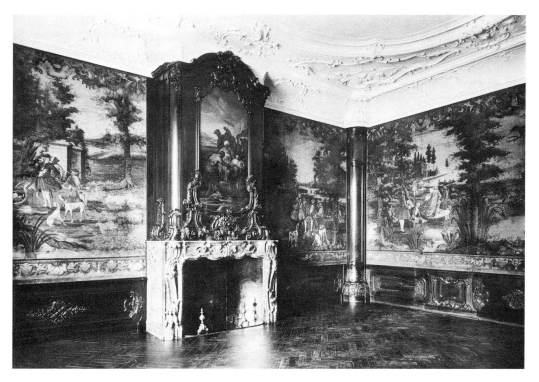

121. Stedelijk Museum, Amsterdam. Rococo room of 1748 from the Burgerziekenhuis on the Keizersgracht, Amsterdam, installed 1888

bought in the Paris *exhibition universale*.[41]

In Munich the Bayerische Nationalmuseum had opened on Maximilianstrasse in 1867 as the German equivalent of the Victoria and Albert. It was not conceived as a display of authentic period rooms, even if some original architectural salvages were incorporated. Not surprisingly, for the next thirty years it also collected miscellaneous salvages, as did the Victoria and Albert Museum and the Musée Carnavalet. The curators and director in Munich could hardly have been unaware of the National Exhibition of Arts and Crafts held at the Hague in 1888, where seven period rooms, mostly of the seventeenth century, and including a Renaissance Room,[42] were presented using some old elements and casts. In that same year the Stedelijk Museum in Utrecht (now the Centraal Museum) had five period rooms, including a more convincing Renaissance Room (Fig. 120)[43] than the Hague's and an entirely authentic, and rare for its time, neo-classic room of 1791 from a house in Utrecht installed in 1892.[44] The Munich curators would also have studied the Stedelijk Museum in Amsterdam when it opened in 1895; a wing would be added in 1900 to house the Lopez Suasso collection of decorative art. Here were now seven historical rooms (Fig. 121) possessing original ceilings and wall coverings taken from destroyed eighteenth-century houses on the Amsterdam canals. Sadly they have now been dismantled.[45] These and others were an obvious inspiration for the new Munich Bayerisches Nationalmuseum opened in 1902, as rebuilt by G.V.

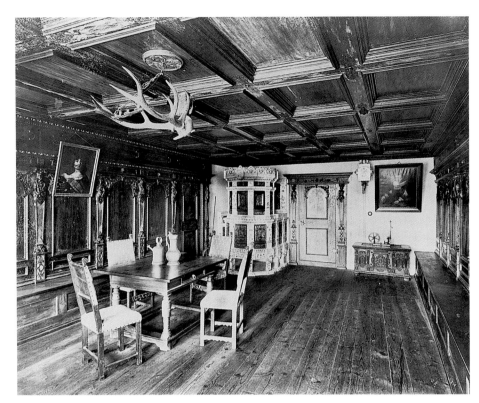

122. Historisches Museum, Bern. Room from the Kramgasse, Bern, installed 1897

123. Swiss National Museum, Zurich. Room from the Rosenburg house in Stans, Switzerland, 1602, acquired 1894

FACING PAGE
124. Swiss National Museum, Zurich. Room from Casa Pestalozzi in Chiavenna, Italy, 1585, acquired 1896

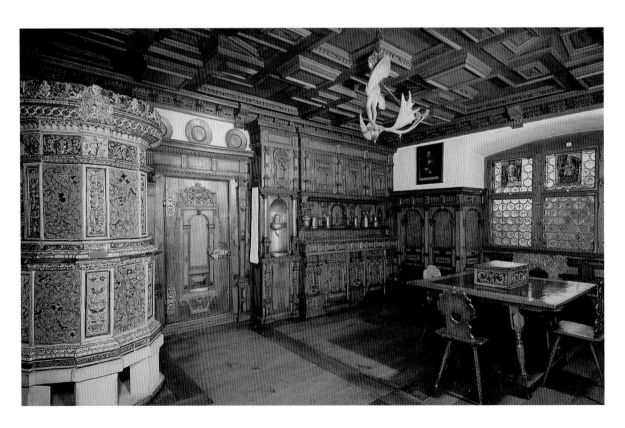

von Seidl, and presenting modern interiors modelled on Bavarian national styles, typified by the Karl Albert Munich Rococo Room. Only occasionally did they incorporate salvages, that included a ceiling from Augsburg Town Hall in the Gothic Room, a ceiling from Dachau in the Dachau Room and a Late Gothic ceiling and door from Schloss Oberhaus in Passau. All are illustrated in von Seidl's lavish monograph,[46] now a precious memorial, for these 'style' rooms have also been dismantled and the original salvages returned to their sources.

The initiative passed again to Switzerland. The Historisches Museum, in Berne was accessioning period rooms such as the room from the Kramgasse, Berne (Fig. 122) between 1897 and 1905,[47] and they overlapped with the gift in 1896 from the Zurich Kunstgewerbemuseum of its Alter Siederhof Room to the new Schweizerische Landesmuseum,[48] later the Swiss National Museum, founded in 1893 and opened to much European acclaim in 1898. It would become the Swiss national repository of period rooms[49] on a scale matched only by the Victoria and Albert Museum. The museum would eventually present fifteen complete rooms, although there were in addition more than forty displays of individual salvages.[50] The rooms include the 'Rosenburg' room (1566) from Stans, Nidwalden, in 1887 (Fig. 123); the Ratsstube (1467) from Mellingen in 1888; the Winkelriedhaus room (1600), also from Stans; the hall (1660) from the 'Lochmann-House', Zurich in 1890; three rooms (1489 and 1507) from the Frauenmünsterabtei, Zurich in 1892; a Winterstube from Schloss Wiggen (1582) near Rorschach, St Gallen in 1893; the Kleines Zimmer from the convent of St John the Baptist in Munster (1630) in 1894;

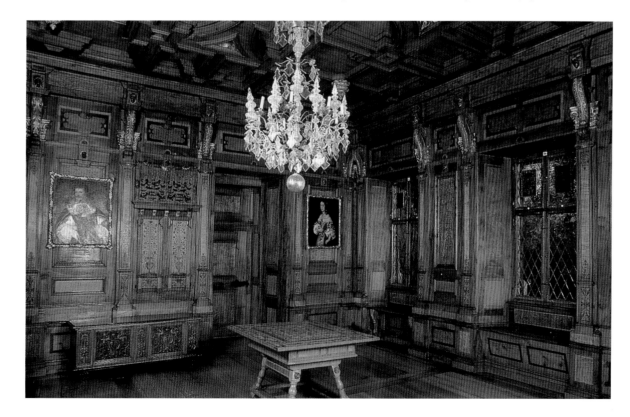

125. Musée Carnavalet, Paris. *Boiseries* from Ledoux's Café Militaire, Paris, 1762. Ex Carlhian

a hall (1585) from the Casa della Pestalozzi, Chiavenna, Italy, in 1894 (Fig. 124); a room (1587) from the Casa Pellanda in Biasca, Tessin, in 1896; and various other rooms including one from the convent of Ötenbach (1521), Zurich; a small room from the Bas-Valais; a room from Schloss Arbon (1515); and a rococo room from Freiburg. In addition the museum acquired many salvages, typically the pair of doors from Schloss Vufflens in 1894.[51] In their entirety the collection of rooms is precious evidence of Swiss interior architecture, the like of which cannot be studied in any other single space in the country.[52]

In France the Musée Carnavalet should have been early in installing sequences of period rooms, but it was not. The preciousness of panelling was recognized, but initially acquisition concentrated on the need for historical wall coverings, rather than containers for stylistically presented ensembles of the decorative arts. Founded in 1868, the Carnavalet would soon amass, install and even inhabit many architectural stone salvages, but was slow to install complete rooms. It is possible that because Paris was so rich in existing décors, there was felt to be no great need to install rooms, which, as museums have discovered, are expensive and, more recently, difficult and disputatious to furnish properly. In any case the Carnavalet was not then a

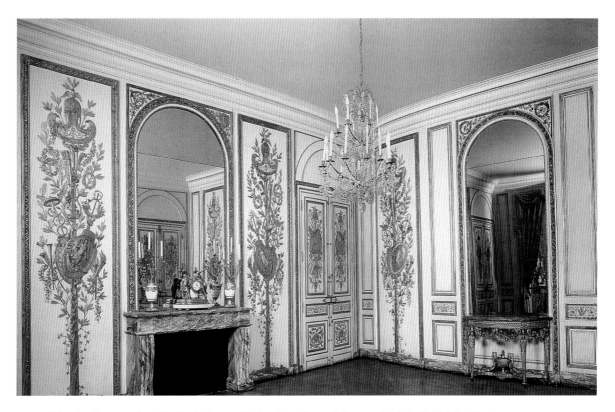

126. Musée Carnavalet, Paris. Saloon. *Boiseries* of 1768 from the hôtel d'Uzès, Paris, dismantled *c.* 1868, moved to hôtel Delessert, dismantled by Carlhian, re-installed in the museum 1969

decorative arts museum intent on displaying ensembles in period rooms. In 1868, it bought from the dealer Alphonse Monbro panelling of *c.* 1728–32 taken out of the hôtel de Richelieu, 21 Place Royale (place des Vosges). In 1878 came Richelieu's *Grand Cabinet* from the hôtel de La Rivière, a major ensemble of 1653 by Louis Le Vau, Charles Le Brun and Gerard van Opstal, removed from the *hôtel* in 1867. This early act of preservation was probably due to the intervention of the architect Victor Baltard, because the *hôtel* was used as a *mairie*. It was an early response in the history of Parisian urban and suburban demolitions, and it led to the founding in 1884 of the Société des Amis des Monuments Parisiens; in any case the museum was seen as a collection of diverse fragments of the most beautiful *boiseries* and wooden carved salvages. The policy was to save and preserve, but at the same time to provide wall covering. As Pons writes, the two Ledoux 'rooms' – Café Militaire (Fig. 125) and the *salon de compagnie* from the hôtel d'Uzès (Fig. 126) – were 'merely the architectural re-assembly of an historic room designed by one of the great names of architecture'.[53] Only recently has the Carnavalet surprisingly adopted a populist policy by its installation of a sequence of sixty rooms and décors[54] that include J.M. Sert's *Salle de Bal* from the hôtel de Wendel in the avenue de New York, Paris, of

127. Musée des Arts Décoratifs, Paris. Salle 38. *Boiseries* from hôtel Le Bas Montargis, place Vendôme, 1707. Gift of 1899, installed 1904

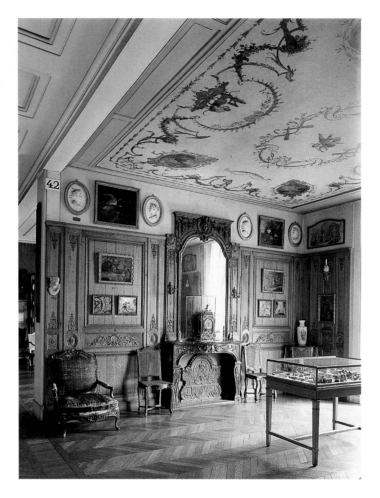

1924. This would seem to be going in the face of popular trends.

The Musée des Arts Décoratifs was different. Officially it did not exist as such until 1882.[55] From 1864 its embryonic collections had been housed in a *hôtel* in the place des Vosges and, to abstract Pons,[56] in a *hôtel* full of original panelling there was no incentive to install more sets of panelling. Indeed, the rooms in the Musée des Arts Décoratifs, after their installation in 1904 in the Pavillon Marsan, rue de Rivoli,[57] evoked to a peculiar degree the wondrous ambience of Georges Hoentschel's own private museum formed in his *hôtel* and galleries on the boulevard Flandrin (Fig. 153).[58] As Pons discovered when studying the physical composition of the rooms in the museum, they were a palimpsest of fragments of *boiseries*, and were knitted even further when dismantled and reinstalled for whatever reason. As salle 38 (Fig. 127), one among so many rooms now tragically dismantled, demonstrates, the installations were done with the greatest taste. This particular room was first presented in 1904. Its *boiseries* of carved oak came from the hôtel Le Bas de Montargis built in the place Vendôme in 1707, and were given to the museum by the Ministry of Finance in 1899. The white marble oval medallions of

the Four Seasons by Jean Naurissart above the *boiseries* were donated in October 1908,[59] and the armchair by Louis Cresson to the left of the fireplace was donated in March 1937.[60] So many historians and decorators flocked to these rooms. The manner and style of the presentations with framed drawings and small paintings in period-style frames, combined with displays of porcelains, and stylistically appropriate smaller objects such as terracottas, exerted an enormous influence on and were a constant joy to decorators and lovers of the applied and decorative arts for more than half a century, whether the Carlhian family, John Fowler and David Mlinaric, or Mrs Jayne Wrightsman. They are a great loss and their dismantling will be seen by future generations as a tragedy.

In general the period room in Europe presented national styles, even if a French room might intrude in a German or Dutch museum, or as in the Museum für Kunsthandwerk in Leipzig, there might have been seen a sixteenth-century room from Flims in

128. Victoria and Albert Museum, London. Columnar screen from Fife House, London, acquired 1869

Switzerland and a 1760s room from a house in Haarlem.[61] The Badisches Landesmuseum in Karlsruhe had panelling from the Redings House, Schwyz, in Switzerland and other Swiss rooms. But in general the internationalism of the Victoria and Albert Museum was exceptional, as was that of the Metropolitan Museum in New York and other North American museums.

Obviously, when in 1910 Henry W. Kent suggested that the Metropolitan Museum of Art 'furnish in the manner of the German museums' he was aware of developments in the Netherlands; but he also knew of Germany and Switzerland, and of the first phase of period room installation at the Victoria and Albert.[62] As a decorative arts museum the V&A had acquired throughout the nineteenth century a vast collection of salvages of all sorts, today nearly all in storage. An early acquisition in 1869 (Fig. 128) was a columnar screen from Fife House, Whitehall.[63] Early sixteenth-century plaster panels from Lincoln's Inn came in 1886,[64] a Cremonese ceiling in 1889, and in 1904 a ceiling from 15 Hanover Square[65] now identified as from the house built for Jervoise Clarke by Charles Cameron in in 1770–74, before he went to Russia. However, despite the De Serilly purchase in 1867, there was no

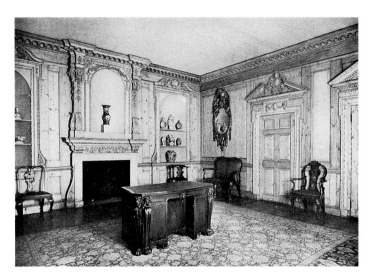

129. Victoria and Albert Museum, London. Hatton Garden Room acquired 1912

follow-up of complete rooms. It was only when Walter Charles Strickland threatened to sell his Sizergh Castle Room[66] in 1891 that its eventual purchase initiated a programme of room acquisition. The threat is said to have involved Gillows of Lancaster and potential export to the USA.[67] The story may be apocryphal, for this would have been an unusually early export, indeed the first after the Lawrence Room in 1876. Whatever the motivation, the cost of £1,000 represented the starting post for a chronological sequence of English period rooms. There are few policy declarations in the museum's archives except for a comment by 'W.R.' on 29 June 1911,[68] criticizing the mode of purchase of the Hatton Garden room when negotiations were in train: 'With our excellent expert staff we ought to be in as good a position to buy direct as any firm of dealers. If our staff gets into the habit of always depending on *dealers*, we should have to regard the era of economical purchase as having been closed.' Someone this early was wary that in matters of room acquisition in general the 'dealer would rule'.

The acquisition of the V&A's rooms falls into roughly three groups: from 1894 to 1912, from 1924 to 1938, and from 1953 to 1981, the intervals being represented roughly by the First and Second World Wars. Throughout these periods there was continuous acquisition of salvages, notably the grandiose 31 Mark Lane doorway of *c.* 1680[69] as early as 1884. The first group of rooms should perhaps properly begin with the façade of Sir Paul Pindar's house and a ceiling acquired at demolition in 1890.[70] The Elizabethan and Jacobean rooms that followed were the Jacobean Bromley-by-Bow, London, 1894 (Fig. 130),[71] and panelling from the early sixteenth-century Tudor Waltham Abbey, Essex in 1899.[72] A decision by the Trustees and Members of the Society of Lincoln's Inn in 1903 provided the V&A with the opportunity to acquire the Cliffords Inn room, a late seventeenth-century room,[73] and it was unusual at this time to have an auction catalogue devoted to one room: *Particulars of the Extremely Valuable 17ᵗʰ Century Woodwork & Carving Ascribed to Grinling Gibbons. Now Fitted in a Room of No. 3 Cliffords Inn the sale held by Farebrother, Ellis, Egerton Breach & Co., London, 23 July 1903.*[74] There followed two Georgian rooms: the mid-Georgian 5 Great George Street, London in 1910,[75] and 26 Hatton Garden, London in 1912 (Fig. 129):[76] both stripped of their paint, a significant point in matters of the presentation of décors. This group also included two unsatisfactory late seventeenth-century French

Victoria and
Albert Museum,
London

130. Bromley by
Bow Room
acquired 1894,
re-installed 2001

131. Norfolk
House Room
acquired 1938,
re-installed 2001

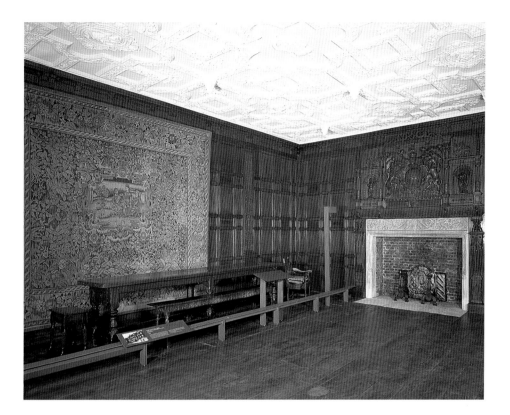

132. Victoria and Albert Museum, London. Room from 11 Henrietta Place acquired 1960, re-installed 2001

painted rooms, one from the Château de la Tournerie, Alençon in 1903,[77] and Swiss panelling and ceiling from the Casa Mattei, Osogna, Ticino in 1907.[78] After the hiatus of the First World War the second group continued filling in stylistic gaps: a rococo room from Berkeley House, Wotton-under-Edge, Gloucestershire, 1924;[79] a neo-classic (1774) hall alcove by James Wyatt from Foley House, Portland Place, London, 1928;[80] the English Jacobean Haynes Grange, Bedfordshire, 1929,[81] bought because of its assumed Elizabethan classicism; the painted alcove from Drakelow in Derbyshire, 1934;[82] then the first Robert Adam acquisition, the ceiling from David Garrick's 5 Adelphi Terrace, London, 1936;[83] and the Music Room from Norfolk House, St James's Square, London (Fig. 131) in 1938.[84]

After the Second World War a third group was acquired, beginning in 1952 with the Italian Renaissance Torrecchiara Coretto from Brasi near Parma, a confessional, or a room within a room,[85] and continuing with representation of Georgian decoration, the Gothick Lee Priory, Kent library in 1953;[86] Robert Adam's Northumberland House, London, Glass Drawing Room, 1955;[87] James Gibbs's 11 Henrietta Place, London, 1960 (Fig. 132);[88] and Robert Adam's library from Croome Court, Worcestershire,[89] 1975. All were casualties of country house or urban post-war demolitions. Attempts were made to fill the woeful gap in Victorian

interiors with the room from the Grove, Harborne, Birmingham, 1964,[90] and art deco with the foyer from Oliver P. Bernard's 1930 Strand Palace, London, in 1969.[91] International design was enriched by the gift in 1974 of Frank Lloyd Wright's Kaufmann office from the Kaufmann Department Store in Pittsburgh,[92] and in 1977 the Welles Coates flat from Yeoman's Row, London.[93] In 1981 a German gentlemen's study of 1911 was acquired at a time[94] when traditional period room displays were already under scrutiny and

133. The Bowes Museum, Barnard Castle, County Durham. Reredos from the Temple Church, London, from 1934 guidebook

when American museums were fast de-accessioning their rooms. The V&A had completed their major re-installation of the British Galleries by 2004,[95] introducing new didactic methods of display.

In Britain the making of sequences of period rooms in other museums is uncommon. The Geoffrey Museum, London, has several interiors as containers for presenting the social history of the more bourgeois or commercial City of London classes. These include panelling from Albyns, Essex, probably as supplied by Keeble & Co., a staircase from Lower Clapton Road, a Stuart Room from the Pewterers' Company Hall, and an Early Georgian room from 46 Chancery Lane. Essentially though the sequences are more wall covering than a stringently selected stylistic sequence. The Museum of London before relocation at London Wall had relied upon pre-existing accommodation. It now incorporates the Poyle Park, Surrey, Room, a curiosity in an extreme 'artisan mannerist' style, presumably to represent a City interior of the 1650s, and some panelling from Garret Lane, Wandsworth, in the Early Stuart galleries.[96] St Fagan's Museum of Welsh Life falls into the category of Skansen with unsophisticated Welsh interiors. Despite a half-hearted attempt by the Birmingham City Museum and Art Gallery to display continental period rooms presented to them by the Victoria and Albert Museum in 1935, and Exeter Museum's acquisition of salvages from Exeter, de-accessioned from the USA, the collection of distinguished English salvages at the Bowes Museum is a notable exception, the museum's policy being to acquire a variety of high quality salvages representative of regional styles.

On 16 August 1840 A.W. Kinglake wrote to his friend John Bowes of Streatlam Castle, Durham, that the benchers of the Temple were intent on selling Christopher

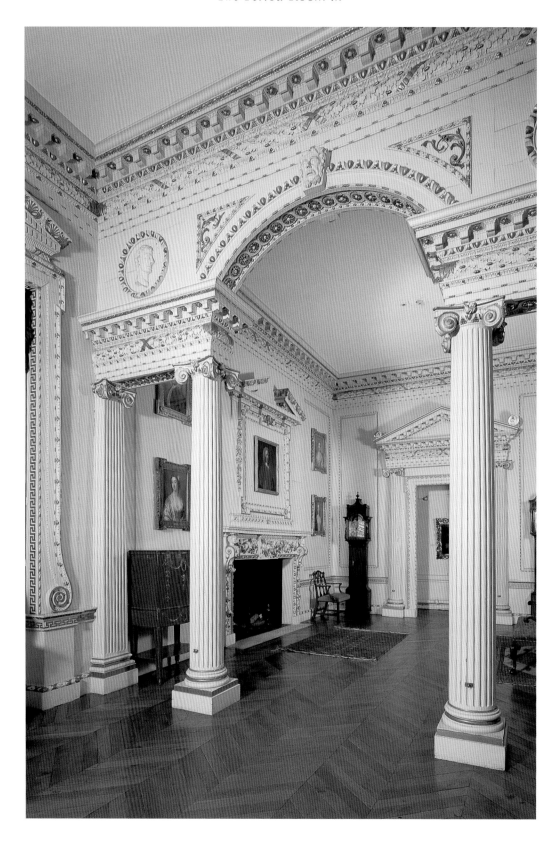

Wren's altar reredos (Fig. 133) and organ loft screen from the Temple church, 'the benchers being of the opinion that the works of the Tudor epoch do not harmonise with the times of Ivanhoe . . . when it is done I suppose it will look as pretty as George 4th in his later days when he adorned himself with youthful hair and calves'.[97] Of course, Bowes intended this for Streatlam Castle, which was then undergoing internal renovations, at a time when a future museum was in his mind only. Such an acquisition may have been antiquarian in intent, as Bowes probably imagined his house to have been of the Wren epoch,[98] if not by Wren himself. In the event, the Temple salvages were put into store, and only the reredos was displayed when Bowes opened his new château designed by Jules Pellechet in 1869 as a house-museum. In many ways the Bowes Museum collection of woodwork is a telling representation of the vicissitudes and movement of salvages, although there seems never to have been a set policy for the making of a sequence of period ambiences. Instead, the salvaged woodwork serves both as a background for display, and as representative of the history of interior decoration principally in the regional north-east.

An early and exceptional acquisition was the heraldic panelled ceiling by Heaton, Butler and Bayne of London installed in the dining room at Streatlam Castle in 1879, and acquired for the museum because of family associations in 1927 when the castle was gutted prior to demolition. This was when Robersons of Knightsbridge were removing rooms from the castle for export to the USA. The Bowes received a financial boost in 1952 when the reredos was sold back to the Temple, so in that year there followed the purchase of a panelled room of the 1670s originally from West Auckland Manor, Co. Durham, which had been removed in 1829 to the Eden family's Windlestone Hall, also Co. Durham, where it remained until sold by Windlestone Hall School. There followed the chimneypiece of 1618 from Dacre Hall, Lanercost Priory, Cumbria, which had been moved to Levington Hall, Cumbria. Schools were then keen to profit from the dismantling of their historic interiors, so when Gilling Castle became a school in 1930, the behaviour of the trustees was horrifyingly disreputable. Not only did they gut the Long Gallery, tearing down its ceiling, but they also disposed of the famous Gilling High Chamber to William Randolph Hearst.[99] The Long Gallery panelling was put into store, where it remained until bought by the Bowes in 1960 and set up (Fig. 134) with an early eighteenth-century chimneypiece acquired in 1963, originally from the Old Mansion House, Newcastle.[100] To complement the decorative richness of the Gilling Gallery, in 1968 the museum installed sections of French style rococo panelling (Fig. 135) from the ante-room at Chesterfield House, Mayfair, demolished in 1934. This panelling had been installed in Whitburn Hall, Sunderland,[101] and was presented to the museum by Sir William Nicholson. In 1972 the museum acquired the Warter Priory room. This late sixteenth- or early seventeenth-century wood-

134. The Bowes Museum, Barnard Castle, County Durham. Compartment from the Long Gallery of Gilling Castle, Yorkshire, 1748. Bought by Randolph Hearst, but never exported. Acquired 1960

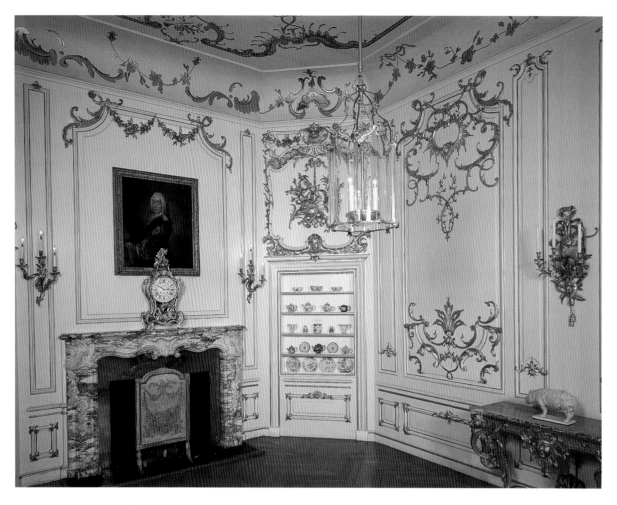

135. The Bowes Museum, Barnard Castle, County Durham. Elements from the Anteroom of Chesterfield House, London, installed in Whitburn Hall, Durham, after 1937, gifted 1968

work came to Warter in 1909 from a house in nearby Beverley, Yorkshire, and was installed with a Jacobethan ceiling by the Beverley 'Art Furnishers' F.E. Elwell assisted by the London decorators Morant & Co. Other miscellaneous salvages in the Bowes include a set of twelve door panels from Burwood House, Cobham, Surrey, painted with arabesques in the style of Marie Antoinette's *Boudoir* in the Palace of Fontainebleau; woodwork from a late seventeenth-century staircase, and a large overmantel from Horden Hall, Durham, that had been removed in 1912 to Castle Eden, Durham; and fifteenth-century roof trusses from Colonel John Bolton's antiquarian collection at The Hall, Bolton-by-Bowland, Lancashire, demolished in 1960. This initiative to use regional salvages for period ambiences sets the Bowes apart from any other museum.

In Dublin there was an attempt to display salvages in the National Museum of

Science and Art. The museum's *Bulletin* for 1911 contains a description of three 'Mantel-Pieces':[102] an Elizabethan one with arms of the Clowes family from Rokeby House, Stratford-at-Bow, London, exhibited with its panelling but with a ceiling copied from one in the 'Old Palace' Bromley-by-Bow; a second one from Cahir Castle, Co. Tipperary, dated 1602; and the third dated 1635 from Old Bawn House, Tallaght, Co. Dublin, combined with later panelling from the same house, from which a 'fine old Jacobean' staircase was taken.[103] The *Bulletin* of 1913 describes the 'Apollo Room', dated 1746, as the back drawing room of 'Tracton House', 40 St. Stephen's Green, Dublin,[104] perhaps designed by Arthur Jones Neville, Surveyor and Director-General of Fortifications. When the house was demolished by the Bank of Ireland in 1912, the room was 're-erected in the Annex of the Museum exactly as it stood in St. Stephen's Green', except for the provision of a Palladian overmantel taken out of Powerscourt House, Co. Dublin.

In Europe as in the USA, period rooms are under scrutiny and subject to change. The British Galleries at the Victoria and Albert Museum have led with a new type of didactic presentation of all aspects of design that might be associated with historic interiors. This could only be achieved by a museum possessing all-embracing collections. Few do. To walk through the great interiors in the Swiss National Museum in Zurich is a saddening experience. They are in desuetude. The sequence of rooms in the Musée des Arts Décoratifs that for nearly a century served as admired models for generations of interior designers are no more. The printed image is easily accessible.

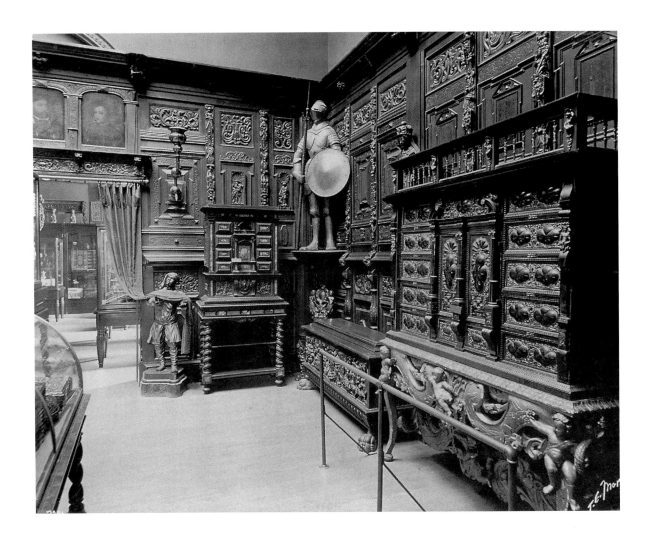

136. The Lawrence Room, an early installation. Accession 1876, de-accessioned 1930

NORTH AMERICAN MUSEUMS AND THE ENGLISH ROOM

THE TRANSATLANTIC TRADE IN ENGLISH[1] rooms obviously cannot be treated in isolation from exports of continental rooms to the USA, and in any case the installation of these European rooms in North American museums cannot itself be dissociated from the spread throughout those very museums, in particular on the American eastern seaboard, of sequences of native American, Colonial, Federal and later rooms. In the history of the period room in North American museums the Lawrence Room in the Museum of Fine Arts, Boston (Figs 136–37) is a one-off, unique and iconic, and was originally an isolated private acquisition in 1876. Although it led to no sequence of installed rooms in the museum, it may well be associated with an exhibition in Boston in that same year, as recorded in the *Catalogue of the Loan Collection of Revolutionary Relics Exhibited at the Old South Church*, in November 1876,[2] whose popularity is measured by the existence of at least three editions of the catalogue. It included loans from Ben:[3] Perley Poore from Indian Hill near Newburyport, notably exhibit 305, an 'Essex County Yeoman's Sitting-Room, from the "Indian Hill Farm" Collection', and exhibit 306, a 'Yeoman's Kitchen', with the same provenance, as was a 'Fire-place from the Old Tracy House, in Newburyport'. Ben: Perley Poore may well have been aware of Hazelius's revised tableau exhibited at the Paris World Exhibition of 1872, although maybe too much has been made of the influence of Hazelius.

The mention of the 'Indian Hill Farm' collection foreshadows later ethnographic collecting. There is a significant parallel to this exhibition in Amsterdam, when at the *Historiche Tentoonstelling van Amsterdam* in 1876 the famous architect Pierre Cuypers installed several seventeenth-century period rooms using old panelling and chimneypieces. Of course, 1876 was also the year of the Philadelphia Centennial Exhibition[4] where there were convincing displays of antique furniture in manufactured period ambiences.[5] Clearly Perley Poore needs re-evaluation in relation to the Boston exhibition, for the first true museum sequence of rooms in the USA is much later, in 1907 when George Francis Dow, secretary of the Essex Institute at Salem, Massachusetts, created three alcoves, rather like frontal picture boxes, partly made

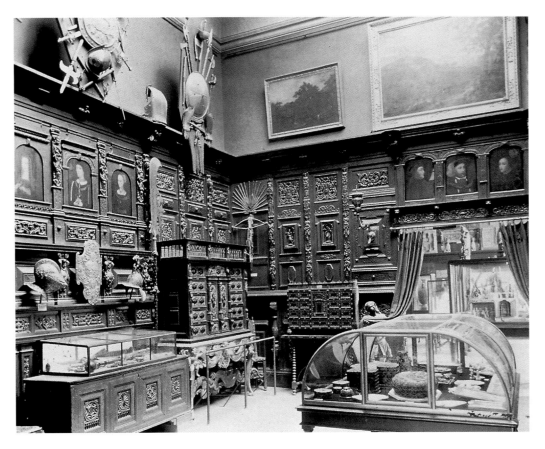

137. Another view of the Lawrence Room

up from authentic wooden salvages, a parlour, bedroom and kitchen giving 'the illusion of daily occupancy'.[6] It should be observed that these were by no means sophisticated compilations. They could be seen as having been based on, or having knowledge of, Charles Wilcomb's colonial kitchens, in particular one exhibited in the Golden Gate Park Memorial Museum in 1896.[7] They should be read with Wilcomb's Colonial Kitchen and Bedroom installed in the Oakland Public Museum in 1910.[8] What is certain is that Dow was aware of period room installations in Europe, and perhaps notably in Holland. A catalyst in this Colonial Revival was the Hudson–Fulton Exposition held at the Metropolitan Museum of Art in 1909, which legitimized the collecting of Americana and the American decorative arts.[9] The displays included some pine panelling and a fireplace, cupboard and door of a Connecticut room from Newington. The illustration of this with its arrangement of furniture was obviously influential.[10] As Henry Watson Kent, secretary to the museum, had written in 1909 to Robert W. de Forest, the museum's president, apropos the exhibition and its consequences, 'might it not be thought desirable to furnish in the manner of the German museums three or four rooms, in use in this country dur-

ing the period of our colonies?'[11] This is commented upon by William H. Valentiner, who joined the staff in 1909 and played a role in introducing 'the idea of period rooms, which I had learned from Bode'.[12] Valentiner would have been a direct channel of communication between developments in the making of period rooms in Europe and emerging policy in New York. Decisions and policy were forwarded by the Committee on American Decorative Art chaired by R. T. Haines Halsey, a trustee of the museum, which oversaw the museum's acquisition in 1910 of its first Colonial woodwork, from the Hewlett House in Woodbury, Long Island.

The American Colonial style was now under reassessment and scrutiny. This would result in the acquisition of no fewer than eleven more American rooms or parts of rooms, eventually to form the American Wing, a building planned in 1922, donated by Mr and Mrs de Forest and opened in 1924.[13] This wing would exert enormous influence, for with the Brooklyn Museum of Art it staged the first presentations in the USA of a systematic collection of American period rooms; the Metropolitan later installed twenty more. In 1915 Brooklyn acquired its first panelling from a house at Danbury, Connecticut.[14] By 1929 nineteen more rooms had been opened to the public, and by 1983 as many as twenty-eight were on show. In contrast to the importation of European rooms, where 'the dealer ruled', Brooklyn strove to document and photograph its proposed rooms while they were still *in situ*, permitting a level of accuracy in installation not granted to other museums and subjecting the museum to severe criticism by the American Institute of Architects, who passed a motion in 1932 that museums should 'abstain from the devastating practice of purchasing or installing interiors or other portions of early American buildings except those whose demolition is inevitable'.[15] The American Wing of Maryland Period Rooms at the Baltimore Museum of Art might be selected as typical of very many East Coast museum presentations, beginning with the acquisition of the Eltonhead Manor Room in 1925 and ending with the entrance hall and double parlours of Weston in Dorchester County in 1968.[16]

The craze for the import of European rooms was a small part of the broader world cultural representation in the arts and architecture that American museums saw as their ideal. By 1895 Stanford White, architect, dealer, collector and decorator, was already scavenging through Europe for salvages, whether 50 yards of linenfold panelling, a Spanish medieval cloister, a Venetian ceiling or a Renaissance wellhead. This activity needs to be considered in relation to the general European situation in the second half of the nineteenth century, particularly in France, Italy and Spain, where there was almost a free-for-all in the removal of ecclesiastical and secular salvages. Cloisters, altars, gateways, fountains, capitals, windows, effigies, were all up for grabs. When that other celebrated scavenger, the sculptor George Grey Barnard (1863–1938), who doubled up as a successful dealer in medieval architectural salvages and sculptures, opened his Barnard Cloisters as America's 'First Gothic Museum' in 1914,[17] his activities were prescient of the great flood of architectural salvages that would be transhipped to the USA. This was the background to the making of period rooms in North American museums and to the role that European and New York based dealers would play.

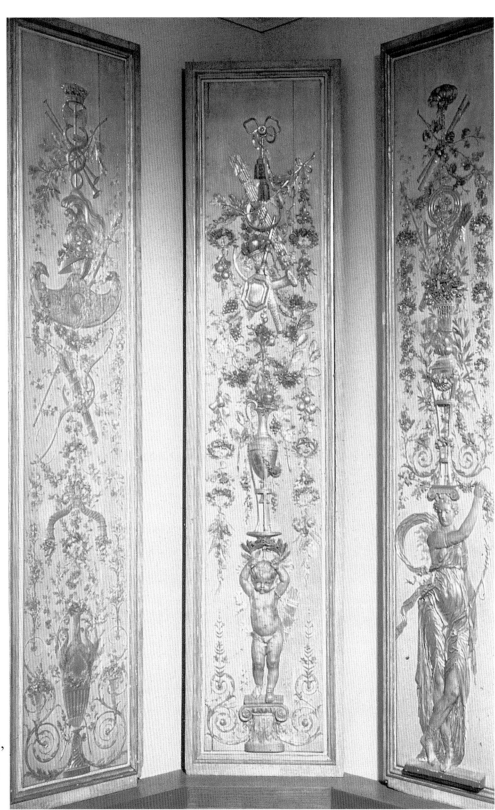

138. Three of
the eight
boiseries from
Ledoux's hôtel
Montmorency,
Paris, *c.* 1773.
Installed in the
Deacon House,
Boston, *c.* 1848,
sold 1871.
Accession 1879

ENGLISH ROOMS IN NORTH AMERICAN MUSEUMS

Museums are discussed according to the date of acquisition
of the first English room

THE MUSEUM OF FINE ARTS, BOSTON

The Museum of Fine Arts, Boston, qualifies for primacy in the presentation of the decorative arts in the USA for its acquisition, in partnership with the Boston Athenaeum, of the eight wondrous Montmorency *boiseries* (Fig. 138). Shortly after the E.P. Deacon house sale in Boston in 1871,[18] the Athenaeum acquired the eight wall panels that comprised what Deacon called his 'Montmorenci Salon', bought in Paris in 1848 from the demolition of C.N. Ledoux's hôtel de Montmorency. Because the Deacon House was apparently shut up from at least 1861,[19] when Deacon's widow came to England, if not from 1851 when Deacon suddenly died, exactly how these panels were displayed in the making of his 'Salon', may never be known. What is certain is that Deacon, encouraged by his father-in-law Peter Parker, was among the first of that much later nineteenth-century breed of American collectors of French works of art.[20] No other import of French *boiseries* would occur in the USA until Jules Allard brought Madame de Serilly's *Salon du Premier Étage* to The Breakers, Newport, *c.* 1894 as a complete room.[21] The Montmorency panels were exhibited as decorative elements in the new art gallery that opened in the Athenaeum in Copley Square in July 1876, and were moved in 1909, when the first Museum of Fine Arts opened on Huntington Avenue,[22] where they were associated with the 1876 Lawrence Room. The influence of the Victoria and Albert Museum was considerable. It was the hope of trustee Charles C. Perkins that Boston would rival 'the great industrial museums at Kensington and Vienna'.[23] Both acquisitions were unrelated to period room installation elsewhere in the USA, although naturally as a room the Lawrence Room would take precedence over all others.

The history of the Lawrence Room (Figs 136–37) begins in 1869 when Colonel Timothy Lawrence died, leaving his collection of arms and armour to the Boston Athenaeum. His widow offered to finance a new gallery to exhibit this armour,[24] an initiative that led to a much grander project of establishing in Boston 'a gallery for the collecting and exhibiting on a larger scale than is now possible, painting and statuary and other objects of virtue and art', in other words a fine arts museum. This was approved in 1870, with Mrs Lawrence as the principal donor. Alas, the Great Fire of Boston in 1872 destroyed the Lawrence armour collection then stored in a downtown warehouse. The new museum went ahead and opened on Copley Square in July 1876. These facts may explain why Mrs Lawrence bought, in this very year, the room that would bear her name. When the present museum opened on Huntington Avenue in 1909, the room[25] went with it. Its iconic importance was not recognized, and unfortunately the room was de-accessioned in 1930 and sold to Lawrence B. van Ingen of Preference, Glen Cove, Long Island.[26]

Photographs suggest this room was a composite of Flemish and English salvages, incorporating the panelling portraits of Henry VI, Henry VIII, Elizabeth of York,

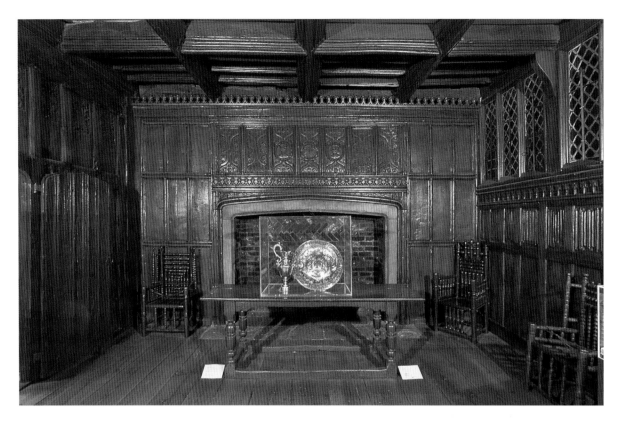

139. Somerset Tudor Room. View to chimneypiece

Edward VI and Cardinal Wolsey. It must have been assembled in London by one of the Wardour Street brokers. Assuming that it started off as a partially complete room, it even precedes the first English one in an English museum, for the Victoria and Albert Museum did not acquire the Sizergh Castle Room until 1891. Its like would not be seen in North America until 1911–12 when the Royal Ontario Museum in Toronto received its provincial Elizabethan Norwich Room. However, as far as Boston is concerned, the room was not the start of a planned programme of period room installation; only in 1920 was the Somerset Tudor Room (Fig. 139) acquired, a spurious but convincing concoction by Gill & Reigate, who advertised it in the *Connoisseur* in June 1920.[27] By November 1923 the dealers were in correspondence with Henry Forbes Bigelow of Bigelow and Wadsworth, the museum's architects, about shipping the room. All that one need observe is an anonymous and disgruntled letter written to the director of the museum on 14 October, 1930:

> This room was made up [under the direction of Mr Gill] in the Gill & Reigate works at Ipswich from pieces of old panelling and beams cut out of old houses, the material being obtained from over a dozen places in different parts of England . . . the building of the room from old materials was all in a day's work . . . This information is true. The time is long overdue for J.H. Gill to be brought to account for this and other things he has got away with.[28]

140, 141, 142. Three views
of the Somerset Tudor Room
as set up in Gill & Reigate's
Ipswich workshops

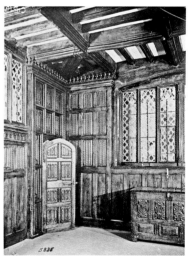

It is fascinating that the deception was known as early as April 1926, when it was referred to in a letter from Fiske Kimball in Philadelphia to Professor A.E. Richardson in London, expressing caution about the provenance of the offered New Place Room: 'In view of the experience of one American museum (which brought [*sic*] a room from a house which had never existed, and which was really manufactured by the clever fellows at Ipswich'.[29] The dealer's three photographs (Figs 140–42) of the room in their Ipswich workshops are a valuable document of this room in its pre-museum state.

Gill & Reigate obviously had the museum in their grasp, for by 1923 they had bought from the Paris dealer Decour a trio of exquisite rooms from the château of La Muette, and these too came to Boston.[30] Along with these acquisitions, the

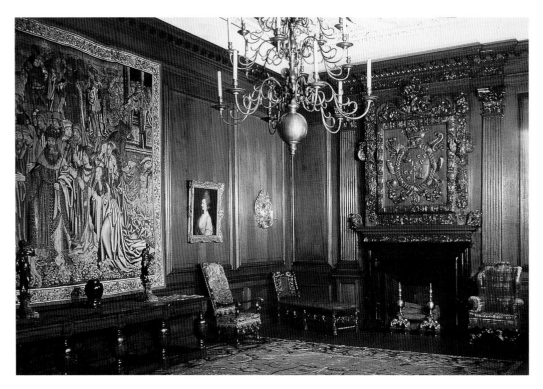

143. Hamilton Palace, the Old State Dining Room. View of long wall and chimney wall. Accession 1924

museum bought from French & Co. in 1924 one of the several rooms from Hamilton Palace (Fig. 143), sold to them in 1921 by Robersons, who had bought all the palace rooms in November 1919. It could not have been known then that this room of the 1690s had been panelled in 1822–28 for the tenth Duke of Hamilton, who had dismantled the original velvet wall covering and had disposed of the baroque painted ceilings.[31] Likewise, the 'Louis XVI salon from Paris', gifted by Mrs Frederick T. Bradbury in 1924, had lost its true provenance, not in Louis-Seize times, but in 1902 when it was made by Jules Allard, probably for the Salomon mansion on Fifth Avenue, New York.[32] The plan to install a series of European rooms in Boston was deflected by the fifteen or so American room acquisitions from 1922 that opened on the Court Floor in 1928. When that was achieved, England came to the fore again, and on 29 July 1930 Gill & Reigate were once more in correspondence with Edwin J. Hipkiss, Curator of Decorative Arts, about the 'Coleford' or rather Newland House, Gloucestershire, Room of the 1740s.[33] For once the room was intact, for as Gill wrote in his July letter, 'It still stands in its original setting', although the Palladian coved and fret frieze ceiling was not transferred.[34] On 25 November Gill could enthuse, 'In all our experience we have never dismantled an old Room with more satisfaction.' From the museum's accession files it is possible to see the room as furnished *in situ* (Fig. 144), then emptied of furni-

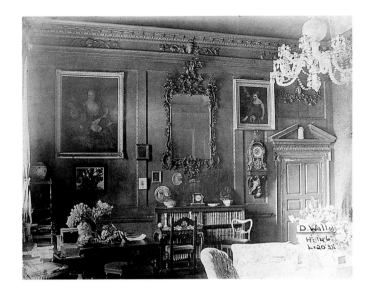

Newland House, Gloucestershire

144. The room in its original setting

145. The room emptied before removal in 1930

146. Early museum installation, 1937

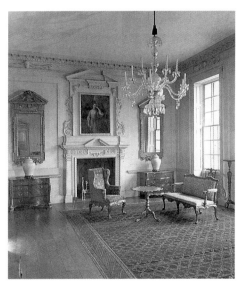

ture (Fig. 145) before dismantling, then as a museum exhibit (Fig. 146). The notice given to the installation of this room in the museum's *Bulletin* in 1937 is a reminder that many years can pass between acquisition and installation.

Boston's most notorious room was opened to great acclaim in 1928,[35] and it was initially notorious because of its furnishings. The Woodcote Park Surrey Room (Figs 147, 148 and 149), given by Eben Howard Gay as his 'Chippendale Room', came from a house upon which, according to Horace Walpole,[36] the sixth Earl of Baltimore had spent in the 1750s 'about £35,000 in making it what he called French'. In 1911 the Royal Automobile Club bought the house for a country and golf club, and in 1913 instructed Harold G. Lancaster of 55 Conduit Street, London to take out most of the historic rooms on the main floor. The Woodcote salvages

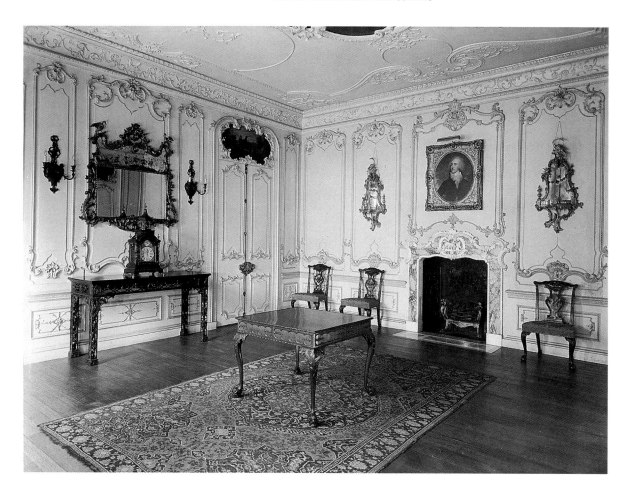

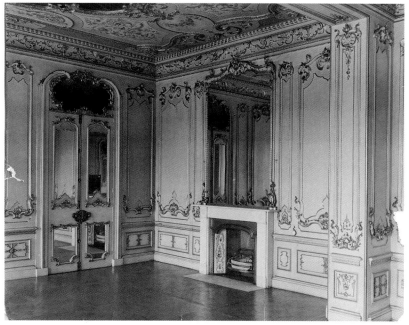

Woodcote Park, Surrey

147. The Chippendale Room at its opening in 1928, as furnished by Eben Howard Gay

148. The room with an early nineteenth-century chimney-piece and overmantel mirror, showing the junction with the adjacent Clermont Room.

FACING PAGE
149. The room in its most recent pre-2004 installation

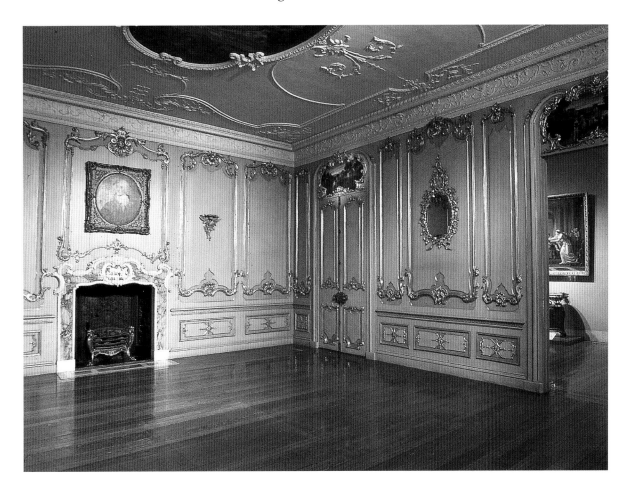

went travelling through a number of other dealers, including Charles of London[37] (Fig. 100) and Roberson and, after Roberson's bankruptcy at the time of the US stock market crash, to the Crowther brothers of Syon Lodge and of North End Road, and to Edwards & Son, who had acquired and sanitised the Library (Figs 150 and 151) long after Eben Howard Gay made his gift in 1928 of the 'Chippendale Room'. When Lancaster advertised in The *Connoisseur*,[38] the Woodcote extractions were probably the most notable of their time, and in hindsight they were a blessing, for the house was gutted by fire in 1934.

At first the Woodcote acquisition was seen as something of a triumph, a very fine English room in the French rococo taste. In 1928 there was no incentive to enquire as to the proper history of the room. Even if it had been recognized that the *boiseries* had been manipulated, and even if the present splendid rococo chimneypiece by Sir Henry Cheere came from another room, behind the Palladian window to the left of the entrance hall, it would not have mattered. What was not obvious from early photographs was the necessary mix and match of *boiseries* when two rooms had been turned into one grand salon (see Fig. 148) in the early nineteenth century. However, what did matter right from the first was the authenticity of the furnish-

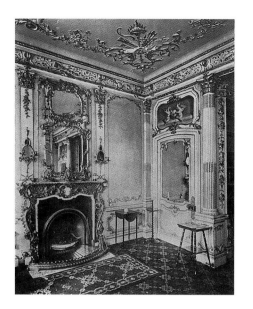

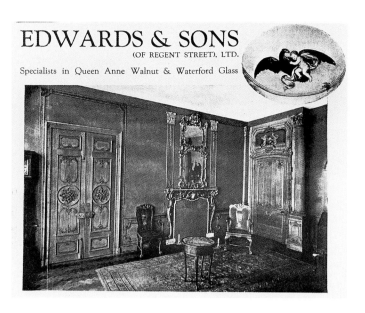

150. Woodcote Park, Surrey. The Library copied from a late nineteenth-century illustration, probably based on photograph taken by W.J. Pickering, 1913

151. Woodcote Park, Surrey. The library as stripped and sanitized by Edwards & Son, copied from an advertisement cutting in 1930s

ings. This was something then better understood by furniture specialists. Mr Gay had been collecting furniture in the Chippendale taste since 1900 and was blissfully unaware that for years dealers had been supplying him with reproductions or outright fakes. The gift to Boston of his 'Chippendale Room' was the culmination of a dream. Poor Mr Gay was shattered when at the opening of the room to fanfares from trumpets, the fakes were exposed in the press. There followed more than two decades of returning or de-accessioning his furniture. As an entity of what was believed to be the Chippendale style, in 1928 it could never have been recognized that the Woodcote Park Room would serve to sum up perfectly the problems that have confronted museum curators in the years after the Second World War.[39]

THE METROPOLITAN MUSEUM OF ART, NEW YORK

Scavenging of the likes of Stanford White and George Grey Barnard, and the distinguished contributions made to archaeology by American universities, were the initiatives that produced for the Metropolitan Museum of Art its first period room,[40] a bedroom from the excavations of a Roman villa at Boscoreale near Pompeii in 1903. As Tim Knox has observed,[41] there is a precedent as early as 1777 for the removal of ancient Roman decoration. Full of excitement, the great collector Frederick Augustus Hervey, Bishop of Derry and Earl of Bristol, wrote to his daughter from Rome in December,

I have been singularly fortunate – several ancient rooms have been unearthed since my arrival – the ptgs were in fresco & almost as perfect as at first – the secret was soon found of detaching the ptd stucco from the walls, & I have bought three complete rooms with wch I propose to adorn Downhill & le render un morceau unique.

Alas, the earl bishop never did bring his rooms back. No doubt the Metropolitan's curators and archaeologists followed the same technique. In 1906 the Metropolitan acquired its first proper European period rooms:[42] the seventeenth-century baroque chamber from Schlossli Flims in Switzerland and the baroque bedroom from the Palazzo Sagredo in Venice (Fig. 152), the latter bought from the dealer Antonio Correr,[43] well known to Stanford White. A further initiative towards the presentation of the decorative arts can be read in the museum's *Bulletin* in May 1907 with the announcement of J. Pierpont Morgan's gift of the Georges Hoentschel collection[44] (Fig. 153) *en bloc*, comprising hundreds of French interior decorative salvages of the very highest quality, from *boiseries* to picture frames or metal ornaments, the total contents of Hoentschel's museum at 45 boulevard Flandrin, Paris.

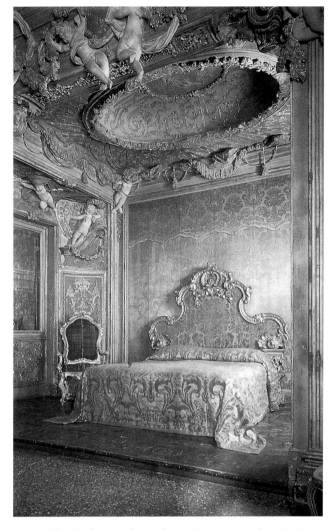

152. The bedroom from the Palazzo Sagredo, Venice, 1718. Accession 1906

This was the Metropolitan's opening foray into the French seventeenth- and eighteenth-century decorative arts, and at once the museum attained pre-eminence in this field. Already McKim, Mead and White had begun the galleries for this department at the north end of the existing museum; its opening is described in the supplement to the museum's *Bulletin* for March 1910.[45] Initially the main hall of this new wing was modelled upon the hall in the Musée des Arts Décoratifs. Here as elsewhere, there would be a considerable delay between purchase and installation. In fact, the Sagredo bedroom was first displayed only in 1926 in the new European Decorative Arts galleries, and was moved again in 1954. In 1913 a little-known

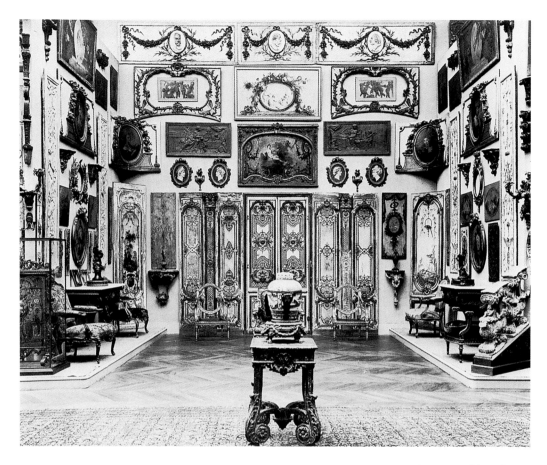

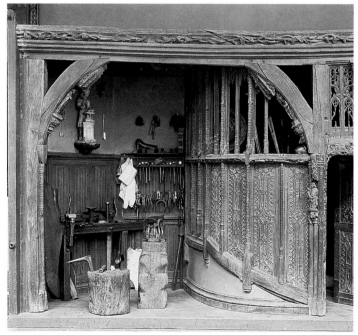

153. An ensemble of *boiseries* and salvages as displayed in one of Georges Hoentschel's galleries in his apartment on the boulevard Flandrin, Paris

154. Doorway and staircase from the courtyard at 29 rue de la Tannerie, Abbeville, as converted in 1913 into an Armourer's Workshop in the museum's Riggs Gallery

155. The Kirtlington Park, Oxfordshire, Saloon, 1748. Accession 1931

'period room' installation was set up that really belongs to the peep-show category of the Essex Institute's 1907 Dow rooms. This was the 'Armourer's Workshop' (Fig. 154) made up by Bashford Dean, Curator of Arms and Armour. As might have been expected, the French dealer provided the woodwork with a royal provenance, the house having once been known as the 'House of Francis I', at 29 rue de la Tannerie, a late fifteenth- or early sixteenth-century house, but probably that of a wealthy tanner in the reign of Louis XII (1498–1515). The woodwork formed the outer part of a spiral staircase leading from the courtyard to an upper story.[46]

Although the Metropolitan's trustees were conscious of European precedents in the formation of period rooms in chronological sequence, notably in Germany, the Netherlands and Switzerland, they would not acquire English rooms until 1931, with the Kirtlington Park saloon (Fig. 155)[47] and the Lansdowne dining room (Fig. 156),[48] following the pioneering English installations in Boston, Minneapolis and Philadelphia.[49] However, both rooms remained crated until 1951, and were only opened in 1954, a delay of twenty-three years! The perfection of the Kirtlington Park room rested upon its entire removal from the house at a cost that included the installation in the house of a replacement copy. The Cassiobury Park staircase (Fig. 157) followed, having first been advertised (Fig. 158) by Edwards & Son in the

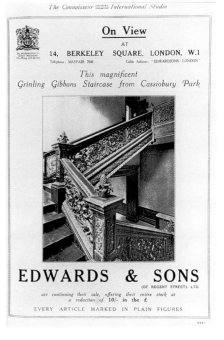

159. Croome Court, Worcestershire. The Tapestry Room, 1771. Assembled as an entity 1958

Connoisseur, in 1932;[50] The museum's admirable presentation of Kirtlington Park, Lansdowne House and Croome Court was due to the high curatorial authority brought to bear upon installation. With the exception of the Croome Court Tapestry Room (Fig. 159), reconstituted in its component parts by 1958,[51] the later English rooms were unwise acquisitions. The Hearst Foundation's gift of three British rooms to the Metropolitan in 1956 should never have been accepted. The panelling of the room from Henwood Priory, Warwickshire, of c. 1636, had been removed on demolition of the house in 1824, divided up and installed in Solihull Rectory and Olton Hall,[52] both in Warwickshire. The Duchess's Bedroom from Hamilton Palace[53] had never been unpacked for scrutiny from crates and was eventually sold to the National Museums of Scotland in 1992, where it languishes because it is not what it should have been. The Gwydir Castle Room[54] had been sold from the castle in 1921 and was bought by Hearst from French & Co.[55] It was

156. Lansdowne House, London. The Dining Room, 1766–69. Accession 1931

157. Cassiobury Park, Hertfordshire. Staircase by Edward Pierce 1670s, as installed in museum. Accession 1932

158. Cassiobury Park, Hertfordshire. Staircase as advertised by Edwards & Sons before acquisition by the museum

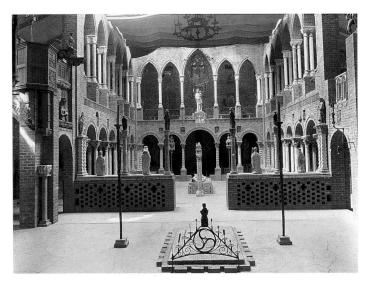

never installed, and was happily returned to Gwydir by the museum in 1996.

The sole remaining English room, the Star Room from Great Yarmouth (Fig. 160), had been bought from a Parke Bernet Gallery auction in 1965[56] as from the estate of Mrs A. Hamilton Rice, who had died in 1957. It was a misjudgment, intended to represent the English Late Elizabethan style. Advertised in the *Connoisseur* in April 1913 and the *Burlington Magazine* in May,[57] it first passed to Commodore Morton F. Plant at 1051 Fifth Avenue and 86th Street, then it was sold to Arthur S. Vernay for stock and advertised in his 1927 catalogue. It is assumed subsequently to have been sold to Mrs Hamilton Rice. After her death her son-in-law and daughter, Mr and Mrs John E. Rovensky, sold it at Parke Bernet on 17 January 1957,[58] after which it languished. It is no wonder that after five lives the room looks a little wearied of life, bowing its head in shame if compared to the nearby Gubbio Studiolo. Tragically, the museum could have had the Great High Chamber from

160. Great Yarmouth, Norfolk. Elizabethan room from the Star Hotel. Accession 1965

161. The Barnard Cloisters at the time of their opening, in December 1914

162. The Barnard Cloisters in December 1914

Gilling Castle, Yorkshire, offered by Acton Surgey to Philadelphia in 1929,[59] which would have served as a worthy foil to the Studiolo, bought in 1939.[60]

The museum's concurrent thrust of acquisition from 1920 concentrated on French rooms – no fewer than fifteen were purchased between 1920 and 1987 – culminating in the opening of the Wrightsman Rooms in 1977. In these rooms it was the intention neither of Mrs Wrightsman and her decorator Henri Samuel, nor of the museum, that the *boiseries* should be installed with accuracy. What mattered was a stylish presentation of the French decorative arts. Of the museum's other French rooms, eight would subsequently be de-accessioned.[61]

When Barnard opened his Cloisters (Figs 161–2)[62] on Fort Washington Avenue, New York, as a public attraction in December 1914 it was ultimately to be for the benefit of French war orphans.[63] Affectionately the public would call it the Barnard Cloisters. To Barnard it was his 'Abbaye', purposely staged and theatric, especially when lit up at night, filled with incense, and with monk-like guardians flitting about in the shadows. Alexandre Lenoir of the Musée des Monuments Français would have appreciated the picturesque constructions and romantic lighting. It was not unlike a jumbled-up medieval church, with arcaded aisles tacked on to two ranges of the cloister arcade from the monastery of Saint-Michel-de-Cuxa. Barnard saw his creation as a poem to medieval art. In an odd way, the Cloisters, when bought for the museum by John D. Rockefeller in 1925, comprised an accumulated salvage of medieval elements, that would complement the great Hoentschel Collection of wooden decorative French salvages. It was surely significant that the Curator of Decorative Arts then was Joseph Breck, from Minneapolis, who before his death in 1933 would contribute as much as anyone to the making of the Cloisters Museum, which in May 1938 opened on its spectacular Fort Tryon site overlooking the Hudson River. Here was the American Musée de Cluny in New York, its plan based upon the Cistercian abbey of Royaumont. As Hubert Landais so well demonstrated in 1992,[64] by the early 1930s there was a growing incestuous relationship among associated salvages in several American museums. When the medieval collections at the Philadelphia Museum of Art opened in 1931, part of the cloister of Saint-Genis-des-Fontaines housed the fountain from the cloister of Saint-Michel-de-Cuxa, whereas at the Cloisters Museum the fountain in the middle of the Cuxa cloister was from Saint-Genis; at the Toledo Museum of Art one colonnade is from Cuxa,[65] another from the Abbey of Saint-Pons near Toulouse,[66] and a third from the cloister of Notre-Dame-de-Pontaut,[67] all three contributing associated salvages to the Cloisters.[68]

THE ROYAL ONTARIO MUSEUM, TORONTO

Priority in acquiring an English room goes to the Royal Ontario Museum (ROM) if it is true that their Elizabethan Room (Fig. 163), reputedly from Norwich, was purchased from Gill & Reigate as early as 1911–12.[69] A physical examination of this room is not possible, but it must be hoped that it is not a product of Gill &

163. Elizabethan room reputedly from Norwich, Norfolk. Accession 1911

Reigate's well-known inventiveness, as at Boston. Enquiries in Norwich have failed to discover any record. It is an anomaly for the museum at the time, for a sequence of period rooms was not begun at the ROM until the early 1920s when the Queen Anne Room was purchased from a company in London called Thomas Sutton. After another interval, in 1928 the Georgian Room, one of the Stanwick Park, Yorkshire, rooms, was gifted by the T. Eaton Company, a large retailing chain. The Rita Lila Weston Room, of the 1750s or 1760s, bought *c.* 1927 from Frank Partridge[70] by the Toronto collector Frank P. Wood for his own house, was then pur-

chased by George Weston in 1955, and in 1968 was given to the museum by Garfield Weston. Clearly there was now the intention of forming a cohesive sequence of rooms, for in the same year the French rococo *Petit Salon* was acquired from J. L. Souffrice in Paris and the ROM received a English Jacobean Room[71] from the Brooklyn Museum of Art, gifted to them when the Aron House at Kings Point, Great Neck, Long Island was demolished in 1968. This room (Fig. 211) had been installed in the Aron House by Charles Roberson in 1926–27, and in their catalogue it was given the improbable provenance of Bladud Castle, Devon. The ROM de-accessioned this in 2003,[72] when the museum's report describes 'extensive nineteenth century additions'. At least the museum may possess a splendid chimneypiece, one (Fig. 102) attributable to the sculptor Thomas Carter from the house built in the early 1770s by Charles Cameron at 15 Hanover Square, London, and demolished in 1904, if indeed it is the original and not a copy made for Sir Charles Allom.

The Minneapolis Institute of Arts

With the exception of the Lawrence Room in Boston's Museum of Fine Arts, 1876, and Toronto's Royal Ontario Museum's Elizabethan Room acquired in 1911–12, the first English period room in a museum in the USA was Minneapolis's Jacobean Panelled Room (Figs 164–5). It was 'well worthy of a collector or museum', to quote the fulsome words of dealer Arthur S. Vernay of 12 East 45th Street, New York, on 16 May 1919, when he offered it to the Minneapolis Society of Arts for $13,800.[73] This was due to the initiative of director John R. Vanderlip. In fact, a policy of room acquisition had been discussed as early as 1909, no doubt influenced

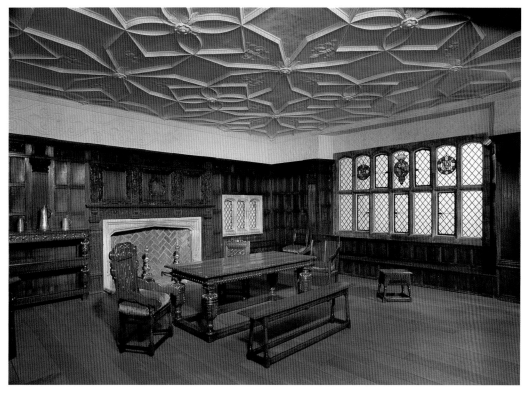

164. Late sixteenth-century room probably from Higham Manor House, Suffolk

by events at the Metropolitan Museum, and the arrival at Minneapolis in 1911 of Joseph Breck, Curator of Decorative Arts from the Metropolitan. Breck forwarded this programme, for he possessed continental interests and had Swiss/German connections. He would leave Minneapolis in 1914 to join the planning team for the Metropolitan's Cloisters, where he distinguished himself. The Jacobean room was transferred to the new museum in 1923. According to Vernay, the room was painted dark yellow when first acquired, and even if it did come from Higham Manor House, Suffolk, this uncertainty as to origins would be characteristic of many period room purchases. This composite of late sixteenth-century woodwork with pilasters of a later date must surely have had earlier lives. The overmantel has the arms of Charles Bowen, silk merchant of *c.* 1680–90, the date for the room first proposed by Vernay. When the museum next acquired an English room it was competing with other US museums and subjected to the influence of Charles Roberson, that fixer in the period room trade. Roberson had taken four rooms out of Stanwick Park, Yorkshire, demolished in 1920. They were soon dispersed:[74] one went in 1928 to the Royal Ontario Museum in Toronto; one (Fig. 210) in 1919–20 to the Frick house at Clayton, Rosslyn, Long Island, the present Nassau Museum of Art; another to Hearst; and the fourth to Minneapolis (Fig. 166).

With many of the rooms supplied by Roberson, there is evidence that he manipulated them in his workshops off Knightsbridge or on Long Island at 484 Van Alst Avenue. However, the Minneapolis room is reasonably intact. A surviving estimate reveals that Roberson would charge £2,150 for room and shipping, and offered a proposal for 'Suitable Furniture' that included writing table, writing chair, armchair, bookcase, settee, wing chair, pole screen, card table, commode and a pair of gilt mirrors, all in the

165. Late sixteenth-century room. Detail of three bays of long wall

166. The Stanwick Park, Yorkshire, Room, *c.* 1730s

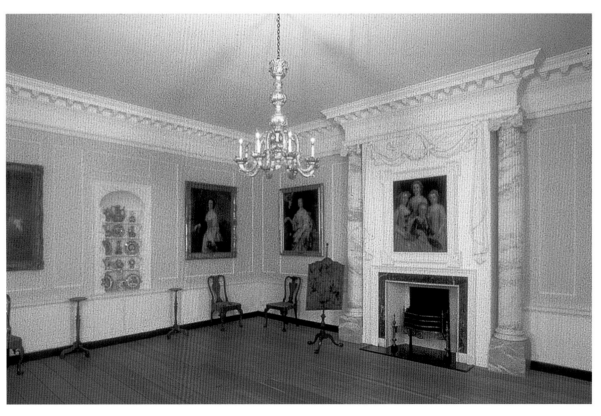

best Roberson-arranged taste, for a further £4,588, a total in US dollars of $33,665. On this occasion Minneapolis did not rise to the bait. In 1931[75] Roberson was pressing Minneapolis again, selling them a Hanover Square early eighteenth-century doorway, maybe from the Earl of Carvarvon's house in Hanover Square, for the astonishing price of $2,700, to which Roberson made a 'special reduction of 20%', no doubt anticipating their sale of a third English room, a 'Queen Anne Oak Room' (Fig. 167) from a house near St Mary's church in Stafford, costing $9,600 on an invoice dated 25 May 1931. In 1928 it had been

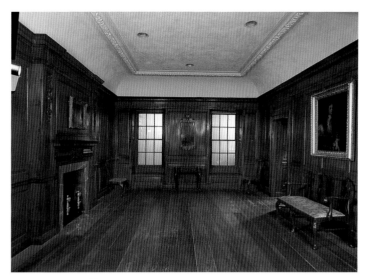

167. The Stafford Room, *c.* 1750

offered to the Art Museum in St Louis,[76] as one of two available Stafford rooms, then priced at £1,475 and £985 respectively. As Roberson wrote to St Louis, 'We propose to remove this antique panelled room from our showrooms to our workshops in New York . . . and to arrange the same to fit into the museum exactly as shown in the scale model sent with the estimate', implying that he adjusted the room after ascertaining the museum's space requirements. This is exactly what happened at Philadelphia. What is signally interesting about the Minneapolis Institute of Art is its recent revival of period room installation, and its acceptance that these rooms have a role to play in a great museum of art. To this end it bought from Dalva Brothers in 1978 the *Grand Salon* from the hôtel Gaillard de la Bouëxière (sometimes known as the hôtel de Pomponne), Paris, a companion to the bedroom in the Art Museum of St Louis. The room was recorded in 1919 as of Carlhian provenance,[77] and it supposedly left Paris in 1922.

THE PHILADELPHIA MUSEUM OF ART, PHILADELPHIA

The early history of the acquisition policy of the first Art Museum in Memorial Hall, Fairmount Park, is imprecisely documented. What is certain is that the museum was seeking panelling in 1916,[78] presumably American Colonial. When Philadelphia acquired the Tower Hill Room in 1922 (Fig. 168),[79] a merchant's interior of *c.* 1760 from Osborne of Bond Street and Grafton Street, it was intended for this first Art Museum. In 1928 it would be joined by the sequence of English rooms in the newly-built Philadelphia Museum of Art (PMA).[80] The initiative in 1921 may have been taken by President John D. McIlhenny.[81] The Tower Hill Room, he said, would be

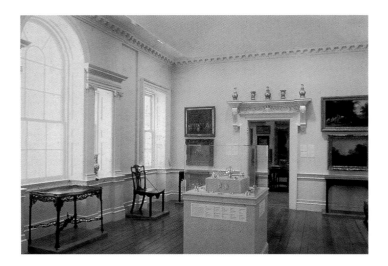

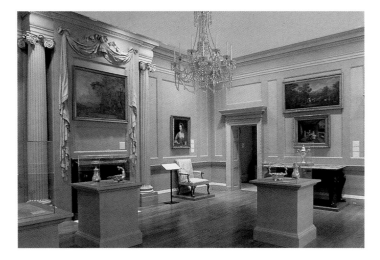

168. Tower Hill, London. Drawing Room, *c.* 1763–66. Accession 1922

169. New Place, Upminster, Essex. Room. Accession 1926

'the first of a series which, when complete, will be the ideal way to exhibit the paintings and furniture . . . of each particular period',[82] a sentiment later shared by Sidney Fiske Kimball, director of the museum in 1925. However, it is clear that there was an intention as early as 1917[83] that 'An unbroken historical chain of thirty-seven period interiors is needed to carry out the plan' of period room galleries, to quote from the museum's *Bulletin* of May 1922.[84] This was probably at a time when a new museum was under early discussion. The scale of the proposed plan suggests that Philadelphia was following policies already established at the Metropolitan Museum of Art. However, it also suggests McIlhenny's views after his European purchasing trip in the summer of 1921, when he surveyed various museums and made comparisons between the PMA and 'the Victoria and Albert Museum with the Arts Decoratives [Paris], both of which are closely akin to our own in their aims and policies'.[85]

The appointment of Kimball to Philadelphia was bold and unconventional, for he was of the breed of architect–architectural historian–connoisseur that existed before architectural history was a professional discipline. As Kimball wrote later, 'The rooms and galleries of different periods . . . will follow in order of chronology and artistic evolution'.[86] The museum opened on 26 March 1928, by which year most of the English rooms had been installed, along with the four American rooms, the Draveil Room as the first of the French rooms, a Dutch Room and a Spanish Renaissance Room. From about 1928 East Asian rooms were dealt with, such as the Chinese Palace Hall, the Chinese Temple, the Chinese Scholar's Study, the Japanese Tea House,[87] and a Japanese Temple, as well the Palazzo Soranzo room and the Stiegerhof. What strikes one at

Philadelphia is that no later administrations have damaged the integrity of these first installations.[88]

As with nearly every other museum in North America, rooms were subject to manipulation, and as for provenance, even if a museum director did question origins, in the 1920s there were few signposts as to where documentation could be found. This is demonstrated by the New Place Room (Fig. 169) from Upminster, Essex, in 1926, Kimball's first acquisition of an English room.[89] It may have come via White Allom in New York, acting for Roberson,[90] and if so it introduced Kimball to that notorious dealer, who claimed to have taken it out of the house. Initially Roberson seemed not to know of the name New Place, but called it 'The Treaty House' Room,[91] and this disparity and uncertainty caused Kimball to defer a decision and to ask the opinion of the English architect-historian, 'The Prof', A.E. Richardson. He answered intelligently that as 'a specimen of a panelled room, representing an English gentleman's home of the period [*c.* 1745], it is interesting and reflects the tendencies of Kent and Gibbs',[92] a comment stylisti-

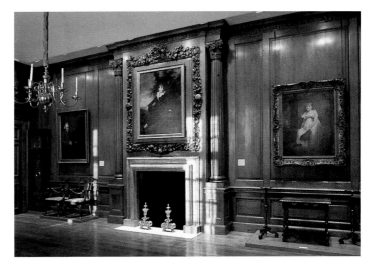

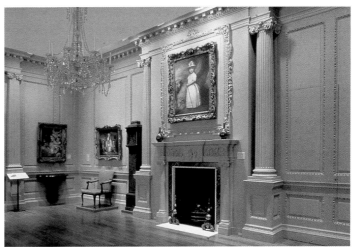

Sutton Scarsdale, Derbyshire

170. Second Oak Room, *c.* 1724. Accession 1928

171. Deal Room, *c.* 1724. Accession 1928

cally not far from the truth. However, attention needs to be drawn to a startling letter from E.E. Newton, who lived in St Mary's Lane, Upminster, and was prominent there as a conservationist who had tried to prevent the demolition of New Place in 1924.[93] He writes on 8 March 1930, 'I do not remember ever seeing any old panelling in the house, although there may have been some covered with paint or paper, but when the house was sold, it was said a lot of material was put into the sale which never belonged to New Place at any time'. In fact, there is no evidence that Roberson was involved in taking rooms out of the house at the end of the sale of

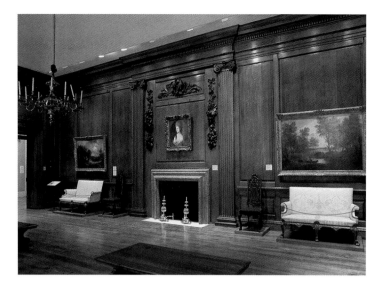

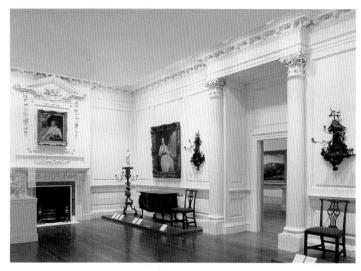

172. Sutton Scarsdale, Derbyshire. Pine Room, *c.* 1724. Accession 1928

173. Wrightington Hall, Lancashire. Room, *c.* 1748. Accession 1928

the contents, although he may well have negotiated removals prior to demolition. It is probable that the room was manipulated by Roberson.[94] This is partially confirmed by the much smaller scale of the New Place room installed by Roberson in the Edsel and Eleanor Ford House at Grosse Pointe Shores (Figs 225–26).

It may have been obvious to Kimball as an architectural historian that the greater height needed in museum galleries would prohibit the easy location of rooms of suitable size. If it is accepted that New Place could not have contained the giant order on a high base, the use of comparable giant orders in Sutton Scarsdale II (Second Oak Room, Fig. 170) and Sutton Scarsdale III (Deal Room, Fig. 171) must be regarded with suspicion. Only Sutton Scarsdale I (Fig. 172) of the three rooms from Sutton Scarsdale[95] can be confidently located to a room in the house.[96] A giant order is also employed in the Wrightington Hall, Lancashire, room,[97] (Fig. 173) which seems to copy the one flanking the division between two rooms in Hooton Hall, Cheshire, a room sold by Roberson to Hearst.[98] The Hearst photograph (Fig. 217) shows an identical Corinthian-columned framed opening. This is highly suspicious because elements of the Roberson Hooton room was almost certainly of the 1860s from the great classical house rebuilt then by J. K. Colling. When the Art Museum of St Louis followed Philadelphia in summoning Roberson for rooms in 1928, his provision of a Charlton House Room (Fig. 181) also contained a giant order on a high base flanking the chimneypiece, identical to the Sutton Scarsdale ones.[99] This strains credulity, surely implying manipulation of elements, or at the worst the making of composites to fit the bill. Kimball must have

been dealing with 'raw space'[100] at that point. Subsequent to Roberson's reply there must surely have been negotiation and the provision of room sizes. What is uncertain is whether Kimball placed undue confidence in Roberson because of his need to meet the urgent deadline to provide period rooms to display the J. H. McFadden collection of English paintings ready for the grand opening of the museum. On the other hand it is not impossible that Kimball was acquiescent in Roberson's manipulations, just as the director of the Art Museum of St Louis was acquiescent in the invention of the Kempshott Park Saloon. Roberson was obviously ingenious in culling and combining

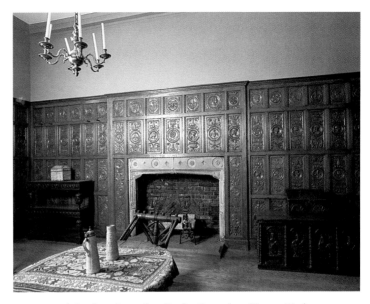

174. Red Lodge, Langley Park, Bromley, Kent. Tudor sixteenth-century room

elements. The giveaway is surely the giant order, which could have been given height only by the use of high bases. But however spurious, there is no denying that the panelled presentation of all these Philadelphia rooms suits the conventional display of McFadden's English pictures.

However, all was not well at Philadelphia Museum of Art when Kimball needed to represent the Age of Tudor. He bought from Acton Surgey in 1929 the oak panelling dated 1529 from Red Lodge (Fig. 174),[101] said to have come from a hunting lodge on the Langley Park estate at West Wickham, Kent. The room has obviously had several lives, although this does not diminish the high quality of the English Renaissance design. As so often the dilemma here was the provision of panelling, but no chimneypiece, no evidence of a ceiling and an insecure provenance. A worse acquisition, as late as 1951, was the gift of an English Jacobean room.[102] It is not surprising that when the Sinklers bought it in 1918 they 'were told that the name of the former owner would not be revealed'. This unfortunate room deserves the trade term of 'boiled-up', meaning panelling that has been so compromised by its many lives that it has lost all integrity.[103] Visually the most spectacular English room, and the one that Kimball felt proud of, was Robert Adam's 1766 Lansdowne Drawing Room (Fig. 175)[104] taken out of Lansdowne House, Berkeley Square, following the sale of the house in 1929 by the sixth Marquis of Lansdowne. When the decision was taken only to reduce the house, in order that Fitzmaurice Place be cut through to Curzon Street, and not demolish the house entirely, the two best rooms on that side, the drawing room and the dining room, became redundant, the latter sold at the same time to the Metropolitan Museum of Art.[105] The Philadelphia room would not

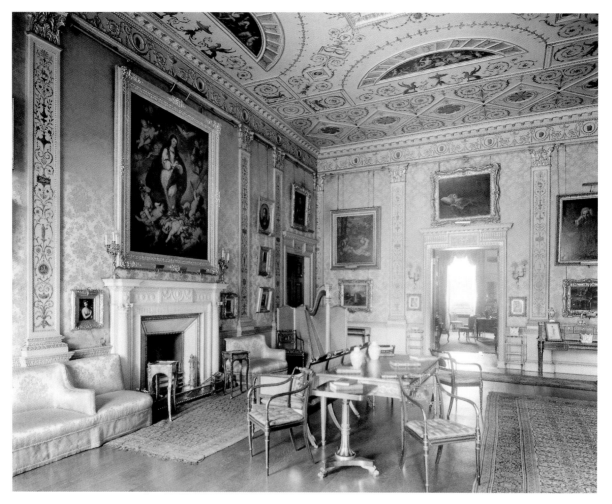

175. Lansdowne House, Berkeley Square, London. Drawing Room by Robert Adam, 1766

be installed and opened to the public until 1943.[106] It was well known that this masterpiece of interior decoration by Robert Adam had never been completed as far as the decoration of the wall spaces between the pilasters was concerned, and it had always been assumed that the covering of yellow silk damask was Victorian. Even so, the mode of covering was adopted by Kimball in the belief that it was post-Adam. It was serendipitous that he did so, for as Karl Friedrich Schinkel observed in 1826,[107] such hangings were original.[108] The first restoration really underlines the depth of Kimball's sensitivities and intelligent taste. Happily the room has now become the recipient of a display of small paintings, as had always been the case.

As the most distinguished authority in the USA on eighteenth-century French decorative design, Kimball did much better with his eighteenth-century French rooms, such as the Louis XV Room purchased from Seligmann in 1928 and reputedly from the Château de Draveil.[109] The room had been altered by Carlhian in 1913 when

he installed it in the place Vendôme. It may have had one earlier life, probably in a nineteenth-century mansion, for had it come directly from Draveil to Carlhian he would have reported the fact in his record books.[110] In 1913 it lacked its chimney-piece, which had been removed in the later nineteenth century.[111] However, Fiske Kimball's triumph was the careful installation and furnishing of the Louis XVI hôtel Le Tellier Room from 13 rue Royale, Paris. Kimball regarded it as the 'best Louis XVI room now on the market', for which the documentation was very complete.[112] Carlhian dismantled it in 1924, and in 1927 it had become known to Kimball. The room was a negotiated gift through both Mrs Hamilton Rice and her son George Widener. Also of Carlhian provenance is the Rice Room,[113] entirely designed and made in 1923 by the Carlhian workshops for Mrs Hamilton Rice's drawing room at 901 Fifth Avenue and installed by Horace Trumbauer.[114] The invention was necessary for the display of Mrs Rice's tapestries of the Boucher/Psyche series and to incorporate vitrines for her porcelains. In contrast to the authority that Kimball brought to bear upon the installation of these eighteenth-century French rooms, his attempts to install a Louis XIV Room in 1929,[115] improved in 1953, led to an unconvincing composite of bits and pieces, some elements with a questionable provenance from the hôtel Lauzun. It was simply that a good Louis XIV room was unobtainable, even in 1929.[116]

The historian of the trade in architectural salvages owes a lot to Kimball's perspicacity in establishing an archive file titled 'Objects Considered'.[117] It deals with rejected offers and covers the years from 1925 to 1931, a period of intense dealer activity. The list below is selective, only including English offerings; it is numbered for convenience.[118]

1. Lichfield & Co., *Catalogue* offering salvages from a west of England house, an old house near Exeter, Coombe Abbey, Warwickshire, an 'Adam' door from Stratford Place, London, and a neo-classic chimneypiece from a house in Tunbridge Wells, Kent [1932][119] (Fig. 100).

2. White Allom offering a timbered roof from old hall near Abergavenny, Wales [1928, n.d.].[120]

3. 'Pergolesi' arabesques from Northwood Park, Isle of Wight [1932].[121]

4. Folder (? T.Crowther of North End Road) of English Gothic rooms, including Tattershall Castle, Lincolnshire, chimneypiece; sixteenth-century room of linenfold panelling, photos dated 15 September 1922; Gothic ceiling from a house in Somerset with Judge Jeffreys associations.[122]

5. Group of measured drawings, maybe sent by Charles Roberson, comprising 'Exeter College' oak room; pine doorway Hanover Square, London; door from Ivy House, Chippenham, Wilts; oak staircase, from Newington Green, London; Port of London pine doorway; St James, London, pine doorway; Spitalfields, London, pine doorway [1926–28].[123]

6. Acton Surgey, offering in 1929 rooms from Tickenham Court, Somerset, a correspondence with Oliver M. Bury of Bristol (? dealer) giving White Allom first refusal on finds, but stating that the Tickenham rooms are his alone to negotiate sale. 'I can offer you what you require . . . room below the solar and . . . all the tracery windows in the building seven in number . . . for £3,500', and concluding, 'You will appreciate that the whole building has to be destroyed to obtain this – its choicest portion.'[124] Regarding Bristol's famous Red Lodge room, 'This room cannot be bought at the moment'. Then a letter from Bury of Bristol to Fiske Kimball regretting that Tickenham room sold.[125]

7. Acton Surgey offering in 1929 a study collection of more than 700 Gothic carved wood

fragments collected by F. Surgey and G.M. Adams Acton on their travels through England.[126]

8. Ugo Bardini of Florence offering arch doorway from Borghese Palace, Rome; sixteenth-century Venetian doorway; ceiling from Padua; ceiling from Mantua offered by French & Co. in 1942;[127] baroque painted ceiling; baroque chimneypiece; also letter of 16 February 1929 re three Florentine doorways.[128]

9. Todhunter, 119 East 57th Street, New York, printed brochure, April 1929, offering marble chimneypiece from 1 Portman Square, London, mansion of the Marquis of Blandford, improbably said to be designed by Robert Adam and carved by John Flaxman, $15,000.

10. Renaissance interior from Peppridge Hall, Oakdale, Long Island, including a French hall of c. 1540 and two Louis XV rooms. Rejected 4 December 1931.

11. White Allom offering to negotiate the sale of Robert Adam's library from Nostell Priory, Yorkshire. Brochure dated 18 March 1929.[129]

12. Robersons offering Long Gallery from Albyns, Essex.[130]

13. Letter from B.L. Smithers of Robersons in London to Charles Roberson in New York, about a hall from Old Canynge House, Redcliffe, Bristol.[131]

14. Coleford House, Gloucestershire: set of photographs of furnished interiors before extraction of room now at Museum of Fine Arts, Boston. 11 September 1930.[132]

15. Edwards & Son offering Cassiobury, Hertfordshire, staircase for £5,000. 1928.[133]

16. White Allom offering in 1928 'Inigo Jones' room from Cothay House, Somerset.[134]

17. Robersons with White Allom offering Banqueting Hall from Dutton Hall, Leicestershire, 1928, 1929 and 1930, £30,000.[135]

18. Gilling Castle Great Chamber, letters from Acton Surgey, January 1929 and 29 April 1929; for sale by Sotheby, 16 May 1929, by Captain K.S. Hunter. Offer by Robersons 28 January 1930.[136]

19. Edwards & Son, 1928, offering panelled and veneered room, c. 1710, also 'Adam' chimneypiece.

20. Hotspur offering Jacobean pine room from Hale Hall, Lancashire. 1925.[137]

21. Acton Surgey offering Haynes Grange, Bedfordshire, room. 1928.[138]

22. Robersons, offering chimneypiece from Hallingbury Place, Essex and one from Haldon Hall, Devon.[139]

23. Litchfield, 1932, panelled room from north London mansion, c. 1730.[140]

24. Litchfield, 1932, panelling from the West of England.[141]

25. Papers regarding project for making a Gothic room and a Tudor room. Chimneypiece from Bradenstoke Priory, Wiltshire with ceiling from Taunton and linenfold panelling. Guest House and prior's lodging from Bradenstoke eventually bought by Hearst for St Donat's Castle.[142]

26. The Grange, Honiton, Devon. Three photographs offered by Robersons.[143]

27. Folder. Maybe Keeble Ltd., re Albyns Long Gallery, Essex, and rooms, also Mildmay House, Newington Green, London.[144]

28. Offering by Robersons, 1927 and Acton Surgey, 1928 of rooms from Hagley Hall, Worcestershire.[145]

29. Keeble offer [1928] Charles II Room from Manor House, Acton, London, £1,200.[146]

30. Keeble. Panelling from Mildmay House (Albyns or London) and chimneypieces and ceiling from Library at Albyns [1928].[147]

31. Keeble, offer south-west oak room, probably from Albyns [1928].[148]

32. Keeble, photo of oak panelled room from Mildmay House, Newington Green, London, as shown in Exhibition of Antiques, Olympia, 1928, £3,500. Also chimneypiece from first floor library at Albyns.[149]

33. Keeble Ltd. Jacobean room from Wrest Park, Bedfordshire, £2,500 [1928].[150]

34. Keeble Ltd. Fireplace from Albyns, Sir Robert Abdy's [1928].[151]

35. White Allom offering to negotiate sale of Adam Tapestry Room from Newby Hall, Yorkshire, 1932.[152]

36. Room offered after 1927 from Plas Mawr, Conway, Wales.[153]

37. Globe Room from Reindeer Tavern, Banbury, Oxfordshire, 1931.[154]

38. Charles Allom offering rooms from Tabley Old Hall, Cheshire, after 1927.[155]

39. Hampton & Co., offering sixteenth-century panelling from The Hall, Tolleshunt D'Arcy, Essex.[156]

40. Treaty House, Uxbridge, Middlesex, the famous oak meeting room [1929].[157]

41. T. Crowther offer the Wren House, 73 Cheapside, City of London [1923].[158]

THE ART INSTITUTE OF CHICAGO

Unlike Philadelphia, and most other museums in North America which installed period rooms as containers for a chronological presentation of cultural artefacts, Chicago's policy was of broader cultural remit, at first following the example of the European national museums in representing architecture and sculpture with plaster casts exhibited in a cast court, as once at the Metropolitan Museum of Art or the Carnegie Museum of Art, the latter the sole remaining cast court in the USA. In 1888 the Elbridge G. Hall Collection was 'designed to form a comprehensive illustration of the whole history of sculpture'. When the Blackstone Collection was installed in the Blackstone Hall in October 1903, Chicago could boast the greatest collection in the USA.[159] It was natural that the Art Institute should extend its scope, encouraged by the founding of the Burnham Library of Architecture in 1912. Interiors would be represented by a few period rooms and larger architectural elements, of the sort as in the Gothic Gallery of Medieval Sculpture installed from 1923, including the doorway from the hôtel des Prévôts, Poitiers, the portal from the hôtel du Sénéchal de Turenne, near Brive, and the portal from Cussey-les-Forges, Burgundy – all accessioned in 1924. The collecting of such elements was in the Beaux-Arts tradition, Chicago being a city where Beaux-Arts architecture was powerfully represented. To this end the Howard Van Doren Shaw Memorial Collection of exemplars was founded after Shaw's death in 1926.[160]

Shaw and his fellow trustee Robert Allerton were no doubt influenced by the negotiations to purchase Chicago's first room in 1919, the Friesian Room from the Pastor's House at Oldehove near Groningen, a composite already made up with a mantelpiece from Bovenkarspel. There followed in 1922 the museum's first English acquisition, a 'deal' room, reputedly by William Kent and from a house on the west side of Argyle Street, London,[161] bought from the Marshall Field department store in Chicago.[162] In 1923 the rococo room from 58 Artillery Lane (Fig. 176) was added, and an English 'Jacobean Room' of unknown provenance.[163] Then in 1925 came the acquisition of the Art Institute's most celebrated, but now notorious room,[164] the 'Hogarth and Thornhill House' double dining room (Fig. 177) and staircase from 75 Dean Street,

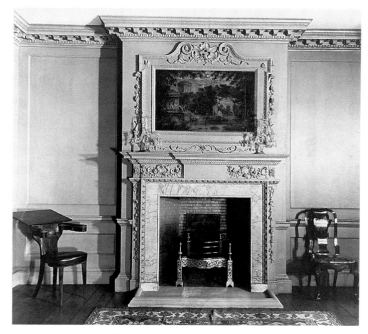

176. No. 58 Artillery Lane, Spitalfields, London. Rococo Room. De-accessioned

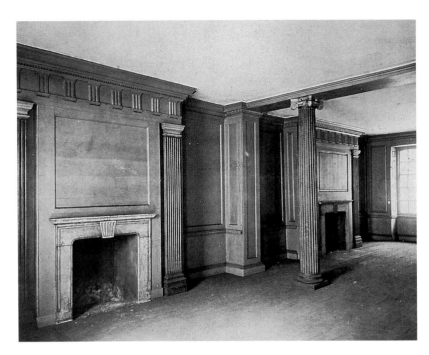

177. No. 75, Dean Street, London. Dining Room. De-accessioned

178. West Harling Park, Norfolk. Chimneypiece and overmantel with portrait of Sir Andrew Fountaine, 1730s. De-accessioned except for portrait

179. Cassiobury Park, Hertfordshire. Inner Library. Grinling Gibbons limewood enframement, *c.* 1675–77. Accession 1926, from Frank Patridge Inc. via French & Co.

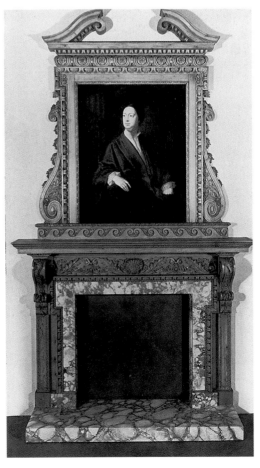

180. Mrs James Ward Thorne miniature room, 'Adam 1770–1790'. Accession 1941

Soho, a house whose threshold the artists never crossed. It was gifted by Mr and Mrs Richard T. Crane, who bought it in 1921 with many other rooms of the house from W. & J. Sloane of New York. They had acquired it from Lenygon & Morant, who fooled themselves and posterity as to its associations.

However, trustees, directors and curators were not persuaded to present cohesive sequences of period rooms as did other museums. Instead they concentrated upon architectural elements, many for the Van Doren Shaw Memorial. The *Régence* or early Louis XV *petit salon*, originally from the *hôtel* of the Prince de Longueville, 55 rue de Verneil, Paris, was surely a composite long before Mrs Henry C. Dangler bought it from the Parisian dealer Doucet in 1922 and gave it to the Art Institute as the Henry Dangler Memorial Room. In retrospect the collection was a disparate one. It included a Regency shop front from Faversham, Kent in 1932. Nearly all the multifarious artefacts, such as a Lombard Street Doorway or the chimneypiece and overmantel from West Harling Hall, Norfolk (Fig. 178)[165] in the Van Doren Shaw collection, were dispersed at Sotheby's, New York on 18 October 1997, following the decision to abandon period rooms and most architectural salvages[166] except those relating to Chicago. However, this dispersal did not include the fine Grinling

Gibbons overmantel enframement from Cassiobury Park (Fig. 179) bought from Frank Partridge in New York.

No account of the Art Institute can omit mention of the famous Thorne Miniature Rooms, given to the Institute by Mrs James Ward Thorne in 1940 and installed in 1954.[167] Mrs Ward had begun making her rooms in the 1920s and exhibited them at the Century of Progress Exhibition in 1933. She may well have been inspired by Queen Mary's Dolls' House begun in 1925. The Ward Rooms are perfect demonstrations of period revival, as in 'Room number 10, Dining Room. English, Georgian Period, "Adam", 1770–1790' (Fig. 180), with all the characteristics of Adam Revival. Naturally, Mrs Ward could not avoid being a child of her time.[168]

CITY ART MUSEUM OF ST LOUIS, MISSOURI

Three numbers of the *Bulletin of the City Art Museum of St Louis*[169] demonstrate the museum's devotion to the period room, with emphasis on American Colonial and English. Their philosophy is expressed in words and with a happy naïvety:

> If by some mysterious means we could put ourselves back in the very room where Raleigh planned his voyages to Virginia – see, touch and handle the very objects he used, wrought by skilful hands and eyes which may have actually seen the Armada sweeping up the channel, and at the same time realize what tremendous human consequences followed upon the life in that room – what more enthralling moment could we have. For an instant we, too, would be among the immortals.[170]

As at Philadelphia, St Louis's director, Meyric R. Rogers, was held in thrall by Charles Roberson, who was 'to supply English rooms as he did at Philadelphia'. There were many deliberations. The execution of this programme of installation of the English rooms can be read in the departmental correspondence that begins on 1 November 1928, when the Vice President of the museum wrote to Roberson enquiring of 'your stock of old panelled rooms. We are seeking the introduction of some such material as this'. Out of Robersons' 'stock of old panelled rooms',[171] by the end of November the museum had rejected the 'Leighall Oak Room', the 'Exeter College Oak Room', a 'Queen Anne Oak Room no. 1', probably one of the two rooms from Stafford, the

181. Charlton House, Greenwich. Room, *c.* 1740s with interventions by Charles Roberson. Accession 1928, now dismantled

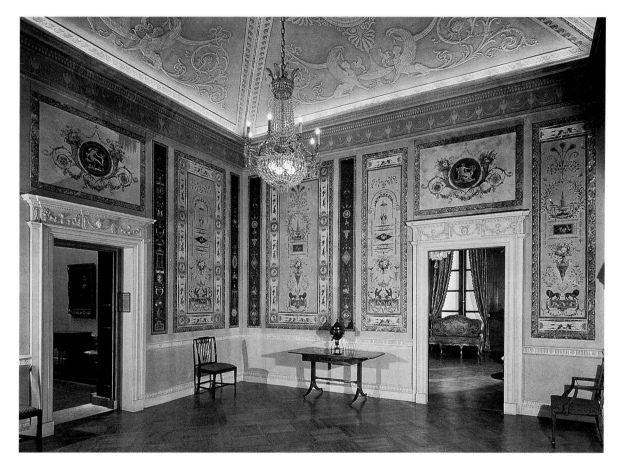

182. Kempshott Park, Hampshire. Saloon. Manufactured 1928. De-accessioned except for the Reveillon wallpapers

'Streatlam Castle Oak Room no. 2', the 'Spettisbury Pine Rooms nos 3 and 4',[172] and a 'Louis XVI Oak Room'. The January 1930 *Bulletin* could present the Jacobean Justice Room from Prinknash Park, Gloucestershire,[173] the baroque Room from Wingerworth Park, Derbyshire,[174] the Palladian Room from Charlton House, Kent, (Fig. 181)[175] and the Neo-classic Room from Kempshott House, Hampshire (Figs 182–3).[176] This phase of installation also included an external doorway from Bristol. The museum's one French room was a singular acquisition in this programme. On 28 February 1929 the museum paid the large sum of $29,250 to Arnold Seligmann for a Parisian bedroom from the 'hôtel de Pomponne',[177] or as it was later identified by Bruno Pons, the hôtel Gaillard de la Bouëxière, situated on the corner of the rue d'Antin and rue des Petits Champs. This excellent and well documented room of the early 1730s was a companion to the *Grand Salon* at the Minneapolis Institute of Arts,[178] now recently installed.

All the English rooms were confections made up or modified in Robersons' workshop at 484 Van Elst Avenue, Long Island. The Charlton House Room[179] was a

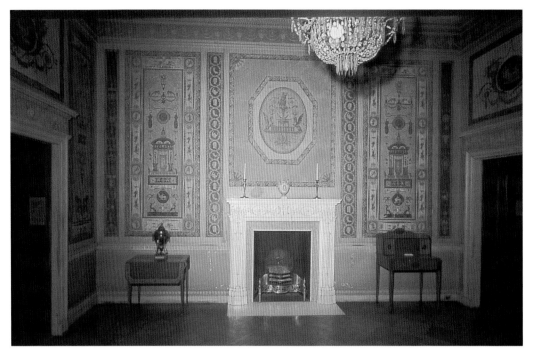

183. Kempshott Park, Hampshire. Saloon. View to chimneypiece sculpted by John Deare in Rome

composite made up with a giant order flanking the chimneypiece, as at Philadelphia to provide added height. The Prinknash Park Room, known as the Justice Room, had in any case been modified in the eighteenth century, its chimneypiece and over-mantel of dubious authenticity. The museum did not acquire either of the two grand Jacobean chimneypieces from the house: one was bought by Hearst, and both are now in unidentified locations in the USA. The Wingerworth Room was also composite. These 'Three Antique Rooms for the Museum' – Prinknash, Wingerworth and Charlton – were invoiced in 1929 for $12,697.76, a reduction from $18,037.76. This did not include the Kempshott Park Saloon, which cost almost $20,000 to invent.

From its public opening in 1930, here was a splendid neo-classical saloon of such quality that it might fairly be compared to Philadelphia's Lansdowne Drawing Room. It was clearly by Henry Holland, for it came from Kempshott Park, Hampshire, where Holland had made designs for altering the house for George, Prince of Wales from 1789. In 1961 this author published it with acclaim,[180] when in the previous year the departmental curators had denied possession of any documentation. In 1988[181] the departmental files were made accessible to representatives of the National Gallery of Art, Washington, for the Treasure Houses Exhibition, following which this same gullible author published[182] 'The Room That Never Was', exposing it as the sort of spoof or fake that is ridiculed in Alice Van Leer Carrick's satire, *Mother Goose for Antique Collectors* (1928). The 'fine old

Adam wall-paper painted by 'Pergolesi', billed for $9,000, was a French *papier-peint* printed by J.B. Réveillon about 1788 with borders by Zuber, that adorned not a room at Kempshott, but a galleried landing on a secondary staircase. The four doors[183] came from a house in Lincolnshire, possibly Cockerington Hall demolished in 1921. The chimneypiece was from Kempshott, costing the astonishing sum of £2,430.[184] The ceiling, long admired as a fine work in the Adam style by Holland, was adapted by Robersons' New York decorator, Mr Louis A. La Baume,[185] from Adam's *Works in Architecture*, in the Batsford edition of 1880. The room was opened in 1930 with pride as the Kempshott Saloon, and so it remained until dismantled and de-accessioned[186] together with the dubious Prinknash Room,[187] and the equally dubious Wingerworth Room.[188] The museum has retained in store the Charlton House room, that when dismantled was found to be made-up from 'much modern woodwork'. Images of this room show the interesting evidence of changes in curatorial presentation, from its Robersons scrubbed, boiled, untreated state, to the final painted version in 1993.

THE NELSON ATKINS MUSEUM OF ART, KANSAS CITY

When the new Nelson Atkins Museum of Art opened in December 1933 it was following St Louis in making a decision to install period rooms or create architectural ambiences. What strikes one is the variety and eclecticism of the acquisitions: the policy to strongly represent the variety of European decorative arts. The first acquisitions took place in 1931, comprising made-up *boiseries* from the *hôtel* of Count Nicolai, quai des Celestins, Paris, bought from the dealer Michel at 12 avenue de Tourville,[189] and a plain but reasonably authentic mid-Georgian, Palladian, room (Fig. 184) from a house in St Margaret's Place, King's Lynn, Norfolk, that had been leased from the Hanseatic League by a Lynn merchant, Edward Everard in 1750–51. The museum bought the room from Acton Surgey, who had acquired it from the owner Mr Frank R. Lloyd.[190] It seems to have been transposed without too much alteration, extracted as an unpainted pine room. An excessively restored Spanish painted ceiling of late sixteenth-century vintage followed in 1933, and in 1940 the museum acquired an

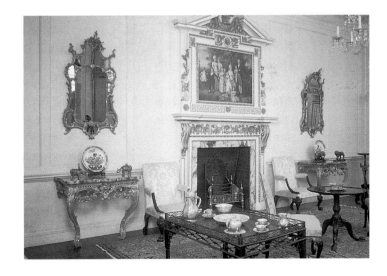

184. King's Lynn, Norfolk. St Margaret's Place Room, *c.* 1751–52. Accession 1931

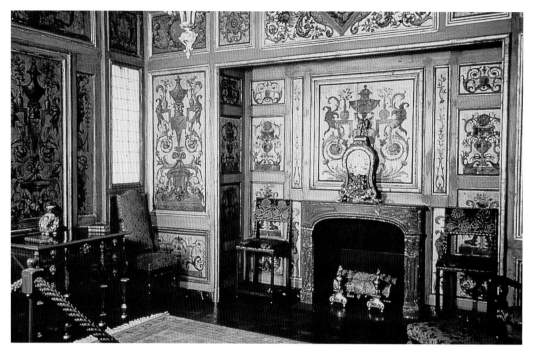

185. French Louis XIV Gold Room from the hôtel du Temple, Paris, *c.* 1660s

Elizabethan oak panelled room taken by Robersons in 1928 from 229 High Street, Exeter.[191] In a letter dated 27 February 1941, to Paul Gardner of the Legion of Honor Museum, San Francisco, Mitchell Samuels of French & Co. wrote that to acquire Exeter's 'three rooms they [in fact Robersons] had to take out portions of six different rooms'.[192] These three comprised the Kansas City Room, the Exeter Room (Figs 193–4) in the Detroit Institute of Arts, which was gifted to them by the Hearst Foundation in 1958, and the room in the Legion of Honor Museum, acquired in 1945, now de-accessioned and repatriated to the Exeter Museum of Arts. The Hearst 1941 sale also gained for Kansas City the French Cloister, reputedly from St Augustine's in Paris, but if so, only after it had been erected in the garden of a M. Simon in Beauvais for 'a number of decades'. A reasonably authentic but now de-accessioned Venetian Alcove was bought in 1942 from French & Co., who bought it from Adolph Loewi, the dealer who commanded the Italian trade in Venice before he was obliged to settle in Los Angeles in 1941. Loewi was the supplier in 1954 of a rare, beautiful and authentic red lacquer Piedmontese *gabinetto* from the villa of the Marchese Vacchetto in Gerbido near Turin, removed as early as *c.* 1912, and subsequently acquired by Loewi, who had possessed it in Venice and later exhibited it in California.[193]

It is for supplying the notorious so-called Louis XIII 'French Gold Room' (Fig. 185)[194] that Loewi is best remembered. He sold it to the museum in 1942 for $8,500, reduced from $15,000. Never has a room been so peripatetic. It is mostly

composed within a 'modern' framing of a variety of painted grotesques, and according to Catherine Futter, it includes no fewer than 'eleven different categories of panels ranging from the early seventeenth-century to the late nineteenth-centuries'. It would appear that in the course of its travels panels were copied or added by several hands. In a letter to Ross E. Taggart, registrar of the museum, dated 11 March 1949,[195] Loewi explained what he knew of its provenance, but not that it was taken out of the hôtel de la Prièure built or rebuilt in the 1660s in the Temple, Paris, for M. de Souvré, Grand Prior of Malta. It is not entirely clear how much of the present 'room' was then installed, but it is probable that the decorative scheme put in place in the 1660s contained earlier paintings and was altered when the *hôtel* was reconfigured in the 1720s. It must have been removed when the *hôtel* was demolished in 1853. Soon after, the panels were taken to Russia and in 1880 they were brought to the Palazzo Woronzow (or Vorontsov) in Florence by Maria Troubetskoi Vorontsov; perhaps more panels were added at this time. The room was sold in 1900 in the Woronzow auction[196] to the dealer G. Salvadori, who sold it in 1908 to Bernheimer[197] in Munich, who in 1928 sold it to Loewi, who installed it in his *palazzo* in Venice. He moved it to store in Los Angeles in 1941, until it was sold to the museum. With seven or eight lives, this must be a record in the history of moving rooms, and it is not surprising that this room before its recent dismantling was a travesty of what the Grand Prièure in the Temple might have enjoyed.

CINCINNATI ART MUSEUM, OHIO

Period room acquisition at Cincinnati was late, post-1945. The museum has suffered from swans that turned out to be geese, and it is baffling that a director, Philip R. Adams, could so lack judgement or be so unwilling to seek advice. Apart from an attempt to form a suite of French period rooms, the two English acquisitions are puzzling. What relevance could a Jacobean chimneypiece from 13 Small Street, Bristol, which has had perhaps four transient lives (Fig. 186), have in Cincinnati as late as 1964?[198] The other was the now de-accessioned Grosvenor Square Room from Lord Aberdeen's house, already mulched up before being installed in 1931–33 by Hitau, the decorator of Alavoine & Co., in the house of Mr Herbert. H. Straus built by Trumbauer at 9 East 78th Street, New York. Correspondence with their daughter Therese K. Straus hints at adaptations, for the panelling was from a room 25 by 26 feet,

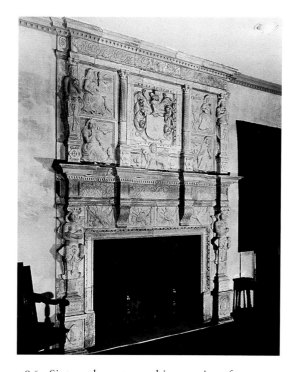

186. Sixteenth-century chimneypiece from Small Street, Bristol

187. The Louis XVI Anson Room. Accession 1945

whereas the installation measures 20 by 26, yet the daughter mentions differing measurements of 25 by 17.[199] As Mr Peter Bezodias, once of the *Survey of London* writes,[200] there is much confusion, and the room could have had a second incarnation when no. 27 in the square (then no. 24) was demolished in 1886.[201] In any case Bezodias suggests that the room could have come from Lord Aberdeen's other house at 58 Grosvenor Street,[202] altered in 1907–8.

The attempt to install a suite of French period rooms in the 1950s was well intentioned, but few museum installations could have suffered more from make-up and pastiche by decorators and dealers. They demonstrate a dismal failure to scrutinize proposed acquisitions at a time when the Metropolitan Museum of Art was exercising scholarly judgement. The Henry IV Cabinet,[203] supposedly of 'rare Henry II wall panelling of Italian workmanship', was at the Dayton Art Institute in 1947, and before that in Susan Dwight Bliss's New York apartment, and goodness knows where it was before that. It comprises forty-eight painted compartments of landscapes and emblems of love. Most of the elements are modern, many of the paintings pastiche, the grisailles come from elsewhere, and the chimneypiece has the sole distinction of having been sold from Stanford White's collections in 1907.[204] The Louis XV Huet Painted Room was acquired in 1955.[205] At least three hands, two of them modern, are identifiable in the paintings, and the room must have had several lives before acquisition by French & Co., who sold it to the Duke and Duchess of Talleyrand-Périgord for their house near Cincinnati. The elegant *Salon* of 1760

from the hôtel de Saint-Simon Sandricourt, 107 rue du Bac, Paris, has been dealt with by Bruno Pons,[206] who shows that it was substantially modified by the decorator Cruchet *c.* 1860, when two doors were changed to six. Carlhian sold this room to the dealer P. Sauvage in 1929, and it was from Sauvage that Mr Herbert H. Straus acquired it in 1931 for their apartment at 9 East 78th Street. However, it is the Louis XVI Anson Room (Fig. 187)[207] that serves as a warning of the minefields to be negotiated in assessing the authenticity of period rooms in American collections.

Today we witness a large handsome Louis XVI room, apparently of the finest quality. Only the deep alcove in the middle of a long window wall arouses suspicion. The room now measures roughly 35 by 21 feet. The departmental files tell all. It was the museum's first French room, given by Mrs Alfred Anson following Mr Anson's death, through French & Co. in August 1945. No doubt French & Co. were clearing out Mrs Anson's house and assessing their French collections at 5 East 68th Street, New York. A letter[208] from Ernest L. Brothers of the Carlhian office at 156th Street, conveying information from Richard Carlhian in Paris, is dated 5 April 1950. It must have been initiated by Adams's discovery when the room was unpacked that much of it was modern. The tale was spelled out in Richard Carlhian's letter. The room had been taken out of a nineteenth-century *hôtel* on the avenue de Tourville, Paris, in February 1913, and therefore this room of *c.* 1780 had had at least one earlier life. After acquisition by André Carlhian, it was bought that same year by Mr and Mrs Alfred Anson for their first apartment in New York. In the 1920s Carlhian et Cie[209] moved it back to Paris for the Ansons' apartment at 38 rue Barbet de Jouy. Then in the 1930s it was on the move again, when the Ansons acquired their 68th Street, New York, apartment. As Carlhian writes with some irony, and no doubt some pleasure in the telling,[210] when he bought the room in 1913 it was a *petit cabinet* measuring 17 feet, 2 inches, by 17 feet and three-quarters of an inch.[211] In its travels it had doubled in size lengthwise and increased by four feet in width. As Ernest L. Brothers concluded, in his letter of 5 April, 'We also believe that some new panels were made harmonizing with the old to fit this old room into its location in the different houses where Mrs Anson used it, both in Paris and in New York, so you probably have old elements and reproductions in your room in the Museum.' The tale is becoming tiresomely repetitive.

San Francisco Art Museums, California

The M.H. de Young Museum, founded in 1894, was the venue for early period room accessions. Of course, these were not necessarily English. One decoratively painted room, from the mayor's house at Tirano, Valtellina, Italy, is recorded as an accession in 1934; another, the Franco-German rococo Wespian House Room from Aachen, in 1943; and a third, the only English accession at this time, the botched-up room, one of three composites made up of six rooms taken out of the house at 229 High Street, Exeter, in 1945.[212] All three have been de-accessioned and sold.

188. Boughton Place, Boughton Malherbe, Kent. Sir Edward Wotton's early renaissance room, *c.* 1520s, before sale to Randolph Hearst via Charles of London

The French neo-classic style of San Francisco's Legion of Honor Museum founded in 1924 was the obvious spur for a programme for French period rooms, although surprisingly period rooms do not initially appear to have been on the agenda. Apart from a Louis XVI room bought from French & Co. in 1946,[213] it was left to director Thomas C. Howe, encouraged by William H. Valentiner, to start a programme of French room acquisition that ran throughout the 1950s and 1960s and can only be described as hasty and indiscriminate; no fewer than twelve rooms were acquired between 1951 and 1966. Among them was the rare suite of three rooms from the hôtel Gaulin, Dijon, installed for a while in the De Young Museum, but unwisely de-accessioned, for not only were they a rare trio, but they were masterworks of the 1770s by the Dijonnaise *ornameniste* Jérôme Marlet,[214] and in any case a suite of such rooms is so rare that it beggars belief that they were de-accessioned by the Metropolitan Museum of Art. Happily the *salon* has been repatriated to the Musée de la Ville, Dijon. A room that deserves investigation is a Louix XVI room painted green that seems to have been sold by French & Co. to Dalva Brothers in New York on 21 April 1944 for $6,000. It was removed from Lord Grimthorpe's estate at Woodlea, Virginia Water, Surrey.[215] All that remain in San Francisco are a Louis XV

room from Rouen,[216] a Louis XVI salon[217] from the hôtel de Humières, 86 rue de Lille, Paris, and an interesting Louis XIV *cabinet* of unknown provenance, with Ionic pilasters and decorative grotesques that may have been bought by Carlhian in 1909, sold to dealer Carolez in 1912, and bought from dealer Barriol for Mrs Harriett Carolan's huge house at Carolands, Hillsborough, California. Never installed, it remained in store in New York until acquired by the museum in 1954.[218] In fact the most distinguished room in the museum is still in store,[219] a rare English Elizabethan Renaissance panelled room (Fig. 188) of distinguished courtier provenance, namely from Sir Edward Wotton's Boughton Malherbe, Kent, bought in 1981 from the Hearst Foundation for $200,000. In 1923 Charles of London had produced a brochure[220] coinciding with what Charles described as 'the occasion of the greatest Exhibition of English Gothic Oak Carving ever held in America'. Not surprisingly, the room, or rather the panelling, was bought in 1924 by Hearst and never installed. Another room that had it been acquired would long since have been de-accessioned as an old crock of an invention, was the 'Sir William Chambers Room from Sudbury Hall, Derbyshire', of which so far no photographic illustration has been found.

The tale of this near-run accession is a case study in what one might call contrived duplicity on the part of both director and dealer. On 11 September 1951, Edward Fowles, director of Duveen Brothers Inc. in New York, offered to a Mr A.G. Loomis, the 'Sudbury Hall, Derbyshire, Eighteenth Century Pine Room by Sir William Chambers' for $15,000.[221] It was declined. Three years later, on 22 November 1954, it was reported that museum director Thomas C. Howe 'came in, looking for an English Room. They have someone willing to present them with one, so that they can put out their English furniture and pictures.' Howe was shown a model and it was now offered for $22,000, a $7,000 hike.[222] There the matter rested for almost five years until on 30 January 1959 Fowles offered the room to the Art Gallery of Louisiana State University at Baton Rouge, enthusing, 'The quality and beauty of the pine is unparalleled, and I think it would be wonderful as it is for English pictures'. He related some facts about the room's lineage: it was by the famous Sir William Chambers and taken out of Sudbury Hall, Derbyshire, when it was originally 'purchased by the late Lord Duveen' for his 91st Street, New York, house, but retained for his home in Kensington Palace Gardens in London. In the interim the room had been 'set up by the late Sir Charles Allom' in White Allom's galleries in London. When rejected by Louisiana on 24 December 1959, it was on course for the Legion of Honor once again, and the correspondence between Fowles and Howe makes clear that the room was being modified for the museum, turning it round so 'that the main doorway was to be on the Palm Court, opposite the chimney piece, and the side doors were to be made at each end, as shown on the plan of your Museum'. In other words, openings were being manufactured. On 12 May 1960 Howe had been obliged to warn Mr Fowles that, 'the Committee of our Board of Trustees . . . are deliberating the problem . . . in the report submitted by Mr Harris'. By serendipity, this author had been asked by Howe to report on the room, but had been kept in ignorance of its history. Twice I examined it, and concluded

that it seemed an entire confection of maybe three different provenances, all in the date range of 1735–45, and that it had never come from Sudbury Hall in Derbyshire.[223] That Howe had been a willing conspirator is revealed in a letter of 11 July 1960 from Fowles to Richard S. Rheem of San Francisco, the potential donor of the room. It is an uncommonly frank apologia from a dealer for making up period rooms tailored to pre-determined museum spaces. At least Charles Roberson never had the nerve to put it in writing. Fowles wrote,

> In principle, for museum purposes, presumably the idea of having a panelled room in exactly its original shape and form is excellent, but in practice it is a difficult one, for the following reasons:
> 1. Original plans, specifications and elevations are seldom available
> 2. The physical space of the confining walls of the museum frequently do not lend themselves to the exact original shape of the room
> 3. The problem of circulation of the public and a good view of the works of art in the room
> 4. Fire laws – the necessity of two exits, etc; all make it most difficult.

It might have been thought that when Howe returned the maquette of the room to Fowles on 25 January 1963, that would have been the end of the saga and the room's invention would have been accepted. It was not, and in March and April of that year Fowles was still trying unsuccessfully to sell 'The Sir William Chambers Sudbury Room' to Blairman Ltd. in London. Two years later, on 15 March 1965, he succeeded with Norton Simon in California, a sale that in truth was a complete confidence job. It was never installed, and the Norton Simon Foundation sold it to French & Co. for $12,000 on 21 April 1966. Two years later French & Co. attempted to sell what they still persisted in calling the Sir William Chambers Sudbury Room to the Los Angeles County Museum of Art for $38,000. The letter of rejection from the deputy director is couched in such a way as to imply that he suspected a fabrication. We may wonder, where is the room now? Who has been fooled yet again?

THE HENRY E. HUNTINGTON LIBRARY AND ART COLLECTIONS, SAN MARINO, CALIFORNIA

Despite the distinguished quality of the architecture, the designed décor, and the high quality of the art collections, the Huntington's acquisition of period rooms can only be described as shameful. The Quinn Room (Fig. 189), acquired in 1940, a composite if ever there was one, was bought from the dealer Alfred Charles Pembery,[224] who had acquired in 1938 some architectural elements that had originated in Castle Hill, Devon, a great house designed in the 1730s principally by Roger Morris with advice from both Lords Burlington and Pembroke. The Morris elements must have been removed from Castle Hill in the 1880s. It has not been possible to identify any earlier provenance. The Quinn Room's larger and smaller

panels are in Morris's Marble Hill style. The chimneypiece is said to have come from Grove House, Chiswick, and the overmantel from 19 Arlington Street, London, demolished in 1936. The Huntington's Jacobean Room, acquired in 1943 with the tag of 'Kentish' workmanship,[225] is also a composite. It may have come from The Priory, Dartford, Kent, as Roberson had already sold one room from this house to Hearst. In 1945 the Overseer's 'Marot' Room was bought via Lenygon & Morant from the Neiman Marcus department store, as another composite in which Daniel Marot could never have had a hand. Finally, in 1954 the Hollywood

189. Castle Hill, Devon. The Quinn Room, with salvages from Grove House, Chiswick, Middlesex, and Arlington Street, London

film director, J. Michael Leisen gave a Sutton Scarsdale Room (Fig. 215) of Hearst provenance that had been degraded and manhandled as a film set. Sold by Roberson to Hearst, the panelling may be genuine, but the chimneypiece is not in the Smith of Warwick style of Sutton Scarsdale. It may have come from elsewhere, married by Roberson to the panelling.[226] Most of the room is in museum store.

DETROIT INSTITUTE OF ARTS, MICHIGAN

The Detroit Museum of Art was founded in 1885 and opened in its first building on Jefferson Avenue in 1888. In 1919 its name was changed to the Detroit Institute of Arts when its collections were transferred to the City of Detroit, and Paul Cret's new museum building opened in 1927. A south wing was added in 1965 and a north wing in 1971. Period rooms have been incidental to the museum's distinguished programme of collecting, and the acquisition in 1922 of a Louis XVI room reputedly from a château near Amiens did not initiate any intelligent sequence of companion French rooms. Although this Amiens room is a composite, no doubt with several lives, its current presentation achieves success.[227] It was left to the Hearst Foundation in 1958 to create a programme of salvage acquisition by their donation of a group of unwanted rooms.[228] This donation comprised the Duchess's Bedroom from Hamilton Palace (Fig. 190),[229] bought by French & Co. from Roberson and sold to Hearst in 1924; the staircase, or rather stair, from Eyrecourt Castle, Co. Galway, of *c.* 1679 (Fig. 191),[230] bought by Hearst from White Allom in 1927; the State Bedroom from Standish Hall, Lancashire (Fig.

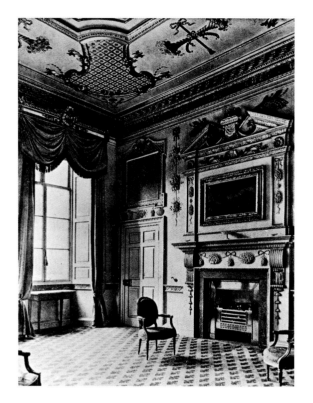

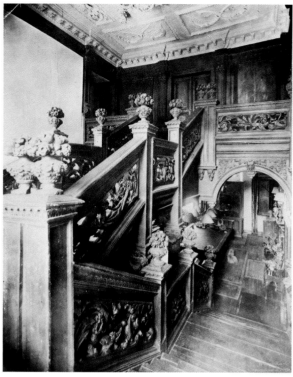

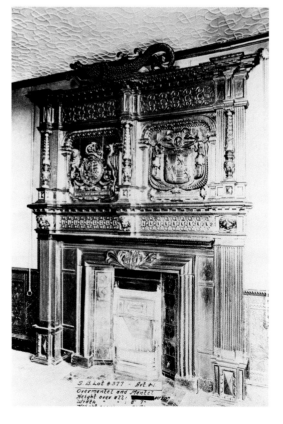

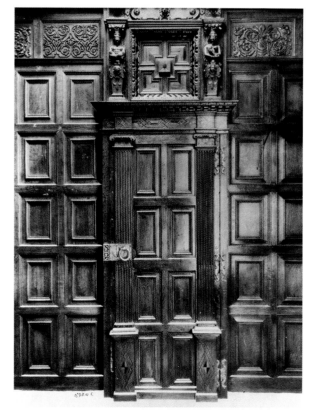

192),[231] bought by Roberson and sold to Hearst on 18 May, 1922[232] prior to the demolition of the house; and finally the Exeter Room (Fig. 193),[233] one of three made up from six, taken out of the house by Roberson in 1929 and sold to French & Co., and then sold on to Hearst in 1934.[234] In retrospect the valuations put on these rooms by the Hearst Foundation are astonishing, when compared to current prices. The Standish Room was costed at $27,500 and the Exeter Room $16,000.[235] A fine 'Adam' chimneypiece, one of two, was an isolated English salvage gifted in 1984 by Henry Ford II,[236] who acquired it for his mansion on Lake St Clair in Grosse Point in 1957. Coming from Bowcliffe Hall, Yorkshire, it was probably designed by John Carr.

DENVER ART MUSEUM, COLORADO

In 1961 Mrs Simon Guggenheim gifted the Late Tudor Bury St Edmunds, Suffolk, Room.[237] This much boiled-up room deserved its removal to store in 1995. It is unclear if the room was related to Hearst's purchase through *Nash's Magazine* of a Tudor 'ceiling' in Bury St Edmunds on 13 June 1927, but it is probable. The location of the house is unknown to the local history librarian in Bury or the staff of the Suffolk Record Office.

NORTH CAROLINA MUSEUM OF ART, RALEIGH

This is an entry about a room that 'never was' installed in a museum. In 1915 two rooms were removed from Beacon House, Painswick, comprising the drawing room, and a dining room with an arcuated system of rococo wall panelling, illustrated in *Country Life* in 1915.[238] The dealer who negotiated this is unknown, but the building firm of Trollope & Colls removed the Apollo ceiling dated 1769 from the drawing room.[239] Both rooms were bought from White Allom in 1924 by Hearst, who bought the dining-room ceiling, but not the Apollo one. The two rooms were sold in the 1941 Hearst sales, but as no annotated catalogue exists, the buyers remain unidentified. The drawing room was not installed when given to

190. Hamilton Palace, Lanarkshire, Scotland. Bedroom from the Duchess's Suite, *c.* 1725

191. Eyrecourt Castle, Ireland. Late seventeenth-century staircase. View from middle landing. Ex William Randolph Hearst Foundation

192. Standish Hall, Lancashire. The State Bedroom chimneypiece. Ex William Randolph Hearst Foundation

193. Exeter, Devon. Room from 229 High Street, showing entrance door. Ex William Randolph Hearst Foundation

194. Beacon House, Painswick, Gloucestershire. Saloon. The travelling room that never was installed in any museum. De-accessioned

Wake Forest University for their new Art Center, nor when passed on by them to the North Carolina Museum of Art, which had it propped up in store (Fig. 194), then de-accessioned it to Sotheby's, New York on 24 October 1992, when it was bought by a private collector. Surviving Hearst photographs show both the rooms with their ceilings *in situ*.[240]

THE J.B. SPEED ART MUSEUM, LOUISVILLE, KENTUCKY

When in 1904 *Country Life* published Colonel Henry Gundry's The Grange at Broadhembury near Honiton in Devon there were only three illustrations, showing just two walls (see Figs 16–17) of the famous Jacobean Drawing Room.[241] This is puzzling, even when allowing for the fact that the article is an early one in the history of *Country Life*. The Oak Drawing Room had first been extolled in 1826 by J.P. Neale in his *Views of Seats of Noblemen and Gentlemen* as 'if not unique . . . in finer preservation, perhaps, than any other in the Kingdom'.[242] Also significant in view of the *Country Life* photographs is the existence of two early nineteenth-

century lithographic illustrations of the same chimney and entrance walls, inscribed 'Reproduced from a stone found in the mansion'.[243] The room was noted for its elaborate iconography based on Ovid's *Metamorphoses*, and its rich heraldry. In this it was not unlike the Rotherwas Park Room (Figs 13–14) now at Amherst College, Massachusetts.

Edward Drewe, a successful lawyer, Recorder of London and a serjeant-at-law to Queen Elizabeth, lived at Killerton in Devon, but before his death in 1598 he had bought the ancient Grange at Broadhembury and had begun a rebuilding that was finished by his son Sir Thomas, who was knighted in James I's first parliament. Of concern in relation to the Grange Room are the consequences of the internal alterations that substantially reduced Drewe's great Elizabethan house in the later years of the eighteenth century, possibly after Francis Drewe's death in 1773. Henceforward, the history of the family is obscure until the Drewes sold the house through Knight Frank & Rutley to Colonel Gundry in 1903. The *Country Life* article was obviously prompted by the sale.[244] There can be no doubt that Charles of London had read Lathom's book, and was aware that Colonel Gundry's widow was attempting to sell the house in 1922. The room must have been removed around 1925. By 1926 or 1927 Charles had produced brochures in two slightly different formats, titled, *An Oak-Panelled Room of James I from the Grange Broadhembury in the County of Devon . . . To be seen at Charles of London [at] Two West 56th Street, New York*, where it was described as 'The Finest And Most Beautiful Panelled Room Ever Known'. The chimney wall and entrance door walls are shown as agreeing with *Country Life*, but the long wall facing the chimney and the shorter end wall opposite the entrance are surely composite compilations by Charles. They must have been arranged as embrasures in such a way that the actual window openings conformed to the two plain Georgian openings shown externally. Perhaps the other two walls, one end, one window side, were so obviously made up of carved wood salvages from the eighteenth-century reduction of the house that they were excused from the lense of the *Country Life* photographer. For this reason they were refashioned by Charles of London, that enthusiast for 'old oak'. Neale's observation, that 'much of the carving was probably collected from more ancient buildings to ornament this room', may well have been made as early as 1823–24, and perhaps referred to what he observed of the window and end walls, following conversations with a member of the Drewe family of the time who could recollect the reduction of the house barely a generation since.

The evidence for an eighteenth-century antiquarian compilation can be deduced from the whole arrangement of the central door with its Franco-Flemish Ovidian panels, salvages from elsewhere, and the elongated Corinthian fluted columns, whose framework looks of eighteenth-century antiquarian manufacture. In 1904 tantalizing reference is made in *Devon Notes and Queries*[245] to the fact that Drewe's muniment room contained rare heraldic armories, evidence of antiquarian tastes. A clue to the sale history of this famous room is the sale brochure cover and attached plan of the room in the Philadelphia Museum of Art Fiske Kimball archives,[246] inscribed 'The Grange Room',[247] and clearly by Charles

Roberson. This was soon after discussions had taken place between Roberson and Charles as to a commercial amalgamation. Perhaps he part-owned the room with Charles. It was exhibited by Charles in New York and sold to Randolph Hearst in 1928, remaining in their warehouse until 1944 when, through French & Co., it was sold to Dr Preston Pope Satterwhite of Louisville, who donated it to the museum.[248]

Mead Art Museum, Amherst College, Amherst, Massachusetts

As a venerated icon, Amherst's Rotherwas Room (Fig. 195) is a companion to The Grange.[249] Both are Jacobean with heraldic displays, and both were exported by Charles of London and New York. Of the Elizabethan house at Rotherwas Court there is little documentation. When Charles Bodenham employed James Gibbs[250] to build a grand new brick house in 1731 he retained a secondary range of the old house that may originally have contained this room, although this is uncertain. In 1678 Thomas Blount eulogized the 'fair parlour full of coats-of-arms according to the fashion of the age', and 'over that a whole dyning room wainscoted with walnut trees, and on the mantel tree of the chimney 25 coats in one achievement'.[251] In 1913 the *Hereford Times* published many letters on the subject of 'The Fate of Rotherwas'.[252] We learn that 'The firm of Charles, in Brook Street, has acquired, lock, stock, and barrel, the Elizabethan building with its Queen Anne additions', implying that Gibbs's Rotherwas Court was bought entire. One letter is explicit about thirteen rooms being taken out and exported directly to the USA. Another, by an apparently knowing correspondent, states that in 1731

> all the panelling was removed from the old house, and set up in the new mansion, there was not room large enough to contain the panelling from the 'fair parlour' and it was consequently distributed over four apartments, and as showing the piecemeal way in which it was distributed, one half of the parlour chimney piece was in one room while the other half was discovered in the cupboard of what is now the bathroom. The remainder of the parlour panelling adorned an ante-room, while the coats of arms were placed on the beams of a fourth room. These fragments will now be restored to their original position, and will no doubt adorn the mansion of the highest bidder . . . as one approaches the historic mansion the sound of saw and hammer indicates the activity of the carpenters and packers.

By April the room or rooms were in the USA, according to *Town and Country Magazine*.[253] Among the few surviving photographs in Hereford Public Library, two (Figs 13–14) show one panelled room with an eighteenth-century wooden beam ceiling, obviously the grander 'fair Parlour', but with an early eighteenth-century cornice,[254] somewhat belying what the correspondent of the *Hereford Times* reported. One of the dismembered rooms must be that shown with an eighteenth-century Jacobean Revival ceiling in the style of J.F. Pritchard, the ubiquitous

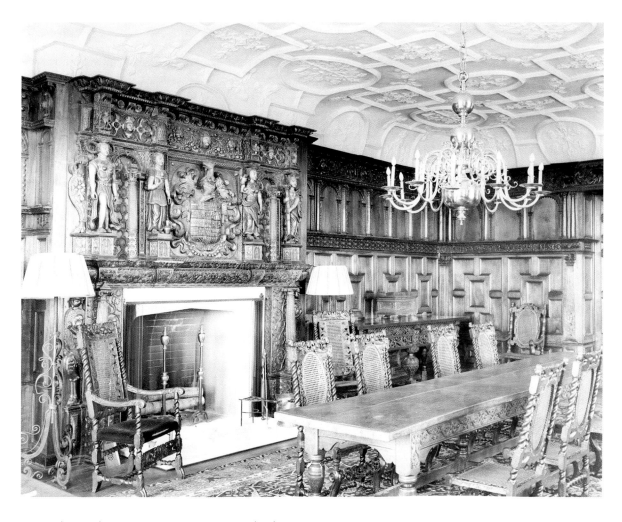

195. The Rotherwas Room. View towards chimneypiece

Shropshire architect, in photographs (Fig. 15) in the C.W. Post College Hearst dock-
ets, demonstrating that Hearst bought that room, called the Julius Caesar Room,
from Charles on 22 September 1916 and installed it in his Clarendon apartments
on Riverside Drive, New York.[255]

Hearst did not buy the 'fair parlour', because for once he was pipped at the post.
Hardly had Charles's exhibition opened in his New York galleries than the room
was bought, reputedly for an astonishing $350,000, by Herbert Lee Pratt for his
neo-Jacobean mansion, The Braes,[256] then being built by architect James Brite on
one of a series of Pratt estates at Dosoris Park, Glen Cove, Long Island. As an
Amherst graduate of '95, Pratt bequeathed the room to his alma mater, in 1945.[257]
It was installed with a copy of the Brite/Jacobean ceiling that exists in the The Braes
today.[258]

RHODE ISLAND SCHOOL OF DESIGN MUSEUM, PROVIDENCE

This museum has fragments of one English room, so dismembered as not to be worthy of listing, but the circumstances of its acquisition provide a case study of 'a pine panelled room' that at first came to the museum without credentials. It was bought by the Rhode Island School of Design from French & Co. for $7,000 in 1936, apparently without provenance other than the fact that the Rockefeller family (Mrs John D. Rockefeller and her sister Lucy T. Aldrich) had sold it to French & Co. It is a perfect demonstration that the Rockefeller family possessed not a shred of interest in provenance. The anonymity of this room obviously set off an enquiry by the director of the museum to Stair & Co. in New York, who are assumed originally to have sold the room to the family. Stair & Co. replied on 22 July 1937, 'We have been informed by our London House that the room erected at above, came from Chipstead Place'.[259] In the *Architectural Review* for October 1931, Norbury Smith & Co., auctioneers of 8 Conduit Street, London, advertised the demolition sale of Chipstead Place, Kent, with 'the Superb Grinling Gibbons Screen included in the Magnificent Collection of Original 17th and 18th Century Period Oak and Pine Panelled Rooms, Marble and Wood Chimney Pieces, Fittings, Fixtures, and Garden Stonework', on 20 and 21 October 1931. It is extraordinary that the elegant arcuated staircase hall screen in the Palladian style of Sir Robert Taylor in the 1750s could be described as by the seventeenth-century wood carver Gibbons.[260] The Rhode Island room is no longer a room as such, but was later modified as a passageway.

COLUMBIA UNIVERSITY, NEW YORK: THE TWOMBLY-BURDEN ROOM AND
AVERY LENYGON MEMORIAL ROOM

The Twombly-Burden Room in Low Memorial Library was removed from Streatlam Castle, Durham, when it was gutted prior to demolition in 1927.[261] It is uncertain if it was removed by Lenygon, or bought by them from Robersons, who are known to have removed rooms from Streatlam. It was installed in 1930 in the Twombly house at 71st Street and Fifth Avenue, New York, where the interiors were decorated by Lenygon & Morant. The room was made up from Streatlam's hall,[262] and was obviously somewhat reduced. Fragments are to be found in the Colonial Williamsburg Collection, wrongly labelled for Blyth Hall, Nottinghamshire. At the demolition of the Twombly house in 1961 the room was saved through the persuasion of Mrs Jeannette Lenygon, subsequent to which Mrs Burden, Mrs Twombly's daughter, gave the room to Columbia University. Brian D. Mitchell observes a mention in the Lenygon inventory in the Avery Library archives of an 'Antique William & Mary oak-panelled room' from Lady Strathmore's collection in 1929.[263] The Avery Lenygon Memorial Room, a gift of Jeanette Lenygon, has a different provenance, coming from 33 Old Burlington Street, one of a terrace of four houses designed by Colen Campbell in 1718–19,[264] of which Lenygon's office was in num-

ber 31. Lenygon advertised this as their 'Room of the Month' at 24 East 82^nd Street, New York. Interestingly, this room by Campbell with a characteristic cornice has a portrait in the overmantel noted as representing Lord Burlington. This is not so, but the house in the background can only be one by Campbell, for it resembles his design for John Hedworth's house at Chester-le-Street, Durham.[265]

ZANESVILLE ART CENTER, ZANESVILLE, OHIO

In the third volume of his *Historical Rooms from the Manor Houses of England* (*c.* 1926) Charles Roberson advertised the 'Pine Room from Hatton Garden'. This was bought by Hearst, stored, and then sold at Parke Bernet Galleries in 1940, when it was bought by Mr Edward M. Ayers for the Zanesville Art Center. It moved with the Center to its present location on Military Road, Zanesville. The installation is reasonably authentic, although as was common in Roberson's time, the original paint had been removed, and in his words, 'The harshness of the wood has been toned down to a beautiful honey colour by age and the use of wax polish.'[266]

FREER GALLERY OF ART, WASHINGTON, DC

The Whistler Peacock Room is really a private installation as it was bought for Charles Lang Freer's Detroit house. First installed at 49 Prince's Gate, London for Frederick Leyland, and painted by Thomas Jeckyll in 1874, it is celebrated for its repainting by Whistler from 1876. It has escaped notice as one of the earliest English rooms to be transhipped to the USA, for following exhibition for sale at Orbach's Galleries at 168 New Bond Street in June 1904, it was bought in 1906 by Charles Lang Freer for his house in East Ferry Street, Detroit (Fig. 197), therefore qualifying as the second English room to enter America. In 1919 Freer removed it to his new Freer Gallery of Art.[267]

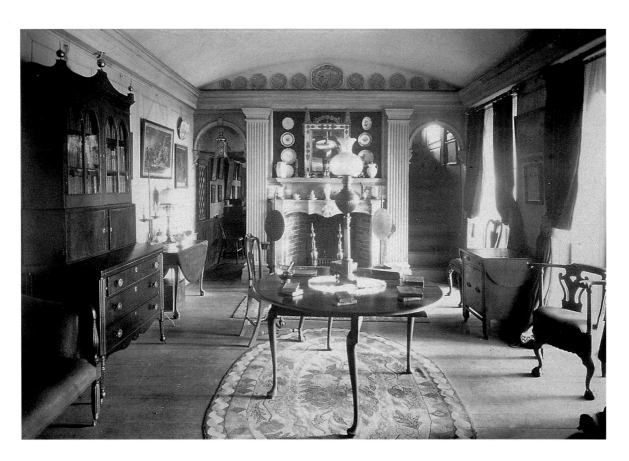

196. Indian Hill, Massachusetts. Interior

9

INTO AMERICAN HOUSES GO
ENGLISH ROOMS

THE RE-USE OF PANELLING OR salvages for the making or ornamentation of rooms, whether European or North American, in Colonial or Federal American public buildings or private houses is an undocumented subject.[1] In general an interior before *c.* 1830 was of its time, but because of scarcity of materials, architectural salvages must always have been re-used. Colonial wood-panelled rooms were detailed simply, due to the scarcity of sophisticated carvers. When in 1816 the panelling from Independence Hall, Philadelphia, a room that witnessed the signing of the Declaration of Independence, was removed,[2] it was obviously re-used.

Similarly, because of the lack of documentation there is no study of the movement of salvages throughout the American colonial period. As early as *c.* 1830 at Perley Poore's Indian Hill, West Newbury, Massachusetts, elements of woodwork from the Stuyvesant House in New York were incorporated, and there must have been more of this type of salvage. This was twenty years before Perley Poore's son Ben compiled what William Sumner Appleton described as 'amazing congeries of rooms' at Indian Hill (Fig. 196) using salvages from famous Boston buildings, including the Old Province House, the Old Brattle Street church, the John Hancock House (demolished in 1863) and the Tracy House in Newburyport. By 1887 the *Exeter News Letter* could describe Indian Hill as a 'veritable museum of antiquities'.[3] As Poore was a genial and much-visited host, the internal décor of this house must have been influential. This was then exceptional in the USA, but of course not in Britain, and it may not be a coincidence that both Perley Poores, father and son, had visited Sir Walter Scott's Abbotsford,[4] and obviously elsewhere in Britain. However, Abbotsford was a very different sort of house, and one in which salvages were not predominant, as they were at Indian Hill, where the manner of incorporation was perhaps closer to the model of unsophisticated antiquarian interiors at Lord Llangattock's The Hendre,[5] compiled in the later nineteenth century from a 'congerie' of old Welsh salvages. When the *American Architect and Building News* reported in 1876[6] on the renovation by the Boston firm Cabot & Chandler of Beverley Farms, originally built in 1845, they specified how the 'interior finish' was

197. 'Whistler's Peacock Room', *New York Herald*, 17 July 1904

'largely made up of old wainscoting and panels taken from the houses of the ancestors of Mr and Mrs Henry Lee, and all new finish is made to correspond'.[7] This was reported as an event of unusual interest.[8] The year 1876 also saw an exhibition of Colonial relics held at the Old South Meeting House in Boston, when a parlour and a kitchen were composed and lent by Ben Perley Poore from Indian Hill.[9] Furthermore, the same year saw the Philadelphia International Centennial Exposition, which not only exhibited interior displays that were remarkably like later antique shop arrangements, but was immensely influential in the reassessment of Colonial architecture: after the exhibition a Colonial Revival gathered pace. We may detect in the Centennial exhibits a tendency towards historicism. In 1876 too, Mrs Lawrence of Boston bought from the London trade what became known as the Lawrence Room, a composite made up from Anglo-Flemish late sixteenth-century woodwork, probably intended for private installation, although she may originally have meant it for the emergent Boston Museum of Fine Arts. No other exported English room is documented until Charles Lang Freer bought the famous Whistler Peacock Room (Fig. 197) for his house on Ferry Avenue, Detroit, in 1904, but this did not form part of a transatlantic trend.

Beauport, a marine villa built by Halfdan M. Hanson from 1907 at Gloucester Harbor, Massachusetts, for Henry Davis Sleeper,[10] was a natural but later successor to Indian Hill. It was known as the American Strawberry Hill, and Horace Walpole would have appreciated its asymmetrical growth, but no more. Like Ben Perley Poore, Sleeper wove into his interiors salvaged woodwork, the first batch of pan-

elling coming from the William Cogswell House in Essex, Massachusetts (Fig. 198). Beauport was almost continuously extended and remodelled until 1925. In 1935 it was sold to Helena Woolworth McCann, who some time after 1936 made decorative alterations to Sleeper's China Room that included the installation of a rococo Gothick marble chimneypiece (Fig. 199) of superb quality comparable to that convincingly attributed to Sir Henry Cheere in the Woodcote Park Room at the Museum of Fine Arts, Boston. In a sense, Beauport represents one of two strains in the history of the American interior, for Sleeper was friend and mentor to Isabella Stewart Gardner,[11] whose celebrated and very influential house/museum at Fenway Court, Boston, opened in 1903. Sleeper may well have had an influence on some of her picturesque interior arrangements. Gardner's tastes were neither American Colonial nor Francophile, but represented the cosmopolitanism of Europe in an amalgam of French, Italian and Spanish styles.[12]

In contrast to the patrons of the Colonial style, Mrs Gardner as a type of collector could hardly have been more different. Her art advisers were Berenson and Duveen, and one of her architectural salvage suppliers was Stanford White. Between them they created what has been called the *grand goût américain*, formed by the weaving in of mostly Italian and French, but sometimes Spanish, architectural elements and salvages with works of art and

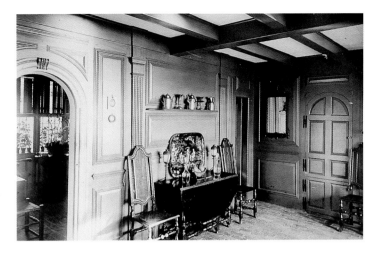

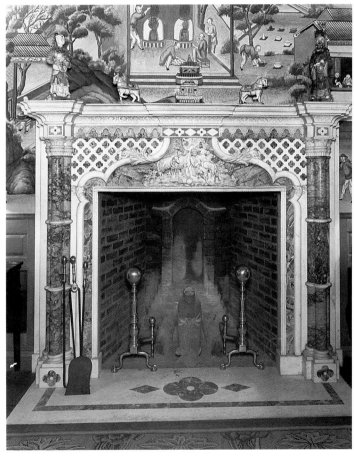

Beauport, Gloucester, Massachusetts

198. Interior

199. The Chinese Parlour. English rococo chimneypiece *c.* 1750s, attributed to Sir Henry Cheere

200. The Frick
Collection, New
York. English
chimneypiece *c.*
1740s, supplied by
Sir Charles Allom.
Now in the
Director's Office

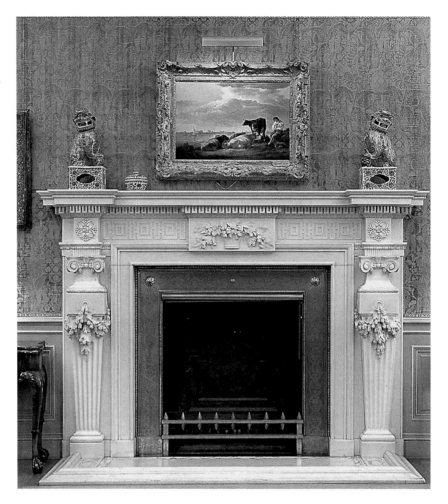

appropriate decorative elements. This was the chosen style for the likes of Henry
Clay Frick, the Vanderbilt clan, Pierpont Morgan, Henry Poor, or William
Randolph Hearst at San Simeon. The existing Frick Collection and the Pierpont
Morgan Library are models of this *grand goût*. For Frick, the interior style was an
invented one, and can be seen on the main floors decorated from 1913 by Sir
Charles Allom, who had been lured to Frick by his work at Buckingham Palace, and
on the upper floors by Elsie de Wolfe. Allom introduced on the second floor land-
ing, in the breakfast room, and in Mr Frick's office (now the director's office),[13]
three splendid English chimneypieces (Fig. 200) of the mid-Georgian period,[14] tan-
talizingly lacking provenance, although one may be from 15 Hanover Square,
demolished in 1904.[15] But then chimneypieces exported to the USA hardly ever
came labelled with their place of origin,[16] proof of which is to be found in most of
the commercial advertisements.[17] An exception was the meticulous documentation
initiated by the Hearst Corporation for Hearst's plundering of European salvages
and works of art. Many of the acquisitions from Italy and Spain went to decorate

and furnish Hearst's many residences, not least his castle at San Simeon, created throughout the 1920s from the twin minds of Hearst and his brilliant architect and interior decorator, Julia Morgan. San Simeon displays a sumptuous and matchless interior, fusing continental salvages of the highest artistic quality with appropriate modern décor.[18]

The one notable and unique exception to this stylistic division concerns an early import of a complete room from Mrs Blanche Watney's 49 Prince's Gate, London, a house that already incorporated salvages, including Thomas Cundy's staircase of 1818 retrieved from the demolition in 1874 of Northumberland House, The Strand. Here was the dining room decorated in painted Norwich leathers for Frederick Leyland in 1876 by Thomas Jeckyll, and 'improved' by Whistler into what became the famous and notorious Peacock Room. In 1904 Mrs Watney, no Whistler *aficionado*, consigned the room to the galleries of Orbach & Co. for sale, and as a Whistler patron, Charles James Freer snapped it up (Fig. 197)[19] for his house on East Ferry Street, Detroit. It did not leave without protest, the contemporary Whistler historians Dennis and Way hoping that the Victoria and Albert Museum might buy it.[20] Perhaps only Freer could afford the $42,000 or 8,500 guineas it was selling for. It could well qualify as among the most expensive of all transhipped rooms.[21] Apart from the exceptional case history of the Lawrence Room, the Whistler Room was the first of many English imports. However, it did not represent any measure of US Anglophile demands or taste. It was something apart from the patrons of a revived Colonial style, or those of the Gardner *grand goût américain* mould, or those Francophiles who pioneered the twentieth-century phenomenon of housing French furniture and works of art in a French *boiserie* environment.

Horace Trumbauer was a role model of an architect who catered for these Anglo-French Americans.[22] Although both Thomas Jefferson, in Paris from 1784 to 1785, and Gouverneur Morris, there from 1792, were familiar with the décor of French interiors and possessed a taste for French furnishings, when decorating their own houses in the USA they adopted a conventional Palladian–Colonial style. Even if they so wished, there were no craftsmen to carve and gild elaborate *boiseries*, and it was too early to expect them to match their French interests by importing them. However, this does not take into account an early French interior that may have incorporated some salvages. The architect was Richard Morris Hunt, the year 1879, the patron Egerton Winthrop at 23 East 33rd Street, New York. Of all Americans in his time, Winthrop was the most Francophile, having spent long periods in Paris. His Drawing Room as recorded by Walter Gay in around 1911 (Fig. 201)[23] is convincingly Louis-Seize in style and amazingly precocious even if it turns out to be copyist. In 1883, according to *Artistic Houses*,[24] the interior looked 'as if he had said to himself, I will create a Louis Seize room that shall reproduce the impression of an absolute original'. This may imply copyist work, but it could be mix and match, and its elegant decorative restraint is most uncommon in American interiors at this time, if indeed the room was coeval with the French Second Empire house as designed by Hunt. As a distinguished collector of French furniture Winthrop would certainly have been familiar with the Parisian *boiserie* salvage trade, although it

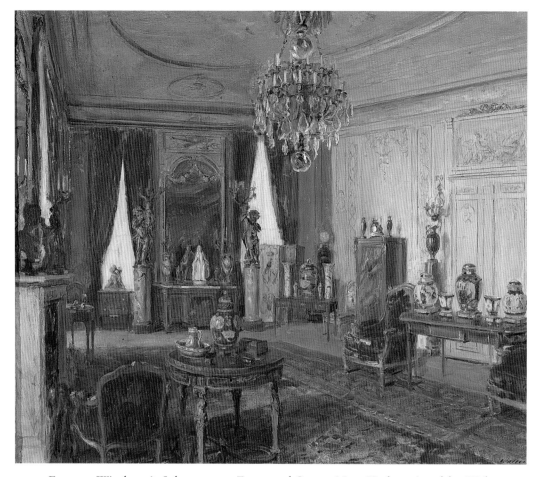

201. Egerton Winthrop's Saloon at 23 East 33rd Street, New York, painted by Walter Gay, 1911–12

would be another twenty years before Carlhian in Paris and French & Co. in New York were at hand to enthusiastically supply authentic *boiseries*.

It is no coincidence that Jules Allard had opened a branch of his decorating firm in New York in 1885, and Lucien Alavoine in 1893. Between them they were at the frontier of the Franco-American style, first demonstrated by Allard's import of Madame de Serilly's *salon* for The Breakers in 1894, and in 1904 by Senator William Clark's purchase, for his huge French mansion[25] at Fifth Avenue and 77th Street, of the famous Louis-Seize *salon* from the hôtel d'Orsay in the rue de Varenne, Paris. In a decidedly *goût grec* taste, this most distinguished room had been designed *c*. 1769 by J.F.T. Chalgrin for Pierre-Gaspard-Marie Grimod, comte d'Orsay. Clark's purchases of French works of art included *torchères* from the estate of the comtesse Dutchâtel, who had owned the hôtel d'Orsay since 1838.[26] Senator Clark's great house was a prominent advertisement for the Franco-American style, far more so than The Breakers.

In 1904 Carlhian, or rather Carlhian–Beaumetz as they were then, were still manufacturing reproductions of famous pieces of French furniture. Encouraged by their friend and associate Joseph Joel Duveen, the firm would soon outstrip all other dealers not only in the supply of *boiseries*, but also in composing faultless mix and match interiors of supreme sophistication and taste. If Winthrop's interiors were mix and match they anticipated this ideal. Whereas Allard's French incorporation at The Breakers had been a pioneering installation, it now became *de rigueur* to exhibit French works of art and furnishings in a French ambience. In this Trumbauer triumphed, with Carlhian and maybe French & Co. on call for French

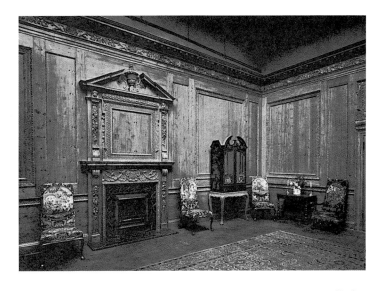

202. Hamilton Palace, Lanarkshire. George I pine panelled room, chimney wall, as set up in French & Co. gallery probably after white and gold paint stripping and before sale to Dr A. Hamilton Rice. Sold New York, 1965

décor, and Sir Charles Allom for English. In fact Trumbauer is a model for the manner in which modern American houses become vehicles for the installation of salvages. This was notably the case with the many members of the Widener family nearly all of whom were Philadelphian and so employed the Philadelphian Trumbauer and his team, only occasionally introducing English salvages. For Robert L. Montgomery at Ardrossan, Villanova, Pennsylvania, 1912–14, the style was invented English seventeenth-century, and not surprisingly White Allom was at hand to provide some original panelling and wood carving in the 'Gibbons' style probably from Holme Lacy, Herefordshire. It would appear that the English-style interiors at Edward T. Stotesbury's vast Palladian Whitemarsh Hall, Wyndmoor, Pennsylvania, 1916–20, were the inventions[27] of Sir Charles Allom in cahoots with Duveen, as at Hursley Park, Hampshire, in 1905.[28] Carlhian came into his own in partnership with Duveen for Mrs Alexander Hamilton Rice[29] at 901 Fifth Avenue, whose work was begun by Trumbauer in 1921. Her exquisite house was a showcase for the French furniture and works of art collected by her and her late husband. In the dining room could be found Louis XV *boiseries* from the Château de Norville,[30] sold by the Paris dealer Fauché to Carlhian in 1907; in the Small Octagonal Drawing Room were *boiseries* from a *hôtel* on the place des Victoires; and as a contrast, in the 'Medieval' Library there was a French Gothic chimneypiece. Yet nothing quite matches the perfection of one of two Louis XVI drawing rooms that Carlhian designed for Mrs Rice, the first when she was Mrs Widener at Miramar, Newport, Rhode Island, 1912–14; the second in 1923 at 901 Fifth Avenue, when she was Mrs Hamilton Rice.[31] In both

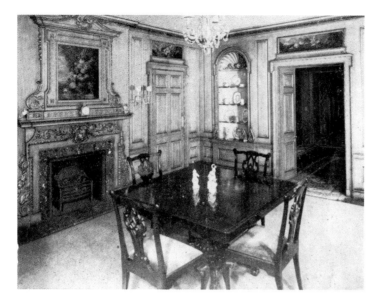

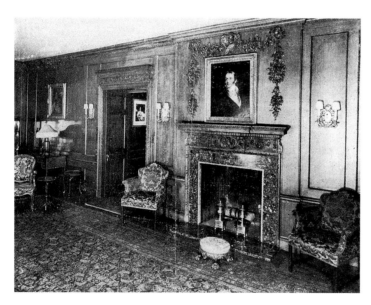

Wynnefield, Philadelphia

203. Horace Trumbauer's English Dining Room

204. Horace Trumbauer's English Sitting Room

cases Trumbauer was the architect.[32] The rooms were based upon the paper evidence of Madame du Barry's dining room in the Château de Louveciennes, and the reason for this copyist solution, rather than using salvaged Carlhian *boiseries*, was Mrs Rice's need on both occasions for an especially large entertaining room possessing built-in vitrines for the display of her porcelain and wall space for tapestries; and of course a room large enough for the arrangement of her superb collection of French furniture and works of art. By repute there were several English rooms upstairs, including a 'George I Pine Panelled Room' from Hamilton Palace, (Fig. 202) one of those bought from Roberson by French & Co. It was acquired by Dr A. Hamilton Rice, installed in New York, but later dismantled and taken to Newport, where it was to suffer in store.[33] The original white and gold painted décor had been entirely stripped away, probably in Robersons' acid baths.

From the post-Depression years French rooms would pour into the USA, indeed into the Americas, for Carlhian maintained an office in Buenos Aires, and it is reputed that from 1913 to 1953 this firm alone exported more than a 100 rooms or sets of *boiseries*. Nearly all would later become peripatetic, so it is no surprise to enter La Colombe d'Or Hotel in Houston to find the Louis XV rococo *salon* of the comtesse de Greffulhe, of unknown primary provenance, but installed in the late 1880s in her château of Bois-Boudran near Fontainebleau. Removed after her death in 1952, it was eventually bought by the Texan oilman John W. Mecom.[34]

Not surprisingly with Trumbauer's English-style houses, the tastes of the client determined the décor of the rooms, as at James B. Duke's Rough Point, Newport, 1922–23,[35] or at Ronaele Manor in Elkins Park, Pennsylvania, 1923,[36] where Fitz Eugene Dixon's passion was for collecting stained glass from old English houses.[37] In both cases the exteriors are in Trumbauer's English Picturesque Tudoresque, and the interiors are, by virtue of the picturesque configuration, asymmetrical and low-ceiled. It may seem surprising that this master of French classicism should choose an English cottage for his own house, at Wynnefield, later 2246 North 52nd Street, Philadelphia, in which he installed at least two English rooms (Figs 203–4) one of an English mid-eighteenth-century Stanwick Park, Yorkshire, vintage, the other with an overmantel of Gibbons-style Cassiobury carvings.[38]

The most striking fact about the purchase of the Hamilton Palace rooms by French & Co. was that ducal rooms on this scale were too high for the average English-style 'Tudorbethan' American house, and certainly for a typical room in an apartment block. Even large houses in Newport, Rhode Island, would have had difficulty in incorporating the ducal rooms. Their

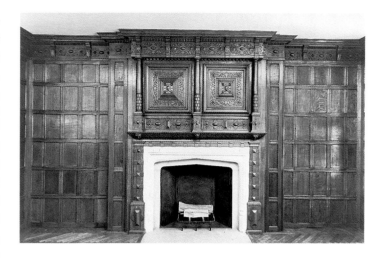

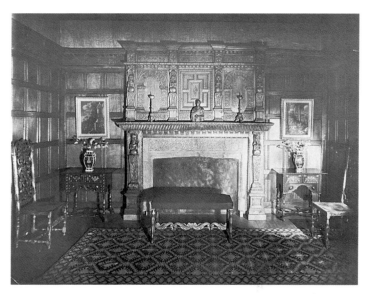

205. Room from Brailes Manor House, Warwickshire as installed for Judge Irwin Untermyer at 560 Fifth Avenue, New York

206. Jacobean room as installed for Judge Irwin Untermyer at 560 Fifth Avenue, New York

scale better suited museums such as the Metropolitan Museum of Art, able to install a grand room such as the Kirtlington Park saloon. Available British rooms on this scale may not have been exported for this reason.

A bevy of dealers and decorators specialized in the supply of composite Elizabethan and Jacobean interiors,[39] notably Charles of London and Roberson of the Knightsbridge Halls. Between them they accounted for much of the transatlantic

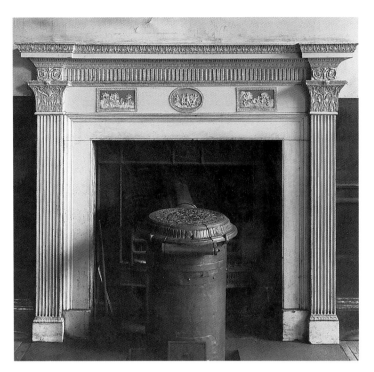

207. Belvedere, Kent. The James Stuart chimneypiece before removal to Crowthers of North End Road. Now installed in a private Michigan collection

trade in the 1920s before the stock market crash. A typical installation might be Judge Irwin Untermyer's rooms (Figs 205–6) in his apartment at 960 Fifth Avenue, New York. At least two panelled rooms with Elizabethan carved wood chimneypieces and overmantels were supplied by Charles of London, one of which was invoiced in 1928 as coming from Lower Brailes Manor House, Warwickshire,[40] to provide an appropriate ambience for Untermyer's distinguished collection of English walnut and mahogany furniture. Untermyer's was no exception, for in truth there must have been hundreds of comparable English Jacobethan-style installations, not only on the east coast, but throughout the USA. The documentation for Charles is sparse, and no study has been made of what salvages might have been installed in those houses illustrated in Charles's *Elizabethan Interiors* [1915], but in compensation Roberson's *List of Some of the Panelled Rooms Installed in America by Robersons of London*[41] is a measure of the extent of the importation of English salvages into American accommodation throughout the 1920s by just this one firm. In general the Roberson houses were in a quite different stylistic category to those of the *grand goût américain* sort. They were either English half-timbered 'Tudorbethan', the style used by John Russell Pope in 1918 for Allan S. Lehman's Elmbrook at Tarrytown-on-the-Hudson, New York,[42] with a mix and match of both salvage and modern imitation, or a Colonial interpretation of a 'Wren' style, as at David Adler's Castle Hill, Massachusetts, for R.T. Crane Jnr in 1924, which absorbed much original panelling from 75 Dean Street, Soho, London. With the exception of Randolph Hearst,[43] the Roberson list[44] includes seventeen private installations, of which ten can be singled out for comment.

Mr Ralph Booth of Detroit was Ralph Booth I of Washington Road, Grosse Pointe, Michigan, whose architect in 1921 was Marcus Burroughs. Significantly, Booth was also a director of Robersons. As Ralph Booth II as commented,[45] it was on 'a visit to the Knightsbridge Halls on or before the spring of 1923 that the following purchases were made': from Hamilton Palace, a 'Very large pietra serena chimneypiece with coat of arms of Cantucci family of Florence, workshop of

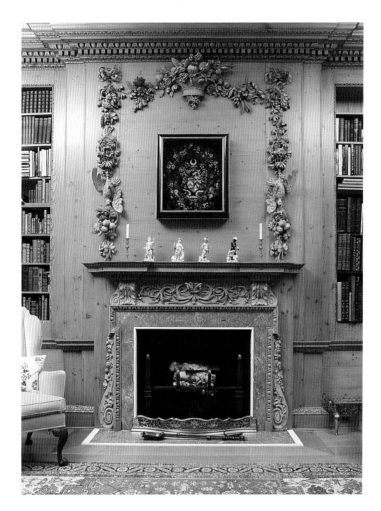

208. Brixworth Hall, Northamptonshire. The Library with added Grinling Gibbons style overmantel carvings

Donatello, *c.* 1490, removed from [the] Throne Hall . . . Plus two Italian carved white marble doorways and overdoors.' From Standish Hall, Lancashire, 'a complete William and Mary oak library or cabinet room.' From Grosvenor Square, London,[46] panelling with carved Corinthian columns, and from Wingerworth Hall, Derbyshire, an 'early Adam Aesop fable green and white marble chimneypiece, taken from small white drawing room' and an early Adam mantel, 'made by Adam from drawings by Flaxman from the collection of Lord Wingerworth.'[47] Robersons also completed all the first floor reception rooms in the house using a variety of salvages. The present family have recently acquired salvages for a different house from Crowthers of the North End Road. These include James Stuart's Wedgwood chimneypiece from Belvedere, Kent, demolished in 1957 (Fig. 207); a panelled room with a Gibbons-style chimney overmantel of *c.* 1725, adapted as a library, from Brixworth Hall, Northamptonshire, (demolished 1954) (Fig. 208),[48] first installed in the house of Mr and Mrs Henry Ford II at 457 Lake Shore Road, Grosse Pointe, demolished in 1983;[49] and a Derbyshire Spa chimneypiece, probably originally from Sydnope Hall, Darley Dale, Derbyshire.

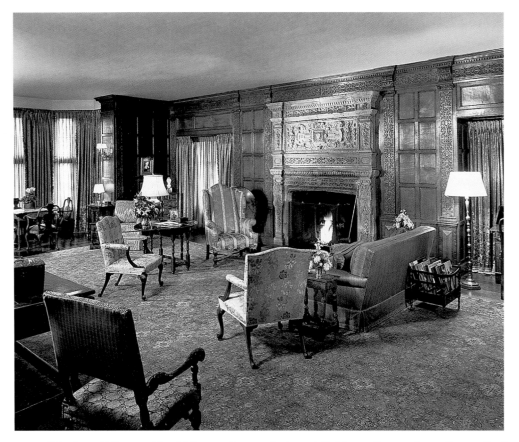

209. Edsel and Eleanor Ford House, Grosse Pointe, Michigan. Room from Deene Park, Northamptonshire, as installed by Charles Roberson

MR R.T. CRANE, JR of Castle Hill, Ipswich, Massachusetts, was the purchaser of the fictitious Thornhill–Hogarth Room (Fig. 177) from 75 Dean Street, London, presented to the Art Institute of Chicago. He and his wife also acquired most of the other panelled interiors from Dean Street which were mulched-up to embellish Castle Hill: the building was created by David Adler[50] from 1924 as a clever pastiche of the grafting of Belton House, Lincolnshire, with Ham House, Surrey. In many rooms, notably Florence Crane's Sitting Room and the dining room, are obvious salvages from Dean Street, although for the staircase it was necessary for Adler to replicate the Dean Street woodwork,[51] which also went to the Art Institute, minus its mural paintings,[52] which are now attributed to William Kent. However, the most distinguished of these salvages imported into Castle Hill was not from Dean Street, but from the the Great Library at Cassiobury Park, Hertfordshire, a superb overmantel enframement by Grinling Gibbons, supplied by Roberson for the Castle Hill Library, in which Cassiobury's later eighteenth-century bookcases by James Wyatt were also installed.

Mr Edsel B. Ford was of the Edsel and Eleanor Ford House at 1100 Lake Shore Road, Grosse Pointe Shores, Michigan, a Cotswold-style house built to Albert Kahn's designs from 1926 to 1929. Robersons installed five rooms, plus a 'Gothic Stone and Oak Gallery' with linen-fold and a late medieval stone-hooded chimneypiece from Wollaston Hall, Worcestershire, a large timber-framed house demolished in October 1925.[53] This was intended for the gallery, to which Roberson added a barrel-vaulted ceiling based on the ceiling at the Wotton family seat at Boughton Malherbe, Kent, as recorded in Nash's published lithograph.[54] In addition he supplied a 'Gothic Stone and Oak Corridor' and a 'Stone Hall with 17th Century Oak Staircase'. The dining room panelling, doors and adapted chimneypiece came from New Place, Upminster, documented by measured prints in Roberson's typical paper-covered brochure, labelled, 'Pine Room from The Clock House, Upminster' (Figs 225–26).[55] The similarity between the rococo carving of the chimneypiece and that in the morning room would suggest that the latter also came from Upminster, although the pan-

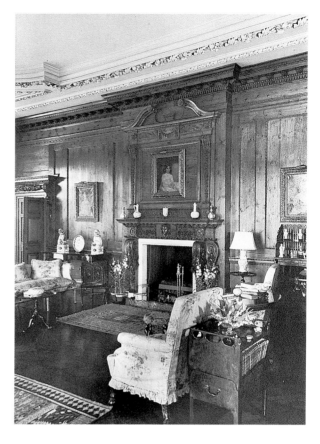

210. English room reputedly from Stanwick Park, Yorkshire, c. 1730. Installed in Childs Frick House by Charles Roberson. Now Nassau County Museum of Art

elling is said to have come from a house in Spitalfields, London. The staircase is noted as coming from Lyveden Old Beild, Northamptonshire, but almost certainly came from Lyveden New Beild, the other and nearby Tresham house. Surprisingly, the library panelling and the stone Elizabethan chimneypiece (Fig. 209) came from Deene Park, Northamptonshire, possibly rejected from the old house when the Cardigan Banqueting Hall was built in the 1860s, but more likely brought to Deene by George Brudenell in 1919 with the Oak Parlour, from a small house near the demolished Howley Hall, Yorkshire, once a Brudenell seat.[56] The date of 1919 would fit in very nicely with Roberson. The study at the Ford House is panelled with a wooden chimneypiece overmantel dated 1585, from Heronden Hall, Kent.

Mrs Childs Frick Roslyn, Long Island is now the Nassau County Museum of Art at Roslyn Harbor. The Roberson list under this entry is inscribed in pencil in a later hand, 'great Room from Stanwick Park', Yorkshire. If true,[57] it was an appropriate salvage, for the house built by Ogdon Codman in 1900 was in English

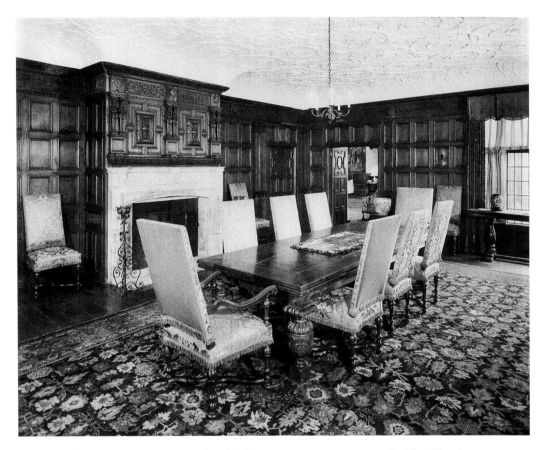

211. Jacob Aron House, Long Island. The Dining Room as supplied by Charles Roberson before demolition in 1968

Williamite style. Childs Frick, son of Henry Clay Frick, bought the estate in 1919,[58] when Roberson, acting for Frick's architect Sir Charles Allom, supplied the grand panelled room with its superb chimneypiece (Fig. 208) whose mantel is draped with luscious bunches of grapes. In the dining room is a chimneypiece identical to one in the Royal Ontario Museum, Toronto, to one at Hursley Park, Hampshire, also a White Allom installation,[59] and to one in the Frick Collection. Therefore its authenticity, as coming from 15 Hanover Square demolished in 1904, is in doubt until the original can be located and identified.

JACOB ARON, GREAT NECK, LONG ISLAND, was of Hamptworth House. The house of that name in Hampshire may be the provenance of Robersons' 'Fine Elizabethan Dining Room' (Fig. 211). At the demolition of the Aron house in 1968 the room was given to the Brooklyn Museum of Art, which passed it on to the Royal Ontario Museum, Toronto, which de-accessioned it. When exhibited in Robersons' Knightsbridge galleries, possibly after removal from Hamptworth House in Hampshire, the room was said to have come from the unidentified Bladud's Castle, Devonshire.

DR EDGAR SAMPSON, FOREST HILLS, LONG ISLAND, the present home of Dr and Mrs Pedro Saye of Forest Hills Gardens, was designed in English half-timber style by Mr Rogers' architect. All the rooms are composites, the staircase with seventeenth-century balusters, the dining room with a good stone late Gothic chimneypiece, the living room with much composite 'Jacobethan' and later panelling under a Tudor-style plaster ceiling. It is impossible to match elements with known Roberson salvages.

CLARENCE LEWIS, BLAIRS BANK, NEW YORK, lived at Skylands Farm, a large stone mixed Tudor-style mansion by John Russell Pope, completed in 1928 and now the New Jersey Botanical Garden. Robersons' contribution of a 'Fine Elizabethan Oak Dining Room' was illustrated in *Country Life in America*.[60] The breakfast room contained a fine Italian early Renaissance marble lavabo.

MR RICHARD, NEW YORK, was of 'Milbury Meadow'. Built by John Russell Pope in 1928 for Harold C. Richard, the house overlooks York Harbor, Maine. Illustrations[61] do not make it clear where the 'Elizabethan Oak Room for Living Room' was sited. The house burnt down in 2004.

MRS MCCANN, OYSTER BAY, LONG ISLAND, MR HUBER, ARCHITECT is 'Sunken Orchard', Berry Hill Road, Oyster Bay, New York, known for its gardens designed by Annette Hoyt Flanders. Mrs McCann was the daughter of F.W. Woolworth, and the house was remodelled and extended for her before 1928.[62] The Roberson entry is pencilled 'Stanwick Park', and this was confirmed when fittings in this house were sold at Parke-Bernet Galleries, New York, 19 November 1942: Lot 7 panelling from Stanwick Park, Yorkshire.

MR WISTER MORRIS, ARCHITECT NEW YORK A Fine quality Pine Jacobean Panelled Living Room fixed in Connecticut, may possibly be 'Quiet Corner', Greenwich, Connecticut, in 1908 the residence of Clyde Fitch and designed by Benjamin W. Morris.[63]

The Roberson installations or incorporated rooms have an overall cohesion, because Roberson was in charge of installing his familiar English salvages, creating what he regarded as an English ambience throughout the house. What strikes the observer is the average, rather than exceptional, quality of the salvages used. Indeed, many of the houses might be described as bourgeois; rarely are any in the American grand style. The Aron House living room is typical of a Roberson furnished ambience, as is that other Roberson job, Elm Court, Butler, Pennsylvania, built by Benno Janssen from 1929 for Benjamin Dwight Phillips, president of the Phillips Gas and Oil Company of Butler. In allusion to Phillips's enthusiasm for his ancient English ancestry Janssen gave him an English manor house with suggestively monastic origins. This house near Pittsburgh was probably the one where 'Mr Fred Olsen', Roberson's 'man', 'has to take charge of the erection of six rooms'.[64] Today it is the home of Fred Koch, and the only identified salvage is in the drawing room,

the 'Anne of Cleves' Elizabethan overmantel, reputedly from Chelsea Manor House, combined with an invented mantel.[65] This may also be the source of the unidentified 'Room from Chelsea' bought by Hearst (Fig. 220).

As Robersons' trade illustrations show, when possible the firm presented their rooms in their galleries as furnished. This was also the case with Arthur S. Vernay, a passionate Anglophile New York dealer, whose early eighteenth-century Ionic pilastered room from Stourbridge, Worcestershire (Fig. 110), was advertised as it might be furnished with appropriate pieces from stock.[66]

Those English Tudor or Colonial style houses or apartments in the USA, built or furnished throughout the 1920s and 1930s, in which English salvages were installed, must number in the hundreds.[67] It is quite clear that in a resort such as Palm Beach, houses and apartments must incorporate many salvages that come and go according to the whims of patrons or decorators. Even when a salvage is located its provenance is usually unidentified. It is telling that in Roberson's list not a single room carries any identification, and with a few exceptions his clients were ignorant of the source. The auction rooms in New York continue to receive a succession of chimneypieces or interior elements bearing no label.[68] An example of the frustration in locating identified salvages is the case of a 1930s vintage Colonial style house with a portico,[69] possibly in Virginia or Maryland, in which a decorator installed Robert Adam's famous octagon Tea Room with papier mâché Palm Tree columns, designed in the early 1760s and removed in the 1930s from a garden pavilion at Moor Park, Hertfordshire. The octagon with the palm trees at the angles had been expanded to occupy a large drawing room. Its location has eluded this author and regional historians for more than fifty years.

Compared to many of Robersons' conservative installations, Caramoor at Katonah, New York, is refreshingly different, illustrating arbitrary and quirky decorator's taste in the assemblage of an eclectic array of salvages. Today it is no longer the private home of Walter Tower Rosen, but the Caramoor Center for Music and the Arts. To come upon its yellow Mediterranean stucco walls and red tiled roofs on the cold eastern seaboard is to experience a house that belongs in style to the warm climes of southern California. Rosen (1875–1951), lawyer, banker and musician, built it from 1929 to 1939 to house his collections, although it is difficult today to distinguish what salvages were abstracted from his town house at 35 West 54th Street, New York, when it was dismantled after his death in 1970 by his widow, Lucie Bigelow Rosen. Much was incorporated into the new wing built for her at Caramoor by Mott B. Schmidt in 1974. The interiors are redolent of Rosen's personal authority, a mix of predominantly Italian and Spanish ornamental and decorative salvages, described in Colin Streeter's *A Guide to the Collections of Caramoor*, which details the source of the salvages when known.[70] Caramoor is not a receptacle for many English décors, with the exception of the reception room's Corinthian pilasters 'made about 1740', and from a house in Dorset, probably Spettisbury House, broken up by Roberson when it was demolished in 1927; and door surrounds from Hales Place, Kent, built in 1743 and demolished in 1938. Elsewhere an English rococo chimneypiece with a papier-mâché overmantel can be

found in Mr Rosen's bedroom, and another bedroom has an English Jacobean chimney and overmantel. The variety of the continental salvages does not make for an entirely harmonious interior, almost entirely due to Rosen's friend, the Venetian antique dealer Adolphi Loewi, in particular the Monkey Bedroom with French salvages; the La Loggia Bedroom with tempera on paper panels from the Villa La Loggia, Turin; the library from salvages from a château dated 1678 in Aveyron, France; the west foyer with imitation oriental lacquer panels from the Palazzo Riccasoli, Turin; the music room with early eighteenth-century painted panels by Girolomo Andrioli, and a coffered ceiling from a *palazzo* in Lecce; the Spanish Alcove with a wooden ceiling from Illescas, Spain; the east foyer with painted landscapes *c.* 1810 from the Cascina Bogino, Moncalieri, Turin; the powder room with chinoiserie scenes from the Villa Menafoglio-Litta at Biumo Superiore, Varese, North Italy; the dining room composed of lacquered doors from the Palazzo Ca' Rezzonico, Venice, gilded door surrounds and overdoors from a villa north of Turin, early seventeenth-century panelling from Brunico in the Italian Alps; the Val d'Aosta Room from a late sixteenth-century house in that place; as well as two rooms from the Rosens' town house, and the Italian Neo-classical Library, painted by Filippo Santi of Perugia in 1802.

No book on the import into buildings of salvages can neglect to mention Henry Francis du Pont's house at Winterthur, or omit reference to Colonial Williamsburg,[71] for both are iconic statements and, in their educational role, hothouses of curatorial expertise in the study and reassessment of American Colonial architecture, decoration and the applied arts, following the initiative of the American Wing opened at the Metropolitan Museum of Art in 1924. Colonial Williamsburg is a creative and learned invention. Old floorboards from English mansions may well have been used, but decorative salvages were never installed.[72] The policy of successive Williamsburg curators has been revision of the status quo.

In 1923 Henry Francis du Pont had been captivated and inspired by Harry Sleeper's house at Gloucester, Massachusetts. Indeed, even more than this, for Du Pont saw Sleeper as a mentor in decoration. The physical end product of Du Pont's odyssey into the collecting and display of American furniture and the decorative and applied arts might be described as a rabbit warren of more than 150 rooms on nine floors.[73] The overall effect is surreal. It is difficult to know where a private house begins and a museum ends. In fact it is the largest collection of such salvages within any single private building in the USA,[74] or, it might be said, in the world! Upon inheriting Winterthur House in 1927, Du Pont instructed his architect, Albert Ely Ives, to begin drafting plans to incorporate his collection of salvaged American woodwork and furniture into what was then a modest house. Even after the Second World War, when this compulsive collector employed the more professional and learned Thomas Waterman as architect,[75] he personally monitored every installation. Of course, Winterthur is a collection of American, not European, salvages, but what is relevant in any assessment of Winterthur – and the same criteria may be applied to the Art Institute of Chicago's miniature rooms – is that they are a product of their time, not of the earlier epochs that they are supposed to present. Indeed,

Du Pont and Waterman's necessary disregard for authenticity, due to the need to stretch or reduce, to mix and match, can be paralleled by that very same need we find in most period room installations in museums. Of the hundred-odd rooms on display at Winterthur, few survived their transition intact from either a dealer or extraction from a Colonial house, as Waterman's designs in the Library of Congress demonstrate. Winterthur is an extraordinary experience, but it can also be seen as an American house writ too large.

The recreation of Colonial Williamsburg, notably the Governor's Palace,[76] can be compared, twenty-five years later, with the recreation of Tryon Palace at New Bern, North Carolina, another Colonial governor's state accommodation. Governor William Tryon's Palace was built from 1767 to the designs of an expatriate English architect, John Hawks.[77] Subsequent to a fire in 1798 that burnt the palace to the ground, the site remained empty except for the ruined and disfigured west wing, until the 1950s when it was decided to set up a Tryon Palace Commission and do a 'Williamsburg' by building a new palace based upon Hawks's surviving elevations.[78] The Tryon Palace that arose phoenix-like from its ashes opened to the public in 1959.[79] Unlike the distinguished consultative committee that advised upon Colonial Williamsburg, determining the making of an entirely modern 'authentic' interior, the Tryon Commission preferred a more 'creative' restoration of otherwise unknown interiors by importing English salvages that seemed appropriate for a house of the late 1760s. Because a full historical study of the restoration programme has never been made,[80] there is little evidence to show how William Graves Perry, the restoration architect, obtained interior salvages from the trade. No doubt he first confided in American dealers, and soon latched on to T. Crowther & Son, a firm notorious for forgetting or even inventing provenances. Therefore it is a surprise to read a memorandum written in 1975 by Gertrude S. Carraway, who was then director of the Tryon Palace Restoration. 'Miss Gertrude', as she was known, had worked closely with Maude Moore Latham who had financed the rebuilding of the palace.[81] In this rare instance Crowthers supplied what provenances they knew, mostly for chimneypieces: from Teddesley Hall, Staffordshire, Weald Hall, Essex, Halstead Place, Kent, Kirkby Mallory, Leicestershire, and Coldbrook Park, Monmouthshire, as well as window shutters from Gopsall Hall, Leicestershire and the dining room doorway from Weald Hall. An exception was a pine chimneypiece bought from C.J. Pratt, 186 Brompton Road, London, for the drawing room.

Since the discovery of the Francisco de Miranda/John Hawks memorandum on the interior décor of 1783, voices at Tryon have been raised urging that the interiors should be remodelled according to Hawks's descriptions. This would be sad, for it would then conform to the failed policy at Colonial Williamsburg, where each successive internal revision has shown itself to be a product of its time. Tryon Palace looks and feels like an interior of the 1950s, and it should surely remain so.

10

WILLIAM RANDOLPH HEARST
THE GREAT ACCUMULATOR

WILLIAM RANDOLPH HEARST (1863–1951), the model for Citizen Kane, is an enigma. So prolific was he as a magpie accumulator of salvages that it is difficult to evaluate his discrimination when the vast scale of his acquisition is considered. 'Collecting' implies acquisition with a collection in mind, but so mind-blowing was the scale of his purchases, so diverse and unequal the quality, so grotesque the utter lack of self-discipline, that his motivation, beyond the lust of acquisition, is baffling. Sir Joseph Duveen regarded Hearst as an accumulator rather than a collector.[1] The two were wary of each other, but in dealing Duveen nearly always came out on top. Hearst had declined an antique room for sale from another dealer for $50,000, but later paid Duveen $200,000 for the same room. Mitchell Samuels of French & Co., one of his trusted agents as well as a friend who tried to save him from rash impulses and to school him in the economics of bidding, sold Hearst $8 million worth of goods. It was more than his business was worth not to bow to Hearst's indecisions. The case of the Hamilton Palace staircase that went back and forth at least twice before ending up once again with French & Co. is notorious.

All of this was possible with a client whose annual income was conservatively estimated at about $15 million.[2] It reminds one of that aphorism, 'Shop, shop shop, till you drop drop drop', which eventually Hearst did. If he possessed one passion, apart from his mistress Marion Davies, it was as a compulsive buyer. Nasaw aptly describes his methods:

> Hearst did not rely on 'experts' to tell him what to buy and why. Like J. Pierpont Morgan, the collector he most resembled in the catholicity of his tastes and the money he spent to indulge them, Hearst did not limit himself to one scholarly advisor, or to one specific period, one genre, or a single standard of taste. And like Morgan, he never sought to strike a bargain for anything he wanted. He bought from every major dealer and gallery in Europe and New York City.[3]

In Britain and Paris Alice Head, managing director of his English company, author-ized and negotiated his buying; in Italy his agent was Luigi G. Gallandt; in Spain

Arthur and Mildred Stapley Byne; in Germany and Central Europe Karl von Wiegand – Hearst evoking all of them 'to employ or retain, with additional payment for each definite assignment, some experts on armor, pictures tapestries, etc'.[4] Thank God that internet buying was not yet invented! Again to paraphrase Nasaw, during every day of Hearst's life priority was given to dealing with the huge piles of catalogues, brochures, letters and photographs that had been sent to him by agents, dealers and runners.

The shipping and reception of millions of purchases, whether shoe buckles, wine-glasses or old New England wagon seats, happened at the five-storey warehouse in the Bronx on 143rd Street near Southern Boulevard. After 1922 Chris MacGregor was his manager there; later it was C.C. Rounds, and Miss Schrader kept the New York accounts at Hearst's Clarendon Apartments. Under MacGregor a staff of twenty – clerks, photographers, bookkeepers, packers, custom clearers, cabinet-makers, and even a Scots armourer – received the artworks from Europe, cata-logued them, and when necessary shipped them west to San Simeon or to another of his many properties. The purchase dockets, now to be found in the library of the Long Island Post College Campus,[5] reveal something of the curatorial methods, containing information on dealer and price, sometimes location, disposal notes, and photographs. As far as is known, Hearst never envisaged a museum, although in his Clarendon Apartments on Riverside Drive he possessed two 'museum' rooms.

His mother, Phoebe Apperson Hearst, in retrospect and probably a little exag-geratedly, commented that at the age of ten her son already possessed 'a mania for antiquities'.[6] One of his first salvage acquisitions may have been made with his sec-retary George Pancoast in 1892, when peering into a courtyard in Verona and exclaiming, 'Look at that well!'[7] Very soon the well-head (*pozo*), weighing several tons, was installed in the gardens of Mrs Phoebe Hearst's Hacienda del Pozo de Verona, near Pleasanton, California.[8] Mrs Fremont Older described Hearst's Worth House on 25th Street, New York, where from 1897 to 1900 he 'put in beamed ceil-ings, tiled floors, rare mantels, and furnished the rooms with antique furnitures and tapestries'.[9] The mention of 'rare mantels' may imply salvaged European ones, although this would be early. In 1900 he moved to 123 Lexington Avenue, where by 1905 he may have installed his first period or composite room,[10] a 'quaint oak din-ing room with deer antlers for chandeliers'.[11]

By 1913 Hearst had bought the Clarendon Apartments at 137 Riverside Drive, eventually occupying five floors. Older refers to the building's 'vast, high, distin-guished Gothic hall, gleaming with armour',[12] in addition to a Tapestry Gallery, a Greek Room, a two-storey Spanish Gallery, the Gothic Room, the Julius Caesar Room,[13] (Fig. 15) a North and South Museum, and an English Room, the last pre-sumably a panelled one. The Clarendon would serve as Hearst's personal head-quarters until he left New York for California in 1935. The first decade in the new century, when Hearst began to make his mark as a buyer and accumulator, was sig-nificant for other reasons. European dealers, such as Charles (Duveen) and Lenygon & Morant, of London, were setting themselves up in New York, where the rallying point for collectors in 1907 was the Stanford White sales organized by the

American Art Association[14] at his Gramercy Park North mansion following Stanford White's death in 1906, when Hearst and John D. Rockefeller 'fought like schoolboys over everything in sight. Hearst got most of the stained glass windows and the Venetian weather vanes to supply San Simeon . . . They divided the Renaissance doorways and sarcophagi and came out even on the Caen stone well curbs'. Hearst paid $8,000 for a 'ceiling with personages identified as Angels Bringing Tidings of Christ's Birth', later installed in the Doge's Suite sitting room at San Simeon.[15]

All this was but a prelude, a sort of quiet before the storm, marking the onset of the colossal scale of Hearst's collecting, nourished by the vast fortune left to him by the death of his mother in 1919. Now he could buy and build for the next twenty years until bankruptcy loomed large in the late 1930s. Hearst had met the architect Julia Morgan in 1919 and so began the progressive development of the San Simeon complex with this brilliant architectural adviser.[16] There was hardly a pause, even with the onset of the Depression. In 1925 Hearst had bought his mother's German Bavarian style castle at Wyntoon, Mount Shasta, northern California, and when it burned down in 1929, Bernard Maybeck and Julia Morgan[17] were commissioned to replace it with the grander village compound intended to house his German art collections; here transhipped salvages were not very evident, although there was at least one French Renaissance mantel. In 1925 he saw an advertisement in *Country Life* for St Donat's Castle in Wales and within a day the castle was his, although Hearst could not visit his new possession until 1927. After just one night's stay he was able to absorb everything that needed to be done, dictating a 25-page letter to his architect Sir Charles Allom, stating precisely what he wanted, eventually inserting more than 200 salvaged bits and pieces.[18]

Not content with this expense, from 1926 he began building the Beach House, later called Ocean House, at 415 Pacific Coast Highway, Santa Monica, for his mistress, the actress Marion Davies, initially to the designs of William Flanner; it was described as 'the largest house on any southern California beach . . . Even Marion does not know how many . . . rooms there are'.[19] Beach House began rather modestly to an original estimate of $7,500 and the intention simply to marry up three properties. Not content with this, Marion's ambitions led within four years to the spending of more than $7 million, including $4 million on furnishings and artworks for this 'Hollywood Versailles', with its 110 bedrooms and 55 bathrooms. It is difficult to disentangle truth from fiction, and it is a tragedy that documentation on the incorporated salvages is also absent. It is rumoured that $600,000 was spent on importing thirty-seven European chimneypieces. Most writers quote from the *Los Angeles Examiner* of October 1949, when the house had been converted into a hotel.[20] The *Examiner* article mentions Duveen, French & Co., Roberson and Charles as suppliers of the salvages. Perhaps the Venetian Ballroom of *c.* 1750 came from French & Co., although it was more likely from Adolph Loewi. From Roberson came the dining room, reception room and drawing room, 'each more than sixty feet long', taken out of from Burton Hall, Co. Clare, a house of 1749. The doorways in the dining room came from 'Beckington Abbey', in fact

Beckington Priory, Somerset; but the focus of attention were the major Grinling Gibbons overmantel enframements from Cassiobury Park, Hertfordshire. According to Howard Heyn, four groups of carvings remained in Ocean House and three were sent by Marion Davies to the Metropolitan Museum of Art.[21] One major enframement can be seen in the *Examiner*'s illustration of the hotel restaurant. Also from Cassiobury came the complete panelling in the projection room, reputedly once Lord Essex's bedroom of 1740.[22] The hotel's banqueting room, once Marion Davies's Marine Great Library, came from 'the country home of Eleanor, Duchess of Northumberland', surely Stanwick Park, Yorkshire. Apparently imported chimneypieces were too many to itemize, but in Marion Davies's suite on the third floor is recorded a marble mantel from a house in Sutton in Surrey, built in 1760, and, again quoting the *Examiner*, 'On the upper floors, every one of the marble mantels in the bedrooms came from famous houses in London', including an exquisite 'English mantelpiece of green and white marble with delicate oval WEDGWOOD medallions, carrying classical figures', in a room 'from Admiral Batey's town house in London'.[23] In the Green Room an eighteenth-century frescoed ceiling came from 'an old London town house', and the chimneypiece from Hatton Hall, Ireland, the 'home of Oscar Wilde's mother'.[24] Another white marble chimneypiece was in the Gold Room, 'from the library occupied by George V while Prince of Wales', surely one from Chesterfield House, London.[25] This Gold Room was made up from a Venetian *palazzo* of 1750, maybe the same source as the Venetian Ballroom. The hotel's Tavern Room was composed from three small rooms from a house in Surrey dated 1560 and supplied by Charles of London.

The achievement – all supervised by the eagle eye of Hearst – was amazing, but if this was not enough, in the autumn of 1927 Hearst bought for his wife, Millicent, Beacon Towers, the vast beachfront estate of the former Alva Vanderbilt, at Sands Point on Long Island's north shore, the model for F. Scott Fitzgerald's Great Gatsby's mansion. Nick Carraway, in looking for Gatsby, 'tried an important looking door, and walked into a high Gothic library, panelled with carved English oak, and probably transported complete from some ruin overseas'.[26] Once again, the Bronx warehouse was ransacked for salvages, including 'extraordinary medieval stone fireplaces brought over from Europe [and a] carved oak dining room purchased [from Scotland and] decorated with paintings by Sir Joshua Reynolds and with gold consoles and mirrors from a mansion near London.'[27] However, the extraordinary influx of salvages into Beacon Towers can be assessed by the 'Index Sands point Building and Parts Owned by A.N.[another] Volume 1.'[28] It lists no less than 16 more or less complete rooms: six English, two of the sixteenth century and four of 'George 1'; two oak rooms from Hamilton Palace with white and black marble chimney pieces; five French *boiserie* rooms: Régence, Louis XV and Louis XVI, including one from the château of St Cloud; four gothic wood ceilings, and various chimneypieces including a 'French Gothic Sculptured Stone Altar Piece'. The Great Acquisitor was lurching to his fall.

Not surprisingly, the unthinkable loomed. Hearst was in financial meltdown. His banks and creditors were in charge.[29] It is almost impossible to accurately recon-

struct what he had spent on his various properties, but certainly $30 million on San Simeon, $7 million on the Beach House, perhaps $1 million on Sands Point, almost $2 million on St Donat's, and $1 million on Wyntoon, but these can only be a small part of the total expenditure. The running and upkeep was colossal. The contents of all his properties had to be sold, and the magnitude of his acquisitions was discovered only when the classification by a bevy of experts before liquidation began. Few knew that there were huge collections in the Lincoln Warehouse on Third Avenue, Manhattan, and the contents of St Donat's were found to be unexpectedly rich and varied. From early March 1938 thirty years of Hearst's collecting flowed on to the market, unfortunately from 1939, due to the European conflict, it was not an international sale. This spelt disaster.

The emotional denouement for Hearst was the sudden and unexpected announcement in the *New York Times*, on 29 December 1940, that Armand Hammer, millionaire petroleum executive, art collector and, as is now well known, con man and maybe spook, was organizing an exhibition and sale of Hearst's paintings at a gallery at Saks Fifth Avenue, followed by a sale of his other collections and salvages at Gimbel Brothers department store, with the entire fifth floor dedicated to the sale. It was a humiliation. Hearst's smarting retort to the Corporation's board of directors was correct:

> You will get nothing from the sale of any consequence . . . nothing compared to the injury inflicted upon your remaining art objects by this method of selling them over the bargain counter. In addition, the widespread advertising of these department store sales – advertising which goes through dispatches into nearly all the papers in the country – does a very serious injury to the prestige and standing of the institution as a whole, and of those who conspicuously represent it . . . I have not advised against these sales at department stores because of any personal pride, but because they are bad business – bad for our antique business, bad for our advertising business, bad for our standing.[30]

How right he was, and no doubt he must have been aware that war in Europe precluded European buyers. In general the pre-1941 and the Hammer–Gimbel sales were a disaster, as is demonstrated by just two examples. Hearst paid Duveen $375,000 for Van Dyck's portrait of Queen Henrietta Maria, but even when reduced to $157,500 by Gimbel's, it was knocked down for a mere $89,000; in the 1937 sales an Elizabethan silver-gilt cup for which he paid $16,375 brought just $2,500.[31]

The catalogue of the Gimbel exhibition was titled, *Art Objects & Furnishings from the William Randolph Hearst Collection: Catalogue Raisonné . . . and Complete Index*.[32] This huge catalogue of works of art is the most telling evidence of Hearst's obsessions and ambitions as an international acquirer and scavenger, for in all probability this accounted for but a third of what he owned prior to the sales. Not everything was removed from the warehouses, and there was, of course, what Hearst was allowed to retain in his many residences. Into Gimbel's two-acre floor were crammed more than 504 categories of objects and salvages. The buildings,

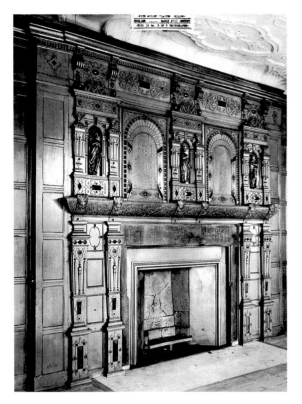

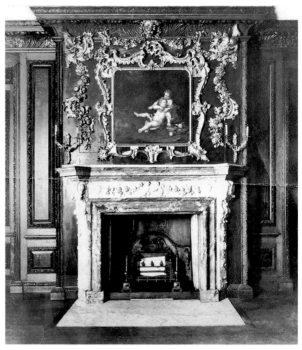

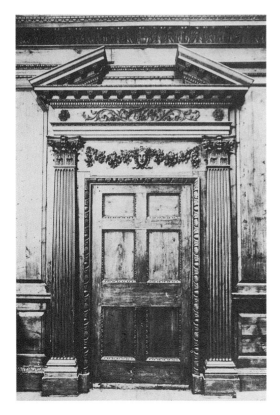

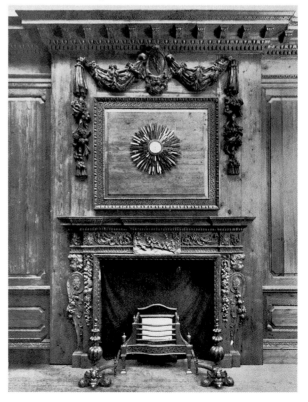

rooms and larger elements were exhibited as photographs, for which James Albro produced the pictorial *Antique Architectural Elements from the William Randolph Hearst Collection*, published by the International Studio Arts Corporation.[33]

In this huge catalogue, as far as salvages are concerned, there is a nine-page section, 'Buildings and Parts'. Never was there, nor will there ever be again, a sale like this. The salvage section was introduced by the offer of a Spanish Cistercian monastery from Sacramenia; the 'Principal Features' of Kiddal Hall, Yorkshire; stone elements from the Spanish castle of Benavente; a Gothic cloister from Saint-Beat in the Pyrenees; and two other French Gothic cloisters. After all his internal domestic incorporations, he could still retain 62 French chimneypieces and 29 English, and in the English section alone he had acquired, and probably never seen, more than 60 crated rooms. The 'Buildings and Parts' section is reproduced from the Gimbel exhibition of the Hearst, New York, Hammer Galleries catalogue 1941.

The 'Panelled Rooms' illustrated by Albro, many of which can be matched to the C.W. Post Campus dockets, include Fig. 2[34] Drawing Room from King's House (The Old House) in Sandwich, Kent, with the Library and Hall also available; Fig. 3 another view of the Sandwich Drawing Room; Fig. 4 the Sandwich Library chimneypiece; Fig. 5 a linenfold oak room from Old Priory, Dartfield [Dartford?], Kent; Fig. 6 a Jacobean oak room from Tong Hall, Kent; Fig. 7 a Jacobean oak panelled room; Fig. 8 a chimneypiece of the Jacobean oak room; Fig. 9 the James I oak panelled room from Standish Hall, Lancashire (Fig. 192); Fig. 10 an Elizabethan oak panelled room from Plaish Hall, Shropshire; Fig. 11 the panelled oak dining room from Albyns, Essex; Fig. 12 a chimneypiece from Albyns, Essex; Fig. 13 an Elizabethan oak panelled room from Exeter; Fig. 14 a chimneypiece in the Exeter carved oak room (Fig. 193); Fig. 15 a carved oak room; Fig. 16 the chimneypiece in the carved oak room; Fig. 17 the Albyns, Essex, Long Gallery (Fig. 212); Fig. 22 the oak drawing room from Wingerworth Hall, Derbyshire; Fig. 23 a detail of the Wingerworth room; Fig. 24 the oak room from Hazlegrove House, Somerset (Fig. 213); Fig. 25 a detail of the carved door of the Hazlegrove room; Fig. 26 a Queen Anne oak room [? from Stafford]; Fig. 27 the door of the Queen Anne oak room; Fig. 28 a William and Mary oak panelled room from Chester; Fig. 29 the William and Mary oak and Gold Room from Combe Abbey, Warwickshire; Fig. 30 a detail of the Combe Abbey room; Fig. 31 the Georgian pine room from Haldon Hall, Devon; Fig. 32 a detail of the door from the Haldon Hall room (Fig. 214); Fig. 33

212. Albyns, Essex. The Elizabethan Long Gallery chimneypiece, *in situ*. Acton Surgey, 1926

213. Hazlegrove House, Somerset. Late seventeenth-century room with 1740s rococo chimneypiece and overmantel, *in situ*. Acton Surgey, 1929

214. Haldon Hall, Devon. Doorway of early eighteenth-century saloon, as sold Hearst, New York, 1941, ex Roberson

215. Sutton Scarsdale, Derbyshire. Chimneypiece from Charles Roberson, *Antique Panelled Rooms*, vol. 3, pl. 10. Bought by Hearst, 1927. Now in store at Huntington Museum and Art Gallery

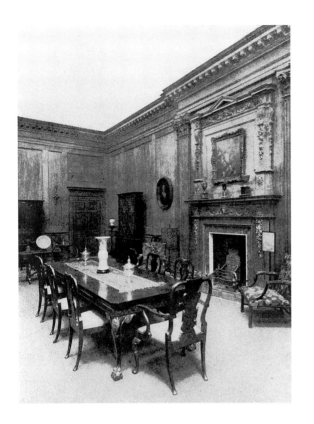

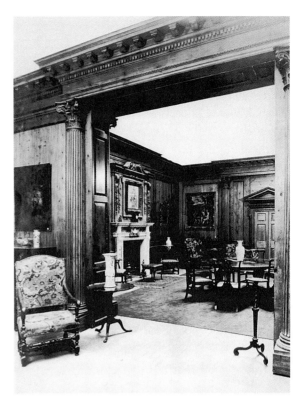

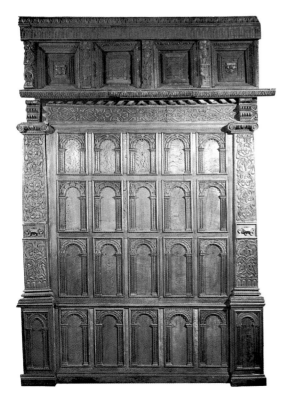

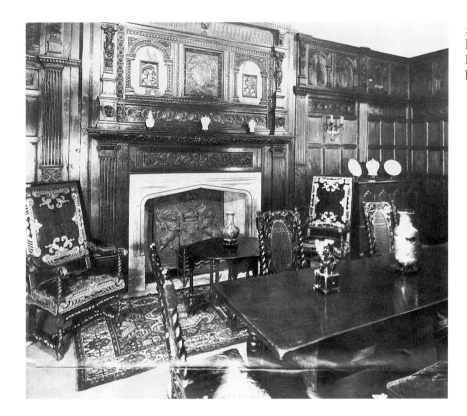

220. Chelsea, London. Room exhibited in Robersons, Knightsbridge Halls. Bought in 1927

a detail of door in a carved pine room from Sutton Scarsdale, Derbyshire; Fig. 34 a drawing of the Sutton Scarsdale room; Fig. 35 panelling from the Sutton Scarsdale room; Fig. 36 a chimneypiece from the Sutton Scarsdale room (Fig. 215); Fig. 37 a William and Mary pine dining room; Fig. 38 the carved pine Georgian reception room from Painswick House, Gloucestershire; Fig. 39 another view of the Painswick room; Fig. 44 the Jacobean carved staircase from Sheldon Hall, Leicestershire; Fig. 45 a carved Elizabethan stairway from East Anglia; Fig. 46 a drawing of the plan of the East Anglian staircase; Fig. 47 the Combe Abbey, Warwickshire, staircase; Fig. 49 a wrought iron stair balustrade from Share House, Ireland; Fig. 52 an Elizabethan chimneypiece from the Worshipful Company of

216. Spettisbury House, Dorset. Saloon of 1740s, from Roberson, *Antique Panelled Rooms*, vol. 4, pl. 10

217. Hooton Hall, Cheshire. Saloon, perhaps enlarged by James Colling, 1860s. Exhibited in Charles Roberson's Knightsbridge Halls

218. Hooton Hall, Cheshire. Section of panelling from Old Hooton Hall. Bought in 1927

219. Room from Sir Dudley Cory-Wright, Northumberland. Bought from Charles of London, 1927

 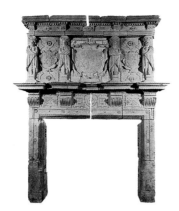

221. Prinknash Abbey, Gloucestershire. Elizabethan chimneypiece, bought via White Allom, 1927

222. Piercefield Park, Monmouthshire. Elizabethan chimneypiece. Bought, 1925

223. Crosby Hall, London. Tudor chimneypiece. Bought via Roberson, re *Nash's Magazine*, 1928

Tallow Chandlers, City of London; Fig. 58 a chimneypiece, one of two, from the Picture Gallery, Hamilton Palace, Scotland; Fig. 61 a chimneypiece from Hooton Hall, Cheshire; Fig. 63 overmantel carvings by Grinling Gibbons from the dining room, Cassiobury Park, Hertfordshire; Fig. 64 overmantel carving from Cassiobury Park; Fig. 65 two panels of carving from Cassiobury Park. From the C.W. Post dockets and their attached photographs a selection[35] might include a room from Spettisbury House, Dorset,[36] photographed (Fig. 216) when in Robersons' Knightsbridge rooms; the Hooton Hall, Cheshire, room,[37] also as at Robersons (Fig. 217); the room from Sir Dudley Cory-Wright in Northumberland (Fig. 219);[38] the Hooton Hall, Elizabethan room (Fig. 218);[39] a room from a house in Chelsea, London (Fig. 220);[40] the Prinknash Abbey, Gloucestershire, chimneypiece (Fig. 221);[41] the Piercefield Park, Monmouthshire chimneypiece (Fig. 222);[42] and the Crosby Hall, London, chimneypiece (Fig. 223).[43]

EPILOGUE

IT HAS BECOME OBVIOUS THAT every English period room to be found in an American museum tells a personal story about its making, the circumstances of its extraction from the house, the circumstances of the family, the fate of the house, the trade itinerary of its travels to its last resting place, its adaptation either for private domestic use or as a period room in a museum, the successive restorations and presentations that it receives in its life in the museum, the changes in curatorial care, and very often its sale in some auction room when de-accessioned by the museum, when once again it becomes a vagrant. I believe that the tale of one notorious room, the Woodcote Park Room in the Museum of Fine Arts, Boston, donated by Eben Howard Gay in 1927, encapsulates the history of the movement and transformation of salvages, for not only does it perfectly illustrate the vicissitudes of a transient room, of dealers' inventiveness and guile, and clients' gullibility; but it is also a lesson in the dangers of the innocent culpability of donors in the furnishing of a period room. As an epilogue it sums up nearly everything that this book has been about.

Woodcote Park, Surrey, an Elizabethan or Jacobean house, which had been the seat of the Mynne family, was passed to Richard Evelyn, brother of John the diarist, by virtue of his wife Elizabeth being a Mynne. In 1691 she bequeathed it to the third Lord Baltimore, who was related to her family. She had employed Antonio Verrio to paint the Great Stairs and several ceilings, and Grinling Gibbons for a new Chapel. This third lord died in April 1715 and the house passed to the fourth lord, who was not allowed to enjoy his bequest because he died two months later, so it passed to Charles Calvert, the fifth lord, and was somewhat neglected, because this lord preferred to live at the family seat of Belvedere in Kent. However, he turned his attentions to Woodcote, and shortly before he died in 1751 he commissioned John Vardy to provide a stone-fronted Palladian range flung across the east front of the old house. The unfinished new building was taken over by Frederick Calvert, the sixth lord, who according to deprecating comments by Horace Walpole, spent $35,000 making its interiors 'ridiculous' and 'tawdry' in a 'French' style. At least three rooms[1] were based upon engravings in Jacques-Francois Blondel's *De La Distribution Des Maisons De Plaisance, Et De La Décoration Des Edifices En Général*, 1738,[2] seemingly executed in 1753 by a joiner named Aaron Hardcastle.[3]

Due to the habits of the profligate seventh lord, the house and contents were put up for sale in 1764,[4] when the contents were in fact bought in. The sixth lord had fled to Vienna in 1768 following a celebrated rape case, and he was reported as living with a bevy of ladies, who were still with him when he died in Naples in 1771.

The house then passed through various tenures, including that of Arthur Cuthbert, until 1788, when it was bought by Lewis De Teissier, later Baron de Teissier. Before De Teissier's death in 1811 he had made a large ballroom by converting two rooms into one. Both had been originally the sixth lord's doing. Until recently it was always thought that a small French room to the right or north of Vardy's Entrance Hall, assumed to be the Boston one, was opened up by de Teissier to the adjacent Drawing Room. It was assumed that de Teissier removed the de Clermont panels to an upstairs gallery, when they were provided with an alluring and entirely fictitious provenance, as having been commissioned by Philip, duc d'Orleans in 1718 for his apartments at Versailles and presented to De Teissier by the 'French king'. However, it is now likely that the sixth lord objected to de Clermont's panels, and removed them in order to panel up the walls with French copy *boiseries* matching those in the adjacent room, which may now be called the Woodcote Park Room in the Museum of Fine Arts, Boston. Beyond the now French 'de Clermont' room, just around the corner on the north front, Baltimore installed the French library. The de Teissier ballroom has led to vigorous debate concerning the dating of the Boston *boiseries*, because in authentic French décors two rooms in a sequence would not be panelled-up in an identical *boiserie* style, as photographs of the rooms in 1913 show. The make-over must have caused much disruption and movement of *boiseries*, whether of the sixth lord or of de Teissier.

In 1911 the Royal Automobile Club, seeking a country clubhouse with the potential for a golf course, bought Woodcote from the Brooks family, who had succeeded de Teissier in ownership. In 1913 the club took the philistine decision to instruct Harold G. Lancaster of 55 Conduit Street to remove most of the historic rooms in the Vardy range. From this time on, Woodcote's interior salvages went travelling. Mr Lancaster must have revelled in what was obviously a trading coup, and many of his extractions were exhibited in his galleries. These included two of the French style carved wood rococo chimneypieces, the Sir Henry Cheere marble chimneypiece and a companion, the Apollo and the Muses ceiling, the seventeenth-century 'Oak Panelled Room' with a ceiling by Antonio Verrio, as well as a gathering up of *boiseries* and other interior salvages from at least three other rooms including the richly ornamented library, and the suite of the twelve Daphnis and Chloe painted panels.[5] There is circumstantial evidence to suggest that the extractions included the famous seventeenth-century chapel with woodwork carved by Gibbons,[6] although it is unclear if the paintings by Verrio were removable. Even with what was advertised in the *Connoisseur* for March, April, May and June 1914, it was an exceptional and much-advertised salvage acquisition, so exceptional that by March 1916 Charles of London had quickly muscled in, and advertised in *Country Life* a

'Woodcote Park Collection' (Fig. 105) that included one *boiserie* room, seemingly that in Boston. What would have attracted him most was the fictitious provenance of the de Clermont panels as having been painted for the 'Duc d'Orléans' apartments at Versailles.[7] But tantalizing questions remain unanswered. What happened to all the other *boiseries* in Lancaster's warehouse? And if the Charles room is the Boston one, was it the room sold to Eben Howard Gay after a limbo of fourteen years? This sale was negotiated, not by Charles of London, but by Charles Roberson, who wrote to the museum on 18 October 1927 that 'it will shortly be dispatched from London . . . the Plaster ceiling has taken a long time to reproduce'?[8] The highly ornamented gilt and painted library (Fig. 150) appears to have passed from Lancaster to Roberson[9] and then to Edwards & Son, who advertised it (Fig. 151) completely stripped of every vestige of paint and gilding. It ended up by 1960 at Crowthers of the North End Road,[10] and may be the same as the 'fabulous English rococo room' reported as in the possession of the dealer Matthew Schutz of Park Avenue, New York.[11] Its present whereabouts is unknown.

The notorious aspect of this Woodcote saga really begins in 1915 when Eben Howard Gay published *A Chippendale Romance*, a philosophy of his personal taste in the furnishing of his house at 170 Beacon Street, Boston, built in the English style by Ogdon Codman in 1900, and possibly the first American house to incorporate an English salvaged chimneypiece. Today with hindsight it is possible to doubt, from the illustrations in the book, the extraordinary 'over the top' 'Chippendale' furniture that he had acquired since 1900, including a magnificent china cabinet, mirrors, tables, chairs and girandoles, most of it destined for the day when he would achieve the fulfilment of his life's dream by the acquisition of the perfect Chippendale Room to gift to his beloved Museum of Fine Arts. The adept Roberson was at hand to assist him, and in 1927 the room arrived at the museum and Gay proceeded to furnish it from his rooms in Beacon Street.

Hardly had the hand-clapping and acclaim died down at the opening of the room (Fig. 147) by the museum on 14 November 1928 than there arose from amongst the bevy of antique dealers who attended that opening, doubts as to the authenticity of certain of the furnishings. When Edward Wenham in January 1929 enthused that 'Chippendale Combined the Beauty of Many Styles' in *Arts and Decoration*, the trustees and Mr Gay were already in worried conference about how to confront criticism that the celebrated Chippendale china cabinet, based on Chippendale's *Director*, and four mahogany side chairs were not what they should be. Indeed, it may already have been known to at least one dealer that the cabinet was one of six made by a cabinet-maker called Dawson in the late nineteenth century and imported into the USA by Henry Simmons.[12] The four chairs were returned to Gay on 11 June 1929 together with two disputed armchairs. No doubt Ralph Edwards's article in *Country Life* on 13 April 1929, when he graciously dismissed 'Furniture Attributed to Chippendale', hastened the demise of the cabinet, which was returned to Gay by the trustees on 17 October 1929. A single armchair was returned in 1934,

but it was left until 1958, after Gay's death, to dispose of three disputed tables and a secretary desk and, in 1960, two tables and an overmantel mirror, all de-accessioned and sold.

If there were disputes over the furniture, there are still amicable differences of opinion about the room and indeed its true location in the house. What is certain is that the Cheere chimneypiece now at Boston originated in one of the smaller French rooms to the left of the entrance hall and behind its Palladian window on the east entrance front. All that can be guessed is that the Boston room is basically the one advertised by Charles of London, but it has undergone manipulation, the chimney wall being now wider by one full bay. This manipulation was surely Roberson's.

The room is also an interesting case study of curatorial attitudes to matters of authenticity of their holdings. When I visited the MFA Boston in 1960, I enthused about this fascinating example of Anglo-French design, and enquired of the department about acquisition information. I was given a folder from which, as I ascertained years later, all controversial facts had been extracted. I was an innocent, and could not understand why the photograph of the room as it was at the 1928 opening, supplied to me by the photograph department of the MFA, should cause such annoyance on the part of a curator, when I published it in the *Connoisseur* in 1961.[13] Then the museum did not want the Eben Gay story to be told. Only later was I given full and friendly access to all the documents.

If in 1928 a distinguished historian such as Ralph Edwards recognized that Chippendale never designed a room, he also knew that Gay's dream of an authentic Chippendale entity could never be fulfilled. Yet in retrospect, when we look at the photographs of 1928, are there not tinges of regret that Gay's dream is not with us today? Were it possible to rehabilitate Gay's furnishings, the tale the room could tell would be more compelling and educative than any attempt to provide a furnished 'Chippendale' ambience, as seen in one (Fig. 149) of the later revised installations. Perhaps there is a lesson to be learned here.

CHECK-LIST OF BRITISH ROOMS
AND SALVAGES EXPORTED
TO THE USA

IT IS IMPOSSIBLE TO FULLY document and identify the export and ultimate location of rooms and the larger architectural salvages transhipped from Britain to the USA, especially those that eventually found their way to private houses and apartments. It is no exaggeration to suggest that more than 200 of these received one or more rooms, or decorative salvages, in the two decades between 1920 and 1940. Not the least of the problems involved in identification and location are changes in ownership and of taste in interior decoration, and even if many English rooms could be located, the majority would be of unidentifiable provenance. Dealers then were not interested in provenance, and in any case the archives of most British dealers have been destroyed, many in the London blitz or due to the patriotic zeal for collecting waste paper during the Second World War. The final section, 'Rooms of Unidentified or Disputed Provenance', serves the purpose of listing a few rooms deserving of identification of location. As the lack of paper documentation held by dealers is notorious, many exports are known only by hearsay. This should not be ignored, for the memory of dealers can go back through several generations. For a trade list of rooms exported to the USA by Robersons of the Knightsbridge Halls, see Appendix 1. Because of that firm's close trade relationship with Charles of London and New York, and because of the widespread fashion in the USA for Elizabethan and Jacobean rooms, it seems that most of Robersons' rooms of this date were exported. In the Check-List the relevant rooms are marked with an E? It also needs to be remembered that rooms or salvages can pass from one dealer to another, and even a third, before export to the USA. For example, the Cassiobury staircase was sold to the Metropolitan Museum of Art by Edwards & Son, but had been offered to Philadelphia by Roberson.

ABBREVIATIONS

AIC:	Art Institute of Chicago
Albro:	James Albro: see Hearst 1941
AMStL:	Art Museum of St Louis
CAM:	Cincinnati Art Museum
Cat.:	catalogue
Clarke–Duveen:	albums of photographs from Duveen's library in the Clarke Institute, Williamstown, Mass.
C. Life:	*Country Life* magazine
CWF:	Colonial Williamsburg Foundation. Woodwork with labels assumed to represent Lenygon exports to USA. Very dubious assumption and not included in this check-list
Dem.:	demolished
DIA:	Detroit Institute of Arts
E?:	of uncertain export. Sometimes the evidence is inconclusive, i.e. that documented offerings to US museums resulted in a sale to another US client
French & Co.:	the company's stock sheets now in the Getty Center for the Humanities: archive account number 840027
GCH:	Getty Center for the Humanities, Los Angeles
HD:	Hearst purchase dockets in the C.W. Post Campus Library, Long Island, New York
HEARST 1941:	International Studio Art Corporation, New York. *Antique Architectural Elements from the William Randolph Hearst Collection. Selected by James Albro* [1941]; see also *Art Objects and Furnishings from the William Randolph Hearst Collection. by Saks Fifth Avenue in Co-operation with Gimbel Brothers under the Direction of Hammer Galleries*, 1941.
HLAG:	Huntington Library & Art Gallery, San Marino
Jussel:	information from Christopher Jussel, Arthur S. Vernay's grandson
L&M/BDM:	Lenygon & Morant information from Mr Brian D. Mitchell
MFA:	Museum of Fine Arts (Boston)
MIA:	Minneapolis Institute of Arts, Minneapolis
MMA:	Metropolitan Museum of Art, New York
PL:	Information from Peter Lang, New York
PMA:	Philadelphia Museum of Art, Philadelphia
PMA/FK:	Philadelphia Museum of Art, Fiske Kimball Archives
Robersons:	four volumes of trade catalogues of *Historical Rooms from the Manor Houses of England*, undated, but mid-1920s
ROM/ROMT:	Royal Ontario Museum, Toronto
Rothery:	Guy Cadogan Rothery, *English Chimney Pieces*, Tiranti, 1927
RSL:	Robersons 'List of Panelled Rooms in Stock in London' c. 1926, in PMA/FK
SFAM:	San Francisco Art Museums; see also Legion of Honor Museum
Tryon:	Tryon Palace, North Carolina. List of salvage incorporations; information from Nancy E. Richards, Tryon Palace. Also memorandum of 1975 by Gertrude S. Carraway, Director of Tryon Palace Restoration. See Appendix 3, 'The Tryon Memorandum'
V&A:	Victoria & Albert Museum, London
Vernay:	Arthur S. Vernay catalogues. Information from Chris Jussel and set of catalogues and stock books in Henry Du Pont Winterthur Library, Delaware

AVON

BRISTOL. 13 Small Street. Early seventeenth-century chimneypiece from French & Co., ex Hearst. Altered pre-1823. CAM, 1964. 220

BRISTOL. Old Canynge House, Redcliffe Street. Robersons's have hall. E?

BRISTOL. Room from Queen Anne House, College Green. L&M/BDM and Lenygon papers, Avery Library, Columbia University, New York

BEDFORDSHIRE

WREST PARK. 1928, offered to PMA. Keebles have Jacobean room with velvet-covered pilasters for £2,500. E? *C. Life*, 21.8.98

BERKSHIRE

BASILDON PARK. Neo-classic room by John Carr removed to Waldorf-Astoria Hotel, New York. Installed (by Vernay?) with many alterations and additions, but retaining remarkable chimneypiece

BASILDON PARK. Internal doorway by John Carr gifted by Mrs Horatio A. Lamb in 1940 to MFA Boston from Baker Residence, Oyster Bay, Long Island

BASILDON PARK. Internal doorway from drawing room by John Carr. Untermyer Collection, MMA

BASILDON PARK. Pair of decorated doors, maybe from Basildon. Parke-Bernet Galleries, New York, 14–16 Dec. 1939, lot 355. PL

HAYWARDS HALL, Maidenhead (unlocated). Mid-eighteenth-century doorcase; and elements of a later eighteenth-century room with chimneypiece. Possibly of Roberson provenance. Parke-Bernet Galleries, New York, 19 Nov. 1942, lots 1–3, removed from Charles E. F. McCann residence at Oyster Bay. PL

MARCHFORD PARK, 'Reading'. Two Georgian mahogany doors. Parke-Bernet Galleries, New York, 15–17 Dec. 1932, lot 619. PL

RADLEY HALL. Hearst 1941 lists 'Elizabethan Carved Oak Panelled Room'; bought from Robersons 10 Nov. 1926 (HD, v. 87). Probably installed in college after 1847

ST LEONARD'S HILL. Nine chimneypieces from Sir Francis Tress Barry (Clark–Duveen)

BUCKINGHAMSHIRE

BEACHAMPTON HALL FARM. Staircase. Bought by Hearst from Permain through *Nash's Magazine*. 7 Dec. 1927. HD

BUCKINGHAM. Jacobean room. Roberson 2. E?

COLNBROOK MANOR HOUSE. Jacobean room. Roberson 4. E?

HIGH WYCOMBE. Church Street. Jacobean panelled room with Edwards of Wigmore Street. E?

SANDLEA COURT, DATCHET. George III chimney surround. Sotheby's, New York, 11 April 1997, lot 802. PL

STOKE POGES MANOR HOUSE. Early sixteenth-century panels of stained glass. DIA, 58.113

CAMBRIDGESHIRE

MADINGLY HALL. At demolition of north wing in 1874 internal woodwork reputed to have been bought by Hearst for USA (E?) and St Donat's, where chimneypiece remains

CHESHIRE

CHESTER. Room with giant fluted Ionic pilasters, listed by Robersons as 'William and Mary Room' at £1,500 (RSL). Bought by Hearst 1926; sold Hearst 1941, Albro Fig. 28

HOOTON HALL. Dem. *c.* 1935. Double saloon or long gallery, shown as set up at Robersons, bought by Hearst 2 Dec. 1925 for £11,679 (HD, v. 85); See also Wrightington Hall, Cheshire Jacobean chimneypiece – sold Hearst 1941; neo-classical Wyatt chimneypiece – sold Hearst 1941, Albro Fig. 61

MOLLINGTON HALL. Dem. 1938. External doorway *c.* 1756. From Stuart & Turner of 13 Soho Square via A.C. Penbury, 1938 for £252 14sh.6d. AIC, 1938.87, sold Sotheby's, New York, 18 Oct. 1997, lot 1063T

TABLEY OLD HALL. Dem. 1927. Charles Allom handling rooms, including hall from 1927. E?

TARPORLEY. See SOMERSET TUDOR ROOM

CORNWALL

STOW (OR AS STOWE). Room removed early eighteenth century to The Cross, Devon. Photo in Clarke–Duveen. Files and drawing by New York architect inscribed for Judge Untermyer, New York. Possibly installed in an Untermyer residence, but unlocated

CUMBERLAND

DALEMAIN. Robersons list 'No. 1 Large Jacobean Room' and 'No. 2 Large William and Mary Room'. E?

PENRITH, OLD CHURCH FARM. Elizabethan room. Roberson 4. E?

DERBYSHIRE

BREADSALL PRIORY. See SYDNOPE HALL

BRIMINGTON HALL. Dem. 1931. Robersons' list an Elizabethan oak drawing room and a Bedroom as sold. E?

SUTTON SCARSDALE. 'No. 3 Pine Room' on Robersons' PMA list. This is one of the three rooms (plus Oak Room and Painted Deal Room) sold to PMA in March 1927, following correspondence from 6 March 1926. Roberson had mentioned having four rooms on 1 March 1927 (PMA/FK). No. 3 also in Robersons 3. PMA (SSI: 28.61.1; SS II: 28.61.2; SSIII: 28.61.3)

SUTTON SCARSDALE. Botched room in HLAG from Hearst Foundation. Bought by Hearst in Brady sale, 5 Oct. 1937. Sold Hearst 1941, lot 202, 1–9, 'Fine Carved Panelled Room', bought by French & Co.; sold to Paramount Pictures Inc., May 1945, and mutilated as stage set. Given to HLAG (acc. No. 54.3) by J. Michael Leisen, film director. Probably Robersons' Room 4

SUTTON SCARSDALE. HD, v. 86 refers to a 'mantel' bought from Robersons 28 Feb. 1927; sold in Gimbels/Hearst sale 1943

SYDNOPE HALL, DARLEY DALE. Erasmus Darwin Blue John chimneypiece, probably originally in Breadsall Priory. In private Michigan collection

WINGERWORTH HALL. Dem. 1924–27. Letter from Roberson to Duveen (Clark–Duveen), 16 Jan. 1925, 'colour at present too red, but that could be altered', seems to refer to the room in private collection of Mr Joe Minton of Dallas, as the wood is peculiarly red in colour. Roberson 2 has 'oak drawing room' (probably the Minton room) and 'oak library' as well as the staircase. This Minton room is the same as the 'Finely Panelled Oak Drawing Room', bought by Hearst from White Allom, 2 Jan. 1926, sold in the Gimbels/Hearst sale in 1941; Albro Figs 22–23, and sold again, Parke-Bernet Galleries, 22 May 1948, lot 9,

the property of Edward I. Farmer, when it may have gone direct to Minton at Dallas. The chimneypiece illustrated in Rothery, pl. 162; see also *Country Life*, 29 Jan. 1910 and M. Jourdain, *English Interiors in Smaller Houses 1660–1830*, 1923, Fig. 4, and Fig. 165 for the chimneypiece, these illustrations from the trade. However, the Roberson letter might refer to Roberson's other 'Wingerworth' 'Oak Panelled Room', a plainly panelled room, sold by Roberson to AMStL in 1928, being offered at $14,145. This AMStL room de-accessioned and sold Sotheby's New York, 1987, to Mrs Barbara Johnson

WINGERWORTH HALL. A chimneypiece described as 'made by Adam from drawings by Flaxman from the collection of Lord Wingerworth', once in private Michigan collection, now rumoured to have been gifted to Flint Museum, Flint, Michigan, but no longer on their inventory

DEVON

BLADUD CASTLE. Near South Molton, but unlocated. Jacobean room, given to ROMT by Brooklyn Museum in 1968, from the Long Island, Great Neck, house of Jacob Aron, demolished 1968. Sold Christie's, New York, 17 Oct. 2003, sale 1285, lot 187, illus. p. 141. In Roberson 2, pl. 8, 'From an old house in Devonshire known as Bladud Castle'

BRADNINCH MANOR. Panelling rumoured to have been removed in 1970s and sold to the USA. E?

CASTLE HILL. The 'Quinn Room', bought by HLAG (000.136) from Alfred Pembury 1940, who had bought Castle Hill salvages in 1938. Panelling probably removed from house in 1887. A composite: mantelpiece from Grove House, Chiswick, and overmantel from Marquis of Zetland's house in Arlington Street

CORYTON PARK, Axminster. Crowthers verbally said to have exported salvages from this house to USA. E?

THE CROSS. 1680s room removed. See CORNWALL, STOW

EXETER. 229 High Street, a remodelling of 1584. House dem. 1930. Prior to demolition Robersons extracted six rooms in 1929 in order to make up three. Bought by French & Co 31 Jan. 30 (GCH: French & Co. stock sheets

840027), via C.J.J. de Hahn. Hearst eventually bought all three, one on 11 Oct. 1934. One of these bought by Nelson Atkins Museum, Kansas City from French & Co. in 1940. Second Hearst room bought by Mrs John Magnin from French & Co. for $5,000 and gifted to the De Young Museum, San Francisco, 1945, this partly repatriated to the Royal Albert Museum, Exeter, 2001. Third Hearst room gifted in 1958 (1958.242) to DIA by the Hearst Foundation (their 1941 'no. 2' room, illus. also Albro Figs 13–14). Note that Robersons offer 'Exeter College Oak Room' to AMStL in November 1928, evidence of their activities in this town

THE GRANGE, Broadhembury. Room with chimney overmantel dated 1619. Robersons list the room at £16,000 and offer it to PMA. By 1927 room advertised by Charles of London, and according to their brochure was then at their showrooms, 2 West 56th Street. Bought by Hearst 29 Nov. 1927, perhaps via French & Co. Not at all clear when Dr Preston Pope Satterwhite of Louisville, who gave it to the J.B. Speed Art Museum there, acquired it

HALDON HOUSE. Dem. 1927. Robersons list 'Pine Room' at £2,000, probably same as Hearst 1941 (illus.); Albro Fig. 31. 'Georgian Carved Pine Panelled Room', with grand pedimented Corinthian fluted door. Bought by Hearst from Robersons for £7,907. Also in Robersons 3

A DEVON HOUSE. Elizabethan 'Sir Walter Raleigh' room in Wilson Library, University of North Carolina, Raleigh; bought after 1900 by William Fahnestock Snr for house in Katonah, New York, moved by William Farnestock Jnr to New York house; donated to University in 1947

DORSET

CANFORD MANOR. Wrought iron part-gilded gates, sold by French & Co. to Hearst 1932 as from 'Crawford' Manor, seat of the 'Earl of Wimborne' (DIA, 58.25); see also WIMBORNE

LYME REGIS. The Tudor House. Jacobean room. Roberson 2. E?

SPETTISBURY HOUSE. Dem. 1927 as St Monica's Priory. Robersons offer AMStL 'Spettisbury Pine Room No. 3'. Robersons also have Pine Rooms nos 1, 2 and 4

SPETTISBURY HOUSE. In HD, v. 86, reference to Charles Roberson sale, American Art Association, 3–5 Oct. 1935, lot 568. The illustration is probably the room as installed by Jules Stein (of Stair & Co., previously Stair & Andrew) at the MCA Corporation, Madison Avenue and 57th Street, New York. Sold for $3,600, the room reported by Chris Jussel as still there

SPETTISBURY HOUSE. Room in Mr & Mrs Leslie R. Samuels's apartment, now maisonette, 660 Park Avenue, New York (inf. Chris Jussel). Intended for sale at Sotheby's, 2–3 Oct. 1981, but sale cancelled as Imelda Marcos bought the lot pre-sale

SPETTISBURY HOUSE. The Corinthian pilasters in the reception room at Caramoor, Katonah, New York, said to be from a house of *c.* 1740 in Dorset, probably Spettisbury

WIMBORNE, 'House of Lord and Lady Lovett'(?). Chimneypiece in second floor library at Hillwood Museum, Washington, DC; but could refer to Canford Manor, Dorset

DURHAM

FELLING HALL. Unlocated. Dining room of *c.* 1750 from house of Charles Branding in McGeary Snider House, Philadelphia, 1924

NEWCASTLE UPON TYNE: THE MANSION HOUSE. Elizabethan chimneypiece removed from the 1692 building to Clervaux Castle, Yorkshire (building 1839–44), dem. 1950–51, when chimneypiece removed to Croft Hall, Darlington and sold by Mr W.D. Chaytor *c.* 1980 to the USA. E? (inf. Anthony Wells-Cole)

STREATLAM CASTLE. Dem. 1927. Oak Room no. 2 (Robersons 4). Unclear if Robersons' rooms are distinct from the Lenygon one; unclear also if this is same as offered to AMStL in Nov. 1928

STREATLAM CASTLE. Baroque chimneypiece. HD. Jussel reports, 'probably still at 124 East 53 Street', New York

STREATLAM CASTLE. 'William and Mary Oak Panelled Room'. The Twombly-Burden Room given by Mrs Jeannette Lenygon to the Lowe Library, Columbia University. In Lenygon & Morant inventory 1929. Had been installed in Twombly House, New York, *c.* 1930

ESSEX

ALBYNS. Gutted earlier, then dem. 1954. The Long Gallery at Robersons, listed at £8,250. Bought by Hearst from Acton Surgey, 2 Sept. 1926. Hearst 1941 (illus.); Albro Fig. 17, bought by French & Co.?

ALBYNS. Hearst 41 (illus.) 'Panelled Oak Dining Room'. Acton Surgey, 22 Dec. 1926; Hearst, 41; Albro Figs 11–12

ALBYNS. Keeble Ltd. offering PMA a chimneypiece and ceiling from the library and a southwest oak room 17 July 1928. E?

BOWER HALL, Steeple Bumstead. Dem. 1926. Early Georgian room with giant fluted Corinthian pilasters flanking chimneypiece. Bought by Hearst from Acton Surgey 17 Dec. for $5,007.37 (HD, v. 85); Sold by Hearst Foundation to A.S. Vernay 1955. Installed in 460 Park Avenue, New York, for Tex Fel Petroleum

GREAT SIR HUGH'S MANOR. Dem. 1930. Colonnade façade of three oriel windows and columned ground floor, *c.* 1600, bought by Hearst from Acton Surgey, 31 March 1927 for $11,752. HD, v. 82, 37, photo of one bay

GREENSTEAD HALL. Elizabethan 'Oak Room No. 1'. Roberson 4. E?

HALLINGBURY PLACE. Dem. 1924. Roberson offers chimneypiece to PMA; Overmantel with swan-neck pediment and panel of rococo carving. Photograph in French & Co. files at GCH

LOFTS HALL. Dem. 1938. Jacobean room of Meade family. Bought by Hearst from Charles, 1. May 1922. HD, v. 88

NEW PLACE, Upminster. House sometimes called Clock House, dem. 1924. Robersons list No. 1 Pine Room at £1,950 and No. 2 William Kent Pine Room at £2,325 (RSL). No. 1 sold to Edsel and Eleanor Ford House, Detroit, for dining room, and possibly also chimneypiece in morning room; No. 2 sold to PMA in 1926 (26.78.1), via White Allom

REDFANTS MANOR HOUSE, Shalford. Oak-panelled room removed between 1929 and 1931, and sold to USA. Inf. Mrs G. Hogger, Redfants Manor House

TOLLESHUNT D'ARCY HALL. Hampton & Sons offer sixteenth-century panelling to PMA. E?

UPTON, house of Bonnell family. 'Adam' room said to be in Medical School, University of California, Los Angeles. Bonnell family also lived at Feltham Park, Middlesex late eighteenth century

WANSTEAD, 'old manor house'. Chinoiserie lacquer room. Robersons 1. E?

WEALD HALL. Dining room doorway. Tryon, Crowther & Son 1954; Pine mantel in alcove bedroom, Crowther & Son 1953

GLOUCESTERSHIRE

GLOUCESTER. Doorway supplied for £300 in 1931 by Robersons for the Stafford Room, Minneapolis Institute of Arts. Described as of 'Gloucester'

NEWLAND HOUSE, Coleford. Room *c.* 1748. Offered by Gill & Reigate to MFA Boston, July 1930 (31.43) for £7,000. Set up in 1937. Reputedly another room in USA from Newland, Coleford, offered to Wadsworth Athenaeum. E?

PAINSWICK. Beacon House. Hearst 1941 (illus. 124; Albro Figs 38–39). Two Georgian rooms, drawing and dining (nos 1381–88 and 1381–89), removed 1915 [?] by White Allom, bought by Hearst, one for £11,305 and the other for £9,044 on 15 May 1924. One bought by Mr and Mrs Babcock of Los Angeles, maybe Hearst sale 1941; given to Wake Forest University, Winston-Salem, North Carolina, 1968, not installed; given to Museum of Art, Raleigh, North Carolina, 1973. Not installed, de-accessioned 1985, sold Sotheby's, New York; bought Mrs Johnson; sold again Christie's, New York, lot 354, 30 Jan. 1993. The other sold to A.M. Adler for $22,000 via French & Co. on 17 Feb. 1924 (HD, v. 90). Adler was a prominent picture dealer

PRINKNASH PARK. The Jacobean (1620) Justice Room, bought in 1928 by Robersons from monks who had acquired the estate in 1927. Robersons' brochure advertised 'The oak room from Prinknash Park'. Sold to AMStL 1930, de-accessioned and sold as a composite in 1987, bought by Fred Koch, repatriated and installed at Sutton Place, Surrey. Rober-

sons also removed Abbot Parker's Oak Room, the Guests' Room, and a drawing room of *c.* 1725, as well as two fine Jacobean chimneypieces, one of which must be that sold by White Allom through the *National Magazine*, 23 Dec. 1927 to Hearst for £9,245, location unknown

SISTON COURT. Of the chimneypieces removed by Charles Angell of Bath in 1936, the Renaissance one from the hall. E?

TEWKESBURY MANOR (or Park?). Jacobean room bought by Hearst from Charles 7 Feb. 1927. HD, v. 88

HAMPSHIRE AND ISLE OF WIGHT

CHANDLER'S FORD (suburban Southampton). Theatric caryatid screen of bed alcove, bought AIC from Mr M.E. Sainsbury, through Stuart & Turnor, 1936 for £75

KEMPSHOTT HOUSE. Dem. 1965. Room in AMStL compiled by Robersons in New York, 1928–29. Chimneypiece by John Deare, bought from Robersons for the making of the 'Kempshott Park Room'. Possibly one of the chimneypieces referred to in a letter from C.H. Tatham to Henry Holland, 7 June 1795 (V&A), re chimneypieces which Duke of Gloucester bought for George, Prince of Wales. Designed by Hatfield and sculpted by Deare. Doors from a house in Lincolnshire (Cockerington Hall?). De-accessioned and sold, retaining so-called Pergolesi wallpapers

NETHER WALLOP. Robersons offer AMStL, 28 March 1929, the 'Nether Wallop Oak Room', possibly from Place Farm, a house of *c.* 1620. E?

NORTHWOOD HOUSE, West Cowes, Isle of Wight. George III carved and parcel gilt mahogany door. Parke-Bernet Galleries, 22 May 1948, lots 6–7, property of Edward I. Farmer. 'Pergolesi' arabesques offered to PMA 1932 (PMA/FK). Same arabesques in possession Ashley Kent Inc. of New York, exhib. The League of Antiques Exhibition, Sherry's, Park Avenue, New York, March 1944, with illustration of drawing room *in situ* showing 'Pergolesi' interior probably of 1838. PL

SOUTHAMPTON, 17 High Street. Panelled room shipped by Lenygon & Morant to USA on Lancastrian in Jan. 1916. L&M/BDM

HEREFORDSHIRE

GOODRICH COURT. Chimney overmantel removed from Hamptworth House, Great Neck, Long Island at demolition in 1968; to Brooklyn Museum, then gifted on to ROMT, de-accessioned and sold

HOLME LACY. Grinling Gibbons carvings. MMA 1916 (16.88a, b)

HOLME LACY. Grinling Gibbons carvings at Ardrossan, Pennsylvania *c.* 1912

ROTHERWAS. Dem. 1925. Built in 1731 for Charles Bodenham and designed by James Gibbs. From this the celebrated heraldic room dated 1611 and now at Amherst College, Mass. Bought by James Brite for Long Island estate. Pratt bequeathed room to Amherst College. HD, vol. 90, 2 is a Hearst room with Jacobean panelling and chimneypiece from Rotherwas, but with an eighteenth-century Jacobean style ceiling attributed to Thomas Farnolls Pritchard. This room, the Julius Caesar Room, bought from Charles 22 Sept. 1916, sold to Hearst for his Clarendon Apartments. See: Cescinsky and Gribble, *Early English Furniture and Woodwork*, vol. 1, 1922, Figs 343–50

ROTHERWAS. Fryers in *C. Life*, 27 June 1914 had a late eighteenth-century dining room. E?

URISHAY CASTLE. Jacobean room. Roberson 1. E?

HERTFORDSHIRE

CASSIOBURY PARK. Dem. 1926. Carving bought by AIC from Frank Partridge 23 Jan. 1928, $3,353, via Edwards & Son, who in 1926 had sold an enframement from Great Dining Room to V&A (W. 46–1926)

CASSIOBURY PARK. Robersons supply living room with carvings for Mr Allen Lehman, Tarrytown, New York

CASSIOBURY PARK. Mr R.T. Crane Jnr of Ipswich, Mass., architect David Adler of Chicago. Pine library with Gibbons overmantel from the Great Library. 1925–28. See *David Adler, Architect*, ed. Martha Thorne, 2002; also H. Avray Tipping, *Grinling Gibbons and the Woodwork of His Age*, 1914, Fig. 66

CASSIOBURY PARK. Robersons list a 'Green Drawing Room' at £2,250 (E?) and the stair

at £5,000 (RSL). Offers staircase to PMA 2 June 1926. Edwards & Son advertise the stair in *Connoisseur*, 1932, bought MMA, 32.152

CASSIOBURY PARK. Peterloon, Cincinnati, has English room composed with 'Gibbons' carvings

CASSIOBURY PARK. Hearst 1941 (illus.). Enframement of large panel on east wall of Great Dining Room; bought by Untermyer, given to MMA (1974.28.14). Two other carvings also Hearst 1941; Albro Fig. 63, Small Dining Room, and Figs 64–65. Not clear if the 'Gibbons' overmantel in the Gold Room installed in Ocean House, Santa Monica, California, dem. 1958 is from Cassiobury, as were reputedly all seven carvings

CASSIOBURY PARK. Panel ex coll. Robert Christie, UK, in possession of Louis H. Allen, dealer, of New York, 1936. *Connoisseur*, March 1936, pp. 159–60. In private US collection

CASSIOBURY PARK. Jussel reports that Vernay had a lot of Cassiobury carvings. May have installed two rooms (still there) at 19 Gramercy Park South for Benjamin Sonnenburg *c.* 1956

CASSIOBURY PARK. Living room made up from Wyatt salvages in McGeary Snider House, Philadelphia, 1924

CASSIOBURY PARK. It is possible that the drawing room overmantel in Wynnefield, Pennsylvania, Horace Trumbauer's house, was made up from Cassiobury carvings

MOOR PARK. Acton Surgey had the palm tree interior of Robert Adam's Tea Pavilion, 5 Dec. 1933 (letter in CAI department files). Now much expanded and installed in unlocated house in Virginia or Maryland

CASSIOBURY PARK. Chimneypiece and carved wood Tudor cornices from the Tudor wing. In the McGeary Snider house, Philadelphia, 1924

KENT

BELVEDERE. James Stuart chimneypiece with Wedgwood plaques, now in private Michigan collection

BELVEDERE. Pine window surrounds, doors, chimneypiece. Unsold Sotheby, New York,

sale 5967, 20 Jan. 1990, lot 1 (PL). Carved rococo woodwork from Great Room from collection of Mr and Mrs William Clay Ford; for sale by private treaty at Sotheby Parke Bernet, New York. PL

BOUGHTON MALHERBE. Gothic Oak Room of Edward Wotton *c.* 1520s, exhibited Charles & Son, New York, 1923 on the occasion of 'the greatest Exhibition of English Gothic Oak Carving ever held in America', possibly acquired by Hearst in 1924. Bought by San Francisco Museums (in store) from a Mr Baker, who is said to have acquired it from Hearst Foundation in 1981

CHARLTON HOUSE, possibly Charlton Grove, grand Georgian house in Charlton village opposite the Jacobean house. Room of 1730s with giant Ionic columns flanking chimneypiece, bought from Robersons by AMStL Dec. 1928. Suspicious compilation suggests a Roberson invention

DARTFORD. The Old Priory. Hearst 1941; Albro Fig. 5. 'Linenfold Panelled Room' from 'Dartfield'. Bought by Hearst from Roberson

EASTWELL PARK. Iron fireplace fittings supplied (by Robersons?) for Woodcote Park Room in MFA Boston

ELTHAM. SHERARD HOUSE. Two Jacobean rooms to Arthur Vernay, New York. H. Cescinsky and Ernest R. Gribble, *Early English Furniture and Woodwork*, vol. 1, 1922, Figs 338–41; one in Vernay cat. 1925

FAVERSHAM. 4 Market Place. Regency shop front. CAI, 1932.1367. Repatriated to Faversham Historical Society

HALES PLACE. Dem. 1928. At Caramoor Center for Music and Arts, New York, a composite room with Corinthian pilasters. House built 1743. Probably supplied by Robersons

HALSTEAD PLACE. Dem. 1952. Pine mantel, library, Tryon Palace, ex Crowther & Son 1953, maybe also panelling in library from same house

HERONDEN HALL. Eastry (maybe Eastry Court). Hearst lists in 1941 'Oak Panelled Rooms no. 3 and no. 4', bought from Robersons 21 Sept. 1926 (HD, v. 7). RSL No. 1 and No. 2 Elizabethan Oak Room, costed at £1,750 and £955. In Robersons 3, a William and Mary

room (E?). An Elizabethan oak room dated 1585 is the study in Edsel and Eleanor Ford's house, Grosse Pointe, Michigan, supplied by Roberson

MOUNT MASCAL, North Cray. Dem. 1959. Panelled room, bought by Crowthers, sold to Mrs Palm Stout of San Anselmo, California, converted to library, sold by Colonial Williamsburg Foundation, Northeast Auctions, 24 Feb. 2006. PL

RED LODGE, LANGLEY PARK. In 1929 Acton Surgey sold to PMA (29.78.1) Tudor renaissance panelling dated 1529, maybe removed from a Tudor hunting lodge and possibly installed in Langley Park (dem. 1913), and moved to cottage in park

RICHMOND HOUSE, Plaistow, Kent. Room and stair and hall of *c.* 1720s. Vernay 1931, sold to Untermyer for $1,200

SANDWICH. OLD HOUSE OR KING'S HOUSE. 'Drawing Room, Library, Hall and Ceiling from "The Old House".' Hearst 1941; Albro Figs 2–4

TONG HALL (Possibly Tonge), Newnham. Jacobean panelled room, bought from Gill & Reigate Aug. 1912 (HD, v. 88). Hearst 1941 (illus.), 'An exceptionally Fine Jacobean Carved and Panelled Oak Room from Tong Hall, Kent.'; Albro Fig. 6

TUNBRIDGE WELLS. Lichfield offers chimneypiece to USA. E?

WEST BROMLEY. Internal doorway of 1740s, Untermyer Collection, MMA. From 'Lord Dartmouth's', probably salvage from elsewhere

LANCASHIRE

AGECROFT HALL. Like Warwick Priory, also moved to Richmond, Virginia, in 1926

HALE HALL. Partly dem. 1935. Hotspur offering Jacobean pine room to PMA in 1925. E?

STANDISH HALL. Partly dem. 1923. 'Elizabethan Carved Oak Panelled Room' dated 1613, bought by Hearst from Robersons 18 May 1922 (HD, v. 88). Hearst 1941. Gifted to DIA (1958.241). Robersons 2 illustrates 'William and Mary oak library' and 'Elizabethan oak drawing room', Robersons 3 'an oak room'. A William and Mary library or cabinet room

bought from Robersons in private Michigan collection. See M. Jourdain, *English Interiors in Smaller Houses 1660–1830*, 1923, Figs 22–23 for trade illustration of library. Two Elizabethan chimneypieces with overmantels moved from Borwick Hall, Lancashire, end eighteenth century to Standish. Sold 1922 for £3,000 to USA (via Robersons?). See: *C. Life*, 10 Aug., 1935, Figs 13–14, p. 146

WRIGHTINGTON HALL. Room from 1748 building, sold by Robersons to PMA in 1928 (28.62.1), but unclear if room had been removed from the house at an earlier date, reputedly 1860s. See also Hooton Hall, Cheshire

'OLD HALL IN LANCASHIRE'. Important Jacobean room offered by Stair & Andrew of London and New York, April 1932. E?

LEICESTERSHIRE

CARLTON CURLIEU HALL. Late seventeenth-century chimneypiece from 'Carlton Park' by repute exported by Moss Harris

DUTTON HALL. A banqueting hall offered by White Allom and Roberson to PMA 1928–30 E?

GOPSALL HALL. Dem. 1951. Panelling of chapel and fittings said to have gone to USA, via Stanley J. Pratt; also the Congerstone Lodge, dismantled piece by piece, 1951 (Glynis Oakley, *A History of Gopsall*, Sheepy Magna, 1995). See L.G.G. Ramsey, 'Destruction Walks in Noonday at Gopsall Hall', *Connoisseur*, Dec. 1951, pp. 160–61. Window shutters in Council Chamber, Tryon Palace. Crowther & Son, 1954

KIRKBY MALLORY HALL. Panelling, and chimneypiece and overmantel in first floor library, Hillwood Museum, Washington, DC. Supplied by French & Co. for Marjorie Merriweather Post. Second floor library also an English room of *c.* 1740s, probably from Robersons via French & Co. Kirkby Mallors Hall. Pine mantel, South West Bedchamber. Tryon Palace, Crowther & Son, 1953

WANLIP HALL. seventeenth-century 'Dado Room', Hotspur. E?

LINCOLNSHIRE

COCKERINGTON HALL. Dem. 1923. Reputedly source of four doors supplied by Robersons for the Kempshott Park room at AMStL, 'from a house in Lincolnshire'

MIDDLEMORE HOUSE, Grantham. Queen Anne room sold 7 Nov. 1920, 'The Artistic Property Belonging to Charles of London', American Art Galleries, New York, lot 1182

LONDON

ADELPHI, 19 ADAM STREET. External door. AIC, 1938.112, from Stuart & Turnor, $1,500. Sold Sotheby, New York, 18 Oct. 1997, lot 392

ADELPHI, 5 ADELPHI TERRACE. Pair of doors. Sold Sotheby, New York, sale 6970, 11 April 1997, lot 804. PL

ALIE STREET, Hackney? (possibly from elsewhere). Pulpit from Zoar Baptist Chapel, bought CIA (1923.421). De-accessioned

ARGYLE STREET AT ARGYLE PLACE. 'Deal' room. AIC, Bought from Marshall Field, Chicago, 1922, 'from west side of Argyle Street at junction with Argyle Place', then Union of London & Smith's Bank. De-accessioned by AIC to Spencer Chemical Co., Dwight Building, Kansas City, 1955. Office now converted to flats; whereabouts unknown

ARLINGTON STREET, no. 19, Sir Laurence Dundas's house. Overmantel in make-up of Quinn Room, HLAG (000.136); also early eighteenth-century chimneypiece acquired by SFAM (1965.31) (see *Apollo*, Feb. 1980, p. 113)

ARTILLERY LANE, no. 58. Rococo Room. To AIC, 1923 (1923.417, $4,000). Sold to Spitalfields Trust for reinstatement. See also SPITALFIELDS

BATTERSEA, BOLINGBROKE HOUSE. Dem. 1922. The Cedar Room. Quoting the *Builder*, 7 April 1922, p. 503, 'the Cedar Room, in which Pope is said to have written his *Essay on Man*, may now go to America, for ... there is little demand for rare antique house decorations in this Country'. Now the library in McGeary Snider House, Philadelphia, 1924, it may be the same as that offered by Robersons to MFA Boston as 'a plain room' from 'Bolingbroke' House. MFA accession files

BOND STREET (facing Burlington Gardens). The George Cruickshank Panelled Pine Room attributed to William Kent or Roger Morris. Perhaps sold by Lenygon to Charles of London, sold American Art Galleries, 7 Nov. 1920, as property of Charles, lot 1183. Bought (?) by Lenygon and shipped to New York from London by Lenygon in 1924 and installed at 910 Fifth Avenue for Mr Bloomingdale. Gifted by S. J. Bloomingdale to the Pink Palace Museum, Memphis, Tennessee: see the *Commercial Appeal*, Memphis, 23 Jan. 1944. De-accessioned and sold 14 May 1975 for $7,500 to L. Kirkpatrick Bobo of Clarkesville, Mississippi

CHARLES STREET, no. 13, off Berkeley Square. Antique style Adamesque chimneypiece. MMA, 29.120

CHELSEA. Hearst 1941 lists 'Fine Elizabethan carved Oak Panelled Room'; bought from Robersons 26 Sept. 1927

CHELSEA. At Elm Court, Butler, Pennsylvania, the 'Anne of Cleves' chimneypiece from 'Chelsea'

CHESTERFIELD HOUSE. Dem. 1937. Caryatid chimneypiece from dining room. Illus. Crowther, *Antiquity of London* (n.d.), bought by Crowther, North End Road, the same as bought by Hearst from William H. Jackson 17 March 1927 (HD, v. 95, 17), mistakenly as from Canons. Hearst photograph inscribed as bought from Lady Carnarvon. Given to MMA (56.234.4), by Hearst Corporation

CHESTERFIELD HOUSE. Drawing room chimneypiece, bought by Hearst (no docket) and put in Ocean House, Santa Monica; sold Sotheby's, New York

CHESTERFIELD HOUSE. Ironwork of Great Staircase, bought by MMA from Lord Harewood. MMA, 65.164

DEAN STREET, no. 75. Entrance hall, part Kentian murals of stair, staircase, two rooms, as well as external entrance door (AIC 1925.1682). Sold Sotheby's, New York, 18 Oct. 1997, lot 391. Seven other rooms broken up and distributed through Crane house at Castle Hill, Ipswich, Mass., 1925–28. See

David Adler, Architect, ed. Martha Thorne, 2002

DOWGATE. 4, Dowgate Hill. Worshipful Company of Tallow Chandlers. Late Elizabethan chimneypiece, bought by Hearst from Charles & Co. 15 July 1912 (1922?). Hearst 1941 (illus. Albro Fig. 52)

GLOUCESTER HOUSE, PARK LANE. See Grosvenor House

GREAT GEORGE STREET. Pine room *c.* 1740s, with B. Altman, New York (*Burlington Magazine Monograph* III, 1929)

GROSVENOR HOUSE. Chimneypiece of 1770s or 1780s. Untermyer Collection, MMA, 64.101.1215

GROSVENOR HOUSE. Floorboards supplied [by Robersons?] for Woodcote Park Room in MFA, Boston

GROSVENOR HOUSE. Two Georgian mahogany doors. Parke-Bernet, New York, 15–17 Dec. 1938, lot 617. PL

GROSVENOR SQUARE. Lord Aberdeen's house, maybe no. 27 (no. 24 until 1887). Earlier house built 1728. Room in HLAG, first installed for Mr Herbert H. Straus for his house by Trumbauer, *c.* 1931–33, assisted by Hitau of Alavoine & Co. Gifted 1955 following sale from CAM. Another Lord Aberdeen room supplied by Robersons *c.* 1923 for private Michigan collection. It is possible that these two rooms came from 58 Grosvenor Street, Lord Aberdeen's other house

GROSVENOR SQUARE? Palladian chimneypiece and overmantel. Made up with barley-sugar columns. Parke-Bernet Galleries, 9–10 Feb. 1940, lot 390. PL

GROSVENOR STREET. Room in maisonette, 660 Park Avenue, ex Mr and Mrs Leslie R. Samuels. Intended for Sotheby's sale 2–3 Oct. 1981, but sale cancelled due to Imelda Marcos buying the lot. This may have come from no. 58, Lord Aberdeen's house

HANOVER SQUARE. External doorway, reputedly from nos 14–17, *c.* 1718. Robersons to MIA, 25 May 1931, $2,700, reduced to $2,120

HANOVER SQUARE. Chimneypiece from no. 15, therefore the Cameron house built in 1774 and dem. 1904. ROMT 1941. This identical to that in the dining room of the Childs Frick house, now Nassau Museum of Art, also installed by Allom. In G.C. Rothery, *English Chimney Pieces*, 1927, no. 122, as in Arts Club. Chimneypiece also in Francis Lenygon, *The Decoration and Furniture of English Mansions during the Seventeenth and Eighteenth Centuries*, 1919, Fig. 110, and Fig. 112 another chimneypiece from same house, probably also exported. See also chimneypiece in breakfast room, Frick Collection, New York, probably also from Hanover Square, via Allom, if not one of Allom's known copies

HANOVER SQUARE. Tenterden Street. Royal Academy of Music. Hindleys had two internal doorways from Lord Carnarvon's house

HATTON GARDEN. Robersons advertise rooms in *C. Life*, 13 Feb. 1926, one of their three listed at £796, £650 and £525 (RSL). Offers room to PMA for $2,331.38 on 15 March 1926. Hearst buys same 15 March 1926 for $2,331.38; sold Parke-Bernet 1941, bought by Ayers for Art Institute of Zanesville, Ohio, where it remains. Also in Robersons 3. Unclear if these relate to the demolition of 26 Hatton Garden in 1907 and the room exhibited by White Allom in the Palace of Decorative Art, Franco–British Exhibition, Paris, 1908; purchased by V&A 1912

LANSDOWNE HOUSE, Berkeley Square. Dining room sold to MMA (32.12) through Hampton & Sons, via Acton Surgey on behalf of developers for $10,904

LANSDOWNE HOUSE, Berkeley Square. Drawing room bought from Hampton & Sons, 1931, for PMA (1931.104.1)

LANSDOWNE HOUSE. Section of balcony sold to MMA

LOMBARD STREET. Baroque doorway sold Stuart & Turner to CIA, 1933.781. Sold Sotheby's New York, 18 Oct. 1997, lot 1068T

LOWER CLAPTON ROAD, no. 179. Corinthian doorway, of later Deaf & Dumb Asylum for Women. Bought by AIC (1933.923), sold Sotheby's New York

MILDMAY HOUSE, Newington Green. Keeble Ltd. exhibit oak panelled room at Exhibition

of Antiques, Olympia, 1928, and offer to PMA for £3,500 but also chimneypiece from library at Albyns (Mildmay family). Robersons 3 illustrates the staircase. Rothery pls 23 and 27 from what is described as 'King John's Hunting Lodge'

OLD BURLINGTON STREET, no. 31, once Earl of Warwick's house, in 1909 the showrooms of Lenygon & Morant. Somewhat reduced Francis Henry Lenygon Memorial Room, given by Mrs Jeannette Lenygon to Avery Library, Columbia University, 1955

OLD BURLINGTON STREET, no. 29 (General Wade's House). Stone escutcheon to PMA *c.* 1929

PARK LANE, no 25. The Austrian Paar Room installed in London by Sir Philip Sassoon, now MMA as The Paar Room

PORT OF LONDON AUTHORITY. Robersons (Robersons 4) offer entrance doorway to AMStL in Nov. 1928. E?

PORTMAN SQUARE, no. 1. Todhunter of New York, brochure advertisement, April 1929 of chimneypiece from mansion of Marquis of Blandford, attributed to Robert Adam, 1775. Probably by James Wyatt

PRINCE'S GATE, no. 49. The Whistler Peacock Room, bought by Charles Lang Freer in 1904 for his house on East Ferry Street, Detroit; removed 1919 to Freer Art Gallery, Washington, DC

RAVENSCOURT PARK, HAMMERSMITH. Crowthers said to have exported to USA a late seventeenth-century door (info. Crowther of North End Road)

RICHMOND HOUSE, WHITEHALL(?). Door of *c.* 1730s. Untermyer Collection, MMA

RUSSELL SQUARE, nos 65–66. Bolton House. Fixtures, chimneypiece, ceiling, etc. from Robert Adam's interiors removed 1910 and through Gerald A. Letts (dealer?) shipped 1911 to the Percy Pyne House, 680 Park Avenue, New York. See Eileen Harris, 'Robert Adam on Park Avenue: The Interiors for Bolton House', *Burlington Magazine* Feb. 1995, pp. 68–75

SACKVILLE STREET. Eighteenth-century panelled room given to SFAM, 1971, de-accessioned 1982

ST JAMES'S SQUARE. Robersons lists (RSL) 'Early Eighteenth-Century Oak Room' at £2,150, maybe Lord Astor's at no. 4 (1912–42), re. inscription on photograph of room with giant Ionic fluted pilasters, and also references in Clarke–Duveen files with roll of drawings

ST JAMES'S SQUARE. Norfolk House. 'Monkey Door 'from Great Drawing Room, sold Christie's 7–9 Feb. 1938, lot 286, companion to one in V&A. Bought Untermyer, gift to MMA (64. 101.1212)

ST JAMES'S SQUARE. Norfolk House. Doorway from saloon. Sold Stuart & Turner to CAI (38.239). Sold Sotheby's New York 18 Oct. 1997, lot 390

SOHO SQUARE, no. 38. Early eighteenth-century panelled room. Whereabouts in USA unknown. See *Burlington Magazine*, Oct. 1915, p. 85

SPITALFIELDS. Morning Room panelling supplied by Robersons 1926–29 for Edsel and Eleanor Ford House, Grosse Pointe, Michigan, 'from Spitalfields'. See also ARTILLERY LANE

SPITAL SQUARE. Robersons 3 with Jacobean room. E?

TOWER HILL. William Stead's house (later the Crooked Billet Tavern), dem. 1925. Room bought by PMA from Osborne & Co. of Grafton Street, 1922 (22.8.1), for the Memorial Hall (pre-PMA). T. Crowther later supplied a door with a pediment

WHITEFRIARS GLASS WORKS. C. Pratt & Sons in *Architectural Review*, March 1924, illustrate early eighteenth-century room, and mention that they have 'twenty Early Georgian Panelled Rooms . . . secured from old houses in the City'. E?

PANELLED ROOM OF *c.* 1740 FROM 'OLD NORTH LONDON MANSION'. Litchfield & Co. *Connoisseur* July 1931; could be same as Mildmay House. E?

MIDDLESEX

ACTON. The Manor House. Keebles offer Charles II room to PMA in 1928 for £1,200. E?

BUSH HILL PARK, Enfield, once known as Enfield Old Park. Litchfield & Co., *Connoisseur*

1910, advertising chimneypieces from Earl of Bristol's house, sold by Ford family 1908, dem. 1927. Now Bush Hill Golf Club

CHISWICK MANOR HOUSE. Dem. late 1890s. Duveen bought interior panelling and carvings. Some exported but what is unclear

ENFIELD, Crews Hill. Hearst possessed room in 1926. Probably from the present Glasgow Stud Farm with salvages supposedly from Theobalds Palace

FELTHAM PARK. See ESSEX, UPTON

GROVE HOUSE, Chiswick. Dem. 1928. Elements of panelling in Quinn Room HLAG (000.136). See also DEVON, CASTLE HILL; LONDON ARLINGTON STREET

HILLINGDON MANOR HOUSE, Uxbridge. Chimneypiece 1720s. MMA (31.90)

UXBRIDGE. The Treaty Room and Presence Chamber from the Crown and Treaty House. Removed by Robersons 1929, possible Lenygon & Morant connection, sold to Louis H. Allen *c.* 1931. Both rooms later sold to Armand Hammer for his personal office in the Empire State Building, 1945. Coronation gift to Queen Elizabeth II in 1953, and reinstated in Treaty House

MONMOUTHSHIRE

COLDBROOK PARK. Marble chimneypiece in parlour, Tryon Palace, Crowther & Son, 1954

PIERCEFIELD PARK. Jacobean chimneypiece bought by Hearst from William Permain via *National Magazine*, 2 Dec. 1925 (HD, v. 95)

PIERCEFIELD PARK. Chimneypiece attributed to J. Bonomi, bought from Rosenbach Co., now PMA (1944.46)

NORFOLK

DIDLINGTON HALL. Dem. 1950. Five Early Georgian brass locks for Tryon Palace, Crowther & Son, 1953

GAYWOOD HALL, Bishop's Palace, near King's Lynn. Two rooms reputed to be in USA (A. Avis, *Gaywood Past: Some Historical Notes*, 1999) E?

GREAT YARMOUTH. Fenner's House. Elizabethan room of 1595. Stair and Andrews 1913; sold(?) to William C. Tozer; bought by Hearst from Tozer(?), 14 March 1927 for $4,817.59. Sold Gimbels for $15,000 (HD, v. 84). MMA (65.182.1). See Herbert Cescinsky, *Burlington Magazine*, Aug. 1913, pp. 300–2

GREAT YARMOUTH. From Star Hotel, ex William Crowe's house, Great Yarmouth, to Arthur S. Vernay Inc., sold to Mrs Morton F. Plant (later Mrs John E. Rovensky) of New York; sold at her death Parke-Bernet Galleries, 22–23 Oct. 1957, lot 337. See Herbert Cescinsky, *Burlington Magazine*, May 1913, pp. 88–92, and Cescinsky and Ernest R. Gribble, *Early English Furniture and Woodwork*, vol. 1, 1922, Figs 320–26

HINGHAM HALL. Dem. *c.* 1927. 'Jacobean Panelled Room' sometimes called 'Tudor Room', bought by MIA from Arthur S. Vernay of New York for $13,300, 1919. Vernay reports having bought it from R. Mathews of Hingham. Arms in overmantel those of Charles Bowen, silk mercer in 1634

KING'S LYNN. 22 St Margaret's Place. Hanseatic League house, purchased *c.* 1750 by Edward Everard. Room sold to Acton Surgey by owner Frank R. Floyd. Sold to Nelson Atkins Museum, Kansas City, 1931 (31.116). From same house a Jacobean chimneypiece and overmantel, sold to Hearst 1934, record in French & Co., stock sheets

KING'S LYNN. Jacobean chimneypiece and overmantel from Clifton House, Queen Street. Photo National Monuments Record, R. Fyff 1888. Same workshop as the Rotherwas/Amherst one. Not *in situ*, but from elsewhere. E? Inf. Mark Girouard

NORWICH. ROMT room acquired from Gill & Reigate in 1912 as from Norwich. Not the Roberson 3 'Elizabethan Oak Room' in Roberson list as sold at £1,450. This also probably in USA

WEST HARLING HALL. Dem. 1931. Chimneypiece and overmantel containing portrait of Sir Andrew Fountaine. Sold Acton Surgey to CIA (1933.798). De-accessioned, except for portrait, sold Sotheby's New York, 11 April 1997, lot 393

NORTHAMPTONSHIRE

ASHBY ST LEDGERS. Early Georgian panelled room. E?

BRIXWORTH HALL. Dem. 1953. Early Georgian panelled room with seventeenth-century overmantel carving, ex Crowthers, North End Road, 1957; sold Henry Ford II, removed from his house 1983 when dem. Now in private Michigan collection

DEENE PARK. Uncertain if Late Elizabethan or Jacobean panelling in library of Edsel and Eleanor Ford House, Grosse Pointe, as supplied by Robersons late 1920s, is from Deene, but probable

LYVEDEN OLD BEILD. Jacobean staircase *c.* 1604 supplied by Robersons (Robersons 4) for Edsel and Eleanor Ford House, Grosse Pointe, late 1920s

NORTHUMBERLAND

MORPETH. Ward House. Room with giant pilastered order offered to PMA in 1925 by Robersons. In French & Co. files at GCH, photograph dated 1925

HOUSE OF SIR DUDLEY CORY WRIGHT (nineteenth century owner?). 'Very Fine Elizabethan Panelled Oak Room', bought by Hearst from Charles of London 3 June 1927 (HD, v. 87). Sir Cory Francis Cory Wright (1838–1909) had a son Dudley Cory Wright. Neither appears to be from Northumberland. A Matthew Cory lived at Parmonte Hall; see also Cory of Dyffryn, Glamorgan

OXFORDSHIRE

KIRTLINGTON PARK. Dining room sold by Hubert Budgett to MMA (32.53.1) for $78,353.64. Installed 1954

SHROPSHIRE

MOAT HALL. Linenfold panelled room, stone chimneypiece, carved doorway and 'important' oak screen. Bought by Hearst from Acton Surgey 31 March 1927 (HD, v. 84). Three Jacobean panelled rooms of Berrington family, bought by Hearst from Charles of London, 1 May 1929 (HD, v. 88). Hearst 1941 illustrates chimneypiece

OAKLY HALL. See SUFFOLK, OAKLEY HALL OR PARK

PLAISH HALL. Hearst 1941 (illus.) 'Elizabethan Carved Oak Panelled Room'; bought from Robersons 1 May 1927 (HD, v. 87)

SHREWSBURY. Great House, Whitehall. One of five Elizabethan rooms purchased by Marshall Field & Co. of Chicago, to display English Tudor furniture in their flagship State Street Store. 'Completed or assembled in 1928 by Charles of London' (inf. Margaret Lukaszyk of Wadsworth Athenaeum, one room for sale in 2001). One room for President of Tex Fel Petroleum (Vernay 'Contract Book', 1956)

SHREWSBURY. Jacobean room described as 'Captain Dugdale's'. Letter from Roberson to Duveen, 1925, Duveen papers, Clark Institute, Bay XXVII, item 8 Roberson folders

SOMERSET

BATH. Carved Pine Room, George III. Parke-Bernet Galleries, New York, 22 May 1948, lot 6. Edward I. Farmer's stock

BECKINGTON ABBEY. Hearst 1941 lists an 'antique stone mantel'. This must be Robersons 3. Three doorways in the dining room of Ocean House, Santa Monica, dem. 1958, are recorded as from 'Beckington Hall'

COTHAY HOUSE. Chimneypiece offered to PMA 1928. E?

HAZELGROVE HOUSE. Late seventeenth-century carved room with sumptuous rococo overmantel to chimneypiece. Bought by Hearst from Acton Surgey. Hearst 1941 (illus.); Albro Figs 24–5. *C. Life*, 18 May 1929 reports room still *in situ*, but to be removed by Acton Surgey

MUCHELNY ABBEY. Great Oak Door and a window. In McGeary Snider House, Philadelphia, 1924

SOMERSET TUDOR ROOM. MFA, 23.604. Gill & Reigate in *Connoisseur*, June 1920. Assembled in their Ipswich workshops 'from over a dozen places in different parts of England' (MFA archives), including three panels in chimney overmantel from house in Tarporley, Cheshire, via the Revd William Cole's Hermitage in Bletchley, Buckinghamshire. Gill & Reigate supposedly bought room or parts of room from sale or shop in Bath 1910, with a provenance in Somerset near the Devon border

STAFFORDSHIRE

BESCOT HALL. Room reputedly exported (L&M/BDM)

LICHFIELD. Yeomanry House. Chimneypiece bought by Hearst from Charles of London, 24 March 1926 (HD, v. 95)

OAKLEY HALL. Baroque chimneypiece with caryatids at angles, *c.* 1730s. Bought by Hearst from Frank Surgey 21 July 1925. Information from Oakley that a room was sold from this house

STAFFORD. From house near St Mary's church. Queen Anne Oak Room in MIA, bought from Robersons 1931 (31.58) $9,600, after first offer 5 Feb. 1931 of $12,000. 'Oak Room no. 1' offered to AMStL by Robersons in 1928. In Robersons' list a 'Large Queen Anne Oak Room' costed at £1,475 and a 'Small' one at £985, both illustrated in Robersons 2, and as 'sold'

TEDDESLEY HALL. Seven pine mantels: Governor's Bedchamber, Miss Tryon's Bedroom, Ochre Bedroom, Margaret's Bedroom, Mrs Tryon's Dressing Room, Butler's Room, Housekeeper's Room, all Tryon Palace, Crowther & Son, 1953–4

UTTOXETER. Removal of nine rooms, high quality, *c.* 1670s–80s, by Gill & Reigate. *Connoisseur*, June 1909. Maybe from Loxley Hall near Uttoxeter. Probable export of at least one or two. Gill & Reigate in *Connoisseur*, Oct. 1915, illustrate seventeenth-century oak room that may be from Uttoxeter

WOOTTON HALL. 'A number of finely carved pine rooms, doors, trim, staircase etc'. Vernay 31 March 1934

SUFFOLK

BROKE HOUSE. See NACTON HALL

BURY ST EDMUNDS. A boiled-up late sixteenth-century room acquired 1961 by the Denver Art Museum from Mrs Simon Guggenheim, who bought it for her Park Avenue apartment from Arthur S. Vernay 1927–28, who may have acquired it from Acton Surgey. De-accessioned to store in 1995. Not clear if related to the ceiling in an 'old house in Bury St Edmunds', bought by Hearst through *Nash's Magazine*, London, 13 June 1927

DEAN or DENNE PARK. If latter, near Horsham. Ironwork gates de-accessioned by MMA

EAST ANGLIA. Jacobean stair. Robersons and

White Allom, sold Hearst 29 May 1925 (HD, v. 83)

HIGHAM OR BARHAMS MANOR OR GIFFORDS HALL. Late Tudor room said to have arms of Charles Bowen, silk merchant. Sold to MIA 1919 (23.67) by Arthur S. Vernay, of New York, who refers to a Mr R. Mathews of Higham Manor House supplying either room or ceiling. MIA archives mention Barhams and Giffords as candidates

HAWSTEAD HOUSE. Room of 1620. Robersons 4. E?

IPSWICH. Tudor half-timbered house on Carr Street, dismantled 1907 and re-erected at the Franco-British Exhibition at White City, 1908, by Gill & Reigate (of Ipswich); then re-erected [on Long Island?] with brick Tudor-style extensions. Undated estate advertisement by Sutton, Blagden & Lynch, Inc. of New York, lacking name of estate. See Edmund Orwell, 'Ipswich Tudor House "Export" recalled', *East Anglian Daily Times*, 1 July 1970

IPSWICH. Holywell or Holywells Park. Dem. 1962. By local repute (Suffolk Record Office) some of the panelling and salvages from Sir Anthony Wingfield's house in Ipswich (Tankard Inn) installed (1920s?) by J. Dupuis Cobbold, Ipswich brewer, exported to USA. See *A Catalogue of the Remaining Contents of the Mansion of Holy Wells, Ipswich*, Knight Frank & Rutley, 9–10 April 1930, lots 1–3 and photos in Suffolk Record Office, Ipswich

IPSWICH. Neptune Inn. Panelling removed to St Donat's Castle and some or all removed from there to USA. Other panelling in Burrell Collection, Glasgow

NACTON HALL. Hearst 1941 lists 'Gothic oak ceiling'? From Broke House

OAKLEY HALL OR PARK, Suffolk. Baroque chimneypiece. MMA, 56.234.5. Provenance uncertain, maybe from Oakley Park, Shropshire

OULTON MANOR HOUSE, probably Oulton High House, Gorleston Road. Still with two fine late sixteenth-century ceilings. Daniell of 42–46 Wigmore Street, advertises two rooms in the *Connoisseur*, Nov. 1912 and Jan. 1913. Whereabouts in US unknown

PARHAM OLD HALL. Stone frontispiece and much panelling in McGeary Snider House, Philadelphia, 1924

SUDBURY. Room of *c.* 1740s, fabricated from at least two others. Intended to be installed in Duveen's New York house, probably early 1920s, but in fact installed in his house in Kensington Palace Gardens, London. Removed by White Allom, and by early 1930s in Duveen's stock. Known as the 'Sir William Chambers Sudbury, Derbyshire, Room'. Bought by Mr Norton Simon of Los Angeles March 1965. Never installed and sold to Robert Samuels of French & Co. in 1968 (French & Co. stock sheets, 1415, have 1966. GCH). Present whereabouts unknown

SWANN HALL, Hawkedon, Suffolk. Jacobean room. Robersons 1. E?

WALDEGRAVE HALL. Said to be near Timworth. Gothic ceiling, bought from Acton Surgey through William Permain, 11 Nov. 1927 for $8,584.06 (HD, v. 92). Hearst 1941

WOODBRIDGE. Old farmhouse. Elizabethan room. Robersons 1. E?

SURREY

ADDINGTON PARK. Invoice 5 Oct. 1929 refers to 'Addington Palace antique Chinese wallpapers', 75 foot run. Accession files AMStL

ASHLEY PARK. Dem. 1920. French & Co. said to have handled the long gallery, present whereabouts unknown. French & Co. stock number 52865(GCH) is a room made up from this gallery, bought 1953 from Mrs Edgar W. Garbisch, and possibly before that in possession of Sara Hunter Kelley. Sold 1968. Also in French & Co. photogaph files are other photographs of Ashley rooms. Although late seventeenth-century staircase reputedly exported, a stair from Ashley put into Fawsley Hall, Northants. In Colonel Balsan's bedroom, Casa Alva, Lantana, Florida, a small room installed 1930s, on market in 1956. Clark–Duveen files mention two rooms with Duveen connections, one a George II pine room bought by French & Co. from Mrs Garbisch

CHIPSTEAD PLACE. Dem. 1931. In 1931 Nobury Smith & Co., auctioneers of Conduit Street, London, W1 advertised the 'important Demolition sale' on 20 and 21 Oct., including the Superb 'Grinling Gibbons Screen' (*sic*!) and the 'Magnificent Collection of Original seventeenth and eighteenth-century Period Oak and Pine Panelled Rooms. Marble and Wood chimney pieces, Fittings, Fixtures, and Garden Stonework'. Acton Surgey had the staircase for sale, 5 Dec. 33 (correspondence in CIA department files). Part of a room in Museum of the Rhode Island School of Design

GUILDFORD. Sixteenth-century cottage removed to McGeary Snider house, Philadelphia. 1924

LEATHERHEAD. Red deal panelling in possession of Robersons. H. Cescinsky and E.R. Gribble, *Early English Furniture and Woodwork*, vol. 1, 1922, pl. 381. At MGM studios, California

THE OAKS, Epsom. Dem. 1957. Room at Paramount Studios, Hollywood, 1983, a composite of an arcuated wall system by Sir Robert Taylor and doors by Robert Adam

SUTTON. Chimneypiece from a 'Sutton' house of 1760

WOODBRIDGE HALL, Guildford. 'Elizabethan Oak Room' on exhibition in New York at £1,500 Robersons PMA list at £1,500

WOODCOTE PARK, MFA Boston. The rooms sold by the Royal Automobile Club out of Woodcote Park in 1913 were bought by Harold G. Lancaster, who advertised them in the *Connoisseur* in Feb., April, May and June 1914. A 'Woodcote Park Collection' was advertised by Charles in *C. Life*. Robersons offer 'Pine Drawing Room', £2,250 and 'Pine Library, £1,750' (undated Roberson stock list PMA/FK). This did not include the MFA room, gifted to the museum by Eben Howard Gay in 1928. The source must have been Robersons via Charles. The 'Fabulous English rococo room' owned by New York dealer Mathew Schutz on Park Avenue (inf. Michael Conforti) might have been the library, now of unknown location. On 10 Nov. 1920, the American Art Galleries sold a collection formed by Charles of London, including 'The Regent D'Orleans Room of Painted Panels'. Rothery pl. 11 shows MFA chimneypiece and pl. 120 another Woodcote Cheere style chimneypiece

WOODLEA, Virginia Water, Surrey. Rooms from Lord Grimthorpe, sold by Philip Samuel of Nice, at the Anderson Galleries, New York, sale 2129, 1927, including two English chimneypieces and a 'Georgian' room in French style, but may be French. Sold again by American Art Association, Anderson Galleries, lot 637, 23–25 April 1936, including lot 636, a *Régence* carved oak library from Woodlea. A Louis XVI room painted green sold by Dalva

Brothers of New York to French & Co., April 1944

PANELLED ROOM. From 'house in Surrey' dated 1560, installed as the Tavern in Ocean House, Santa Monica, California, *c.* 1926, dem. 1958

SUSSEX

EVERSFIELD PLACE, Hastings. Room or salvage to USA. E? (L&M/BDM)

WARWICKSHIRE

BANNER HOUSE, COVENTRY. Jacobean room with arcaded wall system. Bought by Hearst from Acton Surgey Dec. 1926; Hearst 1941. Sold Gimbel Bros 1943

BRAILES MANOR HOUSE [built 1822]. Judge Irwin Untermyer invoice in MMA: 'one panelled oak room from the old Refectory [Old Rectory?] Braile [Lower Brailes], Oxfordshire [Warwickshire]'. 800 square feet, $6,000, from Charles of London. One Untermyer room sold by MMA (11984.28.74) at Sotheby's, New York, 16 April 1996, lot 602. Probably originally from Weston House, rebuilt 1827

COMBE ABBEY. Partial dem. 1925. Staircase. Acton Surgey sold to Hearst 7 Feb. 1927 (HD, v. 83). Hearst (illus.; Albro Fig. 47)

COMBE ABBEY. Robersons offer 'Small Pine Room' at £690. E?

COMBE ABBEY. 'Oak and Gold William and Mary room', in possession Robersons 3 April 1925 (Clark–Duveen). Bought by Hearst from White Allom 2 Jan. 1926 (HD, v. 85) Hearst 1941 (illus.); Albro Figs 29–30

COMBE ABBEY. Rothery 1927, pl. 10 shows Elizabethan chimneypiece, and pl. 18 a Jacobean one. E?

ERDINGTON HALL (North Birmingham). Dem. 1912. Jacobean room. Location unknown (L&M/BDM)

HENWOOD PRIORY. Late Tudor room. With Robersons. Nunnery or Priory dem. 1825, parts going to SOLIHULL RECTORY and OLTON HALL, Warwickshire, but unclear from what house this room was removed. Also with White Allom (at £25,000) 15 May 1924 (archives PMA) and Hearst, who gave it to MMA 1956 (56.234.39). Rothery 1927, no. 9. De-accessioned and sold Sotheby's, New York, 16 April 1998

SHELDON HALL. Jacobean staircase. Robersons 1 [printed as in Leicestershire] also illustrates

'Renaissance oak room'), sold Hearst Dec. 1925 (HD) Hearst 1941 (illus. Albro Fig. 44)

WARWICK PRIORY. The early seventeenth-century range of a house, once seat of Henry Wise the gardener, exported to Richmond, Virginia (now as Virginia House), 1925. The *Architect* reported 25 Oct. 1925, 'greed on the part of the seller, and vanity, ostentation and bad breeding on the part of the purchaser'. Stonework in McGeary Snider House, Philadelphia, 1924

WILTSHIRE

BRADENSTOKE ABBEY. The Tithe Barn in the private Madonna collection at San Luis Obispo, California, ex Hearst. Dismantled and not yet erected

HAMPTWORTH LODGE, Landford. Elizabethan room removed by Robersons from house substantially designed by Guy Dawber. Sold to Jacob Aron, who named his new house Hamptworth, at Great Neck, Long Island. Dem. 1968, given to Brooklyn Museum, passed on to ROMT, de-accessioned and sold

SALISBURY. Jacobean room. Robersons 4. E?

WORCESTERSHIRE

CROOME COURT. The Tapestry Room. Furniture sold 1902. Assembled as an entity by 1958. MMA

EVESHAM, Fryers. *Connoisseur*, May 1914, advertise oak Tudor chimneypiece removed from Evesham Town Hall in 1830 and oak panelling used in summerhouse at Dresden House, Evesham. Also have oak rood screen made in 1514 and removed from Evesham Abbey in 1729 (from Dresden House probably). E?

HAMS COURT, Upton upon Severn. Drawing room and library. E?

STOURBRIDGE. Early eighteenth-century room, Vernay, April 1935

WOLLASTON HALL. Late Elizabethan panelling and hooded chimneypiece supplied *c.* 1927 by Robersons to Edsel and Eleanor Ford House, Grosse Pointe, Michigan

YORKSHIRE

BOWCLIFFE HOUSE, Wetherby. Neo-classical chimneypiece, probably by John Carr. To Henry Ford II in 1957 for his Grosse Pointe, Michigan, house. Given to DIA 1984.86, with another English chimneypiece

GILLING CASTLE, Great Chamber. The School in 1929 sold Great Chamber to Acton Surgey and Robersons, 1929–30. Offer to PMA rejected. Bought by Hearst, eventually repatriated to Gilling

HORNBY CASTLE. Chimneypiece and Ionic pilasters. Vernay 1931. Jussel reports many other items from this house too

KIDDAL HALL, West Riding. Hearst 1941 lists the 'principal features' of this small manor house exported whole. From Wm Pearman through *Nash's Magazine*, 7 Dec. 1927. HD, v. 76, 30–43. Whereabouts unknown

LEES HALL. Probably at Thornhill, West Riding. Robersons/Duveen (Clark–Duveen) reference to the house, 'Whence panelling was removed'. At Lichfield & Co. in 1925

LIVERSEDGE LOWER HALL. 1660 oak room. Robersons 1. E?

METHLEY HALL, YORKSHIRE. Jacobean staircase illustrated in Arthur Stratton, *The English Interior*, 1920, Fig. 72, p. 75. E?

NORLAND HALL, near Halifax. The stones used to line walls of First Presbyterian church, Cambria, California, ex Hearst 1941

RED HILL, Spofforth. Elizabethan room. Robersons 1, E?

SETTLE. Eighteenth-century pine room from house on Constitutional Hill. Vernay 1948 (PL)

STANWICK PARK. Dem. 1923. Room advertised by Robersons in The *Connoisseur*, Nov. 1927. Robersons 4 illustrates 'pine room no. 4'. Uncertain if this is the room at the MIA (28.82)

STANWICK PARK. Parts of room in ROMT, bought 1928. Previous history unknown

STANWICK PARK. Childs Frick House, Roslyn Harbor (Nassau County Museum of Art). Dining room with chimneypiece. Questionable ascription owing to style. Supplied by Robersons via White Allom *c.* 1919 to Childs Frick

STANWICK PARK. Parke-Bernet Galleries, New York, 22 May 1948, liquidation of stock of Edward I. Farmer Inc. lot 3, 'Stanwick Hall Room'. Possibly that reputedly in a New York office

STANWICK PARK. Robersons, *Architectural Review*, Oct. 1924, p. xvii illustrates room with French style nineteenth-century chimneypiece, possibly that supplied by Robersons

to Mrs McCann of Oyster Bay, Long Island. See: Parke-Bernet Galleries, New York, Nov. 1929, 1942, lot 7, 'Georgian Carved Pine Panelling of a Salon'

WALES

GWYDIR CASTLE. The dining room. Hearst 1941. 'Remarkable Fine Oak Panelled Room'. Reference to *Catalogue of Antique Furniture at Gwydir Castle*, May 1921, lot 188. Bought by Robersons, sold on to French & Co., sold on to Hearst. Gifted to MMA by the Hearst Corporation in 1956, never installed, and returned to Gwydir Castle 1996. A second room, the Oak Room, lot 65 also sold to USA, but location unknown (inf. Peter Welford)

TREGUNTER, TALGARTH. Dem. 1924. Sale of fittings in 1914 included doorcases and staircase said to be exported to USA. E?

SCOTLAND

DOUGLAS CASTLE. Lanarks Dem. 1938. Internal doorway by John Adam, AIC, 1932, but accession number 1938.111 from Stuart & Turner £252 14sh.6d. Sold Sotheby's, New York, 18 Oct. 1997, lot 384

HAMILTON PALACE. Letter from Robersons to MFA Boston, 17 March 1927, reports that 'my firm (in November 1919) . . . secured no less than 30 panelled rooms including all the grand reception rooms and the Grindling [*sic*] Gibbons staircase Marble and stone fireplace, etc. and practically everything purchased at Hamilton Palace has now been sold', at the sale held by Christies, 12 Nov. 1919. According to French & Co. archives (GCH, archive acc. no. 840027, box 25, f. 2–3), most of the rooms were bought in 1920, and the following were on the stock sheet inventory: Old State Dining Room, sold to Hearst 1924; Picture Gallery with the black marble chimneypieces, partly sold to Hearst 1924; Morning Room, bought 1921, sold to Hearst 1924; Old State Anterooms, sold to Hearst 1924; State Breakfast Room, sold to Bradbury (for MFA Boston?), 1924; George I Boudoir, sold to Hearst 1924, sold on to MMA, May 1931; Princess Suite, George I Bedroom, sold to Hearst 1934; Princess Suite, George I Ante-Room, sold to Hearst 1924; Princess Suite, George I Dressing Room, sold to Theodore Whitmarsh (for Whitmarsh Court, Philadelphia?) April 1933; Princess Suite, George I Lobby, sold to Alfred Ettlinger 1929; Duchess Suite, George I Boudoir, bought from Symons, sold to Hearst 1924; Duchess Suite, George I Bedroom, sold to Hearst 1924, given to DIA 1958.240. Note on docket to effect, 'We have parts of the ceiling and careful plastic moulds of the intricate parts that were not movable, so the room can be reproduced as it originally stood in Hamilton Palace, perfectly'; Duchess Suite, George I Ante-Room, bought from Symons, sold to Hearst 1927; Duchess Suite, George I Dressing Room, bought from Symons 1921, sold to Hearst 1927. Robersons also sold the staircase to French & Co. in 1920, but inexplicably this does not appear on stock sheets. Hearst 1941 lists six rooms he purchased (HD, v. 86), and the Hearst 1941 list also includes white marble and black marble mantels (Albro Fig. 58). Pietra serena chimneypiece with arms of Cantucci family *c.* 1490, and two white marble doorways and overdoors, now in private Michigan collection. According to the 'Index Sands Point Building and Parts', in Beacon Towers Hearst installed 2 Hamilton Palace rooms and chimneypieces, one black and one white marble. It is unclear if the two George I rooms were from the Duchess suite. A George I room was sold by French & Co. to Mr and Mrs Hamilton Rice for their Fifth Avenue apartment; later dismantled and stored in Newport, Rhode Island, and sold Parke-Bernet Galleries, 22–23 Oct. 1965, lot 338 (illus.). It is uncertain who George Parker Jnr of Dallas, Texas bought one of the duchess's rooms from for his dining room pavilion. See Sotheby's New York, 28–29 June 1999 (sale 7325) and 12 Nov. 1999 (PL)

Appendix 1

CHARLES ROBERSON OF THE KNIGHTSBRIDGE HALLS

IN 1903 CHARLES LOCKHART ROBERSON set himself up as an antique dealer in Knightsbridge, and registered as a company in 1906.[1] He was partnered in 1910 by Ernest L. Roberson as financial director. In June 1910 from 83 Knightsbridge, their first advertisement the *Connoisseur* is for antique furniture and chimneypieces, and for the next ten years there is little published evidence of their dealing in rooms or salvages, although naturally the First World War intervened. In 1920[2] the company acquired the Knightsbridge Halls at 217–29 Knightsbridge 'in which to display the genuine old rooms which come into their possession'. As Ralph Booth's account of the company continues, 'this House stands amongst the foremost of the leading exponents of Decorative and Furnishing Art, and carries out many schemes for Architects, with whom it collaborates with great success'. The workshops were in nearby Kinnerton Street, where no doubt they manufactured their rooms! An indication of their success is the advertisement in the *Architectural Review* for October 1924:[3] 'A Cordial Invitation is issued to all Architects to visit the Unique Exhibition of Antique Panelled Rooms Period Furniture & Old Mantels now being held at Knightsbridge Halls. Sixteen Old Rooms Of Various Periods Are At Present On View, All Tastefully Furnished In Appropriate Style'. They hoped that, 'In these days when so many of the Estates and Country Seats of the Nobility are changing hands, there are many heirloom furnishings, tapestries and art objects which owners desire to dispose of, and the Knightsbridge Hall Galleries will be an ideal medium through which they may be brought to the notice of possible buyers'.

These latter words are from the introduction to their first trade catalogue, *Historical Rooms from the Manor Houses of England* published by the Mendip Press of London and Weston-super-Mare *c.* 1925. This substantial and expensive publication was followed by three more volumes, all like the first bound in cream board and stamped in gold with the title *Antique Panelled Rooms* and a crowned shield with an R. To each volume there was a preface and a photograph of the exterior of the halls, with an accompanying folding floor plan (Fig. 224) of the partitioned exhibition galleries, not unlike the workshops (Fig. 227) of Carlhian et Cie in Paris.[4] In volume 1 there were twelve rooms, from an average each year of about sixty. In most cases Roberson includes a photograph and a plan of the room or staircase; in the absence of a photograph, there is often a line drawing. Significantly, nearly all the photographs are taken of the rooms already set up in the halls and not *in situ*, so they are presented as furnished by Robersons, a clever ploy. Indeed furnishing their rooms was rewarding. The line drawings are partly inventions by Robersons to convey to the client the firm's idea of a furnished ambience. For example, for Jacob Aron at (Hamptworth) Great Neck, Long Island for Walker & Gillett architects, Roberson provided a 'Fine Elizabethan Dining Room (Fig. 211) and all furnishings of same. (and) All furnishings for other living rooms'. To clients they sent out measured or line drawings in a paper cover, titled in capital letters, as they did to Edsel and Eleanor Ford at Grosse Pointe, Michigan: PINE ROOM from THE CLOCK HOUSE, UPMINSTER, SOMETIMES CALLED TREATY HOUSE

(Figs 224–5). The peak of their business was between 1922 and 1930. Although amalgamation with Charles of London had been discussed, it is doubtful if this would have saved the firm from the stock market crash when, with offices and workshops in New York, they were bankrupted. By 1933 their stock had been taken over by Crowthers of Syon Lodge, Isleworth.[5]

Robersons' trade catalogues form an invaluable document at the peak of the first country house crisis when so many of these houses were being demolished.

Volume 1
Sheldon Hall, Leicestershire, the main Jacobean staircase
Whitley Beaumont Hall, Yorkshire, Queen Anne oak dining room[6]
City of London house, Early Georgian pine room
Wanstead, Essex, black and gold lacquer room
Grosvenor Square, London, Corinthian room, made up with chimneypiece[7]
Red Hill, Spofforth, Yorkshire, Elizabethan panelled and carved room
Woodbridge, Suffolk, old farmhouse, Elizabethan oak room
Sheldon Hall, Leicestershire, Elizabethan oak room
Lower Hall, Liversedge, Yorkshire, oak room said to be dated 1660
Leatherhead, Surrey, Queen Anne oak room
Swann Hall, Hawkedon, Suffolk, Jacobean oak room
Urishay Castle, Herefordshire, early Jacobean oak room

Volume 2
Wingerworth Hall, Derbyshire, the main staircase
Wingerworth Hall, Derbyshire, oak drawing room[8]
Wingerworth Hall, Derbyshire, oak library
Lyme Regis, Dorset, The Tudor House, Jacobean oak room
Standish Hall, Lancashire, oak library[9]
Standish Hall, Lancashire, oak dining room
Boughton Malherbe, Kent, the Wotton oak room
Bladud Castle, South Molton, Devonshire, Elizabethan oak room
Stafford, Staffordshire, Queen Anne oak room
Stafford, Staffordshire, small Queen Anne oak room

Old French oak room, 1780s
Seckford Hall, Suffolk, Elizabethan oak screen and minstrel gallery
Corlbawn House, Co. Wexford, Flemish oak room dated 1673 and 1683 brought from continent in 1840 by Francis Bruen
Buckingham, Buckinghamshire, Jacobean oak room

Volume 3
London, Newington Green, staircase: 'removed . . . together with several panelled rooms'
Standish Hall, Lancashire, James I oak room
Standish Hall, Lancashire, state bedroom
Norwich, Norfolk, Jacobean oak room
Beckington Abbey, Somerset, Elizabethan chimneypiece
Heronden Hall, Kent, Elizabethan oak room from old house demolished in 1782
Combe Abbey, Warwickshire, the Gilt Parlour
Sutton Scarsdale, Derbyshire, oak room
Sutton Scarsdale, Derbyshire, pine room
Haldon House, Devonshire, pine room
London, Hatton Garden, pine room
London, Spital Square, pine room

Volume 4* (under authorship of Charles Roberson's Colleague, B.L. Smithers)
Lyveden 'old Beild [sic]', Northamptonshire, oak staircase
Greenstead Hall, Greenstead Green, Essex, Elizabethan oak room
Hawstead House, Suffolk, Jacobean oak room
St George's, Canterbury, Kent, oak staircase
Manor House, Colnbrook, Middlesex, Jacobean room
Salisbury, Wiltshire, Jacobean oak room from house in the Close

PLAN OF THE EXHIBITION OF HISTORICAL ROOMS FROM THE MANOR HOUSES OF ENGLAND
AT THE KNIGHTSBRIDGE HALLS.

Rooms numbered on the Plan.

No. 1.—Sheldon Hall, the Staircase.

No. 2.—Queen Anne Room from Whitley Beaumont.

No. 3.—Early Georgian Room from an old London House.

No. 4.—Green and Black Lacquered Room.

No. 5.—Old English Pine Room from Grosvenor Square.

No. 6.—Elizabethan Inlaid Oak Room from an Old Manor House in Yorkshire.

No. 7.—Elizabethan Oak Room from Woodbridge, Suffolk.

No. 8.—Early English Renaissance Room from Sheldon Hall, Leicestershire.

No. 9.—Oak Room from the Lower Hall, Liversedge, Yorkshire.

No. 10.—Georgian Pine Room from Leatherhead, Surrey.

No. 11.—Jacobean Oak Room from Swann Hall, Suffolk.

No. 12.—Early Jacobean Oak Room from Urishay Castle.

224. Plan of Charles Roberson's Knightsbridge Halls, London. Mid-1920s

225. Charles Roberson's brochure cover advertising a room in the New Place, Upminster, Essex. Mid-1920s.

PINE ROOM from
THE CLOCK HOUSE, UPMINSTER
SOMETIMES CALLED
TREATY HOUSE

Old Church Far, near Penrith, Cumberland, Jacobean oak room
Streatlam Castle, Durham, oak room No. 1
Streatlam Castle, Durham, oak room No. 2
Spettisbury House, Dorset, pine room No. 1
London, Mayfair, Grosvenor pine room No. 1

Stanwick Park, Yorkshire, pine room No. 4
London, near Tower of London, 'Port of London' doorway
Ivy House, Twickenham, Middlesex, doorway
London, Hanover Square, Old Harewood House, chimneypiece

Naturally, not all these offerings went to the USA, although many did. Amongst so many others, Hearst bought rooms from Spettisbury, Haldon, Standish, Combe Abbey, and a Streatlam Castle room, the last now the Twombly Burdon Room in the Lowe Library of Columbia University. Those that ended up in private mansions are difficult to track down today, and in any case many had short lives due to changes in taste by owners and their successive interior decorators.

Like those of nearly all of the London suppliers of rooms and decorators, Roberson's archives have not survived, although this author is grateful to Mr John Booth II of Grosse Pointe, Detroit for a short history of the firm drawn up in 1926 when it was considering a partnership with Charles of London. John Booth I was a director of Robersons. A few other documents can be recovered from museum departmental archives. For example, at the Minneapolis Institute of Arts are the estimates for supplying and furnishing a Stanwick Park room for $33,665 and a room from Wingerworth Hall costing $14,125. Only the Stanwick room was acquired, and then not as furnished by Robersons. In the archives of the Philadelphia Museum of Art is a 'List of Panelled Rooms in Stock in London', with costings,[10] one that is clearly prior to Robersons' published catalogues and obviously related to Fiske Kimball's urgency in installing a suite of English rooms soon after 1925 or 1926. In the course of my enquiries a list of Roberson installations in the USA was identified and is probably related to the history of the company.

Some of the panelled rooms installed in America by Roberson of London

Edsel B. Ford, Detroit [the Edsel and Eleanor Ford House] Architect Albert Kahn: Pine Dining Room, Pine Morning Room, late 16th century Oak Study, early 17th century Oak Library, George I Painted Drawing Room, Gothic Stone and Oak Gallery, Gothic Stone and Oak Corridor, and Stone Hall with 17th century Oak Staircase [as existing]

Edward Farmer of New York [New York antique dealer, 815 Park Avenue, Apt. 6A]: late 17th century Oak Room Christopher Wren period, early 17th century Jacobean Oak Room, 18th century Pine Room [rooms no longer exist]

Albert Wiggin of New York [President of Chase Bank, 660 Park Avenue, Apt. 8] Architect Mr Moran: late 17th century Oak Dining Room, Pine George I Living Room [rooms exist]

Clarence Dillon of New York [124 East 80th Street, New York] Architect Mott Schmidt [1930]: A Pine Room, a late 17th century Oak Room, several marble mantels, several mahogany Adam doorways [now Republic of Iraq, rooms reputedly there]

Clarence Lewis, Blairs Bank, New York ['Skylands', now New Jersey Botanical Gardens] Architect Russell Pope: fine Elizabethan Dining Room and all furniture for the same [see *Country Life in America*, August 1937, pp. 34–41. Tudor style, completed 1928. Breakfast Room with Italian Renaissance lavabo. Dining room with Elizabethan panelling]

Mr [Harold C.] **Richard, New York** [Milbury Meadow, York Harbor, Maine] Architect John Russell Pope [1928]: Elizabethan Oak Room for Living Room [house burned down 2004]

L. Gordon Hammersly [1030], **Fifth Avenue, New York**. Mr Coffin architect [Polemus & Coffin]: Fine Henry VIII Linenfold Room for Living Room, with Stained Glass in Windows [apartment number not located]

Mrs Childs Frick, Roslyn, Long Island [Nassau Museum of Art, Roslyn Harbour]: A Pine Living Room George I period. 50 ft long, 13 ft high [attached note as coming from Stanwick Park]

Mr Allen Lehman ['Elmbrook'] **Tarrytown, New York**: Fine late 17th Century Living Room with original Grinling Gibbons carving [one of two Lehman houses on the Hudson, demolished in 1970s]

Mrs Holmes [Bettie F. Holmes/Mrs Christian R. Holmes] **Fifth Avenue, New York** [Mrs Christian R. Holmes, Barkers

226. Charles Roberson's measured drawing of a room from New Place, Upminster, Essex. Installed in the Edsel and Eleanor Ford House, Grosse Pointe, Michigan

Point Road, Sands Point, NY. Estate built *c.* 1930 Nassau County, Long Island] Fine Jacobean Oak Library [Unable to locate estate. She was daughter of the immensely rich Charles Fleichmann]

Mrs G.M.G. Forman, Buffalo, New York. Architect Mr Edward Green, Buffalo: Early Tudor Oak Living Room, Pine Morning Room, Painted Georgian Dining Room

Jacob Aron, Great Neck, Long Island [Hamptworth House in Tudor style on North Shore built 1922–26, demolished 1968] Architects Messrs Walker & Gillett: Fine Elizabethan Dining Room and all furnishings of same. All furnishings for other living rooms.

Dr Edgar Sampson, Forest Hills, Long Island [the Saye house, existing with the rooms] Architect Mr Rogers: Oak Tudor Living Room, Oak Hall and Staircase, Walnut Dining Room, and all furnishings for same

Mr Ralph Booth, Detroit [315 Washington Road, Grosse Point, Michigan] Architect Mr Marcus Burroughs: late 17th century Oak Study, Georgian Pine Dining Room

Mr R.T. Crane Jnr, Ipswich, Mass. [Castle Hill, Mass.] Architect David Adler, Chicago: Large Pine Library with Grinling Gibbons carvings in limetree

Mr Wister [Benjamin W.] **Morris, architect of New York** [possibly 'Quiet Corner', Greenwich, Connecticut, see: *New York Architect*, April 1908, vol. 2, no. 4, pp. 232–37] Fine quality Pine Jacobean Panelled Living Room fixed in Connecticut

Mrs McCann [Mrs Charles E.F. McCann, daughter of F.W. Woolworth]

Oyster Bay, Long Island ['Sunken Orchard', Berry Hill Road] Architect Mr Huber: Pine Panelled Living Room, noted as from Stanwick Park [room added during remodelling of existing house]

Elyris Steel & Iron Corporation, Cleveland. Architects Meyer & Walsh: Set of Oak Jacobean Offices including Board Room and Director's Offices and furnishing for the same

William Randolph Hearst, New York: Henry VIII Linenfold room, 3 Tudor Oak Rooms, 3 large George I Pine Rooms, 2 Pine Rooms mid 18th century, Elizabethan Oak Staircase, Stone Mantels, Marble Mantels.[11]

List of panelled rooms in stock in London[12]

Albyns Long Gallery £8,250
Woodcote Park Pine Drawing Room
 £2,250
Woodcote Park Pine Library £1,750
Stanwick Park No. 3 Pine Room £1,250
Coombe Abbey Small Pine Room £690
Brimington Hall Elizabethan Oak Drawing
 Room sold £650
Brimington Hall Elizabethan Oak Bedroom
 sold £650
Woodbridge Hall Elizabethan Oak Room
 on exhibition £1,500
 in New York
Corlbawn Hall Flemish Oak Room
 £3,000
Stafford Large Queen Anne Oak Room
 £1,475
Stafford Small Queen Anne Oak Room
 sold
Chester Oak William and Mary Room
 £1,500
Carlton House Terrace Louis XVI Oak
 Room £1,750
Carlton House Terrace Louis XV Oak and
 Gold Room sold £1,500
Norwich Elizabethan Oak Room sold
 (£1,450)

Leigh Hall Elizabethan Oak Room
 £1,550
Hatton Garden No. 1 Pine Room £796
Hatton Garden No. 2 Pine Room £650
Hatton Garden No. 3 Pine Room £525
Cassiobury Park Green Drawing Room
 £2,250
Cassiobury Park Carved Staircase
 £5,000
Haldon Hall Pine Room £2,000
Zion Lodge Pine Room £1,950
Heronden Hall No. 1 Elizabethan Oak
 Room £1,750
Heronden Hall No. 2 Elizabethan Oak
 Room £955
St James's Square early 18th century Oak
 Room £2,150
Treaty House, Upminster, No. 1 Pine Room
 £1,950
Treaty House Upminster No. 2 William
 Kent Pine Room £2,325
Dalmain, Penrith No. 1 Large Jacobean
 Room [no price]
Dalmain, Penrith No. 2 Large William and
 Mary Room [no price]
The Grange, Devon £16,000

Note: The above prices are net in our London showrooms. All freight, packing, insurance and duty (if any) extra.

Appendix 2

THE PARIS FIRM OF CARLHIAN ET CIE, EXPORTERS OF

FRENCH ROOMS

BECAUSE THE NAME CARLHIAN IS ubiquitous in transatlantic trade, even if the firm did not deal in English salvages, any account of period room installation in the USA between *c.* 1920 and *c.* 1945 must consider the influence of André Carlhian and his son Richard, who between them were more learned in the history of French *boiseries* than any museum director, excepting perhaps Fiske Kimball at the Philadelphia Museum of Art. The extent of French dispersals in the years immediately following the First World War can be judged by an examination of the Carlhian archive now deposited at the Getty Center for the Humanities, Los Angeles.[1] It is probably true that by 1900 in Paris alone there must have been a dozen dealers growing rich from architectural salvages displaced from *hôtels* and châteaux. Many of these dispersals were rooms of a second and even third generation, already having had two lives before being installed in a nineteenth-century building. The firm that dealt with more *boiseries* than any other was Carlhian et Cie, founded during the Directorate as a *Manufacture et Magasins de Papiers peints et Véloute de Decorations*, located in the rue des Francs-Bourgeois, Paris.[2] The exact line of succession thereafter is uncertain. It can hardly be a coincidence that after the First World War, Maison Carlhian would become the chief supplier of French panoramic wallpapers to the Americas.[3]

In 1867 the company had been re-founded by Anatole Carlhian and his brother-in-law Albert Dujardin-Beaumetz as Carlhian–Beaumetz, located at 30 rue de la Beaurepaire, Paris. By 1905 both founders had died, and Anatole's two sons, Paul and André, established Carlhian et Cie at 24 rue Mont-Thabor between place Vendôme and rue de Rivoli, with their workshops on avenue Rapp near the Eiffel Tower. Because Paul was an early wartime casualty in August 1914, for the duration Maison Carlhian was managed by their house architect René Sergent,[4] a practitioner of the *style Gabriel* and a sympathetic restorer of *hôtels* and châteaux. It was he who designed the *hôtel* for Joseph Duveen in the court of 20 place Vendôme and, not surprisingly, many sets of *boiseries* came from houses in that place. Carlhian–Beaumetz had specialized in copying pieces of famous French furniture and in what one might call modern antiques. They soon came to the attention of Joseph Duveen because of their skill and a growing friendship between the two families in London and Paris. It was Duveen who commissioned them to make the Coronation thrones for Edward VII in 1901–2, and who persuaded Anatole to stop making reproduction furniture, and to become an antique dealer specializing in panelled rooms. Ultimately, under André's management and with his immaculate taste for the French *dix-huitième*, they became decorators in their own right. Later they moved their office to 6 bis Avenue Kléber, once the eighteenth-century hôtel Sainte-Beuve, where they expanded into the rue Lauriston for workshops. Evocative photographs by Stanley Hale show the *boiserie* warehouse, and workshops for upholstery, painting, gilding, tapestry and cabinet work, a museum for salvages and frag-

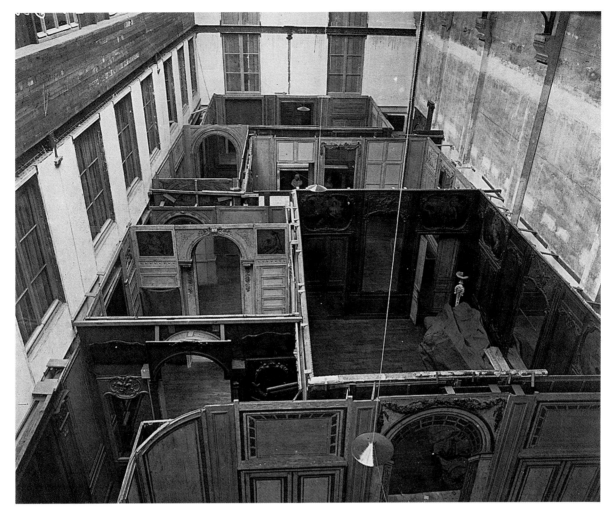

227. View of Carlhian et Cie's exhibition halls in the rue Lauriston, Paris. The Knightsbridge Halls, London, would doubtless have looked similar.

ments, casts of *boiseries*, decorative elements, the chair store, the drafting room, the photographic laboratory and office. Indeed, Hale's photographs show the type of workshop that must have been characteristic of major English dealers, such as Roberson of the Knightsbridge Halls. In December 1927 a house inventory listed 60 'cheminées Anciens', 50 'cheminées Modernes', as well as 'Stock Ancien 338' and 'Stock moderne 121', and 96 models. Presumably 'Stock Ancien' meant architectural and wooden salvages, i.e. *boiseries* or parts of them. 'Stock moderne' may well have described elements and objects of the 1920s and 1930s, for Carlhian was a fashionable Parisian decorator.

Carlhian of Paris was in Buenos Aires with dealers Frères Block from 1908 to 1920; they had offices in New York from 1910 to 1939 and from 1947 to 1953, successively at 11 East 54th Street, Madison Avenue at 57th Street, and then at 980 Madison; and they were in Cannes from 1941 to 1953, and in London with Wildenstein from 1945 to 1966. After André's death in 1968 with Richard in charge they operated as R. & M. Carlhian from

André's lavish apartment at 73 quai d'Orsay until the firm was finally dissolved in 1974.[5] With their web of offices and trade connections, not least with French & Co., Duveen, Sir Charles Allom, and Horace Trumbauer in New York, the number of *boiseries* imported by the firm, or through the firm's contacts, into the Americas, was legion. In any case the most fashionable décors to install in this period were French ones, far exceeding the concurrent fashion encouraged by Charles of London for 'ye olde' English Jacobethan oak style. Carlhian's refined decoration and décors emulating the 'old French style' were unmistakable, as could have been seen in Mrs Alexander Hamilton Rice's rooms at 901 Fifth Avenue, New York, where *boiseries* from the Château de Norville were cleverly interweaved with skilful copywork; or in André Carlhian's own rooms from 1930 at 73 boulevard quai d'Orsay where he used his favoured unpainted Louis XV *boiseries* combined with sculptured and carved wood walnut furniture; or in Madame Carlhian's quai d'Orsay *boudoir*/bathroom and in André Carlhian's *salon*, bedroom, or *petit salon*. However, the firm were also exponents of a distinguished art deco style of interior, especially for bathrooms,[6] as might have been seen in Madame Devoto's property at 26 quai Albert I in 1931. For banks (Banque de l'Indochine), commercial firms (Syndicate de Sucre), hotels (Bar Cambon in the Paris Ritz, Hotel Majestic, Cannes), or galleries and shops (Guérlain, Cartier, Van Cleef, Arpels or Boucheron) the firm provided a contemporary *moderne* look.

Appendix 3

THE TRYON MEMORANDUM

THIS MEMORANDUM, EDITED AND ADJUSTED by Nancy Richards,[1] Curator of the Collections, was compiled in 1975 by Gertrude S. Carraway, then Director of the Tryon Palace Restoration. She worked closely with Maude Moore Latham, who financed the rebuilding of the palace. 'Miss Gertrude', as she was known, was an important member of the Acquisitions Committee until she resigned to become director. The compilation is a key document in the restoration history of the Tryon Palace, New Bern, North Carolina, showing how the restoration architect, William Graves Perry, relied upon T. Crowther & Son of Syon Lodge, Isleworth, to supply chimneypieces and other salvages. Whereas in general Crowthers had always been reluctant to reveal provenances, clearly this was not the case at Tryon Palace.

LIBRARY: 'Early Georgian carved pine mantelpiece with shell and leaf centerpiece' came from Halstead Place, Kent. It was purchased by William Graves Perry, restoration architect, from T. Crowther & Son. The bill dated 6 Nov. 1953 was for £140. In all cases shipping charges were not included. Another bill for £202, dated 10 Nov. 1954, covered the purchase of 498 feet of eighteenth-century pine moulding in various lengths for use in the Library and Mrs Tryon's Dressing Room.

COUNCIL CHAMBER: Sienna marble mantel similar to one described in Tryon's letter to Lord Hillsborough: 'For the Council Chamber . . . a large statuary Ionic chimney piece, the shafts of the columns sienna and the fret on the Frieze inlaid with the same. A rich Vaze and Foliage on the Tablet; medals of the King and Queen on the Frieze over the Columns, the moulding enriched, a large statuary marble slab and black marble coverings. Messr DeVol [John Devall, Sr and John Devall Jr] & Grainger fecit.' The bill from Crowthers, dated 5 May 1953, was in two parts. The first payment was for $564.15; the second payment of $560 was for 'repairs and substitutions' and was acknowledged by Crowthers on 16 Nov. 1953. 'Substitutions' included removal of vase-shaped pitchers above each column and the substitution of marble 'medals' or medallion portraits of the King and Queen. On 10 Nov. 1954, Perry purchased for the Council Chamber from Crowthers two pairs of window shutters, originally from Gopsall Hall, Leicestershire. Three other pairs were reproduced for the rooms. The antique shutters cost £40.

DINING ROOM: The 'Georgian Carved Pine Chimney Piece, Fruit and Flower Frieze, Basket Centre and End Brackets' came from Crowthers at a cost of £125, according to the bill dated 11 Nov. 1954. 'The Early Georgian Wood Doorway, painted and moulding decorated to represent carvings' was bought for £40 according to the bill dated 10 Nov. 1954. It came originally from Weald Hall, Essex.

PARLOUR: The 'Very Fine Georgian Carved Statuary Marble Mantelpiece with Convent Sienna Grounds' came from Coldbrook Park, Monmouthshire, Crowthers's bill dated 10

Nov. 1954, for £575. The 'Carved Pine Georgian Overmantel with Broken Pediment' came from Crowthers and cost £110. Part of the same shipment included about 60 feet of 'Georgian Carved Pine Chair Rail and Skirting' costing £270.

HOUSEKEEPER'S ROOM: This has a plain mantel with dentils below the shelf and is of six 'Mid-18th Century Pine Mantelpieces with plain friezes' bought from Crowthers, purchased from Teddesley Hall, Staffordshire, at a cost of £400 for the six.

BUTLER'S ROOM (formerly the Guard Room): A 'Mid-18th Century Pine Wood Mantel with egg-and-dart and leaf decoration' came from Teddesley Hall, one of the six. Note: recently one more appropriate to a service space replaced that mantelpiece. The original is preserved behind a new wall.

SECOND FLOOR

DRAWING ROOM: The 'Finely carved Georgian pattern second-hand pine chimneypiece' was bought for £90 from C.J. Pratt, 186 Brompton Road, London, SW3. The bill is dated 6 Nov. 1953. The 'Carved Pine Georgian Overmantel' (reproduction) was purchased 10 Nov. 1954 [from Crowthers] at a cost of £70. The 'Georgian Doorway, Pediment with Carved Brackets' also came from Crowthers and cost £55.

SUPPER ROOM: 'Reproduction Carved Pine Chimneypiece with Fruit & Flower Centre and Scroll Side Brackets on Jambs' came from Crowthers with the 10 Nov. 1954 shipment and cost £125.

OCHRE BEDROOM: Mantel of the six bought by from Crowthers for £400, and from Teddesley Hall.

SOUTHWEST BEDCHAMBER (formerly the Mauve Bedroom): The 'Early Georgian Carved Pine Mantelpiece with Flower and Leaf Centrepiece' came originally from Kirkby Mallory Hall, Leicestershire. Bought by Crowthers, the bill 16 Nov. 1953 for £145.

ALCOVE BEDROOM: 'Early Georgian carved Pine Mantelpiece with Running Leaf Frieze' from Weald Hall, Essex. Crowthers' bill dated 16 Nov. 1953 for £90.

MRS TRYON'S DRESSING ROOM: Mantel with small beading and floral and leaf design, one of the Teddesley Hall six. The carved pine moulding is part of the lot purchased from Crowthers in 1954 for the Library.

GOVERNOR'S BEDROOM: Mantel part of the Teddesley six. The 'Carved Pine Georgian Overmantel with Broken Pediment' was purchased from Crowthers, bill dated 10 Nov. 1954 for £90.

MARGARET'S BEDROOM: The 'Mid-18th Century Pine Wood Mantelpiece with plain friezes and carved leg mouldings and shelf mouldings' was one of the Teddesley six.

According to the memo, William Graves Perry bought five 'Early Georgian Engraved Brass Locks, complete with keys, box stables and drop handles' from Crowthers – used for the front entrance door, Butler's Room, Library, Great Stairs and on the inside of the Dining Room. These came from Didlington Hall, Norfolk, bill dated 16 Nov. 1953 for £113.

Appendix 4

THE SHERBORN NOTE

DEREK SHERBORN WAS ONE OF the first to call attention to the country house crisis after the Second World War. He was a fund of knowledge about the destruction of houses and the movement of salvages. Sadly, he never wrote his proposed book on the subject. This could also be said of the late Peter Reid, who was particularly active in tracking down albums of country house photographs. Only in the last year of Derek's life did he attempt to commit his recollections to paper, notably when writing his *An Inspector Recalls: Saving Our Heritage*, published in Lewes in 2003. In his handwritten note addressed to this author he attempted to convey what he recollected about the break-up of houses and the travels of salvages. All the following are quotes, with my additions in square brackets.

The staircase from Rolls Park [Essex, demolished 1953] went to Hinchingbrooke [Huntingdon]. I do not know where the staircase from Great Nelmes [Essex, demolished 1967] now is. [In Hornchurch, Essex]

Look into Rawdon House [Herts]; its chimneypieces went to Rothamsted [Herts]. The panelled room from Wolseley Hall [Staffordshire] went to Gawsworth [Cheshire] but is much cut down. The staircase, also by Pierce, went to Devon but was lost. Doesn't the Knight of Glin have an urn from the stair?

Peter Hone has got hold of the 1670 plaster ceiling from Nottingham which was taken to Holme Pierrepont and never erected.

Some of the architectural features of Wyatt's Lee Priory, Kent, went to Stephen Weeks at Penhow Castle, Gwent, but when I went there some years back they had not been reused. Henry Thorold has at Marston Hall [Lincolnshire] that very remarkable little room dated 1694 with an ornate ceiling, from Burston House, Devon [Installed at Marston in 1972]. When David Styles bought a room at South Park, Penshurst [Kent, partial demolition] there were actually the decorations of two or three other earlier rooms concealed beneath what he had bought . . . paneling, wallpaper and fabric, one on top of the other. It was quite extraordinary.

Didn't Felix Harbord the decorator buy a French Rothschild room from Piccadilly, all the other dealers being under the impression that it was nineteenth century?

The Hall screen from Methley [Yorkshire, demolished 1963]. Is this still stored somewhere? The present lord doesn't reply to enquiries.

Staircase from Willingham [Hall. Lincolnshire. Demolished 1976] went to Kit E. Kat a millionaire in Glasgow. I wonder who he was?

What did the National Trust ever do with the room from Holland House, Holland Street, Barnstable given to them by Marks and Spencer? [In National Trust store]

The staircase from the Red Lion Hotel in Truro went to Godolphin in Cornwall.

I do not know what the National Trust did with it. It was too lofty, going up several floors and Godolphin is only two storeys. [In National Trust store]

I remember an overmantel dated 1617 removed at demolition from Pentecost, Doddridge, Devon, and installed at Broadmead outside of Barnstable.

At Llanarth Court, Gwent, a hall screen dated 1627. Came from Treowen in 1898. Told them they should send it back. [This is now proposed]

I protested about the demolition of Burwell Park, Lincolnshire. You were right about burning the marvellous rococo stair balustrade on the lawn.

Albyns, [Essex] that was a terrible break-up [1954].

Theobalds [Hertfordshire] a farm house on the site, I saw old panelling there.

At Belhus, Essex [demolished 1957] I remember a lorry taking away a pile of panelling. I tried to buy it, but was told to clear off.

Chimneypieces from Wenvoe [Glamorgan, demolished *c.* 1911] are supposed to be in a Cardiff house.

The demolition [1950s] of Stanwell House is a blank to me. You may be right about the Gibbs room there, but I did discover the garden bridge, and temple.

Where did those lovely 18th century panelled rooms at Llanwern, Monmouthshire, go to? I saw them before the demolition in 1952. I think Crowther bought them.

That man Fred Koch has put Elizabethan chimney pieces into Sutton Place, a Prinknash one I think.

I once saw a photograph of a room removed from Wanlip Hall, Leicestershire, but don't know where [demolished 1938. Hotspur the dealers had the room].

I think a Hatton Garden room was put into a house in Kensington Palace Gardens [possibly no. 14 by White Allom for J.H. Solomon].

I saw in the 1970s that house in Denbighshire, Horsley Hall. Its grand Elizabethan chimneypiece went somewhere and in the gardens was an arch or gate from Great Buckingham Street in London, Peter the Great's lodging.

Appendix 5

THE HEARST SALE

BUILDINGS AND PARTS

MONASTERY—KIDDALL CALL, CASTLE BENAVENTE, STONE ELEMENTS

A Spanish Cistercian monastery founded in 1141 by the King of Castile, Alfonso VII, the Emperor, removed from the Village of Sacramenia(600-1)
The Principal Features of Kiddal Hall, Yorkshire, English—Built about 1500(389-1 to 16)
Various decorative Stone Elements from the Castle of Benavente, Spain—Spanish Gothic, XV Cen.(284-1)
A Gothic Cloister of Saint-Beat (Pirenees) Marble French—XIII-XIV Cen..(564-1A to 1TTT)
A Gothic Cloister—French—13th, 14th, 15th Centuries(258-1 to 405)
A Cloister Consisting of Forty-Five to Forty-Seven Arches, French—from the End of XIII or Beginning of XIV Cen.(630-1)

CAPITALS

FRENCH

Two Groups of Five Columns Each, XII Cen. (111-44 to 51)
Two Double Columns with Bases and Capitals, XII Cen.(98-1 to 3)
Two Columns with Their Original Capitals, XII Cen.(173-71 to 74)
Eighteen Stone Columns with Bases and Capitals, XIII Cen.(184-1 to 38)
A Set of 5 Capitals with Columns and Bases, End XIII Cen.(336-6 to 10)
A Double Capital with Double Column and Base, XIII Cen.(331-14)
A Double Capital with Double Column and Base, XIII Cen.(331-15)
A Single Capital with Single Column and Base, XIII Cen.(331-16)
Fifteen Columns with Bases and Capitals, XIII Cen.(1112-1 to 15)
Four Marble Columns with Capitals and Bases, XIII Cen.(1313-1 to 4)
A Pair of Columns with Capitals and Bases, XIII-XIV Cen.(212-28 & 29)
Two Capitals with Double Columns and Bases, XIV Cen.(142-29 to 36)
Four Double Capitals with Columns and Bases, XIV Cen.(272-6 to 21)
Two Columns with Capitals and Bases, XIV Cen.(331-8 & 9)
A Double Stone Capital, XIV Cen.(117-4)
Sixteen Openings in Carved Stone, XV Cen. (173-1 to 32)
12 Pairs of Columns with Capitals and Bases, XV Cen.(626-1 to 12)
Six Columns with Capitals and Bases, XV Cen.(894-11 to 14)
Six Columns with Bases, Capitals and Archivolts (328-1)

ITALIAN

A Capital of Corinthian Column, Roman...(1011-21)
A Capital of Corinthian Column, Roman...(1011-25)
A Pair of Columns with Bases and Capitals, XII Cen.(138-10 to 12)
Four Columns with Capitals and Bases, XVI Cen.(807-1 to 4)
Four Columns with Capitals and Bases, XVI Cen.(807-5 to 8)

Four Columns with Capitals and Bases, XVI Cen.(807-9 to 12)
Six Columns with Capitals and Bases, XVI Cen.(807-13 to 18)
A Pair of Sculptured Wood Columns, XVI Cen.(100-36-37)
A Pair of Walnut Columns, XVII Cen...(419-28 & 29)
A Pedestal with Revolving Capital, XVII Cen. (482-30)
A Pedestal with Revolving Capital, XVII Cen. (482-31)
A pair of Grecian Marble Columns....(163-72 & 73)
Two Italian Marble Pedestals.........(482-28 & 29)

MOORISH-SPANISH

A Set of Columns with Capitals and Bases, XIII Cen.(330-24 to 30)
Four Columns with Capitals and Bases, XIII Cen.(331-10 to 13)
Two Marble Capitals with Coats-of-Arms, XVI Cen.(423-25 & 26)
Two Columns, XVI Cen.(482-42-43)
A Pair of Renaissance Carved Columns, XVII Cen.(382-1-2)
24 Columns with Capitals and Bases, XVII Cen.(871-1 to 24)

FLEMISH

A Stone Column with Capital and Base, XIII to XIV Cen.(383-7)
A Stone Column with Base and Capital, XV Cen.(383-8)
A Pair of Carved Oak Columns, Renaissance (57-74-74A)

BELGIUM

A Stone Column with Capital and Base, XVI Cen.(383-9)

MISCELLANEOUS

A Pair of Columns with Bases and Capitals (327-36-37)
A Pair of Columns with Bases—No Capitals (327-43-44)
A Pair of Columns with Cuivre Dore Capitals(327-38-39)
A Stone Column with Capital and Base, XV Cen.(383-6)

SPANISH

Twenty-Eight Assorted Pino Wood Corbels, Ca. 1500(594-38 to 65)
One Hundred and Forty-Four Corbels, XVII Cen.(769-1 to 144)
Eight Old Spanish Carved Walnut Corbels (482-1 to 8)
Thirteen Old Spanish Carved Walnut Corbels (482-9 to 21)
Twelve Short Wooden Gothic Beams, XIV Cen.(611-179 to 190)
3 of a Lot of 8 Gothic Keystones, XV Cen....(78-13)
4 Carved Ceiling Supports, Early XV Cen. (163-68 to 71)
3 Pair of Limestone Roof Corbels, XVI..(590-5 to 10)

MISCELLANEOUS COUNTRIES

Nine Beam Corbels Supports, French, XIII Cen.(157-1 to 9)

[321]

[322]

A Pair of Marble Pilasters, Italian, Late
Renaissance(327—56-57)
A Pair of Marble Pilasters, Italian, Late
Renaissance(327—58-59)
A Marble Spandrel, Italian, Late Renaissance.(327-74)
A Marble Pediment, Italian, Late Renaissance.(327-52)
A Marble Pediment, Italian, Late Renaissance.(327-53)

ROOMS AND PANELLING

ENGLISH, GOTHIC & XVI CENTURY

Drawing Room, Library, Hall and Ceiling
from "The Old House" Sandwich, Previ-
ously Known as the "King's Lodging,"
Walls of Carved Oak Panelling, English,
XVI Cen.(200-1 to 7)
The Finely Carved Linenfold Panelled Room
from "Moat Hall," Essex, Together with
the Carved Stone Chimneypiece Carved
Doorway, an Important Oak Screen with
Arched Openings, English, XVI Cen.....(267-1 to 4)
The Carved and Panelled Oak Dining Room
from Albyns, Essex, English, Ca. 1600........(534-1)
An Antique English Oak Panelled Room Re-
moved from Henwood Priory..............(548-1)
An Antique English Oak Panelled Marque-
terie Room with Stone Mantel............(571-1)
An Old English Carved Oak Panelled Room
Complete with Over-Mantel and Mantel...(606-21)
An Old Carved Oak Panelled Room with
Chimneypiece(1356-10)
A Quantity of Linenfold Panelling with Inter-
esting Carved Oak Door...................(593-2)
Four Hundred Square Feet in Genuine Linen-
fold Panelling English, XVI Cen..........(180-56)
One Section of Gothic Linenfold Panelling...(606-31)
Two Sections of Carved Gothic Panelling and
One of Moulding, British Origin...........(409-1)

ENGLISH, XVII CENTURY

The Sparkford Carved Oak Panelled Room
from Hazlegrove House, Somerset, English,
XVII Cen.(280-1 to 5)
The Remarkable Fine Oak Panelled Room
from Gwydyr Castle, North Wales, Eng-
lish, XVII Cen.(368-1)
The Original Carved Oak Panelled Room
with Carved Arcaded Pilasters in Each
Panel All Round, Removed from the Ban-
ner House, Coventry, Warwickshire, Eng-
lish, XVII Cen......................(196-8 to 11)
A Carved Oak Panelled Room Removed from
Yarmouth, Norfolk, English, XVII Cen.
(196-12 to 15)
A Very Fine William and Mary Oak Pan-
elled Room from Streatlam Castle, County
Durham, English, XVII Cen...........(102-1 to 5)
Oak and Gold William and Mary Panelled
Room with Brown Marble Mantel Removed
from Coombe Abbey, English, Ca. 1690
(233-15 to 30)
A William and Mary Carved Oak Panelled
Room from Chester, English, Ca. 1690.......(231-1)
The Carved Oak Panelled Room from Bower
Hall, Steeple Bumpstead, Essex, English, Ca.
1700(100-60 to 62)
An Old Oak Panelling with Carved Over-
mantel, Six Pilasters, and Stone Mantel...(1356-11)
A Carved Oak Panel of an Escutcheon, Eng-
lish, Dated 1615(1006-33)

A Six-Section Oak Panel, Each Section Dif-
ferently Carved(425-14)

ENGLISH, XVIII CENTURY

A Queen Anne Oak Room Together with
Marble slips and Painted Ceiling, English,
XVIII Cen.(617-1)
A Collection of Six Panelled Rooms from
Hamilton Palace, Seat of the Duke of Ham-
ilton, Reigning Peer of Scotland, at Lanark-
shire, Scotland, Ranking among the Finest
Oak and Georgian Rooms in Existence and
they are truly magnificent:
No. 1—The White and Gold Bedroom from
the Duchess' Suite, English, XVIII Cen......(92-1)
No. 2—The White and Gold Boudoir from
the Duchess' Suite, English, XVIII Cen......(92-2)
No. 3—The Old State Carved Oak Dining
Room, Ca. 1697..........................(92-3)
No. 4-5—Two Old State Ante Rooms of
Carved Oak, Ca. 1697..................(92-4)
No. 6—The Morning Room of Carved Oak,
Ca. 1697(92-5)
A Magnificent George I, Panelled Pine Room,
from Palace, English, XVIII Cen...........(1246-3)
A Finely Panelled Oak Drawing Room of
George II Period from Wingerworth Hall,
Derbyshire, English, XVIII Cen.......(233-31 to 46)
The Georgian Carved Pine Panelled Room
Together with Two Marble Mantelpieces
(Albumed Under Mantelpieces) Removed
from Hooton Hall, Near Chester, English,
XVIII Cen.(230-1 to 4)
The Georgian Carved Pine Panelled Room
Removed from Haldon Hall, English, XVIII
Cen.(246-1 to 3)
The Fine Carved Pine Panelled Room Re-
moved from Sutton Scarsdale, Derbyshire,
English, XVIII Cen..................(202-1 to 9)

JACOBEAN

A Magnificent Carved Oak Panelled Room
of the Period of James I, 1603-1625, from
the Grange, Broadhembury, in the County
of Devon, England........................(606-30)
A Superb Carved Oak Panelled Room with
Molded Plaster Ceiling, Known, as "The
Albyns Long Gallery," Albyns, Essex, Eng-
lish, XVII Cen............................(383-1)
A Very Fine James I, Panelled Oak Room
with Carved Overmantel Bearing James I
Coat-of-Arms, from Tewkesbury Manor,
Tewkesbury, England(606-17)
A Fine Old James I Panelled Oak Room
"Lofts Hall" English, XVII Cen...........(668-1)
No. 1 of 3 Fine Oak Panelled Rooms of the
Jacobean Period(606-33)
No. 2 of 3 Fine Oak Panelled Rooms of the
Jacobean Period(606-34)
No. 3 of 3 Fine Oak Panelled Rooms of the
Jacobean Period(606-35)
A James I Original Carved Oak Panelled
Room or Morning Room from Standish
Hall, Also Known as Lowery Hall, English,
Ca. 1613(377-2)
A Fine Jacobean Carved Oak Panelled Room.(606-32)
An Exceptionally Fine Jacobean Carved and
Panelled Oak Room from Tong Hall, Kent,
English, XVII Cen...................(243-1 to 4)
A Jacobean Oak Panelled Room with Carved
Frieze and Pilasters, Mantelpiece with Rare
Caryatid Figures, English, XVII Cen...(260-1 & 2)

[323]

269

ELIZABETHAN

An Elizabethan original Carved Oak Panelled Room or Large Bedroom, From Standish Hall, Also known as the State Bedroom, English, Ca. 1600...................... (377-1)
A Very Fine Elizabethan Panelled Oak Room with Carved Frieze, Carved Pilasters, Carved Overmantel and mantel, From the Residence of Sir Dudley Cory Wright, Northumberland, England (606-29)
A very fine Elizabethan Carved Oak Panelled Room—No. 2—Removed from a House in Old Exeter, English, XVI Cen.......... (1246-2)
A Fine Elizabethan Carved Oak Panelled Room Removed from an Old House in Chelsea, London, English, XVI Cen..... (238-1 to 5)
The Elizabethan Carved Oak Panelled Room —Removed from Plaish Hall, Shropshire, English, XVI Cen.................... (201-1 to 5)
The Elizabethan Carved Oak Panelled Room —Removed from Radley Park, Co. Berks, English, XVI Cen.................... (232-1 to 4)
An Elizabethan Carved Oak Linenfold Panelled Room—Removed from "The Old Priory," Dartford, Kent, English, XVI Cen. (203-1 to 3)
The Elizabethan Carved Oak Panelled Room —No. 4 Removed from Heronden Hall, Kent, English, XVI Cen.............. (115-3 to 4)
The Elizabethan Carved Oak Panelled Room —No. 3 Removed from Heronden Hall, Kent, English, XVI Cen.............. (115-1 & 2)

ENGLISH PANELLED ROOMS

A carved oak panelled room of James I period, known as "The Julius Caesar Room," English, XVII Century (1381-91)
A tudor linenfold oak panelled room, known as Jacobean Room (1381-154)
A carved oak panelled room of James I Period, known as "The James 1st Room"—also known as "The Rotherwas Room," English, XVII Century (1381-92)
A carved pine room with coffered recesses, known as "The Georgian Reception Room," from the Painswick House, English, XVIII Century (1381-90)
A carved pine room with plaster ceiling, known as "The Georgian Bedroom," from Painswick House, English, XVIII Century......... (1381-88-89)
King John's Room—Oak Panelling—English, XVI Century (221-1)
King James Room—Oak Panelling—English, XVI Century (221-1A)
Bedroom-Regence Boiserie.................... (226-1)
Reception Room to Bedroom................. (227-1)
Fontaine Bedroom—Louis XVI Panelling.... (228-1)
Fontaine Reception Room—Louis XVI Panelling (228-1A)
One Lot of Silk from the Fontaine Bedroom & Reception Room—Empire Period............. (84-4)
Foyer Hall—Louis XV Boiserie.............. (229-1)
Lower & Upper Tower Room—Gothic Oak Panelling (295—1-1A)
Bedroom No. 1—George 1st Woodwork, Trims, Doors, Etc. (702-7)
Bedroom No. 2—George 1st Woodwork, Trims, Doors, Etc. (702-7A)
Men's Room—George 1st Woodwork, Trims, Etc. (1457-3)
Ladies Powder Room—George 1st Woodwork, Trims, Etc. (1457-4)
Dining Room—Hamilton Palace Oak Room.... (702-8)

Living Room—Oak Panelling From the Hamilton Palace (702-11)
French Princess Room—Carved Antique Oak Woodwork (702-12)
McCloud Panelled Room.................... (1457-2)

CEILINGS

Gothic Wood Ceiling, Early XVI Century.... (702-6)
Painted Wood Ceiling, French, XVI Century (91—1 to 7)
Wooden Ceiling, XV Century................. (823-1)
Wooden Ceiling, Similar to Above............ (823-2)
Portion of HENRY VIII carved oak panelling, English, XVI Century...................... (685-1)
Two panels of old oak Gothic panelling......... (617-6)
Four carved wood panels, Austrian, XVI Century (455-233-236)
Pair of carved wood Moorish panels......... (93-25)
Large carved wood Moorish, panel............. (93-26)
Miscellaneous parts of panelling and woodwork. (337-69)
Two Milanese polychrome plateresque panels, XVI Century (337-114)
Lot of embossed decorated leather panels, XVIII Century, and fragments of English oak panelling (368-2)
Portion of Jacobean oak panelled room......... (557-1)
Portion of linenfold panelled oak room, English, XVII Century (606-41)
15 pieces of oak panelling, Modern, XVII Century (610-13)
Miscellaneous carved woodwork and panelling and six plateresque carved columns.......... (617-2)
Miscellaneous pieces of carved oak panelling... (617-7)
Nine cases of linenfold oak panelling, French Gothic (824-1A to 1Z)
(A1 to R1)

FRENCH

Wainscotting of drawing room guaranteed of the Louis XVI Period sculptured and painted wood, comprising four mirrors, a fireplace and various panels, also wainscotting guaranteed of the Louis XVI Period, sculptured and painted wood. Comprising one large alcove, 5 to 39 XVIII Century (84-75 to 91)
A lacquer and gilded boiserie of a salon, Louis XVI Period, French, XVIII Century.... (339-1 to 74)
Twelve carved oak gothic panels and two friezes, French, XV Century............... (180-54)
Eight carved oak gothic panels, French, XV Century (180-55)

ITALIAN

A carved and painted frieze comprising ten wood panels together with two uprights and overdoor, Panelled and open work. Making up a boiserie, Italian, XV Century.............. (415-1)
A magnificent venetian council chamber with frescoes by Bernardo Parentino and sculptures by Antonio Rizzo, Italian, XVI Century....... (599-1)
A carved walnut fitment from a corner of the Medici Library from the Medicean Palace of Marradi, near Florence, Italian, XVI Century. (495-5)
An important carved walnut panelled room, Italian, XVI Century........................... (333-1)
A carved panel, Italian, XVII Century........ (482-54)

DUTCH

A painted room consisting of five panels by Jan Weenix, Dutch, XVII Century........... (526-1 to 5)
A painted room of eight panels, from a house on the Heerengracht, Amsterdam, Dutch, XVIII Century (57-75)

[324]

MISCELLANEOUS COUNTRIES

Complete room panelling with ceiling, Austrian,
XVI Century (140-1)
A circular marble room...................... (337-92)
A carved panel, Spanish, XVII Century........ (482-56)
An oval carved panel, Spanish, XVII Century.. (482-55)
A carved oak panel......................... (50-100)

SCONCES

Six gilded wrought iron electric wall sconces,
Renaissance Style (81-81 to 86)
Five Gothic style gilded wrought iron wall
sconces (87-87 to 91)
Four polychrome carved wood wall sconces,
Italian, Renaissance Style............... (81-92 to 95)
Polychrome wall sconce...................... (81-96)
Two polychrome wood wall sconces, Italian,
Renaissance Style (81-97 to 98)
Brass wall sconce........................... (455-761)
Seven gilded metal wall sconces........ (611-218 to 224)

MISCELLANEOUS

Renaissance limestone bas-relief escutcheon... (455-201)
Sculptured limestone shell font, Italian Renais-
sance ... (610-1)
Bronze door knocker, Italian, XVI Century.... (50-128)
Bronze door knocker, Italian, XVI Century... (50-128A)
Iron Gothic door knocker.................... (402-98)
Wrought iron Renaissance door knocker....... (402-99)
Metal letter box........................... (402-95)
Metal letter box........................... (402-96)
Wrought iron lock and key.................. (402-97)
Three fragments of oak carvings, English,
XVIII Century (674-53 to 55)
Panelled oak door with jamb............... (18-1 to 2)
One door (19-1)
Early Renaissance carved oak door........... (455-195)
Two white wood stained doors................. (617-8)
Eight panes of diagonal pattern lettered glass. (334-10A)
Wrought iron lock, XVII Century............ (455-416)
Carved wood ceiling support................. (455-231)
Carved wood ceiling support................. (455-232)
Six sections of ceiling polychromed and carved,
Spanish (618-1)
Nine wood beams for ceiling, English Gothic.... (618-2)
Early English cast iron fire back.............. (474-2)
Miscellaneous pieces of vari-colored marble and
carved wood Renaissance Style cornice...... (606-42)
Seven marble slabs........................ (611-130)
One copper cornice......................... (611-228)

COLUMNS & CORBELS

Four gilded carved wood columns with capitals,
Italian Renaissance (574-1 to 4)
Four carved wood corbels, Spanish........ (337-77 to 80)
Two Gothic oak corbels, Spanish............. (50-147)
Two Gothic oak Corbels, Spanish............. (50-148)
Ten Spanish Gothic limestone Armorial upright
corbels (639-2 to 11)
Five small Renaissance marble columns... (331-17 to 21)
Two small Renaissance marble capitals... (331-22 to 23)
Two gilded and polychrome carved wood
pilasters (337-97 to 98)

LUSTERWEIBCHENS

Deer antler, Swiss, XVII Century............ (50-107)
Deer antler with female figure............... (50-158)
Stag horn and Polychrome figure............ (611-25)
Deer antler with female figure, Swiss, XVII
Century (50-159)

DOORS

A pair of doors, Spanish Gothic, XV Century
(1381-152-53)
A pair of linenfold doors, Spanish, XV Century. (1447-2)
A romanesque folding door, Spanish, XVI
Century (1447-1)

VARIOUS ANTIQUES

A pair of Chippendale sconce mirrors, English,
XVIII Century (1399-3-4)
Eight Gothic polychromed keystones, Spanish,
XV Century (1381-134 to 141)
10 of a set of 12 Gothic keystones, Spanish, XV
Century (1381-142 to 151)
5 of a set of 8 Gothic keystones, Spanish, XV
Century (1381-129 to 133)
A Gothic polychromed wooden ceiling, Italian,
XV Century (1381-93)
A Gothic balcony of sculptured stone, French,
XV Century (1413-4)
A painted wooden frieze, Tyrolean, XVI Cen-
tury (1413-3)

DOOR KNOCKERS

A bronze door knocker, Venetian, XV Century. (1216-17)
A bronze door knocker, Venetian, XVI Century. (455-83)
A bronze door knocker, Italian Renaissance.... (681-28)
A Renaissance bronze door knocker, Italian, XVI
Century (681-41)
A door knocker in bronze, Italian, XVI Century.. (122-4)
A bronze door knocker, Italian, XVI Century... (138-18)
A bronze door knocker, Italian, 1525-1600...... (314-20)
A bronze door knocker, Venetian, XVI Century. (1020-3)
A bronze door knocker, Venetian, XVI Century.. (537-8)
Two bronze door knockers, Italian Renaissance,
XVII Century (337-74-75)
An iron door knocker, Italian, Early XVII Cen-
tury (138-19)
Two bronze door knockers, Italian........ (162-10-11)
A door knocker in brass, Hispano-Moorish, XV
Century (106-37A)
A Gothic iron door knocker, Spanish........... (316-8)
A Gothic iron door knocker, Spanish........... (317-7)
A Gothic iron door knocker, Spanish........... (317-8)
A brass knocker, Early American............. (127-13)
Five single and one pair of door knockers, Ren-
aissance (814-4 to 10)

STONEWORK—MISCELLANY

A pair of consoles, Venetian, XIV Century.... (864-1-2)
Two consoles in marble, Greek Byzantine, IX to
X Century (453-7-8)
Two stone brackets, French, XIII Century...... (160-33)
A gable end stone in sandstone, XVII Century... (50-69)
A sculptured gable end stone, dated 1657........ (50-70)
A stone frieze from Burgos, XVI Century.. (216-1 to 11)
A fine carved Gothic stone frieze.............. (279-3)
Three finely carved and painted newel posts,
(1381-29 to 31)
A pair of Chippendale wall brackets, English,
XVIII Century (1399-5-6)

AUSTRIAN ROOMS AND PANELLING

Woodwork of a hunting room, German, Gothic,
(218-1 to 6)
A peasant carved oak room, labeled "Nob
Room," Austrian, XVII Century............. (72-27)
A peasant carved oak room, labeled "Bemp
Room," Austrian, XVIII Century............ (72-28)
A peasant carved oak room, labeled "Santo
Room," Austrian, XVIII Century............ (72-32)
A peasant carved oak room, labeled "Cord
Room," German, XVIII Century............ (72-29)

[325]

A peasant carved oak room, labeled "Alma Room," Austrian, XVIII Century............ (72-30)
A lot of ash, oak and maple panelling, Southern Austria, about 1600........................ (180-59)

WOOD CEILINGS

SPANISH-MOORISH

A large Mozarabe carved wooden ceiling, XV Century (1193-1)
Magnificent Gothic painted ceiling, XV Century. (1351-1)
A Mozarabe carved wooden ceiling, XV Century (1193-2)
A polychromed carved wooden ceiling, XV Century (1193-3)
An Hispano-Arab wooden ceiling, XV Century. (1073-1)
A Gothic beamed ceiling, from Tudela, XV Century (638-1)
A refectory wooden ceiling, XV Century.... (349-1 to 3)
An Hispano-Mauresque carved ceiling, XV Century (545-2)
A Mudejar Gothic wooden ceiling, XV Century. (1346-1)
A painted wooden ceiling from Salamanca, Gothic (1073-2)
A Mudjar ceiling, XVI Century................ (919-1)
A carved plateresque wooden ceiling, XVI Century (649-1)
A ceiling from Refectory of Santa Clara, XVI Century (219-1 to 34)
A Gothic carved wooden "Granada" ceiling, XVI Century (1345-1)
A very important multi-colored wooden ceiling, XVI Century (1320-1)
An important wooden ceiling, XIV Century..... (556-1)
A small ceiling "Moorishceil," XVI Century.... (354-3)
A painted wooden ceiling, XVI Century..... (66-9 & 10)
A pair of twin coffered pine ceilings, XVII Century (351-1 to 17)
An octagonal Moorish ceiling.............. (250-1 to 16)
A Spanish Hispano-Moresque carved wooden ceiling (811-1)

ENGLISH

Two large and very fine Gothic ceilings, XV Century (289-1 to 4)
A carved oak ceiling from Waldergrave Hall, XV Century (239-1 to 5)
A Gothic ceiling, XV Century.............. (290-1 to 6)
A fine Gothic oak ceiling from Nacton Hall, XV Century (291-1 to 5)
An Oak Ceiling, Ca. 1500.................. (265-3 & 4)

AUSTRIAN

A wooden ceiling from the Castle Thurnaue, Gothic (915-1)
A Gothic ceiling, XVI Century.............. (115-5 to 9)
A carved and painted Gothic wood ceiling, XV Century (282-1 to 5)
A large Gothic ceiling in oak, Gothic........ (166-1 to 8)
A Gothic ceiling with wall and two doors, XV Century (130-1 to 7)
A Gothic pine ceiling, Ca. 1450........... (129-1 to 16)
A carved wood ceiling from Landsberg in Bavaria (337-93)

MISCELLANEOUS COUNTRIES

A Tyrolean Gothic ceiling, XV-XVI Century.... (514-1)
A Tyrolean Gothic ceiling from the Castle Pohlheim (417-1)
A Tyrolean Gothic oak ceiling................ (417-2)
A French Gothic ceiling in stone, XV Century.. (240-28)
A French wooden ceiling, XV Century....... (1112-26)

A French ceiling, XVI Century.............. (1138-1)
A Venetian ceiling in wood, XV Century...... (1333-3)
An Austrian Gothic wood ceiling, 1480......... (132-1)
A vaulted ceiling in limestone........... (257-1 to 102)
A canvas painted ceiling attributed to G. De Lairesse (190-1)
Two Gothic carved oak ceilings, XV Century. (288-1 to 9)

LIGHTING FIXTURES — CHANDELIERS, LUSTREWEIBS, ETC.

FLEMISH

A fine Dinanderie brass chandelier, XV Century. (613-6)
An unusual and very fine brass chandelier, XVI Century (1381-63)
A very large brass chandelier, XVI Century...... (10-4)
A brass hanging chandelier, Late XVI Century. (163-67)
A brass chandelier, Late XVI or Early XVII Century (163-66)
A brass chandelier, Early XVII Century........ (716-1)
A brass chandelier, XVII Century.............. (606-7)
An old brass chandelier, XVII Century........ (606-8)

AUSTRIAN

A Weiblustre in wood—polychromed, XV Century (326-10)
A very large elkhorn, called "Luesterweibchen," XVI Century (386-1)
A very fine "Lusterweibchen," XVI Century.... (213-1)
A set of three wood chandeliers, XVI Century, (303-5 to 7)
A Lustreweib in wood, Austrian or Flemish, XVI to XVII Century................... (403-24)
A Lustreweib in Wood, Austrian or Flemish, XVI to XVII Century................... (403-25)
A Luestermaennchen in wood, Middle of XVI Century (852-4)
A very charming "Luesterweibchen," XVI Century (872-4)
A Weiblustre with large Ibex antlers, First Half XVI Century (337-73)
A polychromed figure forming a lustre, XVII Century (47-1)
A polychromed Weiblustre with coat-of-arms, Gothic (212-17-18)
An antique chandelier of carved wood, German, (108-18B)
A large brass church lustre, dated 1728........ (987-4)
A porcelain chandelier with arms, XVIII Century (370-9)

ITALIAN

A Repousse silver cathedral hanging lamp, XVII Century (327-19)
A Repousse silver sanctuary lamp, Late XVII Century (327-16)
A pair of sanctuary lamps, XVIII Century.. (327-14-15)
A series of eight wall sconces, XVIII Century, (163-23 to 30)

MISCELLANEOUS COUNTRIES

A Georgian magnificent cut glass chandelier, XVIII Century (1311-11)
A Georgian magnificent cut glass chandelier, XVIII Century (1311-12)
A Georgian magnificent cut glass chandelier, Ca. 1800 (1311-10)
A bronze and gilded lustre with 6 lights, Louis XIV Period (184-39)
A set of four gilt bronze wall lights, French, XVIII Century (531-1 to 4)
A marvellous Gothic Dinanderie chandelier, XV Century (996-5)

[326]

MANTLEPIECES

FRENCH

[327]

[328]

274

NOTES

Abbreviations

DIA Detroit Institute of Arts

HD Hearst purchase dockets in C.W. Post Campus Library, Long Island, New York

MFA Museum of Fine Arts, Boston

MIA Minneapolis Institute of Arts, Minneapolis

MMA Metropolitan Museum of Art, New York

PMA Philadelphia Museum of Art, Philadelphia

ROM Royal Ontario Museum, Toronto

A Book is Born

1 John Harris, *No Voice from the Hall*, 1998 and *Echoing Voices*, 2002.

2 In fact, the actual two rooms were probably not the meeting place of the thirty-two commissioners, for they must have met in the demolished main and larger part of the house. Armand Hammer and others had been fooled.

3 Armand Hammer in *Witness to History*, 1987 edn., pp. 259–60, relates the circumstances of this gift. For the account of the room see chapter 6, 'The Growth of a Transatlantic Trade in Rooms and Salvages'.

4 D.P. O'Connell, *Richelieu*, 1968, p. 2.

5 Thus saving it from destruction by Bomber Harris in the Second World War.

6 The room is not generally shown in standard literature, but see *Gotisches Haus Worlitz*, Worlitz, 1989, p. 15.

7 Alvar Gonzales Palacios, *Il Patrimonio del Quirinale. I mobile italiano*, Milan, 1997.

8 Alvar Gonzales Palacios in *The Badminton Cabinet*, Christie's, London, 5 July 1990, pp. 28–31; but see also Lucy Abel Smith, 'The Duke of Beaufort's Marble Room', Shorter Notices, *Burlington Magazine*, Jan. 1996, pp. 25–29. The marble was eventually dispersed, to make a Turkish bath in the basement of the house in 1811 (Sir Jeffry Wyatville), and some was sold to Viners of Bath, 1809.

9 Alvar Gonzales, 'Tra Roma e Lisbona ai tempe d'Joao V', in *Il Gusto Dei Principe*, Milan, 1993.

10 See *The Times*, 8 Nov. 1997 and the *New York Times*, 23 Jan. 2000; but also the extensive exploration of the fate of the Amber Room by Catherine Scott-Clark and Adrian Levy, *The Amber Room*, 2004.

11 The Empress Elizabeth writing to the sculptor Alexander Martinelli, 11 Feb. 1743, 'You promise to fix the Room, sort all the pieces you have and find out what is missing and for them make replacement parts and erect the Room' (Scott-Clark and Levy, 2004, p. 53).

12 Hans Ottomeyer, 'Die Ausstattung der Residenzen König Max Josephs von Bayern (1799–1825)', in *Wittelsbach und Bayern*, Munich, 1980, pp. 379–80, Figs 82–83.

13 As well as two other cabinets, e.g. The 'Puille-Kabinett' in the Papal Rooms.

14 The font, pulpit and organ case from the chapel went to St Andrew, Holborn.

15 My card index made in those days was lent to Dr Alan Tait, who lost it.

16 And later identified the Jacobean chimneypiece once in the Hearst Collection. See Check-List of British Rooms and Salvages Exported to the USA.

17 Pons, 1995.

Introduction

1 Published for the Paul Mellon Centre for Studies in British Art by Yale University Press.

2 In particular, in *The Romantics*, chapter 3, 'The Furnishings', pp. 54–69. It needs to be said here that Wainwright would have agreed that a serious lacuna in our studies is any account of dealers, who after all were the source of all collections.

3 Girouard, *The Victorian Country House*, 1971, pp. 60–65.

4 Knox, typescript of lecture, 2006, to be published.

5 Hussey, in *Country Life*, 24 April, 1 May and 8 May, 1942.

6 H.M. Colvin, 'Eythrope House and its Demolition in 1810–11', *Records of Bucks*, vol. 17, part 4, 1964.

7 Shena Stoddard, *Mr Braikenridge's Brislington*, Bristol Museum and Art Gallery, 1981.

8 See chapter 1

9 Although it must be said that Bruno Pons made a start in France.

10 Giles Worsley, *England's Lost Houses from the Archives of Country Life*, 2002, p. 7.

11 Maurice Howard, *The Early Tudor Country House, architecture and politics 1490–1550*, p. 198.

12 These figures are due to the studies made by regional historians since the 'Destruction of the English Country House' exhibition in 1974.

13 See chapter 1.

14 Vide Pons, 1995.

15 The so-called Sir William Chambers Sudbury Room as invented by Duveen was outright forgery. See chapter 8.

16 The museum has retained the Charlton House room despite evidence of much modern woodwork.

17 It must be said that a study of the Carlhian archive at the Getty Center for the Humanities in Los Angeles reveals that the Carlhian family were remarkably well educated in the authentication of what they bought and what they sold.

18 The title of a lecture given by the author to the Victoria and Albert Museum in 2003.

19 That is, the Kempshott Park Room. See chapter 8, Figs 182–83.

20 See chapter 8.

21 As is so often suggested by American historians. See Edward P. Alexander, 'Artistic and Historical Period Rooms', *Curator*, vol. 7, no. 4, 1964, pp. 263–71; and Dianne H. Pilgrim, 'Inherited from the past: The American Period Room', *American Art Journal*, May 1978, pp. 5–64.

22 E.g. the founding of the Nordiskmuseet in 1872 and the creation of Skansen.

23 See Ulf G. Johnsson, *Gripsolm Castle*, Swedish National Art Museums, Skövde, 1994. In particular the Astrak Room, designed and installed in the 1890s restoration, then removed in the 1950s, and replaced again in the 1990s. For this information I am grateful to my friend Magnus Olausson.

24 It is not at all clear if the acquisition in 1912 of the Norwich Room in the Royal Ontario Museum in Toronto was an outcome of this exhibition. No documents as to policy in the museum survive.

25 E.g. as just one example, Amy Stewart of the J.B. Speed Art Museum, Louisville, writing about the *English Renaissance Room* (n.d.), i.e. the room from The Grange, Devon.

26 It is a criticism of scholarship that there has been no study of these accession files, which are major documents informing us of a chronological study of changing tastes and policies in museums.

27 Barnard, in Arnold E. Dickson, 'The Origin of the Cloisters', *Art Quarterly*, vol. 28, no. 4, 1965, pp. 253–74.

28 A recent populist view of period rooms is Roberta Smith, 'Rooms with a View of History', *New York Times*, 14 Jan. 2000.

29 As in Arundel Castle, for example.

30 Information from the curators, although in this case the room was retained.

31 See chapter 8.

32 The late Bruno Pons in correspondence with the author; but see also Pons, *Waddesdon Manor Architecture and Parelling*, 1996, pp. 192–93.

33 See Donald C. Pierce and Hope Alswang, *American Interiors: New England and the South. Period Rooms at the Brooklyn Museum*, New York, 1983. See also particularly the essay by Dianne H. Pilgrim, 'The Period Room: An Illusion of the Past', pp. 22–23.

34 A fascinating and very informative book is that by R.T.H. Halsey and Elizabeth Tower, *The Homes of our Ancestors as Shown in the American Wing of the Metropolitan Museum of Art*, New York, 1925; date of author's edition 1934. Although these rooms are genuine, the illustrations by J. Floyd Yewell give the rooms a period feel of the 1920s, resembling Mrs Ward Thorne's miniature rooms in the Chicago Art Institute.

35 Of course, the 'real thing' might to the untutored American mind appear rather different to anything that English period rooms in the USA presented. The furnished mix and stylistic impurity of English so-called entities might seem puzzling.

36 Although it must be said that attendances at Colonial Williamsburg are dropping, which this author believes is due to the banal influence of television and the dumbing down of programmes.

Chapter 1: Salvaging the Interior: 1500–1820

1 See Murray Adams-Acton, 'The Genesis and Development of Linenfold Panelling – 1 and 2', *Connoisseur*, June 1945, pp. 25–31 and 80–86.

2 Sold Christie's, 7 May 1918, lot 147.

Bought from dealer Turpin by Hearst and installed in St Donat's Castle.

3 See a memorandum (Guildhall Library, London, MS 6122/1) attached to a lease, 21 Oct. 1575, of a house probably in Wood Street adjacent to the Plasterers' Company Hall in the City of London. Raffe and Anne Sheppard were required 'at the tyme of their Dep[ar]ture to leave to the use of the house and company theis p[ar]cells following: a Courte cupbord of waynscot in the p[ar]lor, the portall of waynscot by the same Chimney and the Frame window and glasse in the garrett, and that w[i]thoute any fraude or Deceipt and the Iron Back in the Chimney in the p[ar]lor'. For this reference I am indebted to Claire Gapper, who also sent me the following reference: Guildhall Library MS 6122/1 25 July 1615, 'Md that John Gilson a brother of this Companie dep[ar]tinge into Ireland did freely give to this company the wainscot painted cloth & a Courte Cubbard & a*n* presse w[hi]ch were in the chamber over the p[ar]ler'.

4 *The Wainscot Book: The Houses of Winchester Cathedral Close and their Interior Decoration 1660–1800*, ed. John Crook, Hampshire Record series, 5 and 6, Winchester, 1984.

5 In this case, something that seals off the room from the plastered, or brick, or stone wall or ceiling substructure.

6 'Inventories, Surveys and the History of Great Houses 1480–1640', *Architectural History*, vol. 41, 1998, pp. 14–29. Maurice Howard kindly abstracted relevant inventories for me.

7 See also, in 1603, the 'Goods and Chattels' of Richard Bevyss, late Mayor of Exeter, 1603, that included 'Fiftie fower yardes of Sealing' in '*the newe Chamber over the Kitchen*' in his house in Exeter, Devonshire; and in his house at Heavitree, now a suburb of Exeter, in the hall was valued 'the Seeling & Benches' as well as 'an Enterclose of Seelinge', possibly a wainscot or panelled screen. (Information from Claire Gapper.)

8 Christopher Hussey in *Country Life*, 23 Dec. 1949, p. 1885, Fig. 3.

9 Ibid., p. 1887, Fig. 8.

10 See *Blickling Hall, Norfolk*, National Trust guide, 1987, detail p. 9; and also *Blickling Hall, Norfolk*, guide, new edn. 1998, p. 11.

11 I am indebted to David Neave and Edward Waterson, *Lost Houses of East Yorkshire*, York, 1988, pp. 36–7 and 40–41; and to Neave for help in tracing photographs.

12 Demolished 1951–2. See photograph album compiled by Francis Johnson, now owned by Malcolm McKie, to whom I owe

permission to use this photograph.

13 An appropriate term used by Tim Knox in his lecture 'Piety, Thrift or a Taste for "Curious Antiquity": The Salvage and Re-use of Historic Panelling and Architectural Features in Country Houses *c.* 1550–1900', 2002.

14 James Savage, *History of the Castle and Parish of Wressle*, Howden, 1799.

15 Simon Thurley, *Hampton Court: A Social and Architectural History*, 2003, pp. 63–4.

16 Bruno Pons, *French Period Rooms*, 1995, p. 16–17.

17 It was not, as Simon Thurley asserts to this author.

18 Thurley, 2003, p. 95; but see more definitively, *The History of the Kings Works*, ed. H.M. Colvin, vol. IV, 1485–1660, part 2, London, 1982, pp. 132, 137.

19 See N. Pevsner and Elizabeth Williamson, *Buildings of England, Buckinghamshire*, London, 1994, pp. 282–4; also see *Country Life*, 26 July 1924. pp. 136–42, and 2 Aug. 1924, pp. 176–83.

20 Maurice Howard and Edward Wilson, *The Vyne: A Tudor House Revealed*, London, 2003, pp. 84–9, and see also illustration p. 87.

21 I am indebted to Maurice Howard's observations. The framing of the linenfold needs to be examined in order to date its installation more precisely. See also John Cornforth *Early Georgian Interiors*, 2004, p. 221.

22 See catalogue, *The Artist and the Country House*; exhibition curated by John Harris, Sotheby's, 1995, plate 16. For Nonsuch in general, see J. Dent, *The Quest for Nonsuch*, London, 1962.

23 *Country Life*, 9 Oct. 1969, pp. 896–7.

24 *Country Life*, 6 Nov. 1915; and see Geoffrey Tyack, *Warwickshire Country Houses*, 1994, pp. 71ff. Later, in 1883, the hall at Compton Wynyates would receive a chimneypiece and panelling from another great Northampton house, at Canonbury in London, removed under the direction of Sir Matthew Digby Wyatt, who at the same time removed chimneypieces to Lord Northampton's Castle Ashby in Northamptonshire.

25 Badminton muniments, Gloucester Record Office, QA2/3/2.

26 This author discovered and published as a letter (in *Country Life*?) an evocative eighteenth-century printed description (from *Gentleman's Mag.*?) of a Tudor manor house in Suffolk being demolished, the chimney stacks pulled down with ropes. To

27 Mark Girouard, 'Splendour in Decay', *Country Life*, 9 Jan. 1994, Fig. 9. The stair was used as a model by C.E. Kempe at Temple Newsam, Yorks, 1894. See Anthony Wells-Cole, 'C.E. Kempe's Staircase and Interiors at Temple Newsam, 1894', *Leeds Art Calendar*, no. 65, 1969. A new house was built at Slaugham in 1901.

28 The only account is the excellent one by Michael Trinnick, 'The Great House of Stowe', *Journal of the Royal Institution of Cornwall*, new series, vol. 8, part 2, 1979, pp. 90–108, to which I am indebted; but see Revd. R.S. Hawker, *Footprints of Former Men in Far Cornwall*, 1903, especially Appendix, pp. 274–9 and Revd. R. Dew, *A History of the Parish and Church of Kilkhampton*, 1926. However, I have also relied upon the recent unpublished researches by Tim Knox into Stowe and Michael Chuke.

29 *Country Life*, 8 Feb. 1962, Figs 4–6.

30 Daniel Defoe, *A Tour through Great Britain*, 1742 edition, pp. 77–8.

31 July 10, 1739, 'things bought at Stow in Cornwall by Joshua Bawden by ye order of the Mayor and Burgess'. Archives of Borough of South Molton.

32 This room was sold in the 1920s by Adams Acton, possibly to Duveen, as shown in a crumbled photograph of the room *in situ* at Cross, and an installation drawing inscribed for the New York Anglophile collector Judge 'Untermyer', both documents located among the uncatalogued Duveen photo folders (bay XXVII, item 8) at the Clark Institute, Williamstown, Mass. Mrs Rowena Cotton of Cross has evocative photographs of this room, furnished in situ, *c.* 1900.

33 *A Catalogue of All the Materials of the Dwelling-House, Out-Houses, &c of His Grace James Duke of Chandos . . . At his Late Seat call'd Cannons . . . Sold by Auction by Mr. Cock . . . 16 of June 1747, and the Eleven Following Days*. This is a unique annotated sale catalogue, ex Paul Mellon collection, now Yale Center for British Art, New Haven, USA.

34 Mr H. Philips, *A Catalogue of the Magnificent and Costly Household Furniture . . . several Valuable Statuary Marble Chimney Pieces . . . All the Beautiful Mahogany Doors. . .of Fonthill Mansion*, 17 Aug. 1807, and six following days. In fact, this was not exactly a fabric catalogue. The fabric sale followed on 7 Sept. 1807.

35 See . . . *A Catalogue of the Valuable Building Materials, of Eythrope Mansion House . . . Sold by Auction, by Mr Hermon 15 August, 1810* (Bucks Record Office, Spencer–Bernard papers E 14/3, and 5, and Howard Colvin, 'Eythrope House and its Demolition in 1810–11', *Records of Bucks*, vol. 17, part 4, 1964.

36 This might be 'By Mr Stovell on Account for Wainscot Bot at Cannons', 20 June 1748, 20.5 and 'On further Account of Wainscote bought at Cannons' on 20 Dec. 1748, 7.7, recorded in Beaufort papers, Gloucestershire County Record Office under 'Bounty's and Annuities . . . Extraordinary Payments'.

37 For the dispute about the Chesterfield staircase see John Harris, 'The Staircase That Never Was', *Architectural Review*, March 1980, pp. 131–2.

38 Geoffrey Tyack, 'The Freemans of Fawley and their Buildings', *Records of Bucks*, vol. 24, 1982, pp. 136–7; and also, N. Pevsner and E. Williamson, *Buildings of England, Buckinghamshire*, 1994, p. 325. The identifiable fittings include the pulpit and lectern, chancel panelling, the sanctuary Ionic pilasters, and the nave seats, removed in the 1882 restoration, or rather desecration.

39 Francis Watson, 'A Venetian Settecento Chapel in the English Countryside', *Arte Veneta*, 1954, pp. 295–302.

40 Apparently, Lord Foley purchased the paintings himself, giving instructions to James Gibbs to insert them into a newly designed chapel ceiling. See also Colvin, *Dictionary*, p. 403, quoting the Gibbs *Memoir*, Gibbs being the architect of the Cannons chapel before his dismissal in 1719.

41 Now the London Collegiate School. See also C.H. Collins Baker and Muriel I. Baker, *The Life and Circumstances of James Brydges, First Duke of Chandos*, Oxford, 1949, chapter 20, pp. 436–55.

42 See *William Beckford, 1760–1844: An Eye for the Magnificent*, ed. Derek E. Ostergard, chapter 3: Philip Hewat-Jaboor, 'Fonthill House: One of the Most Princely Edifices in the Kingdom', pp. 51–71.

43 Now in the Victoria and Albert Museum (W.13–1980). See Hewat-Jaboor 'Fonthill House', pp. 3–9.

44 These were part of 13 lots, nos 583–95.

45 One is in the Manor House, Beaminster, Dorset: Hewat-Jaboor, 'Fonthill House', pp. 3–7 (ex. Clumber House, Nottinghamshire, sale), 3–8 (design for the Beaminster chimneypiece).

46 Phillips, 17 Aug. 1807, lot 319.

47 Christie's, *The Remaining Contents of the Mansion of Clumber*, 19 Oct. 1937, lot 289.

this day the publication remains unlocated.

48 See H. Colvin, 'Eythrope House and its Demolition in 1810–11', *Records of Bucks*, XVII, Part 4, 1964, pp. 219–27.

49 Journal of William Robertson of Kilkenny, National Library of Ireland, MS. 248, p. 164.

50 In view of the lack of any study of advertisements in local newspapers for demolition sales, it is interesting to read in Mr Hermon's catalogue that copies may be had at specified inns in the county or round about, in Aylesbury, Wendover, Berkhampsted, Bicester, Banbury, High Wycombe, Amersham, Great Missenden, Buckingham, Stony Stratford, St Albans, Rickmansworth, Beaconsfield, Uxbridge, Watford and Stanmore.

51 Bucks Record Office, E14/34.

52 The reference to an ogee moulding might refer to eighteenth-century Gothick alterations by Sanderson Miller, who probably worked at Eythrope.

53 See Arthur Oswald, in *Country Life*, Nether Winchendon, Buckinghamshire — 1, 28 April 1960, pp. 924–7, and Nether Winchendon — 2, 5 May 1960, pp. 986–8.

54 Colvin, 1964, p. 226.

55 Bucks Record Office, D/SB/E/14/1.

56 For an account of this Armour Hall in an antiquarian context see chapter 2.

57 Colvin, 1964, pp. 224–45, plate 2; see also Geoffrey Tyack, *Warwickshire Country Houses*, 1994, p. 98.

58 See D. and S. Lysons, *Additional Plates with Further Additions and Corrections for the First Volume of Magna Britannia* (1813), p. 418. The style of the house must assuredly been antiquarian Gothic.

Chapter 2: Salvage and a More Amateur Antiquarianism

1 H.M. Colvin, 'Recycling the Monasteries: Demolition and Reuse by the Tudor Government 1536–47', in *Essays in English Architectural History*, 1999, pp. 52–3.

2 Cornforth, 2004, pp. 217ff. discusses this in his chapter 'Preservation, Restoration and Alteration'.

3 See Blount, MS history of Herefordshire in Hereford Public Library. The only recent account is Judith A. Barter, 'The Rotherwas Room', in *Decorative Arts at Amherst College, Mead Museum Monographs*, 3, Winter 1981–82. See also account in chapter 8, under Amherst College, Massachusetts. Mark Girouard has observed that the chimneypiece must come from the same workshop as that once in Clifton House, Queen Street, King's Lynn, a

salvage that is by repute also in the USA. The simple square panelling shown in the photograph by R. Fyfe, taken in 1888, in the National Monuments Record suggests that it has had other lives elsewhere.

4 Unsorted photographs in Duveen collection, Clark Institute, Williamstown, Massachusetts.

5 The Rotherwas or Bodenham Room, now at Amherst College (Fig. 195), was sold on almost immediately by Charles of London to Herbert L. Pratt for The Braes, his Jacobethan mansion then being built by James Brite at Dosoris Park, Glen Cove, Long Island.

6 *Hereford Times*, 1 Jan. 1913, 24 Jan. 1913 and 26 Feb. 1913. This correspondence reveals that Charles Duveen bought Rotherwas as an entity in order to take out 'thirteen rooms'.

7 Of course, it is possible that there occurred a rearrangement of the salvages in the nineteenth century.

8 National Monuments Record, Swindon, BB47/103342, BB87/10380, BB 57/10343.

9 See chapter 8.

10 J.P. Neale, *Views of the Seats of Noblemen and Gentlemen*, 2nd series vol. 3, 1826.

11 Edward was knighted in 1603, and is reputed to have finished the building by 1610, although the room is dated 1619.

12 Inexplicably, the outside wall of the room has two plain Georgian windows.

13 In the PMA archives under 'Objects Considered' is a folder with plans of the room, certainly by Roberson.

14 For general information I have relied upon Amy Stewart's Docent museum handout, *The English Renaissance Room*, n.d.

15 Giles Worsley, 'Sudbury Hall, Derbyshire', *Country Life*, 17 June 2004.

16 For the dispute about Crewe and Sudbury, see also John Harris, correspondence 'Sudbury Sleauthing', *Country Life*, 8 July 2004, p. 72.

17 Oliver Fairclough, 'John Thorpe and Aston Hall', *Architectural History*, vol. 32, 1989, pp. 30–51; see also *Country Life*, 20 and 27 Aug. and 3 Sept. 1953; and Fairclough, *The Grand Old Mansion: The Holts and their Successors at Aston Hall 1618–1864*, Birmingham, 1984.

18 John Harris, *The Artist and the Country House*, London, 1979, no. 15, there incorrectly dated to *c.* 1750.

19 Fairclough, 1989.

20 *Ibid.*, 1989, p. 42.

21 A fact not noticed by John Cornforth, who provides the most recent evaluation of Burton Agnes in *Country Life*, 10 Dec.

1998. Cornforth's attribution of the early antiquarian work to William Etty is speculative.

22 Neave and Waterson, *Lost Houses of East Yorkshire*, York, 1988, deals with Leconfield and Kilnwick.

23 'Wroxton Abbey, Oxfordshire', *Country Life*, 3, 10, 24 Sept. 1981; see also Anthony C. Wood and William Hawkes, 'Sanderson Miller of Radway and his Work at Wroxton,' *Cake and Cockhouse*, Banbury Historical Society, vol. 4, no. 6, 1969, pp. 99–107 and also *The Diaries of Sanderson Miller of Radway*, ed. William Hawkes, Dugdale Society, Bristol, 2005, index p. 449.

24 Colvin, *Dictionary*, p. 654.

25 And similar rails making up the church pulpit steps.

26 See chapter 3 and Figs. 47–8; also Charles Tracy, *Continental Church Furniture in England: A Traffic in Piety*, Antique Collectors' Club, Woodbridge, 2001, p. 290. Susan, Baroness North, married in 1835 Colonel Rt. Hon. John Sidney Doyle, who assumed the surname of North in 1838. See also chapter 5.

27 Various plates in Batty Langley's *Ancient Architecture Restored*, London, 1742.

28 See *Country Life*, 15 May 1920, pp. 656–62, 22 May 1920, pp. 690–96.

29 Colvin, *Dictionary*, p. 654; and *Miller*, ed. Hawkes, index p. 415.

30 For this see also Worsley, 2002, pp. 134–5.

31 In 1761 Walpole specifically refers to this 'hall' with the 'new front', as Gothick work built 'under the direction of Mr Sanderson Miller'. H. Walpole, *Journal of Visits to Country Seats*, ed. P. Toynbee, Walpole Society, vol. 16, no. 31, 1928, p. 34. The armour was dispersed by auctioneers Savile & Turnor, 8 May and the next seven days, 1923.

32 *Country Life*, 15 May 1920, p. 600, Figs 9 and 11 for front door.

33 See Clive Wainwright, 'Plas Newydd, Clydd', *Country Life*, 2 Feb. 1995, pp. 26–9, and in particular Fig. 5, door in the library.

34 According to William Hawkes. There is a reference to Miller's plan for Stanhope's farm being approved on 28 Sept. 1750, see Hawkes, 2005, index under Belhus.

35 *Catalogue of the Remaining Furniture, Ornaments, and Effects, of Eythrope Abbey, Near Aylesbury Bucks . . . Sold by Auction by Mr Berry on the Premises*, 13–14 Aug. 1810, Bucks Record Office, D/SB/E/14/2,4. The 'Antient Armour' in the Great Hall took up lots 103–48; but in general see also D/SB/ E14, 1–32 for associated

correspondence.

36 Claude Blair in a communication with the author expresses surprise that this collection is not mentioned in F.H. Cripps-Day's *A Record of Armour Sales*, 1881–1924, 1925. He writes, 'I wonder if the Civil War pieces represented the remains of the equipment of the troops commanded by Robert Dormer, Earl of Carnarvon, who was killed at the Battle of Newbury in September, 1643.'

37 The designs came from the 'Adderbury' portfolio as coming from Adderbury House, Oxfordshire, mostly related to the Dukes of Argyle and Buccleuch, now in the Scottish Record Office. The association with Ditton was made by Richard Hewlings.

38 Cornforth, 2004, p. 221; and for Montagu and chairs, see also Cornforth, 'The First Gothick Chairs', *Country Life*, 3 Aug. 1993, pp. 50–51; and 'Chairs Ancient and Gothic', *Country Life*, 9 Sept. 1993, pp. 78–81.

39 For Great Halls see *Connoisseur*, Dec. 1910, pp. 237–70, a remarkable visual survey.

40 *Gentleman's Magazine*, vol. 9, 1739, p. 641.

41 Sir William H. St. John Hope, *Cowdray and Easebourne Priory*, 1919, pp. 73–4, pl. xxvii.

42 For the Italianate painters who contributed to the scheme see Edward Croft-Murray, *Decorative Painting in England 1537–1837*, vol. 2, 1970, pp. 191A, 213A, 254B, 255A.

43 Herstmonceux album, ex Paul Mellon collection, now Yale Center for British Art, New Haven, Conn., USA.

44 See John Cornforth, 'Cotehele House, Cornwall – 1–2', *Country Life*, 1 and 7 Feb. 1990.

45 John Cornforth's unsubstantiated opinion.

46 Around this time too, in 1746, the Countess of Oxford gave the Great Hall at Welbeck Abbey Gothick fan vaulting, and in 1754 Sanderson Miller Gothicized the Great Hall at Lacock Abbey.

47 J.N. Brewer, *Delineations of Gloucestershire* . . . [undated, but plates dated 1825–26], pp. 157–9.

48 The only recent literature is Nicholas Kingsley, *The Country Houses of Gloucestershire*, vol. 1, Cheltenham, 1989, pp. 72–6; and Nicholas Cooper, 'Chavenage House', *Country Life*, 1 May 2003.

49 In the possession of the author.

50 An earlier version of those French style panel decorations in the Great Hall at Cobham Park, Kent, or contemporary with the comparable plaster decorations in the Great Hall at Wiston House, Sussex, maybe by James Gibbs.

51 The National Trust, *Speke Hall* guide, 1994.

52 *Lonsdale Magazine*, no. 18, June 1821, pp. 201–5.

53 See Wainwright, 'Plas Newydd, Clywd', pp. 26–9; but also see Elizabeth Mavor, *The Ladies of Llangollen*, London, 1971, p. 176, and *Plas Newydd, Llangollen*, guidebook, 1984, referring particularly to the disastrous sale by George Robbins, auctioneer, in 1832.

54 Wainwright, 'Plas Newydd', pp. 272–3.

Chapter 3: Continental Imports and the Wardour Street Trade

1 Tracy, 2001, chapter 1, p. 36 for Capesthorne, and pp. 37–8 for Towneley.

2 *Ibid.*, p. 39.

3 *Ibid.*, p. 40, quoting L. Réau, *Les Monuments détruit de l'art français*, vol. 1, Paris, 1959, p. 308.

4 Réau, *Monuments*, vol. 1, p. 322.

5 Tracy, 2001, pp. 66–71.

6 See the three articles in *Country Life*, 6, 13 and 20 Dec. 1962; in particular 6 Dec., pp. 1396–9.

7 See Sheena Stoddard's excellent and fully illustrated *Mr Braikenridge's Brislington*, 1981.

8 Stoddard, 1981, pp. 33–4.

9 For the gateway and the dovecot see *ibid.*, Figs 35 and 36, photographed c. 1860.

10 The English Renaissance chimneypiece said to have come from a house in Small Street, Bristol, now in Cincinnati Art Museum (Fig. 186, may have originated with Braikenridge).

11 Where many salvages remain, including the library ceiling and Flemish caryatids from a chimneypiece that Braikenridge bought from Horatio Rodd in 1839 for 10 guineas (*ibid.*, p. 53).

12 The panel with the arms of Henry VIII and the future Edward VII came from a Bristol house in Baldwin Street. See *ibid.*, pp. 50–53. The Dutch late sixteenth-century panels of the Annunciation, Nativity, Purification, and Circumcision in the pulpit at St Andrew's church, Clevedon, are obviously a gift by Braikenridge, as are the altar rails in St Luke's church, Brislington, presented by Braikenridge in 1829. See *ibid.*, pl. 14.

13 Illustrated in Tracy, 2001, p. 54, pl. 21.

14 Illustrated *ibid.*, p. 55, pl. 22.

15 For a general biography see Janet Myles, *Lewis Nockells Cottingham, Architect of the Gothic Revival*, 1996.

16 see chapter 7, 'The Period Room in European Museums'.

17 Myles, 1996, p. 28; but see chapter 3 for an account of Cottingham's museum as a precursor of the making of period rooms.

18 See E. Ashworth, *The Ancient Manor House of Weare Giffard*, 1858; *Country Life*, 2 Jan. 1915, pp. 16–25, Figs 2–4 for panelling in the hall.

19 Buildings of England, Devon, 1989; also Tracy, 2001, p. 268.

20 J.C. Burke, *A Visitation of the Seats and Arms of the Noblemen and Gentlemen of Great Britain*, London, 1852, 1853, 1854, 1855.

21 Burke, second series 1854, p. 96.

22 Auction by Henry Brown, see *Particulars*, in Coventry Libraries and Information Services, Ref.C5. I am indebted to Andrew Mealey, Team Librarian, for information and help.

23 This is confirmed by exhaustive enquiry in Coventry archive offices.

24 In the compilation of this case I have been helped by Sir Hugh Roberts, who showed me the silver plate fastened to the back of a movable panel, inscribed with its fictitious history; and a description inserted into the 1866 inventory of Windsor Castle, observing that the fitting out took place in 1914, with a chimney mantel said to be reproduced from a 'print of one that was in the Star Chamber before it was demolished', and a ceiling based upon one of Cardinal Wolsey's Tudor ones at Hampton Court Palace. For this post 1866 description I am indebted to HM Queen Elizabeth II. For Leasowe Castle see John Martin Robinson, *A Guide to the Country Houses of the North-West*, 1991, pp. 46–7.

25 See chapter 6 and Fig. 104.

26 See H.M. Colvin (ed.), 'Views of the Old Palace of Westminster', *Architectural History*, vol. 9, 1966, p. 62, Fig. 14 and catalogue entry.

27 By Clive Wainwright in 'The Antiquarian Interior in Britain 1780–1850', University of London PhD thesis, 1986, p. 55.

28 6th Duke of Devonshire, *Handbook to Chatsworth*, 1845, the manuscript dated 1844. The room was probably made up by Sir Jeffry Wyatville and is believed to have come from the German Carthusian monastery of Buxheim, secularized in 1809 and sold off by the state.

29 *Country Life*, 29 Aug. 1908, pp. 806–9; 5 Sept. 1908, pp. 320–31; and Tracy, 2001, p. 81, and pl. 38. The Parnham room was installed by an antiquary, Vincent J. Robinson, perhaps in the 1880s. Today there is only the Oak Room with linenfold panelling said to have come from West Horsley Place, Surrey. See also Tracy,

'Colonel Robert Rushbrooke . . . Grand Tourist, Connoisseur, Collector, Amateur Architect, and Wood Carver', *Proc. of the Suffolk Institute of Archaeology & History*, vol. 40, part 3, p. 203, 306ff.

30 I am indebted to Charles Noble for giving me the references in the 6th Duke's Building Accounts (vols V and VI), and for the reference that the duke was not in London at the time of the Deacon sale.

31 6th Duke's Building Accounts, vol. V, p. 244: 26 Jan. 1839; vol. V, p. 250: 23 Feb. 1839; vol. V, p. 387: 21 Dec. 1840; vol. V, p. 389: 26 Dec. 1840.

32 Lord Cavendish informs me that the 'oak pillars in the 'Brown Hall' might have been left over, and comments further that in the same room is panelling from a local farmhouse, and a creation scene from Conishead Priory.

33 Tracy, 2001, pp. 65–71.

34 Squire & Parson.

35 Tracy, 2001, Appendices 1 and 2.

36 See Tracy, 'Colonel Robert Rushbrooke' pp. 203, 306ff.

37 But see the reference in Tracy's listing (Tracy, 2001, Appendix 3, p. 282) of the Scarisbrick–Edward Hull accounts, that 'Panelling from Strawberry Hill' was purchased from the 1841 sale.

38 Despite the fact that he did not support the acquisition of Cottingham's museum for the state prior to its dispersal.

39 See Tracy, 2001, pl. 23, a drawing by Cottingham in the V&A (E. 527-1951).

40 See Tracy, 2001, pp. 50–51, but also Myles, 1996, pp. 135–45.

41 Myles, 1996, p. 137; but in general see also Benjamin Furnival, *Windsor of the North: A History of Brougham Hall*, London, 1999, pp. 47–59; and also Mark Thomas, *A History of Brougham Hall and Highead Castle*, Chichester, 2003. For a descriptive account see Daniel Scott, *Brougham Hall, Notes on 'The Windsor of the North', December 1897*, Penrith, 1897.

42 Best seen in Furnival, *Windsor*, Figs 17 & 18.

43 *Gentleman's Magazine*, June 1848, pp. 618–20, by 'Old Subscribers'. This was in answer to George Shaw's long description of Brougham in the *Gentleman's Magazine*, April 1848, pp. 369–76.

44 Myles, 1996, p. 139.

45 Another possible Cottingham acquisition was the carved oak from the Tally Office in the Old Exchequer Buildings at Westminster, sometimes referred to as the Star Chamber panelling, which Colonel the Hon. Sir Edward Cust introduced c. 1830 into his Leasowe Castle, Cheshire. See J. M.

Robinson, 1991, pp. 46–7.

46 Another seat of the family; later that panelling would go to Herstmonceux Castle.

47 Mark Girouard, 'Scarisbrick Hall', *Country Life*, 13 March 1958, pp. 506–9; 20 March 1958, pp. 580–83.

48 This is from Appendix 3 in Tracy, 2001, pp. 281–3, with the note that Scarisbrick made his last purchase from Hull in Sept. 1848.

49 Although this panelling had never been installed at Strawberry Hill. It could have been related to the building of the Waldegrave wing.

50 Was Hull cheating?

51 Tim Knox, unpublished paper 'though it appears old and unaltered', presented to the Wood Sculpture Conference, London, May 2001.

52 Tracy, 2001, p. 45, pl. 6.

53 Or as Tracy (*ibid.*, p. 45) quotes from Henry Shaw, *Specimens of Ancient Furniture Drawn from Existing Authorities . . . with Descriptions by Sir Samuel Rush Meyrick . . . Prospectus*, 1836, 'The painter, the sculptor, and the architect, when called upon to portray or imitate any article of early domestic furniture have been obliged to trust to imperfect descriptions or to their own imagination.'

54 For reference, nothing could be bettered than Knox's May 2001 lecture paper: All my quotes are from his unpublished text.

55 See also James Lees-Milne, *The Bachelor Duke*, 1991, and Knox, 'Though it appears . . .'

56 Deposited with the Dorset Record Office, Dorchester; see also Anne Sebba, *The Exiled Collector: William Bankes and the Making of an English Country House*, 2004.

57 Lord Dumfermline was the duke's legal adviser.

58 According to Tim Knox, the Dumfermlines moved to Colinton House outside Edinburgh, now the Merchiston Castle School. Not a scrap of this carving survives.

59 For general quotes in this section I have used Sebba, 2004; and for Soughton, ibid., pp. 122–4.

60 Bankes MS Dorset Record Office, HJ1/2.

61 Knox, Information to the author.

62 *Ibid.*, DRO HJ/1/486.

63 Knox, ' "Though it appears old and unaltered" '.

64 Sebba, 2004, p. 220, a quote from John Pemble, *Venice Re-discovered*, Oxford, 1995.

65 There were many leftovers from Bankes's scavenging. His younger brother George installed old brown oak, supposedly from

the old Palace of Westminster, in Studland Manor, Dorset.

66 See *Country Life*, 18 May 1907, pp. 702–9. When Methley was demolished in 1963 chimneypieces and doors went to the 6th Earl of Mexborough at Arden Hall, Helmsley, Yorkshire.

67 This date is disputed by Ben Weinreb and Christopher Hibbert in *The London Encyclopedia*, 1983, p. 117, who write that Woolley rented the house in 1847, in fact the year that he married a very rich lady. The article in *Chambers's Journal* was written in connection with a lawsuit subsequent to a fire on 23 March 1862, that gutted the house. Woolley eventually won the lawsuit over the insurance money. Although rebuilt in the original style, the house was demolished *c.* 1900.

68 *Chambers's Journal*, pp. 774–45. Feering House at Feering, Essex, was the stuff of the romantic illustrators. E.g. S.C. Hall, *The Baronial Halls and Picturesque Edifices of England*, vol. 1, 1848, unpaginated, chapter on Feering House. I am grateful to Mrs Muriel Carrick who lives in the house (before the nineteenth-century called Stranges) which is now divided up. The celebrated room is now the bar in the Sun Inn where some remains of carvings are on beam joists.

69 'Derwydd Carmarthenshire', *Country life*, 11 Feb. 1999, pp. 38–41.

70 *Country Life*, 27 June 1908, pp. 942–9. See also Ward Price & Co., sale catalogue *Gwydr Castle*, 26 May 1921, lot 65, the Oak Parlour, and lot 88, the dining room. The Hearst Foundation gave lot 88 to the Metropolitan Museum of Art in 1956. It had never been unpacked, and was returned to Gwydr in 1996 for a satisfactory reinstatement.

71 See Leonard Willoughby, 'Lord Llangattock's Monmouth Seat The Hendre and its Treasures', *Connoisseur*, vol. 17, April 1907, pp. 149–58; and *Connoisseur*, vol. 18 May 1907, pp. 8–19; see also John Newman, 'Gwent/Monmouthshire', in *The Buildings of Wales*, 2000, pp. 247–54.

Chapter 4: England and the French Connection

1 See James Yorke, 'Belvoir Castle, Leicestershire', *Country Life*, 30 June 1994, pp. 89–93; also James Yorke, *Lancaster House: London's Greatest House*, 2001, chapter 2, 'The Revived Taste of Louis the Fourteenth'; and also *The Diary of Frances, Lady Shelley, 1818–1873*, ed. R. Edgcumbe, vol. 2, London, 1913, p. 132.

2 See below.

3 Pons, 1995 makes no mention of Belvoir Castle, but Pons, 1996 does, pp. 190–1.

4 Yorke, 2001, p. 54, note 15.

5 Yorke, 2001, p. 53.

6 Sir Hugh Roberts, *For The King's Pleasure: The Furnishing and Decoration of George IV's Apartments at Windsor Castle*, 2001, p. 33 and p. 430, note 192; but see also Geoffrey de Bellaigue and Pat Kirkham, 'George IV and the Furnishing of Windsor Castle', *Furniture History*, vol. 8, 1972, pp. 1–34.

7 Although there is the possibility that these door trophies are part of the Paris shipment.

8 And obviously taking into account George IV's tastes and his Gallic-tinctured Carlton House which shows that he was sympathetic to French style interiors.

9 For a personal account of De Rothesay see Harris, *No Voice from the Hall*, p. 159, 'Into the Arms of the Tart Next Door'.

10 For an excellent summary of Lord Stuart see Sarah Medlam, *The Bettine, Lady Abingdon Collection: The Bequest of Mrs T.R.P. Hole, A Handbook*, Victoria and Albert Museum, London, 1996, pp. 16–24; and also p. 14 for a chronology of his life.

11 Tracy, 2001, p. 41, giving as his source M. B. Freeman, 'Late Gothic Woodcarvings from Normandy', *Metropolitan Museum of Art Bulletin*, vol. 9, no. 10, 1951, p. 260.

12 Medlam, *Bettine . . . Collection*, p. 28.

13 Christopher Hussey, 'Highcliffe Castle', *Country Life*, 1 May 1942, p. 856.

14 J. Taylor, Ch. Nodier and Alph. de Cailleux, *Voyages pittoresques et romantiques dans l'Ancienne France, Picardy 1*, Paris, 1835, sheet 32.

15 Victor Hugo, pamphlet, see *Oeuvres complètes*, 1882, vol. 1, p. 320; and Medlam, *Bettine . . . Collection*, p. 36 and Clive Wainwright, *The Romantic Interior*, 1989, p. 57, who illustrates, Fig. 45, the Grand Maison at Les Andelys being demolished, from Taylor et al., *Voyages pittoresques et romantiques . . .*, Paris, 1820.

16 Freeman, 'Late Gothic Woodcarvings', p. 260; but see J.H. Powell, 'Highcliffe Castle, near Christchurch, Hampshire [now Dorset]', *Trans. Ancients Monuments Society*, new series 15, 1968, pp. 83–94.

17 Medlam, *Bettine . . . Collection*, p. 35–6.

18 Quoted from Phoebe Stanton, in 'Sources of Pugin's "Contrasts" ', in J. Summerson (ed.), *Concerning Architecture*, 1968, p. 121.

19 Christopher Hussey's three articles in

Country Life, 24 April 1942, pp. 806–9; 1 May 1942, pp. 854–7 and 8 May 1942, pp. 902–5. For the Andelys salvages see 1 May, pp. 855–6, Figs 4–6; see also Giles Worsley, *Country Life*, 22 May 1986, pp. 1428–32.

20 E.g. Gothic panel to east of main door in Great Hall.

21 *Pace* Hussey, 'Highcliffe Castle', but his sources are not stated.

22 E.g. door to library from south: National Monuments Record, NMR BB67/3673.

23 As can be seen in National Monuments Record photographs BB67/3714–15.

24 Hussey, 'Highcliffe Castle', p. 857, Figs 8–9.

25 Hussey, May 8, 1942, pp. 904–5, Fig. 6.

26 Medlam, *Bettine . . . Collection*, p. 30–35.

27 *Ibid.*, pp. 32–3.

28 I am grateful to Tim Knox for lending me his 'Harlaxton Manor and its Owners: A lecture for a dinner, 26th July, 2003' and to a subsequent and amplified lecture he gave at Sir John Soane's Museum.

29 J.C. Loudon, *Gardener's Magazine*, vol. 16, 1840, pp. 329–42.

30 Burke, *A Visitation*, vol. 1, 1853, pp. 92–3.

31 Tim Knox makes the interesting suggestion that the incorporated salvages at Stoke Rochford for Christopher Turnor in 1841 and at Revesby for J. Banks Stanhope in 1854, were leftovers from Harlaxton. This is possible.

32 Demolished in 1795.

33 It must be confessed that the layers of paint and new gilding obscure a proper assessment. In some cases original Pineu style carvings have probably been copied.

34 In general in the introductions to Pons, 1995 and 1996.

35 Salles, p. 25–6; see Pons, 1995, pp. 30–32, see Olivier Meslay.

36 Acting the part in his novel *Le Cousin Pons*, 1848.

37 For this see chapter 7.

38 For Balzac see Pons, 1995, pp. 41–5; p. 43 for a photograph of the Grand Salon; Pons, 1996, pp. 157–8; but also Simon Jervis, 'Balzac and his Bric-à-Brac', *Country Life*, 5 June 2003.

39 Pons, 1996, pp. 191, 345.

40 See Pons, 1995, pp. 61, 65; Pons, 1996, pp. 175, 327, 338, 344–9, and Figs 306–10.

41 Pons, 1996, p. 191. The whereabouts of these is not known.

42 Illustrated as the West Drawing Room in the Sotheby & Co. sale catalogue 'by order of Victor Rothschild', 14–17 April, 1937.

43 Pons, 1995, pp. 48–57.

44 *Ibid.*, pp. 44, 48.

45 These are summed up in a pamphlet, *The Rothschild Collection: Panelling at Waddesdon Manor*, National Trust, June 1998 as from the Parisian hôtel Dodun, 21 rue de Richelieu; hôtel d'Espréménil, 9 rue Bertin Poirée; hôtel de Humières; hôtel Jacques Samuel Bernard, 46 rue du Bac; hôtel Le Bas de Montargis, 7 place Vendôme; Maison Beujon at Issey; Palais-Bourbon, faubourg Saint-Honoré; Palais-Royal; hôtel Peyrec de Moras, 77 rue de Varenne; hôtel Samuel Bernard, rue Notre-Dame-des-Victoires; hôtel Thiroux de Lailly, 5 rue de Montmorency; hôtel de Villars, 116 rue de Grenelle.

46 See Appendix 2, below, on Carlhian et Cie in Paris.

47 Pons, 1996.

48 Pauline Prévost-Marcilhacy *Les Rothschild: bâtisseurs et mécènes*, 1995.

49 For a fuller account of this see John Harris, 'An English Rococo Mystery', *Country Life*, 15 April 2004, pp. 130–33, and *L'Art Anglais dans les Collections de l'Institut de France, sous la direction d'Olivier Meslay*, Paris, c. 2004, in particular Harris, 'Les Appartements de Berthe de Clinchamp dans le pavillon Bullant', pp. 28–31.

Chapter 5: Interiors and a New Professionalism: 1850–1950

1 See Mahouri Sharp Young, 'George Gray Barnard and The Cloisters', *Apollo*, Nov. 1977, pp. 332–3.

2 *Ibid.*, p. 334.

3 See Ralph A. Griffiths, *Clyne Castle, Swansea: A History of the Buildings and its Owners*, University College of Swansea, 1977, p. 29.

4 CADW (RAHM Wales) *Listed Building Report*, amended 1999.

5 The only accounts appears to be Griffiths, *ibid.*, 1977; and John Newman, *Buildings of Wales: Glamorgan*, London, 1995, pp. 488–89. But see also *South Wales Daily News*, undated but probably about Oct. 1911 (RCAHM Wales, UA/GEN/79E), for which, and much other help with Clyne and Dyffryn, I am indebted to Anna Zofia Skarzynska of the RCAHM of Wales.

6 Sold at the Clyne contents sale in 1952. When taken down after the auction sale, the whole frieze collapsed into dust, except for two large sections about six feet long, one of which is in the collection of the author.

7 Duveen Papers, Getty Center for the Humanities, Los Angeles, 'Things Seen Houses of Fine Goods' (960015. Box 199). The fact that Duveen visited this house might imply that Vivian bought salvages through his firm.

8 See also Dyffryn, *South Wales Daily News* 7 Oct. 1911.

9 It is not clear if the Adamesque doorcases in the drawing room are 'Wyatt' or Vivian imports. The ceiling is copied from the Long Gallery at Knole.

10 Newman, 1995, p. 341, although the CADW listing mentions Habershon & Fawckner.

11 See *Country Life*, 1, 8 and 15 June 1951, especially 15 June, pp. 1884–8. A newspaper article in *South Wales Daily News*, 7 Oct. 1911 (see RCAHM Wales, UA/GEN/89/79E) provides a description of the house inside and outside. Elsewhere in the house is a Coade stone chimneypiece, not examined by this author.

12 The Hesketh family of Easton Neston, Northamptonshire, had bought Gayhurst for the estate. See Sotheby's Easton Neston sale, 17–19 May 2005, vol. 2, lot 334.

13 In particular, the great chimneypiece by Chambers and Joseph Wilton from the Gower House saloon was sold by the school and is now in the British Galleries of the V&A.

14 An unrecorded example of Gothic Design

15 *Country Life*, 22 Nov. 1919, pp. 657–63 and 29 Nov. 1919, pp. 688–94. There are references to Captain Lindsey's notes comparing the situation in 1909 and 1912, presumably in the inaccessible Belvoir Castle archives.

16 See documents (D 894/25 and D 4793/A/8/2) in Staffordshire Record Office relating to legal matters concerning the history of building the mansion and the demolition sale of the house in 1933. George Trollope was also involved in Beaudesert, in 1905 as well as 1909, and E.L. Warre in 1912–13.

17 H. Avray Tipping, *English Homes, Period II, volume 1, Early Tudor 1485–1558*, London, 1929, p. 213.

18 See *Country Life*, 29 Nov. 1919; and in Tipping, *English Homes, Period IV, volume 1, Late Stuart, 1649–1714*, London, 1929, p. 52, H. Avray Tipping says that [at Thorpe] 'the dining room doorways have been reproduced for Beaudesert . . . only one of many instances of Thorpe Hall replicas in this country'.

19 It is not at all clear when this room was removed from Thorpe Hall and from whom it was purchased. It may well be related to the end of Brigadier-General Strong's tenure after 1919. For Leeds, see *Country Life*, 28 Nov. and 5 Dec. 1936, in the latter Figs 2–4 for the room. As Mary Miers observes in 'Leeds Castle, the Inside Story', *Country Life*, 8 May 2003, John Cornforth in *Country Life*, 14 April 1983, p. 925 and 21 April 1983, pp. 1018–21 had written about Lady Baillie and the decorations of Stéphane Boudin, without bothering to examine the Leeds Castle archives and was therefore unaware of Rateau's work, much of which Cornforth gave to Boudin.

20 Miers, 'Leeds Castle', Fig. 2.

21 Articles by Christopher Hussey in *Country Life*, 2 and 9 Dec. (pp. 1442–6), 16 Dec. (pp. 1814–17) and 23 Dec. (pp. 1884–48), 1949.

22 See Christopher Hussey, 'Sutton Courtenay, Berks: The Property of Colonel Harry Lindsay', *Country Life*, 16 and 23 May 1931.

23 See *Country Life*, 12 June 1951, pp. 820–27; 19 June 1951, pp. 870–75.

24 *The Buildings of England: South and West Somerset*, 1958, p. 246.

25 It is uncertain what Phelips V achieved with this new wealth. The chimneypiece and overmantel in the dining room is a composite ascribed to him.

26 Unpaginated text.

27 For this I am grateful to Rebecca More, the historian of Montacute. She gave me extracts from Curzon's inventories (BL F112/731, Curzon Papers). I am also indebted to James Grasby for quotes from Curzon's notes on the Oak Room. See also Jo Moore, ' "An empty and rather embarrassing white elephant": The Refurnishing of Montacute House', *Apollo*, April 2002, pp. 17–22.

28 This is the inn that had the Globe Room, a focus of controversy when attempts were made to export it to the USA in 1912. The room is now reinstated in the Reindeer Inn. See chapter 6, p. 107. Thornton Smith must have taken moulds of the original ceiling, for another Thornton Smith ceiling is to be found in Schoppenhanger Manor, Maidenhead, Berks, one in the Oak Room at Anglesey Abbey, Cambridgeshire, for Lord Fairhaven in 1925, and yet another in John Russell Pope's 1025 Park Avenue, New York, built 1911–12 for Reginald Dekoven. One room had the Globe ceiling, the Great Hall was based upon Hatfield and the staircase upon that at Knole. I am indebted for these references to John Martin Robinson and the internet. In two cases Keebles were involved.

29 Curzon's notes ex James Grasby.

30 The National Trust guide of 1997 is still inadequate. See Christopher Hussey, 'Barrington Court, Somerset', *Country Life*, 17 March 1928, pp. 370–77 and 24 March

1928, pp. 404–12.

31 Was this house the so-called Bishop's Palace at Gaywood, just outside King's Lynn?

32 This must be T. Crowther's 'Wren House', 73 Cheapside, in his stock in 1923.

33 Surprisingly little is known about this restoration. The principal literature is *Country Life*, 2 March 1918, pp. 214–18; 9 March 1918, pp. 242–8; 17 March 1918, pp. 270–78, still in time of war without mention of Lowther's architect.

34 See *Country Life*, 5 Oct. 1912, pp. 454–65.

35 This remains unlocated.

36 Verbally to the author in 1955.

37 Confusingly named Berkeley Castle; after its sale in 1932 it was named Ripon College, and today is called Foxcombe Hall, part of the Oxford Open University.

38 Maybe by Thomas Wright. The best view of the castle at this time is that from the south-west, engraved by J. Couse, and inscribed, 'To the Rt: Honble: the Countess of Berkeley this View of Berkeley Castle in Gloucestershire Copied from a Drawing of her Ladyships is most humbly dedicated' (in poss. collection of the author).

39 I have drawn heavily upon James Miller's two articles in *Country Life*, 2 Dec. 2004, pp. 72–5 and 9 Dec. 2004, pp. 57–61, but also upon the many folders of correspondence, bills and instructions to and from Keeble Ltd., a treasure trove of dealer information, whose existence had long been denied by the archivists.

40 Many of these have neither been examined nor catalogued.

41 At a cost of more than £6,000.

42 All uncatalogued documents.

43 Yate Court in evocative ruin was photographed by Eustace Frith in May 1925. See Alan Sutton, *Wotton-under-edge to Chipping Sodbury in Old Photographs*, Gloucester, 1987, p. 152, foot.

44 Uncatalogued document.

45 Uncatalogued document.

46 Now Atlantic College of the United World Colleges. The principal published references are Alan Hall, *St Donat's Castle: A Guide and Brief History*, HSW Print, Clydach Vale, 2002; and Newman, *Buildings of Wales: Glamorgan*, 1995, pp. 552–7; but for more detail see *Country Life*, 24 Aug. 1907, pp. 270–79 and 31 Aug. 1907, pp. 306–15; also *Country Life*, 18 Sept. 1980, pp. 942–5.

47 Hall, 2002, pp. 47–8, who appears never to have seen this document.

48 Shugborough MS D.615 P(A) 12, Staffordshire Record Office.

49 This removal must have spurred on the

c. 1885 compiler.

50 The wainscot bears the arms of John Harcourt and Margaret Barentyn.

51 Although it must be observed that a sequence of private bedrooms in the late seventeenth-century style may be salvaged from somewhere, but are probably designed by Sir Charles Allom, as they are so like his style for this sort of interior. A priest's room in the north-east range was panelled up from the Neptune Inn at Ipswich.

52 See *Country Life*, 24 Feb. 1906, pp. 270–77; 3 March 1906, pp. 306–15; and 10 March 1906, pp. 342–9; and N. Pevsner, *Buildings of England*, *Hertfordshire*, 2nd edn, 1972, pp. 158–60.

53 An unpaginated advertisement. There are a few bills, mostly from Jackson 1901–1, but also from Keeble Bros for furniture and some decoration. These are among the uncatalogued papers at Rothamstead.

54 See GLC, *Survey of London*, *The Grosvenor Estate*, vol. 50, part 2, 1980, p. 144.

55 Charles Lathom, *In English Homes*, vol. 3, 1909, 'Hursley Park, Hampshire', pp. 401–14. See also *The English Interiors* volume [green cover], ex Duveen library, the Clark Institute, Williamstown, Mass.

56 See Fig. 103.

57 Repatriated to Winchester College in 1952.

58 This suggestion is based upon the existence of Hursley photographs in the Carlhian photo archive at the Getty Center for the Humanities, California.

59 For Fairlawn see Christopher Hussey, *Country Life*, 30 Oct. 1958, pp. 998–1001; and 6 Nov. 1958, pp. 1050–53; but also correspondence in *Country Life*, 27 Nov. 1958, p. 1247, a letter from Derek Sherborn. John Cornforth's scrutiny (2004, pp. 61–2) of the Gibbs Room at Fairlawn oddly omits any discussion of the post-1895 sanitizing of this room.

60 See *Country Life*, 12 March 1948, pp. 526–9; and Clive Aslet, 'Polesden Lacy, Surrey', *Country Life*, 12 Feb. 1981, pp. 378–81 and 19 Feb. 1981, pp. 442–5; and National Trust guidebook, 1981 and later editions.

61 Osbert Sitwell, *Laughter in the Next Room*, 1949, p. 43.

62 *Country Life*, 17 Feb. 1906, pp. 234–41.

63 *Country Life*, 29 July 1922, pp. 114–20; 5 Aug. 1922, pp. 144–9. But see also Jeremy Musson in *Country Life*, 8 June 2000. I am grateful to R.J.H. Carr-Whitworth for conveying his enthusiasm for the house under his National

Trust care.

64 *Country Life*, 21 April 1934, pp. 404–8; 28 April 1934, pp. 432–7.

65 *Country Life*, 24 Feb. 1940, pp. 191–3, reporting the fire.

66 Christopher Hussey in *Country Life*, 4 Aug. 1950, pp. 374–8; 11 Aug. 1950, pp. 442–7; and 18 Aug. 1950, pp. 518–22.

67 *Country Life*, 16 Feb. 1945, pp. 288–91; 23 Feb. 1945, pp. 332–5; the saloon in *Country Life*, 2 March 1945, pp. 376–9.

68 Simon Thurley, 'Chelsea's Phoenix', *Country Life*, 9 May 1996, pp. 76–7.

69 This has all been explained in Steven Brindle's exemplary article on 'Pembroke House, Whitehall', *Georgian Group Journal*, vol. 8, 1998, pp. 88–113.

70 When a paneled room from Cromwell House, Whitehall, appeared.

71 Brindle *op cit.*

72 Or at least it was up for grabs.

73 It was offered to the Victoria and Albert Museum and the Royal Academy of Arts.

Chapter 6: The Growth of a Transatlantic Trade in Rooms and Salvages

1 Transferred to the new museum, the Institute of Arts, Minneapolis in 1923.

2 See Warwick Draper, *Chiswick*, London, 1923, p. 88, note 125.

3 Getty Center for the Humanities, Los Angeles, where I am indebted to Wim de Wit and Teresa Morales.

4 Duveen Papers, Getty Center for the Humanities, Los Angeles, Stock number 14550, Duveen (960015), Reel 19 (Box 50).

5 *Ibid.*, Duveen (960015) Reel 19 (Box 50) sales book no. 1. Of course, an 'Oak' room could well refer to a French one.

6 *Ibid.*, Duveen (960015) Reel 19 (Box 50) sales book no. 4.

7 *Ibid.*, stock number 15012, Duveen (960015) Box 56 London stockbook no. 6, Aug. 1898–Sept. 1899 [reel 21].

8 *Ibid.*, page 102 of stock book, stock number 20008, Duveen (960015) Box 51. Sales book no. 4, June 1899–July 1902 [Reel 19].

9 See: *One Thousand and Twenty Fifth Avenue*, New York, 1912, photographic survey of his collections.

10 The only account of Sir Charles Allom is by Diana Brooks in the 1998 RIBA Heinz Gallery exhibition catalogue, *Thomas Allom (1804–1872)*, Appendix 4, 'Charles Carrick Allom and White Allom & Co.', pp. 95–101.

11 Joseph Duveen paid him $25,000 annually not to use the Duveen name, but to be known as Charles of London. See *A Report on the Archives of Duveen Brothers Inc. at the Sterling and Francine Clark Art Institute*, Jan. 1985, project by Margaret Smith.

12 E.g. September 1903. Nearly all these advertisements are mostly out of main paginated sequence.

13 It may have been a copy of the original.

14 *Connoisseur*, article 'On Collecting', p. 294. Some of these were put into Rothampsted House, Hertfordshire: see chapter 5.

15 In 1928 they would exhibit another set at the *Olympia Exhibition of Antiques and Works of Art*, London, catalogue p. 232, foot.

16 *Connoisseur*, May 1905, p. 12.

17 As so often nearly all neo-classical chimneypieces would be labelled 'Adam'.

18 *Connoisseur*, Oct. 1905, p. 15.

19 Mark Bence Jones, Burke's *Guide to Country Houses – Ireland*, 1978, p. 225.

20 *Connoisseur*, Jan. 1906, p. xi.

21 This may well be the source of the panelling 'from a house at Ipswich', put into Chequers, Buckinghamshire, by Gill & Reigate *c.* 1909–10 (information from John Martin Robinson).

22 Volumes 2 (1907) and 3 (1909) were co-authored with H. Avery Tipping.

23 One set in Ben Weinreb's stock had a Charles of London label.

24 *Connoisseur*, Dec. 1910, pp. 257–70.

25 Herbert Cescinsky, 'The Educational Aspect of Irish Chippendale', *Burlington Magazine*, May 1910, pp. 7–8.

26 This one also in Roberson's *Historical Rooms*, vol. 1 (*c.* 1925), plate 4.

27 In 1915 he would publish *Elizabethan Interiors*, a second edition appearing in 1917. Unfortunately it is not possible to determine what original salvages Charles put in to these houses.

28 Lathom, vol. 1, 1904, p. 291, r.e. Speke Hall, Lancs.

29 The house was one of a terrace of four designed by Colen Campbell. Lenygon would be here until 1953. See Greater London Council, *Survey of London*, vol. 32, part 2, North of Piccadilly, 1963, pp. 513, 516–17. John Cornforth claims that this was the first instance of a dealer occupying a large London house, quoting Andrew Russell at 8 Clifford Street in 1914 and Thornton Smith at 32 Soho Square in 1915.

30 Lenygon illustration facing p. 1.

31 Lenygon, pp. 133, 145.

32 Victoria and Albert Museum, Box II 39G.

33 Ulrich Thieme and Felix Becker, *Allgemeines Lexikon der Bildenden Künstler*, vol. 7,

Leipzig, 1912, p. 219.

34 G. L. C., *Survey of London*, op. cit., p. 489; this new façade, which still exists, was advertised in the *Connoisseur* in 1935.

35 Information from Brian Mitchell as ongoing research.

36 G. L. C., *Survey of London*, vol. 40, *The Grosvenor Estate in Mayfair*, part 2, 1980, p. 38, and p. 348, note 45. The lease was terminated in 1924, so that would determine a rough date when the paintings might have been exported.

37 Two wooden fragments of this room in the Colonial Williamsburg Collection demonstrate the danger of assuming that the Williamsburg Lenygon Collection of architectural salvages did represent an export trade, although the relevance of a photograph inscribed Walter E. Maynard at 200 Fifth Avenue, New York, is unclear.

38 See the *Franco-British Exhibition Illustrated Review*, ed. F.G. Dumas, London, 1908.

39 See the Gill & Reigate brochure, *The Old Tudor House from Ipswich Restored and Re-erected in the Franco-British Exhibition*, 1908 (Victoria and Albert Museum, V&A Library Box 57.C). The house perhaps on Long Island has not been identified.

40 In fact it was Bush Hill Park, Middlesex, demolished in 1927.

41 Probably the room advertised in the *Connoisseur*, May 1908.

42 See also the *Connoisseur*, Feb. 1909.

43 *Connoisseur*, May 1908. It can only be speculation as to whether this is the provenance of the Newtownbarry panelling.

44 It needs comment that, frustratingly for the scholar, dealers' catalogues are generally undated.

45 In the author's collection. One page shows the display of chimney pieces in their catalogue.

46 'Reproduced in 1815 for the first Earl Howe, and was copied from original Gothic panelling in his possession and intended for the panelling of a private chapel' (catalogue p. 4). The 1st Earl was R.W.P. Curzon, of Gopsall Hall, Leicestershire, where Sir Jeffry Wyattville was employed in 1819.

47 Obviously by Robert Adam.

48 V&A Library Box V.47K.

49 One of these was installed as the hall in 13 Lansdowne Road, Holland Park, for Edmund Davis, who had the Haynes Grange Room. See *Architectural Review*, Feb. 1914, pl. IX, top, and pl. X, the Music Room possibly with Uttoxeter panelling.

50 HD, v.88, if the date 1912 is not a mistake for 1922.

51 This was apparently not 'the quaint oak dining room with deer antlers for chandeliers' at 123 Lexington Avenue, New York, but could have been installed in Hearst's Clarendon Apartments at 137 Riverside Drive. See also John K. Winkler, *W.R. Hearst: An American Phenomenon*, New York, 1936, p. 203.

52 *Connoisseur*, Oct. 1911. It is possible that this room is the same as the 'Panelled room formerly in a house in the North of England', of the Wren period, illustrated in Arthur Stratton's *The English Interior*, 1920, p. 22, Fig. 18.

53 *Burlington Magazine*, May 1913, pp. 88–93 and Aug. 1913.

54 Evidence of this is to be found in various undated clippings in the Local History Centre of Banbury Public Library. Potts had written 'Notes on the Globe Room at the Reindeer Inn, Banbury' (Oxfordshire Archaeological Society, *Reports*, 1900–9, 1905, Banbury 1906, p. 26.

55 Gotch, pls XLIX, LXIX and p. 162. In any case Gotch would have been aware of S.W. Kershaw's article, 'The Treaty House, Uxbridge', in *Trans. London & Middlesex Archaeological Society*, vol. 5, 1881, pp. 504–13.

56 L.A. Shuffrey, *The English Fireplace. A history of the development of the chimney, chimney-piece and firegrate with their accessories*, London, 1912, pl. LII.

57 In general see B.S. Tinder, *The Story of the Globe Room*, Banbury Historical Society, 1966, but also *Cake and Cockhorse*, Banbury Historical Society, vol. 2, no. 10, Nov. 1964, with two articles: C.F.C. Beesan, 'The Globe Room as an Antique', pp. 169–70 and J.S.W. Gibson, 'The Recovery of the Globe Room Panels', pp. 171–3; as well as many undated cuttings in Banbury Library files, especially r.e. the Pilgrim Trust rejection of a grant to restore the room to the Reindeer Inn in 1964 (*Oxford Mail*, 28 Dec. 1964).

58 *Banbury Guardian*, 29 Feb. 1912.

59 Minutes of the Executive and Committee of the National Trust, archives copied for me by David Adshead. See also The National Trust, *Tattershall Castle, Lincolnshire*, 1997, pp. 28–30, and see also Marquis of Curzon and H. Avery Tipping, *Tattershall Castle, Lincolnshire*, 1929.

60 'Our Antiquities: Mr. Lenygon's Reply to Lord Curzon', *The Times*, 2 Aug. 1912.

61 *Sphere*, 2 Nov. 1912, p. 128.

62 By representatives of the Berks, Bucks and Oxon Archaeological Society in July.

63 Brian Mitchell believes this to have been removed from no.1 Brick Court, Temple,

London.

64 In this house was also one of the Uttoxeter rooms as sold by Gill & Reigate. See *Architectural Review*, Feb. 1914, pl. IX upper, the hall and pl. IX lower the Haynes Grange Room; pl. X upper the Music Room with a Gibbons-style overmantel.

65 The smaller neighbouring room is not often referred to in the account of the 'Treaty Room'.

66 In fact, the actual meeting rooms could not have been these, but would have been the far grander rooms in the extensive range of this large Elizabethan house that had long since been demolished.

67 Who did not own the Treaty Inn, according to Uxbridge historians.

68 I am in debt to Carolyn Cotton of the Uxbridge Local History department. She has established the true facts as to the date of the room's extraction from the Treaty House.

69 PMA, Fiske Kimball Records Series 1 – General Correspondence 1929–30. Robersons of Knightsbridge, London. Prints of Robersons' measured drawings are Series 7 – Objects, Sub-Series 2 – Rooms and Other Architectural Elements, Box 201, folder 10. I am indebted to Susan K. Anderson, Archivist at the PMA for her kind help in seeking and checking these records.

70 Fiske Kimball Records, Series 1 – General Correspondence, 1929–30, Robersons of Knightsbridge, London.

71 He was an habitual liar when it served him.

72 In Armand Hammer, *Witness to History*, 1987, pp. 259–60. As Hammer was such a crook and liar, his statements cannot be verified, nor does he indicate where the rooms had been before 1945. However, unless Louis H. Allen had the room on his inventory for more than fifteen years, it must have had another life somewhere else.

73 A.F.G. Leveson Gower, 'An Act of Vandelism – The Demolition of St. Mary's Church, Rotterdam', *Architectural Review*, November, 1913, pp. 98–100.

74 In *Connoisseur* for June 1914 Fryer would advertise 'an Adam' room.

75 Suggestively all these salvages came from Dresden House. According to Pevsner, *Buildings of England, Worcestershire*, London, 1968, pp. 149–50, Dresden House, dated 1692, has in the garden a 'large reset Elizabethan stone chimney piece with uncommonly elegant foliage decoration and a three storeyed summer house of *c.* 1750 with an elaborate stucco ceiling'.

76 For the crisis see most recently, Giles Worsley, *England's Lost Houses*, 2002, pp. 15–16.

77 It is important to understand this tax, for before 1909 many US collectors had preferred to retain their works of art in Europe.

78 Earlier, there was the dispersal of the carvings in Holme Lacy, Herefordshire, of which one group was accessed by the Metropolitan Museum of Art in 1916 (accession no. 16.88a,b). Another group may be at Ardrossan, Pennsylvania.

79 It is uncertain if this was the long gallery from Albyns, Essex, in which several dealers seemed to have had an interest.

80 *Connoisseur* pp. xxiv, xxv.

81 *Connoisseur* p. xx.

82 Mistakenly given by Roberson as in Leicestershire.

83 *Connoisseur* p. xx.

84 Volume 3 in the library of the Philadelphia Museum of Art is dated in ink, Jan. 1 1925, therefore one must assume that volumes 1 and 2 had appeared in 1924 or maybe 1923.

85 *Connoisseur* p. x.

86 *Connoisseur* p. xxiv.

87 Rehabilitated to Stowe from Benham Park, Berkshire.

88 *Stowe House and the remaining Portion of the Estate*, by Jackson Stops, the 2nd day, lots 6, 9, 10–15, 20–24 and 32. The house had been a receptacle for many salvages, not least from the Canons and Wanstead sales. According to lot 269 of the chapel from Stowe, Cornwall, paneling had been added as from the Duke of Portland's sale of salvages at Bulstrode in the same county.

89 For a history of Hotspur see Nicholas Goodison and Robert Kern (compilers), *Eighty Years of Antiques Dealing*, London, 2004.

90 Album I.

91 This is an odd claim as Moss Harris's name does not reverberate as a dealer in period rooms, although their premises were spacious. This is not borne out by a view of their amply illustrated three volumes titled *A Catalogue and Index of Old Furniture and Works of Art*, not dated, but probably mid to late 1920s, in which there is only one late 17th century chimney piece from 'Carlton Park' (Carlton Curlieu Hall), Leicestershire (Part I, p. 53), and one from Aston Lodge, Aston-on-Trent, Derbyshire (Part II, p. 181). See also Moss Harris & Sons, *An Abridged Introductory Catalogue of Antique Furniture and Works of Art*, n.d. (but *c.* 1929), p. 82 for one of the Stowe chimney pieces sold in the October 1922 sale. This catalogue was unusual as far as dealers were concerned, since nearly all the

furniture for sale was listed as to provenance.

92 Messrs Puttick & Simpson, July 6–10, 1925.

93 Jourdain, *English Interiors in Smaller Houses*, London, 1923, Figs 8, 161.

94 Jourdain, 1923, Figs 22, 24, 25–8, 141.

95 Jourdain, 1923, Figs 29–32.

96 Jourdain, 1923, Figs 49–51.

97 In New Bond Street.

98 Documents in the possession of John Booth II of Grosse Point, Michigan.

99 Lot 1181.

100 Lot 1183.

101 Lot 1182.

102 Murray Adams-Acton and G. Surgey, once of Charles Allom's team of designers and craftsmen.

103 *Country Life*, June 9, 1928, p. cxvi.

104 The brochure by Brian Brooks, *Keeble Ltd 1668–1968*, London, 1968, possesses an invaluable list of 'Houses recently decorated by Keeble', but contains no evidence of transatlantic activity. In 1903 the firm was of 9 Rupert Street, London. See also the firm's *The History of Carlisle House Soho*, n.d.

105 James Miller, 'Berkeley Castle, Gloucestershire I', *Country Life*, Dec. 2, 2004, pp. 72–5, and 'Berkeley Castle II', *Country Life*, Dec. 9, 2004, pp. 59–61.

106 *Country Life*, Aug. 21, 1926, p. xi.

107 Evidence in the photographic files of French & Co. in the Getty Center for the Humanities, Los Angeles, California; sold on to Hearst, see Fig. 212.

108 The whereabouts of these has so far eluded enquiry.

109 Later of 14 Berkeley Square.

110 *Connoisseur*, p. xxxiii.

111 Catalogue, p. 25.

112 Catalogue, p. 127.

113 Catalogue, p. 275, probably also from Albyns.

114 Catalogue, p. 351.

115 Catalogue, p. 132.

116 Catalogue, p. 218.

117 Catalogue, p. 134.

118 Catalogue, p. 236 bottom.

119 Catalogue, p. 196.

120 Catalogue, p. 134, sold on to Hearst, now Detroit Institute of Arts.

121 Catalogue, p. 136.

122 Catalogue, p. 239.

123 Catalogue, p. 242.

124 Catalogue, p. 232 bottom.

125 Catalogue, p. 136.

126 *Burlington Magazine Monograph*, 'Georgian Art', 1929.

127 Sold to the Metropolitan Museum of Art.

128 *Apollo*, Nov. 1936, p. xxv.

129 By repute exported to the USA.

130 *Apollo*, Aug. 1937, p. v.

131 Mayfair, London.

132 Buckinghamshire.

133 Queensberry House, London, or Richmond, Surrey.

134 Kent, see p. 95.

135 St James's Square, London.

136 London.

137 Berkshire.

138 Near Reading, Berkshire.

139 Surrey.

140 The leaf of an advertisement inserted in *Connoisseur* in February 1931 is for the auction by Perry & Phillips Ltd. of Bridgnorth of the fixtures and fittings of the demolished 1753 wing including 30 chimney pieces. Illustrated in the *Art Treasures Exhibition of the British Antique Dealer's Association*, Christies, 1932, Cecil Miller of 30 Newman Street, W1, exhibited a chimney piece from Kyre Park, mysteriously labeled 'Designed by Benjamin King 1756'.

141 Norfolk.

142 Berkshire.

143 Staffordshire.

144 London.

145 St James's Square, London.

146 See Appendix 3.

Chapter 7: The Period Room in European Museums

1 See Olivier Meslay, 'A propos du Cabinet du bord de l'eau d'Anne d'Autriche au Louvre et de quelques découvertes au palace du Luxembourg', *Bulletin de la Société de l'Histoire de l'Art Francais*, anné 1994, 1995, pp. 49–66.

2 Alex du Sommerard, *Les Arts du moyen age*, 5 vols, 1838–46.

3 For Cottingham in general see Myles, 1996; but I am more indebted to Tim Knox's lecture, 'Soane's Museum and Cottingham's Museum: Rival Architectural Museums in Regency London?' delivered to the Royal College of Surgeons, 16 May 2006. It is tantalizing not to know if Cottingham visited Paris, as he must surely have done.

4 What do survive are the notes and sketches made at the time by the staff of the Survey of London in 1951 when recording the house. See London County Council, *Survey of London*, vol. 23, 1951, pp. 28–30.

5 Alas they never did.

6 The unpaginated *Memoir* has traditionally been ascribed to Cottingham, but if so, obviously it must have been written before his death in 1847; it is reviewed in the

Builder, vol. 5, no. 23, Oct. 1847, pp. 502–3. The sale itself is reviewed in the *Builder*, 8 Nov. 1851, p. 710. For a recent discussion of the collection and display of medieval art in the *fin de siècle*, see Elizabeth Emery and Laura Morowitz, 'From the Living Room to the Museum and Back Again', *Journal of the History of Collections*, vol. 16, no. 2, 2004, pp. 285–309, although curiously the writers appear ignorant of Cottingham's museum!

7 And as Knox suggests, the ante-room may well have been Cottingham's answer to Soane's Shakespeare Recess.

8 An indication of the date of installation.

9 The identification of this museum has defeated this author.

10 It is uncertain what this room contained; but it may well have been salvages from the ancient seat of the Brocas family at Beaurepaire, Hampshire; or casts of the Brocas monuments.

11 Unfortunately, we are not told where this came from.

12 As Knox recounts, surprisingly the house survived until 1949, as recorded by the *Survey of London* for Lambeth in 1951. The record drawings they made have been unearthed by Colin Thom in the National Monuments Record, Swindon.

13 Knox, 2006.

14 See Clive Wainwright, *The Romantic Interior: The British Collector at Home 1750–1850*, 1989, chapter 9, pp. 241–68; but also Hugh Mellor, 'The Architectural History of Goodrich Court', *Trans. Woolhope Naturalists' Field Club*, vol. 42, part 11, 1977, especially for the demolition in 1947, when the Breda ceiling sold for £685 and then disappeared. I am grateful to Dr Konrad Ottenheym for informing me about the history of the palace with its 'William and Mary' ceilings carved by Johan Claudius de Cock.

15 *Goodrich Court Guide*, 1845, p. 21. According to Dr Konrad Ottenheym, after decades of neglect the palace was transformed into a military academy, and all the interior elements removed in 1827–9, a convenient time for Meyrick's acquisition of salvages for Goodrich. See Gerard van Wezel, *Het paleis van Hendrik III Graaf van Nassau te Breda*, Zwolle/Zeist, 1999. The contents of Goodrich were sold in Aug. 1946 in a four-day sale; the fixtures and fittings in 1947 and the building materials in Dec. 1949.

16 For this I am indebted to Marcus Binney, see: 'House of Hidden Clues', in 'Bricks and Mortar', *The Times*, 21 Oct. 2005,

p. 4. Brooke Place, Surrey contains two rooms, the Breda Room and the Rubens Room, one described by Binney as *c.* 1600, 'with vases and exotic birds inspired by Raphael's grotesques in the Vatican'. It may well be that neither came from Goodrich but, like the Goodrich ceiling, came from a shipment into the Wardour Street trade.

17 As indeed it was. See Revd T.D. Fosbroke, *The Wye Tour*, Ross, new ed. 1843; Goodrich is described on pp. 56–88, the Breda ceiling as in the library.

18 A general account of Hazelius and Skansen is Ralph Edenheim, *Skansen Traditional Swedish Style*, London and Stockholm, 1995.

19 See Centraal Museum, Utrecht, *8 Meubelen tot 1900*, contributions by Reinier Baarsen, Dirk Jan Biemond, Paul van Duin and Anne-Sophie van Leeuwen, Utrecht, 2005, Fig. 5. This book with Dirk Jan Biemond's 'Van 'antieke kamers' tot historische kunstkamers' *Het belang van de Utrechtse stijlkamers voor de Nederlandse museale geschiedenis* is the first considered explanation of period rooms in Dutch museums, and to this I am indebted.

20 These had been installed in his own house in 1869.

21 In fact what became the Decorative Arts Department of the Rijksmuseum. See Centraal Museum, Utrecht, *8 Meubelen tot 1900*, Fig. 24.

22 In a local folksy style. Fully discussed by Cornelis Boschma, in 'Two Centuries of the Frisian Museum', *Journal of the History of Collections*, vol. 17, no. 2, 2005, pp. 223–36. By 1908 the museum had received and set up a group of four rooms bequeathed by the painter Christoffel Bisschop from his Villa Frisia at Scheveningen.

23 Information supplied by Reinier Baarsen of the Rijksmuseum, via his colleague Dirk Jan Biemond, who believes that documents about this exhibition in the archives of Utrecht are incomplete. It is possible that at this time evidence of Dutch period rooms was disseminated in Boston. See chapter 8.

24 See also Stefan Muthesius, 'Why Do We Buy Old Furniture? Aspects of the Authentic Antique in Britain 1870–1910', *Art History*, vol. 2, no. 2, June 1988.

25 Panelling from a room near Exeter (V&A 4870–4881), 1856. No chimneypiece was included. Possibly from Bradninch Manor, Devon. See also *Furniture and Decoration*, 1 Feb. 1890, p. 22; and Anthony Wells Cole, 'An Oak Bed at Montacute: A Study in Mannerist Decoration', *Furniture*

History, 1981, pp. 6–7, pl. 14; also letter from John Allen of Exeter Museums to Tessa Murdoch, 10 Jan. 2001, and information from Anthony Wells Cole, in V&A Department files.

26 See Anthony Burton, 'British Decorative and Fine Art at the V&A before the British Galleries', chapter 1 in *Creating the British Galleries at the Victoria and Albert Museum: A Study in Museology*, ed. Christopher Wilk and Nick Humphrey, V&A, 2004.

27 See V&A green files, 1736–1869. Also V&A Department of Woodwork, *The Panelled Rooms, III The Boudoir of Madame de Serilly*, 1915.

28 Lucia Scalisi, 'A Room for all Seasons', *Country Life*, 4 Jan. 1990. However, it must be said that where and how this room was first displayed is disputed.

29 His bronzier had workshops in the house.

30 Quoted out of context in Pons, 1996, p. 192, footnote 129: 'beautiful models of a rigorous and pure taste showing our craftsmen and designers an ideal that they should attain'.

31 Jeremy Musson, 'Back Home to its Castle', *Country Life*, 22 June 2000, pp. 154–7.

32 The museum also has on view an eighteenth-century stair from the hôtel de Hornes, rue des Ursulines, Brussels, and a set of *boiseries* of *c.* 1720 from a *salon de musique* of Rothschild provenance, acquired in 1966.

33 See G. Ulrich Grossmann, *Architektur und Museum – Bauwerk und Sammlung*, Ostfildern, 1997.

34 See the *Schweizerisches Gewerbe-Blatt*, 15 Oct. 1877, for an account of this acquisition; also *Die Kunstdenkmaler des Kantons*, Zurich, Band V, Basel, 1949, and *Die Werdmüller Schicksale: eines alten Zürcher Geschlechts*, erster Band, Zurich, 1949. The house was at Sihlstrasse 20. In general see Fritz Gysin, *Geschichte des Schweizerschen Landesmuseums 1898–1948*, 1948. It is not entirely certain if this room was actually installed in the Kunstgewerbe Museum.

35 E.g. in 1891 from the Spiesshof at Heuberg 7, Basel; in 1895 from Schloss Gross-Undeldingen; in 1903 from a Haus in the Hebelstrasse, Basel.

36 Das Königliche Kunstgewerbemuseum, zu Berlin. *Festschrift zur Eröffnung des Museumsgebäudes, Berlin*, 1881, pp. 34–5. I owe a large debt of gratitude to Marcus Koehler for kindly sending me the fruits of his enquiries about period rooms and German museums.

37 Pons, 1996, p. 192, footnote 130; but see Achim Stiegel, 'Prunkstube, Spielkabinett und Ankleidezimmer', pp. 26–30, in *Vernissage*, no. 12/04, Jahrgang 134/Di 2804, 'Kunstgewerbemuseum im Schloss Kopenik'; and more recently, *Kunstgewerbemuseum im Schloss Köpenik*, ed. Angela Schönberger and Lothar Lambacher, Munich, 2004.

38 Julius Lessing, 'Aufgabe der Kunstgewerbe-Museen', *Kunstgewerbeblatt*, Neue Folge 8, 1897, pp. 81–7. In 1943 the museum installed a mirror *cabinet* from Schloss Wiesentheid, 1724–5, and in 1981 panelling from an Italian lacquer *cabinet* from Palazzo Granieri, *c.* 1740. See Pons, 1995, pp. 109–10.

39 I refer to a typescript by Gerhard Kaufmann on 'Farmhouse Rooms' for a lecture at the Altonaer Museum, 18 Jan. 1977.

40 By 1977 nineteen rooms. See Hildamarie Schwindrazheim, 'Führer durch Die Bauernstuben des Altonaer Museums', *Altonaer Museum in Hamburg Schausammlungen des Altonaer Museums*, Heft 2; and also Gerhard Kaufmann, 'Bauernstuben', *Altonaer Museum in Hamburg Norddeutsches Landesmuseum*, Jahrbuch, band 16/17, 1980. Such burgher rooms can also be found in the Kunstgewerbemuseum, Flensburg.

41 Justus Brinckmann, *Führer durch das Hamburgische Museum für Kunst und Gewerbe*, Hamburg, 1894.

42 *8 Meubelen tot 1900*, Fig. 8.

43 *Ibid.*, Fig. 11.

44 In 1916 when the new Centraal Museum was built, the period rooms were moved, but in the installation they lost their integrity. They were dismantled in 1999.

45 See *8 Meubelen tot 1900*, Fig. 25 for the 1748 rococo room from Keizersgracht 187, Amsterdam. There is also the Gemeente-museum in the Hague, by Berlage and opened in 1935. A Louis XV chimneypiece and ceiling from a house in the Hague had been shown at the museum's earlier location at the Sebastiaansdoelen. To this was added an early eighteenth-century tapestry room from Amsterdam and a Louis XVI room from Dordrecht. These rooms survive today.

46 G.V. Siedl, *Der Neubau des Bayerischen Nationalmuseums in Munchen*, Munich, 1902; and see Ingolf Bauer, *Bayerisches Jahrbuch für Volkskunde*, 1988, pp. 1–38.

47 See *Führer durch das Bernische Historische Museum. Herausgegeben von der Direktion*, Bern, 1912.

48 Designed by Gustav Gull. See Fritz Gysin, *Das Schweizerische Landesmuseum*

1898–1948. *Kunst, Handwerk und Geschichte. Festbuch zum 50. Jahrestag der Eroffnung*, Zurich, 1948; and Gysin, *Historiche Zimmer*, Bern, 1954; also André Meyer, 'Museale Architektur am Beispiel des Schweizerischen Landesmuseums in Zurich', *Festschrift Walter Drock, Beträge zur Archäologie und Denkmalpflage*, Zurich, 1977. The rooms are listed in *Führer durch das Schweizerische Landesmuseum in Zürich*, 1907.

49 It is extraordinary that these rooms are now in desuetude.

50 The number seems uncertain. According to Dr Matthias Senn, the museum's guide in 1907 counts altogether 62 'exhibition rooms', but this includes 13 'historical interiors', i.e. period rooms.

51 1894 was also the year the Historisches Museum in Bern was founded with a few period rooms accessed from 1897.

52 At the time of writing the future of these rooms is in doubt.

53 Pons, 1995, p. 322.

54 See report by Anne Forray-Carlier in *Revue du Louvre actualité des musées*, vol. 1, 1996, pp. 25–7; and *L'Estampille l'objet d'art*, June 1996. Ironic in view of the rejection of the policy by so many other museums.

55 For a general history, see Yvonne Amic, 'Débuts de l'ACAD et du Musée des Arts Décoratifs', *Cahier de l'UCAD*, 1978, no. 1, pp. 52–3; and Rossellas Pezzone, 'Controverse sur l'aménagement d'un Musée des Arts Décoratifs à Paris aux XIX siècle', *Histoire de l'art*, 1991, no.16, pp. 55–65; and Gérard Mabille, 'XVII et XVIII siècles: réflexions sur les collections du Musée des Arts Décoratifs,' *Cahier del' UCAD*, 1978, no.1, pp. 5–6.

56 Pons, 1996, p. 192.

57 See *Les Chefs-d'oeuvre du Musée des Arts Décoratifs*, Editions du vieux Paris artistique et pittoresque, Paris, 1907; but see also *Guide illustré du Musée des Arts Décoratifs, Pavillion de Marsan*, Paris, 1923, salle 38, pp. 56–7; or in 1934, *op cit.*, pp. 72–3.

58 For Hoentschel see Nicole Hoentschel et al., *Georges Hoentshel*, Saint-Rémy L'Eau, 1999.

59 In Oct., by André-Anatole Allard, inv. 15211 D–D.

60 By David David-Weill, inv. 32634.

61 Before destruction in the Second World War.

62 For a recent discussion of the history of the museum see Anthony Burton, 'British Decorative and Fine Art at the V&A before the British Galleries' in Christopher Wilk and Nick Humphrey, eds, *Creating the British Galleries at the V&A A Study in Museology*, 2004, pp. 5–17.

63 V&A acc. no. 191–1869, bought for £18. The screen was probably by John Woolf, 1756–7. Fife House was demolished in 1869.

64 V&A acc. no. 46–1886.

65 V&A acc. no. 1575.1904.

66 V&A, Department of Woodwork, *The Panelled Rooms IV, The Inlaid Room from Sizergh Castle*, 1915.

67 It is neither clear if the owner did threaten to sell it abroad, i.e. to the USA, nor is Gillows' involvement certain.

68 V&A Registry. White Allom Nominal File. I am grateful to Christopher Wilk for this reference.

69 V&A acc. no. 122–1884.

70 V&A acc. no. 6573–1890.

71 V&A acc. no. 248–1894. See also V&A, Department of Woodwork, *The Panelled Rooms I, The Bromley Room*, 1922. Bought from J. Binns, 186 Brompton Road, the panelling costing £75; the chimney piece was bought from the School Board for London for £150.

72 V&A acc. no. 2011–1899. See also V&A, Department of Woodwork, *The Panelled Rooms VI, The Waltham Abbey Room*, 1924. Bought from Thomas G. Nevill, owner of the house in Green Yard, for £375. See J. Chalky Gould, 'Carved Panels at Waltham Abbey', *Essex Review*, vol. 2, 1893, p. 118.

73 V&A acc. no. 1029–1903.

74 V&A, Department of Woodwork, *The Panelled Rooms II, The Cliffords Inn Room*, 1922. Bought through Durlacher Brothers for £606 7sh.6d.

75 V&A acc. no. W.9–1910.

76 V&A acc. no. W.4–1912. See V&A, Department of Woodwork, *The Panelled Rooms V, The Hatton Garden Room*, 1920. Exhibited in the Palace of Decorative Art, Franco-British Exhibition, 1908, by White Allom. White Allom installed another Hatton Garden room (from no. 27) in 14 Kensington Gardens, London, for J.H. Solomon. See printed document in V&A departmental files, referring to doorways in this Solomon room as coming from the committee room of the City Orthopaedic Hospital, i.e. the V&A room.

77 V&A acc. no. 881–883–1903.

78 V&A acc. no. 698–1907. This and the La Tournerie room were de-accessioned to Birmingham City Art Gallery in 1935 and were destroyed by bombing in the Second World War.

79 V&A acc. no. W.93–1924.

80 V&A acc. no. W.72–1928.

81 V&A acc. no. W.1–1929. Offered but rejected in 1908. V&A, Department of Woodwork, H. Clifford Smith, *The Haynes Grange Room*, 1935. Alas the previous early dating of this room must be revised in the light of its probable design *c.* 1610, by the amateur John Osborne.

82 V&A acc. no. P.12–1934.

83 V&A acc. no. W.43–1936.

84 V&A acc. no. W.70–1938.

85 V&A acc. no. W.60–1952. Perhaps more properly a salvage. It came from Lady Aberconway via T. Crowther, for £600.

86 V&A acc. no. W.48–1953.

87 V&A acc. No. W.3–1955, in which year also (V&A acc. no. W.5–1955) and perhaps not coincidentally, an Italian mirrored room of 1780, bought by Sir Alfred Chester Beatty from the Paris art market and installed in his Villa Arena, 104 Boulevard Cimiez, Nice, was acquired.

88 V&A acc. no. W.5–1960.

89 V&A acc. no. W.76–1975. Not properly a room, more wall furniture adapted to a set space.

90 V&A acc. no. W.11–37.

91 V&A acc. no. 758–1969.

92 V&A acc. no. W.9–1974.

93 V&A acc. no. W.13–1977.

94 V&A acc. no. W.15–1981.

95 See Wilk and Humphrey, 2004.

96 Also in store are crates of material from Amen House and from 4 Church Row, Fulham. The museum's salvage holdings are scheduled for de-accession

97 For information on the Bowes Museum salvages I am entirely indebted to the unpublished report written by Sarah Medlam in 1991: *The Bowes Museum, Barnard Castle: English Architectural Woodwork 1580–1879*. Claire Jones, Keeper of Furniture at the Bowes, very kindly had this report copied for me. See also Michael H. Kirkby, *The Bowes Museum . . . English Period Panelled Rooms of the Classical Period*, n.d.

98 In fact built in 1718.

99 Now happily reinstated.

100 The Old Mansion House had been sold in 1835 and gutted by fire in 1895. The chimney piece had been in one of Lord Gort's houses. Later, the original chimney pieces were found at Gilling, and one was reinstated in the gallery.

101 Presented by Sir Nicholas Williamson, presumably of Whitburn Hall, a house destroyed by fire in 1980.

102 Dublin, National Museum *Bulletin*, part 4, Oct. 1911.

103 It is not known if this was ever exhibited.

104 Dublin National Museum, *Bulletin*, vol. 3, part 1, Jan.–March 1913.

Chapter 8: North American Museums and the English Room

1 English yes, but remembering the Hamilton Palace rooms, the only rooms from Scotland to make the transatlantic journey.

2 Christopher Monkhouse alerted me to this fascinating catalogue.

3 He was always addressed as Ben: short for Benjamin.

4 J.S. Ingram, *The Centennial Exposition, Described and Illustrated*, Philadelphia, 1876, pp. 707–8.

5 These were far more significant than the Log Cabin New England Kitchen that is trotted out as an initiative in the making of period rooms in the U.S.

6 The best account is still Charles B. Hosmer, *Presence of the Past*, 1965, p. 213ff.; but see also Edward P. Alexander, 'Artistic and Historical Period Rooms', *Curator*, vol. VII, no. 4, 1964, pp. 263–81, and *The Colonial Revival in America*, ed. Alan Axelrod, Winterthur Museum, 1985, article by Melinda Young Frye, 'The Beginnings of the Period Room in American Museums: Charles P. Wilcomb's Colonial Kitchen, 1896, 1906, 1910', pp. 217–40.

7 Frye, 'Period Room', p. 225, Fig. 3.

8 *Ibid.*, pp. 229–30, Figs 5–6.

9 See MMA, *Catalogue of an Exhibition of American Paintings, Furniture, Silver and Other Objects of Art* by Henry Watson Kent and Florence N. Levy, New York, 1909.

10 See *American Art Journal*, May 1978, p. 11, Fig. 9. Fig. 10 shows the installation in 1924 in the new American Wing.

11 Kent to de Forest, archives MMA.

12 See Margaret Sterne, *The Passionate Eye: The Life of William R. Valentiner*, Detroit, 1980, p. 897.

13 The best account of the history of the museum is Morrison H. Heckscher, 'The Metropolitan Museum of Art: An Architectural History', *MMA Bulletin*, summer 1995.

14 For a conservative assessment see Dianne H. Pilgrim, 'Reopening of the Period Rooms at the Brooklyn Museum', *Magazine of Antiques*, Oct. 1984, pp. 875–83.

15 Hosmer, *Preservation Comes of Age*, New York, 1981, vol. 2, chapter 5, especially note 63.

16 See the excellent publication by William Voss Elder III, *Maryland Period Rooms in the Baltimore Museum of Art*, 1987.

17 For Barnard, see Young, 1977, pp. 332–9; and J.L. Shrader, 'George Grey Barnard: The Cloisters and the Abbaye', *MMA Bulletin*, vol. 37, no. 1, summer 1979; and Harold Dickson, 'The Origins of the Cloisters', *Art Quarterly*, vol. 28, no. 4, 1965, pp. 253–5; and *The Cloisters: Studies in Honor of the Fiftieth Anniversary*, ed. Elizabeth C. Parker, MMA, 1992. For further enquiries see: Philadelphia Museum of Art, George Grey Barnard Papers, series IV, The Cloisters/ Collections and Philadelphia's George Grey Barnard Centenary Exhibition 1863–1963.

18 *Catalogue . . . Deacon House . . . 1–3* Feb. 1871, by Frank A. Leonard, annotated copy in possession of the author. See also, for account of the Deacon sale, *Boston, Daily Evening Transcript*, 1 Feb. 1871.

19 Because there is no literature on Deacon, assumptions must be drawn from diverse documents in the acquisition folders in the Museum of Fine Arts, Boston, particularly newspaper cuttings relating to the auction sale.

20 This can be ascertained from a study of the auction catalogue, and from conversations with Rosalind Savile, Director of the Wallace Collection.

21 Pons, 1995, pp. 371–8.

22 Walter Muir Whitehill, *Museum of Fine Arts Boston: A Centennial History*, 2 vols, Cambridge, Mass., 1970.

23 See Neil Harris, 'The Gilded Age Revisited: Boston and the Museum Movement', *American Quarterly* 14, no. 3 (1962), pp. 544–66.

24 The facts of this are to be read in a useful booklet published by the MFA Boston: *Museum of Fine Arts, Boston, Art Spaces*, Boston, 2001.

25 Malcolm Baker and Brenda Richardson (eds), *A Grand Design: The Art of the Victoria and Albert Museum*, London, 1997, p. 43, Fig. 15, illustrate Enrico Meneghelli's oil painting of the room, without comment.

26 Mosette Broderick identified the buyer as van Ingen. Enquiries of van Ingen's granddaughter, Anne van Ingen, have failed to establish where this room is today.

27 Unpaginated advertisement.

28 Which included the three centre panels over the chimneypiece that had originated in a house in Tarporley, Cheshire, 'lost sight of since 1761', when they had been given by a Mr Allen of Tarporley to the Revd William Cole for his Gothic Garden Hermitage at Bletchley, Buckinghamshire. (Copies of correspondence in MFA archives between the Revd W.F.J.Timbrell of Coddington Rectory, Cheshire, 2 July 1920, and Mr Gill.)

29 PMA, FKP Series 16 85a correspondence, RI to RN.

30 Alas, only after de-accession in 1959 did Bruno Pons (Pons, 1995, pp. 150, 277) demonstrate that the La Muette rooms were designed by Ange-Jacques Gabriel and exquisitely carved by Jacques Verberckt, and as a suite of three were of the greatest rarity.

31 Information from Ian Gow.

32 Museum's accession files.

33 *Bulletin of the Museum of Fine Arts*, Boston, vol. 15, June 1937, p. 35. The presence of photographs of the interiors of this house in the F/K archives at the PMA (the same as at Boston) is evidence that the room had first been offered to that museum, probably in the late 1920s.

34 And apparently has not survived in the existing house.

35 Acc. no. 27.462. A year later the museum published Eben Howard Gay's personal account of Woodcote and this room as *The Chippendale Room at the Museum of Fine Arts Boston Massachusetts*, Department of Decorative Arts, 1928. See also Epilogue for a fuller account.

36 Horace Walpole, 'Visits to Country Seats', *The Walpole Society*, vol. 16, no. 31, 1928, p. 61.

37 See *Country Life*, 4 March 1916, p. 7 (advertisement) and Fig. 100.

38 See *Connoisseur*, March and April 1914 (the library and library chimneypiece, part of the Boston room, the Amigoni oval ceiling), but in particular see description of Woodcote on p. 194; May (rococo chimneypiece); June (the Cheere rococo chimneypiece and the William and Mary 'Verrio' entrance hall); and July (rococo chimneypiece) 1914. A third carved wood rococo chimneypiece was in the possession of Malletts in 1969. A further rococo chimneypiece in marble was illustrated with the Cheere one in Guy Cadogan Rothery, *English Chimney Pieces*, 1927, pls 119–20. For a general if flawed article on Woodcote, see John Harris, 'Clues to the Frenchness of Woodcote Park', *Connoisseur*, May 1961, pp. 241–5. Before Lancaster's deprivations, the library and a painted ceiling by Andien de Clermont are illustrated in John Grant, ed., *Surrey: Historical Biographical and Pictorial*, 1912.

39 For a fuller account of this room see the Epilogue.

40 Although this was more of an archaeological initiative, for the study in North American universities of archaeology was far more advanced and financially supported than that of architectural history and the decorative arts.

41 Delivered in a lecture.

42 For a recent general pictorial history of the period rooms in the museum, see *Period Rooms in the Metropolitan Museum of Art*, New York, 1996.

43 Who may well have been responsible for its composite assembly.

44 For Hoentschel I am indebted to the only intelligent account, by Bruno Pons, 1996; but see also Nicole Hoentschel et al., *Georges Hoentschel*, Saint-Rémy-en-l'Eau, 1999; and also see Gaston Brière and André Perate, *La Collection Hoentschel*, 4 vols, Paris, 1908, and Arsène Alexander, 'Georges Hoentschel et sa collection', *La Renaissance de l'art français*, 1919, pp. 83–7; and also for the displays of elements from the collection see the MMA's *Bulletins*: vol. 2, no. 6, June 1907, pp. 94–8; vol. 3, no. 7, July 1908, pp. 129–33.

45 MMA, Wing of Decorative Arts, Supplement to the *Bulletin*, March 1910, pp. 1–30.

46 Acc. no. 13.138.1. It was later moved to The Cloisters: see R. Dean, 'An Armourer's Workshop', *Bulletin of the MMA*, 10 June 1915, pp. 125–7; and James J. Rorimer, *Medieval Monuments at the Cloisters as They Were and as They Are* (rev. edn by Katherine Serrell Rorimer), New York, 1972, 'The Abbeville Woodwork', pp. 76–8. The house had been disgracefully dismantled in 1907, and this woodwork was in the collection of 'Daguerre, Paris'.

47 Acc. no. 32.53.1. Bought through Acton Surgey for the astonishing sum of $18,353.64.

48 Acc. no. 32.12. Bought from Acton Surgey for $10,904. Margaret Jourdain was a consultant.

49 However, they did present some English furniture against a background of early eighteenth-century panelling in 1913, and in 1915 the Cadwallader collection of 'Chippendale' furniture was shown in a domestic interior (*Bulletin of the MMA*, vol. 8, 1913, p. 116; and *Bulletin of the MMA*, vol. 10, 1915, p. 121.

50 Acc. no. 32.152.

51 Acc. no. 8.75.1–22.

52 Acc. no. 56.234.38. It is not clear what this means. There is no obvious house now at Olton, and in Solihull is Solihull Hall, a timber-framed fourteenth-century house.

53 Acc. no. 56.234.57.

54 Acc. no. 56.234.39.

55 Sale at Gwydir Castle by Ward Price & Co., 26 May 1921, lot 88, bought by French & Co., presumably for Hearst. I am indebted to Peter Welford of Gwydir for information, especially about lot 65, the Oak Parlour with overmantel dated 1597 that is still unlocated in the USA.

56 23 Oct. 1965, lot 337 as the 'Lord Nelson' Room, from the house of William Crowe, later the Star Hotel.

57 Vol. 35, p. 235; but see also 'The Star Room, Great Yarmouth', *Burlington Magazine*, vol. 23, May 1913, pp. 88–93.

58 It was sold at Parke-Bernet, 23 Oct. 1965, lot 337.

59 See PMA Archives, 'Things Offered'. The room was bought by Hearst, never uncrated, and eventually repatriated to Gilling Castle, Yorkshire.

60 We learn from Fiske Kimball's 'Objects Considered' (and rejected) that Adolphi Loewi offered the Studio to Philadelphia for $65,000; the shipment was due to arrive in New York on 4 April 1939.

61 See in general, James Parker, 'The French Eighteenth-Century Rooms in the Newly Re-opened Wrightsman Galleries', *Apollo*, Nov. 1977. In 1920 the J.P. Morgan gifted rue Thorigny Room, lent to the Los Angeles County Museum for a while, then de-accessioned 1953; 1922 the J.P. Morgan hôtel Gaulin suite, also de-accessioned 1953; 1942 the hôtel du Tessé Room; 1943 the Bordeaux, hôtel de Saint Marc Room; 1944 the hôtel Chappuis de Rosières room from Besançon, de-accessioned 1946; 1944 the Crillon Room; 1947 'Hôtel Montmorency Salon', de-accessioned to Cincinnati museum where identified as from hôtel de Saint-Simon Sandricourt, Paris; 1948 Madam Burat's drawing room, de-accessioned to Walters Art Gallery, Baltimore, 1957, later sold; 1949 Bordeaux, place du Théâtre Room, de-accessioned 1953; 1963 the first of the Wrightsman installations: the Paar Room and the Varengeville Room; then in 1972 the Cabris, Grasse, Room; in 1976 the Sèvres Room; and in 1987 the Louis XIV State Bedchamber.

62 The best reading is *The Cloisters: Studies in Honor of the Fiftieth Anniversary*, ed. Elizabeth C. Parker assisted by Mary B. Shepard, MMA, 1992.

63 This was a typical example of Franco –

American co-operation prior to entry into the war in 1917, similar to the American volunteers for Red Cross and ambulance work, or American pilots volunteering to fly for the Escadrille Layfayette.

64 'The Cloisters or the Passion for the Middle Ages', *ibid.*, pp. 41–8.

65 Bought in 1934.

66 Bought in 1931.

67 Bought in 1933.

68 One of the best straightforward accounts is still MMA, James J. Rorimer, *The Cloisters: The Building and the Collection of Medieval Art. In Fort Tryon Park*, New York, 1956.

69 Documentation for this acquisition is imperfect.

70 Who probably got it from Robersons.

71 Acc. no. 969.313.

72 Christie's, New York City, 17 Oct. 2003, lot 187, ill. p. 141.

73 In the course of time the museum would display three 'Colonial' rooms: a Rhode Island Room from the William Russell House, purchased 1923; a Connecticut Room from Foxon, purchased 1926, and a Charleston drawing room from the Colonel John Stuart House, purchased 1931.

74 An uncertain 'Stanwick' room became the drawing room at Clayton, Roslyn, Long Island, now the Nassau Museum of Art, an Ogden Codman house built in 1900 and bought by Childs Frick in 1919. It was supplied by Robersons to Mrs Frick when the house was substantially remodelled by Sir Charles Allom. This room is not in the 1740s style of the rooms at Toronto and Minneapolis, but rather of an earlier generation, and is close to the style of Colen Campbell in late 1720s. Campbell worked in the vicinity of Stanwick. Another Stanwick room is reported as being in a private office in New York.

75 Robersons' 'Pine Entrance Doorway From Hanover Square', 25 May 1931. Obviously originally painted, but as Roberson wrote, 'The paint has been carefully removed and the whole door and surround has been waxed to a beautiful honey colour'. This doorway cost $2,700, an astonishing sum even then for a single doorway.

76 Their departmental files.

77 The museum possesses Carlhian's model.

78 According to a letter from Edwin Barber to Henry Kent at the Metropolitan, 19 July 1916, quoted by Hosmer, 1965, p. 338, note 174.

79 Acc. no. 1922-8-1.

80 For the architectural and installation history of the museum see David B. Brownlee, *Making a Modern Classic: The Architecture of the Philadelphia Museum of Art*, Philadelphia, 1997.

81 To whom Osborne offered two other rooms, of oak, and 'from a house built for James I'.

82 Horace F. Jayne, *Pennsylvania Museum of Art Bulletin*, no. 71, May 1922, p. 9.

83 And this may well be related to the enquiry about 'panelling'.

84 *PMA Bulletin*, vol. 23, no. 116, Nov. 1927, p. 3, quoted by Kimball in 1927 after becoming director.

85 Information from Donna Corbin.

86 Fiske Kimball, 'The Museum of the Future', *Creative Art*, vol. 4, no. 4, April 1929, pp. xxxvii–xlii; but also see Kimball, 'The Modern Museum of Art', *Architectural Record*, vol. 66, Dec. 1929, pp. 563–5.

87 This was purchased in 1928, but not installed until 1957.

88 In general, for this PMA account I have found useful the report by a group of students of the Department of Historic Preservation Graduate School of Fine Arts, University of Pennsylvania, *The Period Room as Museum Artifact: Three Approaches and Ten Case Studies on the Curatorial Management of Architecture* n.d.

89 Acc. no. 1926-78-1. Kimball had been enquiring from Roberson from Dec. 1926.

90 Roberson supplied a room from New Place to the Edsel and Eleanor Ford House, Grosse Point, Michigan, between 1926 and 1927. His brochure of measured drawings is in the Ford House archives. Although this room could have been a secondary one in New Place, it is a measure of the height of the rooms.

91 This writer still believes there is confusion on Robersons' part between the Treaty House Room from Uxbridge, and this one from Upminster, for the Treaty House Room had been offered to Philadelphia before 1930. See Kimball and Roberson correspondence, 9–13 July 1929, Box 15, Folder 9, Series I, General Correspondence, Fiske Kimball Records, PMA Archives. Historians in Essex are puzzled as to the use of this name.

92 Richardson to Kimball, 9 June 1926, Box 169, Folder 15; Sub-subseries 2, Rooms and other architectural elements; Sub-series C, European decorative arts: Series VII, Objects and related topics, Fiske Kimball Records, PMA Archives.

93 Newton to Kimball, 8 March 1930, Box 169, Folder 15: Sub-series 2, Rooms and other architectural elements: Sub-series C. European decorative arts: Series VII.

Objects and related topic: Fiske Kimball Records, PMA Archives.

94 This is the opinion of Nancy Briggs, late Head Archivist at the Essex Record Office, whose study of the house implies that the room heights did not equate with those at Philadelphia.

95 Sutton Scarsdale I, acc. no. 1928–61–1; Sutton Scarsdale II, acc. no. 1928–61–2; Sutton Scarsdale III, acc. no. 1928–61–3. A fourth Sutton Scarsdale room was sold by Roberson to Hearst; then sold in 1941 to Michael Leises for Paramount Studios, and given to the Huntington Museum and Art Gallery in 1954. As Andor Gomme observes, the chimneypiece could not be by the architect of Sutton Scarsdale. The room is in store, but see Fig. 215 for the chimneypiece.

96 I am much indebted to Donna Corbin's valuable observations on this matter of the Sutton Scarsdale rooms and the invention of pedestals.

97 Acc. no. 1928–62–1. Examination of Wrightington Hall fails to locate where this room might have been. Did it exist one wonders?

98 HD.

99 Donna Corbin is the first to observe the provision of high bases to heighten a column.

100 Corbin's observation, re. Sutton Scarsdale is this: 'Let me restate what I think. Based on CL photographs "some" of the panelling in SSI including the pilasters came from Sutton Scarsdale. I am fairly certain I know which room in SS the panelling came from. Additional panelling was definitely added by Roberson to enlarge the room since our room is larger than the room I have identified at Sutton Scarsdale. Roberson also added the overmantel carved decoration and in fact had to widen the panel over the fireplace to accompany the carving. I think it likely that nothing of SSII and SSIII came from the house.'

101 Acc. no. 1929–78–1.

102 Acc. no. 1951–117–1.

103 Although this is a fairly early purchase of an English room by an American family.

104 Acc. no. 1931–104–1.

105 See Fig. 156.

106 The installation is commemorated by Kimball in 'Lansdowne House Redivius', *PMA Bulletin*, vol. 39, no. 199, Nov. 1943.

107 This was most recently demonstrated by Eileen Harris in *The Genius of Robert Adam: His Interiors*, 2001, pp. 125–6.

108 See the commemoration of this in 'Drawing Room from Lansdowne House', *PMA Bulletin*, vol. 82, summer 1986, pp. 351–2.

109 Acc. no. 1928–52–1. The history of the château from its occupation by the American adventurer Daniel Parker in 1803 to today is well documented on the internet under Château de Draveil.

110 Although it may have been extracted from the château when the estate was divided up in 1910.

111 As observed to me by Donna Corbin of the PMA, Carlhian attempted to negotiate the acquisition of the existing ceiling in 1936. Corbin writes, 'In 1936 when we were finally in the process of installing the room Kimball wrote to Seligmann, "Learning that the plaster cornice and ceiling ornaments were still in place, I asked André Carlhian to get them for us, and this he is doing" '.

112 See Pons, 1995, 'Hotels Le Tellier', pp. 380–87 and 392–4.

113 Acc. no. 1939–41–62.

114 Pons, 1995, pp. 104–6.

115 Acc. no. panels and doors, 1929–115–1a & 1b; and panels and pilasters acc. no. 1953–37–1–11.

116 As indeed was confirmed by Gillian Wilson when at the Getty Museum, who never could lay her hands on a fine room of this period.

117 A full listing of the files from the era of PMA history may be accessed online in the Fiske Kimball Records's finding aid (http://www.philamuseum.org/resources/arch ives/findingaids/ead.asp?c=FKR).

118 It is worth listing, if only for interest, the French offerings. From Paris: Hôtel Colbert de Villacerf, ex Carlhian, 1931; Hôtel de Amelot de Bisseuil, 47 rue Vieux de Temple; Hôtel de Botterel Quintin, 44 rue des Petites-Ecuries; Hôtel de Pomponne, rue des Petits Champs; Hôtel de Vigny, a ceiling; and Hôtel Herlant, Carlhian 24 May 1932. Elsewhere: Rouen, late Louis XIV room; Chevreuse, Prieure de St Saturnin; Mesières, a façade of 1798; Mordelles, Chateau d'Artois, chimneypiece, 1937; La Flèche, Chateau de Courcelles; Grasse, Hôtel de Cabris (dealer Hodgkins had set of paneling *c.* 1910); St Malo, Hôtel Marion-du-Fresne, Louis XIV room offered by Seligman, June 1930; Chateau Thierry, small 13th century chapel; Chateau de Montal, doorway dated 1534, ex coll. Edmond Foule, 1881; Régence room *c.* 1708, offered by Dreyfus, 1927.

119 Box 198, Folder 12: Sub-series 2. Rooms and other architectural elements: Subseries C. European decorative arts: Series VII. Objects and other related topics: Fiske

Kimball Records, PMA Archives.

120 Box 201, Folder 9 and Box 1001, Folder 3 and all following box references *ibid*.

121 Box 166, Folder 25.

122 Box 101, Folder 2.

123 Box 208, Folders 1 and 2.

124 Box 201, Folder 7.

125 *Ibid*.

126 Box 166, Folders 20–22.

127 Acccording to annotations by Fiske Kimball on the back of the photograph.

128 Box 202, Folder 4.

129 Box 198, Folder 8.

130 Box 198, Folder 1 and Box 1001, Folder 2.

131 Box 201, Folder 2.

132 Box 1001, Folder 2.

133 Box 201, Folder 3 and Box 208, Folder 1.

134 Box 198, Folder 2.

135 Box 201, Folder 4.

136 Box 201, Folders 5 and 6.

137 Box 198, Folder 4.

138 Box 198, Folder 5.

139 Box 198, Folder 6.

140 Box 198, Folder 12.

141 *Ibid*.

142 Box 1001, Folder 2.

143 Box 198, Folder and Box 208, Folder 1.

144 Box 198, Folder 1 and Box 1001, Folder 2 – except for Mildmay House.

145 Box 169, Folder 10 and Box 1001, Folder 4.

146 Box 198, Folder 10.

147 *Ibid*.

148 *Ibid*.

149 *Ibid*.

150 *Ibid*.

151 *Ibid*.

152 Box 198, Folder 7.

153 Box 169, Folder 5.

154 Box 201, Folder 8.

155 Box 198, Folder 11.

156 Box 169, Folder 13.

157 Box 201, Folder 10.

158 Box 198, Folder 13.

159 It could hardly be believed that the Blackstone Hall Collection was smashed up in 1949–50, and the Blackstone Hall floored over in 1956; but then this vandalism was commonplace in American museums, namely the dispersal of the cast collections of the Metropolitan Museum of Art.

160 See Barbara Wriston, 'The Howard Van Doren Shaw Memorial Collection', *Museum Studies*, vol. 4, 1969, pp. 87–95; Bessie Bennett, 'The Howard Van Doren Shaw Gallery of Architecture', *Bulletin of the Art Institute of Architecture*, vol. 28, no. 1, Jan. 1934, pp. 2–5; and Pauline Saliga, 'Plaster Casts, Period Rooms, and Architectural Fragments: A Century of Representing Architecture at the Art Institute of Chicago', *Fragments of Chicago's Past*, 1990, pp. 52–67; and also Art Institute of Chicago, *English Doorways and Architectural Woodwork of the Eighteenth Century*, Chicago, 1940. For a general history see *One Hundred Years of the Art Institute: A Centennial Celebration*, Art Institute of Chicago, Museum Studies, vol. 19, no. 1, 1993.

161 The Kent association may well be credible, but as this development was the Duke of Argyle's, Roger Morris, who was the architect of other houses on Lord Burlington's development around Burlington Gardens, is a more likely architect.

162 It was sold in 1955 to the Spencer Chemical Company for their Dwight Building in Kansas City. Alas, at the time of writing this building has been converted into apartments, and the fate of the room is unknown.

163 This author has seen no photograph of this.

164 Its notoriety is discussed by John Harris, 'What Might be Called a Frame-up: The Hogarth House', *British Art Journal*, vol. 1, no. 2, spring 2000, pp. 19–21.

165 It was a pity the West Harling salvage was parted from the portrait of Sir Andrew Fountaine in the overmantel, as it is possible that Fountaine himself designed the whole! Unfortunately, the buyer of lot 392 at Sotheby's presumed the overmantel to be a modern design, and got rid of it.

166 See the 'Check-list of British Rooms and Salvages'. The room from 58 Artillery Lane has been repatriated to the Spitalfields Trust; the Regency shop façade from Faversham has been given to the Faversham Society, although at the time of writing the Indian owners of the shop did not want it put back!

167 Now on display in the new gallery of 1989 with 68 rooms from 1600 to 1940.

168 There is no evidence, as suggested by Allen Wardell, 'English Decorative Arts at the Art Institute of Chicago', *Antiques Magazine*, vol. 89, 1 Jan. 1966, p. 79, that the Ward Rooms were surrogates for the lack of period rooms in the Art Institute.

169 *Bulletin*, vol. 15, no. 1, Jan. 1930; no. 2, April 1930; and vol. 16, Oct. 1931, devoted to the American rooms.

170 *Bulletin*, Jan. 1930, p. 2.

171 See Roberson, Appendix 1, below.

172 The existence of four Spettisbury rooms is proof that Roberson gutted this distinguished house, probably designed by one of the architectural family of the

Bastards of Blandford.

173 Acc. no. 188: 1928.

174 Acc. no. 181: 1928.

175 Acc. no. 182: 1928.

176 Acc. no. 42: 1929. Among the Roberson documents is an invoice dated 5 Oct. 1929, referring to a set of Addington Palace [Park, Surrey] antique Chinese wallpapers, a 75-foot run.

177 Departmental archives, Account no. 103F, Acc. no. 23: 1929.

178 Information from MIA files.

179 If it came from Charlton near Greenwich, it was not the famous Jacobean house, but maybe a large house of the 1740s that stood opposite in the village.

180 John Harris, 'English Rooms in American Collections', *Country Life*, 8 June 1961, p. 1329, Fig. 8.

181 When the rooms had been dismantled.

182 See John Harris in *Country Life*, 13 Oct. 1988; but see more recently, his 'A Cautionary Tale of Two "Period" Rooms', *Apollo*, July 1995.

183 'Four' one might fairly question?

184 When the museum de-accessioned the room and the chimneypiece was sold, the then curator seems not to have consulted the departmental files, where could be found a letter from Hugh Honour referring to correspondence between C.H. Tatham and Henry Holland, June 1795, about chimneypieces ordered in Rome by the Duke of Gloucester for the Prince of Wales. These had been designed by Hatfield and sculpted by John Deare. The Kempshott chimneypiece was one of these.

185 Whether Roberson's 'man', Mr Fred Olsen, ever came to St Louis is uncertain. According to Roberson, Olsen was to be in Pittsburgh in 1928 visiting Mr Benno Janssen, 'the well known Pittsburgh architect, where he has to take charge of the erection of six rooms'. In fact, this was Elm Court, Butler, Pennsylvania, where Mr Koch lives.

186 Except for the 25 wallpaper panels and pilasters.

187 Now in Elm Court, Butler, Pennsylvania.

188 Now in Mrs Barbara Piasecka Johnson's collection. One wonders who advised this purchaser of the famous Badminton Cabinet to buy this concoction of old woodwork.

189 Museum departmental file: Hôtel Nicolai.

190 Museum departmental file: King's Lynn Room.

191 This is fully discussed by N. Kuzmanovic, 'Research on the Panelling from the Tudor Period in the Nelson Art Gallery', 1976 (typescript in departmental files).

192 Museum departmental file: Exeter Room.

193 Museum departmental file: Piedmontese Room. I am grateful to Catherine Futter who has led research on this room, and for her kindness in discussing the museum's salvages with me.

194 I was informed by a past curator, Christina Nelson, that she would be publishing this room. She refused to share her discoveries with me, especially the rumour that there is a painting in French collections showing this room. The room is of Louis XIV date.

195 In museum archives.

196 23–28 April and 1–7 May 1900, lot 1221.

197 Catherine Futter tells me that Adolphi Loewi was the grandson of Lehmann Bernheimer.

198 Bought from French & Co., and before that from the Hearst Collection. It is of considerable Bristol interest. See the intern report by Karen Zukowski, 'A 17th Century Stone Chimneypiece in the Collection of the Cincinnati Art Museum', May 1985, in departmental files.

199 In departmental files: Grosvenor Square.

200 G. L. C., *Survey of London*, vol. 40, part 2, 1980, pp. 144–5. A second room is in a Michigan family collection.

201 All to be found in departmental files. The museum was not aware of the second Aberdeen room in a private Michigan collection.

202 G. L. C., *Survey of London*, 1980, pp. 50–51.

203 Acc. no. 1957.486. See Whitney Nicole Huber, 'The Cincinnati Art Museum French Cabinet', MA thesis, June 1991.

204 American Art Association auction, New York, 26 Nov. 1907.

205 Acc. no. 1955.796.

206 Pons, 1995, pp. 284–90.

207 Acc. no. 1945.73.

208 Departmental files.

209 This is presumed.

210 In an earlier letter of 18 July 1949.

211 He writes that it then had one overmantel, one carved mirror, two window trims, two pairs of double doors with pilaster doorcases and overdoors, two large panels and four pilaster panels.

212 In the accession file is a letter from French & Co., dated 21 Dec. 1945, re. disputed provenance.

213 Called the Hôtel St James Room. Sold 2002.

214 See Carlton Hobbs, cat. no. 5, London, n.d., No. 7 library and salon from hôtel Gaulin.

215 Information from Lee Miller of the museum.

216 Acc. no. 51.21.

217 Acc. no. 59.23. Known as the 'Crillon' room, in fact Otto Kahn's dining room in New York. It was ill that Mr Howe allowed this fine room to be manipulated.

218 Acc. no. 54.143.

219 Acc. no. 1981.65.1–360.

220 The copy in the V&A (L. 2031) was accessed 12 Dec. 1923.

221 The extensive correspondence is in the Duveen archive at the Getty Center for the Humanities, Los Angeles.

222 Duveen document 960015.

223 In fact elements may have come from a house in or near Sudbury in Suffolk.

224 Probably an antique dealer, born in Cardiff, died 1957.

225 Report, *The Friends of the Huntington Library*, vol. 3, no. 1, 1 June 1944.

226 The opinion of Dr Andor Gomme, the Sutton Scarsdale scholar.

227 Two French *boiseries* from a hôtel on the place Vendôme gifted by Henry Ford II in 1958 have not been installed.

228 No doubt with substantial tax benefits.

229 Acc. no. 58.240.

230 See John O'Connell and Rolf Loeber, 'Eyrecourt Castle, Co. Galway', *Irish Arts Review*, Yearbook, 1988, pp. 40–48; see also Brian Gallagher (to whom this author is greatly in debt), 'William Randolph Hearst and the Detroit Institute of Arts', *Bulletin of the DIA*, vol. 76, no. 2, 2004.

231 Acc. no. 58.241.

232 HD, vol. 88.

233 Acc. no. 58.242.

234 DIA files, Hearst re. Voucher H–10–11–1934.

235 DIA copies of Hearst inventory files.

236 Acc. no. 1984.86.

237 Simon Guggenheim Memorial Collection (E–906).

238 21 Aug. 1915, pp. 267 and 269.

239 Margaret Jourdain in *English Decorative Plasterwork of the Renaissance*, 1926, illustrates this ceiling as Fig. 153 with permission of Trollope & Colls, and starts the hare (on p. 165) that it was acquired by the MMA.

240 See James Albro, *Antique Architectural Elements from the William Randolph Hearst Collection*, New York, pp. 38–9, as lot 1381–90; the companion to the bedroom, 1381–88–89. According to HD, vol. 90, the rooms seem to have been bought from White Allom on 15 May 1924. one for $11,305, the other for $22,000, the latter presumably the bedroom sold to an A.M. Adler.

241 *Country Life*, 30 July 1904, pp. 162–6.

242 Neale, *Views*, vol. 3, second series, 1826.

243 The same as reproduced in *Devon Notes and Queries*, vol. 3, Jan. 1904–Oct. 1905, pp. 41–4.

244 And not surprisingly the room appears in the second volume of Charles Lathom, *In English Homes*, London, 1907, pp. 189–93, edited by H. Avray Tipping who wrote the *Country Life* article.

245 *Devon Notes and Queries*, vol. 3. Mention is also made of a small door in the north-west corner leading to a wainscoted drawing room with a similar ceiling to that in the great room.

246 PMA archives, 'Objects Considered'. Box 198, Folder and Box 208, Folder 1.

247 The Roberson cover is accompanied by a plan of the room, whose measurements (18 feet 10 inches wide) agree with the room at Louisville, but Roberson's length of 30 feet and 6 inches differs slightly.

248 I am indebted also to Amy Stewart's docent handout, *The English Renaissance Room*. It is surely significant that the room should be featured in the *Connoisseur*, July 1945, pp. 43–8 in an article by a member of the museum's staff: 'Elizabethan Wood Carving in the American Museum'.

249 I have relied upon Judith A. Barter, 'The Rotherwas Room', in *Mead Museum Monographs*, vol. 3, winter 1981–2.

250 This house is convincingly attributed to Gibbs on basis of style and Bodenham's subscription to Gibbs's *Book of Architecture*, 1728.

251 Thomas Blount, MS unpublished history of Herefordshire. Hereford Public Library.

252 Cuttings in museum accession file.

253 *Town and Country Magazine*, 26 April 1913, pp. 52ff.

254 Copies in National Monuments Record, Swindon, BB47/10342.

255 The Hearst docket (HD, vol. 90, 01 and 02) is proof that he only bought the 'Pritchard' Julius Caesar room. The room must have been photographed *in situ* as the ceiling is far too complicated to have been removed to the USA.

256 Now the Webb Naval Institute.

257 Acc. no. 1945.493.

258 See photos by John Callahan of Amherst College, National Buildings Record, BB57/10343.

259 Archives, Rhode Island School of Design. I am grateful to Tom Michie, then of the museum, who provided me with information.

260 Although the house was basically a late seventeenth-century brick one. Photographs before demolition are in the possession of

the author.

261 The information about these two rooms is due to Brian Mitchell's enquiries.

262 *Country Life*, 18 Dec. 1915, plate 6.

263 It is possible that this reference refers to the dispersal of rooms by Robersons, then on the verge of bankruptcy.

264 *Survey of London*, vol. 32, pp. 390–429.

265 Colin Campbell, *Vitruvius Britannicus*, vol. 2, London, 1717, pl. 88.

266 Roberson, *Historical Rooms*, vol. 3, p. 29–30, pl. 12.

267 Linda Merrill, *The Peacock Room: A Cultural Biography*, New Haven and London, 1999.

Chapter 9: Into American Houses Go English Rooms

1 Of course, except for Bruno Pons's studies of French salvages *outré mer*.

2 Edward M. Riley, *Starting America: The Story of Independence Hall*, Philadelphia, 1990. Alas, we do not know to where. See also Elizabeth Stillinger, *The Antiquers*, New York, 1980.

3 Hosmer, *Presence of the Past*, particularly chapter 9, 'Antiquaries, Architects and Museum Directors', and pp. 212–15; see also Josephine P. Driver, 'Ben: Perley Poore of Indian Hill', *Essex Institute Historical Collections*, vol. 89, Jan. 1953, pp. 10–12.

4 When? This is not made clear in the modern literature. See W.S. Appleton's 'Report' in *Old Time New England*, vol. 29, April 1939, p. 144; and Driver, 'Ben: Perley Poore of Indian Hill', pp. 10–12.

5 See chapter 3.

6 April 1, 1876, p. 109.

7 Pauline Metcalfe, ed., *Ogden Codman and the Decoration of Houses*, Boston, 1988, p. 63, note 11.

8 It cannot be dissociated from Ben: Perley Poore's pioneering interest in native colonial architecture and furniture which was paralleled by William E. Barry, *Pen Sketches of Old Houses*, Boston, 1874, and Arthur Little's *Early New England Interiors Sketched in Salem, Marblehead, Portsmouth and Kittery*, Boston, 1878, this latter the first publication on colonial buildings by a trained architect.

9 See chapter 8, 'North American Museums and the English Room', above.

10 See Philip A. Haydon, *Henry Davis Sleeper and Beauport: A Chronology*, pamphlet, Boston, n.d.

11 Who in fact accompanied Sleeper when he first visited the Cogswell house.

12 See Morris Carter, *Isabella Stewart Gardner*

and Fenway Court, London, 1926.

13 See Martha Frick Symington Sanger, *The Henry Clay Frick Houses*, New York, 2001, p. 198.

14 That in the breakfast room (Sanger, 2001, p. 202) appears to be a variant companion, but not a copy, of the chimneypiece in the ROM Toronto, but what is puzzling is that the ROM one is identical to the chimneypiece in the dining room (*ibid.*, pp. 246–7) of the Childs Frick house at Clayton (now the Nassau Museum of Art), also decorated by Allom and probably installed about 1924, and identical also to a chimneypiece in Hursley Park, Hampshire (see chapter 5), also an Allom job (with Duveen) for Sir George Cooper from 1905, as well as the chimneypiece in the dining room of the Ca'd'Zan mansion of John and Mable Ringling at Sarasota. Hursley may have the priority, for Allom must have liked this model. According to a reference in the Frick archives from an invoice of 1914, 'mantels [were] carved according to plaster models'.

15 The house built for Jervoise Clarke by Charles Cameron 1770–74, the chimneypieces by Thomas Carter. However, as Allom seems to have copied one of the Hanover Square chimneypieces as a much-used model, the Frick one may be a copy and not the original.

16 It would not be exaggerating to suggest that a thousand unidentified European chimneypieces entered the USA in the years between 1910 and 1939.

17 E.g. in the *Connoisseur*.

18 See Victoria Kästner's superlative *Hearst Castle, Biography of a Country House*, New York, 2000.

19 Now considered a period room in a museum.

20 T.R. Way and G.R. Dennis, *The Art of James McNeill Whistler: An Appreciation*, London, 1903, p. 101.

21 See Merrill, 1998.

22 See Michel C. Kathryns, *American Splendor: The Residential Architecture of Horace Trumbauer*, New York, 2002.

23 Pauline Metcalfe, ed., *Ogden Codman*, pl. 23 and text pp. 136–8; but for Gay in context, see William Rieder, *A Charmed Couple: The Art and Life of Walter and Matilda Gay*, New York, 2000, pp. 143–4 and p. 145.

24 George William Sheldon, *Artistic Houses*, vol. 1, New York, 1883–4.

25 By the French architect Henri Déglane.

26 Clark bequeathed the room to the MMA in 1925. The museum passed it on to the

Corcoran Gallery of Art, Washington, DC. See Dare Myers Hartwell, *The Salon Doré*, Corcoran Gallery, Washington, n.d.; and especially Pons, 1995, who discusses at length the fascinating history of the painted ceiling décors by Taraval. The ceiling in Washington came from the Orsay *hôtel*, but was not that of the *salon*. Senator Clark required the enlargement of the room by two trophy sections.

27 But it is not entirely certain that all of the interior fitments were modern Allom.

28 See chapter 5, p. 88. But see also 231 Madison Avenue, the Phelps Stoyes house, now part of the Morgan Library, having been purchased for J.P. Morgan Jnr. in late 1904. The interior is clearly a Sir Charles Allom job in the English style, maybe earlier that the Frick house.

29 She was Eleanor Elkins, married to George D. Widener, a casualty of the *Titanic* disaster.

30 Now in the National Gallery of Art, Washington. It had been taken out of the château between 1901 and 1906 (Pons, 1995).

31 Willed to the PMA by Mrs Hamilton Rice at her death in 1937, when Fiske Kimball carefully and authentically installed it and it formed a happy union with the 1780s hôtel Le Tellier room from 13 rue Royale, Paris, also a Hamilton Rice gift.

32 Mrs Hamiton Rice was a perfect client for Trumbaeur who rose to her exquisite taste.

33 And eventually sold Parke-Bernet Galleries, 22–23 Oct. 1965, lot 338.

34 'Texas Two Step in a Grand Salon from France', *New York Times*, 10 July 1997.

35 Kathryns, 2002, pp. 259–63.

36 Ibid., pp. 265–70.

37 All now in the Pennsylvania Museum of Art.

38 Kathryns, 2002, p. 30, bottom; but see also the sale brochure by Louis Traiman of Philadelphia, *'Garden House' Formerly the Home of the Late Horace Trumbauer Internationally Known Architect 2246 N.52nd Street, Wynnefield, October 16, 1940*. I'm grateful to Richard Marchant the custodian of Trumbauer's photo archive.

39 See chapter 6 on the transatlantic trade.

40 The Small Oak Room. Bequeathed to the MMA (1984.28. 74), de-accessioned and sold Sotheby's, New York. The provenance of this was not evident to Untermyer. In fact, it may well have come from Weston House, Warwickshire, built 1588–9, where in the 17th century J. Sheldon established the first tapestry works in England. Weston was the main seat of the family, who moved

to Brailes when they built their smaller house in 1822, presumably removing this Sheldon chimneypiece. See Tyack, 1994, pp. 216–19, 232.

41 MIA archives; see below: Appendix 1, 'Charles Roberson of the Knightsbridge Halls'.

42 See *American Architect*, 5 Feb. 1919, pp. 191–200 and *Architectural Record*, Dec. 1918, pp. 483–500.

43 It is unclear if what Roberson supplied to Hearst in this list was for his several houses, or simply to be stored in Hearst's Bronx warehouse.

44 In Appendix 1, 'Charles Robersons of the Knightsbridge Halls'.

45 To whom I am much indebted for his kindness in sending me information on Roberson and his family patronage.

46 One of two known rooms from Lord Aberdeen's, see *Survey of London*, vol. 40, part 2, 1980, pp. 144–5. Possibly removed from no. 27 (formerly no. 24), in 1912–14. See Cincinnati Art Museum, chapter 8.

47 A characteristic inventive dealer's description of the time. 'Early Adam' in any case does not fit in with 'Flaxman'. Roberson removed many rooms from Wingerworth Hall, Derbyshire, one now in the collection of Joe Minton, Dallas, Texas.

48 Mary Kremposk, 'Restoring the Carpenter's Craft', *CAM Magazine*, vol. 25, no. 6, June 2004.

49 See Katherine Tweed, ed., *The Finest Rooms by America's Greatest Decorator*, New York, 1964, p. 90.

50 Stephen M. Salney, *The Country Houses of David Adler*, New York, 2001, pp. 63–71.

51 Also now de-accessioned.

52 It would appear that these were irrevocably damaged in the process of removal.

53 I am grateful to Josephine Shea for sending me a xerox of the demolition sale advertisement in a newspaper dated 12 Sept. 1925: 'Demolition Sale to Architects, Builders, Demolition Contractors and Others', auction early in Oct. See also James A. Bridenstine, *Edsel & Eleanor Ford House*, Grosse Pointe Shores, 1988.

54 The panelling is now in store at the Legion of Honor Museum, San Francisco.

55 Archives Edsel & Eleanor Ford House, thanks again to curator Josephine Shea. The height of the rooms on Roberson's measured drawings is surely proof that Roberson provided the necessary extra height, putting the order on high pedestals when adapting the Upminster New Place room for the galleries of the PMA.

56 See John Cornforth, 'Deene Park,

Northamptonshire – III', *Country Life*, 25 March 1976, Fig. 2.

57 There is doubt as the room is not in the style of the other Stanwick rooms, i.e. as at the MIA and ROM Toronto.

58 See Sanger, 2001, chapter 4, 'The Clayton Estate', pp. 218–78.

59 The original one, probably from 15 Hanover Square, London, demolished in 1904, defeats identification and location.

60 *Country Life in America* (New York), vol. 72, Aug. 1937, pp. 34–41.

61 *Country Life in America* (New York), vol. 62, Oct. 1932, pp. 49–51.

62 The house has not been identified *in situ*. See *Country Life in America* (New York), vol. 54, 1928, pp. 54–5; and also Mackay 1997, *Long Island Country Houses and Their Architects, 1860–1940*, under George B. de B Gersdorff.

63 See *New York Architect*, vol. 2, no. 4, April 1908, pp. 232–7.

64 See chapter 6, note 71.

65 Anne of Cleves lived at Chelsea Manor House, and no. 19–26 Cheyne Walk are on the site, so the overmantel might have come from one of these houses. It can be seen in Donald Miller, *The Architecture of Benno Janssen*, Pittsburgh, 1997, pp. 116–27.

66 Arthur S. Vernay, *Catalogue*, Spring exhibition, April 1935, plate p. 30.

67 To attempt to discuss so many would be tiresome. For example, Hillwood, the house built for Marjorie Merriweather Post in Washington (now Hillwood Museum and Garden) and decorated by French & Co. in the 1920s, is typical, a wishy-washy decorator's compendium in which may be found one or two composite rococo/Palladian rooms made up from Kirkby Mallory Hall, Leicestershire. Of quite different matter is a recently discovered house outside Philadelphia in Chestnut Hill, once called Lane's End, the estate of Samual Roton, then the Wharton Sinkler House, then the University of Pennsylvania, and today the McGeary Snider House. The architect was Robert R. McGoodwin, building from 1924. One model was Sutton Place, Guildford, and few houses in the US are such a convincing amalgam of English salvages: a seventeenth-century room from Bolingbroke House, Attersea; one of the 1750s from Felling in Durham; a Tudor chimney piece and late fourteenth-century carved wood coving of a ceiling from the Tudor wing of Cassiobury Park, Watford. The porch is made up from a frontispiece from Old Parham Hall, Suffolk, with an ancient door from

Muchelny Priory, Somerset. Lead water heads are dated 1589; stone floor slabs come from Warwick Priory; a complete Tudor cottage comes from Guildford, thus once the name of this house.

68 I owe much to Peter Lang of Sotheby's for locating sold salvages. I was particularly pleased with the elaboration of the location of a Spettisbury, Dorset room in what is now The Maisonette at 660, Park Lane, New York, given to me by Chris Jussel. Mr and Mrs Leslie Samuel consigned the contents of 660 to Sotheby's, but the sale on 2–3 Oct. 1981 was cancelled because Imelda Marcos bought the lot pre-sale. According to the estate description at the back of the catalogue, 'Beyond the entrance foyer, the main living space boasts a magnificent pine drawing room, imported from Spettisbury Manor in the west of England and installed here to exact proportion – spanning fifty feet with double height ceiling and expansive floor to ceiling windows. This splendid room bespeaking the classic dignity of 17th century English domestic architecture [in fact *c.* 1740s!] with finely carved panelling, elaborate cornice, Corinthian pilasters and ornamented chimney breast, is widely acclaimed [as] one of the finest 17th century pine rooms ever brought to this country'. This is almost certainly a Hearst room (see Fig. 216).

69 In the 1960s I saw this room illustrated in an American sporting magazine, forgot to make a note, and its location has been lost ever since.

70 Edited by Anne Bigelow Stern, Mount Vernon, New York, 1978, based on a catalogue compiled by Colin Streeter.

71 One of the most intelligent and percipient accounts of Winterthur and Colonial Williamsburg is by Charles B. Hosmer Jr, in *Preservation Comes of Age*, vol. 2, in particular pp. 898–906 (for Williamsburg) and pp. 912–26 (for Henry Francis du Pont).

72 Francis H. Lenygon was a consultant at this time, but was probably a supplier of furnishings, or an intermediary for such acquisitions. It is interesting that in the 1920s many appropriate rooms and panelling were available, of the sort that Lord Botetort would have recognized. The Lenygon Architectural Fragments Collection given to the Williamsburg Foundation by Jeanette Lenygon is a disputatious accession and is, in fact, a typical trade collection of the sort made by Carlhian in Paris or Acton Surgey in London; the latter, offered to the PMA in

1927, comprised 'more than 700 gothic wood fragments collected by F. Surgey and G.M. Adams on their travels through England'.

73 At this time the definitive history of its growth was *The Winterthur Story*, 1965, excerpts from the *Winterthur Portfolio 1*, 1964, and in particular there Jonathan L. Fairbanks's 'The Architectural Development of Winterthur House'.

74 Even if it was a rather extended one!

75 For Waterman see particularly Fay Campbell Kaynor, 'Thomas Tileston Waterman: Student of American Colonial Architecture', *Winterthur Portfolio*, vol. 20, nos 2–3, 1985, a very telling article on the changes that Waterman found necessary in order to install Du Pont's salvages in his interiors. For a personal view of Winterthur, see. T.T. Waterman, 'Pilgrimage to Winterthur and Hunting Hill', in *Walpole Society Notebook*, 1948, Portland, Maine, 1949.

76 See Graham Hood, *The Governor's Palace in Williamsburg: A Cultural Study*, Colonial Williamsburg, 1991.

77 As the late Giles Worsley will explained, Hawks was working for Stiff Leadbetter at Fulham Palace in 1764–5. Governor Tryon is described as from Norbury Park, Surrey, the house in the valley there, rather than that built on top of the hill in 1774. He must surely have employed Leadbetter in some capacity.

78 See Blackwell P. Robinson, *Three Decades of Devotion: The Story of the Tryon Palace Commission and Tryon Palace Restoration*, New Bern, 1978. This gives a full account of the discovery of Hawks's papers and existing drawings. Unfortunately, at the time of restoration a memorandum by John Hawks attached to a survey of the gardens, and dated 12 July 1783, was not known. See 'Tryon Place Identifies Undiscovered 18th-Century Evidence', *Carolina Comments*, North Carolina Division of Archives and History, vol. 40, no. 2, March 1992. This is in the Archivo de Francisco de Miranda, Tomo 5, Folios 95–7, Academia Nacional De La Historia, Caracas; but see also Alonzo Thomas Dill, *Governor Tryon and His Palace*, University of North Carolina Press, 1955.

79 This opening was commemorated the *The Connoisseur Year Book 1959*, by Gregor Norman-Wilcox, 'Tryon Palace The Royal Governor's Residence and Colonial Capital at New Bern, North Carolina', pp. 104–9.

80 Most recent research work has been conducted, first by John Barden, then by Peter Sandbeck of the Colonial Williamsburg Foundation.

81 I am most grateful to Nancy Richards, Curator of the Collections, Tryon Palace, for her identification of this important memorandum (see Appendix 3), and for her constant help.

Chapter 10: William Randolph Hearst: The Great Accumulator

1 S.N. Behrman, *Joseph Duveen*, New York, 1952, p. 97.

2 See the chapter 'Hell-Bent for Ruin', in W.A.Swanberg, *Citizen Hearst. A Biography of William Randolph Hearst*, London, 1961; but more recently see David Nasaw's magisterial *The Chief, The Life of William Randolph Hearst*, Boston, 2000, and Taylor Coffman, *Building for Hearst and Morgan*, Berkeley, 2003, the last title a little disappointing for its meagre discussion of Hearst's acquisition of salvages – understandable in view of lack of documentation.

3 Nasaw, chapter 17, 'Builder and Collector,' pp. 287–302.

4 Nasaw, pp. 295–96.

5 But these are but a small part of a larger whole. The Hearst Corporation documents may have been available to Nasaw, but to no other.

6 I quote from a typescript, 'The William Randolph Hearst Collection' by Taylor Coffman, prepared for the library of C. W. Post Campus, Long Island University, the repository of the Hearst Corporation's purchase dockets of those items kept in the Hearst warehouse on Southern Boulevard in the Bronx. I am also indebted to Brian Gallagher, 'William Randolph Hearst and the Detroit Institute of Arts', *Bulletin of the Detroit Institute of Arts*, vol. 76, 2004, pp. 54–63.

7 See Mrs Fremont (Cora M.) Older, *William Randolph Hearst, American*, New York, 1936.

8 It is now at San Simeon, next to the Casa del Mar.

9 Older, *op. cit.* She was writing long after the event, and from memory, of the Worth House.

10 If it was a room made up of salvages.

11 John K. Winkler, *W.R. Hearst: An American Phenomenon*, New York, 1928.

12 Older, *op. cit.*, p. 345.

13 This may have been the Jacobean Julius Caesar Room from Rotherwas Park, Herefordshire.

14 Later Parke-Bernet Galleries.

15 Quoted by Nasaw, p. 232 from Wesley

Towner, *The Elegant Auctioneers*, New York, 1970, pp. 182–93.

16 See Victoria Kastsner's magisterial *Hearst Castle. The Biography of a Country House*, New York, 2000. Until the Hearst Corporation archives are fully available, and they are not, very little can be deduced about his collecting mania. In the Bronx warehouses are still masses of crated salvages, and all the inventories and photographs. Mr Hoyt Fields of San Simeon sends me the following from the St Simeon warehouse cards: Tudor Room Panelling was received May 14, 1927 (sold May 1, 1964). Jacobean oak panelling and mantel from White, Allom, via Charles of London, received from Cannell and Chaffin, April 2, 1927. Sent to McGregor, New York, Dec. 15, 1936 (? Sold). Three pieces of linenfold with two oak supports and oak coffer front, from Stair and Andrew, November 16, 1926, received from New York, Feb. 7, 1927. Sent to Hill, March 17, 1930. Sold April 1959. Four renaissance oak panels, two heads in relief, two with floral design. From Stair and Andrew, 16 November, 1926. Sold October 1960.

17 See Sara Holmes Boutelle, *Julia Morgan Architect*, New York, 1988. Hearst proposed installing an 'English barn' there. See Coffman, 2003, pp. 3–7.

18 For a full account see chapter 5, pp. 85–6; see also Older, *op. cit.*, chapter XLVII, pp. 456–65; and Nasaw p. 403, although it is not clear whether this letter of instructions exists.

19 Marion Davies, *The Times We Had*, Indianapolis, 1975, p. 101.

20 Howard C. Heyn, 'Marion Davies' Beach House Becomes Hotel. Rare Carvings and Antiques Grace Modern "Versailles",' *Los Angles Examiner*, 16 October 1949, quoting *Architectural Digest*, vol. XII, no. 2, 1949; see also Anne Edwards, 'Marion Davies' Ocean House. The Santa Monica Palace Ruled by Hearst's Mistress', *Architectural Digest*, April 1994, pp. 175, 277.

21 The Metropolitan Museum has no record of such a gift.

22 This cost $35,000. Cautiously, it must be said that no evidence exists for work of the 1740s in the house.

23 Surely Admiral Beatty.

24 According to Desmond Fitzgerald there is no Hatton Hall. Speranza Wilde came from Elgie, Co. Wexford. She lived at 1 Merrion Square, Dublin, from 1855.

25 See Edwards, *art. cit.*, pp. 170–75.

26 F. Scott Fitzgerald, *The Great Gatsby*, Everyman's Library, 1991, p.18.

27 Possibly a Hamilton Palace room.

28 Nasaw, pp. 365–66, quoting Robert B. King and Charles O. McLean, *The Vanderbilt Homes*, New York, 1989, pp. 164–67.

29 See Nasaw's chapter 'The Fall', pp. 527–42; and Swanberg, pp. 485–509 for an account of Hearst's fall.

30 Nasaw, p. 556.

31 *New York Times*, 11 October and 19 November 1937. Apparently no list of buyers exist, or no statistics have been allowed to emerge from the apparent cordon thrown around the Hearst Corporation archives.

32 New York, Hammer Galleries, 1941.

33 This was a subsidiary of Hearst's holding company through which he paid for his art.

34 These are in fact page references.

35 See chapter 11 for full abstracts from the dockets.

36 CWPost docket v. 86, 35.

37 CWPost docket no. v. 86, 24.

38 CWPost docket no. v. 87, 9. Still unidentified as to location. Bought from Charles in 1927.

39 CWPost docket, no. v. 86, 26.

40 CWPost docket no. v.87, 14.

41 CWPOst docket no. v. 95, 3.

42 CWPost docket no. v. 95, 5.

43 CWPost docket v. 95, 10.

Epilogue

1 Very few photographs survive, but what do are mostly in the Surrey History Centre, Woking, and the Departmental archives of the Museum of Fine Arts, Boston, and seem mainly to relate to interiors removed in 1913. All the photographs appear to have been taken by W.J. Pickering for the Epsom Literary & Scientific Society.

2 Discussed by Edna Donnell in 'The Chippendale Room in the Boston Museum', *Antiques*, May 1930, pp. 412–16. Donnell questions the Chippendale attribution and is also the first to comment upon the complexities of the history of the room.

3 See Mrs Russel Hastings, 'The Versatile Francis Brerewood', *Antiques*, Jan. 1934, pp. 15–16. In this same account, Brerewood himself bills £5 5 sh. for 'Work upon all the Pannels in Mr Clermont's Room' as well as £12 12 sh. for 'an Oval Painting in State Room', i.e. the Apollo and Daphne ceiling in the present Woodcote Park Room, probably enlarging it. The respective roles of Francis Brerewood and John Vardy are unclear.

4 This is almost certainly the date of the

Particular Description of Woodcote in Surry, a single sheet inventory of the rooms in the possession of the author.

5 This last is commented upon by Lancaster's advertising blurb in the *Connoisseur*, March 1914, p. 194.

6 It is odd that no photographs appear to survive of the Woodcote interiors after the extractions and before the devastating fire in 1934 – or so the Royal Automobile Club says. I find this difficult to believe, unless the photographs were burnt in the fire.

7 Sold by him at American Art Galleries, New York, 19 Nov. 1920.

8 Boston Art Museum files: letter from Roberson to Edwin J. Hipkiss, Head of Department of Decorative Arts.

9 Maybe Lancaster ceased trading at some point and Roberson bought his stock.

10 Seen by this author.

11 Probably in the 1960s. Information from Michael Conforti, Director of the Clark Art Institute, Williamstown, Massachusetts.

12 All of these references are to be found in the departmental files at the MFA.

13 John Harris, 'Clues to the 'Frenchness' of Woodcote Park, The *Connoisseur*, April 1961, pp. 241–50.

SELECT BIBLIOGRAPHY

Art Objects & Furnishing from the William Randolph Hearst Collection. Catalogue Raisonné . . . and Complete Index, New York, Hammer Galleries, 1941

Baker, Paul R., *Richard Morris Hunt*, Cambridge, Mass., MIT Press, 1980

Bétourné, R., *René Sergent, architecte 1865–1927*, Paris, 1931

Boutelle, Sara Holmes, *Julia Morgan, Architect*, New York, 1988

Bridenstine, James A., *Edsel & Eleanor Ford House*, Grosse Pointe Shores, 1988

Brownlee, David B., *Making a Modern Classic: the Architecture of the Philadelphia Museum of Art*, Philadelphia, 1997

Coffman, Taylor, *Building for Hearst and Morgan*, Berkeley, 2003

The Colonial Revival in America: A Winterthur Book, ed. Alan Axelrod, Winterthur, 1985

Colvin, Sir Howard M., *A Biographical Dictionary of British Architects 1600–1840*, New Haven and London, third edn 1995; fourth edn 2007

Cornforth, John, *English Interiors, 1790–1848: The Quest for Comfort*, London, 1978

Cornforth, John, *Inspiration of the Past*, 1985

Cornforth, John, *The Search for a Style: Country Life and Architecture 1897-1935*, London, 1988

Cornforth, John, *Early Georgian Interiors*, New Haven and London, 2004

Craven, Wayne, *Stanford White Decorator in Opulance and Dealer in Antiquities*, New York, 2005

Dickson, Arnold E., 'The Origin of the Cloisters', *Art Quarterly*, vol. 28, no. 4, 1965

Edenheim, Ralph, *Skansen Traditional Swedish Style*, London and Stockholm, 1995

Gay, Eben Howard, *A Chippendale Romance*, New York, 1915

Girouard, Mark, *The Victorian Country House*, Oxford, 1971

Gonzales Palacios, Alvar, *Il Patrimonio del Quirinale: I Mobile Italiano*, Milan, 1997

Goodison, Nicholas and Kern, Robert, *Eighty Years Antique Dealing*, London, 2004

Hall, S.C., *The Baronial Halls and Picturesque Edifices of England*, 2 vols, London, 1848

Halsey, R.T.H. and Tower, Elizabeth, *The Homes of our Ancestors as Shown in the American Wing of the Metropolitan Museum of Art*, Garden City, NY, 1925

Hammer, Armand, *Witness to History*, London, 1987 edn

Harris, John, *No Voice from the Hall: Early Memories of a Country House Snooper*, London, 1998

Harris, John, *Echoing Voices: More Memories of a Country House Snooper*, London, 2002

Heckscher, Morrison H., 'The Metropolitan Museum of Art: An Architectural History', *MMA Bulletin*, summer 1995

The History of the King's Works, ed. H.M. Colvin, vol. 4, *1485–1660*, part 2, 1982

Hoentschel, Nicole, *Georges Hoentschel*, Saint-Rémy-en-l'Eau, 1999

Hood, Graham, *The Governor's Palace in Williamsburg: A Cultural Study*, Colonial Williamsburg, 1991

Hosmer, Charles B., *Presence of the Past: A History of the Preservation Movement in the United States before Williamsburg*, New York, 1965

Hosmer, Charles B., *Preservation Comes of Age: From Williamsburg to the National Trust 1926–1944*, New York, 1981

Jourdain, Margaret, *English Decoration and Furniture of the Later XVIIIth Century (1760–1820): An Account of its Development and Characteristic Forms*, 1922

Jourdain, Margaret, *English Interiors in Smaller Houses from the Restoration to the Regency, 1660–1830*, London, 1923

Jourdain, Margaret, *English Decoration and Furniture of the Early Renaissance (1500–1650)*, London, 1924

Jourdain, Margaret, *English Decorative Plasterwork of the Renaissance*, London, 1926

Jourdain, Margaret, *English Interior Decoration 1500–1830. A Study in the development of design ... Illustrated from drawings, prints and photographs*, 1950

Kastner, Victoria, *Hearst Castle, Biography of a Country House*, New York, 2000

Kathryns, Michael C., *American Splendor: The Residential Architecture of Horace Trumbauer*, New York, 2002

Lathom, Charles, *In English Homes*, ed. H. Avray Tipping, London, vol. 1 (1904), vol. 2 (1907), vol. 3 (1909)

Lenoir, Alexander, *Musée Royale des Monuments Français*, Paris, 1815

Lewis, Arnold, Turner, James and McQuillan, Steven, *The Opulent Interiors of the Gilded Age*, New York, 1987

The London Encyclopedia, ed. Ben Weinreb and Christopher Hibbert, London, 1983

Mackay, Robert B. *et al.* (eds), *Long Island Country Houses and Their Architects 1860–1940*, New York, 1997

Maher, James T., *The Twilight of Splendor*, Boston, 1975

McMurray, Enfys, *Hearst's Other Castle*, Bridgend, 1987

Medlam, Sarah, *The Bowes Museum, Barnard Castle: English Architectural Woodwork 1580–1879*, unpublished report, Bowes Museum, 1991

Merrill, Linda, *The Peacock Room: A Cultural Biography*, New Haven and London, 1998

Metropolitan Museum of Art, 'The Cloisters', *Metropolitan Museum of Art Bulletin*, vol. 37, no. 1, summer 1979

Metropolitan Museum of Art, *The Cloisters: Studies in Honor of the Fiftieth Anniversary*, ed. Elizabeth C. Parker, Metropolitan Museum of Art, New York, 1992

Metropolitan Museum of Art, *Period Rooms in the Metropolitan Museum of Art*, New York, 1996

Miller, Donald, *The Architecture of Benno Janssen*, Pittsburgh, 1997

Miller, Sanderson, *The Diaries of Sanderson Miller of Radway*, ed. William Hawkes, The Dugdale Society, vol. 41, Stratford on Avon, 2005

Musson, Jeremy, *The English Manor House*, London, 1999

Myles, Janet, *Lewis Nockells Cottingham: 1787–1847: Architect of the Gothic Revival*, London, 1996

Nasaw, David, *The Chief: The Life of William Randolph Hearst*, New York, 2000

Neave, David and Waterson, Edward, *Lost Houses of East Yorkshire*, York, 1988

O'Connell, D.P., *Richelieu*, London, 1968

Ogdon Codman and the Decoration of Houses, ed. Pauline C. Metcalfe, Boston, 1988

Physic, John, *The Victoria and Albert Museum: The History of its Building*, Victoria and Albert Museum, 1982

Pons, Bruno, *French Period Rooms*, Dijon, 1995

Pons, Bruno, *Waddesdon Manor Architecture and Panelling*, London, 1996

Prévost-Marcilhacy, Pauline, *Les Rothschild: bâtisseurs et mécènes*, Paris, 1995

Roberson, Charles, *Historical Rooms*, 4 vols, London, *c.*1924–26

Roberts, Sir Hugh, *For the King's Pleasure: The Furnishing and Decoration of George IV's Apartments at Windsor Castle*, London, 2001

Robinson, Blackwell, P., *Three Decades of Devotion: The Story of the Tryon Palace Commission and Tryon Palace Restoration*, New Bern, 1978

Robinson, John Martin, *A Guide to Country Houses of the North-West*, London, 1991

Rorimer, James R., *The Cloisters: The Building and the Collection of Medieval Art in Fort Tryon Park*, New York, 1956

Rothery, Guy Cadogan, *English Chimney Pieces: their design and development from the earliest times to the nineteenth century*, London, 1927

Salney, Stephen M., *The Country Houses of David Adler*, New York, 2001

Sanger, Martha F. Symington, *The Henry Clay Frick Houses*, New York, 2001

Scott-Clark, Catherine and Levy, Adrian, *The Amber Room*, London, 2004

Sebba, Anna, *The Exiled Collector: Williams Bankes and the Making of an English Country House*, London, 2004

Sommerard, Alex du, *Les Arts du Moyen Age*, 5 vols, Paris, 1838–46

Stillinger, Elizabeth, *The Antiquers*, New York, 1980

Stoddard, Sheena, *Mr Braikenridge's Brislington*, City of Bristol Museum and Art Gallery, 1981

Stratton, Arthur, *The English Interior*, London, 1920

Thurley, Simon, *Hampton Court: A Social and Architectural History*, New Haven and London, 2003

Tipping, H. Avray, *English Homes of the Early Renaissance*, London, 1912

Tipping, H. Avray, *English Homes, Periods I–VI*, London, 1920–36

Tracy, Charles, *Continental Church Furniture in England: A Traffic in Piety*, Woodbridge, 2001

Tyack, Geoffrey, *Warwickshire Country Houses*, Chichester, 1994

Utrecht, Centraal Museum, *8 Meubelen tot 1900* (contribs: Reinier Baarsen, Dirk Jan Biemond, Paul van Duin, Anne-Sophie van Leeuwen), Utrecht, 2005

Vernay, Arthur S., run of trade catalogues in Henry Francis du Pont Museum and Library, Winterthur, Delaware

The Wainscot Book: The Houses of Winchester Cathedral and Close and their Interior Decoration 1660–1800, ed. John Crook, Hampshire Record series 5 and 6, Winchester, 1984

Wainwright, Clive, 'The Antiquarian Interior in Britain 1780–1850', University of London Ph.D. thesis, 1986

Wainwright, Clive, *The Romantic Interior: The British Collector at Home 1750–1850*, London, 1989

Wells-Cole, Anthony, *Art and Decoration in Elizabethan and Jacobean England*, New Haven and London, 1997

Whitehill, Walter Muir, *Museum of Fine Arts Boston: A Centennial History*, 2 vols, Cambridge, Mass., 1970

Wilk, Christopher and Nick Humphrey, *Creating the British Galleries at the Victoria and Albert Museum: A Study in Museology*, London, 2004

Wilson, Richard Guy, Diane Pilgrim and Richard Murray, *The American Renaissance 1876–1917*, New York, 1979

Winkler, John K., *W.R. Hearst: An American Phenomenon*, New York, 1936

Worsley, Giles, *England's Lost Houses: from the Archives of Country Life*, London, 2002

Yetter, George Humphreys, *Williamsburg before and after the Rebirth of Virginia's Colonial Capital*, Colonial Williamsburg, 2004

Yorke, James, *Lancaster House: London Greatest House*, New Haven and London, 2001

Young, Mahouri Sharp, 'George Gray Barnard and The Cloisters', *Apollo*, Nov. 1977

INDEX

Page numbers in *italics* refer to captions of illustrations

PHOTOGRAPHIC ACKNOWLEDGEMENTS